Artemisia

Alexandra Lapierre is a novelist and biographer. Her book, *Fanny Stevenson*, won the Grand Prix Littéraire des Lectrices de *Elle*. She currently lives in Rome.

ALSO BY ALEXANDRA LAPIERRE

Fanny Stevenson

Alexandra Lapierre

ARTEMISIA
The Story of a Battle
for Greatness

TRANSLATED BY
Liz Heron

VINTAGE

Published by Vintage 2001

2 4 6 8 10 9 7 5 3 1

Originally published in France in 1998 by
Éditions Robert Laffont, S. A.

First published in Great Britain in 2000 by
Chatto & Windus

Vintage
Random House, 20 Vauxhall Bridge Road,
London SW1V 2SA

Random House Australia (Pty) Limited
20 Alfred Street, Milsons Point, Sydney
New South Wales 2061, Australia

Random House New Zealand Limited
18 Poland Road, Glenfield, Auckland 10,
New Zealand

Random House (Pty) Limited
Endulini, 5A Jubilee Road, Parktown 2193,
South Africa

The Random House Group Limited Reg. No. 954009
www.randomhouse.co.uk

A CIP catalogue record for this book
is available from the British Library

ISBN 0 09 928939 3

Papers used by Random House are natural, recyclable
products made from wood grown in sustainable forests.
The manufacturing processes conform to the environ-
mental regulations of the country of origin

Printed and bound in Great Britain by
Bookmarque Ltd, Croydon, Surrey

To my father, with a fond wink

Contents

PART IV: THE ALLEGORY OF PAINTING
London, Venice and Naples at the Time when Painters Were Spies,
1621–1638

PART V: THE TRIUMPH OF PEACE AND THE ARTS
London at the Time When Paintings Were Being Burned, 1638–1641

List of Characters

PIERANTONIO STIATTESI – Brother of Giovan Battista Stiattesi. Artemisia's husband and the father of her four legitimate children. Born in Florence, 16 January 1584. Painter.

PRUDENZIA PALMIRA STIATTESI – Daughter of Artemisia and Pierantonio. Born in Florence, 1 August 1617. Married in Naples around January 1638. Painter and musician.

'FRANCESCA' STIATTESI GENTILESCHI – Real name unknown. Possible illegitimate daughter of Artemisia. May have been born to an unknown father around 1627. It seems likely she was married in Naples on 13 March 1649 to a knight of the order of San Giacomo. Painter.

The Tassi Gang

AGOSTINO TASSI – Orazio's collaborator and lover of Artemisia. Baptised in Rome, 3 August 1578, buried in Rome, 25 February 1644. Painter.

MARIA CANNODOLI TASSI – Wife of Agostino.

COSTANZA CANNODOLI FRANCHINI – Sister of Maria Cannodoli and sister-in-law to Agostino, whose lover she was for thirty years.

FILIPPO FRANCHINI – Obliging husband of Costanza. Apprentice and head of Agostino's workshop.

OLIMPIA TASSI BAGELLIS – Sister to Agostino, who took him to court for incest with his sister-in-law in February 1611.

VALERIO URSINO – Intimate friend of Agostino whom Agostino had imprisoned for debt in July 1611. Painter and colour-seller.

NICCOLÒ BEDINO – Servant and puppet of Agostino. Witness at the rape trial of 1612.

The Patrons of Orazio and Artemisia

THE DUKE OF ALCALÁ (FERNANDO ENRIQUEZ AFAN DE RIBERA) – Third Duke of Alcalá. Born in Seville in 1583, died in Villach, 28 March 1637. Viceroy of Naples from 1629 to 1631, then Viceroy of Sicily from 1632 to 1636. Invited Artemisia to Naples and took to Spain several of her paintings.

CARDINAL PIETRO ALDOBRANDINI – Cardinal and nephew to Clement VIII who was Pope from 1592 to 1605. Commissioned Orazio to decorate his diocesan church, San Nicola in Carcere (1599).

POPE PAUL V BORGHESE – Pope from 1605 to 1621. Commissioned Orazio and Agostino Tassi to decorate the Consistorium of the Quirinal Palace (1611).

CARDINAL SCIPIONE BORGHESE – Cardinal and nephew to Paul V. Great Roman patron. Commissioned Orazio and Tassi to decorate his 'Casino of the Muses' (1611–1612)

MICHELANGELO BUONARROTI THE YOUNGER – Grand-nephew to Michelangelo. Born in Florence, 4 November 1568, died in Florence, 11 January 1646. Dramatist and poet. Commissioned Artemisia to paint one of the panels that decorate the ceiling of his gallery.

CAVALIERE CASSIANO DAL POZZO – Secretary and intimate friend of Cardinal Francesco Barberini, the nephew of Pope Urban VIII. Born in Turin, 21 February 1588, died in Rome, 22 October 1657. Great collector of antiquities, patron of Poussin and all the best painters of the first half of the seventeenth century. One of Artemisia's principal patrons.

CANON LELIO GUIDICCIONO – Art lover and scholar in the entourage of Cardinal Borghese and the Barberini cardinals. Witness at Artemisia's marriage.

HENRIETTA MARIA OF FRANCE, QUEEN OF ENGLAND – Catholic wife of Charles I. Daugher of Henri IV and Marie de Médicis. Born in Paris, 25 November 1609, died in 1669. Commissioned Orazio to decorate the ceiling of the central hall of her residence in Greenwich.

COSIMO II DE' MEDICI – Grand Duke of Tuscany from 1609 to 1612. One of his several commissions from Artemisia was a second version of her *Judith Slaying Holofernes*.

MARIE DE MÉDICIS – Widow of Henri IV. Queen Mother of France. Born in Florence, 16 August 1573, died in Cologne, 3 July 1642. Invited Orazio to Paris in 1624.

Artemisia's Friends

CRISTOFANO ALLORI – Born in Florence, 17 October 1577, died in Florence, March 1621. Painter.

FRANCESCA CACCINI (called LA CECCHINA) – Born in Florence, 18 September 1587, died in Rome around 1640. Singer and composer.

NICHOLAS LANIER – Born in London, 9 September 1588, died in Greenwich, 24 February 1666. Musican, painter and agent on the art market.

The Others

CAVALIERE D'ARPINO – Born in Arpino in 1568, died in Rome in 1640. A painter who was fashionable in his time. Chief painter on many of the projects on which Orazio worked.

GIOVANNI BAGLIONE – Born in Rome in 1573, died in Rome in 1644. Painter whose style is a good example of late Mannerism. He took Caravaggio and Gentileschi to court in 1603.

ANTINORO BERTUCCI – Colour-seller in the Via del Corso. His shop served as a meeting place for artists.

CARAVAGGIO (MICHELANGELO MERISI) – Born in Caravaggio in 1571, died at Porto Ercole in 1610. He revolutionised painting and had a huge influence on Orazio. Artemisia was a follower of his style.

BEATRICE CENCI – Executed on 11 September 1599 in the Piazza di Ponte Sant'Angelo for having murdered her father.

LUDOVICO CIGOLI – Tuscan painter born in 1559. Died in Rome in 1613. A great favourite of the Borghese, he introduced Agostino Tassi at the papal court.

BALTHAZAR GERBIER – Professional rival to Orazio Gentileschi in England and a personal enemy. Born in Middleburg in Holland, 23 February 1592, died in London in 1662. Painter, architect and keeper of the collection belonging to the Duke of Buckingham; Charles I's envoy to Brussels and a great friend of Rubens.

TUZIA MEDAGLIA – Tenant of Orazio Gentileschi and Artemisia's chaperone.

GIROLAMO MODENESE – Suitor to Artemisia and rival to Agostino Tassi.

DANIEL NYS – Flemish art dealer who operated from Venice. Protestant. Between 1627 and 1631 he negotiated the sale to Charles I of the collection of paintings belonging to the Gonzagas, the Dukes of Mantua. The triumph of his career, this deal went on to ruin him.

Preface

My love affair with Orazio Gentileschi and his daughter Artemisia began twenty years ago. I first came across them in a setting that had nothing to do with the seventeenth century or with Italy – in Los Angeles, where a stunning exhibition offered an overview of the work of women painters from 1550 to 1950. I was particularly taken by six canvases, all of them striking in their magnificence, their violence and their originality. Full of admiration, I rushed to find out more about the woman who had produced them. But the only reply I got was a kind of reprimand, almost a warning: 'Don't get involved with Artemisia Gentileschi!'

Being warned off like this inevitably meant that my curiosity was aroused. Apparently there were drawers full of doctoral theses on Artemisia Gentileschi in universities across the United States. Her popularity was partly due to the fact that a high proportion of work done in universities must be devoted to so-called 'minority' artists – Hispanic, African or female. How many women artists were sufficiently talented to justify decades of research? Very few, and Artemisia Gentileschi was the artist everyone went for, particularly in view of the fact that her colourful private life could easily be seen to justify the splashes of crimson blood spurting out all over her canvases.

Over the years, as I travelled, I frequently stumbled across Artemisia quite by chance. Each time I experienced the same feeling of elation. But I was wary. Artemisia seemed to exert too much power. I was afraid of her. My instinct was to turn instead to people whose life and work had been less visible – to powers behind the throne, to heroic figures of whom nothing was known.

But then Orazio's daughter caught me unawares. She grabbed hold of me in a way I hadn't anticipated – via her father.

It happened during a summer visit to Rome. The weather was hot and humid and I was admiring the Caravaggios in the cool church of San Luigi dei Francesi. *The Calling of St Matthew* had attracted such a large crowd that I was forced to wait in a small chapel for it to disperse. I leant on the balustrade, gazing at the folds in the huge marble curtain swinging open to reveal a dazzlingly white dome, admiring the graceful little window through which an ochre light seeped in, and the dancing garlands of gilded motifs and putti. My guidebook told me that this chapel had been planned, designed and built by a woman, an architect called Plautilla Bricci, who had designed churches in the Papal States in Caravaggio's day. This reminded me of an earlier enthusiasm of mine. In the Bibliothèque Nationale in Paris, and in art history textbooks, Plautilla Bricci's name appears alongside that of her brother. And of her father. It was her father who had trained her, and her commissions had come through him and his workshop. Her life seemed to hinge on this family relationship. As I stood there in the chapel, reflecting on her strange career, I heard someone – a tourist or a guide – say something that surprised me: 'You see that painting of St Matthew over there. One of the figures is said to be the portrait of a drinking companion of Caravaggio's – the painter Orazio Gentileschi.'

Now, Orazio and I went back a long way. And our relationship was a passionate one.

Orazio Gentileschi is thought of by art lovers, art historians and dealers as one of the greatest painters in history, but the general public is not familiar with him. Among those who visit the Louvre, however, his work has many admirers. In the Grande Galerie, right next to Caravaggio's *Death of the Virgin*, is a magnificent *Rest on the Flight into Egypt*, very moving, very subtle, very human. The inscription below reveals the artist's name: 'Orazio Gentileschi, born Pisa 1562, died London 1639'.

I had got to know Orazio's work in the Prado, at Hampton Court, in Nantes, and my admiration and my delight increased every time I saw another of his paintings. Thanks to him, I would secretly enjoy the heady thrill of beauty. But ever since the warning about his daughter in Los Angeles a couple of decades earlier, I had felt I could not look into his career and character. Now, in that church in Rome, I felt quite giddy. I could not hold off any longer. I decided to immerse myself in the lives of Orazio Gentileschi and his daughter Artemisia.

As I set off on my hunt for this father and daughter, my own life took a new turning. My pursuit of them led me to leave France. I explored worlds of which I had previously known nothing, learning Italian and Latin, studying paleography. I travelled all over Europe, hanging about on street corners where once the Gentileschis, *père et fille,* had lingered. And advancing one step at a time, I tracked them down. It may well be that this pursuit across the centuries will turn out to have been the biggest adventure of my life.

As I delved into the Vatican's *Archivio Segreto,* the *Archivio storico capitolino* and the *Archivio storico del Vicariato di Roma,* and into the national archives in Rome, Florence, Venice and Naples, and also in Madrid, Paris and London; as I combed through huge registers yellow with age, studied sheets of parchment covered with brown ink – the lines of writing superimposed, overlapping and blending into one another – among all those thousands of first names and millions of deaths, I kept on coming across those two names, Orazio and Artemisia. Thanks to baptism certificates, IOUs, marriage contracts and *post mortem* inventories, their voices can still be heard ringing through the silence. Across the centuries there came to me the insulting tones of denunciations, the vindictiveness of accusations and the cynicism of people as they bequeathed their property, or disinherited someone. Their words have been recorded in a series of documents relating to gifts, wills or lawsuits, exactly as they spoke them in the presence of court officials or notaries. The tiniest details of their lives four hundred years ago have been set down.

Yet I came to realise that this type of research was not enough. If I was to tell their story, I would have to try to put Orazio and Artemisia back into the historical, religious and social contexts of the various worlds they had inhabited. I would have to bring alive the art world and the mentality that influenced Caravaggio's paintings and the building of St Peter's in Rome. I needed to dig up more details, to delve deeper.

I was obsessed by the importance of accurately representing what had happened to the Gentileschis. Yet, paradoxically, after five years of intensive research, I ended up feeling that the only satisfactory way to express the many-faceted reality that I wanted to convey, would be to use the tools of story-telling and to fictionalise elements of the story. For anyone who wants to know the ins and outs of my research – why I adopted certain theories and why I made the choices I did – there is a section of notes at the back of the book.

Translator's Note

The French edition of *Artemisia* contained a number of translations into French of original Italian documents. If the document was available, I used the original Italian for my translation. These translations are generally indicated by an indented quotation in italics.

Liz Heron

PROLOGUE

London

11 February 1639

A galley cuts through the mist over the Thames and docks heavily to the accompaniment of a De Profundis, lugubriously intoned by Capuchin monks on the deck. Amid the dying flames of hundreds of candles, a huge black funeral bier looms up through the blur of the drizzle. A threatening crowd has assembled by the railings of the landing stage and around the carpet along which the cortège will make its way as far as Somerset House, the home of the Stuarts. Borne by six guards, the coffin is carried on to the gang plank.

Then, out of the fog, appears the solitary figure of a woman. As she follows the procession, her voluminous cloak shields her from curious eyes. Who does she weep for, under her veils? Is it her husband? Her lover?

The woman is weeping for her life, and for the man who was the heart of it, her father.

Four days ago, the famous painter Gentileschi died, much lamented by His Majesty, and by all of those who prized his gifts.

The words are those of the Grand Duke of Tuscany's representative, in his report on Charles I and the English court.

The artist being buried in this early morning London mist is renowned throughout Europe. Philip IV of Spain, Louis XIII of France, Pope Urban VIII, all move in the shadow of his canvases. He has worked at St Peter's in Rome, at the Quirinal, the Luxembourg Palaces, at Hampton Court. From Pisa to Florence, from Genoa to Turin, from Paris to London, he leaves a life's work which ranks him among the greatest artists. His rivals are Rubens and Van Dyck. They will outlive him by only a scant few years.

3

As a Catholic and a 'papist', this Italian painter could hardly have expected a fitting burial on heretic soil. Civil war is brewing in every corner of London, the war of religion which will soon bring about the downfall of the Stuart monarchy and Charles I's beheading; the King is accused of being over-sympathetic to the Catholic entourage of the wife who has sworn to convert him.

On this ominous February morning, the men who carry the remains of Orazio Gentileschi are hard put to clear a path through the thick crowd of hostile Puritans. Their anger is inflamed by all this pomp, by a procession which apes those in Rome – the silver candlesticks, the crucifixes, monstrances and reliquaries – by such lavish display in honour of an 'idolater', a maker of images who dared show that which no one should depict.

The column of monks winds its way around the fountains in the park, around the statues of naked women, nymphs or goddesses which the dead man had had brought from Italy.

Walking slowly, at the far end of the cortège, his daughter steps through the triumphal arch which has been built to the west of the Palace. This ephemeral structure, made of plaster and board, marks the entrance of the bier into the forecourt of Somerset House.

The crowd, hot on the heels of the procession, crosses the lawn and gathers under the funerary arch, bent on seeing the ceremony which it condemns. There is a rumour abroad that Gentileschi will be granted the signal honour of being buried beneath the altar of the Queen's Chapel. Henrietta Maria of France had to wait ten years for the present of this chapel from her husband, England's king; it is her greatest glory as a woman, a queen and a Catholic. The burial of the court's Catholic painter here, against the rumblings of an uprising that will soon turn into regicide, marks the ending of a period in which European monarchs have drained state coffers dry to satisfy their passion for splendour and refinement.

In the first half of the seventeenth century, kings, ministers and popes were ruthless and fanatical collectors. From time immemorial, art has served as an outward sign of wealth but, in the hands of seventeenth-century patrons, painters and sculptors were turned into currency. Italy had Bernini, Spain had Velázquez, Flanders had Rubens. Each made use of their neighbour's covetousness by offering titles and provinces, war or peace against the loan of this or that genius whom one or other of the potentates had managed to attach to himself. In short, by 1639 art had become the cornerstone of power – and the artist its instrument. Who else, other than an artist, was able to approach a

monarch in private on the pretext of painting his portrait? Which ambassador, diplomatic representative or spy could ever have enjoyed a daily intimacy like that between artist and model? Who would have had more opportunity than the painter, during these private interludes, to gossip with the king, to influence his thinking – perhaps to bend his decisions? And the chance to interfere in all the cabals at a foreign court? Both Rubens and Velázquez were diplomatic envoys. As was Orazio Gentileschi. In the service of their own nation, in the pay of their most powerful sponsor, at some moment or another, all of them held the fate of Europe in their hands. But none of them ever had any master but their art. This was the overriding business of their lives. What, in his letters, Rubens calls the 'Great Adventure'.

So when Orazio Gentileschi died in despair, at the age of seventy-seven, it was because he was leaving the world without having completed his mission on earth. The 'Muses', which he was painting for the ceiling of the Queen's House in Greenwich, would never exist except in his imagination. His great work, the sign and proof of his genius, would remain unfinished. The imperfection of this final creative work, which he had conceived as a culmination, an apotheosis, reduced his entire life to nothing and condemned him to oblivion. Unless someone else took up the challenge, someone he had trained, was jealous of and to whom he had done great injury – his daughter Artemisia.

At the time of Orazio's death, Artemisia Gentileschi was even more renowned than her father. She had worked for Philip IV of Spain and all the crowned heads of Europe. She was famous, beautiful and scandalous. It was well known that, at the age of seventeen, she had been raped by her father's closest collaborator and had had the audacity to take the matter to law. The outcome was a sensational court case, several hundred pages of testimony, the century's first prominent rape trial.

Yet, twenty-five years later, she featured on the list of the world's wonders, and the virtuosity of her skills was celebrated by poets. In the eyes of her contemporaries she stood as one of the greatest female history painters, perhaps the most brilliant of all. 'In me you will find Caesar's soul in the heart of a woman,' she acknowledged in a letter to one of her patrons.

The King's guards have hurriedly locked the doors of the Queen's Chapel behind Artemisia. The coffin now rests beneath a velvet baldachin with silver tassels.

No artist since Raphael in Rome, or Michelangelo in Florence, has ever received the honours that England bestows this morning on the Italian Gentileschi. But the nave is empty and the atmosphere oppressive. Not an inch of stone, metal or wood is visible. The geometric patterns of the floor, the caissons on the ceiling, the balance and perfection of the building's proportions are all obscured by a vast black canopy of crêpe. It explodes into a froth of ruffles, flounces and rosettes. Unseen musicians chant a mournful Dies irae. The rise and fall of their breath makes the hangings shiver, as if ghosts are singing. Sitting at the foot of the bier, turned towards the back of the church, are two spectral figures in stucco, holding aloft an hourglass and a scythe, as if in greeting to the upper gallery. There, a large statue of a winged skeleton lifts a curtain to disclose Orazio's daughter in the shadows.

Artemisia is alone on foreign soil. She hears the distant shouting of a crowd whose language she does not understand and she looks upon the remains of the man who meant most in her life.

She has come all the way from southern Italy in answer to the ageing artist's call: she will finish his work for him. She will sign it for him: Gentileschi father-and-daughter. Which of the two has most influenced the other, the father or the daughter? Who was the master and who the pupil? What they gave to each other they always took back. Today there is peace between them; and there is death. She accepts it. Orazio taught her everything. Artemisia has come to repay it all to him.

At a time when daughters belonged to their fathers, when art was a matter of life or death, when the dagger and the paintbrush were found in the same hands, both Artemisia and Orazio were prepared to kill in order to prove their superior talent. Both of them did much more than dream of the other's passing. Was there parricide? Incest?

By taking her father to his last resting place, by completing Orazio's work, Artemisia knows that she is bringing fate full circle. She may well go on painting, but art and life are behind her. Her 'great adventure' ends here, in London, in this month of February 1639.

BOOK ONE
THE GREAT ADVENTURE

Rome at the dawn of the seventeenth century

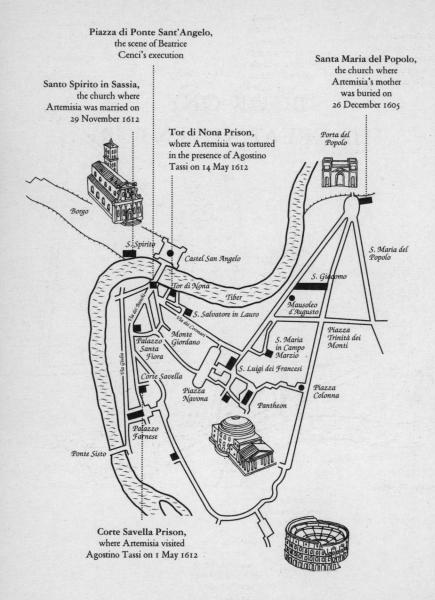

Piazza di Ponte Sant'Angelo, the scene of Beatrice Cenci's execution

Santo Spirito in Sassia, the church where Artemisia was married on 29 November 1612

Santa Maria del Popolo, the church where Artemisia's mother was buried on 26 December 1605

Tor di Nona Prison, where Artemisia was tortured in the presence of Agostino Tassi on 14 May 1612

Porta del Popolo

Borgo

S. Spirito

Castel San Angelo

S. Maria del Popolo

Tor di Nona

Tiber

S. Giacomo

Via del Coronari

S. Salvatore in Lauro

Mausoleo d'Augusto

Monte Giordano

Via dei Banchi

Palazzo Santa Fiora

S. Maria in Campo Marzio

Piazza Trinità dei Monti

Corte Savella

S. Luigi dei Francesi

Via Giulia

Piazza Navona

Pantheon

Piazza Colonna

Palazzo Farnese

Ponte Sisto

Corte Savella Prison, where Artemisia visited Agostino Tassi on 1 May 1612

The Artists' Quarter

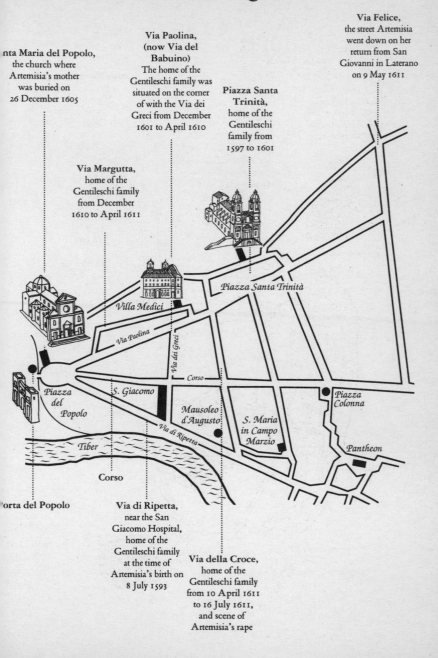

nta Maria del Popolo, the church where Artemisia's mother was buried on 26 December 1605

Via Paolina, (now Via del Babuino) The home of the Gentileschi family was situated on the corner of with the Via dei Greci from December 1601 to April 1610

Via Felice, the street Artemisia went down on her return from San Giovanni in Laterano on 9 May 1611

Piazza Santa Trinità, home of the Gentileschi family from 1597 to 1601

Via Margutta, home of the Gentileschi family from December 1610 to April 1611

Piazza Santa Trinità

Villa Medici

Via Paolina

Via dei Greci

Corso

Piazza del Popolo

S. Giacomo

Mausoleo d'Augusto

Piazza Colonna

S. Maria in Campo Marzio

Via di Ripetta

Pantheon

Tiber

Corso

orta del Popolo

Via di Ripetta, near the San Giacomo Hospital, home of the Gentileschi family at the time of Artemisia's birth on 8 July 1593

Via della Croce, home of the Gentileschi family from 10 April 1611 to 16 July 1611, and scene of Artemisia's rape

PART I
SUSANNA AND THE ELDERS

Rome in Caravaggio's Day

1599–1611

1

Piazza Ponte Sant'Angelo

11 September 1599

Through air acrid with sweat and dust the light blinded thousands of eyes. Though God knows if those eyes really wanted to see. Opposite the scaffold, the dome of the Vatican basilica blazed incandescent beneath a white sun that blanched the great marble statues of Saints Peter and Paul that rose up at the entrance to the bridge, brandishing the Martyr's Sword and the Keys to Paradise.

A feverish, restless crowd had massed on the banks of the Tiber, swarming into the boats which pitched about dangerously between the yellow mud at the water's edge and the river's currents. The roof-tops, dark with people, threatened to cave in. Bare-headed in the scorching heat, women and children were crushed together at windows, or on terraces and loggias. Even the prison gangways, the loopholes of Tor di Nona and the battlements of the Castel Sant'Angelo thronged with captives who had been granted the privilege of watching this *spettacolo edificante*. The nobility's carriages jammed the whole neighbourhood, cutting off streets and squares as far as San Giovanni in Laterano. It was, after all, for the aristocracy's sake that the spectacle was being staged.

What they were about to witness was the obliteration of one of Rome's great lineages: the Cenci, whom the Court of Justice had found guilty of murder. The three children and the second wife of the patrician Francesco Cenci had killed him with hammer blows to the head. The instigator of the crime had been the victim's own daughter – eighteen-year-old Beatrice Cenci.

By publicly executing every member of the family – despite the fact that their nobility gave them the right to a private execution – by subjecting them

all, the women included, to the most appalling agonies, the Pope was sending a deliberate message to his barons: on the eve of the 1600 Jubilee, which would bring five hundred thousand pilgrims to the holy city, Pope Clement VIII wanted Rome to exemplify a new order, and to embody in the eyes of the world a model government. The Pope was not just the spiritual head of Christendom, he was a temporal sovereign and absolute monarch, reigning over all the territories of the Church, which extended across the centre of Italy, between the Adriatic Sea and the Mediterranean. Like all other princes, perhaps more so, his concern was to rein in the age-old anarchy of his feudal lords. Beatrice Cenci's crime gave him just the opportunity. After the Council of Trent a new kind of justice had been born, a brand of justice which was not merely repressive, but preventive. Fairness had no place in it whatsoever.

No one on the Sant'Angelo Bridge was unaware that Count Cenci, the victim whose memory Pope Clement today presumed to revenge and whose murderers he claimed to punish, belonged to that self-same caste of blood-soaked aristocrats, tyrants and monsters which he wished to diminish. At sixteen, the innocent Beatrice had been locked up in a fortress where she had been beaten and raped by her father. By killing him, the young woman had done no more than avenge her lost honour. This at least was the view widely held. But the Father of the Church saw higher and further. He required this young woman's head for the sake of the Eternal City. He had therefore refused to listen to her lawyers, going so far as to insult them for having assumed her defence. His grand scheme to decorate the basilica of St Peter's was emptying the state coffers. Funds were running dangerously low – and the Cenci were rich. By appropriating their wealth, Clement VIII could hope to complete the Clementine Chapel, which held the remains of his patron saint. By the end of 1600 at the latest, the mosaics on the pendentives of one of the small domes of St Peter's – on which a team of more than fifty artists was already engaged – would shine with bright radiance only feet away from the precious relics of Christ's closest companion, the first Father of the Church.

Every single one of this team was in the press of people on the bridge, along with all the other painters from the artists' quarter. And they made their way towards the scaffold with such impatience, such a frenzy of zeal that it might have suggested that the members of their guild had a particularly cruel streak. It was, in fact, no more than a matter of professional duty. 'For depictions of martyrs, be witness to capital executions', the treatises on painting prescribed.

'To represent the torments of the early Christians, observe the gestures of those condemned to death. Note their expressions when they mount the scaffold, their colouring, the movements of the eyes, their precise manner of frowning . . .'

The artists who had paid their annual dues to the Accademia di San Luca, the painters' official body, enjoyed a special authorisation which, either individually or as a group, they presented to the constables, who contrived to get them the best places. Recognisable in the front row was Cardinal del Monte's favourite, a short, thickset, swarthy fellow, Michelangelo Merisi da Caravaggio, for whom his patron had recently procured an exceptional commission, *The Calling and the Martyrdom of St Matthew*, for one of the chapels in the Church of San Luigi dei Francesi. Caravaggio's rivals muttered that he had been seen regularly in the dungeons of Corte Savella the week before . . . as a favoured visitor. In order to capture Beatrice's features without his work being disturbed, he had gained access to her cell to paint her in the guise of Judith or St Catherine, whereas they would have to make do with a fleeting likeness. They would have to retain the memory of her face, her martyrdom, in this heat, in this stench. Such, at any rate, was the complaint openly made by Caravaggio's former master, the Cavaliere d'Arpino, who could not get over having been ousted by his brilliant pupil. He was supervising the work being done on the decoration of the transept of San Giovanni in Laterano, the cathedral of the world, the Pope's personal bishopric. The task of rendering Beatrice Cenci's portrait before her execution should have been his by right!

Next to this illustrious figure, right at the foot of the scaffold, stood a middle-aged man who was also extremely well known on the Roman scene: the painter Orazio Gentileschi. He was a protégé of Monsignor Pietro Aldobrandini, the most powerful prelate after the Pope. His austere attire distinguished him from his fellow artists and he could be observed from a distance, for he carried a child on his thin shoulders. This was a little girl of six, and he was telling her about the 'edifying spectacle' about to be enacted. While he explained the details of the trial and the torments which were to take place, a young man – unnoticed by anyone – cut through the crowd and cleverly inched his way towards the platform. He was boisterous and excitable and, mingling with the most famous artists, he spoke to them as if they were old acquaintances. In the course of conversation he would introduce himself, all innocence, as: 'Agostino Tassi, painter'. He told them that he too could

easily have done a picture of Beatrice Cenci in prison. He'd been there himself for a short spell in March. He was twenty-one and just back from Florence at the time. He had been arrested in the artists' quarter shortly after his return to Rome, which was his native city. A charge of abusing, assaulting and wounding a courtesan who had refused to go to bed with him. He laughed as he described the 'thrashing' he had given her. The business had had consequences, since he had tried to carve up the woman with a knife, inflicting extensive injuries. Giving testimony, the neighbours had relished repeating the words he had used: 'Whore, bitch, trollop, I'll throw a basin of shit in your face! Go and fuck yourself with a flogging-switch! I'll shove my paintbrush handle up your ass!'

This kind of thing was commonplace in the artists' quarter. The law in the papal states was unoffended by such obscenities, of which legal records, cross-examinations and police reports supply plentiful instances. Seventeenth-century men were no prudes; they didn't mince their words, nor did they hesitate to call a spade a spade.

What had really cost the young Agostino Tassi dear in March 1599 was the knife drawn in the margin of the constables' report. The police in Rome prohibited the bearing of arms. None the less, the alleyways of the artists' quarter remained among the most fearsomely dangerous back streets in Europe. And nights in the holy city were the most violent and hot-blooded in Christendom. Men of the same nationality stuck together, living in gangs, and this situation led to all kinds of disorder. The fluctuations of European politics were an excuse for brawls between clans and a pretext for professional jealousies. Every evening, painters from rival factions, Frenchmen and Spaniards, crossed swords under the mocking gaze of groups of Italians who for their part slaughtered one another, Tuscans against Bolognese, Neapolitans against Romans. Therefore no one was allowed to go about wearing a sword unless he was a gentleman, or else a holder of a permit stamped with the seal of the prefecture. Woe betide the man caught by the constables with a dagger in his pocket.

Agostino Tassi had, moreover, been unlucky enough to get caught red-handed at night with a prostitute. Courtesans were so numerous in Rome that the Popes had attempted to pen them into an enclosure along the Tiber, the 'Ortaccio di Ripetta', a few hundred yards away from the artists' quarter. These ladies, of course, tended to escape from their ghetto to walk the surrounding streets. Though their presence was tolerated, they had been

forbidden from setting foot there after sunset. The Ave Maria bells would sound the start of curfew, the time when the constables, invisible in their great brown cloaks, would spread out all over the city.

But from inn to brothel, from workshop to tavern, painters, whores and hired killers continued to roam around in armed bands. Though the population of the city fell short of a hundred thousand, the majority was male, unmarried, young, foreign, ambitious and quarrelsome. How was public order to be assured in such conditions? Criminality was heightened by the number of 'no-go areas': places that were sacrosanct. It was impossible to apprehend criminals in churches – and there were more than four hundred churches where thieves and murderers could take refuge. The same applied to hospitals, hospices, monasteries, cardinals' palaces, the homes of certain noble families, and inside the precincts of embassies, where each nation upheld its own law, in accordance with its own jurisdiction, and with its own guard. The constables therefore had to catch the guilty red-handed, a strategy which explained the speed of their arrival and the arbitrary nature of their arrests; it also explained their uniform, those great cloaks the colour of darkness.

The previous March, by a miracle, papal justice had released Agostino Tassi without banishing him from Rome. He had merely had a taste of strappado. With a rope tying his hands behind his back, he had been hoisted several feet above the ground. Half an hour exposed like this at the corner of the Via del Corso and Via dei Greci, in the heart of the artists' quarter: it was the normal penalty for mischief-makers, a punishment which dislocated the shoulders without causing any lasting mutilation. Although, on the eve of the Jubilee, Clement VIII made plain his concern for order, his severity with regard to suspects and his cruelty towards the guilty, the customary thoroughness of the Roman judges had been restrained in these last few months by the Cenci trial which everyone had on their minds. They talked of nothing but the ordeal of the patrician family, the two brothers, the sister and stepmother, who were suspected of murdering their father and husband. But it was about the incestuous and parricidal young woman that they talked most of all.

Agostino Tassi elbowed his way through the crowd as far as the steps which the condemned woman would climb. He positioned himself right at the foot of the scaffold, next to the painter Orazio Gentileschi, who was attempting to

lift down his daughter; she was too heavy, he said. But the child was in a rage and struggling. She clung to him, begging him to keep her on his shoulders a little longer.

'Your little girl is right,' said Agostino, intruding. 'She won't be able to see a thing . . . Do you want me to hold you?' he asked her.

The child turned away without answering.

Orazio bent over, gripped her by the waist and set her firmly on the ground.

All of a sudden it was as if a wave had risen on the Tiber, a gust of wind which made the boats pitch about and dashed the crowds against the balconies and the parapets along the river and the bridge. A great surge forward thrust the front ten rows up against the soldiers.

A few yards away from the scaffold, four monks of St John the Beheaded, the order attendant on those destined for execution, with their black cowls and long, homespun habits, were dragging the wife of Beatrice's father out of the Chapel of the Condemned. She was an accomplice to the parricide, a witness to the incest, and she was to die first. She staggered, ashen, between the lines of constables who led her to the block. Two of the monks supported her under the armpits. A third murmured into her ear, exhorting her to die with dignity. As if holding up a mirror, the remaining one held a tablet of painted wood close to her face, hiding the scaffold from her eyes. This tablet depicted the decapitated head of John the Baptist on a silver platter. The effort was futile: at the sight of the axe and the executioner awaiting her on the platform, the condemned woman fainted. The miserable creature was raised up to the scaffold and tipped on to the block completely unconsciousness. There was no excitement in this, only slaughter. The drama was still to come. As the solitary figure of Beatrice emerged quickly from the chapel, the entire city reeled. All of Rome, from its prisons to its palaces, seemed stirred by the same emotions of pity, admiration and anger.

All except the group of painters beneath the scaffold, who remained mute. With pencils and paper at the ready, they experienced only the fear of failing to get a good look. Though the number of executions was multiplying on the eve of the Jubilee – up to five every week – those where the victim was a heroine of such youth, beauty and nobility were rare. She was little more than a child, and it was said that she had endured nine hours of torture with unbelievable courage; a child judged by everyone there to be innocent. In the bravery of this very young girl – who now advanced unaided into the crowd and climbed towards her death, erect, self-possessed, praying to God and

cursing the Pope – the Roman people saw the steadfastness with which the Saints Catherine, Ursula and Cecilia had died, all of them martyrs urged upon Catholic memory by the brushstrokes of Christian artists.

Presently, there was silence. The young girl had laid her head upon the block. The executioner was then seen to raise his arms, his axe flashing white in the sunlight. That was all they saw – the sunlight, the axe and the dome of St Peter's. The arms fell again, there was the dull sound of an axe blow. The blade had struck against the block.

Something rolled to the edge of the platform. The long dark hair, until that moment fastened by a kerchief, now spread out, bloodied, towards the crowd. The people let out a scream – a shriek of horror, a shriek of pity and hatred – at the sight of the severed head of a girl who was martyred to a father's tyranny and a pope's iniquity.

Among the painters who had enjoyed a close-up view of the spectacle there were two individuals who had not succumbed to horror-stricken stupor. Orazio Gentileschi and little Artemisia.

Without waiting for the final ordeal – there was still Beatrice's elder brother to be stunned, quartered, and the hewn-off parts of his body exposed to the elements – Orazio cleared a path back through the crowd, dragging his child behind him.

He was thirty-five years old, with a wife and four small children; the youngest had just come into the world. Six mouths to feed. The last-born of a family of goldsmiths, Gentileschi had left his native city of Pisa to work in Rome. There he had made his living as a miniaturist and engraver of medallions for nearly a quarter of a century. Though he had played a part in all the big projects, and was at that moment a member of the Cavaliere d'Arpino's team at San Giovanni in Laterano, his career had been at a standstill. Up until now. Through the mediation of one Cosimo Quorli, an under-steward to the Apostolic Chamber, an old family acquaintance and a Tuscan like himself, and like Clement VIII, the painter Orazio Gentileschi had just acquired a commission to decorate the gallery of the choir in San Nicola in Carcere. This particular church was the diocesan church of the cardinal who was nephew to the Pope – and the man closest to him – Monsignor Pietro Aldobrandini.

Pietro Aldobrandini was also the godfather of the executed Beatrice Cenci, her protector, and the intermediary to whom the young girl had entrusted her

last hope of winning the Pope's clemency. Who could ever be sure that the cardinal had pleaded her case with as much fervour as he claimed? He was the Pope's favourite, and Clement VIII planned to make him one of the prime beneficiaries of the Cenci executions. He had already assigned to him some of their castles and lands.

Perhaps as an act of contrition, a gesture of regret, the cardinal had ordered the painter who was to work on San Nicola, Orazio Gentileschi, to put a fresco on his new gallery depicting a saint with the face of the girl whose head had fallen that morning. For, beneath the high altar of Pietro Aldobrandini's very old church, there lay a treasure: the relics of three martyrs – two brothers and a sister, an entire family persecuted in Rome under Diocletian. The brothers had been beheaded, the sister strangled. And the female martyr (was this the hand of God, a quirk of fate or coincidence?) was called St Beatrice.

2

The Chancery Room of the Corte Savella Prison

12 September 1603

'Horatius, son of Giovan Battista, native of Pisa, will you tell us how, and for what reason, you come to be in prison?'

Short of stature, lean-bodied, the muscles sinewy on the backs of his thighs, Orazio Gentileschi stepped forward to the long table at which the deputy judge of the Roman Curia and the deputy prosecutor of the Papal States were seated.

'I was arrested this morning at home, and I am ignorant of the reason.'

Orazio wore a simple doublet of brown felt and chestnut-coloured cotton hose. He cut a sombre figure, the anonymous figure of all those Romans abroad at night who sought to elude the constables by melting into the darkness.

'Can you write?'

'I can write, but not without errors.'

He spoke the purest Tuscan, which was by now Rome's own official tongue. The common people muddied it with dialect; he did not. His accent, his bearing, a certain grasp of fine manners might have suggested he moved in high circles, but this man worked with his hands. The oils that yellowed his fingertips, the pigments encrusting his nails left his profession in no doubt. Yet something categorical and remorseless in his restless gaze gave his whole being a weight and presence which compelled interest and imposed respect.

When he had entered the Corte Savella prison that morning, the guard had put him as a matter of course in the 'not-poor' section. In the Roman prisons, the captives were not separated by virtue of the seriousness of their offences – or

the charges hanging over them – but according to their social status. *Poveri, non poveri, vecchi* – the poor, the not poor and the old.

Throughout the time of his incarceration, therefore, Orazio Gentileschi would meet the cost of his own needs. He would pay for his food and linen and cover his laundry and barber's bills. He would provide a mattress and bedding for himself. Had he been without any family – without a wife to deliver his meals to the Chancery, without a child to bring him his bedding – the costs of his detention would have fallen to his accusers. In his case, the question did not seem to have arisen. The constables had taken him in secret straight from his house in Via del Babuino to one of the cells located on the prison's lower level, those dungeons cut off from the world and reserved for prisoners awaiting trial.

The occasions when he was summoned to this little whitewashed room, with its crucifix and long table, would be his only relief from solitude. From there, Orazio could hear voices in the courtyard, the chapel bell, the noise of the refectory – the sounds of a transitional zone where prisoners were busy preparing their defence. The cross-examination by the two deputies would at last give him some clue to the nature of the charges against him.

'If you were to see your own handwriting, would you recognise it?'

'I think so.'

He held himself very straight in front of his judges and kept his arms folded across his thin chest. But the cap that shook in his hand, the vibration of its quivering feather at his side betrayed his emotion and his extreme nervousness.

'Have you seen this letter before?'

The eyes that glanced down at the paper were large and grey. The lips, excessively narrow and sinuous, remained pursed. He could have been forty. Or perhaps much younger. For Orazio Gentileschi belonged to that group of men who seem old before their time, and whose features travel imperceptibly from childhood to the grave. His dark little goatee was sparse, barely concealing a determined chin and pallid cheeks. His dry face was full of fire and his restless body consumed by feverish energy. But he maintained his guard. And with good reason. He had been sincere in earlier claiming ignorance of why he had been imprisoned. It was a fundamental aspect of any investigation that the defendant had to be kept in the dark about the crimes of which he was accused. Gentileschi was all the more mistrustful for never having experienced Roman prisons until this moment.

This was a fairly remarkable achievement. It was not that spells in Tor di Nona, Corte Savella and the Castel Sant'Angelo were the rule. But the painters who managed to avoid prison, or at the very least some legal wrangle, were few and far between. It seems that no one could match the inhabitants of the artists' quarter for litigiousness. Debts and promissory notes, tenancies and sub-tenancies, sales, exchanges, donations, revocations, disputes – they set down every last move they made in a contract which they countersigned before the law. They must have spent all their time at the notary's office. At the first difference of opinion, at the tiniest quibble, they would lodge a complaint. And in no time there would be a trial.

Yet there was not a trace of Orazio Gentileschi, either in notarial records or in police reports. Nor even in the doctors' notes on those who turned up at the hospitals with injuries during the night. No brawls? No drunken sprees? Was Orazio Gentileschi such a paragon of virtue? The law had its doubts.

After inspecting the paper which was held out him, Orazio straightened up again and answered candidly.

'This letter you are showing me was seized by the notary this morning at my home.'

'So you recognise it as yours?'

A glimmer came into the defendant's eyes. Orazio Gentileschi had just realised what they were after! He stepped back, faltering.

'I saw it, but I don't remember it any more.'

'Did you see the poem written on the back?'

'I saw it, but I don't remember it any more.'

'Do you recognise your handwriting in this poem, and in this letter?'

'Maybe, yes, but maybe not. I write in different hands. Sometimes I write in ink, sometimes with a pencil. What you're showing me is perhaps in ink. Or it could be something else . . .'

The deputy waved his hand impatiently, settled into his chair and abruptly changed the subject. 'Do you know the painter Giovanni Baglione?'

Denial would have been futile. Giovanni Baglione and Orazio Gentileschi had both participated in all the big Roman projects. Thirteen years earlier they had been in the huge team that executed the frescoes in the Sistine Library at the Vatican. Then the windows of the nave in the basilica of Santa Maria Maggiore. They had worked together at San Giovanni in Laterano under the supervision of Cavaliere d'Arpino and, what was more, at San Nicola in Carcere in 1599: while the paintings on Cardinal Aldobrandini's gallery had

been assigned to Gentileschi and his assistants, an entire chapel had been given to Baglione and his workshop.

'Your Lordship, I've known all the painters in Rome extremely well for a long time now. I mean that I know the leading . . .'

'In your opinion, who are the leading painters in Rome?'

'The Cavaliere d'Arpino, Caravaggio, the Carracci, Giovanni Baglione and others whose names don't come immediately to mind, but who are outstanding.'

'Who are your friends among these painters? List your enemies too.'

'They are all my friends . . . although obviously there is some rivalry between us . . .'

An understatement. What, with a certain frankness, Orazio called 'rivalry', in his and Baglione's case was turning into a lifelong enmity. Throughout the thirty years to come, from Rome to Mantua, from Paris to London, the two painters would respond to the commissions of the same patrons, would share space on the same walls and argue over the same payments.

'It's like this, Your Honour, with Giovanni Baglione, for example . . . Since I had painted a picture representing St Michael the Archangel for San Giovanni dei Fiorentini, not to be outdone, Baglione came along with a *Divine Love*. And he had only painted this *Divine Love* to compete with Caravaggio, who had just finished an *Earthly Love* for Cardinal Giustiniani. The cardinal liked Baglione's *Divine Love* less than Caravaggio's *Earthly Love*. But, despite that, Baglione got a gold chain for his painting. I myself told him that his painting struck me as being very imperfect. *Divine Love* ought to have been an angelic little naked boy; he made him a great hefty thing dressed as a warrior . . .'

'How long is it since you have spoken to Baglione, and Caravaggio?'

'I stopped talking to Baglione after that business of the angel. Even before that. Because, whenever we meet in Rome, Baglione expects me to greet him first. He hopes that I'll be the one to doff my hat first. And I maintain that he should. It's the same sort of thing with Caravaggio. Although we are friends, Caravaggio waits for me to greet him first, which would be out of the question . . . It's six or seven months now since I've spoken to Caravaggio, but I recently lent him a Capuchin's habit and some angel's wings which he had asked to borrow for a painting. He returned the habit to me about ten days ago . . .'

'Do you recognise your handwriting in this poem?'

Giovanni Ballocks, 'Tis no lie
your paintings make foul daubs.
They'll earn you not enough to buy
the stuff to make some drawers
that you could shit in
then show off to everyone
a greater masterpiece
than any you have ever done . . .

It was hard to tell whether the pout which made Gentileschi's naturally puzzled expression more emphatic was prompted by the form or by the content of the poem. Tension imprinted a scowl on his face. By this point he knew that a lot was at stake, that the offence of which he was suspected was as serious as murder, and that the papal courts had a particular interest in making him pay the penalty. For, by a papal edict – and this was another consequence of Beatrice Cenci's execution – 'slanderers' were subject to severe punishments.

The day after the execution, the city had been covered in little verses, lampoons insulting the Pope with accusations of having done a saint to death out of sheer greed. Their presumed authors had been summarily executed. And on 12 January 1601, Clement VIII promulgated a decree against all those who exercised 'their stinking tongues', heedless of either God or the law, by writing letters and verses, broadcasting false news, defaming and ruining the honour and reputation of others. The defamers would henceforth be prosecuted by the Inquisition and brought before the criminal tribunal of the Governor of Rome, regardless of whether they were uncovered by anonymous letters or public denunciations.

Giovanni Baglione was one of the most famous and powerful painters in Rome, a painter who would soon succeed in being elected 'Prince of the Academy of San Luca'. On 28 August 1603, he had submitted a complaint saying that, for the last few months, Caravaggio and his close friends, the architect Onorio Longhi and the painters Filippo Trisegni and Orazio Gentileschi, being jealous of his work, had gone about the city speaking ill of him and denigrating his works. They had written defamatory verses which attacked his honour. These verses had been copied by them dozens of times over and distributed throughout the profession. He enclosed an example: 'Giovanni Ballocks, 'Tis no lie . . .'

The affair augured badly for Caravaggio, who had been imprisoned. But worse still for Gentileschi. Among the artists it was no secret that relations between Orazio Gentileschi and Baglione were of a far more venomous nature than the mere 'rivalry' described by the defendant to the deputy prosecutors. Fuel had been added to the flames a year earlier in November 1602 when, returning from a pilgrimage to Loreto, the extremely conventional Baglione had brought back little medals for his friends with the image of Our Lady. Made of gold, silver or lead, these medals were worn by the artists pinned to their hats. Baglione had given the most valuable ones to the great painters of Rome, to the Cavaliere d'Arpino and all those he counted on for his election to the Academy of San Luca. The rest, including Orazio Gentileschi, got lead.

His friendship wounded, his pride hurt, Gentileschi had indulged in the luxury of a scurrilous letter. An unsigned epistle which nevertheless left no doubt as to the identity of its author. Avarice, vanity, worthlessness: Baglione was spared no insult.

Giovanni Baglione had kept that letter; he had just added it to the investigator's file. An exhibit for the prosecution. There was one disturbing detail: a phrase which was almost identical to one of the lines in the poem: 'Hang a pisspot on that gold chain you wear around your neck and you'll have an ornament befitting your station.' A choice reference to the necklet of charms given to Baglione by Cardinal Giustiniani for that *Divine Love* of his, which Gentileschi so hated while envying its success.

When it occurs to the deputy prosecutor to take a closer look at the papers piled in front of him and to compare the writing on the double-sided page seized this morning at the defendant's home – a page insignificant in itself – with the handwriting of the anonymous letter and the calligraphy of the defamatory poem, a judgement is made. Orazio Gentileschi will spend five years rowing on papal galleys.

How Gentileschi managed to extricate himself from this tricky situation is not explained in the trial records. What the archives tell us, on the other hand, is that the intervention of the French ambassador removed Caravaggio from the clutches of Clement VIII. On 25 September 1603, Caravaggio was free. Are we to suppose that his accomplices were released along with him? Or rather, did Gentileschi owe his miraculous impunity to the protection of some figure close to the Apostolic Chamber, to his connection with the functionary who

had already procured the first significant commission in his career, the frescoes on the gallery at San Nicola in Carcere – the Pope's steward, Cosimo Quorli? The authority of this powerful friend could not, however, influence one consequence of the 'Baglione trial' on Orazio's destiny. While this defamation affair counted for little among the other crimes imputed to Caravaggio, it was to cost Gentileschi very dear. He would pay for it with his posthumous reputation.

Forty years later, Giovanni Baglione would himself take up the pen and turn biographer in order to write down his version of his contemporaries' mores and merits. His chapter on Orazio Gentileschi was to be his revenge. Baglione's *Vite de' pittori, scultori et architetti* remains one of the most valuable first-hand accounts of the life and work of Italian artists in the seventeenth century. It is the only substantial contemporary analysis of Gentileschi, the most complete of the critiques of his work, a biased and lethal version which comes to us from his worst enemy, the painter whom Orazio Gentileschi took pleasure in ridiculing one night in 1603.

3

The Church of Santa Maria del Popolo

26 December 1605, at sunset

On this damp December day, in the wide Piazza del Popolo, the women were beating their laundry at the washtub. Cows, little black pigs, mules and stray dogs were gathered around the water trough. Travellers who had just entered the city gate were resting, perched on the columns that had been rolled to the foot of the obelisk and were lying in the sand . Piemen and water sellers called their wares beside the fountain. Here, between the Piazza del Popolo and the Piazza di Spagna, was the painters' district. More than two thousand artists – French and Flemish, along with Bolognese, Florentines and Romans – had settled within a radius of some three miles. The countless inns lodged newcomers. And the houses, on the slope of the Pincio hill, were home to creators in search of light. The artists formed groups according to nationality and occupied the highest floors, the best lit and the least expensive. They were two or three to a room which also served as a studio. From the farthest flung corners of every land, men in thrall to dreams of beauty converged upon these few streets. Painters, sculptors, gilders, embroiderers and goldsmiths came to learn, of course, but to make their fortunes too.

Christianity owed the origins of this cosmopolitan quarter at the city's northern entrance to the fears of popes, their obsession with using every means to crush the Protestant heresies. As the seventeenth century began, nearly half of Europe challenged papal authority. Rome had need of this vast labour force to offer the world a face that was renewed, embellished and triumphant. Rome's brilliance was to be testimony of its pre-eminence over every city on the globe. Its grandeur, its majesty, its riches were to dazzle the eyes of pilgrims. The splendour of its churches was to dwarf humanity, sweep away doubts,

enlighten souls. And these revelations were to send the visitors home breathless and dumbfounded, conquered by the proof of the Catholic Church's supremacy.

It was in this spirit that the political programme derived from the resolutions of the Council of Trent against the principles of the Reformation would give rise to what history has come to call 'baroque art'. The profusion of gold, marble and precious stones – using the rarest and most flamboyant materials – the striving for effect, the theatricality, the rage for *trompe l'oeil* and optical illusions: this entire *mise-en-scène* sprang in part from the ideological struggle of the popes, from a battle strategy against the doctrines of Luther and Calvin.

In 1605, Rome was recovering its former splendour in one final blaze of glory. Soon the furnaces of the papal forges would bubble with the heat of the forty tons of bronze torn out of the Pantheon. Within thirty years, the spiral columns of the baldachin of St Peter's would be thrusting heavenwards into the Roman sky.

Night was about to fall and, ever since dawn, the solemn chimes announcing the service for the dead had sounded throughout the district. The spectacle of the procession was awaited with impatience. It was to approach the square from the right through Via del Babuino. The dead woman had lived a mere hundred yards away, in the four-storey white house on the corner of the Via dei Greci, owned by the cabinetmaker Francesco Magnessi. Three times in ten years Death had come to knock on that door. An oval door with a bronze knocker in the form of an antique mask, the mask of Tragedy, the mask which weeps and brings bad luck.

Passing alongside the wall of the Augustine convent, the cortège finally reached the square in the last light of day. The bells were still ringing, a dull, unceasing reverberation, a drone now undiminished even by the noise of the washerwomen's laundry beating. The man at the head of the procession wore a gold surplice. Behind him came the bearer of the cross holding aloft the silver gem-encrusted crucifix which the priests of Santa Maria del Popolo took out only on grand occasions. No one could ever have imagined that a painter of the district would have been able to give his wife such a solemn and imposing ceremony.

For her, for Prudenzia, the daughter of the Roman Ottaviano Montonis, *uxor Horatii Gentileschi pittoris*, the wife of the painter Orazio Gentileschi, for

this woman who had died in childbirth at thirty with the ending of her seventh confinement, Orazio had ordered a funeral worthy of a princely family. He had wanted that death knell to sound since the morning. The whole district was working out how much it must have cost him. How much for the carrier of the viaticum? How much for the representatives of the confraternities, how much for the priests, the vicars, the sacristans and all the chaplains of the parish? This funeral would spell ruin for the marriage prospects of a beloved daughter in need of a dowry.

So as to avoid any disputes with their parishioners, the Augustine brothers posted a price list for their different services on the church door. Orazio Gentileschi had paid all that they had asked, even for the twenty torches which were reserved for people of quality who do not work with their hands. God alone knew how many pictures, frescoes or medallions he would have to produce in order to pay off such debts. Had his wife passed away without the church's sacraments, the funeral would have cost less. She could have been taken outside the Porta del Popolo, just yards away from the church, and put beside the renegades, heretics, Jews and 'impenitent prostitutes' who were piled up pell-mell at the foot of the Aurelian wall. It was here, alongside the *muro Torto*, that there extended what could have been called the only cemetery in Rome. Popular tradition had made it the grave site of Nero — the great persecutor of Christians — and the realm of demons and unfaithful wives.

But Prudenzia had made her confession, had received Communion and Extreme Unction; ten Masses were to be said for the salvation of her soul. The only two luxuries which Orazio had not been able to give to his beloved wife were a coffin and a tombstone in the church. As the younger daughter of one of the numerous cardinals' secretaries — a colleague of Cosimo Quorli at the Apostolic Chamber — she was of a standing which he deemed superior to his own. She had been seventeen at the time of their wedding, Orazio thirty. She brought no dowry of gold or household goods, but a network of protectors, a string of connections which would place her husband within the 'clientele' of powerful patrons. In negotiating the contract, Cosimo Quorli had made much of this point to Orazio: the parents of Prudenzia Montonis enjoyed the favour of the great families.

The rank of the personages who presided at the baptism of the six Gentileschi children brilliantly illustrated Quorli's argument. Only the year before, at the baptismal font of this very church of Santa Maria del Popolo, the newborn son of Orazio and Prudenzia had been carried by a relative of the

doge of Venice, Marco Cornaro, the future Bishop of Padua. To be strictly honest, the prelate had been represented at the ceremony by his secretary, Francesco Cavazzi, just as today Orazio Gentileschi's illustrious clients – the Altemps, Olgiati and Pinelli families – sent their servants and their empty carriages to the funeral. This succession of liveries and emblazoned vehicles had the function of boosting Orazio's career; it meant prestige, it meant fame. Rome's painters were in no doubt about that. The Cavaliere d'Arpino, who was also godfather to one of Gentileschi's children, followed the cortège with numerous representatives from the Academy of San Luca. Caravaggio and Giovanni Baglione were missing. Yes, honour compelled Orazio to such expenses. But love above all. What would he not have done out of love for Prudenzia?

With each separation he had feared that he would never see her again. He had experienced the two winters spent in the ancient Abbey of Farfa as a test; a trial sent from God as a punishment for his happiness. In the damp and cold, in the darkness of the chapels, stuck on his scaffolding, worn out by the arduous labour of the frescoes, he had cursed heaven for this commission that was overlong and overburdensome; he had cursed the monks for their impatience and their claims on him. How many times had he foiled their surveillance, walking out on the unfinished works, leaving behind him the *Triumph of St Ursula*, the *Christ on Mount Olive*, to gallop off at top speed on his mule over the Sabine hills and get to his wife in Rome? Prudenzia would always remain the love of his life.

Over the next thirty years, Orazio Gentileschi would tirelessly paint her sweetly virginal face, the velvet of her skin, the light of her translucent flesh. Whether they were madonnas or saints, they would all possess Prudenzia's fragility and indefinable charm.

All of his tenderness had been focused on her. All of his goodness and all of his joy left with her.

The mortal remains of Prudenzia Gentileschi were placed in the left nave, in front of the Cerasi Chapel. The office for the dead was spoken. Her face was lit for the last time by the light of the twenty candles which were set around the funeral bier. Her head, eyes shut, had slumped on to her shoulder. With her lips parted, she looked as if she were asleep. Her hands, laid across her belly, still swollen from pregnancy, held her baby's corpse against her. The child's swaddling clothes, its trailing shroud, splashed the green velvet of her dress with white. The heavy folds of her skirt pressed against her thighs and clung

to the shape of her knees. Her feet were bare. Her shoes and the light veil which had covered her long hair throughout the Mass were already in the hands of the undertakers: by tradition, all women's ornaments fell to them.

A few feet away from the line of torches, three of the undertakers were pushing pikes for leverage into one of the black and white rosettes on the flagstones. These numerous rosettes had two holes pierced in them and they opened into a common grave. The ground below Santa Maria del Popolo was divided into fifteen rooms where several generations of parishioners were piled up, either with or without a coffin.

These were the very last moments, the brief minutes which neither women nor children were allowed to witness for fear of hysteria breaking out among them; when the undertakers lifted up the rosettes, the air would become impossible to breathe and a stench would fill the whole church.

The priests, vicars and chaplains had withdrawn. Only four people were left around the corpse: a monk, two men standing and a little girl on her knees praying. How had twelve-year-old Artemisia won the right to accompany her mother to her last resting place?

Even kneeling, she seemed tall, too tall for her age. Her body was fully formed, her features firmly drawn. The oval shape of her face, the sensuality of her lips, the sombre intensity of her gaze were set for ever. She would doubtless fill out and grow even taller, but she was already a woman. She would have to be married before long.

These thoughts occupied the mind of the family friend, Cosimo Quorli. His closeness to the Gentileschi couple, whose marriage he had arranged thirteen years earlier, explained his presence beside the widower and the orphan at this ghastly moment. Short of stature, like Orazio who stood opposite him, but fat and bearded, Quorli kept his head bent and his bald pate shone in the light of the tapers.

Standing back, he looked down on the adolescent Artemisia, lost to the world. The shawl covering her head had slipped on to her shoulders. Furtively, he observed the vulnerability of her bare, bowed neck, with its straggling curls, the curve of her cheek, her small breasts.

Quorli moved closer to get a better look at her. Her forehead was high and smooth, her eyebrows straight, her eyes almond-shaped. Under their long lashes, her eyelids seemed to stretch back as far as her temples. But the lower part of her face seemed short in proportion to the brow. Her round chin was very close to her mouth and was adorned with a dimple.

Feeling his eyes on her, Artemisia lowered her head further. Behind her silhouette at prayer, eight torches illuminated the pictures by Caravaggio and Carracci, her father's rivals. At the back of the chapel, the Madonna, robed in crimson, opened her arms wide; she rose up from her tomb, carrying Prudenzia's soul with her.

All at once, the monk stepped towards the corpse. He had noticed the undertakers' rods tilting up the flagstones right at the corner of the chapel and the central nave. The pestilential smell caught them all in the throat. Orazio and Cosimo looked at one another: the moment had come to say goodbye to Prudenzia. But something in Gentileschi's expression forced Cosimo Quorli to step aside. He crossed the transept and slipped out through the side door.

What part had Cosimo played in Prudenzia's life before her marriage? Orazio had never asked himself this question. Why had he put her dowry together, albeit a slender one, out of his own pocket? And how had it come about that Prudenzia's father – a cardinal's secretary lacking neither means nor connections – had agreed to give her to a man without wealth, a man who worked with his hands, a painter?

Cosimo supplied the answer to any who were curious enough to want it: he himself had dishonoured the promised bride by deflowering her. Gentileschi, inclined by nature to be jealous, remained the only man in Rome who was ignorant of the rumours the steward spread. The mere fact of querying the circumstances of his union with a woman who gave him sweetness and tenderness would have cast him into despair. He had therefore decided, in some disturbed, unconscious way, not to give it any thought. This genuine blindness, this talent for putting his head in the sand dictated a good number of his actions. But woe betide anyone who forced him to see what he chose to ignore: his anger and resentment would grow hugely out of proportion to the reality of the situation. Aware of Orazio's violent nature, Cosimo Quorli therefore took good care to keep his boasts and malicious gossip – or slander – well away from his friend's hearing. Besides, Cosimo Quorli was a great braggart. Although he was forever intimating that he had deflowered every single virgin in Rome, there was nothing about him to justify this kind of success with women. Nothing but determined wishful thinking, a lack of scruples and a self-regard which made him impervious to dislike, indifferent to rebuffs and deaf to all rejection. Quorli was one of those who are thrown out of the door only to come back in through the window. It was perhaps this tenacity which explained the brilliance of his career, which

remained unimperilled despite the demise of his protector Clement VIII and the elections of two other sovereign pontiffs.

Quorli had managed the household assets of the Apostolic Chamber for nearly twenty years and had recently been promoted to the rank of 'first papal steward'. He had responsibility for the purchase and maintenance of furniture, hangings, carpets and every manner of object − except for religious items − at the Quirinal and Vatican palaces. His function gave him vast power over artisans. Commissions − and payment − for a hanging, the repair of a ewer, the remaking of a picture frame, were all in the gift of the steward. Embroiderers, gilders and workers in stucco fought for his favours and preferments. As for the painters, Cosimo Quorli would recommend them − or not − to the Holy Father, to his nephews and their entourage of rich prelates, for the frescoes on a ceiling or the decoration of a gallery. Moreover, this post gave him numerous advantages by right. He paid neither for his wood, his salt, his oil nor his wine. These came as gifts from the Pope.

At forty, Cosimo Quorli was the happy owner of four houses in the Borgo and several shops which he rented out to artisans in the Trevi district. His wife, the docile young Clementia Romoli, whom he had married five years earlier in 1600, had brought him a dowry of two thousand scudi and some household goods. Quorli had made a good marriage. He intended his two sons for administration and his elder daughter for the convent of the Poor Clares. His first-born was laid to rest in Santa Marta, the church adjoining St Peter's, which was reserved as a resting place for the staff of the papal household − those belonging to the *famiglia del papa*. There, his name, Quorli, was to remain for ever carved in marble. It was more than Gentileschi could claim.

Prudenzia's remains swung from the ropes which would deposit her in the common grave. Slowly, her body sank down through the gaping hole in the middle of the floor. Prudenzia would share her resting place with her dead children, her sons, aged six and two, both named Giovan Battista, whom she had buried here in 1601 and 1603, and the baby that was bound to her belly in its swaddling clothes.

Standing by the side of the pit, Artemisia did not take her eyes off the slow descent of her happiness into the abyss. For her too, Prudenzia would always be an embodiment of all the warmth and tenderness, all the humanity in the world. And her memory of this luminous being, her nostalgia for her mother's love, would drive the adolescent girl far from Orazio's arms, from a father to whom embraces would henceforth be alien.

Engrossed in his own suffering, Orazio could not see his daughter. She remained bent over the foul-smelling chasm. Nothing passed her lips, no cry or lament, not even a sigh.

Orazio had felt her so close to him throughout all these years that he had forgotten that she could have formed other attachments, loving her mother, her little brothers, anyone apart from him. In his infinite distress he took no account that this bereavement struck her just as cruelly.

Artemisia was born on 8 July, the same day as her father; thirty years after him. She owed her unusual first name to the godmother whom he had chosen for her, a great lady of the Roman aristocracy, Artemisia Capizucchi. The man who had held her at the baptismal font in San Lorenzo in Lucina had been the Papal Nunzio in Venice and Florence. Her infant life had had a good start. On 12 June, 1605, the second Sunday after Pentecost, she had been confirmed at San Giovanni in Laterano, along with all the little girls of the parish. For this sacrament, the choice of sponsor assumed an even more important role for the child's fate than at a christening. Artemisia's sponsor was Vincenzo Cappelletti, a Pisan aristocrat, very close to Orazio's two elder brothers, who were also painters. Cappelletti seems to have had a special bond with the second brother, Aurelio, who was working on the cathedrals of Pisa, Florence and Genoa.

More than a quarter of a century earlier, in 1575, following the death of their father – the extremely fine goldsmith Giovan Battista Lomi – Aurelio had brought the baby of the tribe, Orazio, from Pisa to Rome. The two boys, one of them twenty years old, the other thirteen, had studied together, passing through the same studios and sharing the same apprentices' rooms. Aurelio eventually returned to Pisa, Orazio stayed on in Rome. Taken under the care of Francesco Gentileschi, his mother's brother, who held the post of Captain of the Guards at Castel Sant'Angelo, Orazio Lomi had decided to use his mother's maiden name for the sake of his career. Thereafter, he was known as Orazio Gentileschi.

Every member of the family, whether they were a 'Lomi' or a 'Gentileschi', whether they had made their home in Pisa, Rome, Genoa or Florence, lived only by and for painting. The time was coming to hand on the torch. Aurelio had no children. He was counting on his nephews, Orazio's sons. But Heaven had first given Orazio Gentileschi a daughter. From the age of five, Artemisia ground his colours, prepared his canvases, made the solutions for his varnishes. Her apprenticeship was the envy of his other pupils. Her

younger brother, Francesco, could not catch up with her. She always seemed faster, more diligent, more talented than the rest. Except, she was a girl. A girl from whom sooner or later Orazio would have to part, to give her either to God or a husband. A girl who had been left without a dowry by the cost of her mother's funeral.

Prudenzia's remains had gone. The undertakers had pulled up the ropes and replaced the rosette. The tolling bell had fallen silent. The sacristans gathered up the wax and made haste to put out the candles. Chapels, statues, pictures were all sunk in darkness.

Together, Orazio and Artemisia Gentileschi came out on to the front steps of the church. The washerwomen of the district were used to watching father and daughter crossing the square side by side, past the obelisk and the fountain: two sombre, slender figures, now the same height, walking hand in hand. Like two children, or two lovers.

As soon as Artemisia was born, this man whose harshness was well known to his colleagues, had watched tenderly over his daughter's cradle. Without the least awkwardness, he had taken in his arms this tiny being who bore no resemblance to him, or even to Prudenzia, his beloved wife, but who moved him deeply, just as he was always touched by innocence and weakness. Did the bond which was to unite them begin that first time Orazio looked at her? The little girl had gripped her father's thumb in her fist and held on tight. Up until the age of two, she would go all over Rome perched on the painter's shoulders; he took her everywhere with him. In the crowded streets, the child magnified Orazio Gentileschi's slender figure; one body with two heads, a head with two pairs of eyes that stood out from all those around them.

To what can we attribute this passion of Orazio's, so strong that he wanted his daughter always to be by his side? Perhaps because she was the first-born of a family he had started late in life, with a wife whom he worshipped. The arrival of other babies, all of them boys, had not dislodged Artemisia from that place in her father's heart.

As soon as she could walk, he had taken her up on to the scaffolding of the projects he was working on, and the little child tottered along, clinging to his skirts. He had often brought her here to Santa Maria del Popolo, and likewise to all those places where she could come to know what he judged to be great painting. Orazio, who was singular and fervent in his admiration, would devote all his time to teaching her to 'see'. He showed her the works of the

old masters and the canvases of two great living artists – Annibale Carracci and Caravaggio.

'Look at them! Look at them all! . . . Take a good look at these apostles painted by Carracci . . . He has studied Raphael so much that his figures look as if they have come straight out of the *Transfiguration*. Do you remember the picture we saw at San Pietro in Montorio?'

The little girl gazed at these characters out of sacred history and then at her father's beloved face. Her eyes shone with excitement. She listened to him with interest and eagerness. She sensed that he was trying to share with her the things that were closest to his heart; that he was initiating her into mysteries whose secret he possessed. She saw Orazio's endless talk as the proof of his trust and his love. He knew that she would remember every word, every image. It didn't matter that she did not understand it all. Orazio's appeal was not to her intelligence, but her senses. There was nothing he loved more than awakening his child to the pleasures of beauty.

'. . . Do you see that figure on the right below the Virgin's arm, doesn't it remind you of one of Michelangelo's apostles?' he went on. 'Look at how the light is the same . . . Move closer. Do you see? Even the paint surface seems smooth . . . with no thickening . . . like in Caravaggio! . . . Look at the *Crucifixion of St Peter*. Imagine the incredible understanding of perspective he needed to render St Peter's foreshortened torso, and his arm that you see diagonally . . . Yet Caravaggio doesn't draw: the bugger never sketches out any plan! He paints straight on to the canvas . . . Look at that executioner's backside farting into our faces: it's all accurate! How does the bastard manage to produce compositions that are so balanced? The draughtsmanship, the light, the colour, I want all of that! I want Raphael and I want Michelangelo, I want Carracci and I want Caravaggio . . . I – you and I want,' he amended. 'We'll never belong to any school. Why restrain ourselves?'

What Orazio did not tell Artemisia was that he owed the biggest aesthetic shock of his life to the innovative and revolutionary vision of Caravaggio.

Gentileschi's career had been a long haul, a restless, tentative and painful progression, a search full of digressions, abrupt advances and retreats through an archaistic aesthetic. He had kept up this search for years, ardently and tenaciously. Orazio was no more indulgent towards himself than he was towards others. Whenever any of his rivals had an easy success it sent him into a rage which was not without an element of jealousy. But he never

compromised. Mediocrity horrified him and the terror of giving in to it drove him on to ever greater efforts.

Having reached the age of forty-two, he had overcome most of his fears and had a sense of being complete master of his own skills. His talent was approaching maturity. He worked so relentlessly that it was rare for apprentices to last more than six months in his service. He pushed them hard, demanding the impossible. This search for perfection isolated him from the world. Yet Orazio could not endure solitude: he was insistent that his children, even his youngest son, should always stay with him in the studio. He needed them – he needed all of them – to assist him in his work. And ever since the day when he had seen in his daughter what he believed were aptitudes which might well match his ambition, he had not left her alone.

His generosity towards her was total, he was a master who aimed to pass on his knowledge from dawn to dusk. Fearing that she never knew enough, he gave no respite from his teaching.

'In what order are pigments mixed with oil arranged on the palette?' he would ask her when she woke up.

'Light colours near the thumb, darker ones below them.'

'How many pure colours are there?'

'No more than nine . . . White lead, yellow ochre, vermilion, red ochre . . .' the child would recite over her soup.

'When we've finished painting, how do we keep the oil paint left on the palette?'

'In water.'

'What about the white lead?'

Faltering, the little girl put down her spoon. Whenever Orazio was impatient, he would look at her sidelong. He seemed to be listening to her with his staring grey eye. Being looked at like that upset Artemisia so much that she answered in a rush without thinking.

'In oil.'

'In oil!' roared Orazio.

Mistakes like this could cost the child dear.

'In water,' she hurriedly corrected herself.

Making a great deal of fuss, Orazio reprimanded her and had her repeat the lesson, if not with patience, at least with perseverance.

Being docile and diligent, she tried hard to please him. She felt a boundless admiration for this all-knowing father who included her in his life's passion.

He would ask and she would answer. He would give and she would take.

Throughout all those years, only Prudenzia had succeeded in tempering the frenzy of father and daughter. Both of them would appear in the evening, worn out and dissatisfied with themselves. Prudenzia's tenderness and her sense of reality would calm the fear and anxiety which never left them. They had been painfully and deeply happy.

Love and painting, the two wild adventures of his existence, had been lived by Orazio with the ardour of youth at a time when most men have come to know tranquillity, or at any rate resignation.

Like many artists, until his marriage he had only been with the local courtesans. Before meeting Prudenzia he had professed an utter contempt for women. The sweetness of married life stirred up all his emotions and propelled him into the cult of a spotless femininity, a worship of the Madonna, of motherhood and purity.

On his wife's demise, Orazio did not renounce this image of women and love, but he returned to his old prejudices. He felt her death as a betrayal and abandonment. Prudenzia was leaving him, just as once his own mother had left him on his thirteenth birthday, at the age Artemisia was now. She was deserting him, just as all women did. On this point, Orazio shared the views of his peers and relished the jests of his old accomplice, Cosimo Quorli. Women were treacherous. Unless men kept an eye on them . . .

Orazio's delight in the little girl's receptiveness, the happiness her progress brought him, the help she gave him, had stopped him from regarding her as a female child. He handed on his knowledge to her, he surrendered his secrets without thinking that it was the fate of girls to leave their fathers and embrace a husband or the sheltered life of a convent. Until he heard Prudenzia's words, the words she had uttered on her death bed:

'Look at our Artemisia . . . She's a woman now, marry her off quickly, don't delay, or else God knows what will happen!'

Was Prudenzia thinking of the sorry events of her own past? Did she fear that her own fate would become that of her daughter?

On the way back from the funeral, the adolescent girl slipped her hand into her father's. It would be a long time before they would embrace again. When they reached the corner of Via del Babuino, an icy drizzle had begun to fall and Cosimo Quorli had joined them.

Artemisia's irritation, her impatience and the look in her eyes went unnoticed by the two men. But when Cosimo too tried to take her by the

hand, she shook herself away and fled, disengaging herself from both of them. She had hated Cosimo Quorli ever since her childhood. This distaste was something which Prudenzia's reproaches had never been able to overcome.

'How are you going to manage that girl without Prudenzia?' Cosimo murmured.

Orazio did not answer.

It was with painful feelings that he watched the girl making her way in front of him. It hurt him that Artemisia should have let go of his hand at a moment like this, that she should have deserted him so abruptly, when his need for love and comfort was so great.

He saw her as she had been by the grave, absorbed in her prayers and showing nothing of what she felt. Had she sobbed, moaned, given way to lamentation, he would have taken her in his arms. They could have consoled one another. He thought with bitterness and anger that his daughter had inherited neither the compassion, nor the sweetness, nor the humility of the only woman he had loved.

'You will have to subdue her,' observed Cosimo.

Rome was drowning in fog. A cold, opaque and sticky mist blotted out the rooftops and hung against doors and walls. Here and there, faint glimmers of light rose out of it, deceptive in the black night of the alleyways.

Walking home alone up the Via del Babuino, Artemisia wept. She felt neither the rain nor her tears. Just a bottomless anguish. Cosimo Quorli would never set foot in their house again! She would make sure of that. She was nearly thirteen. From now on she was the *padrona di casa*, the only woman in a household of men, the only mother figure for her little brothers, with the youngest still not two years old, and she was her father's only female companion. She was also the only female *garzone* in the whole of the painters' district.

4

Orazio Gentileschi's Studio in the Via Margutta

December 1610

'You stink like a whore, Artemisia, I can smell you from here!' Orazio yelled across the length of the studio.

He was squatting in front of the easel to inspect the canvas which his seventeen-year-old daughter had momentarily deserted. Gently he drew the palm of his hand over the first layer of paint, over the blue impasto of the sky, and the colours on the three figures. With his finger he traced the unfinished outlines of the two men, their sketched-in heads which met at the apex of the composition, the shading of a bald pate, a line of beard, the contour of a hand resembling his own and the raised finger of one of the old men commanding the object of their lust to silence. In the foreground, Susanna turned away, repelling their advances. Her thighs, belly and breasts radiated light; her flesh was rawly exposed to eyes and hands. Orazio touched the faint incisions in the folds of her skin, brushing against the groin of this Susanna whom Artemisia had painted entirely naked, in her own image.

'Your smell even gets into my drawings!'

The truth was that the room reeked of linseed oil, glue, turpentine and varnishes. Nearby in the half-light, two raggedly clothed, giggling apprentices were hunched over mortars grinding up colours with pestles. The sound of them pounding white marble for the vermilion and red porphyry for the lapis lazuli was like the dull, regular throb of a heartbeat. The daylight, filtered through a sheet of paper greased with pig-fat, fell through a single window, a large yellow puddle on the wooden floor where Marco Gentileschi, a lad of seven, sat with a knife cutting up small squares of linen which he would use to strain the various preparations.

With its jugs and cauldrons, its powders, bowls, melting pots, retorts and stills, the place was more reminiscent of an alchemist's laboratory than a painter's studio. Even the piles of fabrics, the crimson trails of velvet, the white drapes of linen, and the artist's accessories heaped up on the trestles at the far end of the room – the Capuchin's robes, the big angel's wings, the martyrs' wheels and death's heads – contributed to the mystery of this den, with its unreal and troubling atmosphere. Thick, black smoke rose from a brasier, with no chimney to let it out. Fifteen-year-old, Francesco, the elder son, kept an eye on a lead-bottomed terracotta pot where some oil glinted like gold; he stirred it slowly with a long feather. But the feather had just burned, releasing a smell of scorched fowl, a sign that the entire operation had to be started from scratch: the oil had not been sufficiently skimmed for the pigments which would make the colours to be incorporated successfully. On the second try, Francesco would have to mix the oil with hot water; shake it for a few minutes in a large glass receptacle; wait for the two liquids to separate, then for the impurities to settle at the bottom of the water; remove the oil from the water and wash the oil in clean water; add chalk powder, then sand, then a few crumbs of bread; wait for these three elements to absorb the impurities of the oil, which was then exposed to the air and moved about in order to prevent a film forming on top; wait again for it to lighten and absorb oxygen. Finally, he had to heat it up while at the same time testing it with the feather. If the feather did not burn, Francesco would strain this 'skimmed' oil through the linen sieves which his brother was cutting up. Then, and only then, would he be able to combine it with the powders prepared by the apprentices. At least with some of the powders. Because there were other pigments which did not mix with oil, but with water, with egg yolk, or with wet-nurse's urine; requiring preparations which were even lengthier, more complex and more skilled.

'This whore-stink is sticking in all our throats,' Orazio pronounced as he got up. 'We can't get you off our skins, Artemisia, and it's bringing us filthy luck!'

'Get me a husband then, Father, get me a husband, that's all I'm waiting for . . .'

Her paintbrush preceded her as she loomed out of the shadow.

Artemisia was tall and ripe-fleshed, with an enquiring look about her eyes and something greedy and rebellious in her lips; at seventeen, she had kept all the promises of beauty glimpsed by Cosimo Quorli on the night of her mother's funeral. Her extraordinary copper-blonde mane of hair, which she

wore in untidy coils, tumbled down in curls over her brow and temples. The freshness of her complexion, the roundness of her curves – her shoulders, her full hips – seemed like a hymn to youth, an invitation to love. If her swaying walk made it plain that she was instinctively aware of her powers of seduction, it mattered not a jot to her. She was unaffected, without coquetry or artifice. Her fingers and dress were covered in stains. Her charm was natural. Artemisia's spontaneity was undoubtedly the most disturbing of her endowments. She walked quickly over to the canvas, her paintbrush handle held up at arm's length; this movement, lifting her breasts together, further heightened the effect of her décolletage.

Artemisia had just dipped the outstretched brush into a secret lacquer, a decoction which Orazio did not lay on his palette, but kept separate, inside the mother-of-pearl of a seashell covered with oiled paper. The technique of mixing a small drop of this preparation directly into the colour was one which Orazio used only on certain flesh tones, a transparent effect of the skin which was his alone. It demanded very speedy application over a layer of paint which was still damp. Artemisia dabbed this luminous pink of Orazio Gentileschi's on to her Susanna's nipple.

'Get me a husband, all I ask is to leave this house where you make your friends spy on me, Cosimo and the rest!'

The studio resounded daily to the sound of their arguments. Artemisia's three brothers, the two apprentices, and the barber who was their model, all witnessed their domestic scenes. Here, in the big upper room which faced due north, among the rolls of hemp from which they would make their canvases and the sticks of wood which they would nail together for their frames, among the saucepans, burners and stepladders, insults were an unvarying background to the work of Gentileschi father and daughter.

Both of them, however, missed their former closeness, the time when they lived united by the same vision.

The day after Prudenzia's funeral, Orazio had gone back to his old bachelor ways. While he toiled away furiously like a lost soul, he gambled his earnings with the same driven impulse, he drank with the same frenzy.

He returned from his descents into the lower depths full of disgust, dissatisfied with the world and discontented with himself. Yet his compositions never seemed more balanced, his colours more luminous, his angels more ethereal, his madonnas sweeter and more noble than when he had been on a binge. So long as he had passed on his anger against himself before

taking up his palette, so long as he had disgorged his disgust at his own sins on to the person who was closest and dearest to him.

Up until the age of fifteen, Artemisia had accepted the fearful crises of this man who found peace only in painting – alongside her. Combining every role required, she had been his companion and his conscience, his disciple and his model.

Orazio painted his daughter tirelessly. And though he appeared not to understand her, to see in her nothing but an extension of himself, an alter ego who existed, felt, worked only through him, he was nonetheless able to convey the young girl's hope-filled eyes, the fire that smouldered in her, her restlessness. Artemisia never looked more like herself than she did under Gentileschi's brushstrokes, when, tenderly setting down the oval of her lovely face, the straight line of her eyebrows, the shading of the dimple in her chin, he represented her as a Mary Magdalene in tears at Christ's feet, a St Ursula or a St Cecilia. Artemisia herself felt no vocation for martyrdom. Now seventeen, she fought every inch of the way, blow for blow. Nonplussed, Orazio could no longer see the receptive child he had loved so much in the belated revolt of this woman. Where did his daughter find this assurance, this unexpected impatience?

For ten years, he had trained her, for ten years he had regarded her as the most talented of his apprentices, without it ever really occurring to him that she too might have the ability to set down her vision on canvas. Only twice had he had an inkling of the painter she could become. The first time was shortly before the execution of Beatrice Cenci. Artemisia was barely six. One morning Orazio had chased her out of the studio, along with her little brothers and all the apprentices. One of his very important clients had just announced his arrival and he wanted to be alone when he received him. But throughout the interview, he had sensed Artemisia behind the door, listening to them. Strangely, he had spoken for her ears.

'My lord, I set about painting living creatures, flesh-and-blood people, figures who breathe and move. But this does not mean that I neglect the balance of my compositions, nor the virtuosity of my plastic effects.'

Did the little girl understand what he was trying to tell her?

'. . . What I want is for a painter to be able both to consult the old masters *and* to paint from nature. Nature comes first, the best master of all. If you study it with care, my lord, you too will achieve those gradations of light on the parts of a head that stand out, those gradations which my lord so admires on the

heads of Raphael . . .'

Orazio had opened the door all of a sudden and the child had run away.

After accompanying his client back to his carriage, he went to her. Artemisia was standing in front of the kitchen table. Around her lay the spatulas, knives, grinding stones and brush-cleaning tray – the tools of the trade which Orazio had made her remove hurriedly from the studio. Like all painters, he knew that an artist must never present himself as a manual worker to those who give him commissions. Dressed in black, looking respectable and self-satisfied, he would show them round his studio giving the impression that painting was nothing but an intellectual exercise. But he knew that he was uncouth and tedious, incapable of holding an audience, unlike his rivals, Giovanni Baglione or the Cavaliere d'Arpino, who owed a great deal of their success to the elegance of their conversation and their fine manners.

'Those two understand nothing about painting!' he muttered as he made his way towards his daughter. 'They bore us with all they know about antiquity, but they've forgotten that good masters took their subjects from life. They copy statues and plagiarise ancient works, but they empty art of its substance. Its substance is life! Baglione and d'Arpino make me laugh with their jewellery and their pretence at airs and graces. I have no need to wear a sword and ride around in a carriage to make myself important in the world . . . But I too would like to have pearls and gold chains! Not so that I can strut about aping everyone else on the Via del Corso, but so that I can prove my worth to them. That is all gold is good for – it is the measure of the painter. Gold establishes the reputation of a work. The rewards all these mediocrities get shall be mine – a hundredfold! I have to sell, sell, sell, to tout my worth. Today, my lord Olgiati tried to pay me less than what we had agreed. My usual price is fifty scudi per figure. He stuck at thirty, so he will have a little more than half a figure.'

In the course of this monologue Orazio's eyes lit on the large sheet of paper spread out in front of Artemisia. Along with the studio tools she had brought out her pencils.

She was drawing the objects laid out on the kitchen table: the brushes, the palette, the pigs' bladders which preserved the colour, the jars – whose volume she was attempting to convey. She had squared out her work, as she had so often seen her father do. And if the whole thing was reminiscent of nothing more than a child's drawing – the brush-cleaning tray looked like a trough and the maulstick like a cane – it indicated solid powers of observation and a

45

very accurate appreciation of the play of light and shade. Looking at this faltering attempt, Orazio had felt a kind of elation and he stared for a long time at the sheet of paper. He could not have said what it was that gave him this pleasure – it was like some intuition of a joy to come, a promise of happiness.

The second occasion was shortly after Prudenzia's death. At the end of a long working day with Artemisia, Orazio had discovered, slipped among his pictures, a small Madonna painted in oils which was not in his hand. He was in no doubt about its author. Instinctively, he had kept silent. He passed no remark – either blame nor praise. He had felt the artist's anguished eyes at his back but had pretended not to notice anything.

That night, he had come back to study the work. The modelling of the Virgin's body beneath her draperies, the transparency of the light, the handling of the white tones had stirred an extraordinary hope in him, a surge of fatherly pride. Yes, Artemisia truly was his daughter, his double, and she would take up the torch. The two of them would become immortal!

But very quickly, an insidious suspicion had arisen to wreck this feeling of happiness. Had he not played with fire by training such a gifted disciple, and lit the conflagration which would consume him and his work?

Torn between an obscure artistic jealousy and his fatherly pride, from then on he set the goals so high that Artemisia could never manage to content him. He put her to work, observing her progress with the dread that she would not succeed, and the fear that she would succeed too well. He justified his unease in his daughter's presence as the mistrust which all reasonable men must maintain towards the female sex.

The violence of their disputes nowadays matched the coarseness of the courtesans and the painters who were their neighbours and to whom Artemisia owed the crudeness of her vocabulary. This virgin – allowing that she still was one, something on which her father's insults cast doubt – had acquired a certain sense of how things were, if only from what she heard shouted in the street. Ever since her mother's death, there had been no room for innocence. There was nothing refined about her upbringing, supervised by Orazio. Artemisia could not write. Like most women of the lower bourgeoisie, she had to struggle to make out a few words. She knew nothing about music, did not sing and could play no instrument. Her aunt Lucrezia from Pisa, a sister of Orazio's who had come to live with them for a time after she herself was widowed, had had enormous difficulty in teaching her the rudiments of needlework. Artemisia did not care in the least about cooking

and housework or any of the domestic responsibilities that fell upon her. She did not make the beds, nor did she wash her linen: Margarita, the washerwoman, would fetch and deliver it because Artemisia never went out. Not even to the market. It was the custom for men, heads of the household, to bring food home. But even this duty was neglected by Orazio. Kept late on major works, he might well not come home all day. And he spent the night at the tavern, leaving his children without any supper. The eldest of his sons, Francesco, would then scour the city, in search of his father and a few coins. Most of the time it was Cosimo Quorli he came back with.

As for Artemisia, she never showed her face. Unlike the courtesans who would stop passers-by from their balconies, she was forbidden to appear at the window. She was prohibited from setting foot outside the house without Orazio's permission. Prohibited even from taking a breath of air by the open door. And though the inhabitants of the Via Margutta were very familiar with the sound of her voice, there were few who could boast of having met her. Her father did not wish her to be seen. He insisted that she attend Matins, but would not allow her to go to Vespers – where there were too many people – or Compline, since a virtuous woman did not go out at night. She was allowed no visits or walks. Gone were the days when Gentileschi would take her around his projects to look at the paintings of his rivals or his peers. Everyone knew that, since the death of his wife, Orazio had been hiding his daughter. Now that she was of marriageable age he locked her up. Even the rich gentleman who came to his studio, even the patrons and clients, did not make her acquaintance. Orazio would obligingly spread out Artemisia's drawings for them, he would open out her sketches, let them rummage around the big room, even invite them to turn over the paintings, showing them the small and middle-sized canvases which he kept in reserve, without ever speaking of his daughter. Without his patrons having the least idea that the small works which Orazio succeeded in selling to them could have been executed by a hand other than his.

If the washerwoman scarcely ever saw Artemisia busy in the kitchen, the apprentices watched her hard at work all day. She was now the one upon whom the output of the Gentileschi studio depended; the *bottega* was reliant on her. Disinclined as she was to domestic chores, no one could accuse her of being flighty or lazy. She was always the first to rise to draw buckets of water from the well, to empty the cistern of rain water, to bring the dozens of basins up from the *cortile* to the studio. With her sleeves rolled up to the elbows, the

sides of her skirt tucked up at the hips, her hair in her eyes, the swell of her bosom carelessly uncovered, she would light the fire, soap the brushes, sieve the stucco powder and prepare the palettes, throwing herself into all the roughest and least rewarding tasks. So long as she carried them out in the studio. That was her domain, the kingdom to which Orazio was gradually handing over the keys, the empire from which he had let himself become dethroned. The truth was that he hardly had time any more to devote himself to easel painting.

At the age of forty-seven, Orazio Gentileschi seemed to be at the pinnacle of his career. Though he was not attached to any princely household, or in the *servitù particolare* of any great personage, though to this day no one had given him bed and board or a monthly stipend, his works could be seen everywhere. His altar painting in one of the most important churches in Rome, the basilica of San Paolo fuori le Mura, guaranteed him daily attention for the present, and immortality for the future. He had moreover recently secured a contract for the execution of the vault of the Consistorium, the hall in the Quirinal Palace where the College of Cardinals was soon to be assembled under the aegis of Pope Paul V. Lastly, to his immense good fortune, his most immediate rival, the painter to whom he owed the greatest artistic upheaval in his life, the painter who had made him aware of his talent and his sore limitations, Michelangelo Merisi da Caravaggio, had just died, leaving the field clear for him. Struck down by malaria, or else by the steel of the Knights of Malta whose trust he had betrayed, Caravaggio had died on a beach north of Rome a week after Artemisia's seventeenth birthday.

'All women have a husband at my age. It's time, high time; I'll soon be old!'

'And how can I get you married, with what dowry?'

'The confraternities to which you belong will provide for it. Or else my godfather will. Or if not, one of your clients, my lord Olgiati for instance . . .'

'Why would my lord Olgiati or any other of my patrons honour you with a dowry, you who dishonour us all?!'

'But it is you who keeps away anyone who might ask for my hand.'

'How could those rascals ask for your hand unless you are showing yourself off behind my back? You put yourself on view at the window, I'm sure of it, you have men visit you . . .'

'You will keep me unmarried if I let you! Unless you sell me to one of your cronies, one of your spies . . . That old pig Cosimo, for example?'

'One more word, and tomorrow I'll silence you for ever! I'll shut you up in a convent!'

'Try it, Father, try it if you dare. Who will cut up your canvases when you've turned me into a nun? Who will stretch them over the frames and heat up your oils for you? Do you think that Francesco will ever be able to make your glazes as well as I do? And will Giulio lay your *imprimatura* with just the right proportion of stucco and glue? Do you think that your two idiot apprentices grinding your colours over there will be able to complete the pictures that you don't finish? And what about the works you keep copies of so as to sell them later on, who else will paint them but me?'

As she challenged him, her face was inflamed by the heat of the burning logs over which she had bent as she kept an eye on the oil which Francesco had failed to purify.

'Unless these are the very reasons why you refuse all my suitors. Because you are afraid that I will reveal to others the secrets of the amber varnish or the green pigment that is your pride and joy. Because you are frightened that your clients might discover how much my copies surpass your originals!'

'Your cleverness isn't just in your fingers, Artemisia, but I'll put a stop to that.'

'Let's make a wager. I know that you are waiting for my lord Olgiati. That's why you've come home today, because he's coming to see your work. But this time you won't shut me away, and that's the painting I'm going to show him.

'That painting, Artemisia, is my composition. It is my drawing. They are my colours. It is my work.'

'Only, there, you see, down on the left . . . that's my signature!'

'*Artemisia Gentileschi fecit.* 1610,' he read, grim-voiced. 'So you can write now, and speak Latin?'

'No, but I can copy. And you are the one who taught me . . .'

'The slut is stealing my paintings, robbing me of them even before they are finished!'

'You are the one who taught me,' she repeated stubbornly. 'You are the one who taught me everything!'

'Not everything, Artemisia, not everything . . .'

Orazio stopped shouting. The sudden silence made more of an impression on his daughter than his threats or his anger. She was left speechless. He returned to the painting of Susanna. He seemed suddenly absorbed and

engulfed by the canvas. Even the apprentices stopped pounding, startled by this lull. As night came, a strange quietness fell over the studio.

Artemisia moved closer to her father. In the half-light, she watched him. She watched his eyes resting on her work, the staring, impenetrable eyes of Orazio, who always caused her the same pain. What was he thinking of at this moment? What was it he saw in her work?

She was blushing. As she waited tensely, tiny beads of sweat appeared on her forehead, on her nose, on her upper lip. The suspense was torture. Fear and hope, need and desire made her strain towards him with her whole body, with her whole soul, he who was both judged by her art and was its judge. Since childhood she had burned, been consumed by the dream that she could reach him through painting. Tonight, through her skill, her talent, through the very beauty of this painting, she would touch him. She would move him. Seduce him. He would at last recognise her as his. Artemisia, Orazio's daughter. Artemisia, Orazio's double . . . Perhaps he would love her . . .

'Your foolish pretension is matched only by your ignorance . . .' He had armed himself with the knife and was wielding it unrestrainedly to correct the line of the shoulders, the point where the two elders' heads met. 'This canvas, of which you seem so proud, is lacking in the fundamentals.'

By fits and starts, Orazio lifted off the top layer of paint, digging his little trowel savagely into the glaze, correcting with a stroke of his blade the position of the hand, the shaping of the finger which she had outlined.

'. . . Even my lord Olgiati, of whom you expect God knows what, has it in him to see what you do not!'

He seized hold of a brush. Swiftly and adeptly, he reworked the elders' cloak, deepening the folds and shadowing the drapery.

'. . . You paint flatly, Artemisia. The foreshortening of this arm is wrong. The perspective of these feet is wrong . . . You have no grounding in our art: draughtsmanship! Without draughtsmanship, there is no painting. For you, it is already too late.'

Petrified, she looked on. She watched her father altering, obliterating and destroying her painting. And what she saw came as a shock: the emergence of a composition which was infinitely superior to her own. A balance and a harmony which transcended anything she could ever have imagined or produced.

This revelation, this proof aroused her admiration. And it cast her into the abyss: 'For you, it is already too late.'

Her signature, *Artemisia Gentileschi fecit*, had no right to appear. A fake! Fake, like her drawing. The only painter in Rome who bore the name Gentileschi was Orazio. *He* was the painter. It was to him alone that Artemisia owed this miracle: the metamorphosis of her Susanna into a masterpiece.

5

The Consistorium of the Quirinal Palace

February 1611

'What do you think, Gentileschi,' a voice thundered down on Orazio from a distance of some twenty-odd feet. 'What do you think about a fellow who sleeps with his mother?'

'What am I supposed to say, Agostino?'

'You must have some thoughts about it! What's your opinion?'

There were three men in the vast Consistorium. Two of them, perched high on the scaffolding, were measuring the vault. The older one, a slovenly and overweight man, was Cosimo Quorli, who was taking notes of the figures that the other dictated. The latter, who was setting his rule against the ceiling, with arms outstretched and his upper body thrust into the void, was the painter Agostino Tassi. This was the great frequenter of prostitutes, who had spent time inside the prisons of Rome and rubbed shoulders with Orazio in the crowd at Beatrice Cenci's execution, twelve years earlier. Neither of the two had any recollection of that brief encounter at the foot of the scaffold.

Since then, Agostino Tassi had stirred up controversy – and made a name for himself – in Tuscany.

Elegantly dressed, the cords at the neck of his cloak jauntily knotted over one shoulder, he moved about the platform with agility. Heedless of danger, impervious to vertigo, he worked so fast that the planks shook under him, and there was no halt in his flow of banter with Orazio, who sat at a table in the centre of the room.

'I think,' shouted Orazio, his head raised, 'that a sin which can be denied does not exist!'

He was blinded by the heavy daylight which fell through an endless line of

windows. The white winter sun struck the newly whitewashed walls of the hall, which occupied two floors of the Quirinal palace on the garden side.

The architects had completed that façade at the end of January, less than a week earlier. Though the great staircase was nothing more than a mess of stone building blocks, all tufa, travertine and marble, and though the left ramp barely allowed access to the rooms, the work was proceeding rapidly. The whole of the Quirinal Hill, with its gardens and palace, was a huge building yard.

The assistants of the illustrious Guido Reni were putting the final touches to the lunettes in the Cappella dell'Annunciata, the Pope's private chapel. Reni, the greatest of the Bolognese artists, had worked on its decoration for more than two years. A jewel, a gem, with which Paul V was so patently satisfied that he had already convoked his cardinals for the Advent celebrations: four Advent-Sunday Masses and the ceremonies of the forty hours of prayer. The Pope was very fond of his Monte Cavallo residence. More than the Vatican, on which his predecessors had left their mark, the Quirinal palace was his work – the legacy of Paul V, Paolo Borghese, to the Eternal City. With each year that went by he settled in for longer, taking over salons and private rooms one by one as the armies of workers made way for him. Nothing was done at the Quirinal without His Holiness having first approved the plans; without his personal choice of iconographic schema for the decoration of each door frame, each window. In the summer, he would give his audiences while pacing the corridors; this daily two-hour walk was his constitutional.

The painters' conversations and banter were therefore not without risk: their coarseness might very well be witnessed by a tall man who, though afflicted with short-sightedness, had extremely acute hearing.

But on this first day of carnival, the honour of such a visit was neither to be feared nor hoped for. Everyone knew that while popular jubilation ran through the streets of Rome, the Pope was shut up in his Vatican apartments. For ten days the city would be absorbed by balls, plays, masques and horse racing. Until Ash Wednesday. Then everything would change and religion would reclaim its rights. The Church would wrest its flock out of the Devil's hands. The clergy would hear the sinners' confessions and Paul V would absolve the penitents.

'Well, what do you think of a man who sleeps with his mother . . . or fucks his sister?'

A sly look came into Gentileschi's eyes. He smiled faintly as he unrolled the drawings he had squared out on to the table.

'I've already told you: a sin that is kept secret does not exist!' he shouted. 'It is confessing it that brings shame!'

He had unfurled the scroll from which he intended to make a fresco, a vast Borghese coat of arms, twelve feet by six, their eagle set just above the famous *dragonetto* which reared up on its dewclaws, its mouth spitting fire, wings spread wide, ready to take flight. At either end of the scroll, Orazio had drawn two angels of which he was very proud, two angels holding up the coat of arms, offering it to the world, to posterity, topped with the tiara and keys of St Peter. The whole thing would be situated at the centre of a huge *trompe-l'oeil* of balconies, columns and loggias, which would open out on to a gap of blue sky, a breach into the infinite.

'But I'm talking about someone who gets nabbed . . .' The voice reverberated. It was a big, powerful, warm voice. A throaty voice thundering gaily above Orazio. '. . . about someone who gets caught in bed with his sister . . . Her without her shift, him completely naked . . .'

The *trompe l'oeil* technique, the art of breaking boundaries with an explosion of space, required a skill which was not in Orazio Gentileschi's repertoire. He had had to call on Agostino Tassi, a man who had worked for the theatre in Florence, who had been involved in the great tableaux at the wedding of Cosimo II, a virtuoso of perspective.

Although his name was not exactly well known in the papal states, Tassi benefited from some illustrious protectors. The painter Cigoli, whose speech on 'The Importance of Drawing in Painting' had been much applauded at the Academy of San Luca, had just employed him on his own project in Rome, at the Palazzo di Firenze. Cigoli had been so pleased with Tassi's little landscapes and seascapes, so impressed by his technique, that he had introduced him to his own patron, the Pope's nephew, Cardinal Scipione Borghese. This recommendation was supplemented by the backing of an old Florentine acquaintance, the Pope's steward, Cosimo Quorli. It was because of his liking for Tassi that Quorli was now beside him on the scaffolding, noting down the measurements of the vault for him.

Although Quorli well knew Orazio's propensity to be jealous, his exclusiveness in friendship and his hatred of rivals and competitors, Orazio had fortunately developed a fondness for the assistant who had been imposed on him. How his pride had become reconciled to the presence of an artist such

as Agostino Tassi on his site was a mystery. The two men could not have been more different in character. Tassi was as flamboyant as Gentileschi was sombre and secretive. Cosimo regarded himself as the only wise man among them, the only one who knew how to live philosophically. He made the most of the power conferred on him by his office, but derived his headiest enjoyment from pulling the strings behind the scenes. A mentor, an intermediary, he possessed an unerring talent for introducing artists to patrons, women to their future husbands. He was a fixer, who always came by to collect his recompense. He mixed in every kind of circle, was on close terms with his barber and his tailor, while being a confidant of the prelate and the captain. He feared neither God nor the Devil; only illness could persuade him to lend an ear to the sermonisers. He claimed to know all the hidden byways of power, all the secrets of the Eternal City. And he was right: there was nothing about men that he did not know, nothing about them that surprised him – except this friendship which now bound Orazio Gentileschi and Agostino Tassi.

Admittedly Tassi had made some effort. Quorli had seen him abandon his arrogance, heard how he toned down his customary boasting in flattering subservience to his elder. Agostino had made it his business to shower Gentileschi with endless attention, to reassure him with fine words. He had even lent him thirty scudi at no interest. Such generosity, such altruism, were not without sincerity. Tassi admired Gentileschi. Working with him was an honour. Surprised by such kindness, and seduced by so much consideration, Orazio had seemed to soften all of a sudden. He was now often heard laughing. No one had known him be so serene while at work on a commission, so easy-going and trusting.

Quorli, Tassi and Gentileschi formed an inseparable trio. They shared their meals and toiled away good-humouredly, impervious to the peals of the bell from the Capitoline Hill which had just announced the beginning of carnival time and emptied the palace of all its workers.

'I'm only asking your opinion of the fellow who gets caught with her, of course!' Agostino insisted, imprudently leaning over the edge of the gallery.

'I think he is committing the greatest sin there ever was,' Orazio shot back. 'An even more ghastly crime than bending over and sucking his own cock.'

This witticism was greeted with hearty laughter. Tassi made the planks shake with it. Of medium height, with a sturdiness verging on corpulence, Agostino's looks were hardly classical. On a first impression, he could not be called an Adonis, or even remotely an Apollo. But one only had to see him

move, to hear him speak, joke, swagger, to be in no doubt about his conquests. Set on a solid pair of legs, with a well-proportioned body, he seemed at home with physical exercise, moving to the very brink of the planks, climbing up the ladders, and taking all kinds of risks to get his work done, while carrying it out with no apparent effort. The skirt of his extremely close-fitting velvet doublet showed off his torso. He wore puffed sleeves with broad black, white and scarlet stripes, which he waved about like flags. Although he wore no boots, just white hose and beribboned shoes, it was as if his spurs clinked at every step.

He had a round, mobile face which was constantly expressive. His skin was tanned by the open air, his eyes were black and fierce. But what struck people most of all was his mouth. A greedy, child's mouth, framed by his fine beard and moustache, with an open and very white smile. Tassi's pride in his appearance made him take great care of his teeth. While he was working on his commissions a barber regularly came to clean them. He viewed with dismay the thinning out of his handsome black curls, but he kept the lace of his shirt-front open on a virile and hairy chest. He was a man of thirty, sensual and self-assured, the embodiment of a certain Mediterranean type. With his elegance, his generosity and aplomb he fascinated his apprentices; their future seemed guaranteed with a master like Agostino Tassi.

'Now ask Orazio what he thinks of a man who sleeps with his daughter,' Cosimo Quorli whispered to him.

'What's your opinion, Gentileschi, of the fellow who sleeps with his daughter?' Tassi repeated with a chuckle.

But before Orazio could answer, Quorli spoke first.

'Come now . . . who can ever be sure of being the true father of his children? Wives are past mistresses of deception! Which one of us can claim for certain that he has found an honest and faithful woman? They all repay us with lies and there is no man alive able to ward off their treachery . . . If I had a girl at home as hot-blooded and lovely as Orazio's daughter, I'd take a chance on sinning myself rather than let her be fucked by God knows who behind my back!'

If this remark met with a favourable response from Orazio, he gave no sign of it.

'It's age, he's going deaf,' Cosimo sneered into his companion's ear.

'So he's got a daughter?'

'A slut.'

'Aren't they all?'

'Indeed. But her . . . you'll see. I'll have you meet her . . . The breasts . . . the mouth . . . the bottom. She's juicy enough to damn all the saints in Paradise. Even Our Lord Jesus, may the Madonna forgive me, even He couldn't resist her! I mean it. A trollop to boot! Scalpellino, Orazio's apprentice, swore to me that he'd had her – that the whole workshop had had her. Even Pasquino, you know, the captain of the harbour at Ripetta. Scalpellino told me that she gave him everything he wanted!'

'Does Orazio know?'

'That his daughter's sucking every cock in the neighbourhood?' Cosimo chuckled. 'At any rate, Gentileschi is jealous. He hasn't bedded a woman since poor Prudenzia died, may her soul rest in peace, and it's his daughter he's obsessed with. I heard him dreaming about her one night when he was sleeping in my bed. They say that he strips her to paint her. He shows her naked, as Susanna, as Mary Magdalene – *before* her conversion!'

'Have you seen the paintings?'

'Good God, he hides them, along with the daughter.'

'He's right to do that. If I had locked up my wife, I wouldn't have needed to kill her. It would have saved me a few trips to Lucca and an outlay in Tuscany. It's not the money. I don't give a fig about the money: I've got a gold mine on the tip of my brushes. But you don't rob a man like me! You don't run off with his worst enemy . . . What did poor Maria get out of it? Death and shame! Anyway, I let God take care of her soul, he is the only Judge . . . I've had the letters I was waiting for; the business is closed. My honour has been avenged.'

The business to which Agostino Tassi was referring had drained his emotions and wreaked havoc on his life for a whole year.

In May 1610, when he was in the throes of departure from Livorno for Rome, his wife Maria Cannodoli had left him, taking with her four hundred scudi, two gold drinking cups and all her jewels. Agostino's jewels.

This was unwise. Yet Maria had thought she had picked the right moment: the night before 29 May, the day Tassi had fixed for their move to Rome. Was she hoping that Agostino would give up the idea of pursuit, as impatient clients summoned him to work-sites far away? She was mistaken. Though Agostino's ambition urged him to reach the Papal States without wasting any time, his pride could not endure that he be treated as a cuckold.

Beside himself with fury, he had therefore dashed off on the trail of his

adulterous wife and her lover, a merchant from Lucca. Yet the cost had been high. The pursuit altered his plans and caused him delays in his work.

Three months before Maria's flight – in February 1610 – Agostino had written to his sister Olimpia and his brother-in-law Salvatore Bagellis, a tanner in the Vatican district, announcing his arrival in Rome. He asked them for hospitality, for himself, Maria, his apprentice Filippo and Filippo's young wife Costanza, Maria's sister. The fourteen-year-old Costanza was pregnant. Agostino did not reveal in his letter that he was Costanza's lover and the father of the child she was expecting. Instead, he stressed the temporary nature of this hospitality; the small party would stay with Olimpia for only so long as it took to find a lodging where they could all live together. Maria's flight postponed Agostino's arrival in Rome, but he had sent on the young couple to Olimpia without him, planning to join them once his marital affairs were in order. Meanwhile, the apprentice Filippo would take care of everything.

Filippo Franchini was twenty-three and had known no other master but Tassi. His own father had himself been Agostino's assistant and he had been taken on as an apprentice on his thirteenth birthday. As accomplice, servant and slave, Filippo had followed Tassi everywhere: to Florence, Genoa and Livorno. When the latter had decided to give him a wife – his ward, as he called her, his own wife's little sister Costanza, an orphan maintained by him ever since the death of her parents – Filippo had raised no objection. The more so since Agostino had given a dowry to this young girl, whom he had taken the trouble to put in a convent. Filippo would get twenty-five scudi on the signing of the contract. And twenty-five more . . . later on.

The marriage of Filippo and Costanza had been celebrated at Livorno in January 1610, shortly before Agostino's letter to his family and his planned departure. Was this ceremony when the 'guardian' enjoyed his seigneurial rights? Or had Agostino already deflowered Costanza well before the wedding? Was the young woman pregnant at the time of her nuptials? Who knows. Whatever the situation, the neighbours in Livorno would one day testify that it was Agostino's relationship with his sister-in-law which had driven Maria – who had no fondness for a *ménage à trois* – to make a cuckold of him.

By the time Agostino finally joined Filippo and Costanza at Olimpia's house in Rome, on 28 June 1610, he had only managed to retrieve the objects stolen by his wife: the two gold cups, the necklaces and rings. Cursing, swearing and gesticulating, he told his woes to anyone who would listen. He

had found Maria at Lucca, but he had not managed to get her back. She was lying low in a convent, under the protection of important people whom Agostino called 'my lords', without naming any names. But the slut would get what she deserved in the end! On the way back through Florence, Agostino had engaged professionals: Maria Cannodoli's time on earth would soon be up.

In August 1610, two men turned up at the home of Olimpia and Salvatore Bagellis, to claim what they were owed. Before paying them, Agostino sent them to stay with one of his friends, the painter Valerio Ursino. He kept them with Ursino for the time it took to write to Lucca, Livorno and Florence, so as to secure confirmation of the news that these men brought. Agostino received the replies by letter in December 1610 and, from then on, he always kept these letters on his person. He would show them to everyone, brandishing a wad of papers which proved to the world that Agostino Tassi had recovered his pride: Maria was dead. The price of her murder was two hundred scudi; Agostino paid off the executioners and they left Rome.

With his honour saved, and his reputation finally cleared of shame, Agostino began the new year of 1611 with serenity. He considered the affair closed and saw his happiness restored. But this episode had cost him dear – very dear: he had never recovered the four hundred scudi stolen by Maria, added to which there was now the cost of her murder. Though the project at Monte Cavallo promised to yield substantial rewards, Tassi would probably have nothing in his hand before spring. His debts to Antinoro, from whom he bought his colours in the Via del Corso, had built up to such a sum that he could scarcely set foot in the shop. Now he needed materials to paint the ceiling fresco in the Consistorium. He could only head off financial disaster by recovering his own claims on debtors.

Some time before, in May 1609, his brother-in-law Salvatore Bagellis had come to Livorno in desperate need; Agostino, in a grandiose gesture of magnanimity, had lent him one hundred and eight scudi which Salvatore had undertaken – before a notary – to reimburse before the month of February 1610. It was a year now since the due date had fallen and Salvatore had made no payment. Instead, emboldened by the scenes he had witnessed under his own roof, he had threatened to reveal Maria's murder and Agostino's liaison with Costanza to the papal courts.

Although no one thought for a moment of reproaching Tassi with his wife's murder, for his friends and enemies alike considered that Maria's

dishonourable conduct had compelled him to get rid of her, Agostino's affair with his sister-in-law ran counter to all laws and was shocking to all points of view. At the first threat made by Salvatore, Tassi had realised the danger. He had packed his bags and rented an entire floor on the Sant'Onofrio Hill; there, his frolics with Costanza would have no other witness but Filippo.

But Salvatore did not loosen his grip. Called on to pay his debt, he continued his blackmailing. At the end of January, Tassi had deemed it wise to make a temporary separation from the Franchini couple: Costanza and Filippo would go and live a few hundred yards away, on Via della Lungara. Agostino himself would not desert the Sant'Onofrio district, but would reduce his expenses by moving across the street, to a bachelor room.

Having taken these precautions, Tassi had struck a decisive blow. On the first of February, he had had his brother-in-law arrested for debt. Salvatore was now languishing in the dungeons of Corte Savella.

Had Agostino given any thought to the reaction of his sister Olimpia? Did he have any idea that this very day, the fourth of February 1611, a letter regarding him had just arrived at the Chancery of the Tor di Nona prison? That, in this letter, Olimpia accused her own brother of incest – the crime most severely punished by morality and religion? Not committed with her – but the crime was the same.

The law prohibited sexual relations between members of the same family. Sleeping with one's father's wife was the same as sleeping with one's own mother. Sleeping with one's wife's sister was the same as sleeping with one's own sister.

Incest: it was Agostino's worry and obsession. And with good reason. In this affair he risked his neck. It was a crime which Rome punished mercilessly with hanging; Paolo Borghese, Pope Paul V, made sure of it.

So, in the vast hall of the Consistorium, there was a heavy charge to the banter that flowed between Tassi, Quorli and Gentileschi. 'What about the man who fucks his mother . . . or tumbles his sister?' All three were fixated by the same idea – and each one of them played with it in his way, passing it on to the others, without suspecting that they all experienced the same dread. 'And the fellow who sleeps with his daughter?'

'Orazio is right after all, a sin you can deny does not exist!' Tassi called out as he leaped down the scaffolding.

Quickly and nimbly, he moved from one platform to the next, criss-

crossing the whole structure from top to bottom. He was a blur of colour, with his white hose, his white, scarlet and black sleeves flapping in a rush of movement, while behind him, at a judicious pace, the heavy grey form of Quorli carefully undertook the descent.

'The guilty man is not the one who gets caught in the act,' Agostino concluded as he jumped on to the ground. 'The guilty man is the idiot who confesses!'

With his plans and measuring rules under his arm, he stepped towards Gentileschi. He tapped him affectionately on the back before erupting into that open laughter which people found so heart-warming.

'The torturer who'll get me to confess has not been born yet!'

6

The Gentileschi Household in the Via Margutta

5 February 1611

'They took him yesterday, when he was leaving the Quirinal Palace!'

Cosimo Quorli had suddenly appeared in the room where the Gentileschi family would sometimes gather and where, by a rare chance, they now all sat round the table: Orazio, Francesco, Giulio, Marco and the apprentice Scalpellino. Artemisia presided over the meal. At that moment she was coming in from the kitchen bearing a large dish of beans which she herself had prepared – once in a while didn't hurt.

'They took him at Costanza's house! Instead of going straight home, the fool dropped in at Via della Lungara, supposedly to fetch the books of drawings which Filippo was keeping for him.'

Cosimo held his hand to his chest and snatched hold of the chair that Artemisia had not offered to him. They had never seen him in such a state. He had raced up the stairs. The house, which was on the Pincio Hill, was built on a series of different levels. It was a steep labyrinth. Once through the porch you had to open a gate and enter into the depths of the house, past the wash house on your left, to reach the stairs to the first-floor landing; from there another cavernous stairway led out into the *cortile*, a sloping garden of sorts with its own cistern and well, finally leading to the kitchen and the room used by the Gentileschi family. Quorli was transpiring profusely and was unable to catch his breath.

'They've arrested Costanza too! And they've locked up Filippo!'

'Filippo?' Orazio had put down his spoon and pushed his bowl away. He seemed appalled. 'Why Filippo?'

'From what I've managed to find out through the deputy prosecutor at the

Roman Curia, Olimpia gave away everything in her letter. Not just that Filippo does not sleep with Costanza, but that he agrees to be kept out in the kitchen while Agostino occupies his bed and enjoys his wife. It even seems that it is Filippo who forces Costanza to go with Tassi if she is reluctant. And that on occasion Filippo stays to watch what they get up to when Tassi orders him to do so. Incest and adultery – I don't know how I am going to get him out of this.'

Unruffled, Artemisia had served her brothers and was following the conversation without showing any particular interest in it. She regarded all her father's companions with a similar contempt. The fact that Cosimo Quorli had this Tassi's interests at heart gave her a good idea of what kind of man he was. She was not in the dark about Orazio's liking for this new friend. She had heard him mention Tassi's name and speak highly of his draughtsmanship, marvel at his sketches and go into raptures over some instrument which Agostino had invented to create his perspectives. Having never met the man, she was uninterested in his vices and misfortunes. For her, the new worksite at the Quirinal had the advantage of keeping her father out of the house and, whenever he did deign to come home, keeping him in a mood which distracted him from his customary misanthropy. This spell of calm in their domestic life coincided with the experience of a new emotion for Artemisia. She too had just discovered the joys of friendship.

On the other side of Via Margutta there lived two young girls and their mother. It was the younger of the two, a little girl of ten, that Artemisia had taken a liking to at the start. Catching sight of her at the window, she had ventured to call out and propose that she come and visit. The child had accepted the invitation, having first asked for permission, and had been brought by her elder sister, Faustina, who was sixteen years old. Two hours later, Artemisia and Faustina were inseparable.

When the mother came to fetch her daughters, she bumped into Orazio, who had returned early. Against all expectations, he made a good impression on her. Having briefly exchanged pleasantries with her and learned that she was married to a man who worked away from Rome, he encouraged her visits, avowing himself to be happy that his lonely daughter might have an honourable woman keep an eye on her. He agreed that this lady, whose name was Tuzia Medaglia, should keep him informed about whoever came near his house. He even went so far as to suggest an arrangement that he would discuss with her husband, Master Stefano, when he returned from his travels.

For Artemisia this marked the beginning of a happy period of female conversation, the exchange of confidences and dreams of love. For Artemisia had a suitor. And when her father suspected her of misconduct, when he accused her of vice, his anxiety was not entirely groundless. Yes, she did try to attract the attention of passers-by by showing herself at the window and parading like a courtesan. Indeed, Artemisia thought of nothing but getting a man, catching a husband.

Though her marriage was Orazio's responsibility, he neglected it. She therefore set about the task in his stead. With her usual determination she deployed the only weapon at her disposal: her charms. Her eyes, her smile, her breasts, the shapely curve of her lower back – the beauty of Artemisia Gentileschi.

In this carnival month of 1611, she was succeeding in her quest: she had found herself a swain. A painter who, in his own words, courted her with honourable intent; a frescoist from Modena with hopes of marrying her. He was twenty. His name was Girolamo and he belonged to Cardinal Bandino's household.

Every morning he would make his way to the site at Monte Cavallo, having first made a detour along the Via Margutta. He worked a few hundred yards away from the pontifical palace – and from Orazio – in the church of San Silvestro on the Quirinal. Together with others from Modena, he was working on the decoration of the sumptuous Bandino Chapel. At night, he would return to sleep at the cardinal's house, once more passing under Artemisia's window.

With his long, thin body, his shuffling gait and his hesitant smile, Girolamo Modenese differed in every respect from Orazio Gentileschi's companions. It was precisely his earnestness, his silence, his shyness, bordering on clumsiness, which had touched the young girl. Although he looked up at her with enamoured eyes, he would probably not have dared to go further, would have attempted nothing, had Artemisia not thrown him a flower. An honourable man.

She knew nothing more about him. But she dreamed of him.

The news of Agostino's imprisonment was to have drastic consequences for Artemisia's affairs, her affairs of the heart. Occupied with saving his friend's neck, Orazio took no interest in his daughter and abruptly forgot his obsessions with her virtue. He abandoned his paintbrushes in order to career

around the streets of Rome from the crack of dawn. He could be seen in palace courtyards, stairways and antechambers, pleading the cause of his collaborator, defending the innocence of his associate even to cardinals' secretaries and to his own patrons. This unaccustomed eloquence of Gentileschi's, the extraordinary energy which he deployed in the service of another, weighed heavily in favour of Agostino – and left the field clear to Artemisia.

'Did he give you his word?' the neighbour Tuzia whispered avidly, holding her youngest on her lap, a little three-year-old.

'We both made promises.'

'Where?'

Tuzia looked round the studio. Artemisia was half-heartedly painting a basket of fruit. Ever since the scene over her *Susanna* and her father's observations on the weakness of her drawing, she had confined herself to ladylike subjects. She would do no more history painting, just fruits, flowers, her new friend Faustina's face and Tuzia's little boy. Working had become painful for her. Her grand plans, her dreams of greatness and immortality, were over.

Tuzia, who knew her way around society, had offered to find her commissions among her acquaintances – madonnas, little religious scenes, depictions of a patron saint, miniatures – which Artemisia could take payment for without Orazio necessarily being told. This would mean that she could get herself ribbons, kerchiefs and ear-rings to please her suitor. By bringing a woman like Tuzia into his house, Gentileschi had not bargained for the influence she might well exert over his daughter.

'Where did you receive your inammorato?' Tuzia sat her son up straight as she repeated her question. 'Here?'

'Here? My father would have found out! We meet at the church.'

'Does he write to you?'

'He sends notes to me through my brother.'

'When we were promised, Master Stefano, my husband, would send me notes too . . .' Tuzia sighed nostalgically. With her sturdy thighs, broad shoulders and the froth of pretty dark curls on her brow, which showed no hint of silver, Tuzia had the appearance of a woman of the lower bourgeoisie, one of those matrons made heavy by time and childbearing who could be described as once having been comely. There was a residue of youth in her

cunning gaze, and something impulsive and light-hearted about her. Otherwise, she had nothing distinctive about her, either physically or morally. She was neither tall nor short, fat nor thin. And she was ageless, although probably around thirty.

'What does he say in his letters?'

'That I am his wife before God . . . But I'm not exactly certain, I can't read well enough.'

'Shall I read them to you? But you must promise me that you will behave. I mean, you haven't yet been . . .?'

Artemisia's brush remained suspended for a moment over an apple. She frowned. Did she know that the apprentice Scalpellino spread rumours about her?

'Dishonoured?' she prompted, her tone serious. The expression that lingered momentarily was severe, almost austere, leaving no doubt about the high value she placed on her virtue. 'The man who wants me, Signora Tuzia, will have to put a ring on my finger first!'

'So, he hasn't touched you? Not even a kiss?'

'Not even that.'

'Presents? Has he given you any presents?'

'No.'

'Then he isn't serious! You must get him to give you an undertaking, compel him to commit himself. Make him give you a ring for a kiss. The Lord will allow it. He allows everything, so long as it's above the waist, for a ring worth at least one scudo.'

The woman was the Devil incarnate! The Devil dressed in the grey habit of a nun from a minor order. For Tuzia, like her husband, belonged to the secular clergy – a pious woman obsessed with flesh and gold.

Even during the religious services to which Gentileschi nowadays asked her to accompany his daughter (confession at Santa Maria del Popolo, Communion at San Lorenzo in Lucina), Tuzia kept up her promptings. As the smoke rose from the thuribles, while the bells were rung at the elevation, she preached her whispered temptations.

'If the ring is worth two scudi, it means that Girolamo cares about you. Let him squeeze your breasts, the Madonna will close her eyes to it. She won't see anything wrong with you giving one another a few tokens of your attachment. You will soon be husband and wife; the pleasure of love will become your duty.'

The pious Tuzia sinned in her thoughts, she sinned in her speech and by omission. To her dreams of lust, she added the vice of corruption.

'Unless the ring is a valuable one, allow nothing below the waist. Accord him the favour of a venial sin, but do not fall.'

In Artemisia's harsh world, this solicitude had opened up an escape route towards happiness. The young girl believed she had found in Tuzia the warmth and humanity of her late mother, a generosity and devotion which expected nothing in return and smoothed the way ahead; hadn't Tuzia spontaneously offered to receive Girolamo in her house, thus making their meetings easier? Overcome with gratitude and drunk on hope, Artemisia surrendered herself body and soul to Tuzia's advice. It was she, Signora Medaglia, who would make her marriage possible.

Day and night, just yards from the Via Margutta, Artemisia could hear the music of the carnival, its laughter and shouts. Rome had turned into a huge masked ball, a theatre where everyone noisily played out the part dictated by their costume. From the window, Artemisia heard the character of the Lawyer who threatened passers-by with a frightening trial, and the masked Prosecutor who arrested women, listing their lovers one by one. She could hear Mattamoros thrashing Harlequin, and Scaramouche beating Pulcinella black and blue. Of course, Orazio forbade her from dressing up in costume. But on two occasions she had let herself be taken as far as the Piazza del Popolo by Tuzia and her daughters. They had seen the high point of the carnival, the *barbieri* races, with the famous Arab horses. Fifteen racehorses stuffed full of oats, whinnying, stamping and pawing the ground in front of the obelisk, amid the firecrackers and cheers, then tearing up the Corso to Piazza Venezia at a mad gallop, with neither riders nor bridles, their flanks strapped with lances to spur them on, blood dripping from their bellies and nostrils, knocking down the idlers who leaned out to gawk.

But what the four women had liked best, what they would remember with great pleasure until the following year, were the naked men's races. Three marathons over the length of the Via del Corso – nearly a mile. Laughing, they had watched the exertions of the band of Jews, all got up as Adam, as the Romans jeered, and the races of the old men and the young boys *in naturalibus*.

What did the February cold and damp matter? A rage for life had gripped the Eternal City. A haste for life – before the mortifications of Lent. And Artemisia grew drunk on this intoxication.

7

Antinoro's Shop in the Via del Corso

· 25 March 1611 ·

'"No, Your Lordship, no, I assure you that I haven't the slightest idea why you have been keeping me here for the last two weeks."'

Agostino Tassi's self-mimicry had a good-humoured audience. There were around a dozen artists at the colour seller's – sculptors, painters and gilders – listening to him recount his adventures. The shop, which was up against the San Carlo Church in the Corso, functioned as a post office and a meeting place for the denizens of the district. Painters went there not just for supplies of canvas, brushes and pigments, but to buy lengths of the brightly coloured cloth which Antinoro dyed himself. He sold colours, it was true, but he was also a dyer, druggist and pharmacist. News and gossip were swapped over the counter. Aquavit was drunk in the evenings by the fireside. Antinoro's fire was famous. He was the only shopkeeper on the Corso to possess a chimney, a hearth worthy of a palace, where he concocted the cleverest paint preparations for his clients. When one of the neighbouring houses had the ill luck to have its last candle blown out by the wind, they ran to Antinoro's for the light that was kept in the hearth. His shop was a cave, a cavern. The jumble of merchandise which glittered in the dark was reminiscent of the spoils of war.

'"Oh!"' Agostino exclaimed, by way of self-parody, '"All I did, Your Honour, was apply myself to studying some treatises on perspective before going home to spend the whole night drawing! This was for the fresco commissioned from me by His Holiness for his fine palace – His Holiness for whom time is of the essence –" I flung in a "His Holiness" with every other word, to make those three imbeciles feel the weight of it, "What will His

68

Holiness have to say when he finds out that the Consistorium will not be ready for the cardinals' meeting? As for myself, Your Honour, I am not concerned about my own fate, I trust in Your Lordship's justness . . . But what about the work? The work, Your Honour! His Holiness sets such store by my endeavours – and my health too. Did not his steward have my bed delivered, have my meals prepared by the palace cook?" I shamed my torturers, I frightened them, by casting up in their faces all the kindnesses done by Signor Cosimo! And then—' Tassi paused for dramatic effect. 'Then, when Cosimo Quorli suddenly appeared in the Chancery room waving that paper signed by the cardinal – the Pope's nephew – under their noses, I thought the prosecutor was going to breathe his last with apoplexy. My pardon! My pardon by Monsignor Scipione Borghese in person! Absolved! I went out of there absolved. Judge Bulgarello even wrote to me to tell me I could stay with my sister-in-law for as long as I liked. My idiot sister and brother-in-law may well shake in their shoes. Salvatore has already shut up shop, his tannery is finished. The courts have forced him to sell so that he can reimburse me. I'm rich!'

Agostino lifted a purse full of scudi off the counter and made it jingle so his audience could hear.

'I for one pay *my* debts . . . And I add on interest. The next round is on me.'

These words, greeted by an ovation, were interrupted by the sudden appearance of Orazio.

'Ah, there he is,' exclaimed Tassi. 'The man to whom I owe everything!'

Gentileschi's eyes were dark and his thin frame trembled with fury as he screamed out, 'I've just seen him! He went into my house!'

'Who?'

'The man I've spoken to you about. My daughter's lover!'

Theatrically, Agostino turned towards the onlookers.

'I never treat the honour of a friend lightly – it is sacred. I'll be the one to fix the man who dares tarnish the reputation of the Gentileschi name. Let's be off!'

They swept out like a whirlwind.

8

Statement of Agostino Tassi and Testimony of Tuzia Medaglia at the Trial of March 1612

Account of the fight on 25 March 1611

One year later, Agostino described events thus:

I shall tell you how this thing came about. That evening Artemisia, daughter of Orazio, believing that Orazio was dining at the house of Cosimo Quorli and would remain there until four or five o'clock before returning home, brought this Girolamo into her house. But because Orazio had stopped nearby to talk to someone, he saw that this Girolamo entered his house, and therefore came at once to find me in the shop of the colour seller in the Corso, where I was waiting for him, and he told me all this, and begged me to go with him. We went there together and I readily went with him so that no one should be hurt.

When they got to Gentileschi's house, Agostino claimed, Orazio beat Girolamo with a broom handle, striking him two or three times so that he ran off. Agostino interposed himself between the two in order to protect the one from the other and to prevent the business from ending badly. He continued thus:

But this Girolamo blamed me for everything and for six months bore me a grudge, and one morning last summer, as I was hurrying to Cardinal Nazaret's vineyard, the said Girolamo and two others bearing arms surrounded me with their swords drawn to attack me. It stood me in good stead that I could defend myself, for if I had not been able to they would have killed me . . .

This, Agostino thought, must have taken place early in the month of April:

A few days after the fight, peace was made between this Girolamo and me, with the mediation of Abbot Bandino, in the cardinal's own house and by his order. Those two others who were with Girolamo also took part in this. They said they were brothers or cousins or blood relations of his, but I don't know their names.

There is no record of what Artemisia thought about all this. According to all the witnesses' testimony, she was not present.

This attack on a man whom Agostino did not know, and the duel over something which did not concern him, would win him the daughter's enmity and the father's recognition. According to their neighbour Tuzia, Gentileschi was overwhelmed with gratitude for the loyalty of this friend who had risked his own life to lend him a hand, sharing in his anger and defending his honour: the honour of a father no longer young enough to see justice done on his own account. The help the two men had given to one another would for ever be a bond between them.

Tuzia took up the story:

A few days later he asked whether we might take a house in common and live there together, and I said that I would, once my husband was informed, for the love I had for his daughter made me wish this too. When my husband returned on Holy Saturday he met with Signor Orazio and a house was found in the Via della Croce . . . where we lived together [. . .] Every time that Signor Orazio went out he would entrust his daughter to my care and say that I was to tell him about anyone who should come to the house. He also gave me warning to speak not a word to his daughter on the subject of husbands, but that I was to persuade her to become a nun. And so I did try a number of times, but she always told me that her father need not waste his time because whenever he spoke to her of becoming a nun she regarded him as her enemy.

Agostino Tassi's release had spelled the end of the truce between father and daughter.

'Girolamo wanted to marry me,' Artemisia wailed. 'He had spoken to his master . . . he was going to ask Cardinal Bandino for his blessing. He was coming to ask you . . .'

'Shame on you! Your dishonourable conduct casts a slur on your brothers and myself.'

If Orazio had only one name on his lips — 'Agostino Tassi' — it was now uttered just as often by Artemisia. But in a different tone of voice. For this

stranger who had shattered her dreams and her life she reserved a hatred which her father alone had the measure of.

How could she ever win back Girolamo's love, Girolamo's trust, after the affront he had endured on account of her? After the shame and scandal of a thrashing? She could imagine that, despite his sincerity, he abhorred being beaten. That he abhorred it more than he adored her lovely eyes. Girolamo Modenese lacked the fibre of men such as Quorli and Tassi. Like them, he was proud but had not their tenacity. He fled from troubles and complications and he was quickly discouraged. A gaze met three times at a window and two meetings in a church were not enough – as Tuzia charitably emphasised – to bind a man. 'How can I lure him back now?' Artemisia wondered. 'What can I do to make him return? And how can I persuade him to face my father's anger and ask for my hand?'

She held endless conversations with Tuzia on what course to pursue, what means to employ and what liberties to permit. Friendship alone gave her help and succour. Friendship and painting. For Artemisia had set to work again, returning to her large-scale history painting, *Susanna and the Elders*.

9

The Consistorium of the Quirinal Palace

15 April 1611

'Artemisia wants to know if she has to obey Signor Cosimo?'

Francesco Gentileschi, Orazio's elder son, a good-looking boy of fifteen, had run all the way to the Consistorium and was out of breath.

'Of course she must obey him!' Agostino interjected, answering a question which had not been addressed to him.

Today, there were a dozen men busy on the scaffolding. The gilded Borghese coat of arms already took pride of place at the centre of the vault, supported by Orazio's two great angels. All grace and strength, the muscles of their arms and legs taut with effort, they held the scroll, so rich and heavy that it appeared to have worked free, hanging suspended between heaven and earth. Tassi's fresco was still only in rough. The red outline of the pillars could be discerned, along with the columns of the balustrade and the beginnings of a building in grisaille. In the corners, four female figures – Justice, Courage, Prudence and Temperance – the four cardinal virtues with which Pope Paul V was glorified, were slowly emerging under Gentileschi's brushwork. Even his sworn enemy, Giovanni Baglione, whom he had ridiculed and defamed with his verses one winter evening in 1602, would recognise that Gentileschi had never done anything finer than this ceiling. Surrounded by his assistants, Orazio was filling in the ochre of the draperies on the still-fresh plaster work.

'The truth is, Father,' Francesco admitted, now beside him under the vault, 'it was Signor Cosimo who sent me. He is outside our door with his wife and his carriage. He wishes to bring Artemisia here so that she can admire your work, and see the chapel painted by Guido Reni, and make a tour of the palace . . .'

'And so?' Tassi, working nearby, cut in yet again.

'So, Artemisia refuses to open the door to him. She refuses to get into his carriage. She shouts out that she must live locked up as if among the Turks, and that she is forbidden from receiving anyone at all, or from going out. There is also your sister-in-law Costanza in the carriage,' Francesco added for Tassi's information.

'Let them come!' Tassi answered before Orazio could. 'Both of them. Let them come together!'

'Tell Artemisia,' Orazio intervened, 'that I give her permission.'

'She will claim that I am lying.'

'Tell her it's an order!'

It was quite a procession of women that alighted in the courtyard of the Borghese papal palace, with Cosimo Quorli leading the way. Strolling around His Holiness's residence like this was certainly an exceptional favour; but in those days there was no obstacle to touring the private collections of princes and seeing the splendours of their castles. On every floor the Quirinal teemed with visitors, the relatives of the workmen, whose curiosity was encouraged by the Pope; Paul V enjoyed the admiration of his flock. The people walked about freely in the gardens as they were being landscaped, and the cardinal-nephew was in the process of having an inscription made on the gateway of his villa: *Go wherever you wish; pick whatever you wish; leave when you wish; these beauties are here more for the sake of the stranger's pleasure than for that of their owner.*

It seems unlikely that the cardinal intended these words to welcome the kind of idle visitor escorted today by the Quirinal's steward. Not only had Cosimo Quorli brought his wife and Tassi's notorious sister-in-law Costanza, but along with Artemisia he had packed in Tuzia, her hefty three-year-old and her two daughters. Six ladies in all, whom he conducted towards the great staircase. A strange crew. The oldest, Tuzia, climbed the stairs with difficulty as she was carrying her youngest child who suckled at her breast. Young Costanza was in the sixth month of a pregnancy – the second fruit of Agostino Tassi's labours – and had an enormous belly. She had lost their first baby on the journey between Livorno and Rome, perhaps because her sister Maria's murder had caused her anxiety. Imprisoned at the same time as Agostino, she had just spent several weeks in jail. She was barely fifteen.

Tuzia would later describe how Costanza and Artemisia – who had never

met before – ascended the pontifical staircase hand in hand. What bond had been established between the two girls in Cosimo Quorli's carriage? Were they both in need of support? Of help perhaps?

Artemisia wore a shapeless, faded gown, covered in paint stains. She had refused to change or to dress her hair. At her temples and the back of her neck, and straying into her eyes, were dark, reddish-blonde strands that escaped from the finger-twists of hair she had piled on top of her head in an untidy chignon. She looked straight ahead, her gaze impenetrable and unseeing. Her antipathy towards Quorli, her resentment of Orazio and her hatred for Tassi (in the carriage, Cosimo had made sure to say he would introduce him to her and make her like him) all heightened her inner turmoil.

Caught between her resistance and her elation at finding herself finally inside the papal palace, Artemisia failed to notice the inexorable approach of the man that Rome had dubbed *lo Smargiasso*, the Braggart: Agostino Tassi.

Without her even being aware of it, Cosimo had led her directly to him. Quorli had been plotting this meeting for a long time. He had been stoking Tassi's curiosity for months. Orazio's complaints about Artemisia's depravity had only served to sharpen it and fuel Tassi's imagination. The duel he had fought for a woman whom he did not know had incited a desire to meet her. But he had had more good sense than to ask Orazio for an introduction. Instead, Quorli had promised to arrange things. Artemisia's presence in the Consistorium on this April day in 1611 therefore followed a plan already carefully laid by the two cronies.

At first, Cosimo was afraid that his plan was a failure. Had he exaggerated the charms of Gentileschi's daughter to Agostino? Had he described that rose-pink mouth, those snow-white breasts in terms that were over-alluring? Contrary to all expectations, it was not Artemisia who recoiled from Agostino Tassi, but Agostino himself who found her much less beautiful than he had expected. The glance he shot her revealed his disappointment. With that sack of a dress she wore, that straggling hair in her face and those nails yellowed by oils, she hardly embodied the image of love, desire and temptation.

For her part, Artemisia did not recognise in this young man's small, dashing figure the image she had conjured of the swordsman who had shattered her wedding plans. Tassi was at his best at this time of day. The colours in his striped doublet stood out in the April sunshine. The gold of his rings, his belt buckle and the little dagger which rode on his thigh sparkled in

its rays. The keen morning light played brightly across his mobile face, highlighting his dimples, the curve of his brow, his cheeks and his attractive mouth; it enhanced the expressive quickness of his eyes. Artemisia only realised that she was in the company of Agostino Tassi because of Quorli's eager and fawning attitude towards him.

Knowing the violence of Artemisia's temperament, Cosimo had expected something out of the ordinary, that she would fly at Tassi's face, that he would witness one of those scenes he had watched between father and daughter. But she affected not to have grasped who she was dealing with, continuing to stare into the distance, over the shoulder of the two accomplices – stiff as a statue, reminiscent of the little girl, the impassive child who had seen her mother's corpse descend into the common grave at Santa Maria del Popolo.

Disappointed, Agostino was already turning away to go back to work on the scaffolding when his eyes met Tuzia's meaningful look and saw the way her bosom was proffered, the naked breast, swollen with milk, her nipple, red from having been sucked. He seized her by the arm and led her with the group of women to the centre of the room.

'Of all the genres to which I have devoted myself, miladies, I think I can most certainly state that fresco painting is the finest and most magisterial,' he declaimed, looking at each one of them in turn.

With Tuzia, Agostino sensed, things would be dispatched in no time at all. It didn't matter whether she was married or widowed, dawn would find him in her bed. He would spend the night upstairs in the Via della Croce. It would have to be there: there was no way he could take a woman back to his bachelor lodgings in Sant'Onofrio as Costanza kept a relentless eye on him. Despite her young age, her fat belly and her pale little victim's face, she kept him on a tight rein. Ever since Maria's murder, Costanza meant to enjoy all the prerogatives of a spouse. She exhibited such violence and jealousy that he was fearful of her scenes. It was she who now held the purse strings of the *ménage à trois* they formed with the apprentice Filippo. And when Agostino was unfaithful, he took care to hide it from both of them.

'And do you know why fresco painting strikes me as the finest of all?' he continued, ogling the five other women whom he was guiding around the Consistorium.

Was it Tuzia's smell, that warm milky smell, which lifted his spirits, sharpened his appetite? Or was it the beatific look on the faces of Tuzia's two daughters, the flattery of awestruck young virgins? The elder was hardly

pubescent, and the younger an ugly thing — but undoubtedly a fresh piece. Who was it that was having this effect on his mood? Cosimo's wife — so pink and soft in her moire dress? Her perversity was well known to Agostino by repute. Though he did not venture to contemplate cuckolding Quorli — the obligations of friendship remained sacred — he recalled with relish the feats into which Cosimo boasted of having initiated his young and docile better half.

'Because fresco compels us painters to achieve in a single day what in other genres we could retouch at our leisure. A single day!' he repeated emphatically. 'How long would it take you, Signorina Artemisia, to paint a picture the size of that Virtue which your father is working on right now?'

He turned towards her with dark, cunning eyes which took in her décolleté.

Not having expected to be singled out, Artemisia became flustered and blushed. There was a silence. She could think of nothing to say — neither a clever lie nor a witticism. Cosimo, who had been on the receiving end of her unsparingly quick wit, smiled. Not even a nasty word . . .

'Come now, Signorina Artemisia, give us an estimate.'

For all her seeming detachment, Artemisia had noticed Agostino's disdain when they were introduced. His disappointment and indifference were a further insult. To the distress this man had caused her by banishing Girolamo from her life, he was adding humiliation. This insulting rejection confused her.

'How long would you take, Signorina? A week, a month?'

She shrugged. If only he would leave her alone. She wished she were a thousand miles away from all this misery — from Quorli, from Tassi, even from her father, who was leaning down from the top of his scaffolding to listen to the conversation. A thousand miles away from Girolamo Modenese too. She wanted to forget every one of them, forget so that she could enjoy this opportunity, this one chance, this gift which might never be given again: to see at last the work of other artists and look on what the best painters in Rome were doing. To admire the talent of the greatest among them. To learn from them, to make comparison between them, to judge herself by them. To confront her rivals.

She raised her head. What did Agostino Tassi read in the quick look which she gave him? Exasperation? Hatred? Or something quite different? She shrugged again. Did he perceive that the girl's pride, her wild arrogance, her mad, dangerous and superb view of what painting meant freed her from all

constraints? Did he guess that the strength of her ambition, the pedestal on which she had placed her art since childhood, made her for ever inaccessible? Something flitted across Agostino's face, something of the hunter's lust, his cruelty and anxiety.

At that moment, Cosimo realised that Tassi would not leave Artemisia alone.

'Beauty, Signorina – your august father will have to achieve it in a single day. He will have seven hours to attain perfection.'

'The whole vault in seven hours?' gushed Tuzia, hanging on to his arm.

'Not the whole vault,' corrected Tassi with a roar of laughter which reverberated across the vast hall. 'I wager, Signorina, that you cannot judge the scope of the task which we have taken on . . .'

Agostino spoke loudly so that Orazio would hear him. The latter, standing on the top platform, continued to paint the dress of his Virtue, pricking up his ears, surveying the comings and goings of the little group out of the corner of his eye. He could see Artemisia and Agostino's sister-in-law crossing the *sala*, still hand in hand. Side by side, the two young girls lingered under the architraves, admiring the views framed in the doorways, and wandering among the paint pots all the way to the windows. Agostino followed on their heels, doing the honours.

Orazio knew that this walk through the most sumptuous palace in Rome was something of a miracle for his daugher – and he dreaded the consequences. He became agitated when Tassi took the women out of his field of vision for a few moments – into the two antechambers or into the corridors – before bringing them back under his ladder.

'Tell me,' insisted Tassi, doggedly, 'you have abilities, your father has told me so. Give me some idea of how a fresco is painted . . . I wager that she doesn't know! And you, Mistress Tuzia, do you know?'

Tuzia simpered. Tassi pointed to the ceiling.

'Do you see this vault? First I gave it a covering of rough plaster: the *arriccio*. Your father, Signorina Artemisia, then transferred his cartoon on to the damp surface, using a stylus to trace the main outlines.'

Artemisia could not help herself listening. And Cosimo, seeing her hang, in spite of herself, on every word that came from Agostino's beautiful lips, applauded his friend for waxing so eloquent to Artemisia about painting, her dream and her obsession.

'Your father divided his drawing into *giornate*, and one of these sections was

given a second layer of plaster, the *intonaco* . . .'

He bombarded her with technical terms while his voice and his eyes spoke of things remote from frescoes.

'Remember that he can only paint as much of his Virtue's lovely body – an arm, a leg, a breast – as he can finish in a day, the *giornata*, our famous seven hours! Seven hours to replicate the drawing on the damp *intonaco*, to lay on the paint surfaces and apply the glaze. Do you follow me, Signorina Artemisia?' he enquired in a tone which suggested rather: Follow me! I may have wronged you in some way, but follow me! 'Your father usually manages to paint three square feet of fresco in a day. I can get through four times as much! [When I beat up your lover, I only did it to please him.] My technique is faster than his. [But you are the one I feel great affection for.] Your father, Signorina, belongs to the old school. [Cruel as the episode was, I believe I gave you a fair enough token of my interest and devotion.] The way I do it is to rub chalk over my tracing and prick the contours with a pin. Or else I push into it with my stylus. [The effort I am making to speak to you rationally proves to you the strength of a feeling which cannot harm you.] Then I dust my incision with blood-red pigment. [So what do you have to fear from me?] I paint in every position imaginable, for seven hours like your father, but continually keeping my tracing wet with damp sheets . . .'

Cosimo chuckled, and whispered in his ear, 'What are you talking about: frescoes or fellatio?'

'Fucking!' he quipped in an undertone. 'I do the retouching and the finish *a secco*, Signorina, on the dry fresco,' he continued out loud. 'And there we are, that's all there is to it! A masterpiece that is everlasting and immortality for me!'

Can we date from that day the account given by one of Agostino Tassi's apprentices at the trial in March 1612, a year later?

I did not know their secrets, but I learned from Cosimo that Agostino had become besotted with the aforesaid Artemisia. I never knew whether it was mutual. But Cosimo kept saying that poor Tassi was mad about her – amoroso cotto.'

Tuzia for her part would relate:

After we had seen the palace we all got back into the carriage, except for the men, and we went to Signor Cosimo's house to eat. Signor Orazio and Agostino were there too

and we stayed all day. Signora Artemisia played at jack-stones with some ladies of the household in a little garden at the back and Signor Orazio, Cosimo and Agostino watched them.

Then, she continued, the women went out again and Cosimo's coachman took them to St Peter's to see the cupola and the work Orazio had done. In the evening they returned home. After that, Agostino began to visit the Gentileschis at any time of day he saw fit, even when the father was out.

Artemisia was to corroborate this testimony:

When my father lived on the Via della Croce last year, he let the apartment upstairs to the aforesaid Tuzia [. . .] Since my father was a close friend of the aforesaid Agostino Tassi, Tassi began to visit our house often and to strike up a friendship with the aforesaid Tuzia. One of these occasions was on the day of Santa Croce last May [3 May] and Tuzia began trying to persuade me that Agostino was a good-mannered and honourable young man and that we would suit one another well. Such were her efforts that she convinced me to speak to Agostino, for Tuzia had told me that one of those who had served in our house [Francesco Scalpellino] went about speaking ill of me and that Agostino would tell me what he was saying; I was therefore desirous to know what this servant called Francesco was saying, and I resolved on that day of Santa Croce to speak to Agostino.

When Agostino had been brought in by Tuzia and our conversation had begun, he told me that the aforesaid Francesco went about boasting that I had given him what he wanted. I answered that it mattered little to me what Francesco went about saying because I knew what I was, and I was still a maiden. But Agostino told me that he was troubled that this Francesco went about speaking these things against me, from the friendship he had with my father, and because he valued my honour highly, and without speaking further he left.

One can hardly imagine the sorry state Artemisia must have been in as a result of all the frenzied machinations around her. Her daily movements were restricted to this neighbourhood whose inhabitants were obsessed by her, making her the object of widespread lust, and she struggled within these cross-currents of self-interest, fantasy and desire. She had thought she could remain untouched by this filth, but in the end she had become contaminated. She too was in the grip of an obsession: to possess the fleeing Girolamo Modenese and bind to her the only man who was not forever at her heels. And to bring about a marriage which promised an escape from her fear and revulsion.

In her painting, *Susanna and the Elders*, she represented the people who harried her. The head of one of the two men which, earlier, Orazio had mercilessly obliterated, would now wear Agostino Tassi's fine dark curls. Faceless, his eyes hidden, he merged into the other figure, that of an older man – perhaps Cosimo Quorli. Or maybe the grey hair, straight nose and sharply angled eyebrow evoked another likeness: that of Orazio Gentileschi.

10

The Gentileschi Household in the Via della Croce

3 May 1611

Orazio affected not to look at Artemisia as she undressed and busied himself at his work bench. But he had bolted the door to the studio and pushed a chair against it. Artemisia was in a corner, behind a curtain which she had thrown over a line. Quickly she loosened her bodice and the strings of her petticoat and, wrapping herself in the hanging, ran over to the dais to sit down. She knew that Orazio would not turn round before she had taken up her pose. It was a rule agreed between them: Artemisia would call him when she felt ready. This was how she dealt with the embarrassment of showing herself naked in front of her own father. On these occasions, they both feigned indifference, displaying the coolness of professionals.

If Artemisia had not been so incensed by her father, she would probably have experienced her usual satisfaction in their contravening of the Roman laws which prohibited painters from undressing their models. Male nudes were used by all the painters of the district, but anyone who used real women as the inspiration for their bacchantes, their Susannas and Cleopatras, and all the notably unclothed heroines of painting's history, faced a stiff penalty. The fine details of female flesh and form were therefore rendered by recourse to the anatomy of young boys, their curves rounded by copying the statues of antique goddesses. Of course, a good number of prostitutes proved willing to sit for hefty payments. But, while their tariffs were in proportion to the risks and accordingly sky high, their charms rarely lived up to expectations. The ability secretly to reproduce his daughter's unveiled beauty put a priceless treasure at Orazio's disposal.

'You'll get caught one day,' she said sombrely, kneeling at the prie-dieu

where she played the part of Mary Magdalene.

Her father took these words as a signal and moved nearer.

'Is that a prediction?'

A smile flitted over Orazio's face. At these times, when the naked Artemisia was surrendered to him, he regained some of his former humour and kindness. He took great care not to offend her modesty. He would build big fires to heat the studio and would dispatch the work as fast as he could. He was infinitely grateful for the considerable favour which she granted to him. For her part, she had come to appreciate these privileged moments when they would observe one another without conflict. She never learned more than when able to watch her father painting in silence during these hours of intimacy. But today Orazio felt her cast loveless and unindulgent eyes upon him.

'Is it a prediction,' he continued in the same artificially light tone, 'or a threat?'

Her clasped hands toyed with the crucifix over which she leaned in prayer. Dodging the question, she answered ironically.

'I shall always have an advantage over you, Father. All I'll have to do is undress and pose in front of my mirror to give flesh to all the women who are forbidden to you.'

'Which means . . .'

'That from now on I plan to make this prerogative my own.'

Orazio's brush hung poised in mid-air. These words, so calmly uttered, struck home more than all the squabbles of the preceding weeks. He realised what they meant: a separation of their interests and a declaration of war in the realm of painting.

'Very well, you can go,' was all he said.

Artemisia did not wait for him to repeat it. She abandoned her prie-dieu and got up. This time Orazio watched her as she crossed the studio. She tripped over the drapery trying to hide her body from him: Eve in flight before her creator. He continued to watch – even when she had to let go of the curtain and throw it over the line so that she could get dressed. He realised how dazzling she was in her nakedness and saw, as if for the first time, the breasts and belly of his daughter, of this woman who was so beloved and who would belong to someone else.

'Did you manage to see Girolamo?' Artmeisia shouted up the stairs at Tuzia.

'Yes, thanks be to God, I saw him, but it wasn't easy,' the matron replied severely.

'What did he say to you?'

'That he was prepared to pay you a visit.'

'When, when?'

'Tomorrow morning. He'll come to my door after your father has gone out. As soon as you hear me letting someone in, come upstairs.'

'Tomorrow morning! Tuzia be praised!'

The new house on the Via della Croce differed little from the previous ones. The ground floor was occupied by a tailor's premises. Across the road there was a soap merchant's shop. These landmarks gave the address, for nowhere in Rome were the streets numbered. After the porch, there was the usual wash house on the left, then the stairs which turned around a *cortile*. The Gentileschi family lived on the first floor.

The apartment consisted of five connecting rooms. First there was the kitchen, then the windowless room where the household would gather. Then the studio with its two vast bay windows overlooking the street. Beyond the studio there were two bedrooms. The one at the far end for Orazio and his three sons. The one next to the studio for Artemisia.

It wasn't possible to make out what was said upstairs, on Tuzia's floor, but footsteps could be heard, comings and goings, and the sound of the front door. Artemisia, always hoping for a visit from Girolamo at Tuzia's, lived constantly on the alert.

'Tomorrow!' She repeated, brimming with joy and gratitude.

Tuzia let Artemisia kiss her before going on. 'I won't conceal that I had an almighty trouble catching him in the street. I nearly had to run after him and then I found him very cold compared with before. I had to reassure him by guaranteeing that your father had given me his consent.'

'It's true. It's almost true. He doesn't talk about the convent any more . . .'

'I still think this Girolamo Modenese isn't good enough for you. What the Devil do you see in him? I'll tell you what – may the Madonna forgive me – that man's got nothing between his legs. Whereas Signor Tassi, now that's a different story. There's one who would suit you.'

'I hate him!'

'Why is that?'

'He's a spy in the pay of my father!'

'A gallant man who defends your honour with no other motive but serving

that of your family.'

'An impostor who uses my father's name and friendship to come to his house and loiter outside my door!'

'A generous heart who is capable of forgiving the offence done in a quarrel and who nobly made peace with your Girolamo Modenese.'

'A hypocrite who flatters my father's trust in him all the better to betray it!'

Tuzia heaved a sigh. 'How complicated you are!'

'And you, Tuzia, you are no longer the same since that meeting at the Quirinal Palace!' Artemisia countered vehemently. 'You no longer love me!'

'So, I no longer love you? Tomorrow morning I shall receive your suitor at my house, in your father's absence, and I no longer love you!'

Artemisia smiled sadly. 'You have changed.'

'You make such a fuss. Agostino is a handsome man. He is rich. He is a widower. You need a husband and I have found one for you!'

'I have given my pledge to Girolamo.'

'But your father would rather have Agostino.'

'*I* have chosen Girolamo.'

'Little one, if you want your father to marry you off some day, you would do better to present him with a man that's to his liking.'

11

First Statement of Artemisia Gentileschi
at the Trial of March 1612

Account of the events which took place on 4 and 9 May 1611

The following morning I was in bed, and my father had gone out [. . .] When I heard people going up the stairs, I threw on my dress and went up to Tuzia's apartment. I saw that the visitors were Cosimo and Agostino and I greeted them, then I turned to Agostino and said: 'You even want to bring that man here,' referring to Cosimo; and Agostino told me to calm down and, when I did, Cosimo came towards me and began urging me to make Agostino welcome [. . .] When I showed him I was disgusted with the way he was treating me, he added: 'You have given it to so many you can give it to him too.' I then answered Cosimo angrily that I had little respect for the words of pigs like him. I asked him to relieve me of his presence and turned my back on him; he began saying that he was speaking in jest, but at last Cosimo and Agostino left. I was upset by these words for several days and my father complained because I concealed the cause of my distress from him. Tuzia took advantage of this to tell my father that he should send me out to walk a little for it did me no good to be always indoors. That same evening Agostino sent word to me through one of Tuzia's children that he would like to speak with me a little that evening and with this message he sent Tuzia a piece of cloth to make a cape for one of her children. When I heard this message I turned and said: 'Tell him that it is not fitting to talk to unmarried women at night.'

The following morning my father told Tuzia that, since she thought I should be taken out, she should take me and go with me to San Giovanni, for he judged her to be a respectable woman. While we were getting ready to go out that morning, Cosimo and Agostino appeared, perhaps having been forewarned the night before by Tuzia that we

were to go to San Giovanni, and they talked with Tuzia, arranging that they would take me into the vineyards. I became angry when I heard this and said that I did not wish any assignation in the vineyards and that they should get out of my sight. They went on their way and we went to San Giovanni.

It would never have occurred to Artemisia that it had been her own father, rather than Tuzia, who had informed the two cronies about the planned outing.

It is hard to believe that Orazio would have been senseless enough to make Agostino Tassi and Cosimo Quorli responsible for keeping an eye on his daughter. Yet the testimonies are quite explicit about this. All the workers on the Consistorium site in May 1611 confirmed Agostino Tassi's version of events.

This is what Tassi told the judges:

While I was at Monte Cavallo early one morning, Gentileschi arrived and told me that Tuzia and his daughter had gone to San Giovanni and they had seemed very eager to go, which made him suspect something, and that he would readily have gone to see what was afoot, but because he had fresh plaster on the wall, and I had finished work on mine the evening before, he asked me as a great favour to go there myself, and I went there as a favour to him . . .

Why should one doubt this testimony of Tassi's? In the circumstances, it seems plausible enough: Orazio, knowing Artemisia's aversion for Agostino, had little to fear by charging him to keep a watch on her; Agostino had adequately proved his devotion to the honour of the Gentileschi family in the business of the Girolamo beating. What Orazio had perhaps not foreseen was that Agostino would join up with Cosimo to carry out this surveillance. And that his colleagues, convinced by Gentileschi's complaints and long since persuaded – by his stories, his fears and his suspicions – of Artemisia's misconduct, would be dreaming only of how they too could share in the pleasures she supposedly dispensed to the neighbourhood.

'Don't you find she resembles me?' asked Cosimo gaily as they made their way towards the basilica of San Giovanni.

'Artemisia? I couldn't say.'

'Some of her features. Her eyes . . . Her eyebrows . . . What would you say to her being my daughter?'

'I wouldn't believe it!' answered Tassi laughing heartily. 'Lusting after your own daughter would strike me as reprehensible!'

'What's this? Narrow-mindedness? How do you think Lot procreated? In any case, as far as being reprehensible, the man who meets a shameless woman is already tainted,' Quorli said, ironically paraphrasing Christ.

'If the sin is there already, one might as well avail oneself and enjoy it,' Agostino approved.

Alone up on his scaffolding, Orazio Gentileschi marked out on the plaster the contours of the woman who would embody the fourth cardinal virtue: Temperance. He was aware of his comrades' sensual inclinations; had he failed to judge their danger? What was he expecting? What hopes or fears lay behind this strange errand of his? Did he derive some obscure pleasure from it? Had he guessed at Agostino's interest in Artemisia and was he counting on his jealousy to punish and get rid of the lover she had chosen?

In both their feelings – Agostino's love and Artemisia's hatred – Orazio found a supreme outlet for his own passion, his obsession with them both.

12

The Basilica of San Giovanni in Laterano

Monday 9 May 1611

'Love not the world . . . all that is in the world, the lust of the flesh, and the lust of the eyes, and the pride of life, is not of the Father,' the priest whispered to Artemisia from behind the screen of the confessional. 'Love not the world, neither the things that *are* in the world, my daughter. If any man love the world, the love of the Father is not in him.'

The voice rose in the shadow, the voice of St John the Apostle, murmuring beneath the gold and marble of his church.

It was no mere chance that Artemisia had come to confess her sins in San Giovanni in Laterano, the cathedral of Rome and of the world. Her visit to San Giovanni, the first of the patriarchal basilicas, on this Ascension eve would gain her a plenary indulgence, earning her a remission from her penances. Kneeling under the painted image of Christ on the cross, her brow against the mesh of the screen, she listened with fervent attention: 'Resist desire, my daughter, the desire which is the start of the evil enacted. Tame this rebel flesh with self-mortification and fasting . . .'

Tuzia and Artemisia's young brother Francesco were also communing inside rustling confessional boxes, small dark stains that punctuated the five aisles of the vast church. The organ thundered over the transept, heralding the four high Masses of the day. Between each arch of the nave, silver censors swung gently, the gems that encrusted them flashing in the dense clouds of incense.

Ever since Agostino had made her privy to the slanders of Scalpellino, Artemisia had been burdened by unease. She felt vaguely nauseated, with a disturbing sense of some sin which she was unable to name; it was like a

weight lodged deep inside her, a weight now so familiar that she had forgotten its origin. Sometimes she would shudder, surprised by her own disgust and fear. 'What have I done to make me fear God's wrath like this?' She would take the Madonna as her witness that she was not guilty. She had never had any dealings with this Scalpellino. A lout with dirty hair, a good-for-nothing, a loafer whom the Gentileschis had employed at the studio for a short time, just to use as a model. He had sat for the head of Goliath and the face of one of Christ's executioners. It would have been no sacrifice to resist his seductions. She had never even suspected his loathsome ardour, and the conquests he boasted of could have no credence among right-thinking people. It was only her father whose mind was troubled by such accusations. Orazio's soul and Artemisia's conscience. She was guilty of revolt and treason towards her father. For she betrayed him by plotting this marriage of which he disapproved and in seeking to abandon him.

Beset by doubts, Artemisia plunged herself into a religious fervour. In search of light and forgiveness she lost herself in the heady fragrance of the incense, in the vibration of the organ, in the image of Christ on the cross, in this voice which urged her, 'Follow the example of St John, the virgin apostle to whom Jesus on Golgotha entrusted his mother, and who cries out to you with all his might, my daughter, to you, to all the faithful, to each one of us according to his estate: "You who yield to concupiscence, be a prey to it no longer! And you who enjoy it within a chaste marriage, think no longer of your flesh and renounce the senses."'

'Holy Mary, Mother of God,' she prayed fervently, 'let my father agree to give me in marriage. Save me.'

Bereft of the advice of Tuzia, who now seemed opposed to her understanding with Girolamo Modenese, Artemisia lost her sense of good and evil; of innocence and guilt. Cosimo's latest coarse insinuations defiled her completely. She came to doubt the purity of her actions.

'For God,' the priest continued, 'who has prepared a remedy for incontinence within conjugal love, with this sacred remedy only makes us see the enormity of evil. Certainly, my daughter, this marriage to which you aspire is good since it is a sacrament, but it is something good which supposes an evil, the evil of concupiscence. Marriage, my daughter, is what puts a brake on licentiousness. But the weakness of wretched humanity cannot be deplored enough. How hard it will be for you to contain yourself within the limits of the conjugal bond. Will not love for your own husband lead to your lust for

all other men? To avoid such disturbances, married people must live chastely, which is to say without surrender to the gratification of the senses. My child, be happier than other women, scorn the flesh and scorn the world. Persist in this inclination to innocence, and you will be the equal of God's angels.'

Cherubs flapped their little white wings above the confessional boxes. Innumerable plaster putti with round baby faces fluttered about the cornices and the keystones of the chapels. On a vast tapestry, hung between the columns of the nave, which rippled in the glow of hundreds of candles, St Michael the Archangel triumphed over Satan. The red and gold of the standards, the patterned foliage and scrolling of the carpets all seemed to tremble and vibrate with the breath of divine illumination.

In the morning sun, the entire church became an explosion of colour – the gold-caissoned ceilings, the coats of arms of the different popes against their blue background, the resplendent pattern of green marble lozenges and cherry-red stone rosettes underfoot.

Dense beams of light fell from the lofty windows on to the high altar where only the Pope could celebrate Mass. The flaming torches, the candelabra and the chandeliers which lit the gold reliquary that held the heads of St Peter and St Paul turned the choir into a dazzling blaze. Everything here wrenched Artemisia heavenwards. She felt the power and sacred force of this place, even in the sombre little island where she made confession. The cleric's voice was directed towards her, the murmured cadences enveloping her in its words and cutting her off from the world. 'Do not say "I am unsullied" and do not believe that God has forgotten your sins just because you yourself have forgotten them. Do not resist the wise counsels of the Father and do not succumb to anger when you are rebuked. For it is the height of pride to rise up against authority when it comes to you from the Father, and to rebel against the spur. Do not seek to learn and to know many things. Do not lose yourself in the art which you practice. Renounce painting and seek no other knowledge but that of salvation. Everything else is vanity.'

When Artemisia had received from the priest the paper of indulgence which granted her remission from the penances and fasts which he had imposed on her, and when she had said her prayers in a side chapel, she rejoined Tuzia and Francesco who were waiting for her in the transept, in front of the altar of the holy sacrament. It was this part of the basilica which Pope Clement VIII had had decorated in 1600 by the Cavaliere d'Arpino and his assistants, among

them Giovanni Baglione and Orazio Gentileschi. An unbroken wave of visitors crowded towards it. The faithful halted in contemplation before the tabernacle, strolled around under the frescoes and commented on the subjects of the paintings. In the choir, Mass had begun without silence being imposed. People continued to saunter about, chattering without lowering their voices. Craning her head back, Artemisia tried to identify which of the twelve apostles, high up between the windows, she could attribute to her father's hand.

It was when she reached the organ, just as she thought she recognised Gentileschi's *St Thaddeus*, that she saw Cosimo's substantial figure half hidden behind a pillar. She also caught sight of Agostino's red-slashed sleeves.

The two of them were standing among the pews in the transept, Agostino bending towards his accomplice's bald head, whispering some witticism in his ear. They were both smiling, their eyes fastened on her.

In her second statement in March 1612, Tuzia gave a fairly detailed account of the scene which was about to follow:

> *While we were in San Giovanni in front of the Apostles, Artemisia said to me, 'Look, Agostino and Cosimo are over there. Let's be off.' [. . .] and we left without hearing Mass. Artemisia began walking as fast as she could so that Agostino and Cosimo would not catch up with us.*

Escape was easy; the spot where Artemisia had been looking at the *St Thaddeus* was very near the door. They had only had to walk past the thundering organ to emerge on to the square in front of the church.

With her arms folded, holding against her each end of the long brown scarf which covered her hair, Artemisia quickly threaded her away through the crowds of poor wretches milling around in the dust of the square – the beggars' crutches, the piemen's trays and the baskets of the wicker workers.

She crossed the intersection of roads, leaving behind her the twin bell towers of San Giovanni, the loggia of the papal blessing and the obelisk of the Egyptian god Ammon, which Pope Sixtus V had crowned with a huge cross. Head down, she plunged among the flocks of goats and the heavy box-like prelates' carriages, drawn by galloping teams of six horses, which passed her with their windows masked by leather panels. She made her way down the Via Merulana, which would take her straight to the basilica of Santa Maria Maggiore. From there she intended to go along the Via Felice as far as

the church of Trinità dei Monte. She had come this way with Tuzia and knew it would take around fifty minutes. The popes had planned this network of streets linking each of Rome's great churches with a clear purpose in mind: to enable the faithful to make a pilgrimage to the seven basilicas in a single day. The Church required this journey through the holy city once a year, preferably during the period of carnival so as to keep its citizens away from the pagan pleasures of the Corso, the horse racing and the balls. This was the great project of the Counter-Reformation: to replace masked parades with the spectacle of pious processions, the excitements of the theatre with even more seductive and dazzling stagings – the splendour and the ceremony of Rome's religious sanctuaries.

Thus for Artemisia, advancing along the Via Merulana, the street gave substance to Jesus's words to the Apostle Philip: 'I am the way.' It symbolised the long march of Consciousness towards Truth, the battle between the angel and Satan, the soul's struggle with the body, as mapped by the holy city.

Tuzia described in her statement how Cosimo and Agostino followed them at a distance. Soon the road plunged into an area of muddy wasteland. They were in the countryside. The walls of an old convent crumbled away into ditches, exposing vast open spaces. Here and there, visible between the gaps in the walls, rose the jagged sandy-coloured ruins of medieval towers. It was going to rain. Flocks of sheep roamed among the beams and wooden planks rotting in the grass: the remains of a stable, what was left of a tumbledown smallholding. Some way off, among the black forms of the pine trees, long-horned buffalo grazed as far as the eye could see in the direction of Aurelian's Wall.

The yellow light of a thunderstorm lay over the fields. The air smelled of humus and dung. Artemisia stumbled on pebbles and stones from crumbling walls. Cockerels and pigs crossed her path. Half-way up the hillsides, avenues of cypresses climbed towards mysterious groves among which villas nestled unseen.

Tuzia was to relate that Artemisia's young brother, Francesco, lagged behind and that Cosimo and Agostino very soon caught up with him. They were very friendly and bought him a pastry. When they finally rejoined Tuzia, Francesco was having a lively conversation with them, although she could not hear what they were saying. Artemisia had quickened her pace and was walking even faster so that they all called out to her not to run.

Agostino admitted:

I think I recall approaching her on the road, and asking what was she doing gadding about so early in the morning. I said that her father had sent me there . . .

She made no answer and her face gave nothing away. The two of them were now walking side by side. She, tightly bound in her scarf; he with his cape flying in the wind. The walls seemed to close in on them.

'It is so deserted here, something could easily happen to you,' he insisted. He was almost running to keep abreast of her. 'And if something did happen to you, we should both be sorry, for we would have to explain it to your father.'

He shot her a glance. She remained silent.

'Artemisia, by running away from me like this you are causing me such sorrow that I cannot put it into words. God has given me many crosses to bear, but none has given me as much grief as the one you are making me carry this morning.

Tassi made full use of the talent for oratory that had earned him his nickname, *lo Smargiasso*, the Braggart.

'But I forgive you for the offensive thoughts you harbour against me. I have your true interests at heart – despite your conduct. So much at heart that I would give my life to prevent you from destroying the work of God which you embody. For by making assignations with men in churches, by yielding to those who lust after you, by deceiving your father, you destroy yourself, Artemisia.'

'I have never made an assignation with anyone,' she protested.

Agostino hid a smile. She had reacted: the battle was under way and he would win it.

'If you were not moved by bad intentions, why would you run from me? If you were without guilty thoughts, why would you ascribe them to me?' They were coming out towards the construction site at Santa Maria Maggiore. 'Why do you assume that you are the only one who comes here to pray?'

Without wavering, Artemisia skirted the basilica and turned right at the corner of Cardinal Montalto's villa. Here, the landscape changed and Rome presented itself in all its majesty. The marble walls, the fountains glimpsed through the six-arched porticoes, the snow-white villa beneath the pewter sky, the antique statues among the orange trees heavy with fruit – suddenly everything assumed an air of grandeur. Artemisia had momentarily outdistanced Agostino, but she halted at this crossroads.

'You are odious!'

Crossing the space between them, she confronted him: 'You are taking advantage of my father's friendship to harass me!' She shook, unable to contain her emotion. 'I find you everywhere I go. You follow me into churches, you even harry me into confessional boxes! I find your insistence unbearable,' she shouted, 'Your indiscretion offends me and your coarseness sickens me. You will never get anything from me with these tactics.'

This speech seemed to have a striking effect. Agostino did not turn a hair, but the violence of the emotion which worked on his features produced a countenance whose brutality was no longer under control. Both had reached the same point of tension, and for a brief moment they sized one another up.

'Leave me alone, or I shall tell my father about your disgusting games!'

Agostino gave up the field to her. Taking the other turning, he left her with the words, 'Watch out!'

Tuzia and Artemisia claimed that they lost sight of him between Santa Maria Maggiore and the Via della Croce. As for Cosimo, he had also given up the chase.

But Artemisia was to add:

> When I got home the parish fathers came by to collect the communion cards and they left the door open, whereby Agostino came up into the house. When he saw these Fathers he began boasting that he would like to beat them, saying so in a mutter so that they could not hear him.

By slipping into her testimony these seemingly insignificant details about Agostino's behaviour in the presence of the priests, Artemisia was laying a trap for him. She was making it plain that he lacked respect for men of the Church and insidiously suggesting that he had not received communion on Easter Sunday, even though Easter communion was a fundamental duty, and the only occasion when the Church made communion obligatory.

During communion, the priest would give the faithful a card as proof that they had fulfilled this obligation. Anyone who failed to produce this card ran the risk of excommunication. Or the stake.

In the war which had broken out between Agostino Tassi and Artemisia Gentileschi, each was preparing for the fray.

Agostino went away again and when the fathers had left he came back and began to complain that I behaved badly towards him and that I did not care for him, saying that I would regret it. And I answered, 'Regret what? The man who wants me must put this on my finger,' by which I meant marry me and put a ring on my finger, and I turned my back on him and went into my bedroom and he went away.

13

The Studio in the Via della Croce

9 May 1611

On the easel, *Susanna and the Elders* sat in sunlit splendour. Standing back, Artemisia inspected her work. Yes, this time it seemed truly finished.

She pulled the easel to the back of the studio. The canvas had to dry well out of the sun, to avoid any yellowing of the glazes and varnishes.

In the shadow the picture gleamed like a great mirror. The faces of the three figures – Artemisia, Agostino, Orazio perhaps – seemed almost vitrified. The elders' shoulders came together in a single line, a monochrome curve, violet altering to red, the arc of a circle which closed off space, weighing down on Susanna's body, crushing her.

Along with every painter in Rome, Artemisia knew the biblical text:

The same year were appointed two of the ancients of the people to be judges [. . .] Now when the people departed away at noon, Susanna went into her husband's garden to walk. And the two elders saw her going in every day, and walking; so that their lust was inflamed toward her. And they perverted their own mind.

Who had recited these verses from the Book of Daniel to her? Was it her father, or had it been Cosimo who had whispered the words in her ear?

And albeit they both were wounded with her love, yet durst not one shew another his grief [. . .] So when they were gone out, they parted the one from the other, and turning back again they came to the same place; and after that they had asked one another the cause, they acknowledged their lust; then appointed they a time both together, when they might find her alone [. . .] And it fell out [. . .] she was desirous to wash herself in the garden: for it was hot. And there was nobody there save the two elders, that had hid

themselves, and watched her [. . .] *Now when the maids were gone forth, the two elders rose up, and ran unto her, saying, Behold, the garden doors are shut, that no man can see us, and we are in love with thee; therefore consent unto us, and lie with us. If thou wilt not, we will bear witness against thee, that a young man was with thee* [. . .] *Then Susanna sighed, and said, I am straitened on every side: for if I do this thing, it is death unto me: and if I do it not, I cannot escape your hands. It is better for me to fall into your hands, and not do it, than to sin in the sight of the Lord. With that Susanna cried with a loud voice: and the two elders cried out against her* [. . .] *Then the assembly believed them, as those that were the elders and judges of the people: so they condemned her to death.*

On the canvas, unable to shield her nakedness from all eyes, Susanna struggled.

14

First Statement of Artemisia Gentileschi
at the Trial of March 1612

Account of the events which took place on 9 May 1611

*And on the same day after midday dinner the weather was wet and I was painting a
portrait of one of Tuzia's children for my own pleasure, when Agostino came by. He
was able to get inside because there were masons working in the house and they had left
the door open. When he found me painting he said, 'Not so much painting, not so much
painting,' and he took the palette and brushes out of my hands and threw them around,
saying to Tuzia, 'Get out of here.' When I said to Tuzia to stay and not leave me with
him as I had motioned to her before, she said, 'I don't want to stay and argue, I want to
be off.' Before she left Agostino put his head on my breast and after she had gone he took
me by the hand and said, 'Let us walk about a bit because I hate to be sitting down.' As
we walked up and down the room some two or three times I told him that I felt unwell
and that I thought I had the fever, and he answered, 'I have more fever than you,' and
after walking up and down two or three times, each time going past my bedroom door,
when we came to the door of the bedroom he pushed me inside and locked it. Once it was
locked, he pushed me on to the edge of the bed with one hand on my breast, and he put
one of his knees between my thighs so that I could not close them, and he lifted my
clothes, doing so with much difficulty. He placed one of his hands with a handkerchief
over my throat and my mouth so that I could not scream[. . .] and with his member
pointed at my vagina he began to push it into me, having first put both his knees between
my legs, I felt a terrible burning and it hurt me very much, but because of the gag on my
mouth I could not cry out, though I tried as best I was able to scream and call Tuzia.
And I scratched his face and I pulled his hair and before he could put it inside me again
I grabbed his member so tightly that I even removed a piece of flesh. But none of this*

bothered him and he continued what he was intent upon, staying on top of me for a long time and keeping his member inside my vagina. And after he had finished his business he got off me. Seeing myself free I went to the table drawer and took out a knife and moved towards Agostino saying, 'I want to kill you with this knife because you have dishonoured me.' And he opened his tunic saying, 'Here I am,' and I threw the knife at him; he shielded himself otherwise I would have hurt him and might easily have killed him. The outcome was that I wounded him slightly on the chest and he bled little because I had scarcely pierced him with the point of the knife. Then said Agostino fastened his tunic and I was weeping and lamenting the wrong he had done me and to pacify me he said, 'Give me your hand and I promise to marry you as soon as I am out of the mess I am in.' He also said to me, 'I warn you that when I take you as a wife I want no foolishness,' and I answered him: 'I think you can see whether there is foolishness.' With this good promise I became calmer and with this promise he persuaded me later to comply with his desires lovingly on several occasions and he also confirmed the promise too on several later occasions.

[. . .] No, sir, I have never had carnal relations with any person other than the said Agostino. It is certainly true that Cosimo did his utmost to have me before then and after Agostino had me, but I never would consent, and once in particular he came to my house after I had been with Agostino and did his utmost to force me but he did not succeed; and because I would not consent to it he said that he would boast about it in any case and would tell everyone about having had me, which he did with a great many people and particularly with [. . .] Agostino, who in his fury withdrew his promise to marry me.

[. . .] And I was all the more certain of said Agostino's promise to marry me because every time there was any possibility of a marriage being arranged for me he would spoil the chances of it happening.

[. . .] And this is what passed between said Agostino and me.

PART II
JUDITH

Rome in Scipione Borghese's Day
1611–1612

15

The Curia and the State against Agostino Tassi
on Charges of Rape and Procurement

Tor di Nona Prison, Monday 14 May 1612

'What would you say if Artemisia Gentileschi came here to confirm her statement in front of you? What would you say if she came in through that door now to tell you in person that you are lying?'

'I would say, once and for all, that the woman isn't telling the truth!'

It was Agostino Tassi's seventh interrogation in the course of two months in prison. He had been arrested on 16 March 1612 and spent the first ten days in solitary confinement. Ever since 28 March, the date of his first statement, the judges had been asking the same questions and Agostino stuck to the same answers.

Today the atmosphere was hardening. After transfer from the cells at Corte Savella to the ghastly dungeons at Tor di Nona, Tassi was now going to have to confront the witness for the prosecution – Artemisia Gentileschi – before the law would at last permit him to take on a lawyer. Once this final confrontation was over, Agostino Tassi would be able to organise his defence and make a counter-attack.

The court had assembled at its full complement. All the highest dignitaries of papal justice were there: my Lord Girolamo Felici, the governor's lieutenant, my Lord Francesco Bulgarello, judge at the Roman Curia; my Lord Porzio Camerario, state prosecutor; the notary Decio Cambri, clerk of the tribunal and his deputy, Ostilio Tucco.

The last of these had taken down Artemisia Gentileschi's initial statement, given in private at her home. This was the first time she would be present before the magistrates in this small Chancery room. But the court had already

had plenty of time to form an opinion about the case: a scandal which was taking the Eternal City's artistic world by storm, involving the painters in the service of the Pope and his steward, one of the highest placed functionaries in the Borghese household. All Rome was thrilled by this trial. Sculptors, apprentices and models had paraded through the dock ever since the start of proceedings. Those artists who had been regular visitors at Orazio Gentileschi's ever-changing addresses came to describe their connection with his daughter. 'I've never seen her,' one of them admitted. 'but at the shop of the colour seller Antinoro, on the Corso, there was a lot of talk. Like everyone in Rome, we liked discussing crime and cunt, fighting and fucking.' According to another: 'There was much argument over Artemisia's virtue. The ultramarine sellers maintained she was a virgin. They said they had dealt with her, since she was the one who ran the studio and painted Orazio's pictures.'

The judges of the papal court did not underestimate the importance of what was at stake, and their reflections betrayed the awkwardness of the situation: whether she was victim or victimiser, virgin or slut, this girl was certainly in a hurry to get married. But what was her relationship with her father and how complicit were they? When Orazio Gentileschi brought the charge, he claimed that she had been *stuprata più e più volte* – 'repeatedly deflowered' – by Agostino Tassi. The absurdity of this accusation prompted the magistrates to doubt him: How can a woman be raped for nine months without her being complicit and consenting? Moreover, how could one seriously believe that this Gentileschi – a man whom all the witnesses described as being jealous – remained in ignorance of his daughter's liaison with his assistant for nine months? And what now drove him to exhibit his own shame in public? For, in the end, it was his name, Gentileschi, which his daughter's defloration smeared with scandal. There must have been something enormous at stake for him to bring charges against his associate all this time after the crime had been committed?

Artemisia was soon to be asked these questions by the magistrates in the torture chamber of the Tor di Nona prison.

For Agostino, it was a hellish business, and Cosimo was no longer there to get him out of the mess he was in: a stone slab in the church of Santa Marta al Vaticano bore down on his mortal remains.

In the artists' quarter, everyone predicted that the affair would end like the trial of the incestuous and parricidal Beatrice Cenci thirteen years earlier: on the scaffold.

16

The First Five Months after the Rape

May to November 1611

Throughout the five months following the rape, Agostino had had a good time. It was true, he had been ready for anything – except finding Artemisia's maidenhead intact, after that fool Orazio had gone about telling everyone his daughter was a slut. But the girl's virginity only made the exploit all the more dangerously titillating.

In the beginning, Cosimo had been there to appreciate Agostino's talent for calming Artemisia's despair and putting a stop to the curses and hysterics which had come in the wake of the defloration. When Agostino had left the Gentileschis' house that day, he had gone straight up to the Quirinal Palace to see Orazio. He had given him an account of his outing to San Giovanni and then he had gone back to the house in the Via della Croce with him to have supper. Artemisia had heard the two men sit down at table together – her father and her seducer – and had shut herself up in her room.

It was then that Agostino realised he had come out of it well. If Artemisia did not accuse him straight away, if she did not shout out her dishonour immediately, she would never be able to talk to her father about it later. That very evening Agostino audaciously persuaded Gentileschi to let Artemisia have lessons in perspective. Was drawing her weak point? Tassi, the virtuoso, offered to remedy that. Orazio was won over. Agostino would generously play the teacher whenever his own work allowed him some time.

Artemisia opposed these so-called lessons with wild and desperate vehemence. But, taking these displays of dislike as a guarantee of his daughter's virtue, Orazio had dug in his heels and forced her to comply. She had had no choice but to accept – to accept everything. An attachment to

Agostino Tassi now remained her only hope of salvation. Marrying him the only possible outcome. What other option did she have? In the eyes of the world, Artemisia Gentileschi was henceforth a tarnished woman. In the state Tassi had left her in, no man would welcome her into his house. Agostino alone had the power to 'make good'. She was dependent on his goodwill, his trust, perhaps his love. Ought she not to assure him of her submission? To regard him as her master? Was he not the only man from whom she could hope for anything? Tuzia had told her that the Church authorised certain liberties such as kisses and caresses, so long as the pleasures of love were quickly legitimised by marriage; that the promises exchanged by the lovers in private were just as serious as the sacrament dispensed by the Church.

From then on, Agostino had come to see Artemisia every day. Every day he purported to teach her geometry, perspective and other skills besides.

'Ah, *perspective*, Signorina Artemisia!' he would call out gaily as he crossed the studio.

Full of hate, Artemisia hung back on the threshold. She knew that he was shouting in order to be heard by everyone in the house.

'Come here!' he bellowed. 'Today you are going to learn how to work out scale mathematically . . .'

Iron and glass, copper and wood all banged noisily together as he set down on the workbench the big bundle containing the instruments of his art.

'Sit over here. Take the set square,' – he waved the object under her nose – 'the compass . . .'

Mischievously, Agostino gave her arm a little pinch. She started back, threatening him with an ominous look. But he pretended to be unaware of her rebellion.

'. . . The ruler . . .' He playfully made as if to hit her with it.

'Last of all,' he concluded, continuing to aim his instructions at a distant audience, 'the famous perspectograph, invented by Leonardo, depicted by Dürer in his engravings, and perfected by . . . your humble servant.'

Passing her the frame, the cloth, the threads and the lead weights, he brushed her hands. He caressed her palm and her wrist and stared deep into her eyes. Each look and touch troubled and disturbed her. Artemisia sought to avoid his eyes. Agostino's presence threw her into turmoil. Overwhelmed by conflicting emotions, she experienced simultaneous disgust and fascination; feelings of fear, even terror, went hand in hand with a

disconcerting sense of complicity. While Agostino's desire sickened her, it also reassured her: after having possessed her, indifference on his part would have been more terrible still.

'The essence of geometry, my child,' he declaimed, 'is a mastery of measurement. The pieces of that clever instrument which you hold in your hands will only be of use to you later, when you know how to solve the big problems.'

He spread a sheet of paper in front of her.

'For now, you are going to draw me a perfect arc, which you shall divide into eight points: A, B, C, D, E, F, G, H . . .'

He moved behind her, lightly touching the back of her neck.

'You will connect them to the adjacent line at P.' He played with Artemisia's curls, excited by the tremor of her flesh under his fingers. 'At P, I said! Don't you understand what you are being asked to do?'

He bent over her, putting his weight against her shoulder.

'Here!' he shouted, tapping his finger on the paper.

Paralysed, Artemisia attempted to follow his instructions, but she did not understand the exercise.

'You really don't know anything,' he went on severely, depositing a kiss on her neck. 'So what has your father taught you?' he murmured, his mouth against her ear.

'Stop it!' In exasperation, she had leaped to her feet.

He placed his hand on her shoulder and leaned on it with all his weight, forcing her to sit down again.

'Don't touch me!'

'Will you please obey your teacher,' he whispered roguishly, 'your master and husband?'

'Let go of me!'

He shook her so that she lost her balance and fell back on to her stool.

'Connect the points P, L, G, M, N, so that these form a right angle with the adjacent line. Then trace the perpendicular . . .'

All through the spring, Artemisia resisted and continued to fight for the sake of honour. But what honour could there be now? A sense of her own sinfulness compelled her to secrecy. Shame made her take a share in Agostino's guilt for the rape, binding her more closely to him with every day that went by. The redemption offered by matrimony meant that she would be tied to Tassi for ever.

Eventually Artemisia recognised that Agostino's footsteps on the stair, his hand on the back of her neck, all his sound and fury, gave her relief from her suffocating distress, wrenched her out of her despair. Rather than nausea and nothingness, she preferred being smothered in the arms of her 'master and husband'.

One evening in July, when Agostino least expected it, she laid down her arms and surrendered. Only love, conjugal love, could save her.

'If Agostino knows me, if he trusts me, he will help me. What could my father do, even if I confessed everything to him? He must know nothing, he would not believe me. I must resolve things by myself.'

In the sweltering heat of Rome, they moved from the studio to the bedchamber. With ardent frenzy, she now yielded to Agostino's desires, responding to his embraces with all the sensuality that he had guessed at in the past. He found he could not live without her beauty.

As the months passed, they discovered a certain intimacy, even tenderness. Agostino described to her the pictures of the great painters with whom he had worked – immortal works which he would show her one day. He conjured up for her the sumptuous court of Florence. He imagined their arrival at the Pitti Palace, the audience he would obtain for her with His Most Serene Majesty. (Agostino took pride in the special protection he enjoyed from the Grand Duke Cosimo.) One day, the descendants of the Medici family would set great store by the works of Artemisia Gentileschi.

Lo Smargiasso, the Braggart. Agostino Tassi had moved in every circle and known a great many women. He was one of those men to whom fear and doubt seem alien. To the moral confusion with which Artemisia was struggling, Agostino supplied the answers: they would open a studio in Tuscany and work together for Cosimo II and all the princes of Europe.

Bound by their secret and their dreams of greatness, they sometimes forgot to bolt the door. Once Tuzia surprised them as they lay in Artemisia's bedchamber, she naked between the sheets, he fully clothed, with his arms crossed behind his head and his boots on the bed.

'Mind your own business!' the young woman shouted.

Strangely, it was not Agostino who demanded Tuzia's silence. Artemisia had got up: 'If you tell my father what you have just seen . . .'

She was not embarrassed by her nakedness. With her beautiful body in full view of Tuzia, she made hoarse threats: 'I shall tell him that you are the one

who betrayed me, that you left me alone with him when I begged you not to quit the studio. That it was you who placed me in this situation!'

Panic-stricken, Tuzia fled.

Orazio, however, seemed not to suspect. He appeared even to have accepted the idea of giving away his daughter to whoever asked to marry her. He often spoke of the possible engagement to Girolamo – a marriage which Artemisia now knew was impossible, but the thought of which made Agostino crazy with jealousy. He sometimes wondered whether Orazio was making fun of him – perhaps of all of them. This suspicion enlivened a good number of his conversations with Cosimo Quorli. Was Gentileschi really that naïve? Had he no inkling of what was going on in his house? 'No . . . ,' Tassi would argue. Throughout his long career as a seducer, he had met such fathers as Orazio, such husbands and lovers who remained deaf to what everyone around them was shouting about. Besides, it was a feature of Orazio's character: despite his jealousy, he was always blinkered to what he did not want to know. 'Blinkers and horns!' Agostino jeered. Wasn't Gentileschi the only one to remain in ignorance of the gossip spread by Cosimo about Prudenzia's pre-marital amours? The steward yielded to this line of reasoning. Orazio saw nothing; he was blinded by his affection and gratitude towards his talented young collaborator. Didn't Agostino do him countless favours? He had just lent him two hundred scudi, a substantial sum which Gentileschi would not be able to repay for a while. Even if Orazio harboured some suspicions, it was in his interest to keep quiet. But Cosimo remained defiant. Agostino should not rely in future on the ingenuity of Artemisia's brothers to get him into the house. The perfect solution would be to settle someone there, thought Cosimo, a paid spy who would facilitate Agostino's comings and goings to the bedchamber. And his own if required.

In July 1611, the Gentileschi family left the artists' district to move nearer to Agostino's apartment. With Tuzia and her children still in train, Orazio settled on the right bank of the Tiber. Tassi had found him a house, an entire building, in the parish of Santo Spirito in Sassia, in the area near the hospital. Only yards away from Cosimo Quorli's house.

This latest move strengthened the bonds within the little group and meant that the three cronies were able to walk together to their new place of work. The success of the Tassi–Gentileschi collaboration and their triumph at the

Consistorium had won them an even more prestigious commission: a loggia for the cardinal-nephew, to rival the Carraccis' gallery at the Farnese Palace – an entire pavilion at the far end of Scipione Borghese's garden, which Rome was already calling the 'Casino of the Muses'.

This task would occupy them for months to come. Who would keep an eye on Artemisia in their absence? Tuzia? Agostino and Cosimo no longer had any illusions about the woman. If she had fostered Tassi's amorous advances, she could equally well encourage other liaisons.

For her part, Artemisia kept everything secret from her erstwhile friend. She even exhibited a fierce mistrust of her. The two women avoided one another, and Tuzia now lived in fear of Artemisia's moods and Agostino's jealousy and violence. Did he not regard her as a procuress who would sell her services to the highest bidder?

In the new house at Santo Spirito, love-making between master and pupil became more hazardous with each day that went by. The studio was no longer next to Artemisia's bedchamber. To move from one room to the other, the lovers had to go through the chamber occupied by Orazio and his three sons. While Gentileschi's children were beguiled by Tassi's wit and vigour, according him a certain veneration, the eldest, Francesco, was now old enough to grasp the nature of the attachment between his sister and his father's associate. How much did he know? Francesco kept quiet, but he forbade the younger two from accepting the treats that Agostino offered in return for passing messages to Artemisia. Likewise he now took care never to leave the studio during the lessons. Agostino claimed that the youth wished to take advantage of his knowledge and his teaching. Artemisia shrugged her shoulders. Her brother's constant presence by her side was irritating. Everything was irritating, particularly Agostino's self-confidence and unperturbability. It was as if he was entirely content with the present situation – with their life as a couple.

Sensing some danger for the future in this attitude of contentment, Artemisia pretended to take up with Girolamo Modenese again. It was a crass stratagem, but Agostino fell into the trap. At least his violent jealousy reassured Artemisia of the strength of their passsion.

Agostino made Tuzia block off the internal stairway which led from her rooms to those of the Gentileschi family, claiming that this was the route taken by Girolamo and others who came to visit Artemisia. He would turn up at

Tuzia's and make a scene, going down to the door – which he had walled up – to listen to Orazio's conversations. Just like everyone else, he was now unable to slip between one floor and the next.

Soothed by these proofs, Artemisia took some wild risks. Sometimes Orazio would go to bed while his associate was lying directly behind him on the other side of the partition wall. To make his escape, Agostino would have to pass the sleeping Orazio, or else wait until he left in the morning before joining him at the Casino of the Muses.

Since the summer, Artemisia had come to know the exhilaration of secrecy and fear. She found a feverish pleasure in the concealment of her passion and took delight in lying. In the beginning, Agostino had shared in this intoxication. He desired Artemisia's body in the night: her willing lips inflamed him all the more and all the better for the sight of their cold remoteness in the daytime. But these risks gradually ceased to interest him. He wanted to enjoy his pleasures without disturbance. Artemisia rashly played with fire, surrendering herself to fortune with the rage and stubborness of despair.

The downpour was unrelenting. Artemisia listened to the gusting wind and the raindrops beating against the windows like hail. The Tiber was rising to such a height under the arches of the bridges, and so close to the house, that she would soon have only to lean out a little to be able to slide into it. During these nights of waiting for Agostino to steal into her bedroom, she would dream as she lay awake. She was so afraid of the future that she thought of ending things there and then. But she loved nothing more than those nights, when she could feel her father, death and danger so near.

One night, when Orazio was having supper at the inn, she herself had opened the door to Agostino, leading him to her room in front of her brothers without bothering to lower her voice. When Francesco had asked where they were going, she had answered with calm irony that they were doing nothing wrong. The minute the bedchamber door had closed, she began to undress. Agostino watched her take off her gown, her petticoat, her shift. 'It's strange how recklessly women can act!' he thought, feeling something between triumph and fear. But when Artemisia's gown had fallen to the floor and he saw her in all her dazzling beauty, he noticed she had tears in her eyes. He pulled her to him. She laid her head on his shoulder and wept soundlessly. Agostino savoured his victory. It was only when he had made a woman weep that he regarded her as his.

He stepped back towards the bed and lay down, holding her above him. Slowly, she bent over him. For a brief moment her face hovered, its expression unsmiling. He breathed in the scent of her hair and her breasts. Pale with excitement, he closed his eyes. She bent closer. He let himself be buried beneath her womanly body. She placed her burning lips on his mouth. The violence of his desire almost made him lose consciousness.

This passion between the victim and her tormentor lasted until Cosimo Quorli put an end to it. Quorli deemed Tassi's crises of doubt to be excessive. The fool had got it into his head that he should 'make amends' for his sin and even thought of marrying Artemisia. Quorli wanted none of it. Ever since Artemisia had rejected his advances, he went out of his way to criticise her. 'She means nothing but trouble. How can you burden yourself with a woman like that?' But Agostino had become less arrogant. 'She's temperamental,' Quorli would insist. 'The sort who will only make your life difficult. That girl brings bad luck. See how we are arguing because of her, when we got on so well before.'

Relations between the two had indeed cooled in the wake of the steward's attempted seduction. This was one mistress whom Agostino regarded as his exclusive property and this jealousy, which comforted Artemisia, infuriated Quorli.

'May she go to hell,' sneered Cosimo.

'You boast that you are her father, so how can you seek to possess her?'

'Calm down, you damn idiot. It's one way of making families bigger!'

But Agostino no longer laughed at these jokes. Now that he was smitten with his quarry, anxiety made him morose. Belatedly, he measured the consequences of his actions. Had Artemisia not been a virgin, her rape would have had no significance. But the value of virginity had just been solemnly reaffirmed in the proceedings of the Council of Trent and made sacred by Pope Paul V: a woman could belong only to one man – her husband. Agostino knew the price to be paid for *stupro violento*, forced defloration. The same crime had compelled him to marry the late Maria Cannodoli. You either married or faced a sentence of five to twenty years on the galleys.

Cosimo knew all about the episode with Maria Cannodoli which occurred at Livorno in 1602. It was he who had provided a *procuratore* for Agostino's defence. This man, a public notary in Florence who had since

been struck off the list of notaries, was a first cousin to Cosimo Quorli and was now in Rome. He lived in the steward's household and Quorli, who saw no way of being rid of him, longed to place him with the Gentileschi family – on condition that the notary should serve his interests there.

'Why not take in my cousin?' Cosimo whispered in Orazio's ear. 'You have a large house.'

It was the twenty-fifth of November, the feast of St Catherine, and Cosimo was giving a banquet in Agostino's honour. He had had a long table set up in his gallery. Like cardinals, the pope's steward prided himself on exhibiting one of the finest collections of paintings. There were no Titians or Raphaels, but a hundred or so canvases signed by the most famous artists in Rome. They were hung from floor to ceiling, each work a bribe, a sop, which Cosimo had received from its author, in thanks for a commission received through his offices. As he grew older, this passion for painting went to his head. He conducted his blackmail openly, his greed with the artists becoming daily more apparent. Thus he had demanded that Orazio give him a portrait of his daughter as Judith as a reward for Scipione Borghese's commission at the famous Casino of the Muses – constantly reminding Gentileschi that he was in his debt for it. Orazio was late with this painting. Overburdened with work, he had entrusted its execution to Artemisia, without letting her know that Cosimo already regarded himself as the owner of the work. Orazio himself did not know what he would do with the *Judith*. Would he surrender it to the steward? Would he sell it? It would all depend on its quality and the price he would be able to get for it. For the moment, Artemisia was working on it under Agostino's supervision. Cosimo was much diverted by the idea of fixing Artemisia's physical form on canvas – her body, if not exactly drawn by her lover, at least composed under his orders. The thought of hanging on his wall a work that united the hands and the paintbrushes of the secret couple entertained him enormously. In fact, everything about Agostino's affairs entertained the steward at present. He had got it into his head to bring about a reconciliation with Tassi's sister Olimpia, the famous Olimpia who had previously reported Agostino for incest. How could Agostino have sensed the danger in such a reunion? There was too much to forgive. Not only had he ruined Olimpia's husband by forcing him to sell the tannery for his sake, Agostino had then accused her of attempted murder, claiming that she had hired assassins to kill him. With this denunciation, he in turn had sent her to prison.

Cosimo aimed to put a brake on things, particularly since fresh troubles threatened his protégé: last August Agostino had had his friend, the painter Valerio Ursino, arrested for debt and the latter now craved vengeance. It was Valerio Ursino who had harboured the murderers of Tassi's wife . . . There were clouds gathering over Agostino's head. Quorli, who excelled in the art of mediation, suggested they all meet around the same table.

Agostino brought Costanza to this peace dinner; Orazio brought Artemisia. Seated side by side, the two young women didn't exchange a single word. They had not seen one another since the visit to the Consistorium and they had no idea to what degree their love affairs bound them together. Yet things between them had changed. Cosimo chuckled as he watched them. With both women regarding themselves as Agostino's wife, the evening promised the pleasant diversion of a cat fight. They all needed a bit of fun. The over-serious turn taken by Tassi's liaison with Gentileschi's daughter was so damned boring. Cosimo thought it high time to throw cold water on the fire. He had therefore placed Olimpia on Artemisia's right. The latter knew nothing of Tassi's past or present life; she had no knowledge of Maria's murder or the liaison with Costanza. Cosimo left it to Olimpia to put her in the picture. He relied upon her insinuations and treachery to reveal the circumstances of Costanza's latest pregnancy.

But the supper progressed without incident. The presence of a newcomer, the sombre notary who sat at the end of the table, had a calming effect on the atmosphere. Orazio and Cosimo conversed serenely.

'My poor cousin whom you see over there,' whispered Cosimo with a look in that direction, 'my poor cousin has had his share of misfortunes.'

The person in question was tall and thin, wearing black as state prosecutors do, and he avoided their eyes. His head was lowered as he smiled into the distance, clenching his teeth and chewing slowly on the food which he gave every appearance of relishing.

'He is invisible . . . secret,' Cosimo continued, 'Pious, into the bargain. He spends his life in the confessional. He respects God and hates the noise of humanity. He is the very soul of discretion – his profession requires it – and wouldn't be in your way. You would have someone at home you could utterly trust. You are too taken up with your commission at the moment. Do you know what Artemisia gets up to in your absence? I should not like to speak ill of the chaperone you have chosen for your daughter, but in your shoes I should be wary of that foul creature Tuzia. Whereas my cousin is an honourable

man. He will watch over your children as if they were his own. He has two sons the same age as yours, and a wife, a fine, decent woman who will keep an eye on Artemisia. Ask Agostino what he thinks about it; he has seen a good deal of them.

The man's name was Giovan Battista Stiattesi. He was forty-two years old. He had indeed known Agostino Tassi for a long time. Their acquaintance dated from their meeting in Livorno. Being a native of Florence, where Tassi had worked, he knew a lot about him, in particular that the ships of the Grand Duke Ferdinand de' Medici, on which Agostino boasted he had travelled the world, had instead seen him row as a galley slave. His ties to his cousin Cosimo were even closer. Giovan Battista Stiattesi had long since taken care of the steward's business in Tuscany. He owed his ruined position to the embezzlement, fraud and confidence tricks performed on his powerful relative's behalf. The last deeds notarised by Giovan Battista Stiattesi for Cosimo had even forced him to flee from Tuscany and take refuge in Rome. He was now without resources. He judged that the steward owed him help and protection.

Stiattesi's unctuous manners and pious talk sealed the arrangement for which Cosimo had prepared the ground: the day after the banquet, Orazio agreed to house him for some weeks – in exchange for trifling labours and considerable duties.

In November 1611, Stiattesi took up his lodgings in the painter's household, with the task of informing Cosimo about everything that went on there.

But the squaring of the Tassi–Gentileschi–Quorli triangle was going to change the course of fate for all four of them. The notary had old scores to settle with two of the protagonists, particularly his cousin the steward. For the first and only time in his life, Cosimo had misjudged a man and made a wrong move. Thanks to his new position, Giovan Battista Stiattesi would now show his hand and make off with the stake.

17

The Stiattesi Affair

November 1611 to May 1612

TESTIMONY OF GIOVAN BATTISTA STIATTESI AT AGOSTINO'S TRIAL

For the last six months I have regularly been in the company of Agostino, Cosimo and Orazio, and I have been present during their conversations, both private and public, about their amorous pursuits. Through Cosimo and Agostino, I learned that Cosimo had attempted to deflower Artemisia and that Agostino had succeeded. Through Orazio, I was charged with negotiating a marriage contract with Girolamo Modenese. But this marriage, like all the rest, was prevented by Agostino who, speaking to me in confidence, confessed that he did not want some other man to assume the right to enter that house. What he meant was that Artemisia must belong to him and no one else. He was in such a state of jealousy, he paid people to stand guard both day and night and give him warning should anyone enter her house. From this information, Agostino concluded that her conduct was honourable. But he mistrusted Tuzia; he suspected her of receiving men who might take Artemisia away from him. In particular Girolamo Modenese, whom her father feigned to accept as a son-in-law. The truth of this can be ascertained by Your Lordship from others. And from Agostino's sonnets, which I have here. And from these letters which he sent to me. And from my answers which I copied. I can also provide the poems which I wrote and the messages which I myself sent regarding this business. I shall take back all of these pieces of evidence when the law has no further need of them.

What a peculiar habit, to keep copies of every letter sent, of the shortest line and the tiniest scribble passed from friend to friend; to set out for each message a kind of textual commentary for the judges, so that they could catch the

flavour and grasp the scope of the allusions and confidences. The judges came to the following conclusion:

> *It is clear from this that Agostino is very much in love with Artemisia. And that it was Cosimo who played the part of procurer.*

Could there be any plainer indictment of the Pope's steward or any stronger accusation laid against Cardinal Scipione Borghese's painter? Procurement and Defloration: the two main charges in the trial brought by Orazio Gentileschi against Cosimo Quorli and Agostino Tassi. Tassi would ask himself one day – but too late – how long Giovan Battista had been building up evidence in this way. Why was Stiattesi compiling a file of this kind on a matter which did not concern him?

The notary's statement continued:

> [. . .] *one night when I slept with him at his house on the Santo Honofrio hill, after a long talk in which I had pressed him closely to tell me the reasons for his suffering, the said Agostino made up his mind and said: 'Stiattesi, I am so much obliged to you that I cannot but tell you everything that has happened to me, but give me your word as a gentleman that you will not speak of it to Signor Cosimo.' And so with a handshake I promised him that I would therefore not speak, of it with Cosimo, and when I had promised, the said Agostino began to speak, saying: 'You should know, Stiattesi, that Signor Cosimo was the man who brought about my first meeting with Artemisia, and it is his doing that I now find myself in this terrible labyrinth, and I am so entangled that I must go away to Tuscany because I know that between Signor Cosimo and myself things will get nasty. I am so much obliged to him, as you know, that I wish to avoid this. But he knows how much I love Artemisia and what has taken place between her and myself and the promise that I made to God and to said Artemisia, and therefore he should not burn with the urge to know her carnally as he has done. Besides having tried to force her twice, once in the Via della Croce, the other in the house in the Via di Santo Spirito, he also told her what he pleased about me; and as if this was not enough he tried also to go to that house and cause trouble for me. Then, after I had many, many times restrained myself with Signor Cosimo so that I might settle this matter and finally arrange to marry her, in keeping with my obligation, Signor Cosimo told me quite firmly that I should not have anything to do with her because she is a woman full of whims and she would bring me sorrows for as long as I should live. Because of my obligations to Signor Cosimo, owing him my life as you know I do, I can do nothing without his approval. So now you see what state I am reduced to.' And so, sighing all*

night long, said Agostino told me that he was in love with Artemisia and he told me of
everything which passed between them in the greatest detail . . .

It is impossible to imagine more damning testimony. For what offence was
Giovan Battista Stiattesi wreaking vengeance?

The precise nature of the disagreement which set him against Cosimo
Quorli remains a mystery. There is no doubt that money was involved, as well
as conflicting interests of a significant nature and old family hatreds, to which
the notary explicitly refers in his letters to his cousin, those letters which, in the
guise of preaching against his immorality, go so far as to threaten him with
imminent death. It seems it was also a matter of honour, since Stiattesi accuses
Quorli of trampling on his dignity as a man of the law, of exploiting his
profession while at the same time taking advantage of his weakness and
poverty so as to degrade him.

Might this trial for defloration and procurement be nothing more than a
settling of grudges, not between Artemisia and Agostino, nor even between
Gentileschi and Tassi, but between Giovan Battista Stiattesi and Cosimo
Quorli? A male affair, from which the last of these will not recover.

The notary went on:

Later Cosimo and I had a discussion about this matter of Artemisia and Agostino.
Cosimo spoke both well and ill of it, but all the while he was persuading me that
Agostino should not take her as his wife; and I, becoming of the opinion that Cosimo
was indeed also in love with Artemisia, probed him so much that he suddenly said:
'Stiattesi, don't concern yourself with this matter any further because, when all is said
and done, Agostino is a very able young man and when he wants a wife for himself he
will have no lack of others to choose from. This one is a shameless good-for-nothing
without a brain in her head and that kind of woman will be his downfall.' [. . .] And I
had such discussions with both Cosimo and Agostino many times over in different
places, most of all at the palazzo of Monte Cavallo, in Cardinal Borghese's garden,
at Agostino's house, at Cosimo's house, at the palazzo of San Pietro, in church, in
hostelries – everywhere. There has been talk of nothing else for these last eight or ten
months since.

Giovan Battista Stiattesi does not refer to the consequences of these obsessive
conversations for the ceiling of the Casino of the Muses. Orazio Gentileschi
worked intensively on one figure on the vault of the summer pavilion in which
the cardinal would soon host his celebrations: his daughter. Artemisia wears

a blood-red dress as she bends towards her audience, one hand on her hip and a fan in the other. Staring down, she walks along Tassi's *trompe l'oeil* balcony.

Nor does the notary refer to the fact that, by indicting Agostino Tassi, he serves his own amorous interests. He is careful to make no comment on one of the sonnets which he complacently files away in his dossier of accusations. In this poem he joins with Tassi in praising the charms of the woman who obsessed them both, confessing that the fire of her eyes has touched his heart.

The notary would coldly relate:

> *During carnival Cosimo gave late suppers and presented plays at his house at which Artemisia, Agostino and his sister-in-law were always to be found; and on the second-last day of carnival, wishing to make Agostino happy, Cosimo and his wife took Artemisia into the players' room and, having brought them together, left the two of them to their pleasure.*

It appears that Cosimo's wife stood guard outside the door, while it was Stiattesi's task to keep Artemisia's father occupied.

The gallery where Cosimo had taken Artemisia still smelled of gunpowder, from an arquebus shot fired during the performance, one of the stage effects. The play had been very successful. The action was located in the imaginary town of Bellapittura, whose king was so besotted with painting that he had lost his reason and wished to give his daughter in marriage to a painter. Despairing, the princess had sought help from her fiancé, whose father was also a king. The difference in station between the two suitors prevented them from fighting a duel. A quick arquebus shot into the painter's back – was all it had taken to rid the kingdom of ridicule and the vanity of painters who presume to marry princesses.

This fable set out in allegorical form the controversy over artists and their patrons. What place did painting have in the hierarchy of arts? Several treatises had recently appeared which debated this question. Was painting a noble profession, removed from the mechanical arts? If so, what place did the painter occupy on the social scale? Cosimo's guests pursued this discussion on another floor as they enjoyed the sumptuous banquet which he provided; yet again, Quorli was aping the cardinals.

The bad weather that year had reduced the carnival to private festivities, and the prelates vied with one another to produce more splendid entertainments. Tomorrow, at the palace of Monsignor Montalto, the play put on

by the Pope's steward would be performed again, but with an intermezzo by Torquato Tasso, a passage from *Rinaldo*.

The floor of Signor Cosimo's gallery was scattered with stools overturned by the departing crowd. Behind the dais hung the backdrop on which a town street in the antique style (one of Agostino Tassi's perspectives) ran into the distance between *trompe l'oeil* statues and triumphal archways. The success of his collaboration with Gentileschi had propelled Tassi into the forefront of the Roman scene. The princes all sought to have his drawings for the entertainments and extravaganzas which they mounted in their palaces. Soon, they would be asking him to decorate the actual palaces. The roles had been reversed. While Orazio was still grouped among the ten best painters in Rome, Agostino seemed unique. There was no one who could match the way he handled material reality, the staggeringly masterful conceptions with which he amplified and expanded it. His complicated architectural forms and the exuberance of his geometry produced timeless images, mysterious and poetic.

Artemisia was aware, more than anyone, of her master's originality. Although she knew the illusionism of the previous century, she recognised that Tassi alone had achieved this explosion of space; that he played with motifs; that he made details catch the eye; that he had a flair for visual pyrotechnics and the festive. Everything in his painting seemed characterised by dynamism, vigour and imagination. The potency of his talent was all of a piece with his powers of seduction.

He waited for her, leaning on the mantelpiece at the far end of the gallery. Even at rest, Agostino Tassi had something alert and aggressive about him. With his broad torso and legs bowed like a horseman's, he seemed perpetually poised for action and display.

Above him, lit by torches, rose the naked body of a *Susanna*, a *St Cecilia* lying on a red cushion, a *Mary Magdalene* at prayer with her eyes raised to Heaven. But the real jewels of his collection, the eight busts of Roman emperors in white marble, lined the room from one end to the other. Budgerigars and canaries chirped in two huge gilded cages.

'What's wrong?' Agostino asked, walking towards her.

The green velvet curtain screening off the gallery closed behind Artemisia. On the other side of the entrance, Quorli's wife kept watch and barred the way. They did not have much time. Artemisia just stood there.

'What's wrong? Why are you looking like that?'

She was pallid and tense, hardly the lover that Agostino expected. This was a unique opportunity to see one another alone, without fear of intrusion by Orazio or Tuzia. All the more so since, after having made a show of being extremely accommodating, Stiattesi now refused to carry out the role for which he had been placed with the Gentileschi family. He balked at smoothing the way for their meetings. He was unctuous and evasive, talking only of the gratitude which he owed to his friend Orazio. Stiattesi and his family lived rent-free. Giovan Battista's wife had dethroned Tuzia once and for all; she and Artemisia were on intimate terms. The Stiattesi clan were making themselves well and truly at home.

'For the last time, what's wrong?' Agostino insisted angrily.

Artemisia had pushed him away.

In her red dress, the one in the portrait etched into the vault of the Casino of the Muses, he found her more desirable than ever. Against the green taffeta of the drapes drawn over the windows, her complexion became paler, her mouth darker and fuller. She had plaited and twisted her heavy, copper-shot mane of hair so that it revealed her small round ears, whose shapeliness he adored. Once again he tried to take her in his arms. Once again she rejected him.

'During the play, I was sitting next to your sister-in-law,' she began tartly. She spoke between clenched teeth. Each word seemed to pain her. 'She told me that she had my portrait above her bed . . .'

Agostino listened with an air of being nonplussed.

'My *Judith*, my painting,' she emphasised glacially, 'the one you took with you the other day . . .'

'Yes, and so?'

'She told me that this painting which you like so much is above her bed. That there was nothing strange about it being there, since you like to go to sleep looking at it. She also said, laughing, that your next baby might bear a resemblance to me.'

Agostino made as if to move. She stopped him with a cry:

'Wait!'

The order was so fierce that he fell silent.

'Wait, I haven't finished! She also said that if the two of you were not married, you . . .'

'But I am no longer married! My wife is dead!'

'That is not what Costanza said,' she went on coldly. 'Costanza said . . .'

'To hell with Costanza! She imagines her wishes are reality. She would like to think her sister was alive – she's a simpleton. But look . . .' He had taken out the packet of letters which he always carried inside his shirt. 'What more do you need? Read this!'

He flourished the letters, which were tied together with string; they were his assurance that the murderers in his pay had done their job well.

'Go on, read this letter from Giovanni Senni, a merchant in Livorno!' he shouted, 'and this one, from Pietro Migone,' he insisted, knowing that Artemisia could not read. You wanted proof? Here it is. They all say she is dead.'

She pushed the bundle aside and retreated to the door. But he wouldn't let her go and shouted all the louder, carried away by his anger.

'Dead! Stabbed twenty times with a knife! What more do you need? And I warn you that if you misbehave when you are my wife, you will get the same treatment.'

She faced him.

'I only want to know what my *Judith* is doing above Costanza's bed!'

'Costanza will say anything. I might sleep in her bed, but she sleeps with her husband.'

'And I would like to sleep with mine!'

'Be patient for a little longer. I am nearly out of the labyrinth.'

For a moment, Artemisia seemed to give way.

'What labyrinth?'

'Obstacles which I cannot explain to you. It's a secret which is not mine to reveal.'

'What obstacles?' she persisted. 'You say that you are free. You say that you love me. You say that I am your wife before God. What obstacles?'

'Cosimo.'

'What do you mean, *Cosimo*? Are you his slave?'

'Cosimo has a hold on me . . .'

'But Costanza hates me! I know it, I can feel it! She is smitten with you.'

'Costanza,' he broke in, 'is an idiot whom my apprentice was foolish enough to burden himself with.'

'Why does she wish me harm? She is jealous! Why?'

'Because I love you! Because I want you! Because I thirst for you . . .' This time, he had caught her. Pulling back her head, he held her by the hair. 'With that unquenchable thirst which once was fired by Circe's love philtre!'

She could feel Agostino's desire. They were the same height, almost equal in strength. She wanted to fight. Breathlessly, he murmured, 'I have chosen you not just for a short-lived passion, but for eternity!' He pressed his lips to her neck, her throat, her breasts. 'I want to keep the heat of your blood on my mouth, my fiery topaz,' he stammered, 'my golden cup, my poison. I would drink you in till it killed me.'

For a moment, he stood back from her. She knew that strange, almost hostile look of Agostino's. She turned pale and closed her eyes.

Just then the door opened and Quorli appeared, with some of the guests behind him.

'If you haven't taken your pleasure,' he announced for all and sundry to hear, 'more's the pity for you!'

'I heard these words,' Giovan Battista Stiattesi would relate. 'And I wasn't the only one. My wife was there, my children, Cosimo's children and Orazio's three sons. I knew moreover that Artemisia had painted a *Judith* – a self-portrait – and that she had given it to Agostino. Well, Cosimo very much wanted to have that *Judith*. It was a theme missing from his collection. To tell the truth, he desired the canvas as much as he desired the model. On the last day of the carnival he hatched a plan to get hold of it. I reproached him. Here's the very letter I sent him on the matter:

> *You ought to be ashamed, seeking to steal a painting of this kind from that young girl. It seems that not being able to possess the original you demand the copy. Prepare yourself to confess and to make restitution for everything you have on your conscience. Today, cousin, we are alive. But tomorrow we could well be laid beneath the earth. [. . .] I advise you to watch your step and to remember all those friends and patrons of yours who were prospering so well and have now become food for worms; you will be judged by your actions. Living or dead [. . .] I leave you to think on this letter.*

Cosimo did not live long enough to experience the full consequences of this ferocious warning. However, the first effects of the threats it contained were not slow in making themselves felt. Only a few days separated these words, written on the 'morrow of the final day of carnival', which is to say Ash Wednesday, 7 March 1612, and the blow which dramatically altered the course of all their lives. So what was the trigger, the final insult that forced Stiattesi to set such a drama in motion? Another sermonising letter to Quorli supplies a few answers.

Dissatisfied with the services of his cousin the notary, Cosimo had for a while been aiming to have him moved out of the Gentileschi household. But with no rent to pay, Giovan Battista Stiattesi hung on tooth and nail. Being thrown out would mean dire poverty. Without the bed and board supplied by Orazio, he would be begging on the pavements of San Pietro; Stiattesi feared the future Cosimo had in store for his wife and children. Besides, he felt quite genuinely grateful to Orazio, who had treated his family well. For all Orazio's bile, his mood swings and the volatility of his emotions from one extreme to the other, he had acted with generosity.

Though Gentileschi and Stiattesi were not wholly taken with one another, they were alike in certain respects. Both men succumbed in a similar way to the charisma of the shady characters in their circle. They shared the same attractions to vice, the same fascination with debauchery – and the same craving for purity. But Quorli, true to form, had recently planted the idea in Orazio's mind that Stiattesi lusted after Artemisia, and that, at any moment, the notary could ravish the honour of the Gentileschi family. What better means for the steward to get rid of him?

It would be this final attack from Cosimo which would push the man of the law to defend himself:

I do not know how to account for your latest onslaught against me [. . .] Put right the wrongs you have done me, otherwise you will give me cause for some diabolical wickedness. If you do not wish to treat me well, or to good purpose, at least do not cause me trouble and harm me. You should not bear me any grudge because I am here without paying rent and am treated with kindness; indeed for this reason and for the sake of the friendship between you and Signor Orazio, you should repay him in different kind from these infamies [. . .] It has always been your custom to abuse poor people and all those who toil for you [. . .] You should be content with all the suffering you have already caused me, and remember that I am a poor man with many children who has been ruined for your sake, and through your bad counsels, and let what you have done to me be enough thus far, good and evil. Go no further with this action of yours, let me alone and torment me unjustly no longer or you will give me occasion to put an end to all the suffering you have caused me [. . .] Remember that in Rome there is fair justice, and there are people who will readily give me a hearing.

Gentileschi and Stiattesi sat finishing their supper amid the noise and bustle of the inn. It had been late when they left the Casino of the Muses where Orazio

had been working. Cosimo and Agostino had gone on their way, while they had stopped at the Osteria del Moro. This inn was a meeting place for artists, and the serving-man who had once brought charges against Caravaggio still worked there. The painter had thrown a dish of scalding-hot artichokes at his head and the result had been a free-for-all which Orazio still enjoyed recalling eight years on.

Orazio was paying for the meal. Above their heads, a wheel studded with candles shed light on the remains of their food: beans, salt cod, some salad – and three dead wine flasks. Too much wine. Giovan Battista Stiattesi had certainly knocked it back in the course of his life, but he could no longer hold his drink. This was among the man's lesser contradictions. One reason that the Quorli–Tassi–Gentileschi trio allowed him familiarity with their group was that the notary had an outstanding appreciation of salacious jokes and over-indulgence at table. He relished these all the more for having to pay the price: his gluttony and ribaldry always left him in the throes of remorse. Tassi and Quorli derived much amusement from Giovan Battista's repentant aftermaths to their orgies, provided that he reserved his sermons for himself and didn't preach them out loud.

'Signor Orazio, you have always shown me the greatest generosity,' Stiattesi began in a doleful voice that was almost tearful thanks to the wine. 'Your distinguished name matters more to me than the honour of my own family. Your children are dearer to me than mine. And I am ashamed before God of your friends' behaviour. I know that they want to estrange me from you by some clever pretext, but . . .'

'Who are "they"?' Orazio cut in.

'Signor Agostino and Signor Cosimo.'

Stiattesi took a deep breath as he prepared to carry out an unpleasant task. His heart condemned what his conscience compelled him to do: his duty.

'There is something you must know, Signor Orazio: my cousin is insulting the honour of your late wife, and he is stealing your paintings.'

Gentileschi was so choked with astonishment that the notary was forced to speak quickly. Knowing his interlocutor's violent nature, he had to get everything out before Orazio exploded with rage and stopped him from saying any more.

'The virtue of the Lady Prudenzia was known to all . . . But Cosimo – Heaven forgive him – makes it public knowledge that Artemisia is his daughter. He asks people whether they don't see her resemblance to him. He

asked his servant woman this, and his coachman. He told them that he would soon have Artemisia's portrait in his house, and he would hang it next to his own portrait so that everyone could see the likeness, that one only had to compare their faces . . . Artemisia's *Judith*, her self-portrait . . .'

'*My Judith*?' Orazio corrected. '*My* composition . . .'

Dread gripped Orazio's temples, squeezing his heart so that he felt sick. He had to struggle to think straight, to take in what Giovan Battista was telling him. But his sense of urgency gave his thoughts a lucidity that the notary had not expected.

'Which Artemisia painted according to Agostino's instructions,' Stiattesi elaborated.

'*My Judith*, completed by me,' Orazio said categorically.

'Cosimo has taken it out of your daughter's hands.'

'She hates him; she would not have allowed that.'

'Nor did she. It was to Agostino that Artemisia sent the picture.'

'What? Without my authorisation!'

'Is Signor Tassi not her master?' The notary uttered these words in a tone which left scarcely any doubt as to the sense which he gave them. 'On Shrove Tuesday, I saw Cosimo writing a note on that little marble table in his study. It was to Agostino, asking him to leave his painting – your *Judith* – with the porter. Cosimo signed this note in my presence with Artemisia's name. The painting is now at his house. Have it seized by the law; it is your right. You have been robbed. Bring charges.'

Orazio was cut to the quick: his wife's memory, his work, his daughter. Giovan Battista Stiattesi, a strategist of subtlety, had achieved his revenge. Child's play. All that remained was for the notary to strike the fatal blow.

'There are other even more dreadful secrets I have to tell you. Last year, in May, you sent Agostino after your daughter at San Giovanni in Laterano. Remember? You gave him an instruction to follow her all the way home to your house in the Via della Croce. He did follow her, but right into her bedchamber . . .'

Enthroned beneath the vault of the great Consistorium, Pope Paul Borghese V listened as his secretary informed him of an affair which he thought the Pope should know about. It involved individuals serving in his household, in particular his painters and his steward. It so happened that His Holiness's secretary attached some personal importance to the

matter: he was a relative of Gentileschi's deceased wife. His family had a longstanding score to settle with Cosimo Quorli. In a monotone voice he read the following petition:

> *Most Blessed Father, Orazio Gentileschi, painter, most humble servant of Your Holiness, respectfully begs to tell you how, by the offices and persuasions of his tenant Donna Tuzia, a daughter of the petitioner was forcibly deflowered and carnally known many times over by Agostino Tassi, painter, intimate friend and associate of the petitioner, there being also the participation of your steward Cosimo Quorli in this obscene business; and that, besides the defloration, the same steward Cosimo did devise a scheme to take from the hands of this same unwed daughter certain paintings belonging to her father and in particular a* Judith *of considerable size. And because, Most Blessed Father, this is a deed so foul and causing such grave damage and injury to the poor petitioner, particularly since it abuses the trust of friendship, it is like a murder . . .*

The Pope did not bat an eyelid. He knew that the word 'Murder' was no vain figure of speech. The dishonouring of a daughter effectively spelt death for a father and the end of his entire line. It was of little importance whether the young girl gave her body freely or not since, legally, she did not belong to herself: she was one of the depositaries of the family's honour. Papal justice had a very precise understanding of the crime of which Orazio Gentileschi claimed to be the victim.

Stupro, a word which we conveniently translate as 'rape', had a much more complex meaning in the early seventeenth century. The Roman penal code subdivided it into three distinct offences punishable by penalties ranging from exile to death. *Stupro semplice*: defloration with consent. *Stupro qualificato*: with consent after a promise of marriage. *Stupro violento*: defloration by force. Accusing Tassi of *stupro violento* meant landing him in serious trouble. Although canon law had little interest in the notion of rape, it did not treat the abuse of virginity lightly.

'But these monstrous acts have been perpetrated by a person accustomed to commit even more appalling offences,' the secretary read, 'since that person is Cosimo Quorli.'

Cosimo Quorli. This name, repeated to him with particular emphasis, worried the sovereign pontiff. Accusing someone who served in the Pope's household, his 'family', of obscene commerce with a virgin, was the same as making Paul V the object of a personal accusation.

Fifty years earlier, such an attack against the sovereign pontiff would not have have carried much weight. But in the aftermath of the Council of Trent, when the Counter-Reformation popes were striving to present themselves as the embodiedment of wisdom, Paul V could not but respond. Indecent assault, theft and procurement – reproaches of this kind against the papacy were fuel for heresy; was not the corruption of the Holy Father and his entourage what gave the Protestant schism its entire justification?

Paul V scanned the ceiling of the vault shortsightedly, taking in the four cardinal virtues and the coat of arms crowned with the tiara and keys of St Peter. At the beginning of the month, bad weather had forced him to leave this hall, this glacial palace of which he was so fond, and move into his apartments at the Vatican. This had been a mistake: during a violent storm, the tree planted by his predecessor on the site of Beatrice Cenci's execution was struck by lightning and almost crushed him. He saw this as a bad omen and now reflected upon what he had just heard. This charge was likely to delay work at the villas of his nephew, Cardinal Scipione Borghese.

He stroked his little pointed beard with his gloved right hand, while with the thumb of his other hand he absent-mindedly turned the diamond he wore on his third finger. He was a man of few words, mild-mannered, of a studious and diligent temperament. He prided himself on his capacity for work and he liked to take a personal interest in everything that went on in his states. He took the petition out of his secretary's hands and held it close to his face.

> *Thus kneeling at your holy feet, the petitioner implores you by the heart and body of Christ to ensure that against this vile intemperance justice is duly meted out to those who deserve it. Besides showing the poor petitioner a great mark of favour, this will prevent him from disgracing his other poor children and he will for ever pray to God for your most just reward.*

The die was cast.

The magistrates who would attach Orazio's petition to the investigation file, along with the papers supplied by the obscure Stiattesi – primarily his threatening letter to Cosimo Quorli – would soon be able to note one interesting detail. By comparing the documents, they would discover that all the letters were written on the same paper – with the same ink and in the same handwriting: a regular, faultless notary's script. The threatening letter to

Quorli of Wednesday 7 March 1612 and the petition to the Pope were by the same hand – that of a somewhat over-zealous minor player.

So when, from prison, Tassi accused Giovan Battista Stiattesi of being the author of the charge signed by Orazio Gentileschi, he was right. It was indeed Stiattesi who was to blame for all their misfortunes.

When Giovan Battista Stiattesi revealed Artemisia's dishonour to Orazio at the inn, he had been unable to discern how much of his interlocutor's suffering derived from fatherly love scorned and how much from friendship betrayed.

Orazio's immediate instinct was to react to the betrayal and demand immediate punishment for the wrong-doers. But when his explosion of anger subsided – after he had approved the course of vengeance suggested by Stiattesi and ratified the petition to the Pope – Orazio had plunged into silence and uttered not another word.

He did not go and wake Artemisia, dragging her from her bed to obtain confirmation of what he had just learned. He could neither bear to reproach her with her conduct nor hear her defence. The idea of seeing her, of being in her presence, terrified him too much. He was afraid of her, of himself, of this mire in which they foundered. He felt horror, fear and disgust, and the only outlet for his feelings lay in flight.

That very night, Orazio emptied his studio of all of his materials, his pigments, his oils, his glues, his brushes. With his bundles on his shoulder, he disappeared. He did not return to the Santo Spirito district or the Casino of the Muses.

'My God, what a mess!'

Artemisia looked around. The floor was covered with bits of plaster, stretchers and rolls of canvas. She bent down to pick up the pieces of a bust and some scattered papers.

'What has been happening here? Who is responsible for this?'

Giovan Battista Stiattesi had followed Artemisia into the studio. He closed the door again and leant against it. He now had to take on the daughter. With his hands behind his back he watched her agitation. His long black cloak, dripping with rain, fell down to his feet like a soutane. In his youth, Giovan Battista Stiattesi must have been very dark, but he was beginning to go grey. He wore his hair so short that he appeared tonsured and his clean-shaven face was monk-like. When you looked at him in profile, his nose had an

over-prominent appearance and his ear appeared huge. His mouth, turned down at the corner, gave him a tense and bitter expression. Face on, however, Stiattesi was more handsome. He had high cheek bones, widely spaced eyebrows, and large green eyes with a limpid gaze that sometimes sparkled. His full lips brought to mind a temperament and a sensuality such as Agostino Tassi's. But by contrast with Agostino, Giovan Battista was tall and thin, without an inch of fat on his hips. His good looks were both austere and troubling.

Artemisia did not deign to look at him. She was bent over a portfolio, searching for her sketches.

'I can't find a thing!'

There was not a single brush or palette left. Even the props, the lengths of cloth, the death's-heads and angel's wings, which had been piled up on the trestles, were all gone.

'Agostino has lied to you from the start, Signorina Artemisia,' the notary began in a neutral voice.

She straightened up, her cheeks flaming.

'We have all been lying to you,' he went on flatly. 'Agostino will not marry you.'

'Why not?' she shouted.

She was haunted by the memory of Costanza and her spiteful talk on the evening of the play. Doubt ate away at her. She pushed her hair back from her brow and tried to pull herself together. She went on in a voice which she made an effort to control, 'I know very well that Cosimo is stopping him. Agostino keeps saying that he would have been hanged without him and he cannot marry without his consent.'

'Would to God that were true. He isn't marrying you because he has been living with Costanza for five years as man and wife. He goes home to sleep with her when you are thinking of him as your husband. It is a well-known fact that they have two children. Costanza threatens to charge him with incest if he leaves her. He raped and deflowered her too in Livorno. As he had raped and deflowered the late Maria. Confess the truth to your father, Signorina Artemisia! Take the matter to law! It is the only recourse left to you. However much Agostino is in love with you, he is caught between Costanza and Cosimo. He will not stand up to either of them unless you force him to. The law alone can compel Agostino Tassi to marry you. Think about it. He is free. Why would he not already have made good his offence if marriage was his

intention? Confess everything to your father. Entrust your honour to the fair Justice of our Holy Father. Have faith in God and his Church.

What the notary did not tell her was that Orazio had asked for pen and paper at the inn; that Stiattesi had drawn up the charge there and then; that Orazio had signed it; that together they had taken it immediately, without any second thoughts, to the Quirinal Palace.

When did Artemisia discover the reasons for the chaos in the studio and her father's disappearance? That Orazio was dragging her towards the shame of public dishonour? Artemisia's first impulse was to warn her lover. Now that her father knew everything, Agostino had to talk to him. Bare-headed in the rain, she swept out, crossed the square in front of Santo Spirito and made her way up the street leading to the church of Sant'Onofrio. Agostino had to be put on guard. He had to be protected.

But Agostino no longer lived on the hill. The landlady at his old room told her that Tassi was now lodging in Via della Lungara. He had gone back to live with his apprentice, and with Costanza.

Two hours later, Agostino Tassi was arrested in the Via della Lungara, just after he had crossed the Sisto bridge on his way home. He was taken to the Corte Savella prison. Tuzia would follow him to the dungeons a few minutes later.

Huddled on her bed, Artemisia could hear the pounding of boots, the shouts and the noise of a table being pushed around on the floor above hers, and Tuzia being dragged down the stairs by force. Then there was silence.

She took the knife with which she had wounded Agostino on the night of the rape and clasped it against herself. Only death could deliver her from this endless nightmare.

She did not move, drink, eat or sleep for two days.

Numb with cold, a damp cold which chilled her to the bone, and prostrate with shame, she was in a state of collapse. No one had any idea that she was still in the house. Her brothers, left to their own devices, had gone to seek refuge with neighbours.

By now the whole street buzzed with talk of the curse that had descended upon the Gentileschi household. The father had deserted his children and was in hiding. His tenant was under arrest, she too leaving her little ones destitute. It was assumed that Giovan Battista Stiattesi would take over the helm. But the labyrinthine ways of Roman justice allowed

Agostino Tassi to bring his own charges against Stiattesi. Not to do with the business which was his immediate concern, but for loans which the notary had not repaid him. Stiattesi soon found himself in prison as well.

Orazio did not reappear until the day of Artemisia's first interrogation. He was seen coming and going, but no one could say what he was about. On the Sunday, a few hours before the law came to his house, he moved back in. But without any baggage. The neighbours whispered that he had pawned everything and drunk away the lot.

The arrival of her father and the court investigators gave Artemisia a rude awakening from her daze. Stiattesi's wife – sent by Orazio – dragged her out of her stunned condition to feed and dress her.

With no guidance, advice or preparation, with no notion of how she was to act, she was taken from her room to the judges. The idea of lying did not even occur to her, though she had been lying and secretive for so long. The fear that poisoned her every moment had disappeared. Her father's prophecies had come true. He was right. She was a strumpet. A whore. She had known this sense of shame, this dread of being exposed to public opprobrium, ever since her mother's funeral, ever since Cosimo Quorli had first cast his eyes on the back of her neck at Santa Maria del Popolo. The worst had happened. What did she have to fear now?

The intolerable grief she had felt when Stiattesi had revealed Agostino's liaison with his sister-in-law gave way to a passive acceptance, though this was not the same as resignation. The memory of what had happened stirred her to revolt against the man who had dishonoured her. For the first time, perhaps, since the day when she was raped, Artemisia Gentileschi had rediscovered the will to assert herself. And to shout out the truth.

'Yes, I have a notion of what you want to question me about, for I have heard my father's comings and goings and I know that he had the tenant upstairs arrested.'

It was Sunday 18 March 1612, and night was falling on the little house in the Borgo Santo Spirito. The entire San Pietro district had gathered in front of the door. The two midwives, whose task it was to inspect Artemisia's genitalia, waited outside with the gawking crowd. They would stay there, giving out details about the case and answering obscene questions, until the deputy called them in for the gynaecological examination.

For close on two hours, Artemisia Gentileschi had been under

interrogation in the main room of the house. She was alone with the court investigators. Her father paced up and down on the other side of the closed door.

'When you were violently deflowered by Agostino Tassi, did you find blood on your private parts?'

Artemisia held herself very straight. She had rested her bare forearms on the table, but she did not lean on them. Sitting opposite the deputy, she addressed herself directly to him. In his great robe, he resembled an ecclesiastic; he listened to her impassively. She stared at him with that dark gaze which compelled attention, a gaze which she sometimes shifted leftwards, to the clerk, to make sure that she was not talking too quickly, and that he had enough time to write down every single word she said.

Had they not both been experienced in their work, this young woman would have disconcerted them. She was tall, fresh and buxom. Her composure and self-assurance, along with a freeness in her manner of speaking and an excessive spontaneity, could have made her one of the innumerable courtesans of the district. But she seemed devoid of any flirtatiousness. She wore no jewels, no ornaments. Only a plain red skirt, a black bodice, laced under her arms and hastily tied at the shoulders, and a shift whose neckline, scalloped with a lace trimming, was quite unrevealing. But the swelling breasts which strained the stitching of the tucks, the sharp-toothed little mouth and the heavy mass of red-blonde hair with its stray strands tumbling over her temples and her eyes – these, and everything about her, were an invitation to love.

And yet there was the voice, the pure, fresh, unmuddied timbre of it, and that authority she had, that precision and succinctness of speech.

'When Agostino forced me, I had my monthly bleeding and I cannot swear to Your Honour that I bled because of what he did, for I knew nothing about such things.'

Nearby, the bells of St Peter's could be heard ringing out the Ave Maria. In the house there was just the sound of the scratching pen, the young woman's clear voice and footsteps going to and fro behind the closed door. Artemisia's oval face, her mouth, her unruly locks all melted into the darkness, which now made it impossible to distinguish those in the room. Sometimes the footsteps would stop. Was her father standing there with one ear pressed against the door, trying to make out what she said?

'I bled not just that first time, but also on the following occasions when

Agostino had carnal knowledge of me. I asked him why I was bleeding, and he answered that it must be something wrong with my constitution.'

'Did you receive presents from Agostino Tassi?'

'No, I did what I did with him because it was necessary that he become my husband, since he had dishonoured me.'

'Have others beside him had carnal knowledge of you?'

'No, never. However, it is true that Cosimo Quorli did everything he could to have me.'

The deputy magistrates ordered that the two midwives be brought in.

In her room, on the bed where Agostino made love to her, they spread her legs wide and examined her under the attentive gaze of the clerk. One can imagine Artemisia's humiliation when the two midwives got up and pronounced that the young lady's hymen had been broken a long time ago.

Taking with them the damning statement against Agostino Tassi, the magistrates left the house.

Artemisia sat on the bed where the midwives had examined her. She did not have it in her to move. She remained in the darkness. But her striving to answer the magistrates' questions had brought her back to reality.

By confirming Orazio's statement, by supplying the judges with spontaneous details of the rape and the conduct of Tuzia and Agostino, had Artemisia been seeking revenge on them? Was she taking her father's side against her lover to pay him back for his betrayal with Costanza?

She had heard her father pacing around like some caged beast throughout the whole of the interrogation. Now she could hear him rummaging about in the studio. She feared him. And at the same time she needed to be with him. Let him beat her. Let him kill her. Anything, rather than his silence, this absence.

In the end she got up. She went through the room where Orazio and her brothers slept and pushed open the door of the studio.

Gentileschi had lit all of the candles, the flares and the torches. Their light danced across the broken plaster, over the papers scattered on the ground, over the canvases turned towards the walls, over the body of *Susanna* – a painting from another life. In the middle of the room there rose the ghostly outline of the easel where her *Judith* – everyone's *Judith* – had once sat. Orazio had placed a large blank sheet of paper upon it, a gleaming white panel which caught all the light. Standing in front of it on his two skinny legs, the sleeves of his

doublet rolled up to the elbows, he was sketching out with hectically sweeping gestures the same X-shaped composition with two figures that Artemisia had produced under Agostino's guidance and of which she was so proud. Their *Judith*. That day the painting had been locked up in the cellars of the chief notary in the Borgo, and it would stay there until Gentileschi proved that it was his property. But what was his word worth against that of Cosimo, who stated that he had bought and paid cash for it?

When he heard his daughter coming in, Orazio's heart leaped into his mouth. He did not turn round, but he could feel her presence and he worked badly. At each stroke of the pencil, Orazio's thoughts turned with fury, bitterness and nostalgia to the time when he had lived peaceably with her. Had that time really existed? He was losing all his bearings. He could neither repudiate the past – his love for little Artemisia; the warmth of his friendship with Agostino – nor reconcile it with the present, with his hatred. This impression of living simultaneously in two different universes, in affection and in vengeance, was a shattering sensation.

Certainly, the period when he had suspected Artemisia of dishonouring him had been a hard one. But he infinitely preferred suspicion to this despair. What he feared most in the world had come about. Unlike Artemisia, Orazio experienced no sense of relief.

The burning in his stomach prevented him from speaking. But when he felt his daughter advancing across the studio, an even more horrible pain gnawed at his belly. He could stand it no longer; he turned round.

Their eyes met. The blood drained from Artemisia's face, yet she held his gaze.

She walked towards him, her head thrown slightly back as if she were defying him. Her face had grown thinner and the hair which framed it, made curly by the dampness, seemed darker than usual. 'Yes, she is defying me,' he thought. Artemisia's pallor and the strange expression, at once haughty and afraid, which seemed fixed on her lips, gave her the ghastly aspect of a spectre. Her large eyes seemed to threaten him with their reproachful stare.

Father and daughter looked at one another without saying a word. They were on the alert like two animals whose fear was mutual. Orazio waited for Artemisia to pounce.

But Orazio was wrong. Artemisia was not threatening him. She was just in the same state of mental confusion as he, divided between conflicting emotions, torn between her guilt and her anger towards her father. Between

pity and hatred. She resented Orazio for what he had done to her – her public shame, the interrogation, the midwives – at the same time as she accused herself for what she was putting him through. She understood him, she forgave him. But she also detested him.

How could she forget that at this very moment Agostino Tassi was languishing in prison? Because of Orazio. Because of Artemisia. The memory of her lover poisoned things between them. Orazio could feel it. He could feel that this slut thought only of the other man, that she felt no remorse for his own suffering. He only had to look at her: the head held high, the contemptuous look. He turned away.

He could no longer bear the scorn which he thought he read on every face, on the faces of neighbours, assistants, apprentices, out in the street, in the city. He could no longer bear the whispers which he now thought he remembered. With hindsight, he could hear the laughter behind his back. Everyone was laughing at him! For how long had Rome been mocking Orazio Gentileschi? He was now quite sure that he had been the object of ridicule everywhere and always! That he had been the butt of derision for years. Yet Orazio had dismissed Stiattesi's revelation that Cosimo had slandered the virtue of his wife. The possibility that Artemisia might not be his child struck him as so absurd that he had not dwelt on it. But now he cursed his daughter! She and Cosimo were of the same ilk, as one with the serpent and the Devil! They gave off the same stink of carrion. Nowhere, since Prudenzia's death, could he find any purity. Yes, ever since Prudenzia's death he had struggled in vain to draw out some glimmers of light from himself, he had striven for beauty, for perfection. To no avail! In the confusion of his feelings, Orazio muddled together his domestic misfortunes and the disappointments of his career: he had not secured the commissions he deserved, nor received from his patrons the honours they owed to his talent. His rivals – Baglione, the Cavaliere d'Arpino – had all been invested as knights of the order of Christ. What had he had? Nothing! Yes, the painters were turning on him like a frenzied pack of dogs out for another dog's blood. His rivals were using his daughter to break him, to belittle his work and rob him of his vision: the ideal of purity which all of his life he had tried to render on the faces of saints and madonnas.

Orazio was obsessed with the memory of his *Judith*, which Artemisia had seen fit to dispose of by giving it as a present to her lover. It was this work, lost to him until the court made its judgement, which Orazio tried to replicate tonight. His pencil squeaked on the paper. He drew two female figures. One

fully lit, holding the sword, turning her troubled face towards him. His daughter. A trickle of blood running down her skirt. The other, Judith's servant, gazing towards the back of the painting. All lines converged on the centre. The blade of the sword, Judith's arm, her servant's sleeve, everything concentrated around a circle of light: the bloodied linen, the wicker basket and the head which had been cut off.

In the Bible, the Book of Judith tells how, to save her city, besieged by the King of Babylon, Judith put on her festive garments and came down from the ramparts. Her servant, the very old and very faithful Abra, accompanied her. It was she who would bring back the head of the tyrant in a sack, after Judith had seduced, inebriated and decapitated him.

But Orazio did not give the servant Abra the features of an old woman. Against all tradition, contrary to the Bible story, he painted her as a vigilant young woman who also bore on her face the violence, the sensuality and the torment of Artemisia Gentileschi.

Standing by his side, Artemisia watched her father at work. Painfully, she noted that she had turned him into an old man. His scrawny neck, his babyish curls and the fine grey down on his face made him resemble a bird. With his skinny legs and his narrow shoulders he had an over-delicate look about him that was worrying. She could no longer endure this pity which he stirred in her.

Silently, without a word or a look, father and daughter set to work. She relit the fire, sharpened his pencils and nailed a fresh canvas on a frame. Standing behind him, she awaited his orders. He only had to signal to her and she would hand him the tools of his work – the spatula, the brush, the palette, the water, the oil.

As she carried out these ritual gestures, Artemisia hoped to rediscover the strength she had had when all her aspirations had been fulfilled working close to Orazio, learning from him, helping him and satisfying his wishes. But she had been innocent then, able to reach for that ideal of beauty, those dreams of grandeur and of glory which obsessed the artists of the Via della Croce. Now she performed these tasks with servility, in flight from her guilty memories.

Regret and remorse had gnawed at her ever since she had given evidence against Agostino. She loved him as people love their sins. His absence drove her wild with distress and she accused herself of having made it irremediable. She thought only of him, of what he suffered, of the harm she was inflicting on him. All other feelings about Agostino had disappeared – her anger, her

jealousy on learning of his liaison with Costanza. Only love was left. How was she to help him? How was she to save him?

Stiattesi had thought about this too. But Stiattesi was in prison. Before his arrest, he had maintained that Agostino's imprisonment would be brief. He was in no doubt that, when forced to choose between prison and a wedding, Agostino would marry Gentileschi's daughter without delay. The more so since Agostino loved her. But Giovan Battista Stiattesi's judgement had failed him. He had not bargained on Orazio's hatred. Tassi's situation in prison looked bleak.

This time, being himself compromised in the drama, Cosimo Quorli could not help his protégé too overtly. Orazio's accusation had brought a deluge of letters from far and wide describing Cosimo's abuses and embezzlements over the last twenty years. Gilders, upholsterers, silversmiths, all those who once had refused to donate a part of their wage to Cosimo Quorli and had therefore found themselves removed from the papal sites, set up a hue and cry. Cosimo could now count his friends on the fingers of one hand.

Was his disgrace at court, his public opprobrium in the artists' district, at the root of his illness? Less than three weeks after Agostino's arrest, Quorli took to his bed. On 5 April, in the presence of his executor, the painter Orazio Borgianni, he dictated his last will and testament.

Did he die of the French malady – syphilis – from which so few recovered that the hospital in the Corso, charged with admitting its victims, bore the extremely optimistic name, Hospital of the Incurables? Or was he carried off by the malaria which was so commonplace in the Papal States? Travellers' accounts advised visitors to the Eternal City against a stay in its insalubrious countryside: anyone spending the night outside the city walls could be guaranteed to catch the 'Roman fever', in whose grip the traveller would remain for the rest of his life, if he did not succumb outright.

To this day, Cosimo Quorli's sickness remains a mystery. Had his excesses during carnival been fatal? He had already suffered several attacks of gout.

His wife, for her part, talked of poisoning and made a great to-do until the moment the will became public. At that point she said no more. Her husband's demise let her recoup her dowry – two thousand scudi, a substantial sum. Quorli named her administrator of his entire estate until their two children came of age. The daughter had a convent in store for her, a cheaper option than marriage. If Cosimo had been poisoned, in whose interest

would it have been, therefore, other than that of a young widow who was now very well provided for?

Quorli fell ill before – and not after – the imprisonment of Giovan Battista Stiattesi and he died less than a month after Giovan Battista Stiattesi's death threats, at the very moment when Tassi was in sore need of his crony's help. But for Stiattesi to have employed any of the noxious powders in use at the time seems a questionable hypothesis. Are we to imagine that either the notary or Signora Quorli deliberately drove the steward to his grave?

Whatever the case may have been, on 8 April 1612, Cosimo Quorli was laid to rest. Not without having summoned to his bedside one last time the only living soul whom he claimed to have loved: Artemisia Gentileschi.

'Save Agostino! You alone can save him. Say it was I, Cosimo, who deflowered you. What difference does it make to you? Say it was I, your father, who did it.'

What strange last wishes.

Cosimo's death seemed to reawaken Orazio's feelings for his newest friend, Giovan Battista Stiattesi. He took himself off to the Corte Savella prison and made himself the guarantor for all the notary's debts. He also swore on his behalf that Stiattesi would regard the house at Santo Spirito as his prison cell and that he would remain at the court's disposal throughout the trial of Agostino Tassi.

The day after Easter, Giovan Battista was free and reinstated in the Gentileschi household.

'Say that Cosimo deflowered you, what do you have to lose? Say it was him and the matter will end of its own accord,' he too advised Artemisia.

Was Stiattesi worried about the turn that events were taking? If he had wished to wreak revenge on the steward and teach Tassi a lesson, then the former was dead and the latter was in a place where he could do no harm for now. The battle was over for want of combatants. Stiattesi now wished for peace. Turning his coat once more, he would take a step whose consequences he doubtless failed to reckon with.

CONTINUATION OF GIOVAN BATTISTA STIATTESI'S TESTIMONY

You should know, Your Lordship, that besides making it my business to do everything I could to ensure that this business be calmly settled to the satisfaction of all parties, I

was requested by Agostino to come to him while he was detained in the larga. *Over these last few days, I made every effort to bring Orazio Gentileschi to prison to talk with him as Agostino had urgently asked me to do, and I did indeed take Orazio there one morning, but because Mass was being said in the hall, they were not able to have a meeting* [. . .] *and so Orazio and I left together, and I was never able to take him back.*

Giovan Battista Stiattesi's coming and goings, the freedom with which he communicated with Agostino Tassi can be explained by the organisation of the Roman custodial system in the seventeenth century. Only defendants awaiting trial stayed in Corte Savella and Tor di Nona. Prison was merely a waiting room where the law kept at its disposal those individuals whom it might or might not punish. It would sentence wrong-doers to the galleys, to exile or to death. Never to imprisonment. Prisons were therefore divided into two areas which corresponded to the two stages of the investigation: the *segrete*, individual cells where the accused were kept in secret, in ignorance of the charge against them; and the *larga*, a floor divided into small dormitories, with a refectory, a chapel and an exercise area where prisoners could walk about freely.

Like all the detainees in the *larga*, at the end of an initial series of interrogations Agostino had finally received the dossier informing him of the main charges against him. He was busy with his defence and in search of a lawyer. He could leave his room, go up and down the stairways and receive visitors. He had therefore summoned Giovan Battista Stiattesi. Stiattesi would often have supper with Agostino. He brought the friends whom Tassi wished to see right into his room; friends who Agostino wanted to testify against Orazio. As for female visitors, these were received in the Chancery hall, where benches were disposed for the purpose.

Agostino urgently implored me to [. . .] *do him a favour by bringing Artemisia with me once so that they could talk and he could try to arrange things between them satisfactorily. Since, as I have already said, I desired to bring this business to a good conclusion and to try any way possible, I spoke about all of this to Artemisia, asking her to do me the favour of going there to talk with said Agostino; and lest Orazio should create any obstacles to this course of action by preventing said Artemisia from going there, we planned to tell Orazio that we wished to go to San Carlo ai Catinari in the evening and as we passed by Corte Savella we would enter there and gratify Agostino's wishes.*

If Giovan Battista Stiattesi believed himself to be master of the situation, and *padrone di casa* in Gentileschi's house, it had not occurred to him that Orazio might be getting information from elsewhere. The painter had written to his family in Florence, Lucca, Livorno and Pisa, where his brothers lived. Orazio was relying on the Lomi clan and their network of friends in Tuscany to supply him with the details he needed to blacken Agostino Tassi's character and accuse him of his wife's murder. He wanted the assassins' names, the place and circumstances of the crime. There were twenty stab wounds inflicted on the adulterous wife. He wanted to know where, when and how.

What Orazio was to discover would astonish him and surprise even his friend the notary.

Stiattesi went on:

> [. . .] *One evening, I don't remember exactly which day, but it strikes me it was the first evening in May, we left the house around the twenty-fourth hour* [at sunset]: *Artemisia, my wife Porzia, Artemisia's brother Giulio and my son Luisio, and we went straight down the Via della Lungara and crossed Ponte Sisto and, seeing that it was late, without going on to San Carlo, we made our way to Corte Savella . . .*

Without hesitating, they turned left to head straight up the Via Giulia. Artemisia, with Stiattesi and his wife on either side, was walking so quickly along the middle of the road that she seemed to be running away. The two little boys had trouble keeping up with her. Behind her, a moon as full as the sun shed its light thickly on the looping river. The Tiber snaked away into the darkness, the colour of a steel sabre.

After the winter storms, these May nights shone clear. The flawless blue of the sky was a great canvas stretched wide and seemingly back-lit. Everything seemed perfectly still.

Artemisia almost ran between the palace walls of the Via Giulia. The harm that Agostino had done her put no brake on her impatience. She scarcely gave any thought now to her suffering. Her memories were too terrible to risk dwelling on them. The future seemed too closed off for her to imagine it without dread. The hope of reaching some solution with Agostino, held out enticingly to her by Stiattesi as he urged her on this hazardous course, justified her excitement, her joy, her happiness at the idea of seeing Agostino again.

She no longer felt angry. Nor did she feel the same remorse for having

testified against him. They were now on equal terms. Tit for tat, as Stiattesi had pointed out. Her resentment towards Tassi could be no greater than her self-reproach for her statement. No winner, no loser, just two people who were prisoners of a situation which they could only get out of together.

Caught up in this wave of hope, Artemisia overlooked her father, deceiving him once more. But she felt no regret for this new betrayal. She was answering the call of the man who had dishonoured her, who had dishonoured them all; she would meet him with the world looking on, in front of guards and prisoners, without it occurring to her that she was going over to the enemy. There was no more enemy.

But when they turned right, into the Vicolo San Girolamo alla Carità, a medieval alleyway half-way between the hospice and the prison, where every beggar in Rome went on the prowl, her spirits flagged. Why had Agostino sent for her? How was he going to justify himself? She did not want to hear his explanations. She did not want to hear anything. Or say anything.

The Corte Savella prison took up the length of a block. The two-storey building was as imposing as a palace. Rats as big as rabbits ran along the outer walls. She saw everything with great clarity. She saw Stiattesi presenting himself to the guards. She saw the sentinels opening the door to him. The notary seemed very much at home in this place. The constables called him 'Sir' and gave him free passage through the sombre porch without bothering to escort him as far as the second gateway. Stiattesi became voluble and took it upon himself to play the part of guide. He pointed out the guardroom on the left and the Chancery hall on the right. He indicated the offices of the different tribunals which were linked to the Chancery: *Tribunale del Governatore, Tribunale del Vicariato, Tribunale del Auditor Camerae.*

She was not aware of blushing under the gaze of the constables, but she felt giddy with embarrassment. Did these men know which prisoner she was visiting? Did they know what infamy she accused him of? Were they laughing up their sleeves as they pictured the act of her deflowerment in detail? Nor was she aware of Tassi's presence among the group of prisoners who waited on the other side of the gate.

He, however, saw her at once. He went to find the guard and had the gate unlocked. But he held himself back for a moment, it seemed from sheer emotion. His face, usually so full, was drawn and drained of colour. Stiattesi thought he was about to faint.

Artemisia too could barely stand up. Stiattesi and his wife led her quickly

towards the bench. They all sat down in a row, with the little boys at the far end.

Agostino had followed them. He stood in front of them, incapable of uttering a word. Artemisia kept her head bowed. Her ears buzzed; black spots passed in front of her eyes. She struggled not to pass out.

Seeing her fragility, Agostino regained some of his composure. He was pale, but he knew that prison had not robbed him of his presence. He was paying a fortune for the barber to give his moustache an impeccable trim; his teeth had never been whiter, his nails more polished.

He was touched by Artemisia's presence and grateful to her for having come. His safety could depend on their interview. He had to play his cards close to the chest. How much time did he have? Ten minutes. Within ten minutes he had to seduce this woman into giving up everything for him, into denying her father and her word. The game was worth the candle. Within ten minutes she had to have signed the paper which he had scribbled and now held tightly in his pocket – a letter in which she acknowledged that her statement was a tissue of lies, in which she confessed that he had never touched her, that she had invented it all in the hope of securing a marriage. Ten minutes to touch her emotions.

This conquest excited him more than all the battles of the winter. He was staking his life on it. For now, Artemisia held the trump card. From what he knew of her, she would play it. But did she know the rules of the game? Her presence at Corte Savella heralded her defeat. And this defeat, from which he expected everything, made Artemisia all the more precious to him.

At that moment, his tenderness overflowed for that bowed head. For that hesitant, shivering body. He loved her docile like this. He loved her vanquished and subdued.

Finally he managed to speak to her. 'I am not a man to break his word to you . . .'

He spoke in front of Stiattesi and his wife. The children, perceiving his emotion, listened earnestly.

'I am ready to take you as my wife, as I have promised . . .' His voice was trembling. 'Oh, *signorina Artemisia mia*, how can you doubt this? You know that you must be mine. That you can belong to no one else . . .

She had lifted her eyes towards him. She was anxious, expectant – how this touched him. And that questioning dark gaze . . .

'I gave you my oath, and what I have sworn to you I shall abide by.' He let his passion carry him along. 'If I do not take you for my wife, may my body be penetrated by as many Devils as I have hairs on my head and in my beard, until the day I die!'

He stooped to pull her gently to her feet.

'Let us be pledged to one another, Artemisia, let us swear to give our love for ever, to love one another in the full light of day, before the whole world . . .'

Sitting on the bench, Stiattesi, his wife and the two little boys missed not a single word.

At this hour, the vast rectangular hall was full of people. Absorbed in their own conversations, most of the inmates paid no attention to the couple. But in the corner where Agostino stood, the crowd had thinned out a little and a number of prisoners, perhaps realising the seriousness of what was happening, had turned round to watch.

Agostino and Artemisia stood face to face. He had held out his open palm and she had held out hers. They joined hands.

Without taking her eyes off him, Artemisia uttered these words: 'I accept your pledge as you have given it to me, and I believe that you will keep it.' Her voice shook. Gently, she added: 'But, Agostino, if you have already pledged yourself to another woman, tell me so.'

'Signorina Artemisia, my wife is dead . . .' He put his hand on his chest. 'I swear it to you!'

He paused, deliberately. Then he implored her: 'But I beseech you, change your statement! Say that I was not the one who deflowered you. Say it was someone who is dead. Say it was Cosimo.'

Abruptly, she withdrew her hand.

'Him, never!' she cried.

'Then say it was the apprentice Scalpellino!'

'It isn't true! I shall never say any such thing. You know very well it was you,' she insisted vehemently, 'that it was no one else!'

He begged her: 'If you want to get me out of this, you will have to retract what you said. After that, I shall do whatever you want.'

'I shall repudiate nothing,' she answered gravely, 'I do not want to go back on what I have said.'

He continued speaking to her in an undertone. She was shaking her head. He took her tenderly in his arms. A bell struck ten.

It was time to go.

Agostino embraced and kissed her. He had not succeeded in making her sign the letter which he had prepared, he had not even got so far as to take the paper out of his pocket, but it didn't matter. He had never felt closer to Artemisia. He would certainly find a solution. He stammered out his thanks to her for coming and begged her to come back. She was weeping. By now all the prisoners were watching them, but neither of them noticed; they were in a world of their own.

One of the inmates later described how he had seen Stiattesi with two women. The younger one was leaning on Agostino's arm as he accompanied her towards the gate. They were very loving towards one another and had had to wrench themselves apart. When Agostino came back towards the prisoners, he looked upset. The inmate had asked him who the woman was and Agostino had told him that she was his wife before God.

'Slut, whore, traitoress, scum, not only do you sleep with all the bastards on God's earth, but you go and lick their boots into the bargain!'

Orazio had just learned from his youngest son in whose company Artemisia had spent the evening – on the pretext of going to church for confession.

This time he gave free rein to his violence, slapping his daughter hard. She wrenched herself away from him, shouting, 'We are both of us trying to make that 'bastard' your son-in-law. I didn't want to betray you. I was only trying to reach an agreement with him. And if he is to be my husband, it is my duty—'

Orazio burst out laughing so wildly that she was afraid she had driven him mad.

'Your husband? You will not have one! You are fit for the street!'

He seized her by the wrist, pulled her across the studio and opened the door wide so as to throw her out on the stairway.

'Get out! You are dead. Agostino may have a wife, but I no longer have a daughter.'

'His wife?' she screamed, hanging on to him. 'His wife is dead!'

'Is that so? Which one? Let me tell you that, at this very moment, there is a certain Maria Cannodoli, the wife of Agostino Tassi, parading about the streets of Lucca on the arm of her lover! Agostino Tassi's so-called avenged

honour is nothing but lies, boasting and showing off! He never succeeded in having her killed. I've had the replies I was waiting for from Tuscany. Oh yes, he certainly tried to kill her. Once – maybe twice – he tried to hack at her with a knife. And then he grew tired of it. Where do you think his money comes from? And those purses he clinks at your ears? And his rings, and his feathers and fine purple cloth? His gold is the price of his gutlessness! The "Florentine gentlemen", the merchant in Lucca, the trader in Livorno, all those who protect Maria have paid her husband to bugger off and leave her be. Agostino is married, and his sister-in-law Costanza knows it. If he married you, it wouldn't get past Costanza: she would accuse him of bigamy. Agostino's head would roll,' Orazio sneered. 'He loves you, he tells you so: it isn't that he doesn't want to marry you, but that he "cannot" marry you! It's under-standable . . . Between marriage and five years on the galleys, he would be glad to choose marriage. But between the galleys and the rope, he'll ditch you. He has no alternative. He's trapped. After all his boasting in the Via della Croce, how can he ever acknowledge that he did not avenge his honour, that he didn't kill his wife, and that she pays him to keep his cuckold's mouth shut! What will Rome have to say when Rome finds out that this braggart goes about wearing a full set of horns? That he is a coward who has sold himself? He has only one way left of extricating himself from this trap he has got himself into. Only one.'

'Denying everything . . .'

'Exactly. "The culprit is never the man who is caught in the act, it's the one who confesses." Denying that he robbed you of your virginity. Denying that he had carnal knowledge of you. Swearing that you are a loose woman, that the neighbours, the street, the whole district has had you. Producing false witnesses to prove that they took you.'

'Agostino won't be able to prove such a lie!'

'He'll make sure of it.' Orazio paraphrased his erstwhile friend: '"The torturer who will pin me down hasn't been born yet!" He'll prove everything that suits him. He'll prove that you prostitute yourself, that I consent to it, that I drove you to it. He'll turn you into a whore. And he'll turn me into a pimp. The only way he can get himself out of this is to blacken the name of the Gentileschi. To drag you into the mud, to drag us all into the mud! You and me, your brothers, our family . . .'

'Let him dare!'

This scene, begun in the most inauspicious circumstances, reached its

sudden conclusion in a truce. The first alliance between father and daughter for months. United by the same rage, bound by the same suffering, they would fight for a single cause — truth — and share the same dream of vengeance.

18

Continuation of Agostino Tassi's
Seventh Interrogation

Tor di Nona Prison, Monday 14 May 1612

'What would you say if Artemisia came here to affirm that you are lying?'

The trial was entering its second stage.

In the *larga*, Agostino had read through the *libellus*, the list of indictments drawn up by Orazio Gentileschi and Giovan Battista Stiattesi, who was now officially Orazio's lawyer. Tassi was preparing a counter-attack, with the help of his own defence.

In the meantime, the prisoner underwent fresh interrogations. From now on, the clerk would write down his answers and note his physical reactions: his complexion, his movements, the tone of his voice. The truth would emerge from the combination of these elements. But the judge could not give a verdict unless the accused actually confessed to his offence. Guilt or innocence had to appear as a divine revelation. In order to seek this truth and reach the soul, it might be necessary to torture the body. The law had faith in trial by ordeal. And torture was applied to witnesses and defendants alike without distinction. In neither case was it a punishment; its purpose was to prove and confirm what was said. If the witness repeated his testimony under torture, it meant that he spoke the truth.

At the end of Agostino Tassi's seventh interrogation, the judge ordered that Artemisia Gentileschi appear in the presence of the entire court.

Artemisia came in, holding herself very straight. For a moment she met Agostino's eye, but then turned away. Agostino had expected to find her less

provocative. She was wearing the only fine dress he knew her to possess. The blood-red dress of their battle at Cosimo's house, where, for the first time, she had suspected his liaison with Costanza. In what spirit was she here today? Agostino had no doubts about Artemisia's inclinations. Hadn't she run to him in answer to his call two weeks ago? He had not seen her again — afterwards, he had been transferred from Corte Savella to Tor di Nona, a prison with a much severer regime — but he trusted her. Had they not pledged themselves to one another?

The deputy judge made Artemisia swear on the Holy Scriptures and asked if she knew the defendant. She nodded. He then asked Tassi if he knew the young woman. He replied that he did, and the judge moved on to the interrogation.

'Signora Artemisia, do you confirm what you have previously said?'

She did not look at her judges. There were four of them, sitting behind a table.

The room was small, with an extremely high vaulted ceiling from which swung a pulley with a rope, used for strappado torture. Artemisia recognised the contraption at once: she had seen something very similar on the corner of the Corso. It served to hoist a man up by the wrists after his hands had been tied behind his back. Artemisia would later remember only this pulley, the brick wall behind the judges, and the way in which her interrogator was dressed. He wore a long black cloak resembling Stiattesi's robe, trimmed at the neck with an old-fashioned ruff. On his head he had a round cap.

'Are you prepared to repeat your statement before the accused?'

'Yes, what I have said in these last few days is true. I am prepared to repeat everything before him.'

Her voice trembled but she did not falter.

Artemisia and Agostino stood side by side, facing the court. They were the same height. Both equally strong. Both striking figures.

The judge requested the chief notary to read aloud Artemisia's statement of 18 March last, in which she described her defloration. Agostino and Artemisia listened.

. . . When we came to the door of the bedroom he pushed me inside and locked it. Once it was locked, he pushed me on to the edge of the bed [. . .] and with his member pointed at my vagina he began to push it into me, having first put both his knees between my legs. I felt a terrible burning and it hurt me very much, but because of the gag on my mouth

I could not cry out [. . .] And I scratched his face and I pulled his hair and before he
could put it inside me again I grabbed his member so tightly that I even removed a piece
of flesh . . .

'Is what you have just heard the same as what you said? Do you wish to
ratify this statement before the defendant?' the judge asked Artemisia.

'I have listened to what you have just read,' she answered straightforwardly.
'I recognise my statement. I bore truthful witness to everything that it contains,
and in truth I confirm it before Agostino.'

'And I have this to say . . .' Agostino interjected.

Throughout the account of the rape, he had been in a constant state of
agitation, repeatedly attempting to interrupt the clerk. Anger distorted his
features. He recognised nothing, relived nothing in the events she described.
He had been prepared for anything, but not such a betrayal. He believed so
strongly in their passion that he had almost forgotten how it began and was
sincerely shocked to hear a statement of such coarseness from the lips of the
woman he loved. At Corte Savella, he had thought her so close to him. How
could she present their love affair in such a sordid light? Dear old Cosimo had
seen through her: the kind of girl who would lead to trouble.

'What I say is that everything Signora Artemisia has had you write down
is a lie. It is not true that I deflowered her. It is not true that I went to bed with
her. Here's proof: there was an apprentice named Scalpellino in her house,
someone you wouldn't even trust with a she-cat. He boasted publicly that he
had possessed her. I regularly visited her house without any offence to the
honour and respect that is owed in the home of a colleague. And I did no
injury either to her or her father. I even avoided going there as much as I could,
since they were forever arguing and trying to involve me in their quarrels.'

'Everything I have said is true. Otherwise I should not have said it!'
Artemisia repeated vehemently.

'Would you be prepared to confirm your evidence under torture?'

She did not hesitate. 'If necessary, yes, I am prepared to confirm it under
torture.'

'Then,' wrote the clerk, 'to remove any trace of doubt, any slur that might
prevail with regard to the person of Artemisia, to reinforce her words, and to all
good purpose, considering her sex and her age – seventeen years, reckoning by
her appearance – the judge orders that Artemisia Gentileschi should undergo
the ordeal of the "sibyl" in the presence of and face-to-face with the defendant.'

The sibyl took its name from the female seers of antiquity whose pronouncements always turned out to be true; it was a torture that made even the most reticent speak.

The deputy judge opened the door and summoned the torturer. The man who came in was shaven-headed, his upper body bound in leather. On the clerk's table, he rolled out the cords which he would fit on to the young woman's fingers and tighten until they started to crush the joints. What state would they leave her hands in? The hands of Artemisia Gentileschi, a painter? She averted her eyes from him, staring instead at the wall in front of her.

The judge made one final exhortation. 'Be warned. Do not accuse Agostino Tassi of "defloration by force with a promise of marriage" if it is untrue. On the other hand, if you wish to confirm your statement do not shrink from doing so, albeit amid suffering and torment.'

'I have spoken the truth and I shall speak it again,' she answered. This time, her voice was shaking and she had turned quite pale. She was afraid. 'I am here to confirm it.'

The judge gave his order: 'Torturer, place the cords between her fingers.'

The torturer went over to Artemisia. He bound her wrists against her chest and turned her round to face Agostino. The two of them looked at one another. To combat her fear, Artemisia decided that she would not look away. She would defy him.

The torturer slid the cords between each of her fingers and tightened them round the joints with slip knots. Slowly, he twisted the garrotte.

'It's true,' she cried as the ropes sank into her hands, 'it's true!'

Holding Agostino's gaze, she said scornfully, 'So this is the wedding ring you promised me, these are your binding vows.'

He remained impassive.

The judge questioned Artemisia again. 'Is it true what you said in your statement, what you have just confirmed before the defendant?'

The torturer tightened the vice again. Her hands were two braziers. The fire increased with each turn of the handle. Her knuckles had turned completely white, her fingers swollen. She tried not to look at them.

'It is true,' she repeated, 'everything I said is true.'

'It isn't true,' said Agostino. 'You are lying.'

The cords crushed the joints. Under the pressure, her swollen fingers made a crunching sound. On the verge of fainting, she murmured, 'It's true. It's all true.'

Agostino was still looking at her, but with lowered eyes. He showed not a flicker of emotion. The torturer kept up his work, but Artemisia could no longer speak.

There was silence. The judges' eyes shifted from one to the other.

'Since neither of the two adversaries has altered a single word of their testimony,' wrote the clerk, 'the judge orders that the young woman's fingers be released. The torture will have lasted the time it takes to say a Miserere.'

Once freed, Artemisia staggered. She had no feeling in her hands. They were purple and twice their normal size. An overwhelming fear engulfed her. Would she ever take up a pencil or hold a brush again? She tried to move her fingers but couldn't.

'If you have nothing further to add, the court authorises you to withdraw.'

Walking unsteadily, Artemisia moved towards the door. Just as she crossed the threshold, Agostino shouted out, 'Do not let her leave. I too have some questions to ask her.'

Artemisia turned towards him, pitifully pale. She no longer had the strength even to hate him. Her eyes pleaded for mercy.

'Here are the questions that I want to ask her,' said Agostino, extracting a piece of paper from his pocket.

He handed it to the judge, who scanned it and gave it back to him. In keeping with the law, the judge authorised the accused to put his questions to the witness for the prosecution.

'Who asked you to testify against me?'

She straightened up. 'Truth.'

'Tell me exactly how and on what occasion you claim to have had physical relations with me. And in what place the first time.'

'I have said a lot this evening. You have heard my statement read out regarding the time and place when it occurred. I believe that should suffice.'

Agostino wouldn't let her go. As Orazio foresaw, he was out to prove that she prostituted herself. If he managed to persuade his judges that they had a courtesan before them, he would have won.

'Tell me, does your father give you everything you need?'

'Yes, my father gives me everything I need.'

'Is there really nothing he makes you go without? Has he never told you to shift for yourself? Has he never left you at home with men?'

'My father has never left me alone with any man.'

'Have you never happened to be alone with the apprentice Scalpellino?'

'Never. My brothers have always been there, and the oldest is sixteen.'

'Have you never complained to me or to others that your father made you go without something?'

'I have already answered you.'

'What resistance did you put up when you were – as you claim – raped? Why did you not call out?'

'As I have already said, I did not call out because you put your hand over my mouth with a handkerchief.'

'In what circumstances were you deflowered?'

'I have already told the court.'

'To whom did you say that I had deflowered you? And what was your purpose in doing so?'

'I told Giovan Battista Stiattesi and his wife. You too had told Stiattesi.'

'Did you tell him immediately? And if so, why did you not bring charges? Why are you saying so now? Who advised you to say so? Who persuaded you?'

'I told Stiattesi when he came to live in our house, at the end of the year. And the only reason I told him was because you yourself had told him. And the reason I did not bring any charges earlier was that you and I had agreed to hide this shame for ever.'

'Do you hope to have me as your husband?'

'I had hoped to have you as my husband,' an impassioned expression crossed her face, 'but now I hope for it no longer. Because I have found out that you are already married.'

She knew. In an instant Agostino took the full measure of the situation's drastic proportions. A fleeting look of despair came into his eyes. From now on, their roles were fixed. They were enemies, separated for ever. Then he rallied.

'Did anyone tell you that I will be compelled to marry you if you say that I deflowered you?'

'No one told me any such thing.' She surveyed him contemptuously. 'I expect nothing from you now. I only speak for the sake of truth.'

All at once she seemed very tired.

The judge raised his hand. The session was over. In a toneless voice, the deputy judge told Agostino Tassi to return to his cell; Artemisia Gentileschi was to go home. The room sank back into silence.

19

The Santo Spirito in Sassia District
The Gentileschi Household

1 June 1612

'Get dressed!' ordered Orazio. 'Where are the earrings that the scum gave you?'

'They're the only present I ever accepted from him,' Artemisia pleaded.

'You might as well have wrung him dry. Put on the drop pearls and the scarlet skirt you wore at Cosimo's. Here is a piece of watered silk. Make a bodice out of it and get yourself properly dressed up. Virtue,' he mocked, 'innocence, these are things to be shown off! You're coming with me.'

Here was a paradox: ever since the revelation of a Signora Tassi living in Tuscany and the irremediable dishonour wrought upon the Gentileschi family by the impossibility of marriage between Agostino and Artemisia, Orazio had stopped locking her up. Fear and mistrust were a thing of the past; he no longer had any cause for jealousy. The false promise of marriage, the last blow dealt to his daughter's heart, had given her a dread of deception.

All her dreams of fame, all her striving to free herself from her father's guardianship through marriage were over. Tassi's lies left her no future but the convent. Her father was her last remaining hope. He still treated her harshly for form's sake, from habit, because he knew no other way of addressing her; but Orazio's insults now appeared meaningless to both of them. When all was said and done, they got on.

Far from leading to her exclusion from the clan, Artemisia's downfall placed her firmly within the bosom of the Gentileschis. Her gifts as a painter were a tribute she owed to her father. Yet, all she had ever dreamed of was that

Orazio would acknowledge her talents, and see his daughter's works as a precious extension of his own art.

'You're coming with me,' he repeated.

'Where?'

'To the cardinal-nephew's. Monsignor likes nothing better than curiosities. Monsters, dwarves, lunatics . . . To the innocent, all things are given!'

His sarcasm had not the slightest effect on her.

'I should prefer not to go.'

'But go you shall!'

He looked at her darkly. Her fingers were still swollen, but this would be gone within a few days. The cords of the 'sibyl' had not mutilated her hands. Was the leniency of her treatment to be taken as a sign of special benevolence on the part of the judges? Orazio recognised that the court had shown consideration towards his daughter. Was he to conclude that papal justice was well disposed towards him?

Both Orazio and Artemisia were secretly thrilled by the way they were now bound to each other. They laboured together from dawn till dusk, resurrecting old compositions, recopying past successes, retouching, varnishing . . . Gentileschi father-and-daughter: a unit once again. Orazio was now so sure of Artemisia that he no longer felt the need to guide her paintbrush. He left her to work freely at her canvas. On the iron-oxide ground which she prepared, she chose her colours alone, applying the lighter hues, working on the highlights and glazes with small strokes of the brush. Whereas he had always imposed subjects on her, now at last he encouraged her to develop her talents in genres where she excelled, in portraiture above all, which was not a strong point of his. Robust children's bodies took shape under Artemisia's hand, her broad brushstrokes turning her little brother Marco into the most fleshy of angels.

Both of them had come to understand that only by pre-eminence and celebrity could they save themselves from disaster: by compelling admiration and exciting the desire of those who gave commissions, by building a body of work which would trumpet their renown across the art market. That the man who had betrayed them might pass for their innocent victim, that he might leave prison acquitted, stirred them with equal fury. Day and night, they pursued the same end: the punishment of Agostino Tassi. They shared the same fear: his release.

It was June 1612, and the Gentileschis still had not won the battle.

There were three circumstances acting in Agostino's favour. First of all, the support of his peers. In Rome he enjoyed the friendship of the greatest Tuscan painter, the artist who had first given him work in the papal city, recommending him to Paul V for the *trompe l'oeil* in the Consistorium: Ludovico Cigoli. At present, Cigoli was executing the project dearest to the Pope's heart, the frescoes in his private chapel at Santa Maria Maggiore. Moreover, he was working near the Casino of the Muses, decorating the second of the large pavilions, the Casino of Psyche. This double position gave Cigoli easy access to the Borghese. Did he daily whisper a few words in the cardinal-nephew's ear in favour of Agostino? Orazio feared so. All the more since Cigoli had no great fondness for him, suspecting Orazio of having been behind a plot against him. Maintaining that his frescoes were worthless, Cigoli's rivals – followers of Caravaggio – had made engravings of the paintings which he kept hidden from the public. They had then put these engravings into circulation, passing them off as plates from abroad whose subject, design and composition had been copied by Cigoli. Orazio Gentileschi was one of the leaders of the movement begun by Caravaggio. He loudly and strongly denied any part in the machinations. But Agostino's pupils and apprentices reminded anyone who would listen of his former moves against his rival Baglione, of the defamatory poetry that had led to his imprisonment . . . in the very same prison where poor Agostino was languishing today, yet another victim of Orazio Gentileschi's professional jealousy. Was Cigoli going to take his revenge by supporting Agostino Tassi against Orazio Gentileschi?

Another advantage for Tassi was that his incarceration held up completion of the Casino of the Muses. And, like all collectors, cardinal Borghese was an impatient man to work for. By provoking this trial and causing this scandal, Orazio Gentileschi seemed responsible for the delay.

Lastly and most importantly, letters had arrived on papal desks from the court at Florence demanding the 'absolution' of Agostino Tassi, the 'painter of the Medicis'.

Agostino had not exaggerated the importance of his protectors. Orazio's greatest worry was the support of the secretary of the Grand Duchess of Tuscany, who bombarded the Borghese administration with petitions in favour of the prisoner. What patron could stand in the way of such pressures? What admirer would be powerful enough to resist such influence?

Orazio would look at Artemisia and calculate the likelihood of success.

There were dark circles under her eyes, but they blazed with more fire than ever.

'From now on, Orazio Gentileschi's daughter must be seen in public.' he said wryly. 'Such a beautiful "signorina". So dignified. So talented. People must come to know the extent of this calamity, to see how great is my treasure, now ruined by that bastard. A pearl, a marvel worthy of a place in the cabinet of a collector . . .'

Artemisia's face lit up. She had just realised what her father had in mind. 'And my paintings?'

'They will be exhibited. They will be put on show like you, of course.'

The moment she had long dreamed of was here at last. But not as she had imagined it.

Orazio understood her feelings. Ever since he had rediscovered the fragile and vulnerable daughter he had known as a child, compassion for her had welled up in him. He had no difficulty imagining the hopes built up in Artemisia's mind by the prospect of an introduction to Cardinal Borghese; just as he could guess at her torment and distress, her loneliness over the whole of the past year. It wrung Orazio's heart to think of the sense of shame which must have engulfed her, proud as she was. The fear, brave as she was. The disgust. He did not doubt for one moment that Agostino had forced himself on her, that she had tried her utmost to resist him, that she had injured him as she defended herself. He even refused to believe that she had been smitten by her aggressor. 'But why didn't you tell me?' he would protest inwardly. 'If only you had let me know!' It was her silence more than the family's dishonour which Orazio held against her. 'You should have confessed your sin that very evening.' Artemisia had lied to him. She had deceived him. She had mocked him. It was only this sense of betrayal which restrained Orazio from moving towards forgiveness. But his daughter had come back to him. She would never leave him now. With this certainty, he could abandon himself to commiseration, to that feeling for the griefs of others which he had always fought against as some kind of dangerous weakness. Artemisia's silence, her new-found gentleness, reminded him of Prudenzia, whose ineffable presence he still felt beyond death. Everything that in his anger he had deemed intractable had now become lucid again: he had regained Artemisia's love. As they worked side by side, Orazio felt in harmony with himself. When he was close to her, just the two of them, he forgot about the trial and saw nothing out of the ordinary in their situation.

But the moment he left the studio, the moment he came into contact with the world, he felt himself compelled to be harsh, as a means of defence and survival.

'Get ready,' he muttered.

He wanted Artemisia to have no illusions about his intentions: he was not taking her to the Casino of the Muses to entertain her, but because circumstances drove him to it. She had to be seen, recognised, admired. He would introduce her to his patrons. She would work for them. She would have a name and an identity. Her signature would have an image behind it: the superb face of Artemisia Gentileschi.

'A beautiful woman painter, that should sell very well. Especially if her art puts her on a level with the grand masters. One of nature's prodigies. A freak – like the bearded lady, or the two-headed foetus.'

He pointed to the *Susanna*, which depicted her naked, and the second version of the *Judith*, which he had reproduced. 'Have your brothers take that to the Borghese Garden – and that too. I want *you* looking like Judith. I want you as resplendent and triumphant as Truth!'

She was not listening to him. Now that she had known the depths of shame, all she had left was pride in her work.

'They will exhibit my pictures under your ceiling! The Pope and the cardinals, the whole world will be able to see that Agostino Tassi's talent as a painter is worth nothing compared with the work of the Gentileschi, father and daughter!'

After his midday meal, the sovereign pontiff, with his court in train, went to see his chapel at Santa Maria Maggiore. He stopped in the garden of his nephew, Cardinal Borghese, to admire the fountains and the effects made by the play of the water.

Dispatch From Rome, Sunday 6 June 1612

Orazio Gentileschi had awaited the Pope's visit in the pavilion next to the nymphaeum. Unfortunately, news of his arrival came too late and he missed him. Paul V went no further than the the lower garden where he admired Cigoli's frescoes.

The Pope only had to cross Piazza di Monte Cavallo to get from the Quirinal Palace to the splendid property being landscaped by his nephew. Submissive to His Holiness in everything, Cardinal Borghese had acquired the property so that he could be nearer to his uncle. The two men were in close

agreement on family politics and patronage. They shared the same architects and recommended artists to one another.

No cardinal before Scipione Borghese had accumulated so many offices, benefices and prebends – whose revenues fell to him. Over seven years this amounted to a colossal fortune. Even the nephew of the previous Pope, the famous Cardinal Pietro Aldobrandini, who had seized the wealth of the Cenci family and from whom Orazio received his first big commission, had not dared to acquire as many palaces and as much land as Scipione Borghese.

To all appearances extremely affable, when it came to art, Scipione had a violent temperament that would stop at nothing.

He would stoop to the basest of actions to get hold of a work that he coveted. In a few years' time the Curia would resound to the din of a battle between Scipione and Pietro Aldobrandini. Having glimpsed the famous *Diana with Nymphs at Play* as it was drying in Domenichino's studio, Scipione became so strongly enamoured of the painting that he wanted to buy it on the spot. When the artist replied that, to his great regret, the picture no longer belonged to him, since Cardinal Aldobrandini had commissioned and paid for it, Scipione Borghese took the simple step of imprisoning the painter while he made off with the picture. By then, his avidity knew no bounds. Thus the Cavaliere d'Arpino, under whom Orazio had worked and who had executed the mosaics in the dome of St Peter's, was cast into a dungeon while Scipione used a charge of tax fraud to strip him of his own paintings and the collection of masterpieces that the Cavaliere d'Arpino had built up over twenty years.

But Scipione Borghese handed out gold and honours in abundance to those artists whom he liked – and who gave him the works he demanded. In the Rome of the Popes, good painting rose above the law – so long as it was commissioned by the cardinal-nephew. If in the service of the Borghese and their entourage, Art always prevailed over Justice. Scipione saw to that.

It was the eye of such a connoisseur that had to be charmed by the works of both father and daughter. Only the Gentileschis' talent and virtuosity – the triumph of their painterly skill – could bring about a verdict of guilty for Agostino Tassi.

20

The Casino of the Muses
Garden of Cardinal Scipione Borghese

1 July 1612

'Heaven is on your side, Signorina Artemisia. Why despair? Thanks be to God, there is a way out of every situation,' Giovan Battista Stiattesi pontificated as he walked about Scipione Borghese's enchanting park with Artemisia.

They were waiting for the arrival of the cardinal, who was expected that afternoon by his gardeners. It was difficult to walk two abreast along the narrow grass pathways with their right-angled intersections, so Stiattesi's black garb followed Artemisia's red skirt and their garments brushed against the low brick walls which boxed in the flower beds, each corner surmounted by little busts of Roman emperors, or by shrubs trimmed in the shape of a globe.

'But you cannot expose yourself like this,' he went on. 'Now especially.'

'And what is it you think I should do?' she asked without turning round, her irritation striking Stiattesi as aggressive.

When, in the heat of wreaking vengeance on Quorli, the notary had reported everything to Orazio, confession had been something of a relief. He congratulated himself on no longer having to betray Gentileschi, to whom he felt indebted, nor having to deceive this poor young woman, whom he wished to defend. Now, however, he was afraid of Agostino's vengeance. This fear for his own safety, and that of his wife and children, had given rise to a certain bitterness towards Artemisia, a feeling akin to spite, which went against his conscience. In his confusion, Stiattesi no longer knew whether he wanted to

save her, or get rid of her. As a result he could not leave her alone. He clung to her skirts and involved himself more than ever in the drama she was living out.

While the Roman tribunal had never bothered to interrogate Orazio Gentileschi, it had summoned Stiattesi many times, comparing his and Agostino's versions of events. The latter claimed that he had paid Stiattesi several dozen scudi to contrive Artemisia's visit to the prison. He claimed, moreover, that Stiattesi was Artemisia's lover and that he was engaged in a double game. This resulted in violent altercations in front of the magistrates. In a blind fury, Stiattesi had yet again taken revenge by supplying fresh proofs of Agostino's guilt.

In common with the two Gentileschis, it was now also in the notary's interest that Tassi should remain in prison – for a long time. He knew that he would not be up to a fight against his former, dagger-wielding, friend. So, with renewed energy, he set about delaying his release. When he was not fulfilling his official post as prosecution lawyer or striding about the streets of Rome in search of prosecution witnesses, Stiattesi stood guard for Orazio at the Borghese garden. Having let slip the opportunity to plead his case with the Pope – on the occasion of the sovereign pontiff's visit to the fountains in June – Orazio was desperate for a meeting with the cardinal. His long experience of asking for favours and string-pulling – a necessity in his profession – had shown him that there was nothing, no letter or petition, that counted for as much as direct contact with the high-placed person who could give him everything he wished for. This was the only advantage he now had over Agostino.

'So? What do you advise me to do this time?' Artemisia repeated for Stiattesi's benefit.

The notary's dubious attentions and equivocal preaching irritated Artemisia, but she put up with them. Tuzia's imprisonment had left her alone with her sin, isolated in her sense of guilt. That matron's prompt house move after her release at the end of March, the disappearance of the whole Medaglia family to a faraway district and the memory of their friendship, overwhelmed her with sadness.

As Stiattesi watched Artemisia gliding among the marbles, straying inside the box-wood maze and stepping through the rose-covered arbours, he deplored the fact that the park's extraordinary beauty should be revealed to them in such circumstances. He had never known anything more pleasant or luxurious. Not

even the Boboli Gardens, open to the people of Florence, not even the hundred fountains of the Villa d'Este whose delights were legend, succeeded in allying the wonders of art and the splendours of nature with such virtuosity.

All the flower beds around them were laid out in a geometric pattern carefully composed of three kinds of blooms in different shades of the same colour. From a distance, the hundreds of squares formed a multicoloured checkerboard resembling the floor of a church, like the vast marble carpeting of St Peter's. A garden devised to charm all of the senses: sight, smell, hearing – the dull roar of water cascading down a stepped slope was audible. From behind the shrubs came the tinkling of fountains.

He knew that she was taking this walk to calm herself. At this moment, Artemisia Gentileschi must have been feeling like a gladiator about to enter the arena. Orazio was sending her out to do combat. What did he expect of his daughter? For all the inconsistency of his behaviour, Orazio had a dread of chaos and randomness. What exactly had he planned?

The balanced composition of his paintings, the elegance of the figures and the refinement of the poses, along with the opulent accessories, told anyone who had eyes that this painter – this boor – had a highly developed sense of grand manners, and unerring taste in decorative effects. His palette was a paean to the iridescence of silk, it delved deep into velvet folds, it wound gold veils about the diaphanous shoulders of his madonnas, aspiring only to convey the Ideal. Nothing in his work was unstudied, undeliberate. He had thought out his daughter's attire and appearance as if he were constructing one of his paintings. Did he have it in mind to sell her?

Of course, that was it. He wanted to sell her! Stiattesi was repelled by the idea. Given her origins, dressed in such finery she could only belong to that class of women who were outcast from Earth and Heaven of which Rome preserved a long tradition dating back to antiquity. How could Orazio have consented to introduce his daughter in the guise of a prostitute? Did this not bear out Agostino's allegations? Stiattesi thought that Artemisia would have been better dressed like a virgin; exhibited as a Madonna, a saint, even a martyr. He imagined her pale-faced, with a veil covering her head. A lily in one hand, a dove in the other . . .

Orazio knew better: his daughter's innocence would never bring him Agostino Tassi's head. And Gentileschi wanted that head. Albeit at the cost of what was dearest to him. The daughter whom he had kept out of sight for eighteen years, whom he had balked at giving away in marriage or putting in

a convent. He was prepared to sell her cheap.

By provoking the trial, Orazio Gentileschi had already proved that he would see things through to the end. That he was prepared to dig his own grave. This prudish and brutal tyrant who was so fearful for his honour and his daughter's virtue as to deny her all pleasure was now going to parade her awash with jewels and in a plunging neckline – at the risk of losing her for ever.

Stiattesi could not take his eyes off Artemisia's bared neck. Where had Orazio found the money to pay for the thick chain fastened with a golden mask that Artemisia wore around it?

The cardinal's accounts of July 1612 show that the last payment for the Casino of the Muses was made on 28 April. Two hundred scudi to go to the two artists in partnership. A tidy sum. Two hundred scudi of which he never received his share, lamented Agostino Tassi from the depths of his prison. The cost of putting on this show of which the two Gentileschis had such high hopes; the gold chain with its mask was Artemisia's first frivolity, and it was a stroke of genius on Orazio's part.

Twenty years earlier, in 1593, a treatise on iconology had been published that was reprinted many times over. It was a bible for poets, sculptors and painters, a dictionary of the symbols and allegories which artists could use to represent an abstraction: Wisdom, Eloquence, Painting . . . So that the idea of 'painting' would be immediately recognisable, artists always conveyed it with the same attributes and in the same form: 'A splendid young woman dressed in a gown of changing colours and wearing a mask on a chain.'

The mask of simulation. When he saw Artemisia, Cardinal Borghese would grasp the allusion immediately. This beauty stepping towards him was not just a being of flesh and blood, she was his dream incarnate, she was Painting!

'Be careful,' warned the notary, staring at the unruly strands of hair that played about the clasp of the chain. 'Be careful.'

Her hair gave out a heavy, disturbing perfume which mingled with the scents of the garden.

'Be careful of what?' she asked in a stricken voice, half turning round.

He saw that she was sweating. Was it fear of disappointing the cardinal? Stiattesi, who knew the prelate by repute, could not venture to imagine the outcome of this meeting with Scipione Borghese. As well as being an art lover, he was a sophisticated voluptuary and a great connoisseur of women. Fear, or

the July heat? Stiattesi's attention lingered a little too long over the tiny beads of moisture between her breasts, under the flimsy lace fichu. Distracted, she let him stare at her breasts without embarrassment. Stiattesi no longer knew whether he ought to feel sorry for this young woman. The loathsome Quorli may have been right, and Tassi not so much to blame. With the heavy braid that her father had wound around her head like a diadem and her dress of deep-red watered silk, she had an intoxicating effect on him, like the tropical flowers cultivated at great expense by the cardinal's gardeners. At her shoulders and either side of her bodice the lacing seemed on the point of loosening. She had a dangerous, reprehensible kind of beauty. Yes, Gentileschi had lost his mind, thought the notary. He was in the devil's grip.

'Leave while there is still time.'

'Where do you expect me to go?' she retorted, glancing around.

Against all the rules of architecture, the cardinal had made a decision to landscape his park before having his palace built. There was as yet no sign of the future residence. The *piano nobile* would eventually be on a communicating level with the highest of the terraces. For now, it was a building site swarming with an army of workmen. But already, rising from the three levels of this vast garden, were the four summer pavilions he had planned for giving feasts.

Orazio had forbidden them from venturing down to the lower level: this was Ludovico Cigoli's domain, where he was working on the casino in which Psyche's amorous adventures were hidden. Cigoli, mistrustful after the plot against him, jealously kept his work secret. The only people who had been able to admire this wonder so far were the Pope and the architect of the grottoes, basins and the nymphaeum. To the west of the Casino of Psyche, at the far end of a large orange grove, there rose a wall of fountains. Between the statues and the jets of water, a curving double stairway climbed to the garden of the Casino of the Muses.

This garden had been landscaped on the floor of the ancient baths of Constantine and it led out on to the Quirinal Square which was at the same height. At its centre, in a green marble basin, stood a statue of Venus. On the right, water tumbled down into a grotto which Scipione had christened *il teatro d'acqua*. Next to this 'theatre of water' stood Orazio's pavilion, planned solely as a casing for the loggia's mural decoration. It was a room measuring around twelve yards by six, the front wall pierced by three arches. The central arch gave an all-embracing view of the fresco, which had been designed so as to be admired from the park.

On the far wall, three *trompe l'oeil* arches echoed the three arches which opened on to the garden. They were the work of Agostino Tassi. Between the arches and in the corners there presided ten figures by Orazio Gentileschi: Apollo and the nine Muses, which at present existed only in sketch form. The painter had not bothered to cover them up. But – mindful of Cigoli's misadventure – he kept his ceiling from the curious eyes of his confrères; a large sheet of canvas hid the whole vault, which was hard to see from floor level because of a two-storey scaffolding. At the lower platform, work was being carried out on the walls. The higher one gave access to the ceiling.

It was the first time that the cardinal would see the work he had commissioned. Gentileschi had a surprise in store for him, and a few gifts that Scipione Borghese was not expecting. He had arranged for four armchairs to be brought and had set up three easels on which stood paintings that were covered up.

'Would you advise me to hide too, Mastro Stiattesi?' The young woman asked, not without a touch of mockery.

'This time, you could fall in earnest. And God will call you to account for it.'

'In earnest?' she echoed bitterly.

'Until now you bore no guilt.'

'And now?'

'Satan could easily tempt you now. Run from your father's folly. It is the Evil One prompting him.'

'I have nowhere to go.'

'Go to your uncle in Florence.'

'Run away and let Agostino win?' she blurted angrily. 'Run away and lose . . .' She faltered, lowering her eyes. 'And lose everything.'

Her voice struggling for self-control and her wandering look, unable to focus either on him or on the splendours of the garden – a look usually so direct – made him realise how afraid she was. At any moment, she could be called back to the torture room at Tor di Nona for a fresh confrontation with Agostino Tassi. It was not just physical suffering that she was feared. It was the presence of the man she had loved, and the abyss of hatred into which she was cast by being near him.

'Once Agostino Tassi is punished, I shall go and bury myself in a convent and I shall die there in silence!'

A wry smile flickered over Stiattesi's austere countenance: Artemisia Gentileschi might well expire before the trial was over, but undoubtedly not in silence. She noticed his irony.

'Let me be the judge of the situation,' she told him gravely. 'I am sickened by it all. But it is impossible to change anything.'

At that moment, Artemisia's brother ran up to them; Orazio had just arrived and the cardinal was crossing the square.

'I thought I was quite clear about the subject I required of you, Signor Gentileschi. We talked about thirty figures, and I can see only ten!' Scipione Borghese exclaimed angrily.

His purple soutane had suddenly appeared on the first platform of the scaffolding. At that height none of the frescoed figures was completed.

'You are taking things at a very leisurely pace, Signor Gentileschi. When I set up a project, I mean to have it adhered to.'

The cardinal-nephew was a man of around thirty-five. He was smaller than the Pope, but, like him, he held himself very straight and had a fine bearing. Although his gestures were a touch more fluid than the Pope's and there was a certain suppleness in the way he held his head, a quickness and liveliness in his step, he seemed heavily built. His *berretta*, set on the back of his head, made his face rounder, while his cape broadened his shoulders and the alb that came down to his knees made his figure more squat. In short, Cardinal Scipione Borghese seemed ill-suited to wearing ecclesiastical garb. In his early youth, he had studied philosophy at the Jesuit College in Rome and led a carefree life at the University of Perugia. The election of his mother's brother to the papal throne, however, had recalled him swiftly to Rome. He had not been born a Borghese, but a Caffarelli, which was his father's family name. The new Pope, concerned to surround himself with those he could rely on, and to place his relatives, friends and dependants in the most lucrative posts, had given him his own name, his arms and the cardinal's purple.

Unlike royal dynasties, sovereign pontiffs could not count on time and the coming generations to guarantee their domination and survival over centuries. All they had was the short period of their papacy. Elected late in life, popes hardly ever reigned for more than fifteen years. Fifteen years to build up a fortune so vast and solid that their name, their family's name, would leave its mark on Rome for all eternity.

Ever since Sixtus V and the Counter-Reformation edicts explicitly

forbidding popes from having direct descendants, experience had proved that the best and most effective way of concentrating maximum power and wealth upon oneself in a minimum timespan was to have two nephews. To the elder would fall the management of the Papal States and the Catholic world. This relative would be the Pope's right-hand man, taking up an ecclesiastical career and assuming the now official function of cardinal-nephew. To the second would come military honours, marriage and the responsibility of guaranteeing a line of descent. But these two nephews had to be quick about it. The election of a new pope would bring a new house to power. 'There is no position in the world more dangerous than that of a nephew after the death of his uncle'; Scipione Borghese was well placed to judge the truth of this adage. Had he not stripped the nephew of the previous Pope, his old enemy Pietro Aldobrandini, of all his privileges? Had he not forced him to leave Rome and go into exile?

To forestall future disfavour, the cardinal-nephew had to accumulate so much wealth that no one would ever be able to dispossess him completely.

'Where are the musicians that we agreed upon? I can see nothing here which refers to music.'

Scipione had proceeded alone to the end of the gangplank; it vibrated under his weight. Disappointment darkened a face made heavy by hearty eating. With his bright eyes, faintly bulging from a thyroid problem, and his naturally clear complexion, Scipione Borghese seemed to burst with health – but health that came at a price. His doctor's stipend was almost as high as his architect's. The cardinal kept quiet about his ailments. Not for the sake of intrigue but because the most powerful man after the Pope, the man fawned upon by ambassadors the world over, liked an easy life. He had little interest in politics. Anyone who asked would be given his promise of a word in his uncle's ear, all petitioners would be treated to the same kindly phrases – while he took care not to meddle. Under the moustache and goatee, his greedy lips would have the hint of smile . . .

He was clever enough to understand that the despotic Paul V expected the cardinal-nephew to back him up rather than take any lead and therefore shrewdly made it his business to echo the Pope's wishes. He in turn took it as his due to be obeyed to the letter.

'I told you I wanted gold and vermilion for Apollo's robe! The pigment you have chosen will not last, nor will the Muse Caliope's ultramarine. Why did you buy powdered vermilion? You ought to know by now, Signor

Gentileschi, that powdered vermilion is a fraud: it is mixed with brick powder and copper red!'

'As a matter of fact I did not work with powdered vermilion, Your Eminence,' pronounced Orazio, his anger getting the better of him. 'I ground it myself, using the mineral from the top of the rock, where the texture is crystalline.'

'You should have checked it more closely, and ground it more finely.'

'Quite right, had I spent twenty years grinding it, it would have been even better,' the painter assented sarcastically.

'As for the tilt of that head there, it strikes me as unlifelike.'

'The figure isn't finished, Your Eminence.'

'That is precisely my complaint. You were provided with a list of the nine seated positions where each of the Muses was meant to be.'

Handing out directives on the subject of a work was not the special prerogative of the Pope's nephew. All collectors would give the painter a brief not just on the painting's theme, but also its dimensions and the number of figures required. These instructions might be set down thoroughly in a contract which fixed the payment and deadlines.

With a connoisseur as powerful as Cardinal Borghese, the fees were non-negotiable and the cost of the work was left in vague terms. The artist would expect his recompense to be all the more generous. According to custom, the work's commissioner would pay an advance and cover the expenses for stretchers, canvases and ultramarine blue for easel paintings, and scaffolding for frescoes.

Relationships between Scipione Borghese and his painters were further complicated by his having a deep technical knowledge of painting. He was not just the most avid and impatient of patrons, he truly and passionately loved the arts. When everything went well, his grasp of the artwork became intensely rewarding for the artist. When things were turning out badly . . .

A second figure had just emerged from the trap door, placing a finely-shod foot with circumspection on the platform. He drove home the point: 'I note, along with His Eminence, that the west and north walls ought by now to be dry enough for work to begin on the surface of the columns.'

The Florentine Antonio Ricci, who was older than Scipione Borghese, had recently been named Bishop of Arezzo, and wore the high-waisted, pale-violet sash round his black soutane, a skullcap masking his tonsure. He shook his head. 'The Muses are as yet no more than sketched out,' he said with a sigh.

'If Monsignor would be good enough to come up to the second level,' Orazio suggested, pointing to the ladder, 'I think that . . .'

Orazio Gentileschi did not underestimate the importance of the man whom he addressed. Antonio Ricci rarely set foot in his diocese. It was he who had introduced the painter Ludovico Cigoli to Scipione Borghese. He bore total responsibility for the cardinal-nephew's numerous worksites. Not only did he have a joint role in planning all the iconography of the decorations, but Monsignor Ricci oversaw accounts and, most importantly, supervised the progress of works. This was a monumental task. Besides landscaping this garden, Scipione was simultaneously modernising his city palace – the Borghese Palace – and having a vast villa built on the Pincio Hill. Work there had begun the day before. This was where the cardinal-nephew meant to house his collections of musical instruments, his books, his paintings and the two hundred classical statues which were his passion. He aimed to install these objects in the galleries by the spring of 1614. This was a tall order. Less than two years for all work on the immortal Villa Borghese to be completed. Scipione seemed in even more of a hurry than usual. Providence had seen to it that his uncle was elected in the prime of life. But Paul V had already reigned for seven years. How many days and hours did the cardinal-nephew still have to give expression to his wealth? How many months to outstrip all the aesthetes known to history for the rest of time to come?

'Indeed, sir, as His Eminence made plain, you are not the only one working for him on this garden,' interjected a third prelate suddenly appearing in his turn on the first platform. 'Your work has its place in a scheme, it is part of an overall project . . .'

Canon Lelio Guidicciono was twenty-eight years old, thin-faced from poring over books, short-haired and sporting a curly moustache. Instead of a soutane, he was dressed in an elegant doublet such as gentlemen wore. His translucent hands with their long, much beringed fingers emerged from lace cuffs, and his short black cape, thrown over one shoulder, swept along the guard rails. A man of letters and a man of science, a fine poet and mathematician, he came from one of Lucca's old families and he too had embraced an ecclesiastical career at a father's behest. The young prelate belonged to the new generation of intellectuals who were passionate about literature and antiquity, a circle of *virtuosi* with whom Scipione Borghese liked to surround himself. Though no formidable scholar, Lelio Guidicciono had an eclectic mind, equally curious about the past and the future. He was to set

up one of the first excavations on the Palatine Hill and would soon give his support to the theories of Galileo. In years to come he would be canon of Santa Maria Maggiore and San Giovanni in Laterano, and would go down in posterity for the eloquence of his funeral orations. Lelio Guidicciono would have the honour of paying resonant homage to the memory of Paul V before the Catholic world gathered around his funeral bier. His friendship for Scipione would be unfailing. Even in adversity. He would dedicate his last book to him.

'This casino was planned for the purpose of giving concerts,' he explained with fervour. 'The serenade to the god Apollo which we commissioned from you is but an echo, an everlasting imprint of the music which will be played here for His Eminence, the god of the arts in our own century.'

'You must paint with your brain, sir, and not with your hands,' the cardinal interjected, without acknowledging the flattery. 'The hand is but a tool of the intelligence. And without intelligence, nothing can be done well.'

'But if I may be permitted, Your Eminence, it is nonetheless with our hands that we painters speak . . .'

'Not at all,' interjected the Bishop of Arezzo, 'you speak with your head. With no thoughts or ideas, there is no image. And just as poetry is painting that speaks, painting, Signor Orazio, is mute poetry.'

'I quite understand,' answered Orazio. 'That is exactly why I make so bold once more to beg Your Lordship to be good enough to follow me up to the level above. Once there, I believe that His Eminence will not be disappointed. For he has seen nothing as yet.'

Grudgingly, the three prelates followed the painter up the ladder. When he was beneath the vault, Orazio untied one of the ropes, releasing the canvas which hid the ceiling. With a great flapping noise, the canvas collapsed at the feet of the little group.

At last they could see the extraordinary balcony designed by Agostino Tassi, with its columns and vaulting in grisaille. The famous architectural drawings of the man who was in prison.

'What astonishing realism!' exclaimed the Bishop of Arezzo. 'Feeling and intelligence, all conjoined here for us to feast our eyes.' His Florentine origins and his friendships in Tuscany had biased him in favour of Agostino Tassi.

Orazio Gentileschi's nineteen figures stood on the balcony. Inclining towards an invisible audience, superb female musicians played the harpsi-chord, the violin and the flute. Dressed in pink, green and ochre draperies

which whirled about in the wind, some seemed to be singing, others listening. A pastel symphony on a background the colour of stone with glimpses of blue sky. A lone woman dressed in the style of the day walked along the gallery, her face turned outwards: Artemisia.

'My daughter, Your Eminence, whom I shall have the honour of introducing to you in a moment.'

'Admirable,' sighed the cardinal, without it being clear whether he was referring to the young person or the ceiling as a whole.

'What a fine relief!' added the bishop. 'That is what I call technique.'

Recovering his customary good humour, Scipione Borghese had taken the painter by the elbow and was making his pleasure plain, stopping by his side in front of each of the figures.

'So what were you playing at? Why were you concealing these beauties from us?'

Orazio had no answer to give. He felt no relief or delight, nothing but an overwhelming despondency. He had been hurt by the cardinal's reprimand. And now the Bishop of Arezzo's clamorous admiration for Tassi's *trompe l'oeil* handiwork was more than he could bear. He was swamped by feelings of bitterness.

The female figures that had cost him so much anguish suddenly struck him as vulgar and banal. Even the colours, in which he took such pride, those shadings in the draperies – the entire fresco had lost its life and complexity in his eyes. And it was his association with Agostino Tassi which tarnished his work.

In one of those reversals of mood to which Orazio was prone, he forgot what he had hoped to gain from his triumphant success with Scipione Borghese. Risking self-denigration, he could not resist his need to besmirch his collaborator.

'Agostino Tassi appears to have copied everything from Veronese, Your Eminence. This ceiling is a pastiche of the frescoes at Villa Maser. He appears also to have purloined some things from Ponchino's Sala della Poesia on Murano. I really do not know how Agostino manages to imitate everyone without ever ceasing to be himself: a thief!'

'You are very hard on yourself,' said the cardinal, tongue in cheek. He went on, leaning over the gangplank, 'In your place, I should be more concerned about the unfinished walls. When do you expect to finish the nine Muses, in the corners there, and that poor Apollo?'

'By the autumn, Your Eminence.'

'In three months? Good gracious! Ludovico Cigoli himself works faster than you.'

'I feel that I am doing a great deal when I paint one hand in a day, so long as it achieves its effect,' Orazio retorted drily.

The cardinal gave the ghost of a smile.

'It's clear to me that your Muses and musicians set you daydreaming, Signor Gentileschi, and from what I have heard, Mars is a thorn in your flesh. But the war between you and Signor Tassi will not last long enough, with God's help, to stop you from finishing within the month.'

'I shall do my best, Your Eminence.'

'Within the month, I'm counting on it. You must not lose the esteem you have won for yourself, nor fall from the rank that you hold among the most renowned painters in Rome.'

At these words, Orazio's dejection turned to enthusiasm. Affection surged up in him and he was flushed with gratitude towards his patron. His fresco suddenly appeared to come back to life. He wanted to say something which would convince the cardinal that his painter saw the concert, Apollo and the Muses with the same eyes as he did – but the cardinal was no longer listening. He was on the ladder and, with his retinue, had started the climb down. Neither the narrow planks, the gaps in the ladder-rungs, nor the unstable supports could frighten the three prelates, who were quite at home on scaffolding.

All year round, every day of every month, the *Avvisi di Roma* – dispatches which gave news of events in the city – referred to the cardinal-nephew's expeditions to cupolas, tunnels and aqueducts, his advisers in tow. Their lives seemed nothing but a succession of visits and explorations.

Scipione Borghese led the way; soutanes brushed against rings. Orazio brought up the rear. He shouted so as to be heard from the ground.

'Precisely, Your Eminence. Perhaps you know that I have lived in this city for more than thirty-six years and I have devoted all of that time to perfecting my art. Throughout my life, I have pursued only one goal: to raise myself up to the level of the great masters, while always behaving as a man of honour.'

The painter leapt nimbly on to the ground. At forty-nine, Orazio Gentileschi was unafflicted by any infirmity. With his wiry chest and his small bird-like head, he seemed ageless. Thanks to his constant effort to keep his nerves under control, he gave his interlocutors the impression of a man of

iron. When the three prelates had admonished him for falling behind schedule, when the cardinal had rebuked him over the quality of his vermilion, when his career and his future in Rome had seemed to be in a state of collapse – just when his expectations were highest – Orazio had not wavered for a single moment.

His footsteps were soundless, muffled by the canvas sheeting which protected the flagstones from dust and paint. The Bishop of Arezzo was right: this Casino was a long way from completion. At the foot of the ladder, exposed to the sand that rained down from the ceiling, lay four porphyry busts of emperors, a number of antique friezes and some large alabaster bowls. From the antechambers, at both ends of the loggia, could be heard the hammering of the stone-cutters as they squared the marble for cladding the walls.

'I have been left a widower with a daughter and three boys,' Orazio continued, shouting to be heard against the din.

Imperceptibly, he was driving the three prelates in the direction of the enclosure he had set up in the middle of the room, situated as far as possible from the pounding of the hammers. It was a makeshift studio, partitioned off with a length of canvas. This canvas, reaching just above eye level, was hooked on to four easels whose shape could be made out through the stretched contours of the cloth.

'A widower,' he repeated, 'with a daughter . . .' He lifted the canvas aside and stood back to make way. 'If Your Eminence will be so good as to allow me – a daughter whom I have the honour of introducing to him.'

Holding her palette and brushes, Artemisia stood in front of an easel and a blank canvas, as if taken by surprise while busy at work. Orazio had staged the whole scene. Its choreography had a number of advantages, including that of isolating the prelates from other petitioners, notably Agostino Tassi's faction, which would not fail to put in a swift appearance as soon as some spy of Cigoli announced the presence of Scipione Borghese at the Casino of the Muses. Above all, Orazio dreaded the intervention of Filippo Franchini, Agostino's former apprentice, the husband of his sister-in-law Costanza, who was now in charge of his site. Fortunately, Filippo had neither audacity nor intelligence; he would not go so far as to speak in favour of his master while Artemisia was in the enclosure.

On the arrival of the cardinal-nephew, Artemisia retreated behind her father, her lips quivering with emotion. In the few seconds of silence that followed, she was so overwhelmed by distress that, in order to disguise her

agitation, she focused on the familiar face of Giovan Battista Stiattesi. He did not return her gaze. Similarly affected, he was watching Scipione Borghese.

Stiattesi had waited with her and had seen her growing anxiety as Orazio and the prelates made each of their stops on the scaffolding.

Blushing, she made to set down her work tools on one of the trestles cluttered with pencils and pots of paint. But this was the moment Orazio chose to turn to her and take her by the hand; she dropped the palette and the brush.

He led her over to the cardinal, who held out his ring to be kissed. She made the slight curtsy which was meant to show off her breast with the chain and the mask, but forgot to take the hand being proffered.

Stiattesi, who did not miss the smallest detail, saw what Orazio did not see: preoccupied with the progress of the work, the cardinal had appeared scarcely to notice the tableau vivant which his painter had contrived for him. But others had observed with interest the beauty of this allegorical vision.

'With the help and grace of God, Your Eminence, I brought up this daughter to be a painter. In three years she has worked so hard and learned so much that I venture to state she has no like in this world. She produces works of such quality that the best artists in our profession may well fail to match her. I shall let Your Eminence judge for yourself . . .'

At these words, Stiattesi, standing between the two paintings as planned, unveiled with a flourish the *Susanna* and the *Judith*.

The three prelates approached with interest.

'Astonishing!' murmured the cardinal-nephew as he leaned over the naked body of Susanna. 'Are you the author of this painting, Signorina?'

'With the help of God . . .' Artemisia stammered. 'And my father.' Once more, she could feel her lips quivering.

'Before starting work,' Orazio interjected, 'my daughter commends herself to the Madonna. She asks her blessing for success. I venture to say that what my daughter has achieved has been through the inspiration of the Virgin.'

'Take care, Signor Gentileschi,' said the cardinal laughing, 'with that kind of backing, the pupil could easily outstrip the master!' Scipione Borghese straightened up and moved from the *Susanna* to the *Judith*. 'Yes,' he repeated, lost in thought, 'the pupil could easily outstrip the master . . .'

'In a gamble of this nature,' Orazio retorted sombrely, 'in certain circumstances, the loser wins. With a mixture of praise and criticism, I have educated my daughter to enter into competition against me.'

'Against you?'

'Against me, Your Eminence, or with herself, which comes down to the same thing.'

'What do you have to say to this, Monsignori?' asked the cardinal, turning to his advisers.

'A woman painter is something out of the ordinary, Your Eminence,' allowed the Bishop of Arezzo.

'And you, Monsignor Canon?'

The young Lelio Guidicciono bowed. 'Its rarity makes the thing the more prized.'

'Do we have any female academicians at the Academy of San Luca?'

'Yes, Your Eminence, three female academicians, but they do not attend the sessions.'

Bemused, the cardinal had returned to the two paintings. He inspected them without a word. His connoisseur's eye shifted from the draperies to the flesh, from the details to the whole.

'Are you quite sure, Signor Gentileschi,' he asked severely, 'are you quite sure that it was your daughter who painted these two canvases?'

'What does Your Eminence mean?'

'That I recognise your hand, sir! This is your design, your composition, your light – and your brush strokes!'

Orazio did not turn a hair.

'Let Your Eminence honour my daughter by asking her to do something. She has everything here at her disposal to draw – or to paint – what Your Eminence desires.'

A smile of satisfaction appeared under Scipione Borghese's moustache. His retinue of two spoke together in an undertone. The Bishop of Arezzo, knowing how the cardinal's time was allotted, gave him a reminder: 'Time is getting on, Your Eminence. Cardinal Serra is waiting for us at the Pauline Chapel. He has to submit the marble for the busts commissioned by His Holiness.'

Sensing the urgency of the situation, Artemisia forgot her fear and intervened.

'What does Your Eminence desire? A male or a female head? Young or old? Happy or sad?'

'What is this, Signorina, you can speak too?' the young canon quipped. 'Have you forgotten that the allegory of painting must be mute? She is seen

wearing a chain and a mask like these – but in particular she wears a big gag on her mouth.'

The cardinal smiled. At last he looked at Artemisia and grasped Orazio Gentileschi's message in the young woman's manner of dress. He was fond of diversion and this situation amused him.

'Make us another Judith then. In this picture you show us the Queen of Bethulia after she has decapitated Holofernes. Show us the moment when she cuts off his head.'

The cardinal's choice of subject was not a casual one: Caravaggio had handled it with magisterial violence in a painting which belonged to a banker. The cardinal wanted that canvas. But the banker had taken rapid steps to have it removed to a secret place, making plunder a difficult task.

Artemisia was deep in thought. Fear contorted Orazio's features. He had not imagined that the cardinal would go this far. A *Judith*! Artemisia would never be able to devise a composition of such complexity in just a few minutes – and before an audience! Her drawing was weak, and the teacher he had intended for her had distracted her with other activities. What madness to have exposed her so openly. She wasn't ready. She would never be ready! Did he dread this failure? Or did he wish for it?

Artemisia began sketching with her brush straight on to the canvas. Orazio followed every stroke.

In the foreground, at the centre of the canvas, Artemisia traced in brown paint the oval shape of the tyrant's head. From there, two diagonals fanned out towards the edge of the picture: Judith's arms. She sketched a face.

The hairs of the brush squeaked against the weft of the canvas.

Time seemed to stand still.

The prelates had sat down behind her, in the ample armchairs of Cordoba leather. They chatted together quietly, so as not to disturb her. Orazio stood near the easel, spellbound by his daughter's movements.

At the top of the picture, Artemisia outlined a third face, that of the servant Abra. This figure was bent over Holofernes, bearing down with all her weight upon the faintly sketched body of the man.

Without a sound, Scipione Borghese got up to stand behind her. His advisers saw him shake his head.

'Amazing!'

Artemisia stiffened. Her hand remained suspended. She did not know whether to go on. She looked enquiringly at her father, but Orazio's eyes were

riveted on the drawing and he left her without an answer. His face showed neither satisfaction nor displeasure. Nothing.

'A fine talent, Your Eminence,' the Bishop of Arezzo pronounced, having got up in his turn.

'And what do you have to say, Monsignor Canon Guidiccione?'

'Before a mediocre work, Michelangelo would say, "A good man did it, it hurts no one." Here, I should exclaim as he did before a fine master, "This was done by a great rascal or a great scoundrel!"'

Artemisia turned to face the prelates' judgement.

As an onlooker, Orazio discovered a new woman. She was surrendering to the intoxication of success. He himself had experienced this headiness and recognised all the symptoms: the fevered eyes, the parted lips and the smile of triumph that seemed to hover between the eyes and the mouth. There was something cruel and terrible in Artemisia Gentileschi's expression.

'This violence,' remarked the cardinal, 'might well displease at first glance. But if you turn away from it, it calls you back. You have a great strength in you, Signorina.'

'Exactly, Your Eminence, a strength,' interrupted Orazio, quick to take his cue, 'a violence. Your Eminence is not ignorant of the fact that two years ago there arrived in the city a certain Agostino Tassi, painter to the late Grand Duke Ferdinand. We quickly became great friends. When he was accused of carnal relations with his sister-in-law, I was the one who intervened to have him released from prison. I venture to say that it was at my entreaty that Your Eminence was kind enough to sign his pardon . . .'

In the corner, Giovan Battista Stiattesi listened to the story whose details he knew all too well. Orazio Gentileschi's ease astounded him. Seeing him moving back and forth, speechifying before such an audience, Stiattesi wondered how he, a humble notary, would ever be able to rub shoulders with the powerful of this world. A painter! What other profession would enable a man to rise so quickly? So high?

In his black doublet and his lace cuffs, Orazio could be deceptive. The distance between the artist and the canon did not seem so great. Would such heights also be within reach of Stiattesi's younger brother, who had stayed behind in Florence to undertake a career in the arts? Would he be able to introduce his children to the most powerful man in Rome, as Orazio Gentileschi had just had the privilege of doing?

It was at this moment that the idea of uniting the fate of the obscure Stiattesi family with the Gentileschi line entered the notary's mind.

'To repay me,' Orazio went on, 'Tassi sought to meet my daughter and, having seen her, insinuated himself into my house. With fine words, he tried to persuade her to respond to his love. He told her that he was much beloved by His Serene Highness of Tuscany, that he would introduce her to the Grand Duke, that he would see to it that her canvases were bought through the mediation of the secretary of the Grand Duchess, a man who, from what I have been told, Your Eminence, begs your favour for this scoundrel. If this rumour is really true, I implore Your Eminence to command that justice be done! Because when you saw the work of my poor daughter – unique in the world of our profession – Your Lordship took the real measure of what harm has been caused to me under cover of friendship by this most depraved of human beings. After he made his proposals to my daughter, and she rejected him, he had knowledge of her by force, deflowering her after a resistance of six or seven hours.'

To stress his point, Orazio was exaggerating the details. Had he wished to punish his daughter for her success, he could not have done a better job of exhibiting her shame. Artemisia's head drooped. She could no longer look these men in the eye, for all their admiration and their praise for her work. She felt as if her forehead were branded, like that of an adulterous woman.

'Having eventually succeeded in his vile purpose, Agostino Tassi made her a promise of marriage. For a whole year he abused her, repeating his promise, until the day when she discovered that the scoundrel was already married. Your Eminence should be told that Agostino Tassi's three sisters are prostitutes in Rome. That his wife too is a harlot. And his sister-in-law, whom he enjoys, is a slut. Moreover, one of his brothers has been hanged and the other is presently banished from the Papal States for having acted as a procurer in a case of sodomy. That he himself has been tried in Genoa, Pisa, Livorno, Naples, Lucca and here in Rome itself, for incest and other obscene crimes, as Your Eminence will be able to see for himself in the proceedings of the Roman tribunals which I will supply to him. For my own part, let me merely present Your Eminence with this modest drawing, from which Your Eminence can judge my daughter's merit and the price that can be set upon the murder of my good name.'

The prelate listened to this speech impassively. He remained silent for a few moments. Then, in an offhand manner, as if he had heard nothing, he said, 'I

beg you to make things up with Agostino Tassi. If you wish to do me a service, you will forget your anger and you will both be reconciled.'

Orazio looked nonplussed.

'But, Monsignor . . . What about my daughter?'

'Agostino Tassi shall marry your daughter. I shall make it my business.'

'He made a promise of marriage to my daughter in the knowledge that he could not keep it; may I remind Your Eminence that he has a wife.'

'Good gracious! Then he will be the one to give your daughter a dowry.'

'May lightning strike me if I lie, Agostino Tassi will never acknowledge his crime, Your Eminence. If you say that this knave is to give her a dowry as his punishment, then I am dead, the honour of my name is lost!'

'Do you mock me? You know that I have ways and means of dealing with such villains. He will give her a dowry, I tell you, and a handsome one. We shall then find a husband for this signorina, your daughter, a good painter who will continue that education begun so well under her father's tutelage. I wish you to develop your exceptional talents in a husband's studio, Signorina. *Ut pictura matrimonium*. Unless you make a sacrifice of your talent for the sake of your special devotion to the Virgin . . .' he said with a little smile, 'By choosing the convent for your greater glory and that of Our Lord.'

'My glory would be to go on working for you and to please you, Your Eminence.'

She had raised her head and her eyes flashed: once again her fate was being placed in the hands of Agostino Tassi.

'Under your protection, my father and I aspire to join the ranks of those artists who should never die. Just as there are others', she added sombrely, 'who ought never to have been born!'

With his characteristic good humour, the cardinal intoned the Latin phrase pronounced by his uncle, a maxim of Paul V which was repeated in artistic circles: '*Pictoribus atque Poetis omnia licent*' (To painters and poets all is allowed) – and with these fine words he concluded the interview, having promised nothing.

But one member of the group had been moved by the vision of Artemisia Gentileschi. In the eyes of Canon Lelio Guidicciono, Agostino Tassi's fate was sealed.

21

The Gentileschi Household and the
Corte Savella Prison

August to November 1612

'Good news, Signor Orazio: Canon Guidicciono has agreed to give Artemisia a dowry,' exclaimed Giovan Battista Stiattesi, collapsing on to a chair. The notary's exhaustion was an act, but a gleam of triumph lit up his eyes: 'On her marriage, she is to have four hundred scudi. He is making this sacrifice on the altar of talent out of his own pocket.'

Orazio seemed unimpressed by these latest negotiations of Stiattesi's. Was he irritated by Artemisia's easy success with the cardinal's advisers? Four hundred scudi. It was almost as much as he had earned for all of his work on the loggia!

'Who would want her, even with four hundred scudi?'

With four hundred scudi, everyone, thought Stiattesi, keeping these tactless words to himself.

'I suppose,' mused Gentileschi, 'that a dowry of four hundred scudi would be accepted at the poor Clares' convent.'

'With all due respect, Signorina Artemisia seems little suited to a convent.'

'All that suits Artemisia is obedience to me.'

'Then make her take a husband, and be quick about it,' Stiattesi insisted, with unaccustomed bluntness. 'Do you think any convent will ever be able to protect her from Agostino's reprisals? Do you think he won't want revenge after spending all these months in prison because of her? When he comes out, he'll kill her.'

'Much good may it do either of them. If this scoundrel takes a new crime

upon his head, I shall take it upon myself to see a noose around it.'

'Signor Orazio, be sensible. Allow me to write to my family in Tuscany. I have a brother in Florence — a very upright boy. If I arrange things as I plan, he could accept Artemisia.'

'What interest would he have in doing so?'

The same interest that made you accept your wife Prudenzia Montone from the hands of Cosimo Quorli — yet again, Stiattesi kept his thoughts to himself.

'Nothing is settled,' he said, 'and I doubt whether it will please my family. But for your sake, Signor Gentileschi, since you are my benefactor, I hope only for a good outcome. With Artemisia married, the shame that sullies your good name will be cleansed and honour saved. What is more, the studio would gain another pair of hands. My brother is enrolled in the Florence guild. He is a painter by profession. And, with the rate at which your work is progressing at the moment, you could do with some help.'

After a pause, Orazio replied, 'I shall not see Artemisia married before Agostino is sentenced. The villain could take advantage of that happy conclusion to secure a pardon. Give me his head, Maestro Stiattesi, and you can have my daughter.'

'*Vostra Signora Illustrissima,*' writes Agostino Tassi, on 25 August 1612, to the private secretary of the Grand Duchess of Tuscany, a personage whose influence with the Borghese is feared by Orazio. 'From the depths of my dungeon, I make so bold as to draw the attention of His Most Serene Highness the Grand Duke to . . .'

To his dire circumstances? Will he tell of his days and nights in the prisons of Rome? Of course not. Agostino Tassi knows who he is dealing with. He knows that he will obtain nothing from the powerful by running to them with a tale of woe. But rather by flattering their greed, exciting their covetousness, leading them to believe that he, Agostino Tassi, can serve their passions better than anyone else.

'. . . to seven paintings from the hands of the great German master Elsheimer. I have had the good fortune to discover this extraordinary series representing the *Life of Saint Helen* and the *Miracles of the True Cross*, as well as a *Paradise*, in the possession of a Spaniard of my acquaintance. The owner would be prepared to part with them provided that I take care of the transaction.'

Agostino Tassi is counter-attacking with the same weapons as Orazio

Gentileschi: only art, beauty and painting can give him back his freedom, and win him victory.

It is the Grand Duke's secretary who replies: '*Magnifico Commesso*. If the paintings on copper of which you speak in your last two letters to me, if these seven works by the German painter Elsheimer which you have discovered in the possession of a Spaniard are of the quality you described and have an acceptable price, His Serene Highness would be prepared to acquire them.'

A strange world this, where art lovers maintain a business correspondence with prisoners, as if no walls intervened.

During the month of September, some ten messages travel between the Pitti Palace and Corte Savella, across the 190 miles separating the Florentine court and the dungeons of Rome.

'If we do not act very quickly, Your Highness, the owner of these marvels will offer them to his king,' Agostino urges.

It is a clever threat. To the Grand Duke it is an intolerable thought that Philip III of Spain – as avid a collector as Scipione Borghese – might secure new paintings, that fresh splendours might decorate the walls of his Prado Palace.

The Florentine secretary replies post-haste: 'What you must do is show these seven paintings to our ambassador in Rome, so that he can judge them for himself and convey his impressions to His Most Serene Highness the Grand Duke . . .'

'And how do you expect me to show anything to the esteemed ambassador, if I continue to be locked up? It is eight months now since a rival's abominable jealousy has robbed me of my freedom, and deprived me of His Eminence the Cardinal's appreciation. For eight months this loathsome man has been stealing the scudi that are due to me – but this would be nothing by itself. Above all, he prevents me from serving my master the Grand Duke with the diligence and devotion due to him.'

'Be so good as to send the Spaniard to our ambassador, either to the Palazzo di Firenze or the Villa Medici . . .'

'I fear that if he meets the ambassador, the Spaniard will realise for whom I intend these marvels. Make no mistake: His Most Serene Highness will pay ten times the price that I can have them for. Would it not be wiser and shrewder for the transactions to take place through my mediation and with the maximum discretion?'

The Tuscan ambassador writes from Rome to the Grand Duke, his

master, on 5 October 1612:

'Your Most Serene Highness, In accordance with your request, I went to the house of the Spaniard owning the seven paintings on copper by the distinguished German master Elsheimer. I deemed the price demanded by the Spaniard to be too high. And the paintings to be of a quality too mediocre for inclusion in the sublime collections of the Grand Duke.'

Would this snub spell Agostino's downfall? He might have experienced this decision as a personal failure, but the quality and acuity of his eye were faultless: seven years later, on 4 December 1619, the ambassador revised his opinion by acquiring the series so much praised by Agostino Tassi for a third of its price. The *Life of Saint Helen* by Elsheimer would at last enter the collections of the Grand Duke – but too late for Agostino Tassi's flair to have served his purpose.

This correspondence would, however, make his links with the court at Florence all the firmer.

While Agostino Tassi wove his web and tightened his network of friendships in the shadows, Giovan Battista Stiattesi had a great deal to do by the light of day. There had recently been a dramatic turn of events: in August 1612 Agostino managed to furnish proof of his innocence.

A little while before Scipione Borghese's visit to the Casino of the Muses, a young boy of seventeen or eighteen named Niccolò Bedino had presented himself at the court. He said he had been the servant, apprentice and factotum of Orazio Gentileschi. This was invaluable evidence. For nearly two years, Niccolò had lodged with Orazio; he had eaten every day at the table of the Gentileschi family, and slept in the room adjoining Artemisia's. Two years of hell ...

'For Signora Artemisia had me dashing all over the city with messages for her lovers – love letters summoning them to the house. When it comes to filth, I've seen and heard everything!'

Though Giovan Battista Stiattesi managed to prove without too much difficulty that Artemisia could not have penned 'hundreds of love letters', since she could not write, Niccolò Bedino described the recipients' appearance and where they lived with such exactness that the court remained puzzled.

In September 1612, the law submitted the witness Niccolò Bedino to the ordeal of strappado. With his arms tied behind his back, the young man was hoisted up and left hanging by the hands for more than half an hour. With

his shoulders dislocated, howling with pain, he confirmed his testimony. In juridical terms, Niccolò Bedino's steadfastness was proof that he spoke the truth.

By the beginning of October, the court seemed persuaded: Artemisia Gentileschi was a prostitute. Whether or not Agostino Tassi had raped her did not matter. Tomorrow, Agostino Tassi and the witness Niccolò Bedino would regain their freedom.

But they reckoned without the skeletons in Agostino Tassi's closet. There was his dear sister Olimpia, whom he had had put in jail for attempted murder after she had reported him for incest – and his old friend Valerio Ursino, the painter whom he had graciously lodged for a few months before demanding that he pay an exorbitant rent, then having him arrested and thrown into prison for debt.

Valerio Ursino and Olimpia Bagellis: the two hands of vengeance so dreaded by Cosimo Quorli that he had organised that grand reconciliation dinner at his house on St Catherine's night – exactly one year earlier.

Cosimo had been so convinced of the success of his peace mission that he had continued to receive Olimpia throughout the carnival festivities. She too had 'seen and heard everything'. She was biding her time.

'I know this Niccolò Bedino,' she related in ingratiating tones, having presented herself before the tribunal on the very eve of Agostino's release. 'I have known him ever since I myself placed him with my brother. I do not recall how he was dressed on his arrival, but it was my brother who bought him those clothes in green half-worsted that he wears now. Niccolò Bedino came to work as my brother's servant in August 1610. He could not therefore have been lodged with Orazio Gentileschi during the period that he describes, for in those days my brother did not even know Gentileschi. Nor could Niccolò Bedino have been lodged with Orazio later on, during Lent of 1611, since he was living with my brother and his sister-in-law Costanza while they were cohabiting. The painter Valerio Ursino can testify to this. He will tell you that Niccolò Bedino has never been the servant of Orazio Gentileschi, or his apprentice. Whereas he followed my brother about like a shadow. When my brother moved to a room across the street, Niccolò followed him there and slept in the kitchen. He would have done anything to please him, even sell his soul to the Devil. I too am faithful to my brother. We once quarrelled a little over a money matter, but I have nothing against him.'

'Nor do I have anything against him,' Valerio Ursino was to say, taking

up the account. 'I even went to visit him at Tor di Nona. Niccolò Bedino was there in the prison yard that day. I asked Agostino why he had got the boy to say that he had been in Orazio's service for two years, when everyone knew it wasn't true. Agostino replied that he had asked Niccolò to tell the truth and that it wasn't his doing if the apprentice had lied. At this point, Agostino had a visit from a gentleman and he left me alone with Niccolò. I asked the boy the reason for his false testimony. He replied that Agostino had promised him a large reward if he said that he had lived at Orazio Gentileschi's house in the Via Margutta and at the Via dei Greci, and if he would say that he knew all the degrading things that Artemisia and her corrupt family got up to.'

'It's Bedino's hide we have to have now. If we can manage to prove he is lying, Agostino's whole defence crumbles,' exclaimed Orazio Gentileschi, after Stiattesi had a given him a report of the hearing. For nine months, the judges had relentlessly followed up every possible lead that might reveal the truth. Every day – even on Sundays – they had interrogated the witnesses for the defence and the prosecution. An exemplary trial.

But now, in October 1612, events were moving fast.

Through Stiattesi, Orazio filed suit against Niccolò Bedino for perjury and had him put on trial once more. The court submitted Bedino to torture a second time. He confirmed every word of his statement. He was therefore speaking the truth.

The day after Bedino's ordeal, Orazio and Stiattesi protested against his release. They demanded that Bedino be declared either guilty or innocent of the charge of false testimony which Orazio maintained against him.

Ten days later, Orazio brought an official appeal against the tribunal's bias in favour of Niccolò Bedino, and, accordingly, in favour of Agostino Tassi. He recalled the accounts of Valerio Ursino and Olimpia Bagellis, whom he cited to appear as witnesses again.

On Tuesday 27 November 1612, the tribunal sat deliberating in the little room where the three magistrates had convened daily.

The State prosecutor, the chief of police and the judge presiding over criminal cases had to find a compromise between their private beliefs and the interests of Cardinal Borghese, the court of Tuscany, the city of Rome and Heaven above.

22

The Sentencing of Agostino Tassi at the
Corte Savella Prison

Tuesday 27 November 1612

'Judgement in favour of Agostino Tassi, painter, imprisoned at Corte Savella, for presumed defloration and suborning of witnesses, in the criminal case brought against him by Orazio Gentileschi.'

'The excellent and most illustrious Hieronymus Felicius, judge, sentences him to a choice between five years on the galleys or banishment from Rome.

'If Agostino Tassi should choose exile, he will swear upon the Holy Scriptures not to break this exile under any pretext and never to seek vengeance upon Orazio Gentileschi.

'Should Orazio Gentileschi be persecuted by Agostino Tassi in revenge, the latter will be sentenced to a fine of two hundred scudi.

'Agostino Tassi will be released on this day and taken to the gates of the city.

How strange to pronounce a ruling *in favour* of a condemned man! If we compare this verdict with the wording of other sentences from the period, it is very surprising.

In the proceedings of all Roman trials, judgements are usually pronounced *contro*, against the guilty. Here, the clerk does not demur; he notes: 'Judgement *pro*', for, Agostino Tassi.

Does this formulation convey the court's unease?

In such cases, whenever the guilty man was unable to marry the young woman whom he had dishonoured, it was customary for him to be sentenced

to pay her dowry to the family, a sum so substantial that a lifelong debt could ensue. Why does the court here make no reference to this financial reparation? Was the need to make a hole in Agostino Tassi's purse rendered superfluous by the intervention of Canon Lelio Guidicciono and the four hundred scudi which he was giving to Artemisia?

Or was it rather that the tribunal had taken care to hand the painter a sentence which would be a moderate punishment? Who was to say that once released Agostino Tassi would ever leave the Holy City? If the power of his protectors did not place him beyond the law, it did perhaps place him beyond its application. In Rome he could take up residence in any of the properties of the Grand Duke of Tuscany, for instance at the Palazzo di Firenze, or at the Villa Medici.

The verdict did indeed betray the ambivalence of the judges. It would be reformulated on the following day, 28 November; this new sentence no longer mentioned the galleys, nor the fine of two hundred scudi, nor even the possibility of reprisals against Orazio Gentileschi. And though the sentence was confirmed, it was now limited in duration – to only five years of exile.

For five years, Agostino Tassi would be unable to work on any site in the Eternal City. He might well remain within the Holy See, safe inside embassy walls, but his career, his meteoric rise in the Roman firmament, had been stopped short.

In a rage, Agostino let loose a threat, a curse intended to sow discord among the victors:

Gentileschi may do his worst, but the time will come when he will have a great need to see his daughter and when she will look at him with pitying eyes: this will be God's will for the unceasing impieties which he has always inflicted upon her.

For now, however, Agostino Tassi's sentence proclaimed Artemisia's innocence to the world and restored the whole family's honour. Orazio regained his pride. Artemisia her dignity.

It was a triumph for both father and daughter.

Forty-eight hours later, two altar boys – Orazio Gentileschi's sons – were serving a nuptial Mass in the Vatican district.

23

Church of Santo Spirito in Sassia

Thursday 29 November 1612

'*Petrus Antonius Vincentis Stiattesi florentinus* . . . Pierantonio, son of Vincenzo Stiattesi, Florentine . . .'

Standing beneath the organ in his parish church of Santo Spirito, Orazio Gentileschi brought to mind the last two years of his life. Each memory provoked in him such pain that he stooped, as if the suffering were forcing him to gather up his thoughts. *I have spent my days educating my daughter in the most noble of arts, I have raised her up to the level of the greatest masters . . .*

The event which Orazio had dreaded was taking place before his very eyes. He witnessed it from a distance, powerless.

I have sacrificed everything for her, my reputation, my honour. I have bequeathed everything to her, my knowledge and my repute.

'*Matrimonium contracterat per verba et praesensis in eadem chiesa cum Artemitia filia di Dominus Horatius* . . . will contract marriage, in this church, in person, and in the presence of witnesses, with Artemisia, daughter of Signor Orazio.'

I gave her my life – for this.

Orazio could see her from the back, in her watered-silk gown which trailed on the altar steps. She had put her right hand in the right hand of the man imposed by circumstances. Each raised their left hand, palms open towards the tabernacle in a sign of affirmation.

So much suffering just for this. Pierantonio Stiattesi. A good for nothing, a blackguard up to his ears in debt – another Agostino Tassi.

Orazio had taken his measure at first glance. The velvet doublet, the feathered cap: Pierantonio was too fond of diversion, too fond of gambling,

too fond of women. But that was only the start. When he received him in his studio, Orazio Gentileschi had the impression that the boy was uninterested in painting, at least in the way that he understood it. Orazio came to the conclusion that Pierantonio Stiattesi belonged to the lowest type in the profession, to that herd of *garzoni* who did not give a fig for art. There were hundreds like him in Rome. *All this fop has of the painter are the tools, and he still doesn't know how to use them. He will never be an artist. He will remain what he was born to be: a craftsman − a third-rate little craftsman.*

For the first time in a great many years, Orazio thought about his father; he could see the old goldsmith at work on the chasing of a bowl. Then he thought about his brother, perched on a scaffold, painting the ceiling of the cathedral in Pisa. He thought too about himself, and how he had left his mark on all the immortal places in Rome.

So much striving, so many dreams, to end up with my daughter allied to mediocrity. My name and my whole line consigned to obscurity.

The outcome of the trial notwithstanding, Gentileschi could no longer go about publicly in the artists' district. Agostino Tassi's banishment had caused outrage. The judges had an accurate knowledge of human nature when they had foreseen the likelihood of revenge being taken against Orazio. If the condemned man's faction were to learn what manner of ceremony was taking place at this moment in the third chapel of Santo Spirito in Sassia, God alone knew how they would react. The banns had been published, in keeping with the new rulings laid down by the Council of Trent, but once only − rather than three times − thanks to the intervention of Canon Lelio Guidicciono. His presence as a witness, to the left of the bride, gave weight and solemnity to the ceremony. Nonetheless, Artemisia did not wear the wreath of flowers customary in Roman ritual, and the altar was not decorated. There were no women at prayer in the sparse congregation. Not a single female presence to arrange her dress with any care upon the altar steps. Even the devout churchgoers who came here regularly were denied entry to Santo Spirito. Contrary to all usual practice, the doors had been closed after vespers, for fear that an armed band might burst in.

Except for this little chapel which blazed with light like a torch in the dark, the whole church was dark. Orazio Gentileschi was having his daughter married at night, in secret. And in spite of himself.

What wiles had Giovan Battista Stiattesi used to extract Orazio's consent? In the heat of their final moves against Agostino, and in the later headiness of

victory, the notary had contrived to have Orazio sign a contract which he could not cancel thereafter. By what means?

The final decision was Artemisia's. At this stage, she alone held the power to accept or refuse the husband being imposed on her.

On this point, the Council of Trent was unequivocal; it had dedicated its twenty-fourth session to marriage. No one could receive the seventh sacrament under coercion. Along with monogamy and indissolubility, the free consent of the spouses became an indispensable condition of the marriage vows.

A few moments from now, Artemisia Gentileschi would commit herself. And, for the first time in her life, she would commit herself freely.

Refuse him! Refuse him, or else disappear from my life! cried Orazio inwardly.

The thought of her belonging to another man – coming to love another man – caused him physical pain verging on nausea. *Refuse or else get out of my sight.* He could accept losing her, provided that she went away. Orazio Gentileschi would no longer have a daughter. Artemisia would cease to exist. *Yes, provided that she goes, that she leaves Rome, that her life comes to an end for me.*

The old painter had a lump in his throat. Tomorrow, Artemisia's husband would take her with him to his native city. She would live far away, in Florence. It was Orazio who had decided this. But was it really his decision? Or Pierantonio Stiattesi's? Who was taking Artemisia to Tuscany, to Agostino Tassi's stronghold? A succession of ideas and arguments jostled and contradicted one another in Orazio's mind. He tried in vain to think logically. Artemisia was leaving for Florence – as Agostino had always promised her. Victory had a bitter taste. Would Agostino also choose Florence as his exile? Would the sentence be applied? Would Agostino ever leave Rome?

Gentileschi returned incessantly to this thought: why had he given his consent to the wedding of Artemisia and Pierantonio?

For a second time, Orazio was losing the woman he loved: he no longer knew whether she was his wife or his daughter.

But if you leave me, Artemisia, you deny yourself. I have turned you into such a great painter that no master can match you.

Today he felt the true weight of the words that he had spoken for effect before the cardinal.

Refuse him and stay in Rome with me, or else we can run away together. If Rome is too much for you, we can go to Genoa, or Turin, or Venice. Together, there is no limit to what we can do. With that idiot who doesn't know how to hold a brush, you'll spoil your precious gifts. With me, you will fulfil yourself. He wants the money that your talent –

my genius — will bring him. If you follow him, it's all over for your art, you'll go back to being a pitiful nonentity.

With lowered head, Artemisia stole sidelong looks at the husband whom Providence had granted her. She had met him for the first time that afternoon. Fortunately, he was young, handsome, a good man.

Born on 16 January 1584, Pierantonio was now twenty-eight. A scant ten years older than her. Was it from his father, Vincenzo Stiattesi, a tailor in the Via del Compaccio, or his uncles, also tailors, that he had inherited his taste for fine cloth? As Orazio had bitterly noted, Pierantonio resembled Agostino in his fastidious appearance. Both were elegant men. Pierantonio had his elder brother's height and slenderness, but instead of Giovan Battista's unctuous manner, his was gentle and pleasant.

He too had had a surprise when he set eyes on Artemisia. He had not expected her to be so beautiful. This dishonoured girl whom he took for her dowry, this wife who would settle his debts, bore no resemblance to the way he had imagined her. Struck by her majestic bearing and her sensuality, as his brother Giovan Battista had been, he treated her with the same kind of faintly fearful reverence.

Don't trust him, Orazio warned her mentally. *He shows you respect today, but he will soon have contempt for you. Your three brothers and I could easily have killed you for what you did to us. Why do you think he accepts you, deflowered by another man? Because you are his final card before ruination, before the debtors' prison, before God knows what other calamity. When he has no further use for you, he'll throw you out. It's one thing to discover his misfortune in the secrecy of the bedroom on your wedding night, but all of Rome, all Florence knows that Agostino had you, and all of Italy will laugh behind his back. Don't trust him. In spite of your dowry, you have nothing to make you a good wife, and he'll see that before long. A virtuous woman should know how to weave and spin, to sew and cook — whereas you could not even keep house for your father! Nature did not make those of your sex for study or for art. And you know so much more than your husband does of his profession, much more than any man . . .*

Facing the altar, Artemisia stood lost in contemplation of the big wooden crucifix which rose up in front of her, a Jesus so pale and white against the black marble. Her emotions half-way between terror and joy, she directed her thoughts to that suffering face:

'Grant us, Lord, Your peace and Your help. Grant us love . . .'

No, Artemisia, you cannot have everything, Orazio thought to himself. *You cannot have happiness in this life and immortality for all time to come. You have to choose.*

'Lord, give me strength to feel only as my husband feels. Grant me the grace to be cheerful when he is cheerful . . .' Artemisia fixed imploring eyes on the crucifix; the Christ's drooping face seemed to be listening. 'And when he is sad, make me sad too.'

The priest was saying, 'They will be as one flesh . . .'

Choose, Artemisia. Choose between shabbiness and greatness, between oblivion and eternity, between him and me.

In a hush so total that the dripping candlewax was audible, Artemisia could not hear her father's cries.

Ever since the ruling which sentenced Agostino, and the publication of the banns which meant her betrothal to Pierantonio, Artemisia's state of mind had been fitful and erratic. Her heart drifted vacantly, remote from hope and anxiety alike. She had experienced none of the anticipated headiness of revenge – but had felt stunned, astounded in a way that left her both empty of sensation and as if invaded by a presence she had difficulty recognising. A person who had been lost for a long time. This strange rediscovery of herself was disconcerting. A bride! Today she was getting what she had always wanted. And this wish-come-true reinforced the sensation of reconciliation, of inner harmony.

Aside from this, she did not think ahead. Especially not about the life that awaited her with the man who stood at her side. All she felt for him was enormous gratitude, an infinite sense of obligation.

She repeated after the priest: 'Pierantonio, will you take me?'

'Yes. Artemisia, will you take me?'

'No!'

Orazio's grief-stricken plea reverberated around the choir. He saw her waver. Disconcerted, the priest shot a questioning look at Canon Lelio Guidicciono and asked the witnesses: 'Is there any impediment to the marriage?' He addressed Artemisia: 'Have you bound yourself by any other ties?'

She seemed to falter. Then she turned round. She sought out her father in the shadow. His tiny dark figure seemed crushed as he stood under the mass of the organ. He staggered towards her down the aisle.

'Remember,' he stammered, 'I have always been right. If you had heeded me, if you had let me do as I thought best . . .'

'Father . . .' She fell to her knees. 'Father,' she murmured, 'give me your blessing.'

Giovan Battista, Artemisia's three brothers, the priest and the bridegroom all saw Orazio's face collapse. His features – his brow, his mouth, his eyes – seemed to dissolve. The mask was falling.

He made one final effort, attempting to pull her to her feet. But his arm dropped, lifeless, and he lost his balance. He tried to speak, but his lips trembled and he could not utter a word. All he could do in this state of emotion was bend over her. So he stayed there, stooping forward, as if frozen.

Artemisia had raised her face. She implored him; her gentleness and tenderness, her compassion were infinite. Orazio's distress became so profound that he could no longer keep it at bay. He let his head collapse on his chest and wept.

For a moment he had a vision of Artemisia as Mary Magdalene, the woman whose love he had striven so often to depict in his paintings, cast at the feet of the Lord. Magdalene promising like Job, to stay, even after Christ has blessed her. And Jesus gave the Magdalene his blessing, and she did not leave him.

But already the image of the saint gave way to another memory. Stooping over this woman, Orazio felt the weight of the child he once carried, the weight of that little girl in his arms. Artemisia. Flesh of his flesh. She had taken his hand and now hung from it, leaning all her weight against him, like the child she once was. Her warmth enveloped and filled him. This was the child he had tried to mould into an image, an idea, an allegory of painting – an extension of himself and of his ambititon.

The daughter whom he had masked and dressed in different guises, now stripped away the symbols with which he had bedecked her. At his feet she became again a being of flesh and blood, a woman who was free and alive. Long-distant words came back to his mind and gave their full force to the feeling of union and peace which swept over him.

Carefully, he disengaged his arm from his child's grip.

'Love's bonds are strong only if there is no wish to break them,' he whispered in her ear, as if to reassure her.

Their entwined silhouettes stood out against the burning candles. But it was they, Orazio and Artemisia, who appeared to blaze in the darkness.

He laid his hand upon his daughter's head.

'Love knows no bounds. It follows the precepts of desire. Its rapture is its law . . .' Orazio's voice broke. 'Its excesses are its measure.'

His final words were stifled by sobs.

'In the name of the Father,' hurriedly, he completed the sign of the cross, 'I give you my blessing.'

On 13 December 1612, Artemisia Stiattesi set out for Florence. With her, rolled up in one of the saddlebags slung across her mule, she took the canvas which she had begun as a rough drawing in front of Cardinal Borghese. She left her father behind in Rome. They would live apart for twenty-five years. And every hour of their separation would bind them more desperately to one another.

With her head held high, and a husband on her arm, Artemisia advanced towards the city of the Medicis.

BOOK TWO
EXCESS WAS THEIR
MEASURE

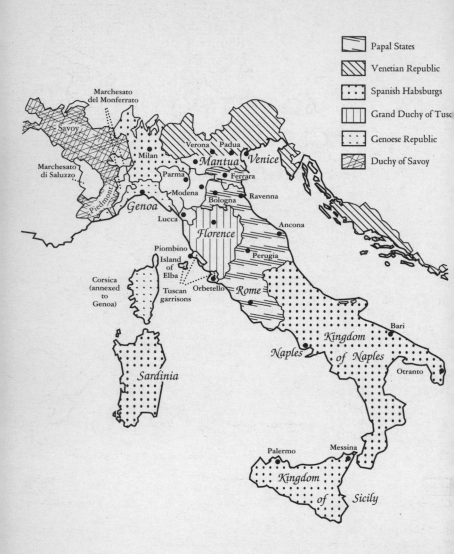

The Italian States in 1625

Legend:
- Papal States
- Venetian Republic
- Spanish Habsburgs
- Grand Duchy of Tusc[any]
- Genoese Republic
- Duchy of Savoy

Marchesato del Monferrato

Savoy

Marchesato di Saluzzo

Piedmont

Milan

Verona

Padua

Mantua

Venice

Parma

Ferrara

Modena

Bologna

Ravenna

Genoa

Lucca

Ancona

Florence

Piombino

Island of Elba

Perugia

Corsica (annexed to Genoa)

Tuscan garrisons

Orbetello

Rome

Bari

Naples

Kingdom of Naples

Otranto

Sardinia

Palermo

Messina

Kingdom

of

Sicily

Europe in Artemisia Gentileschi's Day

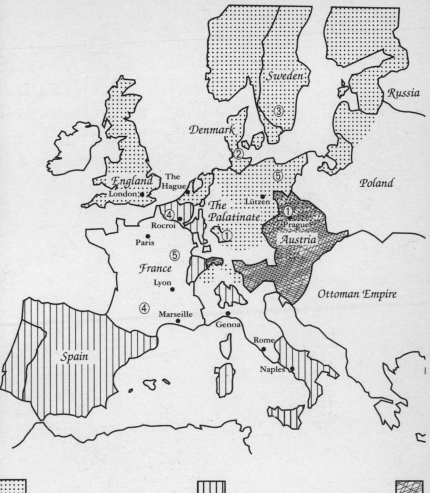

Countries with a Protestant Majority Spanish Habsburgs Austrian Habsburgs

①	1620–1623	: Defeat of the Czechs and the Elector Palatine
②	1625–1629	: Intervention and defeat of King Christian IV of Denmark
③	1630–1632	: Intervention of King Gustav Adolf of Sweden
④	1635	: Intervention by France against Spain and the Emperor
	1642	: Occupation of Roussillon
	1643	: French victory at Rocroi
⑤	1645–1648	: Campaign in Germany by Turenne and the Swedes

PART III
HOLOFERNES

Florence in Galileo's Day

1613—1620

24

The Pitti Palace

17 February 1615

When Artemisia's husband, the painter Pierantonio Stiattesi, climbed the ramp leading to the great mass of the Pitti Palace, guests were arriving in their hundreds. Against the smoky sky of this carnival night, the building seemed to be on fire. Thousands of small torches set into invisible supports framed every window, door and balcony. This incandescent trellising cascaded all the way down to the ground, encrusting the huge masonry blocks of the ground floor, forming a setting for every single stone of the building. A red-gold blaze, with the flames appearing to dance on a golden platter, with light and shadow fashioning solid matter into a precious casket.

Behind Pierantonio, the night reverberated with the commotion of the crowds, the shouts of coachmen, the sound of horses' hooves, the rattle of metal-ringed wheels scraping the flagstones all the way to the Arno. The whole district was choked with traffic. There was no way through on foot, either over the Ponte Vecchio or the Ponte della Trinità. The performance began at nine o'clock in the palace's Sala della Commedia. But in the streets of Florence, the interminable procession of nobility, upper bourgeoisie and the entire Medici administration had begun at nightfall. And in February, night fell early.

For the last fifteen years, since the wedding of Marie de' Medici – niece of the Grand Duke Ferdinand – to Henri IV of France, Florence had seen a succession of festivities unparalleled in their magnificence. Weddings, christenings and funerals were all a pretext for processions and parades, spectacles and shows. Every year, during carnival, there were vast open-air performances – re-enactments of naval battles on the Arno, jousting in the

medieval tradition, Roman chariot races in the piazza in front of Santa Maria Novella. Both the populace and the aristocracy took part in these staged events. The Grand Duke played *calcio* – football – and his gentleman paraded about in the chariots.

Unlike the papal court, this was a court of very young people. Cosimo II, who had reigned for six years, was twenty-five, scarcely past his majority. With his whole gang of brothers and sisters – Eleonora, twenty-four; Caterina, twenty-two; Francesco, twenty-one; Carlo, nineteen; Lorenzo, eighteen – his only wish was for amusement. Also unlike Rome, Florence was dominated by women: the Grand Duke's mother, Christine de Lorraine, and his wife, Marie-Madeleine of Habsburg, both had influential roles. They were rivals, and for all their piety – one might say sanctimoniousness – both were inordinately fond of luxury and entertainment. The great antechambers of their apartments were filled with dwarves, dogs, monkeys and jesters dressed in monogrammed livery. The numerous ladies of their retinue walked up and down in puffed and fragrantly powdered farthingales in front of the huge mirrors in the galleries.

Here, gems adorned not just bishops' mitres and croziers. Nor were art and science discussed only in the colleges of cardinals. Venetian lace and Baghdad silks rustled on the carpets with feminine susurrations, pearls of the Orient perambulated on amply uplifted bosoms. Less than two hundred miles apart, Rome and Florence were different states, different worlds.

While the sovereign pontiffs sought to extend the power of the Church – to establish it throughout the world for all eternity – and Pope Paul V laboured to enrich his family during the limited period of his papacy, the house of Medici had been slumbering in an illusory security for most of its century-long reign. At the start of the seventeenth century, no political project stirred the city or enlivened the court at Florence.

The extreme cohesion of Florentine society enabled each and every sphere in it to feel a direct connection with its past. The people accepted the yoke of an oligarchy which alleged to bring it peace, to share in its joys and sorrows, and which treated it to countless entertainments as the seasons came and went. As for the nobility, they had ceased to be concerned with the issue of their early history and lineage. But in the cultivation of the arts, the quest for elegance – with refinement taken to its furthest extremes – in the adventurous pursuit of intellectual curiosity and aesthetic boldness, Florence lived up to its past.

The present merely repeated the forms of a now well-established tradition; it followed the norms and canons of a Renaissance heritage. A legacy so rich and glorious that it was inexhaustible.

As for the future, Cosimo II gave it so little thought that his first action on inheriting the Duchy from his father had been to close down the Medici banks and their foreign branches. Trade was unworthy of a state allied to Europe's reigning families, unworthy of a sovereign who was the King of Spain's brother-in-law and a cousin of the Queen of France. A fatal error. During the carnival of 1615, Florence witnessed the spectacle of a culture at its pinnacle. But this was its final blaze of glory. Its singers would offer up their swansong, and within ten years all would be consumed.

The line of carriages went as far back as the Santa Maria Novella district. Inside the low-slung, square-shaped vehicles, between the open curtains, the bosoms of masked ladies on their way to court were exposed to the eyes of the populace. Their broad white collars of fluted lace, their turned-back cuffs and the large handkerchiefs they held in their hands shone with a harder light than all the gems adorning their coiffures. The men accompanied them on foot and conversed with them, a gloved hand resting carelessly upon the carriage door. Their sombre figures were exaggerated by voluminous slashed sleeves and puffed knee-breeches like petticoats. The ruffs that forced them to hold their heads erect shed a dazzling light over their faces.

It would soon be time for the curtain to rise. The constables had closed off the four bridges to the gawking crowds. It had taken Pierantonio less than ten minutes to walk to the Pitti Palace from the humble dwelling which he shared with his sisters and brothers-in-law on the other bank of the Arno. He had only had to show the small porcelain plaque which he carried in the warm palm of his hand to break through all the barriers. As he walked along he had run his fingers over the six balls of the Medici coat of arms marked in relief on one side of the plaque, and his name engraved on the other: *Illustrissimo Signore Pierantonio Stiattesi*. This little porcelain plaque with its edging of gold was his invitation card, and it bore the number of his seat in the hall where entertainments were staged. What miracle had brought this tailor's son to a ballet, as a guest of the Grand Duke?

As Pierantonio entered the courtyard, he could hear the sound of lutes, theorbos, harps and harpsichords which were being tuned somewhere in the drawing-rooms. And descending from the Boboli Gardens, the trilling of

women's voices – the singers warming up at the foot of the illuminated statues, in the groves of Diana and beside the basins of Neptune.

Among the equipages parked willy-nilly in the courtyard, strange animals wandered about – cats and little poodles clad in mink coats, which the ladies would later take on to their knees to use as muffs.

Making no attempt to follow the crowd, Pierantonio vanished through a low door in the west wing. He knew how to reach the grand hall as he often came this way when escorting his wife to and from the palace.

They had been married for nearly three years. To their mutual amazement, married life had turned out to be a miracle of happiness. They never quarrelled. No disappointment had yet tarnished their joy. God seemed to be watching over it. Ten months after their union, a son was born. By common agreement, they had baptised him with the name of the man who had sealed their destiny. Giovan Battista, 'Giovan Battista Stiattesi'. Or perhaps Artemisia had wanted to give her first child the same name as her brothers who had died at an early age, the two little Giovan Battista Gentileschis buried at Santa Maria del Popolo. And wasn't 'Giovan Battista' also the name of her grandfather, the Goldsmith Giovan Battista Lomi?

Now she was expecting a second baby: another son, Pierantonio had no doubt of it.

Motherhood had calmed and softened her. She had melted into the solid old family of Stiattesi craftsmen as smoothly as butter into a mould. Who would have believed it? This dishonoured daughter whom her father had described – out of 'honesty' to his future son-in-law – as a shrew, bowed in everything to the wishes of her husband. Admittedly, Pierantonio was not known to be greatly demanding. He had only two weak points: a liking for comfort and a passion for luxury. Luxury was something Artemisia had no notion of at the time of their marriage. Pierantonio was the one who had taught her to recognise and cultivate a preference for rare cloths.

The young wife had been very much surprised by her new husband's concern for furniture and household linen, for ornaments and the dishes served at table. She was still astonished by this attention to detail, this obsession with the little material things of life, this refinement which he called 'Florentine'. There seemed to her something almost feminine about Pierantonio.

The fabrics, the coiffures and the jewels required for the evening ahead had given them both much cause for anxiety. But who would have suspected this on seeing the supreme ease with which Pierantonio wore his doublet, hose and

suede shoes tied with an extravagant bow? In the district where he had grown up, he was held to be the best-looking lad that walked the earth. It was as if he had not given a moment's thought to his feathers and ribbons, braiding and ruching, as if he had been born attired as a gentleman. In reality, these fripperies left him up to his neck in debt. He could not draw on Artemisia's dowry without Orazio's consent and the latter had prudently put the four hundred scudi given by Canon Guidicciono into property in Pisa and *crediti del Monte* – a kind of Treasury bond – in Rome. There was nothing out of the ordinary in this. Roman law, concerned that families preserve their assets within, prohibited husbands from disposing of their wives' capital. Although all interest, all income from properties and general earnings belonged to the husband, Pierantonio had generously allowed Artemisia to spend the interest from her dowry and the income from her work as she wished. For the last three months, she had been setting up her studio in unparalleled luxury. She had had furniture designed with drawers for storing her colours, easels made in many different sizes and a whole lighting system constructed, under the pretext that in Florence there was no light in winter. Heaven and Pierantonio were finally keeping all the promises made to her by Agostino Tassi. Finally she lived in the golden atmosphere he had described, in the distance the hilltops, the gilded shimmering of the air. She never dared think of the dreams and visions that her father's friend had stirred in her, the better to clasp and possess her on those Roman nights. But she could not restrain her curiosity for the beauties of Tuscany, nor curb her appetite for happiness, the haste of her ambition. Drawing, colour, light – she wanted everything: painting had revived her. Fortunately, Pierantonio had understood what would make them wealthy: 'We have a gold mine on the tip of your brushes', he was fond of saying, in unknowing paraphrase of Agostino Tassi.

And yet he had nothing in common with Agostino. Mild-mannered, almost indolent by nature, Pierantonio talked little and never boasted. He was in love with Artemisia, admiring her beauty, her talent, and deriving an obscure pride from her successes. She returned his admiration a hundredfold. Taking his care-free attitude for disinterestedness, his placidity for wisdom, his gentleness for goodness, she deemed him to have a noble soul. She never fell asleep without thanking the Lord for having given her such a husband. Like Jesus, Pierantonio knew how to forgive; he knew how to love.

Orazio had been sorely mistaken when he imagined that his son-in-law, a painter without commissions, would hinder his daughter from working, from

progressing and growing in her art. With all his might, Pierantonio fostered and supported Artemisia's career in Florence. In two years, she succeeded in making her way into the most influential circles. The man who had given her dowry, Canon Lelio Guidicciono, had pursued his studies in literature in Lucca and Pisa, in the company of people who had now become the great Florentine intellectuals. Artemisia's godmother, the Marchesa Artemisia Capizucchi, resided in Florence. Her uncle, Aurelio Lomi, who had studied with Ludovico Cigoli, the artist worshipped by the Grand Duchess, was now one of the consuls at the prestigious Accademia del Disegno. He had no heir and was looking for successors for his studio. He had adopted and trained one of his nephews, a son of Orazio's other brother who had stayed in Pisa. Now he welcomed Artemisia as his child prodigy. By marrying a Florentine, all she had done was return to her roots.

When he had settled in Rome, thirty years earlier, Orazio had wanted to distinguish himself from his elder brother Aurelio. He had therefore adopted their mother's family name, exchanging Lomi for Gentileschi. His daughter repeated history – the other way round. Once in Florence, to free herself from her father's legacy, Artemisia signed her works 'Artemisia Lomi'. Very much aware of her uncle Aurelio's fame throughout Tuscany, and of the doors which this kinship could open for them, her husband had keenly encouraged this change of identity. His advice to her was also to his own advantage: 'Artemisia Gentileschi' had the whiff of scandal. It was nonetheless a name which had drawn attention to his wife and made her a object of desire. What better introduction to aesthetes and libertines than sex, beauty and talent? Pierantonio had quietly profited from the publicity which the trial had brought to Artemisia's painting.

It was, for example, to her – and to 'their' protectors – that he owed his presence on this staircase. Artemisia's patrons – composers, librettists, performers at this evening's entertainment – had procured a seat for her husband. Usually the Stiattesi couple sat side by side at the spectacles that the Grand Duke put on for the populace in the Piazza Santa Croce. But on this final evening of carnival in 1615, Artemisia Lomi was making her official debut on the stage of the Pitti Palace. Pierantonio would join her after the small intermezzo which she was to dance before Cosimo II de' Medici.

Before going into the theatre, Pierantonio wanted to straighten his cuffs, but the crush of people prevented him from stopping in front of the mirrors. An

audience of six thousand was expected. The main entrance to the grand hall was still locked. It would be opened only after the performance, the ball and the refreshments, so as to make all the more dazzling an impression upon the guests who would leave by the grand staircase.

Entering the hall by a side entrance, Pierantonio felt suddenly dizzy. Lining the walls on three sides were six tiered rows of seats; in the centre the floor had been cleared for dancing. The stage was reached from the floor by two side ramps and a big staircase. The guests of honour would sit beneath a canopy opposite the stage. The ceiling was garlanded with roses and lilies, and from it hung fifty chandeliers studded with long white candles. Pairs of statues rose up in each corner of the hall – tall female figures personifying Tragedy and Poetry, Classical and Modern Drama, the Pastoral.

The theme of the performance had been announced by the Grand Duchess's favourite dwarf, wearing medieval costume: the Knight of Immortal Passion and the Knight Fidamante would challenge with axe, lance and sword anyone standing in the way of Cupid. The son of Venus wanted to help humankind enjoy passion undisturbed. Having taken up residence at the Medici court, he planned to establish a new kingdom of Love, without jealousy or anger, discord or deceit. The Grand Duke's guests were about to witness the Triumph of Cupid.

Pierantonio found his place without difficulty. Seated comfortably at the far end of the hall, he cast his eye over the assembled company. He did not feel like an outsider: he was perfectly able to put a name and a title to every member of the great families sitting under the canopy. He recognised the wife of the late Duke Ferdinand I, ' Madama', imposing and severe in her widow's weeds. He recognised 'Her Imperial Highness', the Grand Duchess, with her high, frizzy-haired coiffure and her two strings of fat pearls hanging down to the point of her bodice. He recognised his prince, Cosimo II, so pale of complexion and frail in his *justaucorps* embroidered with gems.

The illness which confined him more and more often to his apartments accentuated his large nose and his fat lips, but he held up his shorn head proudly above his ruff. Pierantonio could name them all behind their carnival masks, every one of the Medici relatives, cousins and bastards. He himself had been carried to the baptismal font by Count Leone, the son of Lord Niccolò de' Medici, offspring of a younger branch of the family, for whom the Stiattesi clan had worked since time immemorial. Seven years earlier, his own father had been among those purveyors to the court invited to the Pitti Palace for the

wedding festivities of Cosimo II. Pierantonio belonged to the 'second generation' of craftsmen and artists of the late Renaissance. The majority of the young people who would presently appear on the stage – painters, musicians or poets – had not come to Florence to make their name. Their names were already well known due to the successes of their elders; they were *figli d'arte*, like Artemisia. And like all of Artemisia's new friends: the singers Francesca and Settimia, daughters of Giulio Caccini, one of the most famous musicians in Italy, who were now Artemisia's confidantes, composing the music and the ballet which the three of them would dance together; like the painter Cristofano Allori, whom Artemisia wished to have as godfather to the baby she was expecting – Cristofano was both the nephew of the great Bronzino and the son of Alessandro Allori, the court artist who for twenty years had been the architect and stage director of palace entertainments. The sense of security brought to all these artists by their long-standing rootedness in Florentine society meant that their rivalries were devoid of the reckless violence which characterised competition between artists in Rome.

Tonight they were all the guests of the Grand Duke, and Pierantonio felt as if he too belonged to this world, an infinite world akin to the new universe which Galileo spied through his telescope.

A round moon rode upon the vast curtain in front of the stage, a moon depicted by Cosimo II's painters according to the scientist's revolutionary instructions: with craters and volcanoes, areas of light and shade. One could also see Jupiter and its four satellites, which Galileo had recently baptised the Medicean Stars. And then the Earth and the Sun. A limitless universe that contradicted the story of the world's creation, refuting the Bible and challenging the Church.

Behind this huge screen – behind the image of this Earth circling the Sun – Artemisia was getting ready.

Quietly sitting among the spectators, Pierantonio gave no thought to how his wife could dare to perform before such a sophisticated audience, after a secluded life untouched by any kind of refinement until the age of eighteen. Artemisia would not be dancing. She would make a show of a few ballet positions – *rond de jambe, saut de côté*, and the three galliard steps that she had mastered – but the brevity of her appearance would not diminish its impact. Pierantonio, however, was unworried. He never worried about Artemisia. She coped with everything and she learned quickly. Hadn't she been illiterate when he married her? Now she penned her own correspondence. She might

well surprise the Grand Duke with the turn of an ankle, a supple wrist or the virtuosity of her heel taps.

Though Pierantonio was much involved in Artemisia's education, he was not so naïve as to think himself alone in overseeing his wife's progress. She owed her knowledge of how things were done in society, and a grounding in music and poetry, to the kindness of the man to whom she now referred, with total familiarity, as 'my godfather'. In Florence he was known as Buonarroti the Younger. Pierantonio caught sight of him now among the motley crowd on the floor, a tall gentleman dressed in black, greeting townspeople and courtiers. He was the great-nephew of the divine Michelangelo and one of the most important dramatists in Tuscany. For the last fifteen years, his best plays had been staged here. He was a member of the Accademia della Crusca and was among those who had compiled the first Italian dictionary, recently published. In his youth he had studied alongside Galileo Galilei at the University of Pisa and the friendship which bound the two scholarly men had been consolidated in adult life. It would be maintained in less happy days: Michelangelo Buonarroti the Younger would remain one of the scientist's staunchest defenders. He would defend him even to their mutual friend, with whom they had shared university quarters, Cardinal Maffeo Barberini, papal legate in Paris under Paul V, and the future Pope Urban VIII.

How had the young Artemisia crossed the path of the influential Buonarroti? Perhaps he had met her in 1610, at Orazio's studio, during his trip to Rome with the painter Cigoli. Maybe they had been introduced by their mutual acquaintance, Agostino Tassi, or perhaps it happened later, in Florence, when Aurelio Lomi took his talented niece to visit Buonarroti in the Via Ghibellina, so that she could contemplate the house of the greatest painter of all time, their common master – Michelangelo.

Buonarroti the Younger was devoting his life and his entire fortune to the greater glory of his illustrious ancestor. He dreamed of turning his home, the building which he had inherited from Michelangelo, into a temple of the arts, exalting painting, sculpture, music and poetry. He had begun this task just as Artemisia arrived in Florence. And for the past three years, he had surrounded himself with all the finest Tuscan artists, from whom he commissioned paintings. These canvases, set into the walls and ceilings of his gallery, were his planned legacy to posterity. His own masterpiece. His gallery meant so much to him that he warded off misfortune in sonnets full of irony predicting

that it would soon be left derelict, fouled by 'fly shit', 'cat piss' and 'pigeon droppings'.

The curtain went up on the first tableau vivant. The performance would last for four hours. Pierantonio knew only that his wife would appear twice. Venus's vast chariot began crossing the stage, drawn by two enormous swans who beat the air with their great wings. In the background, wave upon cardboard wave rose up, creating the illusion of an ocean that glittered as far as the eye could see. Amphitrite sat astride dolphins and Neptune surfaced from the depths in an aquatic ballet with sirens and tritons who were larger than life. An obsession with realistic detail dominated the fantastical extravaganza. The shells which studded the rocks in the foreground of the scene were reproduced with infinitesimal precision; cockles, mussels and clams clung to cliffs eroded by time and the wind. Hundreds of mechanical fish leapt among the waves. It was here, in the theatres of Florence, that Agostino Tassi had learned the rules of perspective, *trompe l'oeil* and stage illusion.

Although Venus's chariot was packed with nymphs and cupids, and Artemisia had her back to him, Pierantonio recognised her at once by the red-gold mass of hair, which had been darkened to bronze by motherhood, and the shapely line of her lower back and rounded hips. Dressed in marble-coloured tights and flanked by the Caccini sisters, she appeared as one of the three Graces. The young women had their arms around one another in the manner of classical statues. The two singers regaled the audience with arias which they had composed.

Pierantonio did not like them. In his opinion the two women exerted a bad influence over Artemisia. The gifts which they received from their patrons should, however, have struck him as a sign of good things to come. In the service of the Duke of Mantua, the younger sister, Settimia Caccini, had recently played the title role of Ariadne in the opera by Monteverdi, who complained to all and sundry that its performer was better paid than he was. And Settimia Caccini did indeed cost the Gonzagas a fortune. As for Francesca, who was known as *La Cecchina*, every court in Europe fought over her. She was twenty-six and probably the most highly remunerated artist in Italy, and the prettiest.

As well as being a singer, Francesca Caccini was also a very talented composer and had set to music Buonarroti the Younger's best plays. Rumour had it that she was his mistress and his Muse. Her husband, one of the court

musicians and a young man of very good family, had the wit to close his eyes
to his wife's amorous adventures. Did she not carry him along in her luminous
wake? Like Pierantonio, Francesca's husband lived off his wife's talent. But if
these gentlemen existed only in the shadow of their wives, the latter were
powerless without them. For a woman artist to feature on the Grand Duke's
list of stipendiaries, she had to be married to a man who exercised the same
profession. A woman could make no progress except in association with her
husband. Pierantonio therefore took good care to remind the consuls at the
Accademia del Disegno of his profession. He was guarantor for Artemisia's
supplies from the colour sellers and he dealt with the carpenters who
constructed the stretchers for his wife's canvases. The social bonds which tied
the Stiattesi couple together were as necessary to them as the bonds of love.

When, at the end of the performance, the Grand Duke went down on to
the floor to conclude the ballet and open the ball, Pierantonio heard the tinkle
of Artemisia's laughter. He did not know the court dances. So he remained
seated, waiting stubbornly for Artemisia to join him. As she handed out the
solid silver shells filled with sugared almonds and candied fruits, the gifts of the
Grand Duke to his guests, she had not gratified him with a single look, nor
had she made her way over to him.

'*Among all these beauties,*' Francesca Caccini sang out on the stage, '*behold the
one who sets hearts on fire with too ardent a flame . . .*'

With a tinge of ill humour, Pierantonio now regretted that he had been
unable to invite his mother, sisters and brothers-in-law to the performance. He
would have liked the Stiattesi clan to be witness to the family triumph.

He had lost sight of Artemisia, but he could still hear her happy laughter,
laughter that he had been the first to know. A quick, rippling laugh that
ended as abruptly as it began, instantly recognisable in places where laughter
was considered a great offence against decorum. It was Artemisia's least
serious failing. She had not yet learned to keep her eyes lowered, nor to profess
modesty, like all well-born persons. She did not always express herself in 'a
mild and sober tone of voice' as all the rules of politeness demanded. When
standing, she never held her elbows by her sides, with her hands joined in front
of her, in keeping with all the tracts on deportment. Walking, she would
swing her arms – which was the height of vulgarity – 'so as to hurry and make
the road shorter'. At table, she would crumble her bread and help herself to
salt with her fingers. When, by some miracle, she was prevailed upon to use
her knife, she forgot to dry it with the large napkin she was meant to keep

folded over her arm. Artemisia, however, thought her education was in good hands. After Tuzia, her chaperone in the bad old days, her friends Francesca and Settimia schooled her in the ways of the world; they taught her about the pleasures of life, about gallantry and frivolity. Pierantonio was not mistaken in his mistrust. In the company of the Caccini sisters, Artemisia Lomi was becoming irresistible. The mutual admiration between the three young women and their awareness of their own talent gave each of them a magnetic, smiling confidence which attracted every seducer at court. When it came to playing with male desire, the Caccini sisters were queens. Playing and sharing . . .

While the hero of the performance, the Knight of Immortal Passion, still sported his breastplate and bird-of-paradise helmet, the three Graces – first seen in the guise of classical statues, then as gypsies – had exchanged their costumes for outfits in crimson velvet. They all wore the same cloak with long slashed sleeves, the same lace collar that fanned stiffly upwards at the back of the neck, the same little cone-shaped hat with a quivering feather. Their coiffures were slightly dishevelled by the admirers who jostled around them in a mass of velvet and brocade, ribbons and pearls.

The fame of the two singers outstripped the still recent fashion for Artemisia, but it was the woman painter who drew every glance. The sound and fury of her past loves aroused curiosity. Tongues wagged as she went by. So this was the superb creature to whom Agostino Tassi owed all his misfortune. Everyone here knew their story. Even the Grand Duchess, 'Madama Serenissima' – Cosimo II's sanctimonious mother – knew all the details.

Three years earlier, in July 1612, at the time when Orazio was introducing Artemisia to Cardinal Scipione Borghese, he had also pleaded his case in Tuscany. With the aim of placing his daughter under the protection of a person of influence, he had written to her Most Serene Highness, Christine of Lorraine, and had sent her a small painting done by Artemisia, as a proof of his poor child's extraordinary talent and as a token of his loyalty to the house of Medici. One of Artemisia's works had therefore preceded her to the Tuscan court.

History does not tell us how Christine of Lorraine reacted, but the fact of a woman painter was in itself so peculiar that it could not have failed to interest her – all the more so since she competed with her daughter-in-law in the patronage of artists of the female sex. One can imagine that she would have

enjoyed belittling her son's wife, Marie-Madeleine of Habsburg, who was the protectoress of Signora Arcangela Paladini, a woman painter of questionable talent.

Unlike Pierantonio, Artemisia had realised that the excitement stirred by her painting was due in great part to the public nature of the trial and the salacious interest provoked by her experience. She did everything possible to make an impression, to be seductive and put people at their ease. Her relations with the artists and collectors at court were tinged with a flirtatiousness that her husband preferred to believe was innocent. But when Pierantonio made up his mind to leave his seat and join his wife on the crowded floor, he was appalled. Even from a distance, he could see the elation on Artemisia's face at being surrounded by the attentions of the painter Cristofano Allori, her patron Michelangelo Buonarroti and the circle of men who surged around her. They exchanged pleasantries with her about the festivities, apparently discoursing on the scenery, the costumes and the ballet, but their eyes spoke only of love. Most of all, the eyes of the very seductive Cristofano Allori, which did not leave her for a moment. He had just promised to visit her studio the following day. This was a victory for Artemisia. Pierantonio knew that the approval and favour of an artist like Allori were worth their weight in gold.

When he was near his wife's side, he faltered. His loving look was not returned. He moved away. But an irresistible force brought him back to her, to that face whose every expression in the ecstasy of love was known to him: the parted lips, the little teeth, sharper and whiter than was normal. Something emanated from her that left him with nowhere to turn. There was temptation in the unruly curls that frizzed on her temples, in the quivering of the feather that caressed her neck, in the sparkle of her lace and her jewels. There was temptation in her décolleté. Pierantonio thought of the feeling of his wife's body against him, he smelled its perfume. She seemed to him to be made for love, only for love. If she did not return his glances, it meant her love was elsewhere. If she loved elsewhere, she was just as Orazio had described her to him.

Helpless, Pierantonio silently accused her of sundry faults: she was a poor housekeeper, she never gave him an account of the money she earned, she neglected their son, or she made too much of him ... Watching her mingle so freely with the leading artists of the court, Pierantonio thought bitterly of the world from which he had taken her. Now this victorious femininity which had so troubled Orazio worried him in turn. It was not the admiration of the

crowd which was having this heady effect on Artemisia, but the enthusiasm of one man. Which one? Buonarroti? At forty-seven, Michelangelo's grand-nephew was a handsome man, short-haired, with a curled moustache, elegantly sober in his attire. He could do everything for her at court . . . Cristofano Allori? Artemisia wanted to make him godfather to the child she was carrying. So he was one of her intimates. How often did he visit the studio? Tall, well-built, witty, the thirty-eight-year-old Cristofano Allori was an aesthete through and through, sensitive to all forms of beauty, and an *habitué* of the Florentine court. If painting obsessed him by day, his nights were filled with poetry, dancing, music and love. He professed an extreme admiration for unusual talent in pretty women, like Francesca Caccini, whose portrait he wished to paint, and Signora Artemisia, whose paintings he wanted the opportunity to admire in the near future, as he said repeatedly.

For a young artist, to secure a visit by Cristofano to look over a piece of work meant the opening of doors to every kind of worldly success and artistic triumph. Cristofano Allori was the Grand Duke's favourite and a close friend of the Grand Duchess. He had such a profound knowledge of painting that many art lovers called upon him to value their pictures, although he would often refuse to assume the role of expert. Before the work of a master, he decreed that he couldn't place a value on it, because it was priceless. Before a painting of average quality, he advanced the pretext that he could not value it, because it was worthless. And before a piece of work which he judged good, but not first-rate, he preferred to say nothing. He himself produced little and the slowness with which he worked had become proverbial in Florence. But when Cristofano Allori finally saw fit to deliver a commissioned painting, the work's splendour justified all the painter's delays.

Having seen her on the stage, wearing close-fitting tights, Allori's interest in Artemisia's lovely anatomy was aroused. At least within the bounds compatible with his passion for his mistress and model, the awesome Mazzafira, whom he was painting as Judith decapitating Holofernes. Wittily, Cristofano had depicted himself as the face of the decapitated tyrant. For the sake of greater realism, he had grown a beard and let his black curls grow. He was obsessed with the theme of virility vanquished by cunning – by female cruelty. Now Signora Artemisia aspired to deal with the same subject, on a similarly large scale. Like him, she had depicted herself on the canvas. As Judith. A self-portrait in which the heroine freed herself from tyranny with

blood and the sword – an interpretation of the theme which was quite at odds with his own.

Only Michelangelo Buonarroti had seen both of these unfinished works. This great connoisseur had praised the two paintings, and the violence in them. Cristofano Allori decided that tomorrow he would go without fail to look at the Signora's *Judith*. He had no great hopes of it; Buonarroti's paternal feelings for Artemisia undoubtedly explained his admiration.

Pierantonio was plunged into suspicion. When he thought of all the male figures who gravitated around Artemisia, he felt suddenly dizzy. He recalled Orazio's warning before the wedding. 'I may be wrong,' he told himself, 'I'm imagining what isn't there.'

But he remembered what he had seen: Artemisia accepting Allori's hand as she stepped out of the wings, without a glance at him. And the past? Agostino Tassi?

He went to take refuge in the Sala della Colazione, so named because only cold meats and light dishes were served there. But the mingled smells of game, vanilla and caramel, beef, orange and cinnamon made him feel nauseous. He could not even go near the dessert table, though he loved nothing better than sweets, poached fruits, compote of quince, dessert wines and macaroons. All the confections which usually stirred his enthusiasm, sugar cupids, marzipan Venuses, wonderful tiered cakes made by the Medicis' renowned pastry cooks, now left him cold. Silver serving dishes, alabaster bowls and ewers – the world's splendour had suddenly faded into greyness.

Anger and suspicion turned to melancholy. He moved to an adjoining salon. He knew no one there, except the lackeys – members of his *calcio* team – who stood between closed windows, watching over the torches set into the walls. The flames licked at the threads in the French tapestries, casting a sinister glow over the greens, ochres and reds, over bloody scenes of animal carnage, of dogs tearing deer to pieces. Uncertain whether he should greet his old friends, Pierantonio ignored them and went into a third salon.

'Should I have locked her up?' Blinded by his fascination with his wife's successes and by his new fear of the future, he forgot that Artemisia had at first wanted only the peace and quiet, the obscurity of their home. 'Yes, I should have locked her up as soon as she arrived in Florence . . . ' He forgot that, for his sake, Artemisia had wanted to give up her art and live like any other wife. That when their little Giovan Battista was born she had felt so fulfilled by mother love and her love for Pierantonio that she had vowed never to touch

her paintbrushes again. And he forgot that it was he, Pierantonio, who had pushed her centre stage and forced her to earn the gold which they needed to maintain the style of life to which he himself aspired. It was Pierantonio who had secured the commissions for Artemisia's first paintings – portraits of women – by hunting down clients among the burghers of the city. And it was he too who had unearthed the name 'Lomi' with which she now signed her canvases. He was a trader at heart and had feared, quite rightly, that his own family name, Stiattesi, might be too obscure and too hard to remember for a clientele which he hoped would extend beyond the walls of Florence. Though he himself had soon tired of running around to chase up payments and commissions, Artemisia now worked frenetically. 'Sell, sell, sell . . .' This was the law that Orazio had stressed over many years and which now drove her. 'Sell, but not so much for the sake of wealth or raising one's standing, as to establish the reputation of an artist's work. Gold is the measure of our aesthetic riches. That is the only use it has: proclaiming a painter's value to the world.' Pierantonio did not dwell on the nuances of this argument. All that he understood was the weight of a scudo, the currency of the Roman giulio and the Florentine lira. He was a sensualist and, though he might be lazy, he knew how to drive a hard bargain.

His dejection had tired him. He went back to his seat. The floor had emptied. Only a few women dancers of the Grand Duchess's retinue were there, executing the slow, complicated steps of a pavane in duple time. The chattering crowd had shifted to the foot of the tall statues representing the theatrical figures of Comedy and Tragedy. The men stood leaning against the draperies, the women lined up in front of them.

Pierantonio had given up looking for his wife in the row of lovely gilded insects glittering on the edge of the dance floor in a last flash of precious metal and gemstones before the shadows encroached. He imagined that their tiny, jewel-encrusted ears would very soon hear the bells that brought them extreme unction. That their long pearl necklaces – those thousands of little white spots dotted around their throats, their breasts – prefigured the thousands of tiny bones to which their corpses would soon be reduced. That the lutes and theorbos, the music, the dancing and leaping of all these skeletons rattling about at his feet merely masked eternal silence.

Rather than depressing him, these dark ideas calmed Pierantonio. He felt no compassion for these spectres who blithely ignored the imminence of the Last Judgement. The idea of all things being equal before death gradually

restored his confidence.

At that moment, he noticed Artemisia, for the second time, in the crowd. Infringing on the area reserved for the dancing, she had moved away from the line of ladies and was pacing up and down the floor in front of them, scorning all the rules of etiquette. Both of the Caccini sisters must have withdrawn, for hers was the only gown that shed a stain of crimson velvet against the pearly watered silks, the gold and silver damasks of the court which gleamed coldly, like blades.

She faltered, looked around, then stopped, only to start walking again. She seemed so anxious and lost that Pierantonio was reassured in an instant. She had looked up towards the spectators' seats. He realised that she was looking for him. But he made no move. Like a child, he wanted her to be the one to find him. Happiness flooded his heart. He recalled those moments of tenderness when Artemisia would gaze at him, eyes filled with humility and gratitude. 'I am nothing without you,' she would say. 'Without you, I do not exist, my painting doesn't exist. Without you . . .' She would fall silent, overwhelmed by a fear she dared not put into words.

Pierantonio saw her turning once more towards the spectators' seats. His heart began beating fast; would she notice him now? All the torches in the amphitheatre had burned out. At this late hour, the lackeys would not replace them. Strange outlines came and went amid the darkness: the monkeys, the dwarves and jesters that chased about among the seats. The shadows had moved up into the gods, where Pierantonio obstinately waited.

What detail made her pick him out? Was it the cream colour of his doublet, with the great dark slashes in the sleeves? Was it the little pearl buttons that gleamed like tears from his collar down to his waist? Was it the perfect oval of his face with its close trimmed beard emerging languidly above the ruff's white froth?

When she caught sight of him watching over her from the distant shadows, she was transfixed. She stood there, her eyes devouring him, her expression simultaneously troubled and smiling.

Did he realise that Artemisia loved him passionately, as one loves the warmth and tyranny of a child?

She picked up her skirts and climbed towards him. When she collapsed against him, Pierantonio was at last certain of her love. He read such fervour in her eyes that all his strength was restored to him. Was he not the best husband and the best-looking fellow in the city?

He took her hand and pulled her away. Together they escaped from the palace.

Outside, dawn was breaking. It was Ash Wednesday and the first Lenten procession was slowly crossing the square. A line of young girls in sackcloth, their hair loose, barefoot on the damp cobbles, made their way to the church of Santo Spirito to receive the ashes.

Chanting mournfully, they walked in pairs along the path that led straight from the palace to the church, from the ballroom to the altar, from pleasure to remorse. The symbols of the Passion – the wooden crosses and nails, whips and a crown of thorns – which the long line of orphans held aloft, swayed in the light of their candles. Bells tolled the hour of penance all over Florence. All at once a gust of wind blew out the flames.

But on the waters of the Arno, on the dust-coloured river, the Moon and Jupiter and all the Medicean stars still danced.

25

The Studio of Pierantonio and Artemisia in the District of San Pier Maggiore

15 March 1615

'To think a woman should paint such ghastly things,' whispered the Grand Duchess's favourite dwarf. This diminutive character was around fifty and her pug-nosed face was framed by a mass of braids tied with big red bows.

An entire troop of female dwarves, tricked out like dolls, scurried and squawked around Artemisia's *Judith*. The fashion for farthingales made them seem even shorter. At court their deformity was a reminder of the relativity of all things and beside it the imperial bearing of Marie-Madeleine of Habsburg was emphasised.

'A blood bath!' smirked one of the tiny matrons. 'The very idea of finding myself alone in a corridor with a picture like that gives me goose pimples.'

'This is a scene drawn by Florence's executioner,' said another.

These ladies made a show of shuddering and shivering as they snuffled in the background. The Grand Duchess had still to pronounce judgement.

With Lent under way, Cristofano Allori had kept his promise. He had come to see Signora Lomi's work. But he had not come alone. He had brought with him his intimates, the Grand Duke himself, his wife and their retinue, who were always on the lookout for fresh talent. There were some twenty courtiers in all. A crowd could be heard gathering in the street outside. The whole city knew that at this early hour, on the market square of San Pier Maggiore, on the top floor of the tailor Stiattesi's little house, Power, Science and Art were assembled: Grand Duke Cosimo II, the mathematician Galileo Galilei and the painter Cristofano Allori. The Florentines were so proud of

their history and their artistic treasures that the name Allori belonged to them, just as they owned that of Michelangelo. For close on thirty years, ordinary people had been saying their prayers before the virgins and saints of Allori, father and son. There would be trouble if any of their pictures disappeared from the churches or left the city ramparts. A law had even been promulgated in 1602 prohibiting sculptures and paintings from being taken out of Tuscany.

Today, however, it was not Cristofano who drew the curious to the Stiattesi's front door. It was Galileo. His fame was so widespread among the poor that it occasioned riots. Only the evening before, when a package for him had arrived with the mails, the traders at the *mercato vecchio* had been sure from its shape that it was the celebrated telescope. Some had wanted to break the seal to take a look, while others had opposed them. Florence would talk of the ensuing fracas for years to come.

The Grand Duke, who had been Galileo's pupil, had just named him first philosopher and mathematician to the Medici household, with no obligation to teach at the university and with a substantial stipend. But Galileo's popularity was due mostly to his numerous practical inventions. The Venetian Republic prided itself on having acquired a machine from him for irrigating fields, a slide rule with which the annual interest on a sum of capital could immediately be calculated, the first barometer in history and, last but not least, the famous telescope. By pointing it from the top of the bell tower of St Mark's, the Venetians could see every detail on the façade of the church of Santa Cristina in Padua. They had quickly grasped this instrument's potential: for sighting pirate ships hundreds of miles away.

It might seem strange for a scholar renowned for his researches in physics, astronomy and mathematics to have agreed to leave his laboratory to visit the studio of a painter, but in Florence, no one was surprised by it. Galileo was an excellent draughtsman and took such a close interest in painting that he had asked to be admitted to the Accademia del Disegno. He had been a member of it for the past two years. Those in artistic circles were fond of recounting that, in his adolescent years, he had greatly preferred painting to all other scholarly endeavours. Painters discussed theoretical questions with him, patrons would take his advice. But Galileo eschewed collecting. He also made a point of distinguishing himself from the courtiers in the Grand Duke's retinue through his dress. No ruff or jewels for Galileo. He had always worn professorial garb: a black gown, a white collar, close-cropped hair and a long

square-cut beard. A world of difference from his two companions: Buonarroti the Younger with his hooked moustache, and Cristofano Allori with his crimped curls.

Cosimo, Galileo, Buonarroti and Allori were very different in age and condition but they were united in pursuit of the same aesthetic credo.

What they encountered now at Artemisia Lomi's studio was the violence of a great painting of the school of Caravaggio – the black, blue, red and gold of her *Judith Slaying Holofernes,* whose sketch had been admired by Cardinal Scipione Borghese.

In the foreground, the blade of the sword stood out against the bed sheets and streams of blood ran down to the edge of the frame. In the middle ground, Holofernes' head was thrown back, his mouth open in a silent scream, his eyes rolling upwards in search of the spectators' gaze, begging for their help. Judith's left hand, clutching her victim's hair, pressed down with her full weight on his temple. The parallel lines of Judith's forearms caught the light and drew the eye to the sleeves of her dress, then to her face.

Each of the four men gathered here knew all the variations on the theme that had inspired the greatest of the Florentine artists: the sculptor Donatello's *Judith* held aloft the head of Holofernes in one of the salons of the Palazzo Vecchio; on the ceiling of the Sistine Chapel Michelangelo's *Judith* fled from the tyrant's tent. But this Judith's savagery, her joy in hacking at the despot's neck, her forceful way of using the sword like a kitchen knife and the realism of the blood, the exactness of Holofernes' anatomy – the muscles in his flailing arms as he tried to fight off the blows, his legs opening so that he could brace himself – were entirely new to them. Never had a murder scene been painted with such cruel violence.

'I cannot abide this painting,' pronounced the Grand Duchess. Marie-Madeleine of Habsburg was a tall, strong woman who was permanently pregnant. She enjoyed hunting, dancing and High Mass. Her interest in art objects was confined to the sumptuous ciboria that she ordered from her goldsmiths and the heavy silver reliquaries which enshrined the remains of St Severin and St Francis's hair shirt. A few devotional works might have held her attention in Artemisia's studio. A *Vanitas,* or a bunch of flowers. Works a lady might produce. Dissatisfied with what she was shown, she shook her head, agitating her pyramid-shaped chignon spiked with combs, pearls and gemstones.

Artemisia watched her gloomily. She hung back in the corner. There

might be a sweet smell of perfume in the room, but things were turning out badly.

She had felt uneasy since the week before, when the event was announced. From the day the messenger had arrived from the Pitti Palace, the Stiattesi couple had done nothing but bicker. It was their first quarrel and a bad omen.

Artemisia's spacious studio was empty and clean, more reminiscent of a ballroom than the alchemist's laboratory that Orazio's had resembled. A waxed floor and whitewashed walls. Chairs in the corners. There was nothing of the painter's den about it except the light. It was bathed in light. Artemisia prided herself on being able to work there at any hour of the day, all year round. Three large copper oil lamps, each with six burning sconces, hung from the central beams. These lamps had reserves of oil and water and their system of suspension was designed for adjusting the degree of illumination in order to eliminate the shadow and supplement the natural light. Artemisia had learned this technique of combining sunlight with the glow shed by flames from her father, and she pushed it to its furthest potential. In the centre of the room, she had cut a large circular opening on to the sky. 'Light must fall from above,' Orazio had stressed throughout her apprenticeship, 'from the greatest possible height. For a painter, the ideal would be the oculus in the dome of the Pantheon. A distant halo that imparts an indescribable softness to the models' faces, even those that are most inexpressive.'

Like the oculus of the Pantheon, Artemisia's opening had no glass or shutters. Nothing but an awning of linen dyed a shade of ochre: the equivalent of the paper oiled with pork fat which Orazio used to filter the Roman light. A few basins placed in strategic spots caught the rainfall. In winter, the rain water turned to ice. It didn't matter. Wind and hail meant nothing to Artemisia in this domain of hers, and she did not feel the cold. She would happily have covered the walls with shelves, cluttered the corners with saucepans and jugs of oil, piled up the rolls of hemp and the wood for the frames. But Pierantonio kept an eye on things . . .

For this visit by the court he had allowed her only a few accessories: a dozen brushes standing in a couple of pots, three differently-shaped palettes – square, round and oval – harmoniously arranged on the workbench. Over one of the chairs he had draped the big crimson velvet curtain which appeared in some of the paintings, most notably as the hanging on the left in the painting of Judith and Holofernes that formed the centrepiece of his exhibition.

Pierantonio had organised what amounted to a retrospective of Artemisia Lomi's works. With his typical practicality and care for detail, he had had some of the canvases framed in heavy stucco, ebony or gilt frames so as to offer the clients a finished product. His intention was to show his wife's pictures as they might be presented in the gallery of a palace. The large pictures hung on the walls, the small and medium-sized works were set on a row of easels.

Artemisia had protested over all of this. Of course she took trouble over her clothes and her good looks; she was prepared to use her physical attributes and employ whatever artifice was called for to contrive meetings with influential patrons, to charm Buonarroti the Younger and seduce Cristofano Allori. But she refused to compromise her principles on painting and the role of the artist. Pierantonio was behaving like a trader. He had managed to borrow back the paintings he had sold in recent years, anticipating a practise that would not become common in the art world for another fifty years. In 1615 it seriously contravened all the rules of the profession.

Artists could not promote their name by exhibiting their works. Only religious congregations and aristocratic families were able to solicit the admiration of their contemporaries and posterity by surrounding themselves with paintings whose splendour exalted God and themselves, in their churches, on the altars, in their galleries and on the walls of their palaces.

Pierantonio's enterprise might therefore have appeared sacrilegious to his wife: it offended both the letter and the spirit of painting as an art. Moreover, this retrospective threatened Artemisia's reputation on a more significant level: the quality of her work. Since she had been painting well away from her father's guiding hand, she was visibly more demanding and harder on herself than Orazio had ever been. From all her vast output in these last years, she had kept only two works. One was a self-portrait in a gold silk gown, *Woman Playing a Lute*, and she set much store by its beauty; the fabric, the light on the musician's face and hands, the strings and wood of the instrument, were all handled with the finest attention. The other was the big painting, *Judith*, the only work which she deemed worthy of her father, and for which she had the highest hopes. But Pierantonio had gone off in search of old canvases, rummaging in her boxes and unearthing her botches and failed attempts.

This intrusion into the painful struggle of the creative act threw Artemisia into one of those violent rages that Orazio had experienced in the past.

'How can you think of showing such daubs to a virtuoso like Allori?'

'To sell them,' he had snapped. 'It's the only word on your own lips, Artemisia – selling.'

'So as to establish my reputation! Not to trample on my work. If you show worthless pieces to an expert like the Grand Duke, you only injure the painter and insult her patron.'

'Your preferences, Artemisia, are those of the artist, and these very seldom coincide with the buyer's tastes.'

'The preferences of a painter like myself and the tastes of a collector like His Highness share a common desire for perfection.'

Artemisia Lomi remembered the lessons of Orazio Gentileschi. She had inherited his revulsion for mediocrity, but it was only since moving to Florence that she had come to appreciate the scope of his teaching. Artemisia's discovery of the Renaissance masters, her entry into intellectual circles, and her acquaintance with aesthetes like Buonarroti and Allori had opened up horizons of which Pierantonio could not have even the remotest idea.

She, however, had understood the revolutionary role of Allori in Tuscany. Like Carracci in Bologna and Caravaggio in Rome, he had set out to break with the generation of painters preceding him. To break with his own father, Alessandro, of whom he would say, with a certain cruelty, that he had been 'a heretic in painting'. To break with those two-dimensional spaces and arbitrarily proportioned figures, with the over-emblematic subject matter and allegories so obscure that only the learned could understand them, in order to renew tradition and return to coherent compositions. To attempt a fusion of colour and design; of nature and idea; of realism and conceptualism. To achieve the ideal of beauty.

This was a quest which Orazio Gentileschi had attempted. Throughout her youth, Artemisia had heard talk of nothing else. Now, here in Florence, Allori, Buonarroti and Galileo were enacting her father's intuitive impulses. 'The draughtsmanship, the light, the colour, I want all that!' he would say, in front of the paintings in Santa Maria del Popolo. 'I want Raphael and I want Michelangelo, I want Carracci and I want Caravaggio. We'll never belong to any school. Why restrain ourselves?' Only now did Artemisia understand that Orazio Gentileschi may have been the only one to grasp how much Caravaggio's naturalism and Carracci's idealism, far from being irreconcilable, could be combined in a single vision.

At last, at twenty-two, Artemisia felt she was ready to take up his challenge. With two paintings. Just two paintings, whose beauty and

boldness would make a striking impression on her visitors.

'Showing them anything else would diminish me,' she pleaded.

The more she had raged and argued and shouted, the more Pierantonio had dug in his heels. Not yielding had become a matter of honour. And he had a second, more prosaic, demand that also gave rise to Artemisia's disapproval: he wanted the entire Stiattesi clan to be present at the visit of the Grand Duke and the triumph of his wife. At the crack of dawn, the studio was invaded by Pierantonio's mother, wearing a smock and a turban, along with his sisters and brothers-in-law. The men crowded along the walls; there were squealing children and babies everywhere.

'Heaven alone knows I am fond of my nephews,' muttered Artemisia, at the end of her tether, 'but they have no business here.'

'Do you look down on my family?'

'How can you say that? There is no one closer to me after you than your sister, no woman I hold dearer . . .'

'Is that so? You are still painting her as a servant – and yourself as Judith.'

'I give her silk for her gowns. Last week I gave Lisabetta . . .'

'You are keeping accounts? When we took you without a trousseau, we didn't keep an account of it!'

'Without a trousseau? What about all my mother's linen?'

It was true that Artemisia was on good terms with her husband's family. She slept under the same roof and ate at the same table. She was fond of them. Nevertheless, she thought it ill-judged to show mediocre works and put herself on show in the midst of a gathering of tailors.

Events had immediately proved her right. Andrea Cioli, the Grand Duchess's secretary, had wasted no time in having the studio cleared by the constables and relegating the Stiattesi clan to the floor below. Chaos ensued: the court was compelled to wait outside in the company of the lower orders. It was this inconvenience that had given rise to Marie-Madeleine of Habsburg's impatience and ill humour.

'I thank Your Serene Highnesses for the honour which you bestow on me today,' the artist proclaimed shyly. 'And I bid them welcome to my humble studio,' she concluded with an unaccustomed coldness.

The slight curtsy she made lacked any grace. Perhaps this awkwardness was due to her condition. She was pregnant and her belly was starting to show under her capacious green smock. When her greetings were over, she withdrew into the shadows.

It was Pierantonio, with much bowing and scraping, who did the honours. As soon as the Grand Duchess expressed her dislike of the painting which Artemisia regarded as her masterpiece, he congratulated himself on having resisted her whims and tried to draw the court's attention to the other canvases. But despite all his efforts, he could not manage to distract the Grand Duke from his contemplation of *Judith Slaying Holofernes.*

'This face, so close to death, brings someone to mind,' the secretary, Andrea Cioli, interjected insidiously. 'A painter, Your Highness . . .'

Andrea Cioli was a small man, of humble origins, and he always displayed a singular harshness towards those who, like himself, strove to rise in the Grand Duke's retinue. He was a native of Cortona and had recently obtained Florentine citizenship. He owed his career to the Grand Duke's mother, Christine of Lorraine, who had given him a diplomatic mission to France and to England, during which he had acquitted himself skilfully. He had a methodical mind that was sharpened by a formidable memory.

'In the face of this poor Holofernes, are you not reminded of that painter who did the decorations for Your Highness's wedding feast?'

'Agostino Tassi!' shrieked the Grand Duke in a high-pitched voice, bursting into childish laughter.

When his lung disorder gave him some respite, Cosimo II had a frantic need of diversion.

'Agostino Tassi, of course,' he repeated, with the satisfaction of someone finding the solution to a riddle.

His face livid, Pierantonio turned towards the corner where Artemisia was standing, her hands on her belly. She met his eyes for a moment, then lowered her gaze. How could she tell Pierantonio that she never thought about Agostino Tassi, that Holofernes bore no resemblance to him?

'Is the lady getting her own back?' snuffled the Grand Duchess's favourite dwarf.

'Your Serene Highness would be very pleased with me,' intervened Cristofano Allori, 'if I were to achieve such technical mastery in the painting of fabrics. . .'

Did Cristofano have any idea of the conjugal drama being played out in front of him? He was sure enough of his position at court to be able to speak his mind, and even to contradict the extremely authoritarian Marie-Madeleine of Habsburg. He went up to her, took her hand respectfully and led her over to the canvas, so as to make her study it closely.

'Look at the sheets . . . at the way the folds are done; you can feel their texture. Look at the little fringe on this turned-back hem. You can see the weave of the linen in it. And the servant's crimson gown. The effect is superb.'

'What I find most interesting here,' the Grand Duke added, 'are the physiognomies. Observe Judith's expression . . .'

The 'disputation' and 'dialogue' were even more fashionable in Florence than in Rome. Scholars would gather in academies to discuss theoretical subjects: the relative values of painting and sculpture; comparisons between Raphael and Michelangelo, between string beans and broad beans.

While Cristofano Allori hated debates of this kind, both the Grand Duke and Buonarroti devoted a great deal of time to their activities as academicians.

'What is your opinion of the two female figures, Signor Buonarroti? In your experience of commissioning the best painters, have you ever seen such figures as these?'

'I fear I might seem biased if I tell Your Highness that this work strikes me as quite singular: what impresses me most here is the conception. The servant kneeling on the belly of Holofernes the better to assist the execution. This whole painting is like a reversal of another biblical theme . . . I am thinking of *Susanna and the Elders*.'

'I cannot quite see the connection. Continue.'

'In *Susanna and the Elders*, there are two men threatening the innocence of a woman. Here, there are two women slaughtering a man.'

The ladies recoiled with horror.

'I cannot abide this painting,' the Grand Duchess reiterated furiously.

Fearing that he might upset his wife, Cosimo changed the subject. 'In all these canvases,' he went on, 'Caravaggio's influence on the Signora is apparent. Since we are on the subject, Signor Allori, when are we to have the pleasure of seeing your own *Judith*?'

'The major difference between this composition and the one I am engaged upon,' said Cristofano evasively, 'is the absence of space around the figures, Your Serene Highness. I could not have conceived of these two women whom we see in profile turning to the right, both looking directly out of the frame . . .'

'But this is not an innovation,' interjected Galileo. 'I think I've observed it in her father's work.'

'So you met the Signora's father in Rome?' enquired the Grand Duke.

'I saw him again, Your Highness, in 1611, during my last visit there. We

are both natives of Pisa. He is a great painter. In his works he applies the three very simple principles which every artist ought to practise in music and in prose: clarity, concision and efficacy. Unlike Torquato Tasso, who talks without saying anything, each one of Gentileschi's brush strokes has a meaning. His compositions seem instantly coherent. But I should say, Your Highness, that his daughter pays even more attention to the passions of the heart. She may well have a greater knowledge of the human spirit. I should say that she is striving for effect. Her painting aims to startle the spectator.'

'Which is the better painter, the father or the daughter?' the Grand Duke cut in.

Artemisia stood motionless in the shadow. Her heart pounded, assailed by the question that dominated her whole life. She knew that she was now capable of undertaking anything with her paintbrush, however daunting. Except measuring herself against her father. It made her neither happy nor proud that people compared them. Instead, she felt deeply dispirited. She could listen to anything that was said about her work – that her best painting was not liked by the collectors, that she was getting her own back on her lover, on life, even on her father – she could listen to anything, except such direct comparison. To prefer one of them would seem to condemn the other, and cast the two of them into an impossible co-existence.

'The Signora is very young,' answered Galileo, 'she is still on the brink of her career.'

'But in a duel for renown,' the Grand Duke insisted, 'which of them do you think would go down in posterity?'

The scientist wavered, smiling. 'Think of Ariosto's *Orlando Furioso*, Your Highness: when two warriors claim rights to the same honour, they submit themselves to the judgement of God. They swear that they are willing to perish if they have lied and they face one another in single combat. The victor is the bearer of the truth and becomes the hero of a cycle of poems.'

'So you are proposing trial by ordeal?' quipped the Grand Duke's secretary. 'The judgement of God to be pronounced upon father and daughter by fire and sword.'

'By painting. That is my proposal,' flashed Cristofano, turning merrily in Artemisia's direction. 'The judgement of God by painting!'

It was as if she were chained to the wall, mesmerised by what she was hearing.

'And I shall take up the Signora's challenge,' joked Cristofano. 'I shall pick up her gauntlet *against* her father!'

The expression on Artemisia's face and the intense look she gave him compelled Allori to silence.

'Let Our Lord's will be done,' murmured Galileo, exercising a certain caution after his recent brushes with the Church. 'The outcome of every battle is in His hands.'

But the Grand Duke persisted: 'You must have some idea who will win. Who is favoured? Who has God's grace?'

'In the matter of grace, like all of us here, I leave that up to Providence, Your Highness. One thing I can say is that Signora Lomi surpasses her father in conveying the human passions. As for everything else – composition, design and colour – Orazio Gentileschi hovers between what he sees with the eyes in his head and the vision of his soul. He does not paint people and things as they are, but as they appear to him: in his work, the visible world becomes poetry.'

'One cannot say the same for his daughter,' snapped the Grand Duchess, turning away from *Judith Slaying Holofernes* with icy scorn. 'There is no need whatsoever of fire and sword, Signori, for God's judgement to be expressed. The voice of the Almighty can be heard quite clearly through the song of good poets and the hand of great painters. I cannot hear the faintest echo of it here.'

Her jewels clinking, she turned on her heels and left the studio with her retinue swiftly following.

If Artemisia and Pierantonio viewed the court's response as a disaster, they were wrong. Of course Cosimo II did not purchase the *Judith* which his wife so disliked, but he commissioned another version of the same composition in an even bigger format, a more Florentine *Judith*, with richer colours and more sumptuous costumes. He would, moreover, acquire the *Woman Playing a Lute* so highly regarded by Artemisia, and would ask her for a *Mary Magdalene*, the saint whose namesake the Grand Duchess was. Artemisia now belonged to the Medicis.

Yet the intense interest excited by her paintings had effects which were potentially more dangerous than any failure. On 16 March 1615, the day after the Grand Duke's visit, the Secretary of State, Andrea Cioli, wrote to the Tuscan ambassador in Rome:

It has been widely rumoured here that Signor Orazio Lomi de Gentileschi is one of the most excellent and famous painters to be found today in your great city, a fact which is

all the more readily given credence in consideration of the works by his daughter the
Signora Artemisia, also a painter by profession, which are to be seen here. Since it is
His Highness's wish to be more fully assured of this, he desires that Your Lordship
should seek out information of the most precise and well-founded nature and send it here,
which is my object in writing to Your Lordship . . .

Things had come full circle. The pupil's success now turned all eyes on the master.

Artemisia had not seen her father for three years. Her marriage had put an abyss between them. Marriage, and happiness with another man.

While all the talk of the trial had helped Artemisia's career, the scandal had shattered Orazio's. Agostino was freed on 29 November 1612 – the very day of Artemisia's wedding – and never left the city. He lay low and plotted his revenge. Orazio's apprentices were beaten black and blue in back alleys. His drawings disappeared from the studio; his colours and glazes curdled in their pots. His reputation had collapsed. With all his troubles, threats and slanders, clients had stopped coming to rummage through Orazio Gentileschi's sketches. Even Cardinal Borghese had given up pestering him to finish his work on the Casino of the Muses; he had instead entrusted its completion to Agostino Tassi's *bottega*.

By the spring of 1613, Orazio Gentileschi was well and truly without employment – the hard times that Tassi had predicted. It was he who was forced into exile by the rape case.

In April he took on a commission in the Marches and moved away with his three sons to Urbino. He ventured to hope that time and distance would calm down the hostility of his confrères. At fifty, Orazio Gentileschi went back to work in the obscurity of provincial churches.

Agostino did not, however, have long to relish this triumph. It was now that his former lodger, the painter Valerio Ursino, chose to take revenge for his long-standing grievance by reporting him to the criminal court for 'breaking his exile'. Agostino Tassi therefore found himself once again behind bars at Corte Savella. The consequences of his love affair with Artemisia were never-ending. A second sentence confirming the first condemned him to an even heavier penalty – exile for five years, not just from Rome, but from all the Papal States.

But the day after this verdict, 28 April 1613, there was yet another dramatic

turn of events. A third ruling, reversing all the earlier decisions of the court, annulled the judgement of the previous day, as well as that of November 1612. Absolving Agostino Tassi from all of Orazio Gentileschi's 'base and deceitful' accusations, it issued from the Borghese circle and was irreversible.

Proclaiming Tassi's innocence meant accusing Artemisia all over again: a prostitute prepared to go to any lengths to secure a marriage.

Pierantonio's family were frightened and Artemisia attempted to seek advice from her father. She wrote to him in the Marches, but didn't receive a word in response. Orazio's stubborn silence sealed the rupture between them.

Her father's rejection had dimmed, and at times destroyed, Artemisia's happiness. Her wish to see Orazio, to have his advice and his guidance in artistic matters, along with her constant need for his approval, continued unabated. She recalled his paintings obsessively in her work. He was everywhere: in the construction of her drawings, in her choice of subjects, in her composition, technique and the range of her colours. Each pencil mark, each brush stroke was made to please him – to satisfy that eye which she knew was unerring.

It was not to Cristofano Allori that she had dreamed of showing her *Judith*. There was only one man who could pronounce judgement upon her work – a man forced into exile by Agostino Tassi's manoeuvrings.

Riven by guilt, Artemisia Lomi had long felt responsible for Orazio Gentileschi's shattered career. But not any more.

After long months of waiting, after Orazio had remained deaf to all her appeals, Artemisia's sadness abruptly altered into a profound aversion – a detestation of everything to do with the past.

From one day to the next, for no apparent reason, the countless wounds inflicted on her by her father came back to mind. Injustices and humiliations which she had thought were quite forgotten, now, ten or fifteen years later, threw her into a retrospective rage at her suffering. Far from soothing her anger, the passing of time only made it more bitter. At the very mention of Orazio Gentileschi's name, a grey veil of despair descended over Florence. Artemisia was obsessed by the fear that he would reappear in her life, destroy her home and annihilate her creative powers.

Motherhood had increased her determination to protect the future of her family against her father's spite. The joy that burst upon her with little Giovan Battista's arrival in the world in September 1613 gave her a self-confidence

which was apparent even in her painting. For the first time in her whole life, she felt capable of mastering her art, of drawing lessons from her failures, and of savouring her success, without needing Orazio present to be its judge. She did not merely dread comparison with him, she was afraid of his memory, his intrusion into her life, his very existence.

The shadow of her father over the city of the Medicis threatened to send her whole world tumbling into the mire. Orazio Gentileschi meeting Michelangelo Buonarroti the Younger meant that the spectre of the Via della Croce had her in its clutches. Her life with him in the artists' quarter and his insults remained Artemisia's nightmare.

Injustice, betrayal and shame – these were what Artemisia Lomi unflaggingly painted. She drew her inspiration from the proud battles of history's great female protagonists: biblical heroines who stood up to falsehood; mythical figures who rose up against tyranny. On her canvases, Judith frees her people by slaughtering the despot whom she has just seduced. Jael saves the future of her family by hammering a tent peg through the head of an enemy. Lucretia brandishes her dagger and Cleopatra her asp, each of them taking her own life rather than submit to the law of the conqueror. Swords, daggers, poisons. Amazons, sinners, seductresses. Mary Magdalene, Galatea, Esther and Bathsheba – all of them struggle with love, death and freedom. All of them liberate themselves. All of them triumph.

Artemisia's finest works date from this period which carries the threat of her father's appearance – her master and rival.

Late in March 1615 the Tuscan ambassador replied to Andrea Cioli, the Florentine Secretary of State:

> *I have enquired widely and become fully informed as to the talents of Orazio Lomi de Gentileschi, painter, and I have also been to see a number of his works, large and small. He is a man who cannot draw, neither to compose a scene from history nor even to make a good likeness of a single figure. One quality he does possess is application, indeed the taking of great pains, and on alabaster he has produced certain charming and diligently made small works, and it would appear that he can make a head or even a half-figure with competence, because he copies from nature or from a thing he places in front of him. He takes trouble in the imitation of clothing, draperies and arms, and other things of this kind [. . .] From this I do not perceive this Gentileschi as a man to give satisfaction, for he cannot draw, is unremarkable, indeed his skills are commonplace, struggling to*

rise above the mediocre. And this is shown by a loggia which he has painted in the garden of Cardinal Borghese, and in the Cappellina della Pace for Settimio Olgiati, which are the only large works of his in Rome as far as I have been able to see; I shall leave aside that he is a man of such dissolute ways and of such a character that it is impossible to deal with him or reach agreement and all the while he is out of temper; he is employed at present by Prince Savello and lives in his household, and were my Most Serene Lord so inclined, the Prince would willingly surrender his services to you, and Gentileschi himself would be most willing, but as for the excellence of his painting, you may take note, Sir, of what I have described and found therein.

This judgement fell like an axe-blow. It came from a man who was in touch with Agostino Tassi: the Grand Duke's ambassador in Rome, whom Tassi had formerly advised to purchase works by the German painter Elsheimer. The phrase 'Orazio Gentileschi cannot draw' could have come straight from the mouth of the virtuoso of perspective, Agostino Tassi, who had constructed his entire body of work upon the straight line and the varnishing point. Such an appraisal put an end to Orazio's career in Tuscany. To Artemisia's very great relief.

Most excellent Lord my godfather, I desire a favour of you, that you should be so good as to let me have twenty-one lire which I shall give back to you as soon as I can. From your most affectionate Artemisia Lomi, who is almost your daughter.

Artemisia wrote this letter in September 1615 to her patron Buonarroti the Younger. The latter's accounts have offered enough evidence to suggest that his 'daughter' cost him three times as much as his other protégés. But he knew how much she was in need of money. For her colours, her canvases and her models; for her son – she aimed to find protectors for him; for her husband's costly frivolities; for herself, her gowns and her jewels, and for showing off her beauty at the court receptions.

Concerts, hunts, weddings and funerals – Artemisia attended all the worldly festivities, all the religious ceremonies. Nowadays, the Caccini sisters paraded through her studio with their entourage of poets, musicians and playwrights. Her name, which was unusual in Tuscany, had become fashionable. She carried neighbours' daughters to the baptismal fonts of San Pier Maggiore – little Artemisias. Cristofano Allori was often the godfather. The Florentines now placed the two painters' names on the same level.

Lomi, Allori. 'What I propose is the judgement of God by painting,'

Allori had once lightly declared. Artemisia felt able to take up the challenge against Cristofano. They were rivals, but also close associates, discussing their experiments, sharing their secrets, each compelling their creative vision upon the other. Which of the two had more influence on the other? Buonarroti played at refereeing and compared the bottle green, the yellow ochre and the crimson, the three colours which he found appearing in their work in similar relationships.

So, on that day in September 1615, Buonarroti wrote down yet another advance for the painter in his book of accounts, referring to her by her first name only. She had yet to deliver the painting which he had commissioned for his gallery, but Buonarroti kept an eye on the progress of this work and could be deemed satisfied.

Six months earlier, he had set out his iconographic programme in these terms: 'For one of the ceiling panels, I should like a young woman of very bold demeanour [. . .] unclothed [. . .] and embodying the Allegory of Inclination, the allegory of all the divine Michelangelo's artistic virtues.' With an extravagant lack of inhibition, Artemisia depicted herself – completely naked. At a stroke she asserted the beauty of her body and the brilliance of her talent as an artist.

Buonarroti was a scholar well-versed in reading symbols, besides being a curious man always intrigued by the bizarre, and he appreciated the sharp humour of the message. In order to please him, Artemisia Lomi cultivated her oddness and difference to the utmost.

The bonds she formed with the Medici circle became extremely close and lasted her whole life. To them she would owe her career, the display of her works on the walls of the Pitti Palace, and a great deal more. They made her the woman she was: witty and well-read, able to enjoy the pleasures of the intellect, to hold her own in argument, to compose verses and play the lute; the epitome of a Florentine painter such as all the courts of Europe dreamed of.

The whole course of Artemisia's life was influenced by her formative years in Tuscany. In October 1635, twenty years after Galileo's first visit to her studio, when the scientist was found guilty by the Church, made to recant the heresy of his discoveries and put under house arrest, she wrote to him from Naples with a familiarity of tone and voicing a sense of guilt indicative of their old friendship:

I know that Your Lordship will say that, did I not need to avail myself of your kindness, I should never have thought of writing to you; and indeed, given the infinite

obligations I hold in your regard, you could by all means draw that logical conclusion, since you do not know how often I have tried to obtain news of you, and been unable to find out anything for certain. But now that I know you are there and in excellent health, thanks be to God, I will have no recourse to any other channels, but turn to you, whose favourable assistance I am secure in seeking, rather than relying on any other gentleman; I do so all the more gladly since this situation is similar to the one when I gave a painting I had done of Judith to his Most Serene Highness the Grand Duke Cosimo of glorious memory, which would have been forgotten about had it not been for Your Lordship's protection in bringing it back, and thereby obtaining for me an excellent remuneration. I beg you, however, to do the same thing now, because from what I see there is nothing spoken of concerning two large paintings which I recently sent to His Serene Highness through one of my brothers, and I do not know whether they have given pleasure. I know only, through a third party, that the Grand Duke has received them, and that is all [. . .] and so I ask Your Lordship to discover the truth, and convey to me all that can be known about the Prince in this matter [. . .] in this you would do me the greatest favour, and I would hold it in the highest esteem, above any other granted to me by Your Lordship.

Intellectuals, scholars and scientists were to bestow much more than practical assistance upon the young illiterate of the Via della Croce. They would enable her to discover a world to which she had never had access, either through her father or her husband: the world of knowledge.

It was a world which would always remain closed to Pierantonio, even though he thought himself also attached to the circle of Buonarroti the Younger.

In a postscript to the note written by Artemisia on 15 September 1615 requesting an advance from her 'godfather', Pierantonio asked for four or five ducats to be sent instead of the meagre twenty-one lire requested by his wife, adding to his plea that 'Your Lordship well knows the disasters that have afflicted me'.

To what 'disasters' was he referring?

26

Artemisia's Bedroom

13 November 1615

Artemisia lay on her bed, her eyes closed, the back of her neck sunk into the pillows. With an outstretched hand she held on to the wicker cradle she had placed within reach. She had just been bathing her newborn baby, Cristofano; he was five days old.

Napkins and swaddling clothes were scattered next to two large copper bowls filled with water. Artemisia was too worn out to get up and tidy the room. Yet she was expecting visitors, most importantly the servant of Buonarroti the Younger, who was to deliver a new advance of three florins to her in person.

Pierantonio's mother had chosen Artemisia's clothes for this churching ceremony months ago and she was now dressed in all her finery. But her velvet bodice, which she was wearing for the first time since her confinement, was painfully tight on her chest. Her breasts were swollen with milk. The inflammation caused her such discomfort that the doctor had attempted to puncture it, with a scalpel first, then with a syringe.

Artemisia sighed; she would so much have liked to breastfeed Cristofano as she had Giovan Battista, but her mother-in-law was against it.

In the third month of Artemisia's pregnancy, the older woman had begun looking for a wet nurse, as custom decreed in aristocratic families. She claimed that her daughter-in-law's milk was useless; that the varnishes, oils and concentrated spirits used by Artemisia for her art had made Giovan Battista sickly. She had fussed about this so much that Pierantonio himself had become frightened in the end that Artemisia and her painting might, this time, give birth to a deformed creature.

Artemisia, however, had gone through this second pregnancy without any worries. Her condition struck her as quite natural. Managing to avoid the constant checks on her, she washed her hair every month, against all the rules (washing could have a negative effect on the baby's health), and furtively drank cedar juice to combat her morning sickness. And at no point had she stopped painting. As with Giovan Battista, the labour had been over in a few hours. The midwife was going around Florence telling people that she had never known anyone who had it 'pop out' so easily.

The door opened, and Pierantonio looked in.

'Have they brought you the florins?' he asked morosely.

She gave a negative wave of her hand, but her eyes stayed shut.

Then she heard the sound of unsteady little footsteps running towards her. She sat up and held out her arms. Two-year-old Giovan Battista climbed on to the bed, his cheeks burning with fever.

She always felt a physical pleasure in holding her son. She took delight in squeezing his chubby hands and would rub his tummy and caress the fine blond down of his hair, crossing Florence from one end to the other just for the pleasure of putting him to bed. She would make the sign of the cross on his forehead in blessing and watch him sleeping for a while before plunging back into the throng of the party. During these moments of solitude with her child, her whole being was soothed, as if she had finally succeeded in making past and present coincide.

In him she could see her brother Marco at the same age – he was two when their mother died – throwing himself at her skirts, rushing across the studio in Rome. She could see Francesco and Giulio, tousled from quarrelling, coming to her lap in search of consolation and fairness. She thought about her three brothers – her first children – and reproached herself for having been unable to protect them from their father.

When Agostino Tassi had entered her life, she had forsaken them. They were men now. She tried to imagine them. Francesco, tall and with a pretty face like a girl's; Giulio, rougher, always trying to dislodge his elders; Marco, her 'baby', who wanted to defend her . . .

'Giovan Battista, get down at once!' Pierantonio ordered.

He folded the napkins, cleared away the basins and rolled up the swaddling clothes. He performed these irksome female tasks laboriously, all the while circling the bed as if there was something he wanted to ask.

'How much more do you think you can get?' he said finally.

She shrugged as if she had no idea.

'The apothecary asks me to settle his account every day,' he insisted. 'Giovan Battista is costing me a fortune. His hernia . . .'

'He has never worn that horrible iron belt that you ordered; give it back.'

Pierantonio shot his wife a look in which exasperation vied with anxiety. Her solicitude for her son and her vigils during his illnesses struck him as distinctly unnatural. He was irritated by her oddness. But since he had no trouble selling her portraits of Giovan Battista as the Infant Jesus, he did not complain.

'It's clear that you are giving in to his every whim,' he grumbled.

'Whims? Have you heard him crying? You subjected the poor child to a pointless torture with that belt . . .'

'Everything I do is wrong.'

'I've never said that. It is just that we have so many expenses.'

'Whose fault is that?'

'You can talk. And what's more, I don't know the half of your extravagances . . .'

'May I remind you that it is none of your business!'

'I, however, am the one who is attacked.'

'It doesn't matter . . .'

'What do you mean, it doesn't matter?' she echoed, her voice raised.

'With Buonarroti, you have nothing to fear.'

'But I am the one on whom judgement is passed!'

Between 1613 and 1616, Artemisia Lomi's name was cited eleven times for debt before the tribunals of the Florence guilds. Carpenters, drapers, apothecaries, all the guilds filed suit against her. There were inquiries and counter-inquiries, and on each occasion she was, in the end, forced to pay.

There were times when she was not to blame – when Pierantonio financed his own peccadilloes with loans of which she knew nothing. But her creditors harried her mercilessly. They knew that in this strange couple, both artists, it was only the wife who worked; that she alone had powerful enough protectors to make the two of them solvent. Artemisia's brilliant success simply aggravated the Stiattesis' sordid financial breakdown.

Only one institution could shield her from prosecution by the artisans' guilds: the Accademia del Disegno. In its half-century of existence, the Accademia del Disegno had never admitted a woman to its ranks. But

Artemisia dreamed of joining. The protection of the Grand Duke, the Accademia's patron, and the weight brought to bear by its three consuls – one of whom was none other than her uncle Aurelio Lomi – would allow them to separate Artemisia's interests from those of her husband. If she belonged to their small society, numbering a hundred people in total, she would cease to depend upon the corporations by which Pierantonio was bound.

The Accademia del Disegno was one of the most prestigious associations in the art world. In their day both Titian and Michelangelo had applied to join. It was a society that brought together the elite among painters, sculptors, architects, scholars and professors. A society which had the power to protect its members from claims made against them or defaults in what was due to them. Formed in 1563 by Giorgio Vasari, it maintained the dual purpose laid down by its founder: the training of young artists and academic disputation. These two activities were clearly reflected in the two amphitheatres set up in the Cistercian monastery at Borgo Pitti: the workshop and the debating hall.

Unlike Rome, which followed the medieval teaching tradition (the apprentice would enter a studio at a very young age, grinding colours, preparing canvases and learning technique before theory), Florence offered courses in mathematics and physics, perspective and drawing, before the neophyte could venture to pick up a paintbrush. The impetus came from Leonardo da Vinci, who had aimed 'to elevate painting from being a manual task to the level of an intellectual activity' – to turn the artisan into an artist, the painter into a poet. The Accademia del Disegno sprang from this idea.

Cosimo I had granted the privileges of gentlemen to the elected members of the Accademia. They carried a sword and in any civil suits either between members themselves or between members and the rest of the world, they were answerable only to one another and the Prince. All court decisions were a matter for the three consuls of the Accademia (selected by the members), the magistrate appointed by the Grand Duke and the Grand Duke himself. These privileges were a public reminder that the great painters, sculptors and architects had broken away from the artisans' guilds. Thanks to Michelangelo, who was idolised in his native city and raised to the status of a demigod – *Michel più che mortal, Angel divino* – the position of the artist in Florentine society had been transformed. This new social condition meant that the artist could reject all forms of authority – except that of the Prince and the Accademia – and freed a young academician from parental governance.

The fact that membership gave freedom of action, unbound by any

guardian, father or brother, would alone have been enough to exclude the weaker sex from attaining to the ranks of the Accademia, since women were legally minors for the whole of their lives. Entry was made even more difficult by the fact that the head of the family – to whom an artist under twenty-five years of age was answerable – had to sanction this transfer from paternal authority to the jurisdiction of the consuls: the legal document had to be ratified by the father. If the Accademia del Disegno were to make an unprecedented break with tradition and one day admit Artemisia Lomi to the forum of the debating hall at the Cistercian monastery, it would require Orazio Gentileschi's presence in Tuscany. Artemisia would have to obtain from her father what he would never grant to her: the honour of becoming the first female academician in Florence's history. At the age of twenty-three.

27

Travelling between Rome and Florence

July 1616 to February 1620

Jolting along on the back of the mule that carried him to Florence, Orazio Gentileschi could not have imagined his daughter's contradictory feelings at the prospect of meeting him again.

Surveying the sun-baked Roman countryside with its long, red-arched aqueducts, its towers, burial mounds and ruined tombs, Orazio's spirits lifted. The closer he got to his daughter, the more he surrendered to the joy and exhilaration of seeing her again, and he let himself be buoyed up by a hopefulness which swept away the bitterness of the past. In earlier days he had certainly blamed Artemisia for his exile in the Marches, for his winters spent in damp chapels; but distance and time had subdued his grievances and softened memory. This was a reverse progress from Artemisia's. Though she had at first experienced separation from her father as agonising and wrong, remembering him now only gave her pain. And Orazio's imminent arrival made her anxious and fearful.

For all that, the purpose of this meeting, in July 1616, was to do each other a mutual good turn. Artemisia could not enter the Accademia without her father's presence in Florence, nor could Orazio work in Tuscany without his daughter's influence at the Grand Duke's court.

'The time will come when Gentileschi will need Artemisia's help,' Agostino Tassi had once predicted. 'And God will permit this just reversal because of Orazio's total lack of compassion towards her.'

Over the past four years, it was Orazio who had felt himself the object of indifference. Everything proved that his daughter had never loved him: her marriage, her departure and her silence – in his misery, he forgot that she had written and he had left her letter unanswered. He had even harboured terrible suspicions about the part she had played in his exclusion from the Florentine

court and for the dismissal of his work. Orazio Gentileschi had come to hear about the negative opinion of his work through one of the ambassador's secretaries, a well-intentioned friend who had made sure to pass on a copy of the letter to him. If he had discerned in it certain ideas of Agostino's and his old rival Giovanni Baglione – the man who had brought an action against him thirteen years earlier, a painter now in close contact with the Pitti Palace – it also contained phrases which had brought to mind the brutal words of his daughter during their disputes. 'He cannot draw.' No reproach could have wounded him more deeply. Was drawing not the very point upon which he had once criticised Artemisia's pictures?

But all his worries had been swept away by the message he had received from her in Rome. She would welcome him to the Stiattesi household and introduce him to the Grand Duke. She would secure him commissions.

The desire to prove the perfection of his art to his daughter had a great deal to do with his haste in accepting this invitation. He urged his mule along the road that wound towards Viterbo with an increasingly light heart. Under the broad felt hat that shaded him from the sun, his face seemed thinner than ever, his cheeks made pale by the dampness of the churches at Fabriano, Urbino and Ancona, his eyes inflamed by fresco-painting, an arduous labour for a man of fifty-three. Although he had spent the previous winter in Rome, with bed, board and laundry provided at the Savelli Palace as a member of the Prince's *servitù particolare*, this domestic position reduced him to the ranks of gardeners, clockmakers and fountain-builders – in other words, a servant.

From being an independent painter, the master of his own studio, Orazio Gentileschi had fallen into a condition which, for all its advantages, would only have seemed an honour to an artist at the beginning of his career. He had had to produce for his patron almost a dozen works in six months: history paintings, still lifes – and some portraiture, a genre which was not always suited to his talents. With the exception of a *St Francis*, which presided over the Savelli Chapel in San Silvestro in Capite, he could take no pride in any of these official commissions.

Working for the Medicis was now his most heartfelt dream. Settling in Florence. Living at his daughter's house. Resuming their collaboration of old. This project had erased all his rancour at a stroke. Inwardly he repeated the words of St Luke, patron saint of painters and of the Roman academy of painting to which he belonged: *the worthy disciple will be as his master.*

As he rediscovered this Tuscan countryside, the landscape of his childhood – the white road winding between rolling hills, the black cypresses against a gold background – he felt the elation of a man returning to harbour. He was coming back to his daughter, coming back to Florence, coming back to himself. Orazio expected his reunion with Artemisia to bring serenity. He hoped to become at one with himself again through being united with her. He was reminded of little Artemisia at six, grinding colours so quickly, mixing pigments so cleverly – his extension, his double. It would be like the old days.

In the powerful hope aroused in him by this return to the time of innocence, the time before the trial and before Prudenzia's death, he forgot about the existence of Pierantonio Stiattesi. In four years, Orazio had not given a single thought to his son-in-law. He had learned of the birth of his grandchildren, Giovan Battista, now aged three, and Cristofano, one year old, but had immediately put them out of his mind. On the other hand he was concerned for his three sons, whom he could see jogging along in front of him on their donkeys: Francesco, nineteen; Giulio, seventeen; Marco, fourteen. They were now men.

After Artemisia's departure, Orazio had lived alongside them day and night, sharing the same bed and the same drinking binges. They had worked together in the small-town churches of the Marches and in Prince Savelli's household. Their presence by his side gave Orazio Gentileschi a sense of security which made him reckless. For a four-day journey between Rome and Florence, he ought to have employed the services of a *vetturino*. This was a guide who would provide the mules, organise the staging posts, the meals and the overnight accommodation at inns; and who would come to an agreement with bandits so as to spare his clients any nasty encounters. But Orazio was too impatient to put up with any delays. He knew the road and had complete confidence in Francesco's harquebus, and Giulio's and Marco's daggers. In the company of his children, he thought he was invulnerable.

When they reached the city gate, the four men supplied their 'bill of health' to the Florentine customs as a guarantee that they had had no contact with plague victims. They let themselves be searched and stripped of some of their effects – notably their weapons – which they would recover when they left the city; or if they were to settle there, after having obtained their residence permits. The Grand Duke's administration regulated every detail. They sold their poor

mounts, since travellers entered the city on foot for reasons of hygiene. Only draught horses and oxen, pulling coaches, traversed the large flat stones that paved the streets.

Walking in the shade of the overhanging roofs, the four men made their way past the walls of the Boboli Gardens. In the early morning stillness they could hear the three hundred horses of the Grand Duke's stable pawing the ground and the lions, wolves and hyenas of the Pitti Palace menagerie, the most extraordinary zoo in Europe.

When they had crossed the Ponte Vecchio and arrived at the Stiattesis' house on the market square of San Pier Maggiore, they found the downstairs workshop shut up and the house empty. In the first floor apartment, lengths of funeral crêpe covered the credenzas and the ebony cabinets, the tables and the mirrors.

Perplexed, Orazio lifted the veilings, disclosing the precious objects purchased by his son-in-law: a collection of small wine glasses, a crystal dish, a vase made of semi-precious stone. The four men rummaged in the chests, fingering the linen and gowns, handling jackets with taffeta-lined long sleeves. With each yard of cloth, Orazio's conciliatory mood changed. While he had toiled away in the cold and dark, Artemisia had been strutting about dressed in silk.

The gnawing jealousy of old came to the fore again. His eyes fixed on all this flashy finery, Orazio did not move. He had reassumed the severe expression that he had discarded on the road leading back to his daughter.

He had never had any doubt that the mediocre Pierantonio would bring misfortune in his wake. The crêpes veiling the mirrors spoke plainly of mourning. But the gowns and objects, the order which reigned throughout the house, all screamed opulence. When he and his sons were in penury. Because of her. They would suffer no further for Artemisia's sake, Orazio solemnly swore. And the wealth which he now saw at first-hand suggested that he might soon be recompensed for all his troubles.

'They are in the church across the road,' said Francesco, who had gone out for a moment to make inquiries.

'What are they doing in church at this hour?'

'The children are dead.'

'Whose children?'

'Artemisia's.'

For a split second, Orazio was frozen in shock. He imagined his daughter

as she must be at this moment, her poor face distorted with grief. Emotion choked him.

'Both of them at the same time?' he muttered.

'A few hours apart. The sickness was contagious.'

No one – save his children – had any idea that Orazio sometimes displayed a sentimentality at odds with the harshness of his character. When, as a matter of propriety, he had had to attend the funeral of a neighbour's child, or the burial of a baby (a frequent occurrence, since six children out of ten died before the age of seven at that time) he found the ceremony unbearable. Perhaps it reminded him of the deaths of his own sons, his two Giovan Battistas? And the loss of Prudenzia. He felt a physical pity, a compassion that he could not control.

In the past, Artemisia had guessed at her father's fragility, for he could not see a child suffer without being disturbed by it. But rather than taking advantage of this, she protected him by using all her will power to hide her wounds from him, to bite her lip and hold back her tears. Later, she had forgotten about this emotional side to Orazio, neglecting to make the most of it during their disputes. Perhaps in the end she came off the better for it. Since Orazio's reaction to his emotions, which he took for weakness, was anger and flight.

'Go to the church,' he ordered the three boys roughly. 'Go and pray with her.'

He watched them crossing the square and disappearing beneath the portico of San Pier Maggiore. Once they were out of sight, he shook himself out of his torpor and walked outside to look at the house. Standing back from it, he could take it all in: it was well-to-do. He would have a comfortable life in it. His gaze was arrested by the opening in the roof – the oculus of the studio. Quickly he went inside and climbed up to the loft. Forcing open the bolted door with a blow, he entered the realm of Artemisia Lomi.

The shock which was to determine the rest of his life was not immediately felt. Slowly and cautiously, he advanced towards the row of canvases drying in the light. The sun struck on the back wall, splashing the paintings and making them seem, from a distance, like big white mirrors, blank and unsilvered.

Orazio cast a shadow on the floor, and as he made his way across the studio it grew larger, spreading up over the paintings and darkening the work. He had to take a few steps to the right, backing away at an angle so as to get a good

look at the *Allegory of Inclination* intended for Buonarroti. But there was still a reflection of his shadow on the varnish.

On the easel his daughter's body, quite naked, was displayed in front of him. She was sitting with her head turned to the left and her face raised towards him. A star shone above her hair, which was plaited into a diadem in the way that he liked. She had attached little bells to her ankles, symbolising speed. In her hands she held a compass, symbolising her determination.

Making an objective assessment, Orazio could see that this figure was successfully executed: the body given form by the play of light, the meticulous detailing of the female anatomy, the transparency of the flesh, the figure's solidity and weight, its balance within the space. He reassured himself that it was no more than another version of their *Susanna and the Elders*. His own *Susanna*! Artemisia had simply inverted the composition, shifting the knees from right to left and the pose of the arms from left to right. It was just a pathetic variation.

Somewhat ill-humouredly, he moved away so as to study the second canvas. A *Penitent Magdalene*. The sinner at the moment of her conversion, when she renounces the world to devote herself to Our Lord – far less persuasive than his own Mary Magdalene that he had recently painted in the San Venanzo church at Fabriano, kneeling and clasping the cross in her arms, repeating Artemisia's tearful gesture at the moment when she asked for his blessing on her wedding day.

The figure he was now studying, with one hand on her breast, the other pushing away the mirror which she was renouncing, was no supplicant. She did not beseech the Lord for either mercy or forgiveness. Painted in the image of Artemisia, with one bare shoulder and her breasts on display, she was turned not to God but towards the world, and she tempted the man now surveying her with her charms. He stooped closer to make out the inscription Artemisia had painted in gold letters on the mirror's frame: *Optimam partem elegit* – she has chosen the better part.

Angry now, he could not but admire the painting, dazzled by the brilliance of the colours, the explosion of whites, by the cascade of golds that streamed over the gown. That gold was his secret! And that green, and that crimson – how hard he had had to search and experiment to achieve them. His colours, the keys to his art. But these were stronger – richer and more dramatic. Artemisia *had* chosen the better part: she had taken everything from him. But this theft was as nothing compared with what Orazio was now

realising. The chair on that canvas – its velvet was exactly the same as the cloth on a stool in the work he had just finished in Rome. A *Woman Playing a Lute* in a dress of gold, which at that very moment was drying on the top floor of the Savelli Palace. A painting that his daughter had not seen! And yet, each fold in the fabric covering the *Magdalene*'s knees echoed his own work on the draperies for the *Woman Playing a Lute*. Without the possibility of drawing any inspiration from his work, without the possibility of copying it, Artemisia was reproducing it.

He took fright. Was he losing his wits? Both women were seated but Artemisia had depicted her figure face on. His was viewed from the back. In Artemisia's case the woman's hand was on the heart, in his on the strings of her instrument. In her case the other hand was pushing away a mirror, in his the hand held the neck of the lute. No, he was not mistaken. The *Magdalen* seemed to replicate the *Woman Playing a Lute*, but it did so by inversion, amplifying and dramatising it.

Two paintings, each seeming to reflect the other. Orazio was at a loss to say which was the original and which the double. The same image from both sides of a mirror. Yes, Artemisia had taken the better part: she had taken everything from him.

Furious now, he went from one canvas to the next. A *Diana at her Bath*. A *Rape of Proserpine*. *An Amazon at Arms*. Always the same face, the same body repeated over and over. Artemisia. Powerful. Massive. Quite unrelated to the kind of femininity that he favoured.

He might perhaps have accepted that his daughter should imitate him, but not that she should betray him. For she did not stop at copying him. In her hands, Orazio's colours, his compositions and his figures changed their nature. He could find not the least trace of fervour in these flesh and blood heroines, the least aspiration towards divinity. There was no sense of the sacred in her saints and martyrs, not a hint of mysticism. Artemisia had betrayed everything – a bloodsucker, emptying his art of is essence in order to nourish her own.

Orazio was very aware of his own strengths. Idealisation. A delicate balance between the religious sentiment of his subject and the humanity of his model. Who else could balance such splendour and restraint, such opulence and delicacy? But beauty, harmony and art all collapsed under Artemisia's violence, a flood tide sweeping his work away, wrenching it from him, cutting it off from God. How could Our Lord allow that her shamelessness should

attain such aesthetic perfection? For Artemisia's painting was coarse. It was human – appallingly human.

It was at this moment that he heard the sound of the latch. He turned round. She was coming in.

She stood in the doorway for a minute without moving, a small black-garbed figure bowed down by grief. Her face showed no surprise at finding him there.

Face to face, at opposite ends of the studio, father and daughter spoke not a word. He saw that she was weeping.

What were his feelings at the sight of this grieving mother? The feelings of a man who had endlessly painted the sorrow of the Madonna intent upon the child, whose death, she knows, will precede her own?

His emotion was so powerful that Orazio could not contain it. He ran towards her. Artemisia thought he was coming to clasp and embrace her, but with tears on his face, he jostled past her, rushed down the stairs and disappeared.

Orazio probably took up lodgings in one of the city's numerous inns. During this brief stay in Florence, he must have visited monasteries and chapels and seen Masaccio's frescoes, along with the paintings of Botticelli and Fra Angelico. For Orazio Gentileschi's work would hereafter reflect the combined influences of the Florentine Renaissance masters – as well as that of Artemisia Lomi. But he did not see his daughter again. He refused her overtures and kept his distance from her.

He did, however, ratify all of the papers required by the Accademia del Disegno. The Grand Duke's personal protection, the support of the consuls and the friendship of the most eminent members had made possible the admission of Artemisia Lomi without her name having to be submitted to a vote that might have been unfavourable. On 19 July 1616, 'the daughter of Orazio Gentileschi, wife of Pierantonio Stiattesi' paid the sum of four scudi, which enrolled her *ad vitam* on page 54 of the register of the most prestigious artists' association. By acknowledging the payment and the matriculation number, Orazio granted his daughter what she desired most of all in the world: an identity. He made her the gift of a profession, a career, and her freedom. Then he went on his way in silence.

But on the morning of departure, two of his sons, Francesco, the eldest, and Marco, the youngest, came back to Artemisia's house. They found their sister in her bedroom prostrate before the empty cradles. Not knowing what to say

to her, they simply took her in their arms. Artemisia let herself fall against them and they held her for a long time, wordlessly, before making their escape.

Orazio disappeared from Florence. Artemisia's emancipation confirmed their separation. By this procedure, father and daughter were now released from any mutual responsibility. There was now nothing owing between master and pupil. Neither gratitude, nor help.

Orazio refused to listen to any words of thanks and returned to work in the Marches with his sons. He would continue to retreat further and further into exile.

Her father's flight and his generosity occurred at what was the most terrible period in Artemisia's life: the moment when God struck at her through her own children. No longer a woman who was a mother, she became again the daughter of Gentileschi, a daughter who had a furious need for love and support. Why had her father abandoned her? In their brief exchange of looks, she had thought she saw the tenderness there once was. Why had her father ratified her entry into the Accademia if he did not love her? If she did not have his recognition, his admiration?

Or perhaps he felt such scorn for her painting that he saw no point in opposing her success. She knew that he could act mercilessly when he felt threatened. He probably so despised his daughter's talent that it was no affront to him. 'Which of the two is the better painter?' In Orazio Gentileschi's eyes, the question seemed to be settled. In a duel for glory, Orazio Gentileschi would have nothing to fear from Artemisia Lomi. So why those tears in the studio? Was he weeping out of pity for the sorrow that afflicted her? Or from fear and envy?

Throughout the quarter of a century to come, she would be obsessed by these questions. What had he seen in her paintings on that July day in 1616?

Their failed meeting in Florence had opened up a breach in the hearts of both father and daughter that no success or triumph could fill. An abyss of doubt and dread which would force them to seek one another out, in a cycle of flight and pursuit, until they found the answer.

'As for my painting, I swear to Your Lordship that I should not have given it to anyone but him for this ridiculous price, to no one, not even my father,' Artemisia would write nearly thirty-three years later. Orazio Gentileschi, her ultimate reference point.

Had his fleeting visit to the Stiattesi household hastened the estrangement between Pierantonio and Artemisia? Or was it the loss of the children that had a destructive effect on the balance of the relationship? Confronted with illness and death, the two of them reacted in quite different ways. Artemisia could not forgive Pierantonio for his passivity, his inertia, his fatalism in the face of the calamity afflicting them. Pierantonio could not forgive Artemisia for her excessive despair. 'One would think she is the only mother in the world to have lost children,' he thought with exasperation. His own sister, Lisabetta, had buried six of the ten children she had brought into the world. Now Lisabetta and Artemisia were both expecting babies, and Pierantonio had no doubt that they would live to a ripe old age. But his wife's weeping and wailing persuaded him that he had no place in the house, that he counted for nothing in her life.

Artemisia's entry into the Accademia – the honour and the consequences of her emancipation – cast them into two enemy camps. She no longer had any need of her husband in order to exist professionally. Pierantonio, for his part, knew that he was too insignificant and obscure to follow her on to the heights she was now attaining. Or was it rather Orazio's return into his daughter's heart that separated her inexorably from her husband?

This time, no one could have accused Gentileschi of spreading jealous and malicious gossip about his son-in-law, since he had not seen Artemisia again. But the warmth of her reunion with her brothers had soothed Artemisia's suffering and given rise to a longing for a more profound and enduring reconciliation between all the members of the Gentileschi clan. Their departure left her with a new emptiness. They left her alone with a husband who took his mind off his misfortune, his worries and dissatisfactions by spending the couple's money. All of their income went on the purchase of countless costly trinkets.

When she left the elevated company of sessions at the Accademia, scholarly meetings at the house of Buonarroti and visits to Cristofano Allori's studio, she came home to marital squabbling, debts, mourning, legal complaints and suits.

On 5 June 1619, she wrote to Cosimo II de' Medici:

Most Serene Grand Duke, Artemisia, presently the wife of Pierantonio Stiattesi, most humble servant of Your Serene Highness, advises you with respect that her aforesaid husband has indebted himself to a certain Michele, a shopkeeper, and wishing

to be paid, this man has obtained a ruling from the Accademia del Disegno against the said Artemisia without her knowledge of any of this since the summonses were placed in the hands of her said husband, this being a legal petition [. . .] Artemisia comes on her knees to the merciful feet of Your Most Serene Highness to beg that this judgement be revised, because as a woman she cannot become indebted so long as her husband is living with her, all the more so since he has had the whole of her dowry; and to suspend the damages against her. For this grace she will always pray to Our Lord God for his greatest happiness and glory.

Love sadly foundering in sordid financial disputes? Or a scheme to avoid confiscation of goods, with the couple conniving in an attempt to spare themselves ruin by dissociating their property and their interests?

Whichever is the case, five days after the dispatch of this plea, death once more came knocking at their door, carrying off with it their last-born, little Lisabella, who, on 9 June 1619, was buried by her parents in the church of San Pier Maggiore. Giovan Battista, Cristofano, Lisabella: one by one they were taken from them by illness. Was the Lord punishing Artemisia for her rapid and excessive success?

Throughout the years of her extraordinary rise, she had danced, her girth heavy under her ball gowns. She had worked, her belly protruding under her green smock. She had painted at an angle, sometimes using long brushes to cancel out the distance between her and her canvases.

In five years she had brought four pregnancies to full term.

She had given these children powerful godparents to watch over their future: grand aristocrats, scholars of high standing – Cristofano Allori, of course, but also the satirical poet, Jacopo Soldani, as well as the wife of the illustrious dramatist Jacopo Cicognini, and the Cavaliere Aenea Piccolomini d'Aragona.

Only one of these babies was to survive: a daughter. Hers was a name dear to Orazio Gentileschi's heart. A name that was sacred: Prudenzia.

Artemisia Lomi, Prudenzia Stiattesi: from now on mother and daughter would not be parted.

Mist slithered over the roof-tops and swathed the whole of Florence in its heavy gloom. Cosimo II de' Medici was dying. And though the Pitti Palace continued to describe the blood that stained his handkerchiefs as a 'haemorrhage of the gum', the whole court was aware that his diseased lungs

were sapping his strength. Word came at once from the sovereign pontiff in Rome begging the Grand Duke to 'make lean days fat'. He was to eat meat during Lent, stuff himself with pastries and drink Tuscan wine – excess by authorisation of Paul V Borghese. But Florence was not deluded. The Pope's dispensation offered no invitation to pleasure. Balls and festivities did not prevail over penitence and fasting. Instead, anguish triumphed over youth and happiness. The sound of laughter no longer echoed through the spacious salons of the Pitti Palace.

Only the soaring voice of Francesca Caccini tore through the silence of the night. Behind the closed doors of the Grand Duke's chamber, she sang arias to lighten the weight of fear and give relief to pain. She gave voice to Buonarroti's verses, making music of love's sighs. In a voice that was likened to the music of the angels, she sang, until dawn, of springtime and life.

As a pale February sun climbed into the Tuscan sky, the Grand Duchess Marie-Madeleine of Habsburg left the sick man's bedside to throw herself at the foot of the altar. She had all the painted cupboards in her chapel opened wide, and she fell into contemplation of the rock crystal coffers stacked up to the ceiling. Reliquaries set with gemstones, caskets of ivory, ebony and mother-of-pearl – her precious relics. She felt as if the hundreds of gold and silver cherubs who kept watch over the treasure of Christianity were looking down on her. In turn they offered her one of St Lawrence's teeth, one of St Benigno's arms, adorned with a bracelet of pearls, and the blood-stained linen of St Cecilia, who was martyred with her throat cut. Touching these relics, kissing them, was the only cure for healing bodies and souls. She had a sacred flask brought into the Grand Duke's chamber – containing the breast milk of the Virgin Mary. All day long, the Grand Duchess's priests anointed the belly of Cosimo II with oil from the lamp of Santa Maria of Trapani. At dusk, his confessors administered a drop of the Madonna's milk.

While the lutenists' music rose from a courtyard outside – the sick man could no longer tolerate their presence in the room – the Grand Duke's exhausted body lay covered by every relic in Florence.

A few hundred yards from the Pitti Palace, the Medicis' old friend, Cristofano Allori, was also dying. He was suffering from a gangrene that had spread from his foot through his entire body. Surrounded by the succour of the Church, he prepared for death, aspiring to be at peace with the Lord, and repenting his obscene paintings and lascivious works. He would not see Artemisia Lomi again.

Locked up by Pierantonio, she stayed in her studio. Her husband was wild with jealousy, believing, as did all of his family and the whole of the city, in a love affair between the two distinguished painters. He had scarcely given a thought to Artemisia's past throughout the first three years of their union, but now it obsessed him. If she had given herself to Tassi before her marriage, why not to others? The words cuckold and whore carried the same charge of violence in Florence as in Rome, and Pierantonio wallowed in them. He felt unloved and neglected by his wife.

From now on, Pierantonio would be no more able to endure Artemisia's talent than he could resign himself to his own mediocrity. Orazio's prophecy was fulfilled. Artemisia's husband, once so mild, began abusing her. In sudden fits of tyrannical behaviour, he would keep her locked up for weeks at a time. She would fight back. The days of her extreme gratitude towards the man who had pulled her out of hell were a long way off. Now she despised him, because Pierantonio was weak and he was taking them along the road to catastrophe.

'You can't have everything,' Orazio had shouted. 'You can't have the love of a husband *and* the perfection of your art: Happiness here on earth *and* immortality.'

On 10 February 1620, Artemisia Lomi made one final appeal to the benevolence of the dying Grand Duke. She wrote to him asking to be allowed to spend some time with her family in Rome.

What did she expect? To be with her brothers again? To be reunited with her father? She forgot that Orazio would refuse to meet her. Indeed he would run from her – to Genoa, to Turin, to Paris, to London, to the ends of the earth – rather than relive his confrontation with Artemisia's paintings.

Had Orazio Gentileschi been older, had he already painted all the works that he carried within him, perhaps he would have tolerated the sight of his talent absorbed into his daughter's art. But this mirror that Artemisia's painting held up to him disturbed his creativity. It threatened his soul, impairing his vision of things at its deepest source.

Prompting her trip to Rome, Artemisia explained to the Grand Duke the many 'indispositions' she had suffered, in addition to the 'not insignificant difficulties' she had with her home and her family. To recover from these troubles she wanted to spend some time with her friends in Rome but would return within a few weeks at most.

Artemisia was wrong. After her departure her Florentine friends were to

die. On 21 February 1621 Cosimo passed away. A month later, Cristofano Allori followed him to the grave. Their death knell was also the city's. Florence fell into the hands of two women, the Duke's mother and his widow, two religious bigots who would place power in the hands of ignorant priests. Tuscany would no longer want Artemisia. The regent Marie-Madeleine of Habsburg would see to it: she had never appreciated Artemisia's paintings.

With Pierantonio and their daughter, Artemisia settled in Rome, in the Via del Corso – the street where carnival was celebrated – in the heart of the artists' quarter. She rented a little two-storey house with a red door and three front steps, not far from the Via della Croce, where in the past she had been raped, and close by the Via di Ripetta, a street in which prospered the business of a famous decorative artist who painted frescoes in the princely salons of the Eternal City: Agostino Tassi.

Now wreathed in honours and sure of her identity, she was back on the ground where all her battles had been fought. The time had come, she knew, for reunion and reconciliation with herself. Artemisia Lomi and Signora Stiattesi were no more. She readopted her father's name, and gave it the lustre which Orazio had been unable to preserve. In Rome, she would be 'Gentileschi', the head of her family.

At the age of twenty-eight, she had achieved a social position. But above all she had won for herself the status of a legal entity, with rights and powers before the law. Hereafter, posterity will discover her initials at the foot of notarised documents; her signature will authenticate tenancy contracts and bills of sale. No women before her – except for widows – had enjoyed such privileges.

Free of all guardianship, mistress of her fate, Artemisia was bound only by herself. In census registers she would appear from now on as a *padrona di casa*. 'Artemisia Gentileschi, painter'.

PART IV
THE ALLEGORY OF PAINTING

London, Venice and Naples at the Time
When Painters Were Spies
1621–1638

28

London

Six years later, December 1626

It is some two months since Signor Orazio Gentileschi, painter, arrived here from France. I am given to understand that, besides the pursuit of his art, he is engaged in another matter of great importance...

Thus the London envoy of the Grand Duchy of Tuscany noted in one of his weekly dispatches.

The 'matter of great importance' to which Artemisia's father seemed to be devoting his attention was none other than the Thirty Years War – slaughter on a grand scale, putting Europe to fire and sword.

At stake was the pre-eminence of the House of Habsburg, with its two wings, the Austrian Habsburgs and the Spanish Habsburgs, a hegemony which was unacceptable at any price to England, France, Venice and Rome.

The envoy in the service of the son of Marie-Madeleine of Habsburg, the Grand Duchess who had so detested Artemisia's painting in Florence, continued thus:

This supposition of mine on the role of the painter here in London is fuelled by the fact that he has frequent meetings with the lord Duke of Buckingham, and also with the King, and also by the quantity of correspondence which he sends, and moreover some secret expeditions to Brussels.

What had an Italian artist like Orazio Gentileschi been doing in Brussels? The conflict was already devastating Flanders and the Low Countries. The massacres sprang from the ambition of the German Prince Ferdinand II, an Austrian Habsburg, who aimed to rid the world of Protestant heresy and to

transform the Holy Empire into a vast, centralised Catholic state. His efforts were backed by Madrid, which had recently undertaken a fresh armed intervention in the Low Countries upon the expiry of the twelve-year treaty between Spain and the United Provinces of the North. The Danish sovereign, followed by the King of Sweden – both Lutherans – quickly intervened in defence of their co-religionists. But, as rivals, each feared and was threatened by the other. For now, France was hindered by her internal difficulties from taking on Austria and Spain which, intent on surrounding her, whittled away at all her borders, and found herself forced into secret agreements with the Protestant adversaries of Spain. Louis XIII and Richelieu, the Very Christian King and the Cardinal of Mother Church, suppressed the kingdom's Huguenots with one hand, while with the other they sought alliances with the heretical states. Primarily with England, to which, as proof of its good faith, France offered one of her daughters – a very Catholic queen.

Alliances overturned, fortunes reversed, *coups de théâtre* – all of the complications and betrayals of the Thirty Years War are explained by the fact that it was a war of religion, in which the participating states defended their immediate interests, which fluctuated with circumstances, rather than the faith they proclaimed.

Thus the Spaniards, implacable enemies of Protestantism, sought to sign a secret non-aggression pact with the English heretics, a pact which would enable them to fight and conquer their Catholic friends: the French.

Negotiations of this nature could not be conducted in the light of day, nor by official ambassadors. And so Richelieu, Olivares and Buckingham – the prime ministers and all-powerful favourites of the kings of France, Spain and England – employed a host of emissaries, agents and spies whom they dispatched to all the foreign courts. These men had to work under cover of activities remote from politics and diplomacy: music, architecture, painting, for example. What foreigner would ever be granted an interview with a sovereign lasting several hours a day except for the painter immortalising his likeness? Who better than the artist – during that privileged time when the painter has his model to himself – to elucidate the events of the day under a favourable light to the country he serves?

As a socially hybrid individual, half-way between the manual worker – whose word counted for nothing – amd the creator of genius, bearer of the word of God, fixer of the royal personage in space and time, the artist had

access to the secrets of the great, to the rumours and schemes of the rich and powerful.

No one at the courts of London and Madrid was ignorant of the reason why Richelieu was soon to deprive Rubens, whose talent he admired, of the second part of the great commission given to him by the Queen Mother for her Luxembourg Palace. Rubens was working for Spain. Having come to Paris to execute a series of paintings to the glory of Marie de Médicis, Rubens had managed to surround himself with supporters of the Spanish faction, and to intrigue against Richelieu in favour of the Queen, Anne of Austria, thereby contributing to the division in France.

The letter of the envoy from Tuscany continued:

> *... I am persuaded that* [Gentileschi] *may be employed upon opening the way to some kind of accommodation with that Most Serene Archduchess* [the infanta Isabella, the aunt of Philip IV, who ruled Flanders in Madrid's name] *and through her with Spain, and I am the more convinced of this by my observation of the lord Duke's secret intrigues and his often employing one of his gentlemen from foreign parts. But this is a negotiation of such delicacy that it will be ill-perfected without the authority of a Great Prince, and one who is neutral and disinterested* [such as your Highness].

How is one to believe that a man like Orazio Gentileschi could have crossed the gulf between the Via della Croce and the court of England; that this self-absorbed individual, who was consumed by his art, could have become the confidant of kings, and an emissary in the service of any other cause but painting? And yet Orazio Gentileschi did indeed arrive in London on 6 October 1626 in the train of the Marshal de Bassompierre, Louis XIII's Ambassador Extraordinary to Charles I, the ambassador whose task it was to avoid war between the two countries.

Bassompierre's arrival in London was the result of a diplomatic incident between England and France that had occurred two months earlier: the Duke of Buckingham had expelled the entire French entourage of the Queen, the very Catholic Henrietta Maria, the daughter of Henri IV and Marie de Médicis. This ejection of the French from the country contravened the articles of the marriage contract; such at least was the official complaint of the French. England's reply to this argument was that the selfsame contract stipulated a dowry, which had never been paid in full.

Ambassador Bassompierre now found himself with the responsibility of securing the unconditional return to England of the Queen's Catholic

entourage. He brought two men with him. The first of these, Father de Sancy, was an undesirable in London; the Protestants had already experienced his religious zeal and his influence on Henrietta Maria. The second was an Italian. Worse still, he was a papist. He had worked for the Vatican, for Clement VIII and Paul V Borghese. His name was Orazio Gentileschi.

For the twelve years between 1612 and 1624, Orazio Gentileschi's life had been far from easy. He had been made unwelcome by Florence and by his beloved Rome. After working again in the Marches, he had pushed on to Genoa, spending two years on the shores of the Ligurian sea, decorating the churches, palaces and villas of the Sauli and Doria princes, Van Dyck's patrons. Unfortunately, the fashion for the young artist from Antwerp, along with his fame, had compelled the Italian to seek his fortune further and further afield.

From Genoa, Gentileschi had travelled even further north. He wrote to a general in the pay of the Venetian Republic that he was hopeful of a commission to decorate one of the rooms in the Palazzo di San Marco while aware that another Roman painter had also put himself forward. In the end, it was the 'other painter' who secured the commission.

Entering the service of the Dukes of Savoy, Orazio had found his way to Turin. There, beneath the grey sky of Piedmont, Divine Providence had intervened and his luck had turned. It was April 1624. Marie de Médicis, Queen Mother of France, had written to her second daughter Christine, the wife of the Grand Duke of Savoy, asking her to recommend an Italian artist who could work on the decoration of her Luxembourg Palace in Paris. There was nothing unusual about the letter in itself. Ever since her accession to power, Marie de Médicis had made similar enquiries of all the courts in Italy. In her frenzied passion for luxury, she wished to attract the best architects, painters and sculptors from her own country to the French court. A few years earlier, she had even sent a request to her aunt, the Grand Duchess of Tuscany, for the plans of the Pitti Palace so that she could have them copied and adapted to the grandiose project she was devising for her personal residence. Her palace was now finished. But, to her great disappointment, Italian artists were refusing to venture as far as Paris, which they knew was more crowded than Naples but much further from the sun. Marie de Médicis did not therefore have a great deal of choice. She would have to make do with this Gentileschi, whom her son-in-law, the Duke of Savoy, said was an excellent painter and prepared to undertake the journey. Orazio had sent her several paintings from Turin, of which her entourage had spoken highly. She had therefore invited him.

In the spring of 1624, the artist and his three sons took up residence at the Louvre, in the apartments reserved for the household of the Queen Mother, who was also a native of Tuscany. Orazio Gentileschi would at last experience the recognition that his talent deserved.

This triumph would last for one year, during which time he became familiar with all the nationalities and factions which schemed and conspired around the Queen Mother and was drawn into every intrigue. Marie, extravagant and without reserve towards her protégés, involved Gentileschi in her tortuous affairs. She used the artist to sing her praises on canvas, the man – the Italian – as a messenger, turning him into her official emissary in the entourage of the papal nuncio, along with the cardinal-nephew Francesco Barberini, who had come to Paris to settle the grave disagreement between Louis XIII and the new pontiff Urban VIII.

Gentileschi's extraordinary favour lasted for a whole year, until Paris began to acclaim the allegories of Rubens, in which he glorified Marie de Médicis, as well as the canvases of the man who, twenty-two years earlier, had given Orazio Gentileschi time to reflect upon the libeller's deserts in the dungeons of Corte Savella: Giovanni Baglione. Ever since the start of their respective careers, Gentileschi had judged Baglione's talent to be the most overrated in the entire history of painting.

In time-honoured fashion, Baglione's work had arrived at the French court in the form of a bribe, a gift from the Mantuan court to the French court in exchange for a helping hand. A sweetener for the Queen Mother. The Dukes of Gonzaga, rulers of the Mantuan city state where Baglione had worked for many years, passionately yearned to be given the rank and title of Royal Highness, a privilege enjoyed by the Medicis in Florence, the rival house of the Gonzaga. Marie might agree to secure this favour for them if Mantua were to present her with some rewards from its hoard of treasures. A cycle of tapestries, for example? Or some classical statues? Or else, paintings for her Luxembourg Palace . . .

When Rubens hung his works in the great gallery, ten canvases by the divine Baglione already adorned the Queen's study. Connoisseurs had quickly placed these paintings, with their scantily clad figures, above the talent of Gentileschi, above even that of Rubens.

While Artemisia's father had endured comparisons with the great Flemish painter in silence, the accolades for Baglione made him fly into one of his uncontrollable rages against the fools, dupes and rascals who let themselves be

dazzled by such base artifice. *Giovanni Bollocks, t'is no lie/Your paintings are foul daubs*: twenty years after writing those words, Gentileschi's revolt against mediocrity – his old enemy – would draw down upon him the fearsome censure of the Queen Mother's entourage.

By May 1625, the atmosphere at the Luxembourg Palace had become suffocating for Gentileschi and his three sons. Orazio had therefore given a favourable reception to the proposals of the Duke of Buckingham. The English King's favourite was also in Paris in the spring of 1625, having come to escort back to England Henrietta Maria, Charles I's new wife whom he had married by proxy. In the short period of time he had spent in the French capital, the dashing Duke had managed to dazzle the court, become enamoured of Anne of Austria and have France present him with a number of canvases. Richelieu, however, refused to part with *La Gioconda*, and this rebuff made Buckingham bad-tempered. He had therefore decided to rob Louis XIII of his best artists. First, he had asked Rubens to sell him his collection of antiquities; then he had commissioned him to do several versions of his own portrait. He had also bought two paintings from Gentileschi, variants of canvases executed for other clients some years earlier. Moreover, he enticed him with glowing prospects: Gentileschi was to follow him and work in London. His journey from France to England would be paid for, likewise that of his three sons; he would be granted a dwelling on the estate of York House, Buckingham's residence – a palace, rather – which the Duke's administrators would furnish for him at a cost of up to four thousand pounds, the annual income of a comfortably-off member of the English gentry. His youngest son, Marco, would enter the service of Buckingham's wife as a page, a position which was highly promising for the boy. As for himself, Gentileschi would receive a stipend from the King of one hundred pounds a year, to which would be added the price of the paintings commissioned by King Charles and the Duke of Buckingham. What a reversal of fortune for this artisan's son from Pisa, for this painter from the Via della Croce, whom the dishonour of a daughter's rape had forced into exile.

But England? Gentileschi was well placed to know that all the great Italian painters categorically refused offers from England. These refusals had nothing to do with the mist that hung over the British Isles. All of them, including Guercino and Guido Reni, had declined to cross the sea and work in a land of heretics; all of them had resisted the alluring offers of an anti-papist sovereign and his minister. Hence the Duke of Buckingham's determination to bring

Gentileschi to London and have him work for him. Buckingham was a handsome and wealthy man, an obsessive collector whose agent on the art market was fond of saying that he had purchased more paintings by masters on his behalf in five years than all of the princes put together had amassed in half a century – close on four hundred pictures; he was unaccustomed to anyone resisting his munificence. And yet, the artists of the day rejected his invitations.

During the summer of 1626, at the point when relations between London and Paris were turning sour, English diplomats posted in France reiterated the Duke's proposal to Gentileschi. Undecided, Orazio listened and let the incentives increase. The Queen Mother's infatuation with his paintings had certainly cooled; but she would never agree to let the English in their castles appropriate this Italian whom she had had so much trouble acquiring. Unless Gentileschi should become an item of currency in his turn. Another bribe. Perhaps she would let him go off to her son-in-law – so long as Charles yielded to Henrietta Maria's entreaties and allowed the return to London of Father de Sancy, the priest recently expelled by Buckingham.

Thus, in October 1626, the painter and the confessor arrived together in London in the train of Marshal de Bassompierre, due to whose skill the seventy French priests incarcerated in the prisons of London would be released within two months and the Catholics would return to the English court. In his memoirs, the Marshal recorded an event which must have been the conclusion to this successful mission:

> On Saturday 21 November 1626, I went to say goodbye to the Danish ambassador. Then my guests at dinner were the Duke of Buckingham, the Earls of Suffolk and Carlisle, Earl Montagu [...] and Gentileschi. [...] After dinner, [...] we all went together to see the Queen at her palace ...

Night was falling on the grey expanses of the courtyards at Hampton Court Palace, whose thousand rooms had belonged to Henry VIII, and which foreign ambassadors persisted in describing as a 'country villa'. Situated on the banks of the Thames some twelve miles west of London, the red brick building sprouted a forest of chimneys. A cloud of smoke, issuing from the countless fires that burned in the kitchens and apartments submerged its crenellations, towers and roof-tops. Although this was regarded as one of the most salubrious spots in the land, its smell caught one in the throat, an acrid

smell of smoke soured by the vapours off the river and the chill December damp. The cawing of crows and the hurrying footsteps of the last courtiers to make their way through the arcades connecting the yards were the only sounds. At this hour, no one halted to exchange greetings. Yet a melodious Italian voice had just stopped a man going past.

'The distinguished Signor Lanier?'

'The very one.'

The two men's paths had crossed in the windswept centre of Base Court and their cloaks billowed around them.

'The King's *maestro di cappella*, who knows Italy so well?'

'And who certainly intends to return,' the Englishman replied cheerfully, glad of the chance to speak the Tuscan language, which he had mastered to perfection.

'When are you going back?' the Italian quizzed, in friendly fashion.

'To serve His Majesty, as soon as I can. May I ask of whom I have the honour?'

The Italian removed his hat and bowed with a triple flourish. 'The court painter of the Queen Mother of France,' his hat grazed the frost-covered cobblestones, 'of His Majesty King Charles I and my lord the Duke of Buckingham.'

The other man was enthusiastic. 'The distinguished maestro Orazio Gentileschi! How delighted I am, Sir, to make your acquaintance.'

'And I yours, Signor Lanier. I had the privilege of hearing you sing this evening in His Majesty's chamber. It is most unusual to meet gentlemen such as yourself, who combine all the talents.'

Nicholas Lanier's grandfather, of French origin, had been one of Queen Elizabeth I's musicians. Ever since 1561, the large Lanier family had provided the English court with its greatest singers and its best lutenists. Nicholas's mother, whose origins were Venetian, also belonged to a famous family of musicians who had settled in London more than half a century before. Lanier himself was regarded as the most brilliant player of the English viol in his generation. He was now First Master of the King's Music. He had introduced Italian *canto* into England – the 'recitative style' as it was practised by the diva Francesca Caccini in Florence, and in the compositions of Monteverdi in Venice. His artistic sensibility, coupled with his great facility as a courtier, opened the door to every court in Italy. But he did not stop at winning over music-loving princes. For their and his own greater pleasure, he painted their

portraits, and took a knowledgeable and passionate interest in their art collections.

He therefore belonged to the small group of connoisseurs sent to the Continent by King Charles I, the Duke of Buckingham and the Earl of Arundel – the three highest dignitaries in the realm – in search of classical statues and the paintings of old and new masters. Such agents, who covered all of Italy, as well as Greece and Turkey, either worked together for the same patron, or in competition for rival patrons. The funds at their disposal gave them unlimited power. The choices made by these half-dozen individuals influenced taste throughout Europe – a tyranny which exasperated Orazio Gentileschi. In his view, some of the works brought back to England were not worth the sums invested in them. Ever since his arrival in London, Orazio had unremittingly expressed this opinion loud and clear. His criticisms had won him the enmity of the Duke of Buckingham's keeper of pictures, whose every choice he had disapproved. With each day that went by, this man became an ever more fearsome enemy. As one highly placed at court, with the ear of the Duke and the King, he repaid Gentileschi in his own coin by systematically denigrating his work, discrediting his pictures and manoeuvring so that His Majesty would dismiss the Italian. In order to resist these attacks, Orazio fought to ensure the backing of the other influential agents on the art market, and make himself admired by all lovers of Italian painting in London. This Nicholas Lanier, whose taste was regarded at court as infallible, was without the least doubt the best ally he could have found. Chance had brought them together.

'I am at a loss to tell you in what high regard I hold your inestimable abilities.'

'It is I, Sir, who desire to express my respect for your own talent. And then I have such admiration for your daughter.'

'My daughter?' Orazio tried to hide his surprise with the abrupt gesture of putting his hat back on. 'You know my daughter?'

The years had left scarcely a mark on Orazio's face. Though short of stature, he seemed indomitable as he stood unbowed by the wind off the Thames. Ever since adolescence he had seemed ageless. Today, at sixty-three, he enjoyed robust health. His eyes burned with the same fire as before.

And yet he had changed. He had been one of those individuals without any special distinction, neither handsome nor ugly, his looks unremarkable. Now there was something striking about him. The grand idea he assumed of

his place in the world from rubbing shoulders daily with the great had helped to give him a new presence.

Without any dandyish affectations, he took the greatest care of his appearance and decked himself out in more ribbons, lace and feathers than the English courtiers. His stay at the Louvre had much to do with this metamorphosis. France still dictated Europe's fashions. And if Marie de Médicis had brought Italian style to Paris, the Italians in Paris were astounded by French grace and refinement. Cavaliere Marino, a celebrated Neapolitan poet residing in the Palais-Royal quarter, wrote that in Paris the men had adopted the showiness and lace of the feminine sex. That they went around wearing nothing over their shirts even in the bitter cold. And that they even took things so far as to wear a waistcoat *under* the shirt. They strutted about booted and spurred, although they had never had a horse and had not learned to ride. Marino quipped in conclusion that if this was why the cockerel was an emblem of France, it would be more appropriate to use the parrot, since although many of these fellows were dressed top to toe in scarlet so that they all resembled cardinals, others were more multicoloured than a painter's palette.

Even if he had not gone so far as to exchange his habitual black for multicoloured knee-breeches, Orazio had been influenced by the casual elegance of this world. More than any other Italian artist in Paris, he had adopted the aesthetic fastidiousness of the court of Louis XIII. Hadn't he always striven to render the richness of materials, the nuances of tones? Was not the quest for some ideal beauty at the very heart of all his work? For the last forty years, the decorative splendour of his paintings had been in dramatic contrast to the violence of his person; the grace, subtlety and harmony of his creative work to the fierceness of his behaviour. But on this December night in 1626, the gulf between the man and his work seemed to have disappeared. The old gentleman swathed in a sable cloak, with a mask and a muff in his hand, seemed to belong as closely as his painting to the world of palaces and the domain of kings.

'So, you know my daughter . . . ' he repeated haughtily.

The Englishman, eager to please him, proceeded in lively fashion: 'No foreigner would think of visiting Rome, Sir, without attempting to meet your daughter! Being received in her studio has become as essential for art lovers as visiting the Colosseum.'

Hearing someone sing Artemisia's praises always produced the same emotion in him. He had not been wrong: she was fulfilling all her promises.

He was proud of her success, full of love and admiration.

'Genoa, Venice, Mantua, the whole of Italy speaks only of her talent,' added Nicholas Lanier.

The agitation his words provoked in the painter did not escape the musician. Interpreting it in his own way, Lanier continued, 'I am doubtless telling you nothing you do not know already. In Paris you will have admired the fine drawing brought back from Rome by the French painters, *The Hand of Artemisia with Paintbrush* by Dumonstier le Neveu. I saw it done in the lady's studio at Christmas in the Jubilee year . . .'

Despite Orazio's pride in his daughter, the Englishman's volubility and enthusiasm were beginning to irritate him.

'Do you have one of the plates that Jérôme David engraved after her self-portrait? I myself have only managed to acquire the preparatory sketch for the engraving, a polished enough piece of work but in no way comparable with the quality of the plate. On the other hand, I was fortunate to be able to bring back the medallion struck by the German goldsmiths in honour of your daughter. Her noble face appears in profile, surrounded by a very pretty inscription in Latin. Would you allow me, Sir, to make you a present of it? You have produced a wonder, Signor Gentileschi, that all the poets are celebrating as the eighth of the world.'

What business is it of his, thought Orazio. Did he, Gentileschi, concern himself with singing or dancing? Certainly, the Englishman made a good impression, he turned charming compliments, he had mastered Italian to perfection. But what business was it of his, in truth? This display of knowledge, these artists' names with which he spattered his conversation. The musician should leave painting to painters. Yes, let him go on ravishing the royal ears with the sound of his viol-playing and leave painting to painters.

'You have a reputation for being a connoisseur, Signor Lanier,' he acknowledged with abrupt coldness. 'I have seen the paintings you brought back from Rome for His Majesty. And the three pictures by Guercino which you bought. If my daughter is the great painter that you say she is, why did you not choose one of her works?'

'Alas, the Signora Artemisia is much too expensive for my purse, Sir! His Majesty had not then allowed me the funds that he makes available today. Your daughter works only for the Pope, his two nephews and their secretary.'

'Doubtless you mean Cardinal Francesco and the Cavaliere dal Pozzo,' interjected Orazio, aiming to show that he too rubbed shoulders with the

powerful. 'I knew them when they were in Paris on their diplomatic mission. I must confess that our talk was more of the war than of my daughter's art. So you say you are soon to leave again for Rome?'

'For Venice.'

'So you will not see my daughter again?'

'Should the Signora Artemisia deign to receive me, I shall go and see her wherever she is. And this time, I shall attempt to acquire from her some masterpieces to adorn His Majesty's picture rails, next to your own works. Perhaps you could persuade her to accept my invitation to come and work here at the English court, alongside you?'

Orazio felt a growing antipathy towards the man. This Lanier dreamed of buying Artemisia's portraits, wanted to invite her to England, placed her on the same footing as the painter of the King's household, submitting him, Orazio Gentileschi, to comparison. Was this conceited fellow closer to Artemisia than he let on? Orazio scrutinised his face more intensely.

Nicholas Lanier was a good-looking man of around forty. He had a pale complexion and fair, slightly reddish hair, light-coloured eyes and a penetrating gaze. Under his moustache and goatee his lips were pursed, but the mouth's sinuousness gave a hint of gluttony and sensuality. And the faintly ironic expression which never left his face, even when he flattered and enthused, betrayed an attractively caustic humour. One hand rested indolently on the pommel of the sword he wore at his side and, with the other, he held fast his hat and the edge of his cloak. His puffed silk sleeves, broad-striped in white, crimson and black, gleamed in the darkness and suddenly brought to Orazio's mind the figure of Agostino Tassi framed against the ceiling of the Quirinal.

Orazio was struck by the intense suspicion that he might be face to face with Artemisia's lover. His certainty of it stirred a pain that was close to nausea. The past was repeating itself. Artemisia belonged to another man. This Englishman, this heretic, was damning his child's soul and soiling her body. She was giving herself to him as she had given herself to the devil Tassi. This revelation explained everything: the Englishman's exaggerated enthusiasm for his daughter's art; and his own mistrust of the man.

'And my son-in-law?' he asked, not without disingenuousness.

'The Signora's husband no longer lives with his family.'

' Has he died ?'

'Disappeared. . .'

'She'll have got rid of him.'

' I have not been privy, Sir, to your daughter's confidences regarding her misfortunes,' the Englishman retorted sarcastically. 'I am telling you what is spoken of in Rome.'

'And what is spoken of in Rome?'

'That your son-in-law disappeared four years ago. He had had some brushes with the law. It seems that with the help of some friends he murdered a group of Spaniards who had installed themselves outside his door. It was an unpropitious moment to pick a quarrel with representatives of a country that your Pope was then trying to win over to his cause. That is all I know about the business.'

'She will have had him killed!'

Nicholas Lanier's hand tightened on the pommel and he glared at Orazio icily.

'I can see, Sir, that you are ever quick to slander where a woman's honour is concerned. If you were not her father and a servant of the King, I should ask for satisfaction.'

'There is no need for that, Signor Lanier; I humbly beg you to accept my apologies. You see, I come from a world – my daughter and I both come from a world – where poison, paintbrush and dagger are to be encountered in the same hands.'

'Well, take care that they are not still to be found there. I bid you goodnight, Sir.'

The two men curtly took their leave of one another and went on their way at a brisk pace.

Under the clock tower, Orazio turned round one last time. He was sure that he had judged quite accurately the bond between his daughter and this Englishman.

What Gentileschi could not have imagined was that, more than a thousand miles from Hampton Court, Artemisia was packing in preparation for a journey to join Lanier at a meeting place appointed by him in Venice. And that together they would attempt to pull off the biggest coup in the history of painting.

29

Travelling between Rome, Genoa and Venice

Winter 1626

In the black carriage going along the coast road, a little girl sat with her back to the driver and watched her mother whose face was bent over a sheet of paper. Light played on her hair and the sun beat on to her forehead. The child observed the muscular, wiry hand sweeping broadly across the page and wondered how it was that it never trembled or slipped when her head was nodding at every jolt. She took in the writing case and the mirror her mother had attached flat across it. A little oval mirror in which the artist could see herself without looking up. Prudenzia, who was all of ten years old, knew everything there was to know about their little household: that self-portraits by Artemisia Gentileschi commanded a high price, very high, and that the commissions were flowing in. Letters, always the same, arrived from Genoa, Naples and Venice, and the child would read them aloud before answering them. 'I beg you to do me the honour of sending me your likeness painted by yourself,' the collectors would write. 'Thus I shall be able to celebrate your talents and make your name known. Be mindful that there may be people who doubt that your canvases were executed by a woman. When I have shown your *St John the Baptist* to gentlemen of my acquaintance, I have been unable to persuade them this is so. Whereas, having your self-portrait, I should win my case without argument. Your beautiful countenance will take its place in my gallery of the illustrious. And I myself shall possess two marvels in one: the woman and her work.'

The little girl wondered how she would depict her mother were she one day to have a commission. Certainly not from the angle reflected by the looking-glass. In this reversed mirror image, the nostrils seemed more gaping,

the chin receding. And besides, she would not draw her. She would paint her directly on to canvas with blocks of colour. Her skin white, her mouth very red.

Her mother wore a bodice, a wide skirt of coarse silk and long slashed sleeves all in black – a mourning attire which the child knew was a ploy, a social alibi in the absence of a husband, father or brother on their travels. The austerity of these widows' weeds that Artemisia affected in certain circumstances was given the lie by the exuberance of her coiffure, auburn locks tumbling in loose curls over her eyebrows and across her cheeks. Her hair was gathered into a round chignon which she secured very high at the back of her head. The few stray ringlets escaping from it were hidden by the frothing crimson of a huge ruff that swallowed up the whole of her neck. The white ruffs and the demure lace of the Florentine court were no more. Now the collar was spread wide right across the shoulders, tilting the face so high that the head seemed to be laid upon a large, blood-stained platter. The effect was superb. When Artemisia was not absorbed in her work, her upturned brow, her eyes and her chin caught the light. And her hands, emerging from red lace cuffs, appeared paler and longer, the fingers tapering more against the black background of her dress. Prudenzia had inherited her father's fondness for materials, but she hated Artemisia wearing these sumptuous outfits. She hated the stiff skirts that prevented you getting close to her; and the blood colour which attracted so much attention.

The little girl was proud of the family's fame. She had no trouble accepting that Artemisia's work should interrupt their closeness, but she abhorred any other kind of intrusion. For the child, too, painting was sovereign – her mother's painting, and the love between them.

Abruptly, the little girl got up and sank down on to the seat opposite, against Artemisia's shoulder; the latter smiled without halting her work. Prudenzia looked up, still engaged in observing her mother, noting that her eyebrows were straight and her eyes almond-shaped. That the curve of the cheek cast a shadow against the base of the nose. In profile the nose was short, but with a slight irregularity. And the chin? It was a little round chin very close to the mouth and dented with a dimple that the child could not see but could picture. The intensity with which Prudenzia's eyes took in every feature of her mother's physiognomy captured Artemisia's attention in the end.

'What are you doing?' she asked, smiling.

'I'm painting you in my head.'

The mother set down her pencil and put an arm around her daughter's shoulders; Prudenzia hugged her.

'And what do you see?'

'I can see that you have shadows under your eyes. I can see that you look tired, that you work too hard.'

Artemisia smiled again, put away her sheet of paper and closed the writing case. She always took a physical delight in having her child near her, in feeling her caresses, and her mind was eased by listening to her questions, hearing her critical comments and, very often, her advice. Little Prudenzia spent her life trying to safeguard her mother. And yet no one would suspect Artemisia Gentileschi of needing protection. At thirty-three, she was utterly radiant with beauty, at the peak of her splendour as a woman and an artist. She knew it. She was tall, powerful and buxom, bursting with health, and for everyone but her daughter, she was the living image of strength and sensuality. Everything about her was seductive: her zest, the quickness of her repartee, her tireless intellectual curiosity. And, like everyone around Artemisia, the child was charmed by her. But Prudenzia's admiration was mingled with a kind of generalised fear. It was not that she was afraid of her mother, but she feared that something might happen to her.

Artemisia experienced the same anxieties about Prudenzia. But it was a more natural thing for her; the loss of her other three children led her to fear the worst.

Prudenzia was slight and frail and had her father's indolence, his practical sense and his passive resistance. Though Artemisia tried to teach her drawing and had taken her to places all over Rome where the child could become familiar with the old masters – as Orazio had done for her – Prudenzia displayed no particular gift for painting. Willing to please, but without passion, she did as her mother told her, grinding colours lethargically and slowly mixing the oils. But it did not matter. It did not matter that Prudenzia would never become a great painter. Her mother had a better future in mind for her.

Artemisia was intensely proud of her own success and the independence she had won by dint of her talent. Her own sights were set on nothing else but the pursuit of her art. Each picture sold was worth only that: getting on, rising higher. Breaking all boundaries. Her ambition had never known any bounds. Now her fame justified her frenzy. But she dreamed of an easy, aristocratic life for her child, a destiny which would spare Prudenzia any struggles, doubts,

hatred or fear. Prudenzia had therefore studied music, she played the spinet, she read her breviary, she could make a passable curtsy and knew a few ballet steps. Moreover, she could write in a very fine hand, and Artemisia made the most of it.

'You make me think of my mother,' she would sometimes tell her. ' Our Lord will give you the life she deserved.'

'But I am not so pretty as she was,' Prudenzia would simper, liking nothing so much as to receive Artemisia's compliments.

'For me, my love, no one can be prettier than you.'

'Not so sweet, then? Not so nice?'

'You are more lovable than anyone I know!'

A smile of satisfaction would then enter Prudenzia's eyes. She treasured these journeys which cut her mother off from the world, locking them up together in the snug cocoon of the carriage. No more cardinals' banquets, no more ambassadors' balls, no more endless sittings at the Accademia. With her head resting on her mother's breast, the child gave way to a sense of well-being.

The warmth of this young body nestled against her also gave Artemisia a sensation of peace, a feeling of ease that none of her lovers – they had been numerous in these last few years – had given her. Through the window, whenever the wind blew open the curtain that Prudenzia had pulled tight so that nothing outside should distract them, Artemisia could see the round moon that hung low over the glittering sea. And, along the coast road, the olive and chestnut trees and the tall umbrella pines that spread out all their dark branches over the vast emptiness.

Prudenzia had fallen asleep. Artemisia uncrossed her legs and fell to thinking. In a few years her daughter would have to be found a husband. She stretched her legs under her skirt and made some calculations. Ever since Pierantonio's disappearance, she had been placing one-fifth of her profits in a dowry fund in Florence. Four years of savings. Even with the interest, Prudenzia's little hoard would rise to one thousand scudi at the most. There was no hurry.

Artemisia looked down at the round cherub's face, she listened to her even breathing. Yes, the pearl-grey dress that she had had cut on the same pattern as her skirt suited the little one. Like those braids coiled on her head to reveal her delicate ears with the two quivering tear-shaped pearls. Prudenzia's regular features recalled her father's face.

Did the little girl remember her father? Artemisia had heard nothing from

Pierantonio for the last four years. Was he still alive? What did it matter? 'Get out! Get out, I tell you!' – words she had shouted so often.

When they had settled in Rome, Pierantonio – taciturn, gloomy and idle – had shut himself up in the studio at the Via del Corso. Then he had started drinking. His drunkenness had exacerbated his jealousy. He followed his wife everywhere, forever on her heels, only emerging from the shadows when she received the payment for a picture, to demand his share. He had stopped hitting her, but the woefully threatening looks he gave her and her canvases weighed on her more heavily than any blow. Sometimes he would burst into tears, alleging between sobs that she was wronging him and that he would be avenged. . .

Artemisia sighed. Truth be told, the fight with the Spaniards that had made Pierantonio's excesses public had been useful to her. Although God knew the business had worried her. Yet again, her reputation was being sullied. Pierantonio had been imprisoned: Artemisia Gentileschi would soon have a galley slave for a husband! When pleading his case to her patron, the Cavaliere dal Pozzo, the cardinal-nephew's secretary, whose protection she had solicited, Artemisia had taken good care not to mention that her husband's victims sang at the tops of their voices under her windows, that they played the guitar and serenaded the 'Lady painter'. This time, the whole district knew that Pierantonio had been cuckolded. Through what indiscretion had he discovered Artemisia's liaison with that Spanish gentleman of Cardinal Borgia's household whose name now escaped her? Doubtless Pierantonio had followed her – once too often – as far as the Via dei Serpenti where she would rent two-room apartments for her personal use. She felt towards her husband the revulsion of a swimmer to whom a drowning man clings. Separation from him had become a matter of life or death.

It had been easy to obtain the protection of the Cavaliere dal Pozzo who, of all her clients, was closest to her, and have him see to it that her work was made safe and she was left in peace.

With some monetary assistance, Signor Pierantonio Stiattesi had been requested to make himself scarce. If ever it took his fancy to visit the Papal States, the gallows awaited him. With a tidy little sum in his hands, Pierantonio had complied; he came out of it well.

Artemisia's conscience was, however, still troubled by her own conduct during this episode. The image of the young man who had taken her as his wife at a time when no one would have anything to do with her lived on in her

memory. She could see Pierantonio as he had appeared to her the first time, standing by her side before the great wooden crucifix in the church of Santo Spirito in Sassia. But that man no longer existed.

After five years of relentless hard work, Artemisia could congratulate herself on having conquered the papal city. She attended the receptions of the best-connected prelates. She was the only woman guest at the concerts of Cardinal Maurizio of Savoy, the only woman admitted to the sessions of the Accademia dei Desiosi, a group of erudite libertines who gathered every Wednesday at the palace of Monte Giordano to debate the progress of the arts and sciences. What now? Instinctively, she could tell that this sense of having accomplished her objective was potentially dangerous for the pursuit of her art. Things had come full circle. She had obtained all she could from Rome. She had even seen Agostino Tassi again.

From the moment Artemisia Gentileschi moved into her house in the Corso, the entire artists' quarter had been waiting for their paths to cross. They had the same colour seller, the same washerwoman, the same notary. the meeting seemed inevitable. It came about in the choked traffic of the Piazza di Spagna, on the day when the conclave of cardinals had announced *urbi et orbi* that Urban VIII Barberini had been elected to the papal throne. It was 6 August 1623. One wheel of her carriage was momentarily jammed against the wheel of the one alongside. Artemisia immediately recognised the female passenger – blonde, white-skinned, nicely plump – as Tassi's sister-in-law Costanza. On seeing Artemisia, she ducked out of sight. Then, framed in the carriage window, there appeared the face of Agostino. Artemisia was instantly struck by his baldness. It made his face heavier, his weathered cheeks rounder and fuller. Otherwise, Agostino was just as he had always been. He lorded it in his carriage and had the same proud swagger of old. A thick two-stranded gold chain was slung across his chest and he wore a ring in his ear.

He too was shocked by the encounter. Artemisia was the first to recover self-control. She was alarmed. Was Agostino going to accost her? Submit her to a fresh assault? She made no movement. But when Agostino shook himself out of his torpor and made as if to join her, she shot him a glance that nailed him to the spot. Wordlessly, she was reminding him that he had just come out of prison again; that the second trial for incest brought by his rivals – a trial which once more made public his criminal bedding of Costanza, and aimed to have him hanged – could still go badly; that it was altogether in his interest not to provoke her, to behave himself.

Ten successive years of scandal had not held back Agostino Tassi's career. The great families of Rome still asked him to decorate their palaces. But he was no longer of a stature to seduce or deride Artemisia Gentileschi. Both of them understood this.

The memory and the fear of Agostino Tassi would no longer give Orazio's daughter nightmares. She had accomplished everything she had set herself to do in Rome. Portraits, still lifes, history paintings – she had tried her hand at every genre and had overcome every obstacle. What now? Success was prompting her to self-plagiarism. She was repeating her own compositions, copying her colours and her light. The time had come to move on.

In this winter of 1626 Artemisia had a number of good reasons for leaving the papal city for a time, to spend Christmas in Genoa and move on as far as Venice in the spring. The first was her need to confront her father again.

Secure now in her own worth, intoxicated by the certainty that she was rushing headlong towards fame at the same speed and on equal terms with him, she ardently desired to see his paintings again. Orazio's last Italian works were located on the road to Venice. It was said that the father in Genoa and the daughter in Rome had simultaneously attained the same mastery of their art. That her pictures hymned the beauty of the female body like those of no other painter, and that Orazio's excelled in their study of the male anatomy. That in Liguria he had executed a painting of *Lot and his Daughters* whose effect was poignantly moving. This was the picture that Artemisia was on her way to find in Genoa: the drama of a man deprived of a beloved wife by the fires of Sodom, and made drunk by his daughters so that they could sleep with him. 'Come, let us make our father drink wine, and we will lie with him, that we may preserve seed of our father.' In this work, Orazio transposed all the themes which made his daughter's paintings so successful. In an inversion of Artemisia's *Susanna,* it was now two young women who lusted after an old man. Orazio did not depict them before their heinous deed, but at rest after the act of incest. Artemisia was impatient and curious to see it. She had been told that the position of Lot, the amorous father huddled up on one daughter's knee, was an exact duplication of the position of one of her own figures: Sisera, the general who fell asleep on the knees of his enemy, the courageous Jael. But while, in Artemisia's painting, the woman's hand was raised to pierce the drowsing man's temple with a nail, in Orazio's the same gesture was transformed into one of fondness and protection: Lot's daughter was caressing her father's head just after she had seduced him. Artemisia's thoughts returned

tirelessly to the similarities and differences, the criticisms and comparisons, which were incessantly discussed by their admirers and whoever championed one or the other. Now she had to see and judge for herself. With her fear that Orazio's departure for England would prevent her from getting an answer to the questions that tortured her, came flooding back all the old anxiety of her childhood.

A second motive, one which was even more imperious, had impelled her to undertake this journey. The woman who had once told herself, 'My heart lies free in my breast, I serve no one and I belong only to myself,' was now in love with a foreigner: the Englishman Nicholas Lanier.

Artemisia had met Lanier in Rome six months earlier – in September 1625 – at the Palace of Monte Giordano which was rented out to Cardinal Maurizio of Savoy by the Orsini princes. At the time, she was just beginning the cardinal's portrait and was received by him punctually every day on the stroke of noon.

One day the guards had met her at the top of the staircase and escorted her across the ostlers' hall into the first, then the second antechamber. They had asked her to wait on the threshold of the *sala* where audiences were given. She waited for nearly three hours. Beyond the canopy and the empty armchairs, beyond the chairs arranged in a semi-circle and the stools in the corners – the placing, form and colour of each seat corresponding to the rank of the different visitors – she could see the heavy purple velvet hanging that closed off the cardinal's bedchamber. An unfamiliar, foreign voice, could be heard in the distance; its warm, deep timbre interrupted by abrupt silences and chords played on the viol. In the privacy of his apartments, Maurizio of Savoy was having an interminable music lesson.

At last, the hanging quivered. Artemisia saw the cardinal draw back the curtain and advance into the *sala*. She realised then that His Eminence was escorting his teacher into the antechamber. Such an action carried more weight than a cartload of gold. It was reserved for ambassadors, at least certain ambassadors. The Tuscan ambassador could be accompanied as far as one and a half antechambers. But the ambassadors of Bologna and Ferrara had a right only to the *sala* and half of one antechamber. For the Maltese ambassador, the cardinal went three-quarters of the way into the *sala*. Artemisia took in the distance walked by the two men. This breach of etiquette betokened the high regard in which the musician was held. Monsignor the Cardinal of Savoy had made this same gesture once before, as a sign of respect for the talent of another

artist: Artemisia Gentileschi. This man was therefore being accorded the same status as herself. She was intrigued and also irritated by this. The stranger moved forward. Like his voice, his dress showed him to be a foreigner. But he wore none of the accoutrements of the aristocracy. He was neither a knight of the order of Christ nor of the order of St James. He displayed neither the Maltese Cross, nor wore the sheepskin of the Golden Fleece.

As he came closer, Nicholas Lanier stared back at the tall woman whose eyes were on him. She stood very straight, a dark outline against the red and gold patterned background of the antechamber with its Cordoba leather hangings. The cardinal whispered into Lanier's ear that they were looking at one of nature's wonders – a female artist who outstripped the greatest masters.

The prelate left his visitor two-thirds of the way into the *sala*. The musician passed close by the painter on his way out. He took off his hat in front of the young woman and greeted her, but he was not introduced. Thereafter, he was impatient to see her again and he would not have to wait long: she belonged to the small circle that the cardinal gathered together for his concerts.

Though interested in one another, Artemisia Gentileschi and Nicholas Lanier were circumspect, not to say mistrustful, edging feverishly closer throughout the autumn. They attracted one another, amused one another with their powers of seduction, and each enjoyed these games that they took only so far. Artemisia's amorous concerns – and her interests – had detained her in other arms; she was known to be the mistress of Spain's ambassador to the Holy See, a liaison whose very official status flattered her pride and favoured her career.

Night was falling. Artemisia and her daughter would not reach Genoa before curfew. Sitting up next to the driver of the coach was the young servant Dianora, who had belonged to the Gentileschi ladies ever since she had followed them from Florence to Rome. The Signora had provided her with a dowry and given her in marriage to her coachman. The ownership of this carriage signified that Artemisia belonged to the ranks of those great ladies whom the Church would bury by the light of thirty torches. The Signora's carriage would therefore pass through the gates of Genoa with no customs check other than the handing over of passports and a quick scanning of health documents. Moreover, Artemisia carried letters of recommendation: she was travelling under the protection of Spain, and Genoa bowed beneath the yoke of Madrid. Although there was no coat of arms displayed on her carriage door,

the cushions were embroidered with the monogram of the Duke of Alcalá, the ambassador of King Philip IV, and her former protector and lover.

The Duke's recall to Madrid had broken off their liaison at the very moment when she had discovered she was with child by him. Another reason to leave Rome. She would give birth to this fifth baby in an inn somewhere between Genoa and Venice. When she returned to the Via del Corso, no one would be any the wiser about how many children her husband had given her.

Far from being a cause for worry, this new pregnancy made her happy. The Duke of Alcalá would not acknowledge the child, but she knew that he would guarantee its future. Did he not already have three bastards, each already promised a cardinal's *berretta* by the Pope? Through her, the blue blood of the oldest aristocracy in Europe would soon flow in the veins of Orazio Gentileschi's descendants – the prospect delighted her.

The Duke had had the three heavily framed pictures she had sold to him packed up: two original canvases by Artemisia Gentileschi and the copy of her famous *Christ Blessing the Little Children*. He planned to show her works to his King. But he intended her *David* for his austere Andalusian residence on the banks of the Guadalquivir, and the *Sleeping Magdalene* for his own parish church – Seville Cathedral. Like her father's, Artemisia's painting was crossing frontiers.

In Rome, the representatives of the great powers were lavish in their flattering regard for Artemisia. Not only Spain but France and England considered her an outstanding painter, as well as a woman who could be useful. Madrid, London and Paris were looking for fifteen informants in Italy to indicate the pictures and collections which were being offered on the art market – and who would also be able to keep them abreast of the secret political positions adopted by the different states, and alert them to the rumours circulating in Rome, Florence, Genoa and Venice. The winter of 1625 had seen both the Duke of Alcalá and Nicholas Lanier propose to Signora Gentileschi that she work as a spy in their pay. In each case she had declined, though in the end becoming the mistress of both men. One had succeeded the other, a few hours apart, in her bed.

The Duke had left the papal city in February. Artemisia had followed the procession of two hundred carriages that accompanied him as far as the Aurelian Walls. When Alcalá's thoroughbreds set off at a gallop on the road north from the Porta del Popolo, Artemisia's turned back and took her, unhurriedly, to the courtyard of the Monte Giordano palace. That evening,

the cardinal was giving a concert for the music lovers among the city's prelates, principally his friend the Marquis Vincenzo Giustiniani, who wished to devote an entire chapter of his scholarly treatise on music to the comparative merits of the lute, the viol and the lyre viol. He was to hear an English virtuoso who was on a visit to Rome for the Jubilee celebrations – a certain Nicholas Lanier.

Before her liaison with the Duke of Alcalá, Artemisia had had more affairs than she could keep count of. Visiting diplomats, painters and architects came to Rome seeking fame and new experiences. Love affairs were undertaken discreetly, but passionately.

Artemisia had learned many things in the Via della Croce. Tassi, who boasted everywhere of having taught her how to 'handle a brush', did not mean these words merely in the painterly sense. It was to him that she owed her initiation into the delights of the flesh, the revelation of certain secrets, and her expertise in certain games which had given much pleasure to both of them. When she married, Artemisia had thought she must renounce such ardour. From the start of their union, Pierantonio had taken only an intermittent interest in her charms. Despite being in love, he neglected her as a lover. What did it matter? Matrimonial affection and motherhood had fulfilled her.

But the discovery of intellectual pleasures with her patron Buonarroti the Younger and the painter Cristofano Allori, along with her growing awareness of her powers of seduction, had stirred her enjoyment of sensual pleasure and – to her husband's great misfortune – her coquetry. Fifteen years after the trial that had made a public show of her hypothetical life of debauchery, Artemisia allowed herself certain liberties and sinned happily.

She none the less took care that her reputation should not sully Prudenzia's honour or threaten the glorious future she dreamed of for her daughter. As for her art, there was no man, no whim or passion that could divert her from her task. Of all her amorous adventures, only the affair with the Duke of Alcalá was likely to be of any consequence – because of the child she was carrying. But what of Nicholas Lanier?

If their patron did not see them run off together on the evening of Alcalá's departure, that night the disreputable Suburra quarter noticed their carriages parked at either end of the Via dei Serpenti, where Artemisia rented the dwelling that she kept for her own use.

During their month-long liaison, Artemisia was to find in his company

that happiness she had once known with her friend Cristofano Allori: a complicity between artists, a spirit of rivalry. Like Cristofano, Nicholas seemed to have a talent for everything. But unlike Allori, whose multifaceted gifts slowed him down and made creative work a torment, Lanier was single-minded and unswerving in his goals.

For his part, he loved pictures and he loved women – all women. His fondness for overnight affairs that were delightful and meant nothing provoked the passions of others. He himself had succumbed to none – until he encountered the heady lure of Artemisia Gentileschi's beauty, power and exoticism.

When it came to conducting a love affair, they were perfectly in tune. Experience had made them both refined connoisseurs.

At the thought of her amorous encounters with Lanier, a shudder ran through Artemisia's body; she curled up in a corner of the carriage. The memory of what she had felt in his arms reawakened her emotions. She struggled with herself, sat up again and cast a quick, guilty glance in Prudenzia's direction. The child was still sleeping. Huddled back in her corner, Artemisia closed her eyes and let herself drift.

She could see her large studio in Rome that looked due north out on to the green trees in the garden of the *Ospedale degli Incurabili*. She could see the easels with her canvases drying on them, set in front of the fireplace. And Nicholas – a strong figure outlined against the light. All she could recall about his face was its expression. There was something distant and foreign in his grey eyes, a remoteness that was cancelled out by his tenderness and humour.

Even more than the memory of their passion, she preserved the imprint of the freedom of the mind and the senses, the imagination and gaiety that she had known only with him.

'I'll make a bargain with you: let's exchange roles,' he had suggested playfully. 'You will make music while I shall paint you as a *Woman Playing the Viol* – quite naked!

A smile flitted over the traveller's face as she recollected this scene which could have cost them dear, had anyone seen or heard it from the street.

In broad daylight, in front of the balcony overlooking the Corso, he had unlaced her and pulled off her skirt. She had let him do as he wished. He had loosened her hair. He had taken her by the shoulders and stood her in front of him, placing the viol against her belly and arranging her hands

carefully on the neck of the instrument. Then he had stepped back to judge the effect, narrowing his eyes, mimicking Artemisia's every gesture as she worked.

'Don't move,' he ordered in the neutral tone of voice she used with her models.

Made uncomfortable by this gaze which measured and appraised the perfection of her anatomy, Artemisia would not stand still. He went to select a book at the back of the room, opened it and set it on a lectern in front of her.

'Sing the tune of the Magnificat from Monteverdi's Vespers of the Holy Virgin, and put these words to it. That will keep you still.'

He went back to the easel and sat down in front of it.

With Artemisia's palette resting on his arm, he plunged his brush into the colours. Then, with his hand poised, he scrutinised the swell of her breasts, the texture and complexion of her skin, the flesh tones in the folds of her elbow and her groin. He was inspecting her, dissecting her. She blushed. Had her four pregnancies made her heavy? She feared so. She made as if to cover herself.

'Yes, what is it?' he said, affecting coldness.

She let go of the fabric and started to sing.

'*I hate embraces which leave not each outworn,*' she chanted in Latin, her voice angelic and demure. '*I hate her who gives because she must, and who, herself unmoved . . .*' She widened her eyes and burst into the giggling laugh that Pierantonio had loved so much. 'Whose are these verses? Propertius's? Virgil's?'

'Ovid's – from *The Art of Love*, book II. Go on.'

'*And who, herself unmoved, is thinking of her wool,*' she went on at the top of her voice. '*Pleasure given as a duty has no charms for me . . .*'

'*I like to hear the words that confess rapture,*' he continued, still painting, '*that beg me hold back and stay a while,*' he sang in his warm, vibrant voice which was so expressive that it had earned him the admiration of princes. '*May I see my mistress in frenzy . . .*'

Nicholas knew entire volumes of Latin poetry – not just licentious verses, but *Metamorphoses* and all of the *Aeneid* – and he was reciting by heart. Without taking his eyes off Artemisia, '*With eyes that confess defeat . . .*'

She had fallen silent. Instead of bothering her, her nakedness in front of the musician began to be pleasing. She had become aware of Nicholas's admiration, and of the tricks he was playing with his own desire.

He gave her a solemn look from behind the canvas. She joined him in a duet, singing naughtily, '*May she be languid, and long refuse to be embraced.*'

Neither of them could resist any longer; they downed paintbrush and viol. The painting remained unfinished.

But on the 28 March 1626, one month after the recall of the Duke of Alcalá, Lanier in his turn had to go through the Porta del Popolo. He had delayed this departure for England for as long as possible. Now his King demanded his presence at court. And, in the little village next to Greenwich Palace where his family lived, Nicholas Lanier had a wife fretting. Two seas and a continent ravaged by war and plague were soon to separate Artemisia Gentileschi from Nicholas Lanier. They had no hope of seeing one another again.

This time she accompanied her lover on foot as far as the Piazza del Popolo. They took a walk, their last together, down the long, straight Via del Corso. Lanier led his horse by the bridle.

Without touching one another, they went past the drinking trough, in front of the obelisk and the wash-place. Without speaking, they skirted the monastery wall that the funeral cortège of Artemisia's mother had once passed alongside. They lingered together for a few moments on the steps of Santa Maria del Popolo – as Orazio and Artemisia had once done.

When the time came for goodbyes, they embraced. Then, without any tears, speeches or promises, they parted. Back to back like two duellists, arms hanging by their sides, their bodies inexpressive, they moved away. Lanier went through the gate. Artemisia crossed the square.

When she was back inside her studio, on the evening of this sad separation, when she breathed in the smell of the varnish and bent to look at her unfinished canvases, she drew a long sigh that had something of relief in it. 'It is all over,' she thought. I can go back to work now.'

For thirty days, Artemisia had taken up her brushes only to surrender the secrets of her art to Lanier. She had initiated him into her father's techniques, into the methods used for preserving colours and their transparency. She had shown him how to mix a drop of amber varnish into pigments on the palette. Together they had sought the means to obtain a greater solidity in the whites, a procedure for staving off yellowing, a recipe for preventing silver paint from blackening in the sunlight. But, for a month, Artemisia had found neither the time nor the inclination to work for herself, for her patrons or for her reputation.

'Thanks be to God, I can begin work again as before.'

She was wrong. Nothing would be 'as before' any more. The memory of

Nicholas Lanier, of his voice and his laughter, would soon haunt the studio; while, at Hampton Court, Artemisia's ghost would stalk the music salons. Every night during the summer of 1626, Charles I and the Duke of Buckingham would prevail upon Nicholas Lanier to play the air that he had composed on his return from Italy, the lament of the separated lovers, 'Hero and Leander', forced apart by the gods, each of them cast on the opposite shore of the Hellespont. Lanier would sing of their heartbreak with a smile that enraptured the ladies. But inwardly, the separation weighed daily more heavily upon the musician. In London, as in Rome, absence made the heart grow fonder.

At the start of the winter, a letter arrived at the Via del Corso from England. In it Lanier did not speak of love. He merely dwelled on the presence of Orazio Gentileschi in London, the favour showered on the old painter by Charles I, the splendour of his pictures. He announced his own return to Italy. To Venice. For this new undertaking, he was assuming the services of two Italians residing in London: Francesco and Giulio Gentileschi, Artemisia's brothers. Lanier suggested that she should come to meet him on the shores of the lagoon.

The proposal came at an opportune moment. She accepted it.

30

The Island of Murano

January to November 1627

It was four o'clock in the morning, the hour when Venice finally succumbed to sleep. But the silence that fell over the gardens of Murano was broken by a love song and the melancholy chords of a viol. On the top floor of a large villa that lay between the canal and the sea, a few candle flames flickered; it was here, in a vast chamber beneath the rafters, that Nicholas and Artemisia had retreated to savour the happiness of their reunion.

A few days earlier, Lanier had come to join her – or rather to surprise her – in a church at Padua. The meeting had lived up to both their expectations. Catching sight of one another in the shadows of the nave, they had at first been frightened, for the emotion that had overwhelmed them seemed of a kind to change their lives for ever. Slowly, they had walked towards one another and embraced, in the same silence with which they had parted. For the last forty-eight hours, they had shut themselves up in this room on Murano and made love wildly.

Nicholas had arranged this hideaway with his customary vigour and efficiency. No one in Venice knew about it. Not yet. He made the most of his last secret hours with Artemisia.

Exhausted and sated with passion, Artemisia was resting on the rumpled couch. What joy, she thought, to be able to lie here watching and listening to him. Her eyes were half-closed and she seemed to be drinking him in like small sips of strong, sweet wine. She looked at Nicholas's pale body as he sat at the foot of the bed. He was bending over his viol, the tapering fingers of his long white hands sliding slowly and deftly along the neck of the pot-bellied instrument. His voice, which was naturally warm, vibrated with contained

tenderness. Artemisia could feel the tears coming into her eyes, and she smiled inwardly. I confess, she acknowledged, in an attempt at self-mockery, I confess that he moves me more than any of the others.

It was not Nicholas's beauty that touched her so much, nor the poem that he sang so tenderly. But the contrast between his strength – the colossal energy of Nicholas Lanier, his vital force – and the extreme intellectual refinement of this music. Artemisia had learned exactly what demands the composition of such scores made upon Lanier, and how much virtuosity he needed in order to perform them. Yes, it was the conjugation of elegant, scholarly artistry and intricate skill with the boldness of the adventurer that enthralled her.

The music was becoming faster and more violent. Nicholas was staring at Artemisia; he too seemed enthralled. He got up without taking his eyes off her. She was familiar with this solemn, almost hostile expression, of a surging, overwhelming desire. Abruptly the viol notes and the singing ceased. Artemisia watched Nicholas put down the instrument and closed her eyes.

'Tomorrow, you'll come with me,' Nicholas whispered as he clasped her to him. 'I shall introduce the owner of this villa to you. The first pictures are on their way . . .'

She fell back, enveloped by this powerful male body.

'Good Lord,' murmured Artemisia.

She knelt down slowly on the flagstones at the back of the store room, an old *salone* of the Murano villa. Her head on one side, she studied the huge canvas rolled out for her against the heaped-up crates by her host, the wiliest dealer in Venice: Caravaggio's *Death of the Virgin*.

Among the chests and packages, like a gilded stand of trees, rose the denuded frames of the pictures that had been removed for transportation across the lagoon. Statues stood at angles in the damp straw, ghostly goddesses, fragments of naked bodies. The water-saturated air smelled of tidal mud. In the distance the angry cries of seagulls could be heard and, nearby, the lapping of the waves.

'Good Lord,' she repeated excitedly.

She looked at the body of the Madonna lying in front of her. She studied her red dress, and the huge crimson draperies hung above the apostles. And then the light! A single ray of light that fell from a high window and accentuated the figures by brushing a hand, a skull or a neck.

'My father had understood everything!'

The men standing silently behind her exchanged the same questioning look.

It was an August evening and Lanier, the English ambassador and his First Secretary were submitting the painting to the professional judgement of Artemisia Gentileschi – the first of hundreds of pictures belonging to the Duke of Mantua, which the dealer Daniel Nys wanted them to buy on behalf of King Charles I.

Much depended on Artemisia's verdict. If the transaction went ahead, the sum involved would exceed the total of a year's taxes collected throughout the length and breadth of Ireland.

The English ambassador, Sir Isaac Wake, disapproved of these negotiations and took part in them against the grain. But he had received a formal order from His Majesty to back Nicholas Lanier's commercial undertaking. For his part, Daniel Nys mistrusted the influence that might be exercised by this woman, Lanier's mistress, over the buyers' decision. He was used to mixing with artists and was a great connoisseur of painting, so he feared Artemisia Gentileschi's jealousy of her rivals' works.

Artemisia had thrown her cloak on the ground and taken hold of the candle offered to her by the merchant. She slid her hand over the picture's surface. Her palm caressed the painting, she felt its texture under her fingers.

'I was never able to touch this canvas,' she murmured. 'It was commissioned by the monks at Santa Maria della Scala, but when it arrived they refused to accept it. They found this virgin undignified, too close to us, too human. But my father took me to see it. It was exhibited for only a week. He wanted me to see it. He had loved it.'

Artemisia fell quiet, absorbed in her memories.

'We had left my mother about to give birth when we went to look at this picture. She died while we were gone. I was twelve years old.'

After a moment's silence, she asked, 'Was it really Rubens who bought this canvas on behalf of the Duke of Mantua?'

'Indeed it was,' Lanier replied. He could not see her face as it was turned towards the canvas, but by the emotion in her voice, he could judge how much the delight in it vied at this moment with nostalgia, admiration and fear.

'Are there other Caravaggios still in Mantua?' she asked, turning again to her companions.

The candle in her hand fired her eyes with a golden light. Nicholas Lanier

had known Artemisia resplendent as a court artist, a ruff encircling her neck, her bosom festooned with pearls and chains. He would now meet her daily in this Venetian storeroom with her sleeves rolled up to the elbows, like a woman of the people, a bar in her hand for prising open the crates. She hefted the marbles in her arms, she lifted and unrolled the canvases. Never, not even during lovemaking, had he seen her eyes so brilliant and her lips so red and full. Artemisia certainly showed an ardour in bed that he had never experienced in any of his mistresses. But he had not known she was capable of such exaltation before the works of others.

Paying no heed to the answer, she went back to her contemplation of the picture. Perhaps this Virgin took her back to some earlier image – the image of her own mother with her knees apart and her feet naked under her dress, just as Artemisia had seen her exposed at Santa Maria del Popolo, before her body vanished into the nether regions of the church. This work recalled her childhood and all of her father's teaching.

'We must have the other pictures fetched quickly,' she pronounced. 'All of those left in Mantua, before Spain and France get their hands on them . . .'

The scene unfolding here, in one of the countless such storerooms across the lagoon, would have keenly interested Richelieu at the Palais Cardinal and Philip IV at the Escorial.

'Buy! Buy everything you can,' she continued, getting up. She faced the four men. 'And what you cannot buy, buy that too!'

'Sell! Sell everything!' exclaimed Vincenzo Gonzaga, Duke of Mantua, as if in echo, 125 miles away from Venice. 'And what you cannot sell, sell it elsewhere!'

The Duke's collection of paintings and classical statues was famed throughout Italy. A collection, assembled thanks to the fervent patronage of five successive reigns, and including, besides works by Caravaggio, several dozen pictures by Mantegna, Giulio Romano, Correggio, Titian, Raphael and Leonardo da Vinci. The celebrated collection of which Rubens had been curator for eight years.

The citizens of Mantua took pride in what they regarded more as a public museum than a private collection. Because of its pictures, Mantua had come to be regarded as the eighth wonder of the world. But the Mantuans would be brought down a peg. Fifteen years before, in 1612, the city state found itself in a financial impasse that demanded radical measures. In the Gonzagas' shoes,

every other prince in Europe would have sold off titles and offices, prebends and benefices; they would have borrowed, mortgaged and taxed before drawing on the symbol of their potency: their treasure. But the reigning Dukes of Mantua were no longer great Renaissance men. The random nature of succession had placed on the throne former cardinals who had no passion for works of art. All they would acquire now would be relics; all they would collect would be parrots, prostitutes and dwarves.

England, France and Spain knew their weaknesses, and with eyes turned on Italy, all three awaited their chance for plunder. It was a fitting reversal: Italy had been the first to pillage works of art. At the first defeat of the Protestant states, the Pope had sent his archivist to Heidelberg to bring back, in its entirety, the library of Charles I's brother-in-law. All the manuscripts and printed volumes would be added to the holdings of the Vatican Library. In order to facilitate the transportation of the books, the Pope's constables had lightened them by removing their bindings. They had even taken out their ex-libris so that their provenance would sink for ever into oblivion. In September 1624, Artemisia Gentileschi, along with all the people of Rome, had seen a long mule train come through the Porta del Popolo and make its way up the Via del Corso. A silver plaque swung around the neck of every mule: *Fero Bibliotecam Principis Palatini* – I carry the library of the Prince Palatine. Swaying on their backs each had one of 196 crates packed with unbound pages, trophies stripped bare from the most legendary of the German libraries.

Now, three years later, one of the heretic states was taking revenge by attempting to lay its hands on one of the finest collections held by a Catholic prince. This time, it was not a question of plunder and pillage. Merely a legitimate transaction. But the strength of feeling that this 'sale' would provoke throughout Europe, its consequences on the Thirty Years War and on the Siege of La Rochelle, its direct connection with the tragedy that would soon befall Charles I, all made this 'negotiation' akin to a *coup d'état*.

Lanier had made Venice his headquarters. No other city in Europe could provide him with so many built-in advantages towards the favourable outcome of his mission. The diplomatic relations which, for twenty years, had bound England and La Serenissima smoothed the way to commerce. There was such a special relationship between the two states that London had thought itself on the verge of converting the republic to Protestantism. Even better: to Anglicanism.

Ever since the Council of Trent, the Pope had mistrusted the Venetians –

a distrust grounded in their patriotism, their spirit of independence and, above all, the long-standing autonomy of their clergy – and England played on this suspicion on the part of the Holy See. In the Grand Council of the Republic the ruling group maintained that the clergy's independence was justified by the fact that the Jesuits, who swarmed all over Venetian territory, were the hidden face of Spain, the enemy of La Serenissima which pulled the strings of papal power and intrigued to encircle the republic.

Rome had tried to break Venice's resistance by requiring that the Council of Ten should hand over two clerics who had been arrested on charges of murder, rape and other violence. These two men, who held only ecclesiastical livings and had not been ordained, were subject to secular law. But the Pope decreed that they should be put under his jurisdiction forthwith and judged by his tribunal. The Holy Father used this situation to demand the immediate repeal of the two laws prohibiting the construction of churches, hospitals and religious buildings on Venetian territory without civil authority. On 17 April 1606, the Pope made public an ultimatum: if the two prisoners were not surrendered and the laws repealed, the Venetian states would be anathematised.

A month later, Venice was excommunicated. The interdict concerned the carrying out of all religious services, including administering the sacraments.

'We ignore your excommunication: it is nothing to us,' replied the Doge. Notwithstanding the papal briefs, threats and anathema, religious life continued as before. Venice compelled priests to celebrate the holy offices. When the capitular vicar of Padua said that he would have to wait for the Holy Spirit to move him before he could say Mass, the Venetians replied that the Holy Spirit had already moved the Council of Ten to hang all those who disobeyed. Some parish priests who refused to baptise babies or give extreme unction found a gibbet erected outside the church door.

This battle of wills between Rome and Venice was a gift to the interests of the Reformation. Adding fuel to the fire, London suggested a military and moral alliance between Venice and the Protestant cantons of Switzerland against Madrid – and the Pope. Venice was sliding ever so gently into the arms of the heretic states. In the end, Paul V Borghese became worried by the consequences of excommunication for Venice. If the city went over to the Reformation, Rome would have another schism on its hands. He hastily lifted the ban.

The republic had never seriously considered conversion to Protestantism,

but England's support and complicity during this period of religious crisis, and during years of moral and spiritual isolation, had wrought a connection between the two states that would endure throughout the century. Venice would become the meeting place for the English aristocracy travelling in Italy. And its university, Padua, would welcome scholars from Oxford and Cambridge. Even uncultured upstarts like Buckingham would succumb to the game of collecting – drawn in by Venice. At the start of his career, the Duke had acquired pictures only to follow fashion, but the discovery of canvases by Veronese, Titian and all the Venetian masters was to turn him into a judicious art lover, one of painting's most sincere devotees. When the rumour went around that the Duke of Mantua might well be willing to part with his collection, the English court was advised of it by Lady Arundel, the wife of Buckingham's rival collector. Lady Arundel had been to see the Gonzaga collection accompanied by Anthony Van Dyck, the young painter whose protectoress she was. It was her enthusiastic report that had brought about Nicholas Lanier's first trip to Italy.

He had used that visit to win over the merchant who had in the past acquired for the Duke of Buckingham's agent the Veronese paintings that were now the pride of York House. This man, Daniel Nys, was a formidable mediator and dealer, and a collector himself: he controlled the entire Venetian art market.

Said to be a Protestant, Daniel Nys was of Flemish origin. During the Thirty Years War he supplied both sides with arms. But he didn't just trade in muskets and harquebuses: vases, jewels, perfumes, furs and 'curiosities' from all the courts of Italy passed through his hands. His biggest client was the court of Mantua. On the pretext of recommending the talent of an English virtuoso on a visit to Venice, Nys had brought Nicholas Lanier into the Grand Gallery at the ducal palace of the Gonzaga. Between his concerts, Lanier had been able to inspect the pictures and draw up an initial inventory. He had taken home this list in his saddlebags, along with the engraved portraits of Artemisia and the thirty-six paintings he had acquired in Rome on the King's behalf – small beer by comparison with the works in Mantua.

Lanier had stayed in touch with Nys from London. His instructions took twenty days to reach the merchant, who pursued the negotiations and swore, in the name of the King of England, to everything that Vincenzo Gonzaga wanted to hear: that of course there would be total secrecy regarding the sale; that neither the Medicis in Florence, nor the Savoy court in Turin, nor the

Farnese in Parma would get their hands on a single picture; that the collection would leave for London quite intact. The possibility that a single object belonging to the Dukes of Mantua could come to hang on the walls of a rival house was so dreaded that it held up the sale, and might even prevent it. Lanier had grasped their anxiety: if the Dukes decided to sell the paintings, they would wish them to go far away, to an island across the sea, a heretic land where no Italian prince would ever see them again. Nys had to reassure Mantua on this point. But Mantua was suspicious; what proof did they have that Nys was indeed negotiating on behalf of the English? Charles I's master of music had therefore proposed that he make another trip to Italy. Alongside Daniel Nys in Venice, he would negotiate with the Gonzagas, and would personally convey the hundreds of pictures to London.

His departure for the continent was delayed for many months by the treaty that the Spanish Prime Minister signed with the French ambassador on 20 March 1627; a treaty that envisaged the invasion of England by France and Spain. This aggression pact closed all ports to English travellers. Nicholas Lanier was none the less skilful and clever enough to get back to Venice by July 1627, six months after Artemisia's arrival.

The delay imposed on their love affair by the European wars had allowed Artemisia time for herself and she had quietly given birth to a little girl, in Padua, at an inn whose whereabouts remain unknown. She named the child Francesca, in memory of her friend Francesca Caccini, the Florentine singer. Her servant and her coachman had held the child of the Duke of Alcalá at the baptismal font, but Artemisia hoped that later she would have another ceremony, with more prestigious godparents.

As was the custom in those days, she had at first placed her baby with a wet nurse, on a farm in the Veneto, keeping only Prudenzia with her. Mother and daughter had stayed on beside the River Brenta until spring. They had been able to work in the villas of friends of the Cavaliere dal Pozzo, the Cardinal of Savoy and the former ambassador of the republic, who was now back in Venice. The protection of these three patrons had introduced her into scholarly circles, and notably to a certain Antonino Colluraffi, tutor to all the young aristocrats, a man who professed the most enthusiastic admiration for her. Colluraffi was the founder of the Accademia degli Informi, and he had asked her to design the emblem for this society, whose purpose was the pursuit of political ideas. He wrote asking her to draw a bear licking its newborn cub

and smoothing its fur into shape. Like the mind refining matter, or knowledge improving the mind.

Small commissions of this nature could only enhance Artemisia's prestige. They suited her condition perfectly. Motherhood was giving her a new softness, a need for privacy, an inclination to secrecy. But when, with full household complement of little girl and baby, wet nurse, servant and coachman, she arrived in Venice and settled into a house in the parish of San Fantin, it was to cause quite a stir.

Women in Venice led the most sheltered lives in Europe. Unmarried girls saw the world through a gap in the shutters, while wives went out only to church, and then with an escort of two duennas. Yet this patrician society still aspired to some myth of liberty and liked nothing better than debates on the role and place of the weaker sex in the world. A number of small volumes, signed by three Venetian ladies, demanded women's freedom to study, to travel, to live the life they chose and to move freely within the family and society. One young nun, cloistered in a Benedictine convent at the age of sixteen, had proclaimed her rebellion to the young aristocrats and their tutor Antonino Colluraffi, and to all the intellectuals with whom she had numerous family ties. Her books, *The Hell of a Nunnery* and *Paternal Tyranny*, had been in clandestine circulation for many years, fuelling witticisms and controversies. The arrival in Venice of Artemisia Gentileschi, the living embodiment of the poor nun's dreams, would give added piquancy to the debates. But all the talk of her love affair with the famous English musician, Nicholas Lanier, would manage to distract attention from the real reasons behind the turmoil at the English embassy.

When the bells of St Mark's called the 2,500-strong nobility of Venice to the Sunday sitting of the Grand Council, their prolonged ringing could be heard all the way to the district of Cannaregio in the north of the city. It was here that the English embassy stood, exposed to the elements. Not far from this palazzo, out on the lagoon, a boat raised its plain red sail and disappeared into the mist. It sailed past the island of San Michele, with its dark yews and its ghostly walled convent. Then it crossed the Marani Canal which led to the open sea and, after tacking, sailed into the Grand Canal of Murano. It then turned off past the Fondamenta Navagero, rowing the rest of the way. Amid the cries of seagulls, the vessel cut through the green water that held the still reflections of a line of Palladian villas, with the white frontages, balconies and high

windows typical of the Venetian aristocracy's country houses. The felucca moored at the first landing stage where five steps led up to the *fondamenta* and the door of the villa rented by Daniel Nys from the great patrician family of the Doge Loredano: a mysterious property enclosed by walls and locked between two pathways which led into the island's hinterland. Behind the house could be discerned the tops of tall trees, the dense foliage of a garden which extended perhaps as far as the sea.

Three masked figures stepped out of the boat, walked quickly across the *fondamenta*, banged on the door with the knocker, then disappeared into the shadows of the entrance. The fact that they were masked would be unsurprising in Venice. Here, there was no need to wait for carnival nights in order to hide one's face under the *bauta*. Even at noon, in the middle of August, men would drape themselves in voluminous black cloaks. Tradition, necessity and inclination prompted patricians to shield themselves from curious eyes and disguise their identity. There was no one to match the Venetian aristocracy for ostentatious display, conspicuous luxury and dazzling opulence. But unlike the Florentine and Roman nobility, the nobles of La Serenissima reserved their munificence for public ceremony. In their own daily life, they tended to silence and frugality, not to say austerity. In this respect, the nobility of the republic was distinct from all the rest in Europe.

Like Florence, Venice now despised the trade that had created its splendour. And like Rome, it let itself be ruled by a prince it had elected: the Doge. But, unlike Rome and Florence, its aristocracy took a great deal more interest in the study and practice of government than in any other form of power. Its passion was for the art of politics, for the craft and study of affairs of state. The young Venetian's entire education had as its framework a schooling in and mastery of simulation – and dissimulation. Its cardinal virtue was 'impenetrability', one much lauded by Antonino Colluraffi, friend of Artemisia Gentileschi and tutor to Gian Francesco Loredano, the heir to that Murano villa inside which the masked figures had just disappeared.

Perhaps the mystery shrouding these figures went unnoticed, but the absence of servants, officers of the law or armed guards for their protection had attracted the attention of La Serenissima's informers. During this period of extreme instability, people did not go about Venice without an escort. The different districts were held by rival families who kept hired assassins in their pay. These *bravi* would randomly attack any masked person who had strayed into their territory. Security compelled people to go about in groups, which

meant that their movements were too cumbersome for anything to remain truly secret. The gossip of mercenaries and the indiscretions of servants, the revelations of countless secretaries in the service of the Grand Council, the Senate and the Signoria, the numerous denunciations and betrayals meant that no power in Europe had more 'leaks' than the republic. State secrets were worth fat sums in all the embassies. Double agents, triple agents and the spies of France, Spain and England likewise sold political secrets to the agents of the republic. In Venice, everyone was viewed with suspicion. This was why it was better for the transaction between Mantua and England to take place in an empty villa on the remote island of Murano, rather than in Venice itself.

Expecting the paintings whose departure from Mantua had to remain secret, Artemisia, Daniel Nys and Lanier waited together every night for the boat at the end of the garden . . . When it arrived they transported the crates through the low gate opening out on to the lagoon, as far as the ground floor of the villa. There they opened them. The first samples of the collection dazzled them; not just Caravaggio's *Death of the Virgin*, but Titian's *Entombment* and a great many other masterpieces.

'If we do not ensure the transfer of all the other pictures from Mantua very quickly, Cardinal Richelieu's man will make a higher bid,' said Artemisia excitedly. 'A little while ago, I saw the agent of the King of Spain prowling around outside your villa, Signor Nys. How does he know that the pictures are here in Murano? Would you seek out another purchaser? I imagine that competition is altogether in your interest. The more you raise the price, the greater your commission will be . . .'

The merchant's face altered. Daniel Nys was very short of stature, like the ambassador and his secretary, but more thickset, with prominent cheekbones in a broad face. He had a reputation for knowing how to defend himself. His wealth enabled him to brush aside anyone who opposed him. For twenty years now, he had rubbed shoulders with every ambassador posted to Venice. He himself held the post of Swedish consul, although neither his provenance nor his business made him suitable in any way. If one judged by appearances – for Daniel Nys was a pastmaster in the Venetian art of secrecy and subterfuge.

He chose to answer the only question that he had not been asked. 'Indeed,' he acknowledged, 'the inventories drawn up by my proxy in Mantua match neither the pictures nor the statues which we have received; I wonder whether Cardinal Richelieu might have got wind of—'

Artemisia interrupted: 'Mantegna's *Death of the Virgin* and Raphael's *Holy Family* are missing.'

There was an intent look in her eyes as she turned towards Lanier and the ambassador. Quickly, she crossed the little salon, her footsteps clattering on the flagstones and reminding anyone who had forgotten that she did not belong to the aristocracy and had been given none of the lessons in deportment which fine ladies receive. She reached the three men who had sat down around a pedestal table, the last relic of what the room had been before being turned into a storeroom. Nys drew an chair towards her. She chose to remain standing.

'*The Holy Family* is missing, it's true,' Nys acknowledged. 'I asked His Highness for it in my last correspondence.'

'There are a great many other things missing too. What is more, none of the prices matches the agreements we made. Would you give me a glass of wine?'

While Nys was pouring her wine, the ambassador went over to her.

'Do you think that Mantua is trying to cheat us?'

'I am sure of it, Your Excellency. And if it is not Mantua . . .' Artemisia turned towards Nys. 'It seems to me,' she went on, her voice no longer lowered, 'that Venetian merchants are full of nice sentiments which they do not put into practice.'

'Why are you speaking to me like this, Signora?'

'You know very well,' she retorted briskly. 'It is not just that the list you drew up in Mantua fails to correspond with the one you gave me today, but both *The School of Love* and *Venus and Cupid with a Satyr*, which you claim are Correggio's, are forgeries. Mantua is sending us copies and you are backing their duplicity.'

As he listened to her doing battle with the fearsome middleman, Lanier's eyes sparkled. How he loved her like this, all fury and passion. And how right he had been to call on the expertise of Artemisia Gentileschi in the service of his mission and his King. He would never have imagined that, for his sake, she would become so involved in the sale of the Mantua collection to the crown of England.

Ever since Lanier's arrival in Venice, 'the sale' was all they thought about. They both lived at fever pitch, obsessed with the fear that Spain and France might rob them of their booty. They were fired by the intrigue and secrecy of it all, by playing a game, by the magnitude of what was at stake. They had a sense of working for history and were enjoying themselves as they would never do again.

*

During the initial period of her life with Lanier, Artemisia had felt wonderfully happy and vibrant. The birth of her baby, and having Prudenzia with her, greatly heightened the joy of their being together. The more she came to know Nicholas Lanier, the more she admired him and was in love with him. She loved him not only for himself – for his vigour and gaiety, his capacity for work and his intellectual curiosity – but because she could feel that he adored her. Their mutual enthralment remained a pleasure that was always fresh for her. Her complicity with Lanier, an intoxication. In everything which he undertook, Artemisia could discern a grand plan that excited her. She was almost frightened by this excessive admiration and looked in vain for some flaws in him.

For his part, he found total happiness by her side. The satisfaction of his every desire, heightened by this great battle to acquire the finest paintings in the history of art, gave him the joy which he had hoped for while riding at full speed towards Venice. He was so pleased with her, with their affinity and understanding, that he sometimes forgot that Artemisia might have other desires and other interests. To be accurate, he did not exactly forget it. But the euphoria he discovered in his companion's complete availability, an availability which he had not expected, in her subjection to all the demands of their mission, in the absolute devotion which she exhibited towards him, sometimes led Lanier to neglect Artemisia Gentileschi – if not her existence, at any rate her *raison d'être*: her art.

None the less, she remained an object of constant concern for Nicholas Lanier. He was respectful, loving, thoroughly conscious of the honour she did him by sharing his life; he fussed over her solicitously and plied her with questions. But the rushing sound of their horses' hooves drowned out the answers. Lanier was carried away by this whirlwind and heard only the clamour of his passion. For Artemisia. For the collection. And for the sale.

Expertise and counter-expertise, lists of prices, inventories, protests and complaints: between Venice and Mantua they criss-crossed Italy, riding so hard that they overtook the messengers, couriers and mail carriers.

On 10 July 1627, Daniel Nys wrote to the counsellor of the Duke of Gonzaga:

In answer to your letter of 15 June, I have laboured exhaustively to persuade my purse [Nicholas Lanier] *to be willing to spend more than fifty thousand Mantuan scudi.*

After many a battle, we have come to an agreement that we must return to Mantua to discuss prices directly so as to bring this business to a conclusion [. . .] I have moreover become besotted with those vases of rock crystal, those small bowls made of agate and other semi-precious stones [in your collection], *thinking that we might fix upon a price for them according to the judgement of Your Most Illustrious Lordship.*

Two weeks later he continued this correspondence:

Your Lordship proposes to lodge us with him in Mantua, too great and undeserved a favour. One which I should accept with great joy were it not likely to attract attention and raise the alarm. I think it preferable to put up at an inn where we shall be incognito.

On 4 September:

On Thursday night we returned to my villa on Murano, where I received the second consignment of pictures. I shall pay all the monies to your chargé d'affaires on Wednesday.

In a message sent to his master on 6 September, Vincenzo Gonzaga's chargé d'affaires claimed that Daniel Nys refused to pay him because he didn't believe that he was authorised to take receipt of such large sums. Less than a week later he was still complaining:

I have expressed my concern to Daniel Nys that the news of the sale should have been broadcast everywhere. Even the common people of Venice speak insultingly of this transaction [. . .] To this he answered that the information was not divulged by himself, but by spies in the pay of those who covet our pictures. He claims a personal injury from this.

Finally, on 22 September 1627, the Gonzaga's chargé d'affaires, now back in Mantua, sent the following distressed letter to their ambassador in Venice:

I went to see His Most Serene Highness the Duke Vincenzo to give him an account of what I had heard said abroad concerning the sale of his pictures, concerning the serious damage to his reputation brought about by this sale, and concerning the losses to his Treasury as a result of the excessively low prices which he had agreed upon [. . .] His Highness listened to everything I told him in private and requested me to write to you under most secret seal so that you might contrive to ascertain [. . .] whether there is any way of recovering our statues, our objects and all our pictures. By buying them back? By taking them back by force? By seizing them at Murano? You can send a letter to his Most Serene Highness who wishes to be informed. Let him be well advised of the

*harm that the sale has caused to his reputation. I myself have told him how much you
and I have wept, wept tears of blood over this affair and the deplorable manner in which
it has been conducted. I shall deliver your letter to His Highness by my own hand lest
anyone be apprised of our intentions. Besides this, His Serene Highness has become
enamoured of that female dwarf whom I described to him in accordance with your own
account. He must have this dwarf, he wants her at any price, even if we must abduct
her. His Highness will send you a band of men experienced in this manner of action, a
carriage and everything that you will require. For the love of God, make it your
business to give his Highness this creature which shall console him for this dreadful sale,
and make him forget it.*

While Vincenzo Gonzaga's advisers pressed him to regain possession of
his pictures whatever the cost, while the common people manifested their
concern beneath the windows of the ducal palace in Mantua and the burghers
of the city collected money for the purpose of recovering the collection, new
difficulties arose in Nicholas Lanier's life, in the form of Gentileschi's sons,
who were bent on opposing the will of Artemisia's lover.

During Lanier's absence, Orazio had persuaded Charles I to acquire a
second great Italian collection, a series of paintings being put up for sale on the
Genoa market by a Neapolitan art lover. The family of his brother, the
celebrated painter Aurelio Lomi, had settled on the Ligurian coast and
Orazio had had this information from them. His sons, Francesco and Giulio
Gentileschi, had therefore embarked on 28 August 1627 to join Lanier in
Italy as planned. But Francesco and Giulio intended to bypass the musician's
authority. Following their father's orders, they would now seek royal favour by
purchasing pictures for the English sovereign on their own account. Were not
they refined connoisseurs too? Two artists schooled by Orazio Gentileschi?
Two painters, more competent to judge a picture than any musician!

Leaving Venice, Lanier had ridden at all speed to Genoa. He feared that
Artemisia's brothers would buy works inferior to those of the Gonzaga
dynasty and would squander the royal treasury which he so badly needed.
Furious at having had to abandon the negotiations with Mantua at such a
crucial moment, he covered two hundred and fifty miles in four days.

With his characteristic prodigious energy, Lanier stayed in Genoa for
only twenty-four hours. Long enough to inspect the canvases, to meet with
the Genoese representative of the English bank and to place a total veto upon
any purchase whatsoever by Francesco and Giulio Gentileschi. He did not

take the trouble to meet the two brothers, nor to advise them of his visit, nor to give them notice of his decision. Riding hell for leather, he left again for Venice.

Artemisia's brothers were not men to be trifled with. Though they accepted their father's supervision, following him from one place to another, carrying out his orders and bending to his authority, they did not allow anyone else to treat them lightly.

Giulio therefore set off hot on Lanier's heels. He insisted on an explanation, an apology. Most of all, he wanted money. Would Lanier reimburse him for the journey? Would he pay for his expenses in Genoa? Would he give him recompense for all his trouble?

It was November 1627. Artemisia would renew links with her family, a loud and vengeful clan out for every last penny.

31

The English Embassy in the
Cannaregio District of Venice

28 November 1627

'I have been sent to Italy on the order of His Majesty to buy a collection,' Giulio bellowed, crossing one of the small reception rooms that Lanier used for his business in Venice.

The Englishman, pale with contained fury, stood in front of his desk.

'Of course, Signor Gentileschi,' he acquiesced, between clenched teeth. 'But under my supervision. And with my authorisation. Why did you not come to ask me for them?'

Giulio had his hand on his sword as he headed straight towards him. The chandelier shook at his every step. He was a man of around thirty, very good-looking. But uncouth. He walked with the brutal swagger of a soldier; the greedy expression in his eyes betrayed the venality of a mercenary.

'I did so. Only, in London I was told that you were in Genoa.'

'*Who* told you?'

'Sir Thomas Cary,' barked Giulio, 'one of the King's gentlemen. He sent you the order to give my brother and myself the necessary sums for our expenses.'

'If he indeed told you that he wrote to me in those terms,' – a scornful smile played over Lanier's face – 'I quite understand why you would want to find me.'

This sarcasm was lost on Giulio, who was too busy justifying himself.

'It was in Milan,' he went on, 'that we learned you were in Venice. To make sure of finding you, Francesco took the Genoa mail coach while I rode

here. Mr Daniel Nys informed me that you had just left to reach us and I followed you back. But in Genoa no one had been given notice of your visit, with the exception of the banker who refused to honour our letters of exchange.' Giulio's face wore a threatening expression. '*Basta*! I've had enough. Pay me now, otherwise . . .'

The door behind him opened and Artemisia appeared on the threshold. When she heard her brother arguing with her lover, she stopped and came no further. Giulio did not see her.

'Otherwise?' echoed Lanier.

A sly smile lit the young man's face.

'I have admired the fine pictures you are hiding away on Murano. And all your statues. What a haul! I am sure that this treasure will be of the greatest interest to the Spanish friends I have been able to meet along the way . . .'

Lanier shot a glance over Giulio's shoulder at Artemisia.

'Did you receive your brother at Nys's villa in my absence?' he asked, icily.

'I saw him,' she acknowledged.

Lanier remained silent.

Giulio's first appearance in Venice, some ten days earlier, had surprised and overwhelmed Artemisia. She had found him so handsome and so changed. She had not seen him since her wedding day. They had done a reckoning: nearly fifteen years. She still thought with nostalgia of her brief meeting with Francesco and Marco in Florence and had never forgotten the warmth of their reunion on the day after the death of her children. Giulio was the only one who had been missing. Embracing him, it was as if she clasped the little boy of old in her arms. She had bombarded him with questions. How was their father? What was he working on? Did he like England?

Giulio had boasted of Orazio's position at court, of his influence with all the sovereigns of Europe and his diplomatic triumphs. But he had not been able to give her any more personal news. Artemisia, on the other hand, had opened her heart. In her joy at seeing him again, she had revealed all her secrets. And those of her lover.

'You are now going to let me cash the letter of exchange for five hundred pounds sterling,' Giulio snapped at Lanier.

'So, you mean to avail yourself of what the King had allocated to the purchase of the Genoese collection,' quipped Nicholas.

'I want you to let him know that it is by your order . . .'

'That you are helping yourself to his purse?' mocked the Englishman.

Artemisia reddened and gave a shudder.

She knew Lanier well enough to be certain that his banter boded ill for her brother. The mistake she had made, by taking Giulio into Daniel Nys's secret warehouse, prevented her from pleading on his behalf. She wished she could defend him but she was compelled to acknowledge that, for all his gentleman's sword, his boots and lace, Giulio remained a thug of the same species as Agostino Tassi. A thug and, moreover, a blackmailer. Of the same stripe as Cosimo Quorli. She was ashamed.

'I must discuss it with my ambassador,' Lanier said haughtily, concluding the interview. 'Come back tomorrow.'

Giulio came back the next day. He came back the day after. And every day. His insistence only exasperated his interlocutors. Nicholas was thinking of having him thrown in prison.

'Spare him,' Artemisia begged. 'He is tiresome, but he does no harm.'

'What do you mean, he does no harm? He has spent the sum that was assigned him for travel. He tried to cheat me in Genoa. He threatens to hand over the Mantua collection to Spain. He is stealing from the King . . .'

The unspeakable contempt written on his face prevented Lanier from finishing his words. She bowed her head.

'I know,' she avowed. 'But he is my brother.'

Lanier's love for Artemisia won him to her cause; in the end he agreed to finance Giulio's stay in Italy.

'You may cash your letter of exchange, Signor Gentileschi. I shall take responsibility for it. Now, go and be hanged!'

Giulio did not need to hear more. He left without fuss to spend the winter in Pisa with his Lomi cousins, where his uncle Aurelio had recently died. Meanwhile, Francesco pursued their murky affairs in Genoa.

Her family's lack of delicacy had placed Artemisia in a difficult position with her lover. But she had been able to admire her brothers' tenacity and pugnaciousness. She did not doubt that Giulio and Francesco would have resorted to armed violence, or to some form of treachery against Lanier had they not got what they wanted. The 'Gentileschi boys' would stop at nothing to be recompensed for their efforts.

Selling, delivering, acting as agents, these would henceforth be the occupations in the domestic economy of the Gentileschi family. Throughout

the ten years to come, Artemisia would share their services with Orazio. But when the two painters sent them to the courts of Rome, Paris or Madrid to collect the payments for their pictures, they would take good care to keep them well in check.

For now, rid of their interference, Artemisia and Nicholas could once more devote themselves to the business that their contemporaries were already calling the 'sale of the century'.

32

Venice and Mantua

December 1627 to April 1628

Fate had decreed that Duke Vincenzo should die of an illness in the month of December. His successor, the Duke of Nevers, would have to defend his throne against the claims of Spain. Mantua was more badly in need of money than ever, and its desire to rescind the sale now seemed inappropriate. But if Lanier thought his troubles were over, he was wrong. Mantua might be selling, but London was not paying.

The sum called for by Nicholas Lanier from the King of England's banker put a strain on the budget set aside for the war effort against France, and among the King's advisers in London, it provoked an outcry comparable to the one in Mantua.

At that moment Buckingham was surrounding the walls of the Île de Ré, in a ghastly siege where the English were completely unprovisioned. If Charles I wanted to defeat Louis XIII, he would have to raise fresh troops, clothe them, feed them and arm them.

In October 1627, the King's banker wrote to one of the gentlemen of his bedchamber:

> *Sir:*
>
> *By the letters I send you this morning you may have seen Nicholas Lanier's demand. Here are the notes and descriptions sent to me. I pray let me know his Majesty's pleasure, but above all where money shall be found to pay this great sum. If it were for two or three thousand pounds sterling, it could be borne, but for fifteen thousand, besides the other engagements for His Majesty's service, it will utterly put me out of any possibilities to do anything in those provisions which are so*

necessary for my lord Duke's relief. I pray let me know what I must trust, and so I rest . . .

A brief note signed by the King was to answer this pressing question: the banker was to buy the collection.

At a stroke, Charles I lost the Île de Ré, he abandoned La Rochelle and he lost the confidence of his subjects, whose religion proscribed holy images and who hated those who worshipped pictures. Though England could impute its defeat to the negligence of the Duke of Buckingham rather than to any shortage of resources, the country would now be on its guard against a monarch who would sacrifice victory to his passion for material objects.

It was the triumph of the arts, of painting and music, of Artemisia Gentileschi and Nicholas Lanier. It now remained for Lanier to transport the canvases and the classical statues by sea, avoiding the covetous intentions of French and Spanish ships, pirate vessels and Turkish raiders, storm and shipwreck. The adventure was only beginning, Yet for months now it had so occupied Artemisia that she had forgotten to mistrust the intrusion of a man such as Lanier upon her life.

Vanquished by a determination equal to her own, fascinated by the vast means at his disposal for the realisation of his projects, Artemisia lived only on Lanier's dreams. She had abruptly forgotten her fear in the studio at Rome, her flash of intuition that the vital power of Nicholas Lanier could easily annihilate the creative power of Artemisia Gentileschi. But she now had to face the fact that since settling in Venice she had produced nothing. Not a single canvas. Not a single drawing. Nothing more than three rough sketches that she clung to as the last evidence of her talent. As for the *Lucretia* and the *Susanna* that she had sold to collectors in La Serenissima and which were lauded by the Venetian poets, they were both works which preceded her arrival by several months. The Muses had abandoned her. Inspiration seemed to have died. Even worse: the splendour of Venice left her imagination cold.

Artemisia was becoming aware that the revelation of Tintoretto's and Bassano's canvases, that all the pictures she had discovered with such excitement at Daniel Nys's villa – Titian's *Entombment*, Raphael's *Holy Family* – would have no influence upon her vision, leave no trace on her art. While Nicholas was away, she recalled some of the pictures that they had admired together in the Murano storeroom. First and foremost *The Death of the*

Virgin. Though she might still be clear-headed enough to judge Caravaggio's influence on her father's work, and though she might even be able to measure the distance separating Orazio's work today — what she had been able to see and admire of it in Genoa — from his old rival's innovations, Artemisia had lost any sense of the value of her own work.

Trapped by what was coming to strike her as the total incompatibility between her attachment to Lanier and her painting, she struggled with herself. She could uncover no trace of regret now for her lost independence. Nor could she find any joy or desire, any curiosity or hope. Nothing but this amorous passion which blotted out every image inside her. What does it matter? she thought. Happiness means loving Nicholas, living through his thoughts, his desires, his needs. But she was haunted by strange dreams and experienced a perpetual sensation of dizziness. It seemed to her that the boundary between Venice's water and stone, between Nicholas's body and hers, was dissolving. Whether in a gondola or on dry land, she felt as if she were constantly at sea. She was sinking.

She tried to find in herself once more the passion that had absorbed her throughout her life. When her boat crossed the lagoon and ploughed into the ragged mist of the canals, Artemisia would contemplate La Serenissima. Her gaze would come to rest on the extended mass of the islands, her eye would be caught by the tops of church steeples. Then, on to Venice's great clear sky, she would project the compositions of the pictures that she dreamed of painting. Mentally, she reproduced the swell of its cupolas, the upright lines of the bell towers, the curves and grooves of the gondolas and barges. She recreated the play of light striping the white flagstones on the *fondamenta* and recalled Agostino Tassi's invaluable lessons on the rules of geometry and perspective. A smile of satisfaction would appear on her face. She studied the vanishing point of a canal's perspective, the set of a head seen from below, the foreshortening of a leg. That's it, she would decide, narrowing her eyes as she imagined the figure she would reproduce. She saw the raised arm of a Lucretia on the point of suicide. That's it, perhaps the hand ought to be lifted, the knife and the background draperies altered a little.

In Rome, at the start of their relationship, Nicholas would constantly ask to watch her while she painted. Now, he would push away everything that might distract her from their passion. 'You've worked long enough,' he would say, gently removing her folio. 'Don't paint so much,' he would murmur, on those rare occasions when he surprised her grinding her colours, mixing her

glues and varnishes. 'Don't paint so much': the words Agostino Tassi had uttered in the studio at the Via della Croce on the night of the rape. 'That's enough painting!' he had shouted, snatching away her palette and brushes. For Nicholas's sake, she readily agreed to relinquish them. Her cauldrons, mortars and pots, all the tools of her art lay abandoned. With time, she had come to think of aesthetic experiment as the prerogative of others, of Caravaggio or Orazio Gentileschi. She saw beauty as having murky and disturbing qualities. As something painful. As almost a self-reproach.

'What were you thinking about?' Nicholas would ask whenever he found her with a faraway look.

'Always the same thing,' she would sigh sweetly. 'About you.'

He would be satisfied with this answer. With no doubts about either her or himself, he had in mind to take Artemisia with him to England.

In March 1628, a month before they were due to leave Venice, Agostino did something that was to compromise his hopes. He rummaged through Artemisia's boxes. Had the habit of acquiring all the pictures, statues and objects he coveted gone to his head?

He found the three sketches she was keeping. Nothing spectacular. Just the three roughs that she planned to use some day for a *Lucretia*.

Deeming them quite ordinary, he had bartered them for three statuettes, fragments of Roman goddesses that belonged to Daniel Nys, which he thought suitable as a personal gift to the Duke of Buckingham. This exchange was to cost him dear.

'Was it you who took my drawings?' she exclaimed in vexation.

'There was no harm done. They were worth nothing.'

Seeing the look on the face of the woman he loved, Lanier realised the seriousness of the blow he had dealt her.

He tried to make amends. 'Artemisia, Artemisia, I beg you, forgive me.'

But to Nicholas's surprise, when he raised his voice, she bowed her head.

'It was not my intention to humiliate by giving away your sketches,' he said by way of entreaty. 'I did not know that they mattered to you . . .'

'If I were a man, you would never have dared to appropriate my work!'

'If you were a man,' he answered flippantly, 'I should not have loved you. All I did was take your roughs . . .'

'When the blocks of shadow, the outlines and the figures are already set down on paper, then the execution of the painting is child's play. It all lies in

the vision – the invention! With the three sketches you gave to Nys, anyone at all can use my work.'

'In six months I have not seen you paint for even one hour. I thought that these drawings were of no account to you. I thought that you yourself would have made a gift of them to Nys, had it made him well disposed towards us. You know how much we still need him. Mantegna's *Nine Triumphs of Caesar* are still in Mantua. So long as we fail to acquire that series, we will have acquired nothing. What are your drawings compared with the finest pieces in the Gonzaga collection?'

'No one has the right to dispose of my work.'

'I thought that to serve the King of England—'

'I don't care a fig for the King of England! And you . . .' She raised her head. 'You are only serving your own name.'

Their quarrel did not last long, but it marked the start of a new life in Venice. Artemisia renewed her links with the academies, abandoned the Murano villa and deserted the English embassy. Lanier took her conduct as a betrayal. But what could he do about it? She would counter his every attempt at discussion with a laughing astonishment, feigning flippancy and remaining inscrutable.

'Yes, of course, I have agreed to paint Doña Inés's portrait. Yes, she is indeed the daughter of the King of Spain's agent. What of it?'

The distance between the two of them grew more noticeable by the day.

On 28 April 1628, Sir Isaac Wake, the ambassador in Venice, wrote to the Secretary of State in London:

Right Honorable My Singular Good Lord:

In your Lordship's letter of 26 March, there is one clause, which commands me to give His Majesty an account of Mr Lanier, as likewise of the pictures by him provided, for His Majesty's service, the ship upon which they were loaded and the time of departure of that ship. To discharge myself of that duty, I must tell here Your Lordship that no care or diligence has been wanting on the part of Mr Lanier, who has embarked them very well conditioned, upon the Margaret of London, whereof Thomas Browne is master [. . .]

In this business I have done whatsoever was commanded me, by Mr Lanier, and no more, and all that I did was this: first I did move the Prince here for a warrant to export the pictures without payment of customs, which would have come to a round sum, and

this was granted and effected. Secondly I went personally aboard the ship to see the cases orderly and safely stowed, wherein I could observe nothing amiss [. . .]

Concerning the person of Mr Lanier, I can only tell Your Lordship that he departed from hence yesterday the 27 of April, with an intention to pass through Helvetia, Lorraine and so to Brussels; he has a passport of mine to facilitate his passage [. . .] *I have likewise written to my servant Oliver to serve him and assist him in whatsoever he shall require in those parts. I have further caused a trusty guide to come from Bergamo hither expressly to undertake the care of his transportation . . . lastly I lent him my barge, to transport him to Padua, from whence he is to go in coach as far as Bergamo and there to take horse. He carries with him the best paintings, namely those of Correggio . . . being in watercolours, they would not have brooked the sea.*

I hope that by the time this letter arrives, he will not be far off . . .

33

The Island of Murano

April 1628

In their chamber beneath the rafters of Daniel Nys's villa, Artemisia and Nicholas could find no rest. It was their last night. They could neither speak nor embrace one another, they could not even touch. Naked, they lay side by side, motionless like two supine effigies in the gloom. They were chilled by grief at the thought of separation. Not a sound. Only their breath, which they tried in vain to hold back. She does not love me, thought Nicholas. She has never loved me, or she would leave with me, she would come with me to England. If I follow you, she thought in her own defence, I repudiate my art, I fall and die like every other woman. Without painting, I do not exist: in your eyes, I do not exist. In these last few moments near him, she struggled with herself and with her doubts, her decisions and how she had reached them. No, I should not be afraid of making a drastic choice, she thought with sadness. Nicholas despises me already. He cannot still love me, for he has no respect for my work. But how can I live without him?

Late into the night, when she could feel Nicholas's body weigh more heavily beside her, and realised that he had fallen into slumber, she walked around the bed, drew close to him, held up her torch and studied him for a long time. The light of the flames gave life again to the strong face, alert even in sleep. Artemisia looked at his sinuous lips, his delicate lowered eyelids that hid a gaze whose authority she knew. And the fair skin that she so loved to breathe the scent of, the body that she adored to caress. To acknowledge my desire for him is a small thing, she admitted to herself.

She stepped back, weeping. She tried to reach out and touch him lightly, but she recoiled, frightened of waking him. He would look her up and down

with that severe expression of his and ask her again why she refused to follow him to London. He would reproach her with preferring her painting – *Judith*, *Lucretia*, *Susanna*, *Bathsheba* – all of her pictures, to him! He would accuse her of sacrificing him to her ambition.

There is no solution, she thought. My love will become more and more passionate, his will gradually fade, and my art will be dead. What would become of me in London? His King, his music and his wife will take him away from me completely. Should he stop loving me, should he be good to me out of pity, should he be smitten by another woman, what would become of me in London? She tried to think things through. Let us suppose that Our Lord should take Nicholas's wife, that Pierantonio should die, that my father should be no more. Let us suppose that we become pledged to one another and I marry Nicholas – he would never allow me to continue painting. Let us suppose all the same that he encourages me and invites me to continue . . . But then I am the one who would not be able. I am not strong enough against him; my soul, my art, everything yields in his presence. I have bartered my work for a different passion. And I do not complain of the exchange. But there is no solution.

'And now what do you want me to do?' he asked simply as they followed the path through the Murano garden for the last time.

She laughed with that forced new laughter that had separated them ever since he had sold her sketches without consulting her.

'I want you to take your pictures back to your King,' she said flippantly, as she descended the steps of the bridge. 'I want you to be very careful not to get caught by the French – and not to get killed along the way!'

'Is that all that you want?' he asked bitterly.

She wavered. He felt that she was forcing herself to give one answer, while her thoughts and desires tended towards another. Artemisia's eyes were clouded with tears. He took this chance to seize her by the elbow and hold her against the parapet.

'I want you to come with me to England. My love for you . . .'

'If your love is so great,' she disengaged herself from him, 'give me back my strength and peace of mind.'

'But you have never known peace of mind, Artemisia! I can see no way of having peace of mind. None at all, neither for you nor for me. Follow me to London. Come and be with your family. Come and paint alongside your father.'

Her laughter was sarcastic. 'Alongside my father? Within six months, he would have me turned into a slave. Look at my brothers. I should be like them, working *for* him!'

He answered her in the same vein. 'You underestimate yourself . . .'

They exchanged a long look.

'If my father did not live in London, perhaps I should go with you,' she admitted.

'Is it that you are afraid of him?'

She did not answer. He looked her in the face.

'You are every bit as good as he is! What is it that you fear?'

'Giving up.'

'You have neither courage nor honour, Artemisia. I am offering you life, I am offering you love, adventure and the glory of serving a great prince, and you are running away.'

'I am running away as my father fled: so as not to lose myself.'

My God, he thought, incensed, just as she is on the point of agreeing to be mine, she makes off again and it is the other who prevails.

'Your father will go back to Rome in the end. Where will you run to then?' he jeered.

With a mischievous smile, she countered: 'To London?'

'Artemisia, think hard about what I'm saying. I cannot part from you. And I know that, for you too, we are as one.'

She shook her head and corrected him: 'Painting and I are as one.'

'If you persist, all I can see for you and your daughters, and for your future, is wretchedness and despair.'

'If I persist in what?' she asked, with an abrupt jerk of her head.

'On this absurd path, on this quest for some kind of renown, in this duel between your father's paintings and yours.' He glowered at her. 'You already have honour and renown. You have achieved everything. I am proposing nothing more than that you continue . . . I am proposing that you be happy.'

'How happy that would be!' she exclaimed sarcastically. 'Going back to where I started: "Gentileschi father and daughter".'

'Do you know how many pictures the King of England has bought in the space of three years? When he was crowned there were twenty-one canvases listed in the inventories of his collections. There are now five hundred. Work it out. In England, your creative powers would have no limit.'

She shot him a look of desperation.

'It is because I love you that I cannot follow you,' she said.

'I realise that my presence is disagreeable to you, so you will not see me again,' snapped Lanier. 'But the happiness of our life together depends on that single word that you used to say with such ease, and that now seems to scald your lips.'

'Love,' she acknowledged slowly. 'If it scalds my lips, that is because for me its meaning is vertiginous. Because of the way that I experience love, I would sacrifice everything for it. For your sake, I would deny what I owe to myself.' She hesitated. 'For yours and for my father's. So . . .'

She walked quickly down the last few steps of the little bridge, then she went along the *fondamenta*, passed by the gondolier and went into a church.

On the green water Nicholas Lanier's broken reflection was caught in a web of foam. He stood in the bow of the ship, his eyes scanning the *fondamenta*, looking for Artemisia. Suddenly he glimpsed her among the casks and bundles, lost in the shadow of the ducal palace's arcades. Without moving, she watched him disappear from her life for the second time.

It would be ten years before Lanier and Artemisia saw one another again. Artemisia would soon leave Venice. In February 1629, her former protector, the Duke of Alcalá, was made Viceroy of Naples, which belonged to Spain. For over a century, the Spanish Habsburgs had been using Naples as a naval and military base on the boundaries of the Papal States: a colony which they burdened with taxation. The government of the Kingdom of the Two Sicilies represented the highest office that a grandee of Spain might vaunt. For five years, the duration of his reign, the viceroy had it in his power to plunder Italy, to sack its treasures and to employ the most audacious of contemporary artists on his own account and that of Philip IV: so the Duke of Alcalà was inviting 'his' painter to come and join him.

Spain and England: Artemisia and Orazio. Father and daughter would now serve two countries and two masters whose respective histories and religions threw them into a merciless rivalry.

In the spring, Signora Gentileschi travelled to Naples to take up residence in the fief of her powerful patron.

34

Naples

July 1629

'I don't like Naples,' murmured young Prudenzia.

'Why not?' asked Artemisia. 'Naples defies the imagination!'

Swept along on a human tide, mother and daughter held on to one another. They were trying to make their way through the damp side streets. But the peasants, beggars and Spaniards milling around everywhere kept pushing them apart.

Four hundred and fifty thousand people lived within an area of some twelve miles. Naples was the most densely populated city in Italy, with the highest population in Europe – comparable only with Paris.

The press of people around the two women hindered them from moving forward. They would be separated only to come back together, get lost yet again and then catch up with one another.

At last they left the maze of alleyways and came out on to the Via Toledo. This great thoroughfare swarmed with soldiers in Spanish helmets and Neapolitans affecting the manners of Madrid. From end to end, all the way from the hills to the bay, the street was bustling with thousands of people. It was hugely congested. Crowds of idlers jostled one another, on foot, on horseback, in carriages and carts. If they were not in rags, they wore ruffs and wide cloaks, had pointed beards and hair cut below the ears.

Artemisia was dazed and disoriented by these rowdy, chaotic surroundings. In the commotion she tried to resume her conversation with her daughter, and reassure her by communicating some of her own enthusiasm.

'If we were to go into any one of these churches along the way,' she continued, out of breath, 'you would find them still packed with people.

There would be teeming crowds in the side chapels and among the pews. And everything would be clad in precious marbles. Everywhere, on the altars and tombstones, you would see nothing but jasper and porphyry, and mosaics of every kind, artistic masterpieces,' she explained, enraptured.

Prudenzia did not share this admiration; she looked straight ahead, taking care not to let herself be jostled or thrust apart from her mother.

She was acting like a frightened child, and this stopped Artemisia from saying more about what impressed her: the contrast between light and shadow; between the glittering sea, the blinding sun and the dark mass of Vesuvius; the scorching heat of the streets and the dampness of the courtyards. The vast difference between the huge convents and the rudimentary huts crammed together in the culs-de-sac, between the palaces and the shacks, between the six-storey buildings and the makeshift dwellings.

Cathedrals, monasteries, grand houses: the Spanish nobility vied with the Neapolitan aristocracy, the oligarchy pitted itself against the merchant burgher class to commission more and more spendid buildings. The port traded with Spain, of course, but also with the Orient, with England and Flanders. The priests, monks and nuns were even more numerous than in Rome and the clergy, determined to preserve every last one of its privileges, did not balk at taking on the court, the Royal Palace and the Habsburgs. And the common people! The influx from the countryside was so huge that only one person in three had a roof over their heads, only one in six had employment; an impoverished, idle rabble lived in holes and corners, sleeping in the loggias or under the porches.

'I hate Naples!' Prudenzia reiterated.

A gang of beggars came between them. In the pandemonium their voices became inaudible.

From the entrails of the earth, beneath the shouting and the din, there rose a murmur that spread to the foot of Vesuvius, a ceaseless tumult which, perhaps confused by the threat from the volcano, foreigners all described in their travel journals as 'the rumbling of Naples'. But now, in July 1629, the bay hummed only with one piece of news: that the outgoing viceroy – the Duke of Alba – was refusing to hand over his powers to his successor, the Duke of Alcalá.

The problems of Artemisia's protector were further aggravated by the ill humour of the Neapolitan aristocracy, who judged him guilty of failures of etiquette during his enthronement ceremony. He was also mistrusted by the

lawyers, in rebellion against his claims to make checks on the validity of their qualifications, and the merchants who were refusing to pay the taxes levied by his administration. In short, the Duke of Alcalá did not find favour in the eyes of his kingdom. No more than in the eyes of his erstwhile mistress.

Events had not turned out as expected. Artemisia was more affected by her Venetian experiences than she had imagined and she did not embark light-heartedly upon sharing the viceroy's bed. She was repelled by the rituals of the court that isolated the Duke from the world; Alcalá's pride, his piety and his coldness intimidated her without his now exciting her. For his part, he soon wearied of a woman in whose arms he no longer saw the sensuality of old.

After a few weeks, Artemisia ceased to set up her easel in the viceroy's private apartments. After a few months, there were no more of the inscriptions they used to compose together for 'their' paintings. The Duke of Alcalá still held her in regard. He maintained some modest support for the child whose father she swore he was. But their relationship was over.

By choosing Naples rather than London, Artemisia had opted for autonomy rather than dependance. For the first time in her life, she would now have to manage completely on her own. What place was there for a woman of thirty-seven – the prime of life in the seventeenth century – in this world of violence and extremes? A woman with no personal wealth? With no husband, father or brother, no man to defend her and her daughters? A woman and a foreigner, with no family tie connecting her to Naples or to Spain?

'Why don't you like Naples?' said Artemisia, resuming the conversation.

'There are too many people,' Prudenzia grumbled. 'And . . .'

'And?'

'You are sad here.'

'I? Sad?'

Without slowing their pace, mother and daughter eyed one another. Impelled by the need to find commissions, their errand took them to the farthest-flung convents and monasteries. They hunted for clients everywhere, among the Carthusians and Carmelites, the Dominicans and Poor Clares.

'You never take a rest,' Prudenzia remonstrated. 'You go from one aristocratic house to another. You go to Piedimonte d'Alife to paint the Duchess Caetani, you come back to the Chiaia to paint the Count Carraciolo, then you rush off to the Royal Palace to work on the Empress's portrait.'

'Prudenzia,' Artemisia protested, 'do you know how many painters in Naples would dream of having such commissions? Being the portraitist of the King of Spain's sister means fame! And the door opens on . . .'

'It is always *fame*,' Prudenzia retorted darkly. 'Painting, nothing but painting. Don't paint so much.'

Plunging into the hubbub, Artemisia sighed and looked away. The same words with which Agostino Tassi and Nicholas Lanier had reproached her were now being echoed by her daughter. When they came from her lovers, Artemisia had refused to listen. But from Prudenzia? Could it be that her efforts to draw some final particle of beauty from within herself had devoured her to the point of neglecting Prudenzia? Yet when Artemisia recalled their arrival in Naples, living at first in a convent, then renting a large house on Montecalvario, she was convinced that her two daughters, Prudenzia and Francesca, had been the centre of her life. Had it been her husband Pierantonio who had said once in Florence that there could be no place for any other passion between the two sides of her creativity, between painting and motherhood, between her pictures and her children? Was this remark her husband's or was it Nicholas Lanier's? Three years on from their separation, the memory of Lanier obsessed her, the memory of his voice, his smell, the weight of his body. She dwelled now on the questions she had avoided asking herself when they parted.

She was probably turning into an old woman tortured by the past. Lovers were becoming rarer. Her renown gave her many to choose from, but none of them could move her any more. Yet she still enjoyed sensual pleasures. There had been a succession of unnoteworthy companions in her bed: clerks and secretaries whom she engaged to look after her affairs. They took letters under her dictation, protected her household and escorted her through the cut-throat alleys of Naples when she came home late from a portrait sitting. As for the apprentices who were bound to her studio, all of them dreamed of sleeping on the *piano nobile*. Artemisia was all too well aware of it. Their presence in her house reminded her of the perils of temptation and forced her to be vigilant. She watched over the virtue of her daughters. Did she not plan that their lives should follow a path altogether different from her own? Time and again she taught them the same two maxims: 'Do not behave as I have behaved. Do the opposite of what I have done.'

What was she afraid of? None of her father's prophecies had come about. 'If you follow this nonentity to Florence,' he had predicted when she married

Pierantonio, 'you will not become a great painter.' Orazio had been wrong. Artemisia Gentileschi's art had not been threatened by mediocrity, but by admiration. By her attraction to Lanier, a man as powerful as herself, Artemisia had sacrificed this love. But she could not recover from this renunciation. 'How else could I have acted? What else should I have done?'

'Join us in London,' Francesco Gentileschi whispered in her ear, having come three times to Naples with this answer.

Francesco was as good-looking as his younger brother Giulio, but more refined, cleverer and more cunning. He was skilled at exploiting family successes. The Gentileschi sons complemented one another: Giulio saw to practical tasks and was the strong-arm man; Francesco did the talking and negotiating. As for young Marco, he brought the family respectability by serving as a page to the Duchess of Buckingham.

On his repeated trips, Francesco described to his sister the sumptuousness of the English castles. He praised the magnificence of the pictures being painted by their father for Somerset House, for Greenwich and for Hampton Court. He told her in detail about Nicholas Lanier's sea voyage and the arrival of the works from Mantua in England. As the ship drew into harbour an appalling discovery had been made. Some pictures that had been thought stowed well away from harm – away from the sacks of grapes and the casks of mercury conveyed aboard the *Margaret* – had become covered with a blackish soot during the crossing. Lanier had imagined the worst of catastrophes, but not the effects of heat and condensation on the sugar and the mercury in the hold. Could he have foreseen that the evaporating mercury would leave a sticky layer of ink-coloured quicksilver that settled on the canvases, and saturated the drawings? By good luck, he had had the crates opened before presenting the works to the King. For several weeks, he had set himself to cleaning them. But sponges soaked in milk or dog's slaver – the customary methods – had not completely erased the ghastly overlay. Nicholas had called on his relative, Jerome Lanier, an expert in the tricks used by painters, and then on the most famous chemists in the realm. Following their suggestions, he had dabbed the worst affected paintings with brandy. Without success. Taking countless precautions, drop by drop, he had dripped alcohol from distilled wine on to some of the most damaged areas. Without success. Finally, he washed the finest canvases in plenty of water. Determination, luck and a mastery of the techniques of painting enabled him to restore some of the masterpieces. He enjoyed His Majesty's favour more than ever.

Francesco then boasted of the unimaginable luxury to which an artist could aspire in London – the residence of Nicholas Lanier, the concerts given by Nicholas Lanier, the court held by Nicholas Lanier!

But Francesco took good care not to mention Orazio's troubles: the hatred of the English artists, the rivalries at court between the Catholic painters and their Protestant and Anglican counterparts; the ferocious opposition of the London guild to the presence of the Gentileschi family.

He also hid from his sister the cruelties of an even more fearsome persecution: that of the ambitious and vindictive Balthazar Gerbier, chief keeper of Buckingham's collection.

35

London

1629–1630

Balthazar Gerbier was a painter and architect, albeit without talent; an artistic adviser without training; a diplomatic representative, albeit without tact or honour. He had scoured all the capitals of Europe in search of works of art for Buckingham.

He was one of those men who leave their contemporaries puzzling over how they managed to reach the heights they occupy. Gerbier made acquisitions in Rome, Venice and Paris. He dealt directly with collectors and painters. He was authorised to commission whatever paintings he wanted for the English crown, to discuss prices, to supply colours, canvases and brushes. Any artist who took a stand against such overriding control would simply be digging his own grave.

Orazio Gentileschi was no exception. Did Balthazar Gerbier remind him of someone else? Like Agostino Tassi, Gerbier possessed what Orazio would never have: charm, eloquence, ease of manner and a gift for sycophancy.

After Buckingham's assassination in August 1628, Gerbier had entered the King's service and set about persuading His Majesty that he no longer needed a painter as mediocre as Orazio Gentileschi. The Italian and his three sons ought to pack up and go. In this he was setting an old grudge: when Orazio arrived in London, Buckingham's administrators had evicted Gerbier from the superb house he occupied on the Duke's land so as to put the Gentileschi tribe there in his place. This initial incident had sparked a relentless war of attrition that eroded Orazio Gentileschi's creative powers, blunting his vision and dissipating his talent.

The two men had found a battleground to engage upon: the Thirty Years

War. The part they played in the unofficial negotiations between England, Italy and Spain enabled them to give a European scope to their petty strife.

Between 1626 and 1628, both of them were sent to Brussels, where each met Philip IV's envoy, an artist whom Orazio had known well in Paris: his rival, Rubens. During his visit to London, the Flemish painter, who had come for talks as a representative of Spain, stayed at the house of his great friend Balthazar Gerbier. He was to immortalise the entire Gerbier family in a painting which he would give to the King. Orazio Gentileschi had lost the first round. Gerbier's worldly success and his diplomatic triumph stripped the Italian of his prerogatives as an intermediary between the Catholic power block and the Protestant world.

Orazio retaliated by dispatching two English travellers to Naples with recommendations to contact a Roman painter working for Spain: Artemisia Gentileschi. Like Rubens, these Englishmen carried no official credentials, but they could speak in the name of their sovereign. It was therefore Orazio's wish that his daughter should introduce them to the court of the Spanish viceroy. He required her to open the doors to Madrid for them.

Thus the Gentileschi father and daughter began to serve the secret desires of Charles I and Philip IV. Together they played a part in the alliance between the two enemy powers against France.

In Orazio's view, Artemisia was eminently suited to this role as emissary between England, the kingdom of Naples and the courts of Italy. She still maintained contact with powerful patrons such as the Pope's nephews, and she was intimate with their trusted confidant, the Cavaliere Cassiano dal Pozzo – connections to which were added the long-standing friendships which bound her to Florence, her correspondence with the Medici entourage and the fact that she continued to enjoy the protection of Galileo. Her political usefulness gave him a pretext to resume communication with her, yet his letters to her bore no personal message. They said nothing about painting, and made no reference either to his pictures or his successes. These notes, however, ensured the continuity of their relationship, notwithstanding distance, separation and the passage of time.

But, for the time being, Artemisia had to give most of her attention to a rivalry that was even more dangerous than the vexations and harassments to which her father was exposed.

36

Naples

1630–1634

Portraits of duchesses for their family mansions, still lifes for burghers' dining-rooms, licentious mythological allegories for prelates' cabinets of curiosities — Artemisia tackled every genre and made her way into every milieu. Her background, her friendships and her travels opened many doors to her: those of Florentine bankers, Venetian or Genoese merchants; those of the aristocracy and the clergy, brought to Naples in the household of a nuncio or the train of an ambassador. The decoration of the new palaces that the feudal nobility were having built in town, and of the convents, charterhouses and cathedrals that the Church was erecting everywhere gave her endless opportunities. An artist who could stand up to the attacks of rivals could produce work on a titanic scale in the capital of the Kingdom of the Two Sicilies.

The city was the measure of those who managed to survive in it.

The painter Domenichino arrived in Naples around the same time as Artemisia. Writing to their common patron Cassiano dal Pozzo, he described competitors ready to pounce and tear him to pieces with their own sharpened teeth. His hands were 'bound with iron chains' by the obligations under which his clients forced him to work for them. His contracts compelled him to swear not to undertake any other commissions, and he was threatened with terrible penalties should he do so before finishing the work due to them. All of these circumstances caused him such 'great distress' that he felt as if he were living in Hell.

Others before Artemisia Gentileschi had unhappily endured similar inconveniences, poison and stabbings being not the worst of them. The famous Guido Reni was invited to Naples to decorate one of the chapels in the

cathedral and, after several anonymous letters and a number of death threats carved on his door with a knife, he found his manservant riddled with stab wounds on the threshold of his studio. Between his groans, the man delivered the message that the attack on him was only a warning. Reni had packed up and left.

Some time later, a ship was chartered by the monks of the cathedral for the transportation of a number of Bolognese painters whose work they looked forward to seeing in Naples; it sank, with all lost, off the island of Ischia. As for scaffoldings, which the bravest of the foreign artists persisted in climbing, these would come crashing down, taking them and their assistants with them. The works of the Florentine fresco painters would mysteriously flake, their outlines and colours fade. Everyone in Naples knew the source of these attacks: the 'Cabal'. Three painters, bound by family ties – fathers-in-law or brothers-in-law – had sworn that no foreigner would work in the shadow of Vesuvius. The members of this fearsome triumvirate were not, however, Neapolitans. The most inspired and famous of the group claimed Spanish nationality. His name was Jusepe de Ribera, and he was known as *Lo Spagnoletto*. His violent ways explained the clients' harsh requirements: because patrons knew that days were numbered for the foreign artists whom they had brought to Naples for the embellishment of palaces and churches, they allowed them no respite. Would the new arrivals last six months under the pressure of the Cabal? How were they to protect them? Fear of the problems that awaited painters from Rome or Bologna in Naples drove artists to turn down all invitations. How were they to be enticed and persuaded?

The ecclesiastics responsible for the decoration of the Cappella del Tesoro in the cathedral of San Gennaro had found a solution to these problems by promulgating a decree that was, to say the least, paradoxical: no artist of Neapolitan origin could participate in the great works of the cathedral, either in the present or in the future. The cupola, the lunettes and walls of this fabulous chapel, built on the right-hand aisle of the cathedral and financed with public contributions, would always be beyond the reach of local painters. The holy place that Neapolitans held dearest would owe its beauty, fame and immortality only to the talent of foreigners. The arbitrariness of this ruling and the resulting segregation heightened jealousies and greatly aggravated the cruelty of reprisals. Ribera would go to any lengths. For nearly fifteen years he had been working for the Spanish aristocracy of the Kingdom of the Two Sicilies and had enjoyed the admiration of three successive

viceroys. He could therefore act with considerable impunity.

Made by Jusepe de Ribera, Spaniard, decorated with the Order of Christ, the new Apelles of his day, he would inscribe henceforth on paintings for Alcalá, his new patron.

Neither the artist nor the duke were being modest: if Apelles remained the greatest painter of antiquity, his patron was none other than Alexander the Great.

The viceroy did not live up to his pretensions. He would not last for two years under the attacks of his enemies. The outgoing viceroy, the Duke of Alba, accused him of having insulted the sister of their sovereign, Philip IV. He claimed that the Duke of Alcalá had given her a very poor reception on her visit to Naples; he had not offered her a new bed and a new coach, though these were hers by right as Empress of Austria and Queen of Hungary. Such allegations, coming on top of the difficulties the Duke of Alcalá was experiencing in the running of his states, provoked his recall to Spain.

In May 1631, Artemisia's carriage accompanied Alcalá to the gates of a city for the second time. She watched as the sails of his ships disappeared over the horizon; the Duke was leaving for Madrid to answer for his conduct. Not without first having loaded aboard ship the masterpieces that he had amassed over twenty-two months: seventy-six canvases, including several self-portraits by Artemisia Gentileschi as the Muse or as the Allegory of Painting.

He might be leaving the original behind on the shores of the Tyrrhenian Sea, but he left her in the hands of another collector who had every means of satisfying his passion for painting: the new viceroy, the Count of Monterrey, brother-in-law of the Count Duke of Olivares, the Prime Minister and all-powerful favourite of the King of Spain.

As the Count of Monterrey was familiarising himself with Artemisia's work, Madrid was becoming acquainted with Orazio's talent.

In May 1633, Francesco Gentileschi took a picture there as a gift from his father to His Majesty Philip IV. The sovereign appreciated the beauty of the canvas and the significance of the gesture. Taking advantage of this success, Francesco brought it to the attention of the King of Spain's advisers that the painter, Orazio Gentileschi, daily had the ear of Henrietta, the Queen of England. That he was a Catholic and a Florentine. That he was therefore very sensitive to the interests of his erstwhile patron, Marie de Médicis. The former Regent, presently exiled to Brussels, was now plotting with Spain against Richelieu. Perhaps it only needed an artist such as Orazio Gentileschi – who

had the ear of both Marie de Médicis and the Queen of England – to stress to them both the advantages that each side could derive from a war against France.

Monterrey was counting on Artemisia to reach an understanding with her father, and work to join the interests of England with those of Spain and the Queen Mother of France. He would make it his business to provide her with every means to undertake this delicate mission.

37

Naples
1634–1638

A visit to the studio of Artemisia Gentileschi had become obligatory for travellers and foreigners. The young Bullen Reymes, former secretary in Paris to Sir Isaac Wake, who had been the English ambassador in Venice at the time of Nicholas Lanier's transaction, records paying an after-dinner call on her. The date in his journal is Saturday 18 March 1634. He notes that Artemisia's daughter played the spinet for the visitors, and that she too painted.

Artemisia's studio was something akin to a political salon, where guests would talk about the course of the war under cover of discussing painting. Just as Rubens and Balthazar Gerbier had made a sea crossing together to Holland in the summer of 1627 on the pretext of hunting down pictures in Delft and admiring the wonders of Amsterdam and Utrecht, while all they were doing was paving the way for the signing of a peace treaty between Spain and England, so Artemisia would gather information from the young painters who arrived from Rome, Venice and Florence to meet Artemisia Gentileschi. They brought her news of the courts where they were regular visitors, they disclosed the secrets they had discovered and they broadcast information – be it true or false – that they meant to reach Spain. After years of bitter rivalry, *La Gentileschi* seemed to have triumphed over the Cabal. Her person, her painting and her studio were as firmly a part of Naples as Ribera.

Until now, Artemisia had worked only for private art lovers. Her canvases adorned the salons of princes and the oratories of cardinals. But the Mantua affair and her relationship with Nicholas Lanier had taught her that works move around, that they disappear across the sea; that collections get dismantled,

sold and dispersed. Often it was only altarpieces and public commissions that remained *in situ*. Such works were not admired only by the guests of a prelate, but by the mass of the faithful, by thousands of believers who would continue to visit churches and sanctuaries for centuries to come. She coveted work that her father had only rarely secured: the walls of cathedrals. She wanted it to be her hand that decorated the choir of the new cathedral at Pozzuoli. Thanks to her backing at the court of the viceroy, she got her way.

Artemisia's competitors did not attribute her success to her talent, but to her complicity with Ribera's enemy, the great painter Massimo Stanzione. The Cabal feared him so much that it would one day vandalise a *Pietà* of his by throwing acid on it – at least, that was how the story went in Naples. It was also said that Stanzione had known Artemisia in Rome and that she had been his mistress. The resumption of their liaison ten years later explained the sudden stylistic kinship between their works, and the presence of a picture by *La Gentileschi* among the cycle of canvases that formed *The Life of St John the Baptist*, painted by Massimo Stanzione for Philip IV and the Buen Retiro Palace.

Talk of Artemisia Gentileschi's love affairs was, it seems, nothing out of the ordinary in the capital of the Kingdom of the Two Sicilies. The women there had a reputation for being extremely lubricious. Her 'debaucheries', a weapon which those jealous of her could easily have brandished against her success, didn't seem to interest anyone; Artemisia Gentileschi's adversaries had a much more wounding strategy: Orazio.

They used the painting of one to belittle the creative work of the other, saying that Artemisia stole everything from Orazio – her subjects, her design, her colours – that she plundered his very signature. They claimed that the *Susanna and the Elders* in Rome, and the *Judith Slaying Holofernes* in Florence, Artemisia Gentileschi's greatest achievements, were not and never had been by her hand; that the reason Artemisia had just secured a commission for an altar painting in the church of San Giorgio – the parish church of the Theatine fathers and of the Genoese living in Naples – was that Orazio Gentileschi had once worked for the Theatine order in Genoa; that the Theatine fathers had asked her for the same subject as Orazio's – an Annunciation – and that Artemisia had done no more than reverse his composition, simply by changing the places of the Angel and the Virgin, and had emptied her own pictures of all religious sentiment by eliminating the décor, using theatrical gestures and darkening her palette of colours.

Orazio Gentileschi lived and worked far away. It cost nothing to sing his

praises. On the other hand, Artemisia was in Naples and she threatened to make off with all the commissions. *La Gentileschi* was a fake, protested her detractors. Her work was spurious, merely appealing to the Spanish taste for the grotesque. Madrid went wild over *The Bearded Lady*, *The Club-Footed Dwarf* and the *Self-portrait of Artemisia Gentileschi*.

The painter Lanfranco wrote to a Roman art dealer that he had ceased to be surprised by a Neapolitan client's spitefulness. Nor was he surprised when, having shown his painting to a certain person, he had heard it described as a joke, a piece of drollery, a mess that looked as if it had been painted by a woman. His answer to this was that if his work had been painted by a woman, the speaker would have been aware of it since it would have cost him three times as dear.

'I shall show you what a woman can do,' retorted Artemisia. But her triumphs now brought her a different and more alarming form of competition. Her virtuosity as a painter had made female artists fashionable. Artemisia Gentileschi had so many emulators in Naples that she had to defend the public work she did against the intrusions of her own sex. Lanfranco was only exaggerating a little when he claimed that canvases produced by women sold at three times the price of others. He lumped them all together as 'a mess'.

Artemisia had everything to fear from such a verdict, worried at being included in a group that existed only through the whim of collectors. For all that she aspired to have 'the soul of Caesar in the heart of a woman', her singularity was important to her. The peculiar nature of her talent remained the most effective means of sustaining her fame. She began to be disturbed by feelings of jealousy and mistrust of younger women. In particular, of a certain Anna de Rosa, who was, like her, the daughter of a painter; who, like her, worked with Massimo Stanzione; and who also secured public commissions for altar paintings in churches. There was no comparison between their art. Anna de Rosa succeeded in Naples only thanks to Stanzione, who sponsored her work for their patrons. Artemisia despised her. Had she succumbed to fear and envy, those evils so rife among Neapolitan artists? To her relief, her rival was murdered by her own husband, a painter who suspected her of adultery with Stanzione. Anna de Rosa would go down in posterity only because of this incidental event, a tragic everyday story.

Artemisia Gentileschi knew only too well the cost of that sort of fame. She had trained her two daughters in her art, but she encouraged them only to undertake work typically done by 'ladies', and though she included them in

the gatherings of diplomats who visited the studio, she kept them well away from the world of painters. She aimed to shield them from the lustful attentions of men like Agostino Tassi. She had little Francesca educated alongside the young ladies of the higher bourgeoisie, with the nuns of the Convent of the Conception; and gentle Prudenzia, who lived with her, was given lessons in music, dancing and deportment. The latter was approaching her twentieth birthday. But, like Orazio before her, Artemisia refused all the matrimonial offers that were made. Like him, she found it too hard to be separated from her daughter. The suitors never seemed worthy of her child, their wealth never solid enough, their family name never great enough. Unlike her mother at the same age, Prudenzia was not eager for marriage. Under her mother's wing she felt well satisfied. However, for nearly seven years she had kept up the same refrain: 'Why do you stay here? You are not happy in Naples . . .'

In July 1637, Francesco Gentileschi came to Naples yet again to extend an invitation to his sister on behalf of Charles I. He spoke a great deal of how the King had recently knighted Rubens and Van Dyck. Might not His Majesty confer honours upon the Gentileschis, father and daughter?

Francesco had come directly from Liguria where the Duke of Savoy and the King of England had sent him to buy new pictures. He had just acquired *The Self-portrait of Artemisia Gentileschi as the Allegory of Painting* for Charles I. The Duke of Alcalá had unpacked this canvas when he returned to Seville in 1631. But he had taken it with him on his last mission to Austria. He had died in Villach on 28 March 1637, depriving Artemisia's daughter of a father's protection. The Duke of Alcalá's will acknowledged debts amounting to nearly thirty thousand ducats, a staggering sum. Immediately after his funeral, his creditors had put 130 of his pictures up for auction in Genoa, including several works by artists whom he had favoured.

'You could take your *Allegory of Painting* to the King of England yourself,' Francesco prompted. 'You are the model, the subject and the author of his new picture. What is it that keeps you here? It is true that you are working for the Neapolitan aristocracy. But you are not the court painter of a monarch. You may sell your work to the Count of Monterrey, but you have to secure each single commission by dint of hard work. Spain is going to war. The conflict with France looks set to be a long one; it will drain the coffers of the Kingdom of the Two Sicilies. Naples will be no exception. And then how will you and your daughters survive?'

The complicated and prestigious marriage which Artemisia was negotiating for Prudenzia with a member of a newly ennobled family would ruin her financially. The dowry that she would have to pay in full on signature of the marriage contract would leave her without a penny. Sad and alone.

'And you will have other obligations and duties to come,' Francesco insisted. 'A new dowry to put together, a second daughter to be married. Why not find her a husband in England? England means peace,' he pressed. 'It has a sovereign who puts off affairs of state until later, so as to take pleasure in the beauty of a picture; a patron who admires his artists and gives them pensions.'

Who in Naples would give Artemisia Gentileschi a pension? Her latest protector, the Count of Monterrey, was packing his bags. His term was over. He was not returning to Spain with twenty-four chests – as the Duke of Alcalá had done – but with forty shiploads of treasures that he had acquired in Naples and the rest of Italy.

'You will have to start all over again with his successor,' argued Francesco. 'Seven years of struggle. Having to win over the new viceroy's entourage, establish yourself all over again with the Spaniards, assert yourself against the artists they will bring from Rome. Who knows whether you will manage to fight off your rivals this time? Whereas in London . . .'

In London, Orazio's work was killing him. Without his daughter's help, he would never be able to finish the project he had embarked upon. Francesco reminded her that at sixty-four their father was no longer of an age for large-scale undertakings; he had neither the strength nor the heart for them. He said that Orazio wanted to see her again, one last time before he died. That the old artist implored her to grant his last wish. That the time seemed to have come for them to meet and be reunited.

Twenty-five years without each other! Had Orazio seen a single painting by Artemisia? Did he have any idea of the greatness and importance of her work? For twenty-five years she had asked herself the same question about each of her canvases: 'What would my father think of it?' Her uncertainty about her work only increased with the passing of time, unassuaged by her success. Her entire creative output was still suffused with the agony of doubt.

She studied the painting owned by the King of England that Francesco had left with her: the *Allegory of Painting*, which sat resplendent on an easel in the full light of day. A work that was seven years old. Artemisia had executed it on her arrival in Naples. She intended it at that time for her Roman patron, the Cavaliere dal Pozzo. He had commissioned it from her, to a pre-ordered

size, for his gallery of illustrious figures. But the Cavaliere dal Pozzo had had to be kept waiting, for she meant to show the canvas to the court painter of the King of Spain, Diego Velázquez. Velázquez had visited Naples late in the winter of 1630, when, at the same time as Artemisia Gentileschi, he was painting the portrait of the Empress, the sister of Philip IV, who lived at the Royal Palace, the residence of the Duke of Alcalá. The viceroy had taken very little interest in the portrait of the Empress – for which he had paid dearly – but he had bought the *Allegory of Painting*. He desired to have it at any cost. He had taken it, arguing that he was depriving no one: Artemisia could execute a second version for the Cavaliere dal Pozzo.

She moved closer to the painting; it rose in front of her, like a mirror. She was reassured by how little her looks and work methods had changed over all these years. She still held the long brushes she used close to the tip. She still rolled up her right sleeve as far as the elbow, pushing back the lace as high as it could go on her arm. She still used the same brown smock spotted with stains, the same rectangular palette. She laid out her colours in the same order: the white near the thumb, then red, brown, green. It was the order her father had taught her. What would he think of her portrait? Would he recognise the long gold chain she wore round her neck with the charm in the shape of a mask – the present he gave her when he had introduced her to Cardinal Borghese in the Casino of the Muses? And her dress, with its shifting colours? Her dishevelled hair? All the attributes of the allegory of painting, just as they were prescribed by the treatises on iconology used by artists. What would he have to say about that shade of gold-green, which was his own secret? And the work on the draperies? Would he notice the virtuosity with which she had used small brush strokes to render the light striking her brow, and the shadow made by the necklace on the flesh at her décolleté? Would he appreciate the originality of the composition, the wide diagonal of her upper body cutting across the canvas from top to bottom, corner to corner? To paint herself in half-profile she had had to set up two large mirrors at right angles in front of her. Unlike many artists who offered the world a decorous image of themselves, looking calmly out at the viewer, Artemisia was standing, captured in mid-gesture, occupying the full height of the picture. Her eyes were not turned towards the audience, but directed towards her model, her own reflection in the mirrors. With her entire body in movement, she was bent on the creative act, her arms wide open, her breast plain to see and her hair in disorder. She seemed to wage battle.

Would Orazio Gentileschi recognise his daughter's boldness in

immortalising painting as it really was? A war. A fight against matter. A physical, bodily struggle with form and ideas.

Artemisia's studio turned out dozens of pictures every month. What she painted did not so much follow her own inclinations as the requirements of her clients. She mastered every kind of technique. Her painting could be dark and dramatic, 'in the Neapolitan manner'; sumptuous and rich in colour, 'in the Florentine manner'; or 'Caravaggesque, Roman style'. She ran a business, employing armies of apprentices. The most talented among them, Viviano Codazzi, had come straight from Rome, from the Via del Corso and the studio of a master who had been hers: Agostino Tassi. In her hands she held the skein of times past, all the tangled threads of her life.

In October, she wrote to Cassiano dal Pozzo that as soon as her elder daughter's wedding had taken place, she would be free and hoped to return to Rome, to enjoy her native city, to see her friends and serve her patrons. She asked in this letter for news of her husband: would her correspondent be so good as to tell her whether he was dead or alive? Was this regret or remorse? Or merely a practical question with the future in mind? Artemisia would need the consent of Prudenzia's father for this slow-moving marriage settlement.

Writing to Andrea Cioli, the secretary of State of the Grand Duke of Tuscany, she confessed that she no longer had any desire to stay on in Naples – because of the atmosphere of war, the high cost of living and the struggle to make a livelihood. Was this a painter mentally exhausted and running out of steam?

'Don't leave me, I beg you,' whispered Prudenzia, hugging her mother close inside their sedan chair.

It was the night of Good Friday and the two women were following the procession of monks from the church of the Solitaria. The honour that had been conferred on them drew all eyes in Naples. No other women appeared in the cortège. The carriages of the great ladies stood on either side of the street. These were draped in black and harnessed to black horses decked with black plumes, and they lined the Via Toledo for its whole length of two and a half miles. Six pages stood by the doors óf each carriage, holding flaming torches which illuminated a long series of female figures framed distinctly in the windows. Within this pathway of fire, their powdered faces appeared like the pale ghosts of widows wearing mourning for Christ. They were dressed in black, but a black that was threaded with gold, their necklines and ears studded with gems, their hair covered with blood-red mantillas whose

gold/scalloped edges fell over their brows. Galloping back and forth, their escorts rode past them, throwing sweetmeats into their laps in the form of little white bouquets, tiny skulls made of almond paste.

This traditional procession was organised by the Spanish. On the night of Christ's Passion, they would exhibit the 'Mysteries', twelve scenes with life/sized statues in painted wood insulting Christ, striking or stoning him with hate/filled faces. Hidden under tall brown hoods, the monks of the Solitaria carried these representations of the Passion in groups of eight. Bearing their terrible burdens, they advanced solemnly between the rows of torches.

Every year, the Spanish would invite twelve notables to lead these 'Mysteries'. Thus they honoured representatives of the city's old houses and heads of the great Italian families. In April 1638, they had asked Signora Artemisia and her *casa*. Some thirty people – her pupils, apprentices, clerks and servants – were walking behind her sedan chair, holding aloft in the darkness the tall white candles she had given them.

'Why should you have to go?' insisted Prudenzia.

Sitting close together inside the snug little box, the two women held hands. Far in front of them, they could hear the long, lugubrious bugle call that accompanied the condemned man to the gallows. And then, very near, the regular beat of the thongs lashing the penitents' shoulders.

The Spaniards had hired the two cortèges of men whipping themselves that headed and closed the procession. They paid each man fifteen soldi and provided them with their hoods and a habit which was cut open at the back to expose a rectangle of flesh and display their bloodied wounds to the crowd. The Spaniards gave twenty soldi to those penitents who requested a metal/studded whip.

'Why do you have to set out on this journey?' said Prudenzia tenaciously.

She had been married for nearly a month to the heir of a powerful family of lawyers. Her wedding ceremony had contrasted in every detail with Artemisia's long/distant nuptials at the church of Santo Spirito in Sassia in Rome. Her trousseau and wedding gifts had been put on show for nearly a week, and Artemisia's fellow painters would continue to talk for a long time of the splendour of the fabrics and jewels, of all the objects made of vermeil and silver that the artist had given to her daughter.

'I beg you, do not go . . .'

'I shall come back,' Artemisia murmured. She brought Prudenzia's hand to her breast. 'I swear it before God. I shall come back to Naples.'

'And what of my sister?'

'I am counting on you to watch over her. In my will, I have given her—'

'You are not thinking of leaving Francesca?' protested Prudenzia.

She pulled her hand away, her first gesture of revolt in twenty years. She did not see the tears in her mother's eyes.

'What else can I do?' asked Artemisia. 'All the roads are cut off by war and plague. I shall have to sail from Naples. I dare not expose Francesca to such dangers.'

'Last night, at supper, my husband spoke of Turkish pirates taking advantage of the war to capture Spanish ships.'

'Do you think I am not afraid of that?'

'Do not leave my sister in Naples!'

'What would happen if the Barbary pirates were to take us? I cannot run a risk like that for her.'

'You ran risks like that for me,' Prudenzia answered drily.

Artemisia gave her a look of surprise. She did not know how to interpret these words. Was Prudenzia reproaching her for their travels? Had she been mistaken in thinking that her daughter liked nothing better than their shared escapades? But I didn't take you all the way to England, she thought to herself in defence. I didn't bring you to a heretic land.

'Heaven alone knows when I shall get to London,' she sighed. 'How many days or months it will take me. I shall probably make a halt at Genoa and Marseilles. They say that the bills of health issued by foreign states have no validity there. For fear of contagion, all of the cities isolate travellers in lazarets outside the ramparts. If I am compelled to stay in each port for forty days—'

'Don't go,' Prudenzia interrupted her. 'You have no need to undertake this journey.'

A sorrowful expression clouded Artemisia's face.

'If I were at death's door, if I called for you, you would come, wouldn't you?'

'I should do what Our Lord bade me do,' Prudenzia answered calmly. She fell silent for a moment before adding, 'And I should do whatever my husband ordered.'

A smile crossed her mother's face; Prudenzia had always belonged to another world. If her young husband were to die, she would probably cut off all her hair as custom decreed in Naples. She would throw her lovely long brown locks into the grave, covering the face of the corpse with them. She would remain faithful to the dead man and keep her love for him until her hair grew all the way down her back again. In keeping with tradition.

Tenderly, Artemisia again took the hand that her daughter had drawn away from her and gave her a long look. How pretty Prudenzia was like this, as a widow of Christ. Mourning suited her complexion. And that little red veil on her head made her just like the women of the aristocracy. That was what Artemisia had wanted. Prudenzia's new place in the upper ranks of society, as a member of the new 'nobility of the robe' which was assuming importance in Naples, separated them. In public, mother and daughter addressed each other formally.

Prudenzia lowered her eyes. In Artemisia's gaze that was overlong and over-tender, she thought she could sense the passion of someone who looks for the last time.

Mother and daughter were stiff and silent as their minds dwelled on the same thoughts. Both were recalling the last departure of Francesco Gentileschi, his symbolic gesture in leaving behind in Naples the *Self-portrait of Artemisia Gentileschi as the Allegory of Painting*. Doubtless he was trying to present his sister with a *fait accompli*. From then on, Artemisia had felt the burden of responsibility for delivering this work to the King of England. She had understood the injunction, but she had not yet yielded to it. Nor had she sent the canvas on to its owner. Numerous opportunities had presented themselves – a great many English merchant ships put in at Naples – but she had not taken them.

In the late winter of 1638 she had confined herself to dealing with matters under way. She had settled Prudenzia's marriage, finished the canvases that she owed to her clients and drawn payment for them from the agents. She had also had long consultations with her notary, drawing up the inventory of her assets and putting in order the details of who would inherit her estate.

Had her daughters suspected these plans for departure well before Artemisia finalised her decision? Since childhood, Prudenzia had known her innermost thoughts and felt it her duty to give her warnings, to lecture her and make her see reason. With only a few signs – Artemisia's abrupt silences, her feigned serenity, her concern with order and propriety – she had uncovered the doubts tormenting her mother. She had forseen the threat of a departure and an imminent separation. Artemisia's silence and detachment reinforced this anxiety. Since the wedding she had kept her daughter at a distance. With the daughter married and her task complete, the mother was letting go.

Prudenzia knew her too well to believe in her indifference. But she saw in Artemisia the same evasions and volatile moods as at the time of her break with the English musician. A break that her mother had imposed on herself.

Prudenzia could appreciate the conflicts underlying her mother's coldness; had she not been the witness to her mother's suffering in Venice? The child's intuition then had grasped everything and understood it all. Now she intuitively realised what sacrifices this new move would cost.

Though Artemisia might well claim not to like Naples, she had friends and protectors here – she had a life of her own. How long would she stay far away from her studio? One year? Two years? Five? Would her admirers, her patrons, pupils and apprentices wait for her all that time? She would scarcely have left Naples than her rivals would tear her apart with their slanders and malicious gossip. She might well swear to her daughter on the Holy Cross that she would come back, but she would never be able to make her mark on Naples again, or only with an impossible amount of effort. By answering Orazio's call, Artemisia was abandoning everything that mattered in her life. She was giving up her career. She was wrenching herself away from her daughters.

'I pray you not to be so hard on yourself this time, Mother,' Prudenzia pleaded.

Upset by her impotence, the young woman reassumed the formal cadences of public speech.

'Jesus does not require you to give up your art, nor to sacrifice those you hold dear.'

Artemisia started. The formality and politeness only emphasised more bluntly the assurance of the voice and the vehemence of its tone. Gentle Prudenzia, so pious and so passive, was speaking in Christ's name and gave all appearance of knowing what was in God's plan quite as well as He did.

'If the Good Lord had not intended you to be as you are, He would not have given you the gift of painting, and He would have refused you the love of your children,' she said insistently. 'Your duty, of course, calls you to your father's bedside. But its call on you here is stronger, beside your daughters, who cherish you.'

Touched, the mother looked her child in the face. Prudenzia knew about passion and suffering. She used this lofty language merely to cover up her emotion. Tonight, for the first time, Artemisia saw her daughter's true face. How could she have thought that Prudenzia did not resemble her? Prudenzia had her frown, her sulky-lipped expression, the same violence, the same anger, the same heat. In Artemisia, emotion would inflame her eyes, redden her mouth and her cheeks. In Prudenzia, the radiance of the fire was within.

'Be sensible,' urged the young woman, rediscovering her unrestrained ten-year-old self in her desire to persuade. 'The upheavals of war and the thunder

of its cannons, which you constantly complain of in Naples, are worse and louder in the north of Italy. They say the west of France is under fire and sword. How will you get to England? Your generosity to your father in embarking on such an expedition is madness. Do you have to be reminded that journeys are unsuited to a person of your age and your sex?'

Artemisia pursed her lips. In the heat of the moment, her child was insulting her. She decided not to react. Both women sat in silence, hands in their laps, eyes fixed straight ahead.

Could the mother risk confiding in the daughter? Prudenzia was hugely underestimating the sheer boldness of Artemisia's undertaking. At the age of forty-five, she planned to cross the whole of Europe to reach Flanders. There, she would join Orazio's former patron, the Queen Mother of France, Marie de Médicis, who was now an outcast everywhere. Exiled by her son Louis XIII and rejected by her son-in-law, Philip IV, she sought to have Charles I welcome her to his kingdom.

By now the penitents at the tail of the Good Friday procession were passing the seafront and the first of the 'Mysteries' was reaching the courtyard of the Royal Palace. Signora Artemisia, her daughter and their *casa* would have to take their places on the balconies reserved for the viceroy's entourage. Their duties would soon separate them. They had little time left.

'I can see that you have made your decision,' Prudenzia sighed bitterly. 'I am unable to keep you here,' she added with sadness. 'At least, make things easier for yourself. Don't sacrifice too much. Don't demand so much of yourself that your courage will fail you before you can reach London. This time, don't give up those you hold dearest.'

The two women exchanged the same loving look. But it was the younger one who had the last word: 'Take Francesca,' she ordered.

Travelling by coach, boat, mule, sleeping on the mattresses of verminous inns and the straw of the lazarets where quarantined travellers were crammed together, Artemisia undertook her journey with a child of eleven in train. Just as Orazio had once taken her with him at the same age, to the forests of the Alban Hills, to the remote monasteries whose chapels he would decorate.

At the end of October 1638, after four months of wandering, mother and daughter embarked at The Hague on a ship of Marie de Médicis's fleet. Surrounded by an escort of abbots, priests and ladies-in-waiting, Artemisia Gentileschi set sail for England.

PART V
THE TRIUMPH OF PEACE
AND THE ARTS

London at the Time When Paintings
Were Being Burned
1638–1641

38

London

November 1638

'So, are we going to die?' Francesca asked her mother calmly.

'Our Lord will not permit it: we still have so many tasks to accomplish, the time has not come for us.'

'And for them?'

The child's eyes took in the ladies-in-waiting and the clutch of maids who were vomiting shamelessly on the deck of the ship. The Queen Mother was travelling aboard the first of the vessels, and Artemisia and her daughter watched as its stern ploughed through the high waves in front of them. At each squall they could hear the whinnying of the horses, the terrified screeches of the monkeys and parrots and the creaking of the ropes that held the carriage wheels secured a few feet away from where they stood. The hemp could easily work loose, sending the carriages flying as far as the ship's rail and crushing them both.

For three days, the storm had prevented the royal fleet from docking at Dover, as planned. Through the lightning and the heavy seas, small figures could be glimpsed moving about on land, probably the gentlemen of the King's bedchamber and the mayor and notables of the town who were patiently awaiting the arrival of Her Majesty, the queen's mother. But none of the flower-decked boats would risk leaving port to meet them. Marie de Médicis and her household were drifting several miles offshore, tossed about and cut off from the world by their plight. 'So near our goal,' thought Artemisia. 'So close.' She could see boats being thrown against the mole, small craft smashed against the rocks, and the men on the shore. Perhaps Orazio was there among that crowd. What if she never reached him?

'Are you quite sure that we are not going to die?' Francesca asked again.

Like her elder sister, the little girl had a talent for asking awkwardly pertinent questions. But she lacked Prudenzia's imagination and so was a stranger to fear, since she seldom had any grasp of danger. She was on the brink of adolescence, and the same height as her mother; yet she had a taller, more slender appearance than Artemisia in her youth. Her face was angular and severe, like a Spaniard's.

'Look,' she said, insistent: 'all the ladies who aren't vomiting are making their confession to the chaplain. They are kissing and weeping and forgiving one another. So they are preparing to perish.'

Artemisia did not turn round.

The wind was whipping her brow, but it failed to ruddy her complexion, made pale by seasickness. Her hair seemed darker than usual, almost black in the rain. It was without a single thread of silver.

Age had made Artemisia's figure heavier – she had turned forty-five in July – but she still stood tall, and her gaze shone with the same fire as ever. Today, however, as she scanned the crowd on the quayside, her eyes glittered with anxiety and betrayed much more than impatience: a fever of desire tinged with fear.

In the end they did not dock at Dover, but three days later at Harwich, in Essex. Marie de Médicis rested there for a week, then, amid clamorous jubilation, moved off towards the capital.

Charles I was there in person to welcome his mother-in-law at the gates of London. The court painter was not among his gentlemen. Orazio Gentileschi sent word to his daughter that he awaited her at Greenwich Palace. The old artist once more deferred the moment of reunion, one which he had feared for so long.

Certainly, Orazio had called her to his aid. He needed her to complete his work for him, for her to re-form the 'Gentileschi studio' around him, for her to see through the enormous project that he had undertaken. But the work was partly an excuse. Orazio dreamed of a grand reunion and he had been setting the stage for it for months. He was close to death and he wanted their meeting to be an event befitting the two of them. When it came to a theatrical meeting, Artemisia was several steps ahead of him: by joining the entourage of Marie de Médicis in The Hague, she had sought only to impress her old rival. She was not arriving on this heretic soil as an anonymous visitor, a traveller buffeted and battered by all the trials of a protracted journey, but as a great lady in the

entourage of a queen, an Italian and a Catholic like herself, as an aristocrat who stepped out of finely decked carriages. She made her way to London to the sound of trumpet fanfares, and was fêted by English towns all along the road. She was introduced to His Majesty Charles I, not by her own father, but by the mother and mother-in-law of three kings.

Though it was filial piety which had dictated Artemisia's mad escapade, love formed only one facet of it. For this was to be a final duel between them. They were calling on God at last to give His verdict on the agonising question: master or pupil, father or daughter, which would turn out to be the greater painter? For the sake of this contest, for this truth which she had sought ever since her first success in Florence, Artemisia had braved everything.

'The English are a mysterious people, and the sea that you have crossed to visit them is a symbol of their temperament.' With these words Pope Urban VIII issued a warning – a prescient one – to the papal nuncio, whose report on the freedom of Catholic worship in London had struck him as over-optimistic.

It seemed, moreover, that Charles I's entire court suffered from this disease of excessive optimism. The Thirty Years War was raging on the Continent and Marie de Médicis was landing on the English coast. Meanwhile the King deemed himself the happiest monarch in Christendom. He was living an illusion. By patronising the arts, Charles I was realising his dream: to control the forms and symbols of an inalterable society; to isolate his kingdom from war, from the clashes and tumult of the world; to reign over a universe of artists in his pay, as he would have liked to reign over an English parliament devoted to him.

During countless court masques – those grand entertainments which combined theatre, ballet, music and poetry – the King and Queen, dressed in allegorical costumes, would arrive on stage like the gods descending from Olympus, amid thunderclaps, lightning bolts and spectacular effects devised for them by the royal architect, the illustrious Inigo Jones. At the behest of Henrietta Maria, the latter had just built the most spectacular Roman Catholic church seen in England since the time of Henry VIII: the Queen's Chapel at Somerset House.

Gold and silver reliquaries, ciboria, chalices, embroidered stoles – the splendour was to bear dazzling witness to the supremacy of the true faith and to touch hearts and stir souls. This, at least, was what was claimed by the Queen's Capuchins: Henrietta Maria had left France to reign over a heretic

country with only its conversion in mind; her marriage was not merely a political alliance, nor a private matter, but a religious mission. Rome and Paris expected nothing less of her than that she lead England back to God. By signing the letter of dispensation authorising her union with a Protestant, Pope Urban VIII, her godfather, had required that she commit herself to becoming the 'Esther of her own oppressed people', the guardian angel of Catholics. No one at the time imagined that Charles I and Henrietta Maria would fall so much in love that they could not envisage the smallest part of their lives without one another. Conjugal affection would obtain a lot more from the King than bigotry. This church – the Queen's Chapel – was a gift from Charles I to his beloved wife.

Though awash with good intentions, the King was a poor judge of how much room he had for peaceful manoeuvre between the various factions of religious fanaticism agitating Europe and his own country. For close on a century, Anglicanism had been the official religion of his subjects. But the Church established by Henry VIII was still disputed; a large number of English Puritans saw it as an inadmissible compromise with papism. For them, salvation lay only in the Bible; they rejected the King's authority as a spiritual leader and condemned all the arts at court. In their eyes, painting, music and poetry charmed the senses and perverted souls. Beauty was but a snare, an illusion employed by the Evil One to corrupt mankind.

Now, late in 1638, religious conflicts brought war between the Anglicanism of the King and the Scottish Presbyterians: the Puritans in London blamed Queen Henrietta Maria for all the country's ills. Marie de Médicis paraded about the city with her hundreds of horses, her six coaches, her retinue of marquesses and baronesses, her dwarves, monks and confessors. Her presence and conduct seemed nothing less than an extravagant provocation aimed at the Protestants. Steeped in piety, she was already turning her oratory into a chapel for the dead, and she proclaimed to all and sundry that she was undertaking her son-in-law's conversion. The likelihood of Charles I's conversion was the very betrayal that England had feared ever since the King's marriage to a Catholic. His subjects' mistrust of his intentions dated back to the arrival of the works shipped from Mantua. Now, Anglicans and Puritans regarded with suspicion the hundreds of naked statues that stood in his parks, the pagan goddesses that filled his castles, the altar paintings, angels and crucifixes that adorned his galleries.

What were they to think of all these objects which had cost the Treasury so

dear and which had played a part in the Protestants' defeat at La Rochelle and Île de Ré? For four years, the flood of crates coming from Rome had worried Londoners. Did the appearance of all of these masterpieces mean that the King was selling his soul to the Devil?

The hopes of the Catholics and the fears of the Protestants far outstripped Charles I's intentions. He might well ponder the role and purpose of beauty in religious ceremonies, but the idea of conversion did not cross his mind. He had not the vaguest desire to give up his privileges as spiritual leader of his kingdom, and no intention of submitting to the Pope. No one understood this; Catholics and Puritans alike believed that his wife was influencing his feelings, and that the Pope's gifts were a form of spiritual seduction. The King's passion for scenes of martyrdom, for swooning Mary Magdalenes and queenly Virgins, had become a byword for temptation in London. Marie de Médicis had believed so much in the power of painting over the mind of her son-in-law that she had surrendered the skills of Orazio Gentileschi to him, and for the same reason now brought him the talent of another Italian painter.

Under Elizabeth I, a series of acts of Parliament had outlawed the Catholic religion and denied the Pope's authority; these included the stipulation that anyone in possession of medals, crucifixes and other such things blessed by the Pope would be judged guilty of *lèse-majesté*. The punishment for such crimes was severe: the culprit was to be dragged to the place of execution, strung up on the gibbet, then cut down while still breathing, stripped naked, castrated and disembowelled. The executioner would tear out his still-beating heart and show it to the crowd, calling out, 'Here is the heart of a traitor!'

It was in a land where the Pope was viewed as the Antichrist that Orazio Gentileschi was engaged upon finishing the master work of his whole career: nine huge panels which were planned for the ballroom ceiling in the Queen's House at Greenwich.

In the course of her long journey towards her father, Artemisia had been obsessed by the fear of never seeing him again. Standing on the deck of the ship as it approached the ramparts of Dover and of Harwich, she had scanned the coast of England. When she recognised her brother Francesco on the shore, she no longer had any doubt: she was arriving too late, Orazio was dead. Her grief at having lost him was searing. Even after Francesco had reassured her and had sworn to her that their father was in the best possible health, that he was working like a fiend, that he had not a single minute to waste and that he

put every ounce of his strength into his work, Artemisia's suffering was not dispelled. She had crossed the whole of Europe in answer to his call, exposing her own daughter to the direst perils, giving up her studio in Naples – and her father could not even spare her a welcome? Who was being made a fool of? In her anger and her disappointment, she violently refused the old artist's invitation: she would not go and join him at his studio in Greenwich Palace.

Father and daughter lived for ten days only a few miles along the Thames from one another, without either of them deigning to take the little skiff that would have brought them together within less than an hour.

Artemisia looked at the river through the tall windows of the Bear Gallery at Whitehall Palace. Below, a forest of ships' masts closed off the view on all sides. The narrow pathways of the city opened out on to vistas of grey water. Downstream, heavy barges, loaded with blocks of stone and tree trunks, were berthed in front of the warehouses. Out at sea, brigs were firing cannon salutes in honour of some ambassador, and the salvoes reverberated amid the cries of oyster sellers, the oaths of tripe vendors and the insults of carriage drivers. London seemed nothing but one enormous din.

Her brow pressed against the glass, Artemisia could not take her eyes off the sight of the Thames. Sloops, rowing boats, lighters, a whole flotilla of small craft shuttled from one bank to the other. This was the only way for Londoners to cross the river, for the huge city had only one bridge, London Bridge, crammed with people and buildings and vendors' booths, its gateway spiked with the decapitated heads of the executioner's victims.

'He won't come,' she thought. 'There is no point in waiting for him any longer. I know him, he would prefer to die alone rather than condescend to make the first move.'

With resignation, she recalled the incidents that used to occur in Rome, when two painters, each convinced of being superior to the other, would refuse to greet one another. She remembered the encounters between Gentileschi and Baglione in the Via del Corso, when the two stood face to face, each waiting for his rival to take his hat off first. This question of precedence and the doffing of hats had gone so far as to involve them in a trial for defamation. He wouldn't come. Artemisia sighed: If the winter had not prevented her from sailing immediately, she would already be on her way back. Not that she had lacked a good welcome at the English court. The King, his wife and the Queen Mother showered her with favours. She lodged with her daughter Francesca at St James's Palace, in the apartments reserved for Marie de

Médicis's ladies-in-waiting. There, she could admire Titian's canvases. Her own self-portrait was already hanging in the royal residence of Hampton Court. Twice daily, the court went past the image of Artemisia Gentileschi, as she herself had just gone by that of Nicholas Lanier. The musician's portrait, executed by Van Dyck, was on the wall behind her. Among the thirty-five pictures in the Bear Gallery at Whitehall, it was regarded as a masterpiece. Artemisia had not dared look at it. The faces of Artemisia Gentileschi and Nicholas Lanier might be rivals in beauty upon royal picture rails, but the two models had not yet seen one another. Was Lanier avoiding the turmoil of his old love affair? Since her arrival, Artemisia had made enquiries. Now fifty, Nicholas was still known as a fearless man and an excellent musician. He had no children. He continued to travel the world, but would always doggedly return to his wife, the gentle and stalwart Elizabeth, a witty, clever woman, whose intelligence taught her to stay in the background. What was he like these days? Unable to resist any longer, Artemisia left the window and went over to the imposing picture.

The canvas probably dated from the time of their relationship, perhaps when Lanier was passing through Antwerp on his way back from the Venetian exploit. She recognised the red-striped doublet that he used to wear, the cape that he draped under his arm to throw back over one shoulder, the signet ring on his little finger. She saw again all the lineaments of that face she had loved so much, the intense, hard grey eyes that looked down on her and seemed still to quiz her. She stepped forward to study the *pentimento* under his left wrist; Van Dyck – or Lanier perhaps – had obliterated the lute that he held in his hand, replacing it with a sword. According to courtiers, it was the quality of this portrait that had prompted Charles I's enthusiasm for its author. He had invited Van Dyck to settle in England with a stipend twice as high as the staggering sums received by Orazio Gentileschi.

Artemisia smiled. In this work by the Antwerp painter she recognised certain forms and techniques that she was familiar with from her father's paintings. The model stood against a large area of brown wall. To the left, a landscape and a vista of sky occupied a quarter of the canvas and opened up the horizon. On the edge of the wall abutting the sky, the stones, the plants growing in the cracks and the way the leaves hung were a typical motif in Orazio's work. There was nothing to be astonished by in the fact that Gentileschi should have influenced an artist of Van Dyck's stature; the two painters had known one another in Genoa nearly fifteen years earlier. But

finding Nicholas's face and Orazio's techniques together on the same canvas moved Artemisia. It reawakened in her the need to complete her mission. I shall go and see his work tomorrow without fail, she suddenly decided. She would go to Greenwich Palace. Just once. She would take the measure of her father's work, of the magnitude of the task that he expected of her, and she would make up her mind about her own life, about the past and the future. Tomorrow she would answer that searing question: what was the worth of Artemisia Gentileschi's art?

In the mist, her footsteps echoed on the boards. She walked quickly to the end of one of the long jetties that stretched into the water. The Thames went far out at low tide.

Although her abrupt decision to meet Orazio might have given the impression of a rush of affection, Artemisia had not forgotten what was at stake in their meeting. She had made careful preparations. First, her appearance. She had planned it with the meticulous attention of a woman in love meeting her suitor. The cold and the wind compelled her to swathe herself in sable. She made a virtue of it. The lustrous glints in her fur hood combined with her own curls to lend her eyes a golden hue. Nothing else of her face could be seen, for she wore a mask, not as she had done in Venice, to conceal herself from spies, nor as in Rome, to melt into the carnival crowd, but as all the English aristocrats did, to protect her complexion from redness and chilblains. Her skirt picked up the brown shades of her muff. She had gathered all the folds of her ample garments in front of her. The movement of the draperies emphasised the beautiful line of her lower back and showed off her feet in their high-heeled shoes tied with bows. She hailed one of the numerous sailing boats cruising on the river.

Sitting on a stool, half-way between the deck and the covered cabin which sheltered passengers when it was raining, Artemisia let herself drift on this final journey towards her father. Columns of black smoke rose from the chimneys that sprouted all over the roof-tops of London. These were the fumes of coal from the Northumberland mines that had been heating the city's houses for the last twenty years. The pollution and the acrid-smelling soot produced by carbon combustion were becoming so foul that trees were being choked to death. To combat the stench and cleanse the air, every household would hang little bags of aromatic herbs on the handles of cupboards. These small coloured pouches swung from the end of the nielloed silver keys which opened the picture galleries of the King of England. Ever since her arrival in London,

Artemisia had continually been drawing inadvertent comparisons between what she found here and what she had left behind in Italy. She noted the coldness of the light, the lifelessness of the colours, the raw textures of materials, all gloomy brick and wood. Slowly, she sailed past the new palaces, past Whitehall – a tall building entirely clad in marble – without being moved by any of this opulence and beauty. The whole landscape remained dark and straitened in her eyes. Even the harmony of the gardens, the neat squaring of the little walls, the rows of poplars, even the alignment of the steeples and the perfect symmetry of the two towers of Westminster struck her as oppressive. In everything she saw and heard, in the bustle and the life of London, she found something threatening, as if everywhere there lurked some violence beyond her control. And the croaking of the crows that wheeled above her head, as once the birds had done over the Tiber, seemed a sinister echo of the seagulls' cries in Rome. Again and again she remembered the city of her childhood – much more often than the Bay of Naples, the mysteries of Venice or Florence's refinements. For her, the light of Rome was the symbol of the past and it obsessed her. In the distance, the boats left high and dry on the shoreline at low tide, their hulls overturned, their masts lying sideways, the little red-uniformed figures moving about at the foot of the ships, the men repairing their nets or fishing about in the mud for bait, brought to mind a familiar scene: one of the great seascapes that Agostino Tassi used to paint.

Artemisia tried to shake herself out of her torpor by imagining the confrontation that awaited her at Greenwich Palace. Orazio's absence at Harwich had removed any element of feeling from their reunion – this at least was how she saw it. She thought she felt nothing for him. She could not even picture him. In the past, whenever she had felt a surge of affection towards him in his absence, she would see him as he had been at the time of her mother's death. A dignified and tender man who hid a wealth of passion beneath an exterior coldness. But this reassuring figure could be replaced in her memory by a different one: a man with lips so pale and thin, with eyes so fevered that he seemed to be consumed from within; a man whom Artemisia had deceived and betrayed, and whose love and trust she wanted to win back. All of these reflections blurred in the great unsilvered mirror of the Thames.

Although she had wished for this meeting for nearly a quarter of a century and prepared for it in the course of long months of travelling, Artemisia had not anticipated the violent emotions that this final encounter with her father would arouse.

39

The Queen's House at Greenwich

November 1638

A large, balustraded white building with a single upper storey and fourteen high mullioned windows, the Queen's House stood on the very site where Elizabeth I's favourite, Sir Walter Raleigh, had spread out his cloak at the Queen's feet so that the mud would not sully the royal shoes. A Palladian villa, under a rainy grey light.

Artemisia's shoes sank into the mud of the vast buiding site that still surrounded the house. She shivered and hurried on up the driveway. Through her brother Francesco, she had sent word that she was coming. She knew that this time her father was waiting for her, at the top of the double staircase there in the Great Hall. This was where Orazio was working, painting a ceiling area of some 1,500 square feet, divided into nine panels. A royal commission: an *Allegory of Peace and the Arts under the English Crown*. It was an iconographic project that seemed to echo the states of mind of both Gentileschis and bring things full circle. The nine female figures that he had conceived for the *tondi* and the caissons of his ceiling brought to mind those which he had executed long ago for Cardinal Borghese at the Casino of the Muses. Then, Orazio's Muses had resembled his daughter, the seventeen-year-old Artemisia who, through her father's jealousy, would fall prey to the desires of his collaborators. Would Gentileschi finish his life's work as he had begun it?

Artemisia tore off her mask and went up the steps to the terrace. She walked along the balustrade to the doorway, waited for a moment, then walked into the vast entrance hall. It was a perfect white cube, rising the entire height of the building. Between the windows, on six pedestals in gilded wood, stood the Mantua marbles; Artemisia immediately recognised the

statue of Diana the Huntress that she had seen at the house of the dealer, Daniel Nys. Her heels clicked on the black-and-white flagstones. In the silence her jewels clinked and her stiff skirts crackled. There was not a single piece of furniture, not a single carpet or tapestry to warm the room. Above, a gilded balcony formed a great wooden gallery. The broad dividing beams on the ceiling echoed the geometric lines of the floor: the central roundel, the square panels in the corners and the long rectangles at the sides. For the moment there was nothing in the caissons. They were empty frames. Orazio Gentileschi's great project still remained out of sight, eluding Artemisia's impatient eyes.

Looking up, Artemisia stopped in the middle of the hall. A latch clicked somewhere on the gallery above and a small door opened between the two windows. Orazio appeared on the balcony. 'Always dressed in black', was how the witnesses at the rape trial described him in 1612. 'Of medium height, thin, slight.' He was exactly the same. His goatee, which was greying before, had turned completely white. His hair with its boyish curls was white too. But the severity of the look that he lowered on Artemisia, the master's mistrust of his pupil, remained unchanged. Did Orazio recognise her? Wrapped in her furs and swathed in velvet, with her fat baroque pearls at her throat, her kiss-curls at her temples, her aglets and brooches, she resembled a great lady painted by Van Dyck, a Genoese or London aristocrat. Nothing linked this patrician to the girl raped in the Via della Croce. Orazio hesitated. She was still beautiful, yes, Francesco Gentileschi had told him often enough. But it was a silky beauty, full of artifice and devoid of any violence. Could this dowager be the painter whose judgement and superiority he so feared?

She too was hesitant, collecting herself. For all his doublet and his ribbons, he was still an unassuming individual. He lacked grandeur and nobility. He had learned nothing in his wanderings from kingdom to kingdom. And though this look of his still frightened her, the feeling would be short-lived. She drew herself up, already rising to the challenge. Here I am! she shouted inwardly. She tried to catch his gaze but was unable to. You called me to your aid and I heard you. Yet you have not even begun the work you wanted me for! Why have you made me come?

But he was too fast for her. He retreated into the shadow and barked, 'Get rid of those clothes.'

Disconcerted by these words, the first she had heard from him in twenty-five years, Artemisia did not understand.

'Take off that finery! You are sweating,' he told her. 'When you are ready for work, there will be plenty for you to do.'

He made to leave the balcony.

Forty years of struggling, for this: the coarseness of a Cosimo Quorli, the violence of an Agostino Tassi, the rudeness of an Orazio Gentileschi! Forty years of fighting, only to end up back in the mire of the artists' quarter: take off that finery, you're sweating.

Artemisia had just lost the final battle. She might have won fame and freedom, but she still had her feet in the slime. She had no doubt that she was fortunate enough to have a great facility for painting, a rare talent in a woman. She knew equally well that her soul and her art could never co-exist with Orazio Gentileschi's. Her father's hand wrought hers, and the master's skill would outlive the pupil's.

Watching keenly, Orazio missed nothing of his daughter's bewilderment. It was beyond her, he imagined, to make the leap across the distance that separated him, an artisan without culture, without intellect or emotional acuity, from the poet who fashioned the faces of virgins. He was only waiting for the moment when he could set her to work on his great task.

He backed away and disappeared. The latch of the little door clicked shut behind him.

Artemisia threw her cloak on to the flagstones and gathered up her skirts. She crossed the hall and turned left into the first doorway, dashing up a staircase that led to the first floor and then up to the roof. She returned to the hall and followed another corridor and another staircase, always running towards the light, until she came to a grand doorway. She forced the door open with a shove. Her instinct did not deceive her: the Queen's sun-filled apart-ments still housed studios for the stone cutters hewing the marble for the mantelpieces and the wood carvers doing the decorative work on beams, pedestals and picture frames. And the painters. Orazio, Francesco, Giulio and Marco were all there. Without addressing a single word or glance at them, she walked straight over to the wall where there were nine canvases drying — Orazio Gentileschi's freshest canvases.

Artemisia took hold of a frame and turned the picture round. At last she would find out who would outlive who! She was riveted to the spot by the surprise of what she saw. Her father had cheated her, robbed her. What had become of that ineffable tenderness on Orazio's faces, the balance of his compositions, the harmony of his colours, the transparency of his light? The

large figure lacked expression, grace or force and was contorted into an implausible posture. The most elementary study of the human body would reveal the inaccuracy of this anatomy: the arms were too short, the head disproportionate in size. And the play of light and shadow made no sense. Artemisia was at a loss. She had seen some of her father's pictures in London – *Joseph and Potiphar's Wife*, *The Finding of Moses* – and they had seemed to her to combine all the lessons of Veronese, Raphael and Caravaggio. She glanced once more at the canvas she was holding at arm's length. The weakness of the draughtsmanship was matched only by the thickness of the light and the ugliness of the colours. It was all bland and flat. Unless this was an accident? A painting that had gone wrong? Hadn't she too experienced this kind of thing? In a fever, she seized the other canvases. But there was no assuaging her anguish. You would not find heavier, more awkward draperies in a bad picture by a beginner. There was no volume to the forms covered by these fabrics. This could not be the work of Orazio Gentileschi. Of course! Why had she not thought of it? What she was seeing must be Francesco's clumsiness. Marco's incompetence. Giulio's ineptitude. But when she looked up it was her father's face that she saw, and on it she read terror and death.

On his frightened face she saw that the ideal of beauty for which Orazio had sacrificed everything – his peace of mind, his happiness, his daughter and God – now eluded him. That he would soon pass away, but that he was already dead to himself. It was not just his body that betrayed him, his hand that trembled, his eyes that were dimmed; his soul had deserted him. For all that he sought within himself, he could find only old forms, old ghosts, the remote echo of a world of colours that he could no longer see. Orazio may have had recourse to his sons' handiwork, but he alone was the author of these paintings. Artemisia realised that she was looking at his final works. In her father's eyes, so hard on the efforts of others, she perceived only a pathetic prayer. The old artist was imploring her to withhold the truth. He was beseeching her to conceal his mediocrity from him, to obscure the void of his existence and the despair of his approaching death.

Suddenly she made sense of his absence from Dover and Harwich and why he could only appear before his daughter standing on a balcony ten feet above her. He was trying to impress his will upon her one last time. She considered how much he must have suffered knowing she was in London, admiring the paintings of 'Orazio Gentileschi'. How long ago were those grand creations done? Five years? Ten? She could guess at the grief of the painter who no longer

compared his art with that of his peers, or with that of his daughter, but with himself.

The weakness of these last canvases by Orazio discredited his art and his memory. Artemisia knew that a failure at the end called the whole life's work into question.

The father's despair distressed the daughter; she agreed to his bargain. She would complete his work. She would take up the torch and their name would endure. Thanks to her, her father's fame and brilliance would go down in posterity.

Artemisia had finally obtained the answer she had been seeking. And the look she bestowed on the old man's face was a tender one, full of compassion and indulgence.

40

The Studio of Orazio and Artemisia at Greenwich

January 1639

'I saw it as a symphony of golds, greens and lavenders,' Orazio murmured. 'Twenty-six figures to be spread between nine panels. Are you following me?'

In the studio's large fireplace, under the cauldron where the oil was boiling, the nine canvases he had begun without her were burning. The huge blaze lit up the whole room.

'I had pictured the Muses sitting facing one another,' he continued, his voice hesitant.

Artemisia was drawing. The scraping sound of the graphite disturbed the stillness. Slowly, the father's vision was given new life by the daughter's hand.

'And then, in the middle of the central roundel, a woman sitting in a ray of light against the perspective of a blue sky like the Roman sky behind the cupolas: she would be Peace.'

Father and daughter had bolted the doors to the studio and set up their easels side by side. Francesco, Giulio and Marco watched them standing together in front of panels so heavy that they seemed about to topple and crush them.

For the sake of speed, they were sharing the work. Each was engaged upon several pictures at the same time. Artemisia ground Orazio's colours, sized his canvases and applied the ground layer. While one canvas was drying, she went over a first layer of paint on another, retouching a shadow or brightening a glaze.

They were both enveloped in voluminous dressing-gowns that they had donned to protect themselves from spatterings and to keep out the cold. The stained garments drowned their bodies, making them sexless and ageless.

They stood all the time, stepping forward and back so as to gauge their work. They lunged like duellers. But it was no longer against one another that they wrestled. Side by side, paintbrushes at the ready, they fought the same adversaries: mediocrity and oblivion.

Watching them, Artemisia's brothers recognised the passion of the two painters from the Via della Croce. Artemisia waited for her father's orders, submitting without a murmur to his guidance and instructions. She seemed to have fallen back into all the servile ways of her childhood.

'Take the linseed oil and mix it with the walnut and the poppyseed oil,' he told her.

She put up with everything from him, even his signature on her work. Her brothers found it hard to accept the spectacle of this woman voluntarily shedding the things that she had fought for, her freedom and her fame. They saw her obedience as a renunciation. For his part, Orazio knew that master and pupil were a thing of the past. They were just two artists carrying out their work, in the little time at their disposal.

'The brush now. No, not that one,' he snapped, 'The fine one! Dip it in the varnish. Mix it with the green. Yes, directly on to the palette. That's it. Now apply it quickly.'

'Over the yellow? But the yellow isn't dry.'

'The green, I tell you, quickly.'

'But if I apply the green now, the colours won't cohere.'

'Get on with it. Do what I tell you.'

Artemisia complied. Then she went back to her palette, flicked the tip of her brush in the pot and poised herself to apply another delicate dab of colour.

'No. Don't put any more on, you'll spoil the tone. Show me what you've done.'

Docile, she let her father see her work.

'The shadow under the right eye is still much too green,' he lamented. 'Add some vermilion.'

She softened the colour with a rag, and corrected the tone.

In no time, they had ceased to feel the winter cold, or the dampness, or the English mists. They were unaware that outside plague was raging through London, that four hundred people were dying every day; that the King was levying new taxes that were maddening the country; that he was losing his battle against the Scottish Presbyterians and that the mob was threatening the chapels of all the Catholic embassies. Each dawn that rose over Greenwich

found the Gentileschis at work. At night, they were still toiling away. Haunted by time and by death, the two of them shared the same dream and the same vision.

But Orazio's hand trembled. His daughter's energy was wearing him out. He was drained by the efforts she drove him to and wanted to rest. But Artemisia never stopped. She wouldn't eat, sleep or change her clothes. In two months, she had already completed four of his pictures, the largest canvases.

'Too fast . . . You're going too fast,' he pleaded.

She wouldn't grant him any respite now. Greedily, she fed off his teaching. She absorbed his light, his colour, his substance.

'Wait,' he begged her. 'I can't keep up with you. Why is this red here? How did you do this green? It's beyond me.'

Artemisia might seem to have forgotten even the memory of personal ambition, but her hand, once said by poets to be capable of wonders, never strayed from her mortars, brushes and canvases. After twenty years of practice, Artemisia's hand painted by itself. Yet her Muses bore less and less resemblance to the women that her father would paint. None of the sturdy, bare-breasted women drying behind the bolted doors at Greenwich belonged to the world of Orazio Gentileschi. Artemisia's figures were violent and dramatic; they had a solid weight in space. They moved. They spoke.

Impotently, Orazio looked on as his great project was taken over. What he had once feared, in the studio at Florence, had come about: Artemisia was plundering him. She might leave to posterity the compositions that he wanted, and doubtless she would find the tones he strove for. But each colour, form and shadow, each brush stroke would produce an effect completely contrary to what he had in mind. He dug his heels in one last time.

'For the flesh tones, mix me some silver white with yellow ochre, and add vermilion to it. For the darker shades of skin, heighten the ochre with red for me.'

She obeyed. But she could not restrain herself or curb her instinct. He could see clearly that she was stealing his work. But even that had ceased to matter.

Stretched out on the makeshift couch she had set up for him, Orazio watched her for the last time. Her hair was dishevelled. He saw her from the back, her forearm stretched out, her large palette resting on it, dark against her skin. Between her thumb and her index finger, she held a bundle of paint-brushes that caught the light like the stems of a long bouquet. She turned round.

'You aren't asleep?' she asked, worried by his expression.

'No. I have been observing you for a while. You are beautiful.'

She blushed as if these words and that look were a reminder of old emotions.

'I want to see you. Come here.'

He held out his arms and drew her to him. It seemed such an easy gesture, so familiar.

'God will not judge us,' he murmured. 'God refuses to choose between us.'

His eyes clouded over. His words echoed through her as if he were no longer alive. She imagined other words for herself and for him that they could have spoken in the past.

'But Our Lord is parting us. He is putting a distance between us. Only swear to me that you will not open this door before the whole task is done.'

Did he need to ask her? Orazio let his eyes close. Submerged in a feeling of security that he had never known before, he surrendered; he had found her again as he had made her: that industrious and talented daughter of his. His double. This was the Artemisia of the time before their meeting with Agostino Tassi, of the time when she saw beauty through the eyes of her father, when the great challenge of life was met with paintbrush in hand.

41

The Queen's Chapel at Somerset House

7 February 1639

'Death, oh death!' The words thunder out from the choir in the Queen's Chapel.

The crêpe hangings shudder ominously with the breath of the musicians, who are curtained out of sight.

'Come, come, this coffin see,' these ghastly voices call, 'and look upon the folly of your pride.'

The slow procession of Henrietta Maria's twelve Capuchins moves around the bier which stands at the foot of the high altar. Their footsteps follow the geometric design of the floor, the great marble rosette that recalls the black-and-white pattern of flagstones at the Queen's House, just as the ceiling of the church brings to mind the nine gilded caissons of the Grand Hall.

There, *Peace and the Arts* explodes in a symphony of greens, golds and lavenders, just as Orazio had dreamed. At the centre of the composition, Peace sits on high in the midst of beams of sunlight which suffuse the clouds. The light spreads, like a vibration, across the faces of all the divinities. The virtuosity of the visual effects succeeds in reconciling the artificial realm of allegory with the tangible world. It is a beauty that combines the pomp by which Orazio set such store with the full-blooded truth to life that Artemisia demanded. The ceiling immortalises a single vision: that of both Gentileschis, father and daughter.

The splendour of Orazio Gentileschi's funeral, his burial in the crypt of the Queen's Chapel, open the gates to eternity. But what does eternity matter now? From the gallery that overhangs the choir, Artemisia does not take her eyes off the coffin. Her mourning for her father, her master, the creator whom she has

loved above all other men is also a mourning for her rage-filled dreams of vengeance. The swords of Judith, the hammers of Jael, the daggers of Lucretia, the asps of Cleopatra – the anger and life of Artemisia's heroines – are all being laid to rest in the tomb. Softened and appeased, she forgives. She lets go. The nightmare visions and the ideal of beauty disappear along with Orazio. With his passing, the death knell has tolled for both of them. Artemisia will never again know the fire of her conquering years, when she painted to live up to her father's demands.

'*But the works will speak for themselves,*' she would write not long after.

The monks raise their arms and swing the thurible three times above the death's-heads. A white vapour envelops the skeletons, the scythe and the hourglass. The whole church is wreathed in incense, columns of it curl their way up to the gallery. Artemisia perceives nothing, not even the sacred fumes of the incense, the perfume of God. But the turpentine that impregnates her gown, the smell of glue in her skirts, of resin in her hair, of oils and essences and varnishes on her skin, these smells permeate her flesh right through to the bone. The thundering of the organ, the shouts of the Puritans protesting outside the chapel against this pomp for the funeral of a painter – none of it distracts her from the music playing quietly in her head: a faint rubbing sound, back and forth, the friction of animal hair on weft, rasping and scraping. The sound made by a paintbrush on canvas. And now and then, the resonant chime of the handle clinking in the pot.

What Became of Them

ARTEMISIA GENTILESCHI: After Orazio's death, she was to stay on in England for nearly two years. She would paint portraits of which nothing is known. Her brothers were to lead chequered and adventurous lives which included a spell in a Portuguese gaol. At the age of sixty-four, Francesco would take a young girl as his bride in Angers, describing himself at the time as a court painter to the King of France.

In England, the Queen's Chapel at Somerset House would be sacked at the onset of the Civil War. The mob broke down the doors, smashed the statues, wreaked havoc on the pictures, tore down the painting on the high altar – a work by Rubens – and threw it in the Thames. The Puritans' rage against painters and Catholics would compel Artemisia to return to the Continent, possibly with Marie de Médicis, in 1641. She would go back to Naples. There she would find, unaltered, her studio and her rivals, as if the English interlude had not taken place. And yet, her work was no longer as it was. The small number of canvases which art historians can date to Artemisia Gentileschi's second Neapolitan period have nothing in common with her great works produced in Florence and Rome. Are these last pictures attributed to her really her own? Or are they by her pupils? Are they work from her studio? Was Artemisia bowing to fashion? Or to commercial imperatives? Whatever the case may be, she would continue making her livelihood as an artist, and would give her younger daughter in marriage to a knight of the order of St James. She would die at the age of sixty – a respectable age for 1653 – and it is very likely that she was buried in the parish of the Florentines in Naples. The archives refer only to an inscription which

could be hers: *Heic Artemisia*. Here lies Artemisia. There is no surname or epitaph.

NICHOLAS LANIER: After Artemisia's departure, the outbreak of the Civil War in England forced the court to leave London. A royalist, Lanier followed the King, then went into exile on the Continent. He settled in Antwerp, though continuing to travel all over France in the service of Queen Henrietta Maria. Following the execution of Charles I, the royal collections were dispersed when between October 1649 and November 1651 Cromwell's Commonwealth organised the largest-scale public sale in the history of painting. The Kings of France and Spain were secretly to purchase numerous works through their agents, bankers or ambassadors, shamelessly sharing in what was plundered from their beheaded 'cousin'. This is how Caravaggio's *Death of the Virgin*, which Lanier had admired in Venice, comes to be in the Louvre today. In the course of this sale, Nicholas Lanier would buy his own portrait, executed by Van Dyck, for the sum of ten pounds. Artemisia's *Self-portrait* would go for double this amount to one of the King's creditors, a lawyer named Jackson.

When the son of Henrietta Maria, Charles II, brought the monarchy back to power, he would reacquire some of his father's pictures – in particular the works of Orazio and Artemisia Gentileschi. The *Self-portrait* remains in the Royal Collection and is on exhibition at Hampton Court Palace.

AGOSTINO TASSI: He would stay in Rome, where his career continued to flourish. At sixty, he was still living in the Corso, cohabiting with a very young woman who had two young children by him. He would die in 1644, nearly ten years before Artemisia, crippled with arthritis, and was buried at Santa Maria del Popolo.

THE WORKS: The ceiling of the Great Hall at the Queen's House in Greenwich was dismantled in 1711 and transferred to Marlborough House. The paintings of Orazio and Artemisia are exhibited in the world's greatest museums, in particular the Louvre, the Prado and the Metropolitan Museum of Art in New York.

Notes

Six books were the foundations and mainstays of my investigation into the Gentileschis, and my main sources. They sat permanently on my desk and I am enormously grateful to and admiring of their authors.

As I have said, this book was triggered by the catalogue to the 1976 exhibition in Los Angeles, where I first saw Artemisia Gentileschi's work. Its title is *Women Artists, 1550–1950* by Ann Sutherland Harris and Linda Nochlin.

A few years later, in 1982, Éditions des Femmes in Paris, who had pubished a French translation of the catalogue, brought out *Actes d'un procès pour viol en 1612*, together with *Lettres d'Artemisia Gentileschi*. It was this book that first introduced me to Artemisia in her own words. Before long I was deep into the original edition, published in Italy in 1981: Eva Menzio's *Artemisia Gentileschi/Agostino Tassi, Atti di un processo per stupro*, an extremely faithful transcription of the most important statements made to the court during the 1612 rape trial, in the form in which they are kept in Rome's national archives.

Then, in 1985, new images were conjured up by the publication in French of a novel called *Artemisia*. The first edition had appeared in 1947 in Italy and the author was the well-known art historian and critic Anna Banti. Her husband Roberto Longhi, who founded the celebrated art history journal *Paragone*, had written (in 1916) the first major article on the Gentileschis, 'Gentileschi padre e figlia'. It was published in *L'Arte* and is still one of the major studies of Orazio and Artemisia Gentileschi's work. The attention of the museum world and art collectors was first drawn to the Gentileschis by

Roberto Longhi's scholarship and Anna Banti's imaginative approach.

Shortly afterwards, R. Ward Bissell adapted his University of Michigan Ph.D. thesis to produce the first *catalogue raisonné* of Orazio Gentileschi's work, *Orazio Gentileschi and the Poetic Tradition in Caravaggesque Painting* (1981). Sadly, at the time I was writing this book, Ward Bissell's major study of Artemisia's work, *Artemisia Gentileschi and the Authority of Art* (Pennsylvania State University Press, 1999) had not yet been published and I was unable to benefit from his years of important research.

In 1989, Mary Garrard, who had worked on the 1976 exhibition in Los Angeles, published the first monograph on Artemisia Gentileschi. It was called *Artemisia Gentileschi, the Image of the Female Hero in Italian Baroque Art* and contained an appendix giving a translation into English of a substantial part of the 1612 trial, plus some previously unpublished archive material. Mary Garrard's work was absolutely invaluable to me.

Lastly, in 1991, two Italian art historians, Roberto Contini and Gianni Pappi, edited the catalogue to an exhibition of Artemisia's Gentileschi's work shown first at the Casa Buonarroti in Florence, then in the cloister of San Michele in Rome. This exhibition, called simply 'Artemisia', was the first devoted entirely to her work.

Since my book was published in France, there have been many more books, articles, exhibitions and even plays and films about the Gentileschis, father and daughter. Not having been able to read or see them when I was researching and writing *Artemisia*, I will not list them here. I do, however, want to mention the recent exhibition at the National Gallery of London, which was the first to be devoted solely to the work of Orazio. The beautiful and informative catalogue edited by Gabriele Finaldi, *Orazio Gentileschi at the Court of Charles I* (National Gallery, London, 1999), is a book I am particularly sorry that I had to do without.

A large number of outstanding articles have been written on Orazio and Artemisia Gentileschi, on their circle and on the background to their lives and work. The bibliography gives full details of these articles, so I have not included the date or the name of the magazine or journal in these notes. The same applies to the books I consulted: full publishing details appear in the bibliography. The bibliography also includes the references for published archive material, where I was not able to consult the original.

Whenever possible, however, I went back to the original sources. In so

doing, I frequently came across details that had had no bearing on the research done by my predecessors, and these would give me new leads to follow up. In such cases I have given the references for this material in the notes, along with a transcription of the original documents.

In my narrative and dialogue I have made a point of using the actual words spoken by the various protagonists. In some cases, however, I have had to adapt what was said for the sake of clarity. The original texts are given in the notes, but I have not included a translation since it already appears in the body of the text.

These notes also gives the references of all the unpublished sources for each chapter, along with a list of the documents I was able to track down in the various archive collections in Rome, Florence, Genoa, Pisa, Livorno, Venice, London and Paris. It was these documents that enabled me to put my story together. Luck often seemed to be on my side and I made some amazing discoveries. On the other hand, fate sometimes decreed that things should not go to plan. This was particularly true in Naples, where, despite the hours I spent poring over account books, and the number of times I went back to the notaries' registers, to the *post mortem* inventories of the town's leading families, and to the parish and archdiocesan religious records, I invariably ended up empty-handed. This explains why I have given virtually no source material for the scenes depicting Artemisia's life in Naples. I have tried to make up for this by describing the circles she moved in.

Rome, however, brought me luck. The original material relating to the action brought by the Curia and the State against Agostino Tassi, accusing him of rape and procurement, can easily be consulted in the Archivio di Stato di Roma (ASR), *Tribunale Criminale del Governatore* (TCG), *Processi, sec.* XVII, vol. 104, ff. 270–447 under the old page numbering system, or ff. 1–340 under the new system. The large amount of evidence given by ordinary people proved to be essential to any understanding of the reasoning behind the case and the structure underlying it. The criminal justice system in papal Rome is surprisingly rational. After reading the published extracts from the trial, I had been left with the impression of an arbitrary system. But in fact the magistrates proved tireless in their willingness to probe human psychology and demonstrated an absolute integrity. Throughout, they applied the law. In view of this, the fact that no verdict was reached – a fact accepted up until now by historians – and that, in a case that had taken nine months to prepare, no sentence was ever passed, seemed to me nonsensical, an aberration.

In fact, a document showing that Agostino Tassi was sentenced *does* exist, along with a substantial number of other key documents connected with the trial. All this material is in the ASR, but dotted about in a huge number of different legal registers from the TCG. The references for these scattered documents are given under the relevant chapter heading.

Prologue: London, 11 February 1639

The news of Orazio Gentileschi's death is given in a despatch sent from London to Florence by the Grand Duke of Tuscany's agent, Amerigo Salvetti. He was in England around 1639 because he had fled there when the city of Lucca financed hired assassins to kill him. His brother was hanged in Lucca, and the whole of his family was banished and stripped of their possessions. Salvetti was a pseudonym – his real name was Alessandro Antelminelli. On 11 February 1638 (1639 according to the Roman calendar) he wrote: '*Mori quatro giorni fà il Gentileschi, famoso pittore, regrettato molto da Sua Maesta e da ogn'altro amatore di quella sua virtù.*'

This despatch is in the Archivio di Stato di Firenze (ASF), Carteggio Mediceo 4199. It was published in R. Ward Bissell, *op. cit.*, and by Anna Maria Crinò in her very helpful article, 'Rintracciata la data di morte di Orazio Gentileschi'.

BOOK ONE: THE GREAT ADVENTURE

Part I: Susanna and the Elders

1 *Piazza Ponte Sant'Angelo, 11 September 1599*

Stendhal had the story of Beatrice Cenci's trial copied out and his manuscript is in the Bibliothèque Nationale in Paris. He retold her tragic story in his *Chroniques italiennes*.

There is a huge amount of information about Beatrice Cenci's execution in the *Avvisi di Roma* (the bulletins about Roman life that circulated at the time), to be found in the Biblioteca Apostolica Vaticana (BAV) among the manuscript collections labelled *Urbinati Latini* 1067 and *Vaticani Latini* 9727. *Beatrice Cenci* by Conrado Ricci, published in 1923, sets out the facts very clearly.

The preparations for the jubilee celebrating the holy year 1600 are described in detail in *Gli Anni Santi*, published in Rome in 1899 by Virginio Prinzivalli.

The birth of Orazio Gentileschi's son and his baptism five days after Beatrice Cenci was executed are recorded in the *Liber IV baptizatorum*, 1595–1619, for the parish of Santa Maria del Popolo, f. 52v, in the Archivio Storico del Vicariato di Roma (ASVR). The boy was called Giulio and his godfather was a relatively famous Flemish painter, Vincenzo Cobargher. His godmother was the wife of the cabinetmaker Manessi, who owned the house the Gentileschi family lived in, on the corner of the Via Paolina (or Via del Babuino) and the Via dei Greci. Cobargher, Manessi and Gentileschi were presumably neighbours. All three of them appear under 'Via Paolina, verso Margutta' in the 1601 *Stati delle Anime* for the parish of Santa Maria del Popolo, which are in the ASVR.

Art historians state that Agostino Tassi was in Rome from spring 1610. But he seems to have made various forays into the Papal States – where he was born – well before that year. This is confirmed by a police report dated March 1599 (ASR, TCG, *Relazioni dei Birri*, vol. 100, reg. 5, ff. 1r, 2r, 51–v). The incident covered in this report (the references have been published by Riccardo Bassani and Fiora Bellini in *Caravaggio assassino*) appears to be the first time that Tassi tangled with the law in Rome before he was tried for incest in February 1611. But I did manage to track him down in Livorno (Archivio di Stato di Livorno, *Tribunale del Governatore e Auditore*, bundle 52 (1609), ff. 71–2). And I also found several deeds executed by him in Livorno in the presence of a notary on 29 May 1609. All these deeds, along with several IOUs signed by his brother-in-law, are in the ASR, *30 Notai capitolini* (TNC), *Ufficio* 22, vol. 42 (for the year 1610, part 3), ff. 332–4 and 344r.

Tassi's first documented brush with the law in Rome – thirteen years before the action brought against him by the Gentileschis – tends to confirm Artemisia's allegations. His approach to women seems to have been to take them by force.

A highly entertaining summary of Tassi's many trials and lawsuits in Rome was published by A. Bertolotti in 1876. But he missed a few instances. I have transcribed in full the documents relating to the two incest trials in ASR, TCG, *Processi, sec. XVII*, vol. 62, ff. 109–42 and 550–97. These gave me a wealth of information about Tassi's relationship with his wife, about his sister-in-law's arranged marriage with his apprentice, and about his relationship with

his pupils. In between these two trials, he was involved in other wrangles with his friend and fellow lodger, the painter Valerio Ursino, in July and August 1611. I unearthed the details of their disputes in ASR, TNC, *Ufficio 19, Testamenti*, vol. 5 (1611) (unpaginated), and in the *Ufficio 19* (volumes unnumbered), ff. 131–133v. One of the repercussions of their disputes was Ursino's vindictive statement during the Artemisia trial in 1612 – it was this statement that persuaded the magistrates that Tassi was guilty.

A decade later, on 17 June 1622, Tassi was again in court, to answer a charge of '*insolenze ed altro*' (assault and battery) inflicted on a courtesan called Cecilia Durantis, known as 'Bella Pelapiedi' (ASR, TCG, *Processi, sec.* XVII, vol. 181, ff. 407–13). I discovered that in this case – which again I transcribed in full – Tassi had two mistresses at the same time, both of whom were called Cecilia, which confused the magistrates. I found the verdict which sentenced Tassi to exile, as well as the verdict commuting this sentence into compulsory residence at the home of the *Tesoriere*, Costanzo Patrizi (ASR, TCG, *Registrazioni d'Atti*, vol. 195, ff. 1r and 1v). This 'house arrest' at the Treasurer's *palazzo* makes sense when we realise that, at that point, Tassi was busy painting the palace alongside Guercino. He had already worked on the ceilings a few years earlier, with Domenichino.

The sentence further stipulated that he could not leave the palace without a safe conduct from Cardinal Ludovisi, who in 1622 was the most powerful man in Rome, since he was the cardinal-nephew. He commissioned the superb frescoes painted by Tassi, again with Guercino, in the Casino Ludovisi, which can still be visited.

Tassi crops up more and more frequently in the court archives until February 1635, nine years before his death.

The endless bad language used by Tassi and Orazio Gentileschi – both written and spoken – and all the obscenities uttered by those in the artistic milieu, particularly Cosimo Quorli, are an integral part of the way men communicated in seventeenth-century Italy. The high incidence of swear words in their language may not seem very different from the words that pepper modern speech, but they were conforming to a 'code of practice' for insults, a ritual governing verbal attacks that is virtually forgotten today. Contemporary Englishmen doing the Grand Tour expressed their amazement as they noted down the eight blasphemous terms that Romans, Venetians and Neapolitans could get away with. They even drew up a catalogue of Italian insults. For men there were *ladro* (thief), *traditore* (traitor),

poltrone (poltroon, coward), *spia* (spy), *bugiardone* (liar), *ruffiano* (pimp) and, even more common, *becco, beccone* or *beccaccio* (cuckold). These terms would be made even stronger by the use of an adjective, usually an ironic one, as in *becco contento* (happy cuckold). Among the insults levelled at women, two constantly recur: *puttana* or *bagascia* (whore) and *ruffiana* (procuress). This time the standard adjective tends to be unpleasant: *puttana scrofolosa* (scrofulous whore).

The ability to come up with a quick rejoinder was viewed in seventeenth-century Italian culture as the key weapon for winning, undermining or holding on to power – long before the same was true of eighteenth-century France. People are constantly described as having a *lingua mordace*, a 'caustic tongue', though I cannot always be sure whether this is a compliment or a criticism.

Italians being Italians, these insults would be accompanied by gestures. A treatise on gestures published in the early seventeenth century lists a series of threatening gestures. For instance, putting your own index finger in your mouth and biting on it vigorously indicated that you intended to inflict bloody revenge on your enemy – the gesture symbolised that he was about to be castrated.

Insults aimed at the authorities, or at someone more powerful than yourself, would come in the form of letters, lampoons or anonymous graffiti. The courts were inundated with complaints that the plaintiff had been dishonoured by having a piece of paper stuck to his front door at dead of night. These were referred to as *cartelli infamanti* and they could destroy for ever a family's reputation, and that of their descendants.

A situation where people were constantly taking others to court, suspects were imprisoned and trials and lawsuits were commonplace can be explained by the concept – very strong in that period – of a plebeian sense of honour, combined with ordinary people's faith in the law. See Peter Burke's two fascinating essays on this topic: 'Languages and Antilanguages' and 'Insult and Blasphemy', in *The Historical Anthropology of Early Modern Italy*.

Throughout the book I have tried to reproduce the vehement language used by men in seventeenth-century Italy. I did not want to tone it down, as I felt I would be betraying their way of thinking and behaving. The quotation on p. 16 is a translation of: '*bugiaronaccia poltrona puttana de dio te voglio tirare una pignatta de merda sul mostaccio* [. . .] *fatti fottere dal boia e ho in culo te con quanti n'hai*'. These weren't in fact Tassi's words, but were spoken by another painter

embroiled in a similar dispute with a courtesan at the same time (ASR, TCG, *Investigazioni*, vol. 347, f. 65r, sec. XVII, for the year 1602).

2 The Chancery Room of the Corte Savella Prison, 12 September 1603

The painters were so often in and out of prison that I spent a long time researching the prison system in Rome. The books and articles I consulted for my description of the two major prisons, Tor di Nona and Corte Savella, are listed in the bibliography. But I must refer particularly to Vincenzo Paglia, whose work I found extremely helpful: '*La Pièta dei Carcerati*', *Confraternite e società a Roma nei secoli* XVI–XVII.

The details of the action brought by Giovanni Baglione on 28 August 1603 against the architect Onorio Longhi and the painters Michelangelo Merisi da Caravaggio, Filippo Trisegni and Orazio Gentileschi for *libello infamante* can be found, along with all the ancillary material – libellous poems, Gentileschi's anonymous letter and the innocuous letter taken from his bag – in ASR, TCG, *Processi, sec.* XVII, vol. 28 bis, ff. 377r, 383r, 387, 390, 391r. It is worth mentioning here that the notary in question, Decio Cambio, was the *pro charitate* notary who acted during the Tassi/Gentileschi trial in 1612; and also that the architect Onorio Longhi was an old acquaintance of Orazio's, since in 1595 they had both worked on Cardinal Altemps's catafalque in Santa Maria in Trastevere.

The case papers were initially transcribed by Samek Ludovici in *Vita del Caravaggio dalle testimonianze del suo tempo*, published in 1956. The whole of the proceedings were published once again by Cinotti and Dell'Acqua in their magnificent book *Il Caravaggio e le sue grandi opere da San Luigi dei Francesi*.

As I read and reread the trial documents, I felt that the cross-examinations by the magistrates and Orazio's replies would be unintelligible unless I added endless explanations about who the various people were and what had happened. I eventually decided I would have to edit together the two occasions when Orazio was cross-examined on 12 and 14 September 1603, so as to finish up with a coherent whole. But the questions and answers in this scene, plus Orazio's arguments, have all been taken from the court proceedings.

When it came to the libellous poem, I tried both to be faithful to its spirit, and to convey its coarseness. Here is part of the original:

Gioan Bagaglia tu non sai un ah
le tue pitture sono pituresse

volo vedere con esse
che non guadagnarai
mai una patacca
che di cotanto panno
da farti un paro di bragesse
che ad ognun mostrarai
quel che fa la cacca [. . .].

The anonymous letter really was produced by Giovanni Baglione, on 13 September 1603, as evidence that Orazio was guilty. Orazio used the following words to allude to the gold chain given to Baglione by Cardinal Giustiniani: '. . . *che a quella chatena che tu porti al colo ci atacasi una coratela che farebe ornamento uguale ala tua grandetza.*' The poem described the chain thus:

[. . .] *massimme s'intrassi ne la catena*
d'oro che al collo indegnamente porta. [. . .]

It was Baglione himself who, in his petition, pointed out how similar the two images were.

3 The Church of Santa Maria del Popolo, 26 December 1605, at sunset

In describing the atmosphere in the artists' district and the rules governing the way their careers progressed, I relied heavily on four books: *Rome 1630* by Yves Bonnefoy; *Patrons and Painters* by Francis Haskell; Olivier Michel's *Vivre et peindre à Rome au XVIIIe siècle*; and *Nicolas Poussin* by Jacques Thuillier.

Artemisia's mother's death certificate is in ASVR, Santa Maria del Popolo, *Morti IV*, 1595–1620, f. 140:

Prudenzia: Anno 1605, die 26 decembris Prudenzia de Montonis romana, uxor Domini Horatii Gentileschi pictoris aetatatis [sic] *annorum 30 moram trahens in una ex domibus Francisci Maneffii viam Paulinam rite susceptis sanctis sacramentis in communione sanctae matris ecclesiae animam reddidit cuius corpus sepultum est in ecclesia Santae Mariae de Populo hora 24 dum esset puerpera.*

Prudenzia died after giving birth. She was buried at 24.00, which does not mean midnight, but sunset. In that period the day officially started at dusk (*tramonto*), so one o'clock at night meant an hour after sunset, i.e. 5 or 6 p.m. in Italy today.

Orazio's baptism certificate, bearing the date 9 July 1563, is in Pisa, in the Archivio della Primaziale, *Libro dei Battezzati*, 1561–4, f. 91. It was published by Roberto Carità in his article 'La data di nascita di Orazio Gentileschi'.

Orazio's elder brother Aurelio Lomi was baptised six years earlier, on 29 February 1557, also in Pisa. His baptism certificate was again published by Roberto Carità, and is quoted by Tanfani Centofanti in *Notizie di artisti tratte dei documenti pisani*.

The excellent monograph by Roberto Paolo Ciardi, Maria Clelia Galassi and Pierluigi Carofano, *Aurelio Lomi, Maniera e innovazione*, provided a wealth of information about the Lomi/Gentileschi family. I should add here that, right from the outset of his career, Aurelio would use either Lomi or Gentileschi as his surname. My evidence for this is a document in the Archivio di Stato di Pisa, in *Sagrestia debitori e creditori*, for the years 1576–98, under the date 17 April 1589: '*Adi supradetto io Aurelio Gentileschi ho ricevuto da . . .*'

Artemisia's baptism certificate, dated 10 July 1593, is in ASVR, San Lorenzo in Lucina, *Liber baptizorum* 1590–1603, f. 78r. The date and place of birth are given as 8 July 1593 at her parents' home in Via di Ripetta, near the San Giacomo degli Incurabili hospital.

Her godfather was Offredo de Offredis from Cremona, and I found the details of his ecclesiastical career in Moroni's *Dizionario di Erudizione Storico-Ecclesiastica*. Her godmother is referred to as Artemisia Capizacchia in the baptism register, but she was in fact Artemisia Capizucchi, the heir to one of Rome's most illustrious families. I found the family tree in *Storia delle Famiglie Romane* by Teodoro Amayden, vol. I, p. 250. And in the Biblioteca Apostolica Vaticana I found the history *Della nobile et antica famiglia Capizucchi*, published in 1684 by someone called Vincenzo Armanni. He was distantly related to Francesco Armanni, the Pope's steward and a close friend of Cosimo Quorli. In 1574 Artemisia Capizucchi had married Giovan Battista Ubertini, a Florentine nobleman. She bore him five children, who were soon claiming two quarters of nobility by virtue of their Capizucchi mother and their Santa Croce grandmother. Artemisia Capizucchi seems to have had a good introduction into the court of the Grand Duke of Tuscany. Her husband's family belonged to the knights of Malta and to the order of San Giacomo. Artemisia Gentileschi's daughter would one day also marry a knight of the order of San Giacomo – a highly prestigious marriage, so much so that her mother was financially ruined.

I tracked down Artemisia's confirmation certificate in ASVR, San Giovanni in Laterano, *Cresime*, vol. III, 1601–8, Sunday, 12 June 1605. Her confirmation godfather, Vincenzo Cappelletti, would later appear as a witness in a case brought by Artemisia's uncle, Aurelio Lomi, against Cesare Borghi in Pisa in 1615 (ASF, *Accademia del Disegno, Atti e Sentenze*, vol. 64, 1595–1621). It is worth adding that someone called Alfonso Cappelletti was the papal nuncio's auditor from 1628 to 1632 – the early years of Artemisia's period in Naples. Cappelletti was even in charge of the nunciature when it was vacant between 22 April and 3 June 1628.

I hunted through the registers for all the parishes where Orazio Gentileschi might have lived between 1590 and 1593 in an attempt to find the certificate for his marriage to Prudenzia de Ottaviano Montoni, or a contract they entered into in the presence of a notary. But I failed to find anything. I have not therefore been able to work out how soon after the wedding their first child was born, which would throw light on the claims made by Cosimo Quorli that he was Artemisia's father, a fact referred to by witnesses during the 1612 trial. This possibility must therefore remain matter for speculation.

As for who Cosimo Quorli really was, I was fortunate enough to find his date of birth in the Archivio dell'Opera del Duomo in Florence. He was one of thousands of infants christened 'Cosimo' after the Grand Duke of Tuscany, Cosimo I. I found him among the baptism certificates labelled *Battesimi Maschi A–G*, for the years 1561–71, f. 7v. He was born two years after Orazio, on 8 December 1565, in the parish of San Lorenzo in Florence, and his father, Filippo Quorli, was one of the dependents of the house of Aldobrandini in Tuscany. Cosimo had naturally enough followed Cardinal Ippoliti Aldobrandini (who would later become Pope Clement VIII) when he came to Rome for his election to the papal throne. I also found references to his family, and to his father, in the ASF, in *Cittadinario Santa Croce*, bundle 4, f. 107r.

For information on Cosimo Quorli's career as a papal official, see the description of the office of steward in Moroni, *op. cit.*, vol. 23, p. 74. I found the dates on which he rose up through the various grades of the papal service in ASR, *Camerale I, Ufficiali camerali*, vol. 1725. The payments made to him each year are recorded up until his death in 1612, along with a list of the perquisites he was entitled to (ASR, *Camerale I, Maggiordomo del Pontifice*, vol. 1368).

On 27 June 1595 he was officially appointed to the *Fureria del Palazzo Apostolico*, to succeed Ludovico Rotanus di Rocca Contrata. He was sworn in the following day (ASR, *Camerale I, Ufficiali camerali,* vol. 1725, f. 451 and 45v).

The tombstone of his son Paolo Emilio Quorli, who died at the age of four, is listed in Vincenzo Forcella's *Iscrizioni delle chiese e d'altri edificii di Roma*, vol. IV, p. 30, no. 1036. He was buried in 1604 in Santa Marta al Vaticano.

On 16 February 1605, Cosimo Quorli was summoned as a witness by Caravaggio in connection with the action he was bringing against the painter Alessandro Ricci, accusing him of having improperly removed, in Caravaggio's name, a carpet from the papal steward or under-steward, 'Cosimo Coli' (in Cinotti and Dell'Acqua, *Il Caravaggio, op. cit.*, p. 158, f. 63).

In August 1605, Quorli took on at the *Fureria* the services of Francesco Armanni, of whom the witnesses in the Tassi/Gentileschi trial would later say that he was his evil genius. The payments to the pair of them are listed at considerable length in ASR, *Camerale I, Maggiordomo del Pontefice*, vol. 1605.

The payments Quorli made in 1610 to the craftsmen working on the Quirinal Palace can be found in ASR, *Camerale I, Giustificazioni di tesoreria*, vol. 39, and *Camerale I, Mandati*, vol. 949–50.

I found Cosimo Quorli's will in ASR, TNC, *Ufficio 34*, for the year 1612, part 1, ff. 337r, 337v, 338r, 338v, 381r, 381v. It is dated 5 April 1612. He appointed Francesco Armanni, his colleague at the *Fureria*, as his executor and had the will witnessed by the famous painter Orazio Borgianni.

Quorli's death certificate, dated 8 April 1612, is on microfilm in ASVR, San Pietro, *Morti*, reel 38, f. 203. This death certificate confirms that Quorli was buried in the small church of Santa Marta.

On 14 April 1612, his widow Clementia went to see her late husband's protector Cardinal Serra, to have her role as guardian and heir confirmed. I found the relevant document in ASR, TNC, *Ufficio 34*, for the year 1612, part 1, ff. 354, 355r, 355v, 364r, 364v, 365r.

Lastly, my research miraculously brought to light the inventory of Quorli's whole estate – personal effects and property – made after his death. This document, drawn up on 11 May 1612, gives an extremely detailed description of his estate, together with a plan of his house and a list of the paintings in his collection. It even indicates the colour of the counterpanes and the number of handkerchiefs in his wardrobes. The inventory is in ASR, TNC, *Ufficio 34*, for the year 1612, part 1, ff. 446–56v.

By taking all these various documents, and comparing them with the proceedings of the Tassi/Gentileschi trial, I was able to work out the social status of the man who would soon bring the whole Artemisia drama to a head, and assess his intellect and his character.

4 Orazio Gentileschi's Studio in the Via Margutta, December 1610

Most of the places where Orazio lived between 1593 and 1612 are recorded in the archives. Both R. Ward Bissell (in his *Orazio Gentileschi*) and Mary Garrard (in her *Artemisia Gentileschi*) tracked down these addresses and published them. They can be found in the *Stati delle Anime* in ASVR, under the parishes of San Lorenzo in Lucina and Santa Maria del Popolo. The Gentileschi family did not leave the painters' district until 1611. From 1593 to 1596 they lived in the Via di Ripetta, near the San Giacomo Hospital. From 1597 to 1600 they were in the Platea Santa Trinità (Piazza di Spagna), then from 1601 to 1610 in the Via Paolina (Via del Babuino). Orazio is listed as living in the Via Paolina on the Via Margutta side in 1601 and 1606. In 1605 he is said to be living in the same street but on the Corso side.

This may mean that he moved, but then went back to his old address. This is perfectly possible, since the painters were constantly on the move. They would spend two or three months in one place, then pack up and move to somewhere close by. But I tend to think that, in this instance, the priest who was doing the census for the Via Paolina in 1605 got it wrong. I say this because in that year everyone appears to have moved to the other side of the street. Another painter, Ottavio Leoni, switched sides along with Orazio – in 1605 he is living in the Via Paolina on the Corso side and in 1606 on the Via Margutta side. I should also say that all the witnesses in the 1612 trial refer to Orazio's spending a long time in the Via Paolina on the Via Margutta side, on the corner of the Via dei Greci. They do not mention any other home until he moved into a house in the Via Margutta itself, where he lived from around September 1610 to 10 April 1611. He subsequently left the Via Margutta to move to the Via della Croce, staying there from 10 April to 16 July 1611. Then he moved out of the artists' district to be nearer Tassi and Quorli, both of whom lived not far from the Vatican. He lived in the Santo Spirito in Sassia district from 16 July 1611 until December 1612, or thereabouts.

One of Tassi's apprentices, Niccolò Bedino, gave an extremely detailed description of Orazio's house in the Via Margutta, including the exact layout

of his living quarters and his workshop. That was in the statement he made on 8 June 1611 (*Artemisia Gentileschi/Agostino Tassi, Atti di un processo per stupro, op. cit.*). These descriptions were confirmed by Orazio's model Giovan Pietro Moli, in a statement he made on 27 July, and again on 12 and 16 December 1612 (ASR, TCG, *Processi, sec.* XVII, vol. 104). Some amazingly detailed information is given in the statement made by Orazio's washerwoman (*ibid.*, July 1612), and by his barber, Bernardo de Franceschis, who was also the family's doctor (*ibid.*, statement made on 31 July 1612).

My description of the relationship between Orazio and Artemisia in the period 1610–12 is based on the testimony of their neighbour Tuzia, wife of Stefano Medaglia who was absent from Rome for work reasons. I did not manage to find out what he did. Tuzia's standard of living was clearly pretty modest, since her husband refused to pay Orazio an annual rent of twenty-five scudi. The only possible clue I found to the Medaglia family is that Quorli refers to Tuzia's husband as 'Master Stefano', which might indicate that he was a craftsman.

In the statements she made on Wednesday 21 March and Friday 23 March 1612, Tuzia gives a minutely detailed description of the atmosphere in the Gentileschi household in the Via Margutta before she lodged with them, first in the Via della Croce, then later in Santo Spirito in Sassia. Orazio gave rooms to Tuzia and her family so that she could keep an eye on Artemisia and act as her chaperone. It is probably better not to try to imagine what the atmosphere was like in that household when Orazio denounced his daughter's confidante, his subtenant and neighbour, for procurement. Thanks to this action of Orazio's, Tuzia was arrested at her home and put in a prison cell for a couple of weeks. She left behind three children to fend for themselves – a sixteen-year-old daughter who was Artemisia's companion, plus two small boys aged three and seven – and her aunt Virginia, who was about forty-five. I eventually found the certificate releasing Tuzia from prison in ASR, TCG, *Fideiussioni*, vol. 58, ff. 15v to 17r. It was signed by someone called Giovanni Parzanghi, a clothmaker, who vouchsafed that once Tuzia was released, she would remain at the disposition of the court at her home in the Via Santo Spirito. Once again, it is probably best not to try to imagine the atmosphere in the house. A second certificate, dated 28 March 1612, states that Tuzia has moved: she is now living in the Via della Scrofa with one Sebastiano, a lettuce seller. She stayed at that address throughout the trial.

For the relationship between Quorli, Tassi and Gentileschi, see the

statement made by Antonio Mazzantini, the apprentice who worked for both
the painters as their *incollatore*, which means that he did the preparatory work
for their frescoes (*Artemisia Gentileschi/Agostino Tassi, op. cit.*, evidence given on
Tuesday 8 May and Wednesday 9 May 1612). See also the evidence given
on 15 June by the tailor they all used, Luca Penti (ASR, TCG, *Processi, sec.*
XVII, vol. 104, ff. 184–9). Penti's evidence offers a wonderful account of the
sort of friendship linking the Quorli/Tassi/Gentileschi trio, plus some idle
gossip about Artemisia. As far as I am aware, it has never been published, so
here it is:

(f. 186) [. . .] *Respondit: È' un pezzo che sono tre in quattro anni che Cosmo mi
cominciò à dire che lui haveva havuto che fare con detta Artimitia, che me l'ha detto per
Roma mentre andavo à spasso con lui che era amico mio et me lo diceva con occasione
che s'entrava in raggionamento come si suole fare in Roma che non si raggiona d'altro
che di liti et di fottere e non c'era nessun'altro presente.*

*Subdens ex se: Quest'inverno passato che non mi ricordo del mese stando una
mattina a fare collatione alla hostaria alla fontana di Trievi sul cantone passato l'Arco
in compagnia di Cosmo, Agostino et uno che si chiama il Stiattese che sta in casa di
detto Horatio che facevamo collatione tutti insieme si venne a raggionare di detta
Artimitia et il Stiattese disse che era una poltrona et una puttana e disse che l'haveva
sverginata il detto Pasquino di Fiorenza che gli l'haveva confessata lei.*

*(f. 187) Interrogatus: Qua occasione fuerit habitus sermo de dicta Artimitia in dicto
loco et quis fuerit causa dicti colloquii.*

*Respondit: Io non mi ricordo con occasione se entrasse in raggionamento di detta
Artimitia, ne meno chi fosse che principiasse e desse occasione di questo raggionamento
ma tutti ne dicevano male e se ne burlavano.*

Interrogatus: An sciat quare praedicti obloquerentur de dicta Artimitia in dicto loco.

*Respondit: Io non so perché causa costoro dicessero male della detta Artimitia
perché non sapevo di loro secreti e quell che havessero nel cuore.* [. . .]

*Signore io ho intesto dire da Cosmo suddetto che Agostino era innamorato di detta
Artimitia, che questo me lo disse da un anno fa incirca che io cominciai a conoscere detto
Agostino, mai io non so, ne meno ho intesto dire da alcuno che detto Agostino habbia
havuto a che fare carnalmente || (f. 188) con detta Artimitia, ma Cosmo mi diceva che
Agostino ne era innamorato morto di detta Artimitia.*

*Interrogatus: An ipse unquam fuerit conversatus cum dicto Augustino, quomodo
eum cognoverit et an cum eo conversando animadverterit esse amore captum praedictae
Artimitiae.*

Respondit: Io ho conosciuto detto Agostino per via di Cosmo et ho praticato con lui in compagnia di Cosmo ma non mi sono mai accorto, che fosse innamorato di Artimitia se non quanto mi diceva Cosmo.

Interrogatus: Quomodo et qua occasione cognoverit et cognoscat praedictum Pasquinum et an sciat quid sit ad praesentem de eo.

Respondit: Pasquino io l'ho conosciuto per via di Cosmo che andava sempre con esso e non l'ho visto che sarà un anno et ho inteso che è morto.

Tradition has it that Artemisia worked with her father on the frescoes in Scipione Borghese's Casino of the Muses at Monte Cavallo (now part of the Rospigliosi Pallavicini Palace and occupied by the Banca di Spoleto), but I do not believe she did. She undoubtedly visited the rooms in the Quirinal Palace, particularly the Consistorium (see all the evidence given in the proceedings of the 1612 trial in *Artemisia Gentileschi/Agostino Tassi, op. cit.*). But I am not sure that she even went to see Scipione Borghese's *casino*, let alone painted there. For a start, fresco painting is exhausting work that requires a great deal of stamina. But if that is not a convincing argument, there is another one: during the trial, all those who worked with Orazio and Tassi, their servants and their apprentices, and all Quorli's friends who were frequent visitors to the *casino*, said exactly the same thing – they had never met Artemisia at Monte Cavallo. Most of them said they'd never even seen her. But they'd all heard about her, either from Orazio, from Quorli, or from Tassi. And what they'd understood was that Orazio kept her hidden away. The best evidence for this is Tuzia's comment: 'When I took her for a walk near San Giovanni in Laterano, it was daybreak. It was very early, still dark, because her father was jealous about her and did not want her to be seen'. (Trial proceedings, statement made on 23 March 1612, *Artemisia Gentileschi/ Agostino Tassi, op.cit.*) See also the *incollatore's* statement in answer to the question 'Do you know whether Orazio has any children?': 'I know he has because I've seen the boys. And there's a girl, because Orazio spoke about her' (*ibid.*, statement made on 8 May 1612). The handful of painters who did meet Artemisia never once spotted her working on site with her father. She would either be at home, or in a carriage, or out visiting, for example for tea at Quorli's. But Tuzia kept on insisting that she was generally on her own, and that being shut up at home like that was damaging her health and affecting her brain.

To get a picture of everyday life in Rome, the weather, how things sounded

and looked, and all the little incidents that made up the daily round of gossip in Rome, see J. A. F. Orbaan, *Documenti sul Barocco in Roma*. See also the *Avvisi di Roma* for 1610, 1611 and 1612 in the BAV (*Urbinati Latini* 1078, 1079, 1080), in particular the account given by Giacinto Gigli in his *Diario di Roma*, which tells the everyday story of the Eternal City as seen by a middle-class citizen from 1608 to 1644.

Books and articles giving details of how Rome looked and of daily life in the city during the Baroque period are listed in the bibliography. But I should like to give a special mention to five outstanding titles, which were my bibles: Jean Delumeau, *Vie économique et sociale de Rome dans la seconde moitié du XVIe siècle*; Francis Haskell, *Patrons and Painters*; Gérard Labrot, *L'Image de Rome*; Torgil Magnuson, *Rome in the Age of Bernini*; and Massimo Petrocchi, *Roma nel Seicento*.

The bibliography gives details of the books and articles I consulted when I was describing the painting methods used by Orazio's contemporaries, and the specific techniques he himself used. But I must mention John Beldon Scott's article on scaffolding: 'The Art of the Painter's Scaffold, Pietro da Cortona in the Barberini Salone', and Mary Beale's book *A Study of Richard Symonds*, about a seventeenth-century English tourist who, when he was staying in Rome, carried out a sort of investigation into an Italian painter's workshop, equipment, pigments, paints, oils and varnishes. And lastly, 'La Technique de la peinture française des XVIIe et XVIIIe siècles', an article by Ségolène Bergeon and Élisabeth Martin.

5 The Consistorium of the Quirinal Palace, February 1611

There is a great deal of documentation enabling us to follow the various phases in the decoration of the Consistorium. In particular, Pope Paul V (Camillo Borghese)'s account books which are in ASR, *Camerale I, Mandati delle Fabbriche*, vol. 1542, for 1611–12. The payments made to Orazio or to Tassi – or sometimes to both of them – appear on ff. 11v, 29r, 29v, 30r, 31r, 32v and 33r.

I should also point out that, when it was first being built, this Sala del Consistorio was called the Sala Regia, even before the work on the actual Sala Regia was carried out. This explains why these two rooms are often mixed up. Tassi worked on both of them, but Orazio worked only on the Consistorium, which was officially opened by the Pope in August 1611 (see Orbaan, *op. cit.*).

For information on the way the work progressed and on the layout of the palace, see Giuliano Briganti's *Il Palazzo del Quirinale*. A two-volume study called *Il Patrimonio artistico del Quirinale* proved particularly helpful.

Pope Paul V's personality is discussed in L. von Pastor, *Storia dei papi*, vol. III. See also Torgil Magnuson, *Rome in the Age of Bernini, op. cit.*, and the excellent entry in *Dizionario biografico degli Italiani*.

Tassi's sister Olimpia gave a fairly detailed description of how he looked during the first trial for incest that she had instigated. The proceedings can be found in ASR, TCG, *Processi, sec.* XVII, vol. 62, ff.109–42.

On f. 111, Olimpia's description reads: '*E questo mio fratello è un piccolotto grassoto, di poca barba . . .*' ('And my brother is a fairly small man, plump, without much of a beard . . .'). Considering that Tassi had the reputation of being a great ladies' man, he does not seem to have been very attractive – at first sight, that is.

His first biographer, Giovan Battista Passeri, speaks of him as being elegant in his *Vite de' pittori, scultori ed architette che hanno lavorato in Roma, morti dal 1641 fino al 1673*. At the end of Tassi's life he lived in some style, wore a sword and had himself addressed as '*Cavaliere*', though he was not entitled to do so.

Teresa Pugliatti's *Agostino Tassi tra conformismo e libertà* is a good source of information about his life and work. She was the first art historian to piece together his career.

As for his character, Passeri (*op. cit.*) describes him as a notorious liar, so much so that in Rome he was invariably known as *Lo Smargiasso* ('The Braggart'). His date of birth was for many years a contentious issue, but Patrizia Cavazzini found it and published it in her excellent doctoral thesis, *Palazzo Lancellotti ai Coronari and its Fresco Decoration*.

It was Patrizia Cavazzini who very kindly introduced me to the poetry and charm in Tassi's work. I had known that he was one of the most famous of Rome's fresco painters, and one of the cleverest contractors working in the first half of the seventeenth century, but I had not thought of him as a great artist. I was wrong.

But despite his talent, he was still a lout. Passeri (*op. cit.*) reports a revealing comment by Pope Innocent X, to the effect that Tassi was the only artist he hadn't been disappointed in. When those present asked His Holiness what he meant, he replied that he had always thought that Tassi was a scoundrel, and he'd never failed to live up to this impression. Indeed every aspect of Tassi's life seems to have started and ended with trials and lawsuits.

In the proceedings of the first trial for incest (in ASR, TCG, *Processi, sec.*
XVII, vol. 62, again on f. 111), Olimpia does not just describe her brother,
she gives details of his apprentice Filippo Franchini, and Franchini's wife
Costanza, whom she accuses of being Tassi's mistress: '. . . *E suo cognato è un
uomo grande, e lei è una donna piccola e più volte ho visto mio fratello bagiare la detta
Costanza . . .*' ('And his brother-in-law is a tall man, and she is a small
woman and I've seen my brother kissing the said Costanza several
times . . .')

The previous life led by the Franchinis, how they met, their wedding and
their relationship with Tassi are all related with a wealth of detail by Filippo
Franchini himself, in a statement he made on 19 October 1619 during Tassi's
second trial for incest, instigated this time by another of his apprentices (ASR,
TCG, *Processi, sec.* XVII, vol. 62, ff. 550–95). At that point Costanza was
about twenty-three. She was taking a big risk, because it looked as though she
had colluded in the incest, and committed adultery. She presented herself as a
matron who was very much in charge of her household. She looked after the
finances of this *ménage à trois* and invested their money. She even managed to
control Tassi. He clearly remained very attached to Costanza, because in 1641
– thirty years after the first trial – he was still living with her. I was fortunate
enough to discover that all three of them lived together in that year in the Via
della Lungara (ASVR, Santo Spirito in Sassia, *Stati delle Anime* for the year
1641, f. 550). I should add that one of the members of that household was an
employee of Tassi's, who had already played an important part in an earlier
trial. This might suggest that Tassi tended to be rather loyal in his friendships
and love affairs.

Mario Trotta, one of the men working on the Quirinal Palace in spring
1611, was later to give evidence about his relationship with Tassi and with
Orazio. His statement, dated Friday, 22 June 1612, has never been published.
It appears in the trial proceedings (ASR, TCG, *sec.* XVII, vol. 62, ff. 550–95)
and confirms that Artemisia did not work on either the Quirinal Palace or the
Casino of the Muses:

(f. 196) [. . .] *Io conosco Horatio Gentileschi et Agostino Tassi perche ho lavorato
a giornate con loro a Montecavallo questo Inverno e mi davano tre giulij il giorno et non
son debitore, ne creditore lore e son amico dell'uno e l'altro perche l'un et l'altro mi ha
data da lavorare e non voglio più bene all'uno che all'altro.*

[. . .]

(f. 197) Io non ho visto practicare il signore Horatio se non con Agostino Tasso con il signor Cosmo furiero con il custode delle fontane di Palazzo e con noi altri lavoranti che ci dava da lavorare.

[. . .]

Signor no che io non conosco Artimitia figliola di Horatio et io non so di che fama e conditione si sia, io || (f. 198) la lasso nel grado et honore suo.

[. . .]

Io ho sentito dire sempre da diversi pittori, che uno è Carlo Venetiano et delli altri non mi ricordo delli nomi, che la figliola di detto Horatio era virtuosa e buona zitella, e sempre ho inteso dire che era zitella e questo è stato da 16 mesi in qua quando io stavo in casa di Antinoro Bertucci che vendeva li colori et li ci praticayano delli pittori la sera à veglia, e raggionavano qualche volta della figlia di detto Horatio et dicevano che era virtuosa e buona zitella come di supra e la tenevano tutti per zitella se non che una volta il detto Carlo disse, che l'haveva vista alla finestra molto sfacciatamente e del resto non ho inteso altro, che quanto mi disse quell nepote di Horatio come ho detto di supra. [. . .]

6 The Gentileschi Household in the Via Margutta, 5 February 1611

To find out what Tuzia was like, see the two statements she made on 21 and 23 March 1612, in the trial proceedings published by Eva Menzio in *Artemisia Gentileschi/Agostino Tassi, op. cit.*

A description of her appearance and of her relationship with Tassi appears in the evidence given on 18 June 1612 by Tassi's washerwoman, Fausta Cicerone (ASR, TCG, *Processi, sec.* XVII, vol. 104, ff. 191–3). As far as I am aware, this evidence has never been published. Here it is:

(f. 191) [. . .] Io conosco Agostino pittore da un anno incirca con occasione che mi ha dato li panni à lavare e so che litiga con uno che è pittore per quanto intendo che dicono, che habita rincontro al portone di San Spirito, ma io non lo conosco [. . .]

(f. 192) Questa donna che io ho detto che contrastò con detto Agostino in casa sua si chiama Tutia et habita in casa del signor Horatio Gentileschi per quanto mi disse la cognata di Agostino perché quando io le portai li panni Agostino gli braccò e le disse: poltrona se tu vieni più qua ti voglio buttare per queste scale e perché à me parse male dimandai alla sua cognata chi era quella donna e lei mi rispose come ho detto, e non ci fu nessuno presente perché in casa c'era solo detto Agostino che stava in capo le scale e braccò a colei che all'hora era entrata e veniva su pur le scale, et io m'affacciai in capo le

scale e la viddi e c'era anco la cognata di detto signor Agostino, ma perché causa li braccasse io non lo so.

To find out about the shadowy figure of Girolamo Modenese, see the descriptions given by Tuzia and Niccolò Bedino among the trial proceedings published by Eva Menzio (in *Artemisia Gentileschi/Agostino Tassi, op. cit.*). I did not manage to identify this young man, who came from Modena, among the group of painters who did the lavish decoration for Cardinal Bandino's chapel in San Silvestro al Quirinale. Nevertheless, it is likely that he worked there for a long time. In 1611 and 1612 he lived in the cardinal's palace, and it was there that he made his peace with Tassi, 'with Abbot Bandino acting as a go-between'.

I have amalgamated this man Girolamo with another of Artemisia's suitors. He was called Artigenio and was mentioned by Tuzia and Tassi from time to time, although they do not say anything about him except that he was a 'procuratore del cardinale Tonti'. As I have no way of knowing what sort of man he was, I have decided to fall in with Artemisia, who said he was of no significance.

Tassi's arrest on a charge of committing incest, brought by his own sister, took place on 5 February 1611. I was fortunate enough to find the IOUs signed by Salvatore Bagellis, Olimpia's husband. It was these debts that led the couple to want to take revenge on Tassi – and get him off their backs. These IOUs, signed by them in the presence of a notary, some in Livorno, some in Rome, have not previously been published and I list them below. They indicate that, on an occasion when Tassi was short of money himself, he had handed over one of his letters of credit to the colour seller Antinoro Bertucci to cover his own debts. The witness to this transaction was none other than the painter Valerio Ursino, who was at this point a close friend of Tassi's but would soon become his mortal enemy. They also reveal that Orazio was already in debt to Tassi in early February 1611.

The IOUs are in ASR, TNC, *Ufficio 22*, vol. 42 (1610), part 3. Here is what is significant in them:

- ff. 333–4: on 29 and 30 May 1609, Salvatore Bagellis acknowledges that he owes Agostino Tassi, the son of Domenico Tassi of Rome, the sum of 108 scudi, which must be paid back by February 1610; this IOU, drawn up in the presence of a notary, was signed in Livorno at Tassi's home in the parish of San Francesco; also present were Filippo Franchini

(Costanza's husband and Tassi's apprentice) and Pietro Tomaso Cavalieri from Florence.

- ff. 332r, 332v, 343r: on 19 October 1610 Salvatore Bagellis acknowledges that he owes 108 *scudi*, which he borrowed in Livorno and which should have been paid back by February 1610 (i.e. eight months earlier); but out of affection for his ten-year-old niece Vittoria Bagellis, Tassi offers to reduce the debt by thirty scudi, which are to be used as a dowry for the little girl; the thirty scudi are to be invested by Salvatore in a 'dowry fund'.

- f. 331: also on 19 October 1610, Tassi and Bagellis sign a receipt saying they are in agreement over their accounts (though it is not spelled out that Bagellis still owes Tassi seventy-eight scudi).

In the files of another notary (whom Artemisia herself used in 1625), I found out what happened to these IOUs (ASR, TNC, *Ufficio 19*, for the year 1611, part 1).

- f. 375: on 2 February 1611, Tassi acknowledges that he owes 100 scudi to Antinoro Bertucci (a colour seller in the Via del Corso); so he assigns to him the IOU for seventy-eight scudi from Bagellis, plus another amount (the number of scudi is illegible) representing a debt to Tassi contracted by Orazio Gentileschi; there were two witnesses to this assigning of the two IOUs: Giovan Battista Gattola (a lawyer from Rome) and Valerio Ursino, a painter from Florence.

By 5 February 1611, Bagellis was already in prison for debt, because Tassi had taken legal action against him. The trial for incest began that same day. Parts of the proceedings were published by Bertolotti in his highly entertaining article 'Agostino Tassi, suoi scolari e compagni pittori in Roma', *op. cit.*, but they are incomplete and contain some errors. So I decided to go back to the original and I will refer to this, with the original page numbering, when I quote passages from it. One amusing detail is that it was Cosimo Quorli who arranged for Tassi's bedding and clothing to be taken to him in prison. As early as 1 March 1611 Tassi was released. He counter-attacked by suing his little niece Vittoria, in an attempt to recover the thirty scudi invested for her dowry. I was lucky enough to track down this second set of documents in ASR, TNC, *Ufficio 19, Testamenti*, vol. 5, no page number.

On 7 March, Tassi signed a deed accusing Vittoria and her father. The following day he had this deed registered. Then on 21 March he had Vittoria served with a summons. This time his lawyer was Giovan Battista Gattola,

who had witnessed the assigning of the IOU in February 1611. On 21 May he again had Vittoria and her father served with a summons. And again on 25 May. But he had changed lawyers. The new lawyer was called Pompeo, who, less than ten months later, acted for him when he was sued by the Gentileschis. On 1 June, he again brought an action against Vittoria and her father. On 15 June, the Bagellises were summoned to refute his accusations. They were given four days – the matter must have concluded on or around Sunday 19 June.

I did not find the legal document confirming that Tassi won his case. Maybe he lost interest in that particular issue because he had other irons in the fire. On 17 July he was involved in litigation with his one-time close friend Valerio Ursino. He had him imprisoned for debt on 20 July. That case dragged on until at least the end of August. A whole series of unpaginated deeds is filed in ASR, TNC, *Ufficio 19, Testamenti*, vol. 5. They have never been published and are exceptionally interesting when you remember that Ursino later took his revenge on Tassi on two occasions: firstly when Tassi was taken to court by the Gentileschis in 1612 (see below, part II, chapters 19 and 20); and secondly in April 1613, when he denounced Tassi for never having served the sentence imposed on him and never having left Rome at all. Thanks to Ursino, Tassi's sentence was made harsher – he was exiled from the Papal States. I discovered this sentence in ASR, TCG, *Registrazioni di Atti*, vol. 167, ff.192r and 222v.

For a description of Rome's carnival, see Filippo Clementi, *Il Carnevale Romano*, and Jean-Jacques Bouchard's very lively *Journal*, which provided a great deal of helpful information. Lastly, see Giuliano Briganti *et al.*, *I Bamboccianti. Pittori della vita quotidiana a Roma nel Seicento*.

7 Antinoro's Shop in the Via del Corso, 25 March 1611

Antinoro Bertucci seems to have been a key figure in the artists' district. He spoke at length during the 1612 trial, particularly on 12 September (*Artemisia Gentileschi/Agostino Tassi, op. cit.*). All the artists speak of evening gatherings in his shop, where they would get together for a good chat. Here is the previously unpublished evidence given by an ultramarine seller called Marco Antonio Coppini, who was constantly to be found in Antinoro's shop (see ASR, TCG, *Processi, sec.* XVII, vol. 104, ff. 204–7):

(f. 204) Io sentito [sic] *dire quella volta nella bottega di detto Antinoro dalli supradetti che ho nominati di supra che detta figliola del Gentileschi non fosse zitella, e l'ho sentito dire anco in bottega di un scultore in Piazza di Sciarra da certi pittori che non so chi siano dove c'era tra l'altri un certo Mario che non so il cognome ma è pittore et è giovane sbarbato et il padrone di detta bottega si chiamava Angelo che detto Mario è di la di Regno et sta quasi sempre in detta bottega dove si dissero molte cose della figlia del Gentileschi, cioè che era una bella giovane e che il padre l'haveva trovata de maritare e non l'haveva voluta maritare e che quando faceva qualche ritratto nudo la faceva spogliare nuda e la ritraheva et che gli piaceva che ci andassero le genti à vederla, e dicevano che non era zitella e che faceva servitio à qualcheduno, e questo disse haverlo sentito dir anco detto Angelo scultore, e cosi anco disse detto Mario che costei non era zitella e lui l'haveva inteso dire e nomino doi o tre dalli quali disse haverlo inteso che io non li so il nome || (f. 205) et anco l'ho sentito dire da Gio. Batta. nepote de detto signor Horatio che hora è morto che disse haverlo fatto avvertito al padre di detta giovane, e che per questo c'entro discordia tra loro e l'haveva mandato via, e mi disse ano che un zio che stava a Pisa voleva maritare del suo detta figliola del Gentileschi e che lui non ce la voles mandare, ma chi l'habbi sverginata io non l'ho inteso dire.*

[. . .]

(f. 206) Saranno da tre anni in circa che questa figliola del signor Horatio è stata sverginata che cosi io ho inteso dire da tutti questi che ho nominati e da altri che non mi ricordo ma io non so in che luogo e casa sia stata sverginata. [. . .]

Respondit: Signor si che può essere che a quel tempo che questi dicevano che era sverginata la detta figliola del signo Horatio non fosse vero che fosse sverginata e questo io non lo so, se non quanto ho sentito.[. . .] *Super* 10m *dixit: quando Agostino fu preso preggione io intesi dire da diversi che il signor Horatio l'haveva fatto || (f. 207) metter preggione per non darli 200 scudi che gli haveva da dare e per fargli pigliar per moglie la figliola e questo l'ho inteso da diverse personne per publica voce e fama che non mi ricordo chi siano e l'altra sera detto signor Horatio mi disse che vuole che la pigli per moglie et io li dissi che haveva fatto male a scoprirsi di queste cose e lui mi rispuose: è fatto mò pagarei la mano dritta di non haverlo fatto, e ne son pentito e poi che ci sono voglio vedere di farglila pigliar per moglie e poi vada al diavolo.* [. . .]

Antinoro continued to be a close friend of Tassi's and his sister-in-law Costanza's, since soon after this he became godfather to one of Costanza's children (see the second trial for incest in September–November 1619).

I should add that there is still an art shop in the Corso, very close to the church of San Carlo al Corso, on the very spot where Antinoro's shop once stood.

8 Statement of Agostino Tassi and Testimony of Tuzia Medaglia at the Trial of March 1612

I've kept to the way Tassi told the story on 8 April 1612. See *Artemisia Gentileschi/Agostino Tassi*, op. cit., and the original document (ASR, TCG, *Processi, sec.* XVII, vol. 104):

[. . .] *(f. 90) Io vi dirò la cosa come passò. Quella sera Artimitia figlia di Horatio, credendosi ch'Horatio andasse a cena da Cosmo Quorli e si trattenesse sino alle quattro o cinque sin'a tornare a casa, introdusse in casa sua questo Geronimo, ma perché Horatio si trattenne lì vicino a casa a raggionare con non so chi, vidde quando questo Geronimo entrò in casa sua e però venne subito a trovarmi nella bottega di quel che vende li colori lì al Corso, dove io lo stavo aspettando, e mi riferse tutto questo, et appresso mi pregò, ch'io andassi seco, et andammo di compagnia et io c'andai volentieri acciò non seguisse mal nessuno. Ma questo Geronimo il tutto hebbe da me, e me la tenne carica || (f. 91) sei mesi, et una mattina questa estate passata, andando io in prescia per andare alla vigna del Cardinale Nazaret, detto Geronimo in compagnia di due altri armati mi se mise a torno con le spade sfoderati per volermi dare, che mi valse il sapermi difendere, che se non mi sapevo difendere, mi ammazzavano. [. . .]*

Interrogatus: An inter ipsum constitutum et dictum Hieronimum fuerit sequuta aliqua pax seu reconciliatio e per manus cuius.

Respondit: Tra detto Geronimo e me alcuni giorni doppo che fu fatta questione ci seguì pace, che fu fatta per mezzo dell'Abbate Bandino in casa proprio del Cardinale e di suo ordine, che c'intervennero anco quegli altri (f. 92) doi, ch'erano con detto Geronimo, che dissero essere fratelli cugini o carnali suoi, che non so come si chiamino. [. . .]

I have also drawn on the statement Tuzia made on 21 March 1612, which can be found in ASR, TCG, *Processi, sec.* XVII, vol. 104, ff. 27, 30. Here are the two passages:

(f. 27) [. . .] *Et alcuni giorni doppo* [Orazio] *mi disse se volevamo pigliare una casa di compagnia e star assieme et io dissi ch'havrei fatto del tutto consapevole mio marito et havrei visto di fare in modo che si fosse contentato perché l'amore ch'havevo messo alla sua figliola ancor io ciò desideravo. Tornato che fu mio marito il sabbato santo s'abboccò il Signore Horatio con detto mio marito e fu trovata una casa in strada della Croce* [. . .] *dove habitammo di compagnia.* [. . .]

(f. 30) . . . *Il signor Horatio quando si partiva sempre mi raccomandava questa figliola ch'io gli havessi cura et che gli sapessi dire le genti che capitavano in casa e mi*

disse anco quando ci andai a stare che stessi avvertita e non dir alla sua figliola né parlarli di mariti, ma che li persuadessi il farse monaca et io l'ho fatto più volte, ma lei sempre mi diceva che non occorreva che suo padre perdesse tempo perché ogni volta che li parlava di farsi monaca li diventava inimico.

9 The Consistorium of the Quirinal Palace, 15 April 1611

This scene was related by Tuzia in the statement she made on Wednesday 21 March 1612, and by Giovan Battista Stiattesi on Saturday 24 March 1612 (see *Artemisia Gentileschi/Agostino Tassi, op. cit*).

I found the inscription that greeted Cardinal Scipione Borghese's visitors when they entered his villa, '*fuori di Porta Pinciana*', in David R. Coffin's *Gardens and Gardening in Papal Rome*:

> [. . .] *Ito Quo Voles Carpito Quae Voles*
> *Abito Quando Voles*
> *Exteris Magis Haec Parantur Quam Hero* [. . .].

10 The Gentileschi Household in the Via della Croce, 3 May 1611

Artemisia spoke of Tuzia's behaviour in the statement she made on Sunday 18 March 1612 (see *Artemisia Gentileschi/Agostino Tassi, op.cit.*).

11 First Statement of Artemisia Gentileschi at the Trial of March 1612

Whenever possible, I have made a point of letting Artemisia tell her story in her own words. I felt that her evidence was a thousand times more accurate, and more moving, than any paraphrase I could produce. In order to ensure that some of the allusions to life in the seventeenth century would be understood by readers today, I occasionally clarified the language, or added an explanatory sentence.

This evidence from Artemisia has been published by Eva Menzio (*op. cit.*). The original is in ASR, TCG, *Processi, sec.* XVII, vol. 104, ff. 13–16.

12 The Basilica of San Giovanni in Laterano, Monday 9 May 1611

Tuzia relates this scene in the statement she made on Friday 23 March 1612 (Menzio, *op. cit*). The original is in ASR, TCG, *Processi, sec.* XVII, vol. 104, f. 33.

I drew on Bossuet's *Traité de la concupiscence* for the words of Artemisia's confessor.

The words of St John 'Love not the world . . .' come from the First Epistle of St John, chapter 2, verses 15–17.

For the description of the streets leading to Rome's seven churches, see the outstanding work done by Gérard Labrot in his *Images de Rome, op. cit.* I found myself constantly referring to this book.

Tassi gave an account of how he pursued Artemisia in Rome during his fourth cross-examination, on 12 April 1612. The relevant document is in ASR, TCG, *Processi, sec.* XVII, vol. 104, f. 101. Here is an extract from it:

(f. 101) [. . .] *et a me pare che per la strada mi gli accostai, e li dissi, che girandoli erano queste di andare la matina così a buon'hora e che suo padre m'haveva mandato lì.* [. . .]

Artemisia's account of how she returned home and Tassi burst in is given in her 18 March 1612 statement. The relevant document is in ASR, TCG, *Processi, sec.* XVII, vol. 104, f. 16:

(f. 101) [. . .] *E mentre io ero in casa capitorna lì li Padri Parrocchiali a pigliare li bollettini della Comunione e lasciorno la porta aperta e perciò Agostino salì sù in casa e vedendo questi Padri cominciò* || *(f. 17) a braccare di volerli bastonare dicendolo così da sé senza che li Padri sentissero e se ne ritornò via et andati che furono via li Padri ritornò a cominciò a lamentarsi ch'io mi portavo mal' di lui e che non li volevo bene dicendomi che me ne sarei pentita et io li risposi: 'Che pentire, che pentire, chi mi vuole bisogna che mi metta questo' intendendo di sposarmi et mettermi l'annello e li voltai le spalle e me n'andai in camera e lui se n'andò via.* [. . .]

We owe our knowledge about the movements of Rome's seventeenth-century inhabitants to the priests practise of collecting communion cards – Artemisia refers to this in her statement – and visiting every street in their parish, every house, every floor. This exercise was carried out in eighty parishes, the object being to track down parishioners who hadn't fulfilled their duty by taking communion on Easter Sunday. The names of the inhabitants of each district would be noted down, with details about where they came from, their age and their occupation. These records, known as *Stati delle Anime* or 'States of Souls', are in ASVR, and they are a mine of information, enabling us to keep track of the city's artists year by year, over several centuries, as they moved from one address to another; to find out

who their neighbours were; and to work out what their standard of living was.

13 The Studio in the Via della Croce, 9 May 1611

The biblical story of Susanna and the Elders is told at the end of the Book of Daniel, verses 13 to 43. It was a very common theme in seventeenth-century painting, offering as it does an excuse for portraying a female nude.

14 First Statement of Artemisia Gentileschi at the Trial of March 1612

The long-drawn-out love affair between Artemisia and Tassi leads modern art historians and biographers to cast doubt on whether Artemisia was really raped. All the various texts – exhibition catalogues, monographs and prefaces – refer to the rape, but their authors cautiously add a qualifying adjective that seems to deny that it took place. Was it, they wonder, a 'virtual rape', a 'fictional rape', or an 'imaginary rape'? They do not say that Artemisia was lying. But they do refer to her 'storytelling'. And they are amused by Orazio's over-the-top denunciation: '*stuprata più e più volte*', 'deflowered over and over again'. The hyperbole of this expression encourages historians to reassess the facts. Can you rape a woman over a period of nine months without her consenting?

But anyone who asks such questions clearly does not know much about the psychology of a woman who has been raped – she experiences shame and a feeling of guilt, which forces her to keep silent; she believes that she and the man who has attacked her are somehow accomplices, and that this means she must give in to him. This type of behaviour, which is very common in such circumstances, closely resembles the way Artemisia conducted herself. See, on this topic, Georges Vigarello's *Histoire du viol*.

The evidence Artemisia gave on 18 March 1612 struck me as so heart-rending that I thought it important to keep to her words when I told the story, exactly as she told it and the clerk of the court took it down (see also chapter 11 above).

The full text of her statement was published by Eva Menzio (*op. cit.*). The original is in ASR, TCG, *Processi, sec.* XVII, vol. 104, ff. 17–22. The following extracts are the ones I used; I have transcribed them with their page numbers:

(f. 17) [. . .] Et il medesimo giorno doppo mangiare ch'era tempo piovoso, stando io pingendo un ritratto di un putto di Tutia per mio gusto, venne a capitar' Agostino che bisognava ch'entrasse perché si faceva murar in casa e c'erano li muratori ch'havevano lassato la porta aperta, e trovatami a depingere mi disse: 'Non tanto depingere non tanto depingere' e mi levò la tavolozza e li pennelli di mano e li buttò chi là e chi qua e disse a Tutia: 'Vattene via di qui', e dicendo io a Tutia che non si partisse e non mi lassasse ch'io l'havevo accennato innanzi lei disse: 'Non voglio stare a contendere qui me ne voglio andare con Dio'et avanti che si partisse Agostino mi mise il capo in seno e partita che fu Tutia mi pigliò per la mano e mi disse: 'Passeggiamo un poco insieme che lo star a sedere vien'in odio', e così passeggiando doi o tre volte par la sala li dissi che mi sentivo male e che credevo havere la febre e lui || (f. 18) rispose: 'Io ho la febre più di voi' e doppo haver date doi o tre passeggiate, perché nel passeggiare ci venivamo ad accostar alla porta della camera, quando fummo alla porta della camera lui mi spinse dentro e serrò la camera a chiave e doppo serrata mi buttò su la sponda del letto dandomi con una mano sul petto, mi mise un ginocchio fra le coscie ch'io non potessi serrarle et alzatomi li panni, che ci fece grandissima fatica per alzarmeli, mi mise una mano con un fazzoletto alla gola et alla bocca acciò non gridassi e le mani quali prima mi teneva con l'altra mano mi le lasciò, havendo esso prima messo tutti doi li ginocchi tra le mie gambe et appuntatomi il membro alla natura cominciò a spingere e lo mise dentro che io sentivo che m'incendeva forte e mi faceva gran male che per l'impedimento che mi teneva alla bocca non potevo gridare, pure cercavo di strillare meglio che potevo chiamando Tutia. E li sgraffignai il viso e li strappai li capelli et avanti che lo mettesse dentro anco gli dettiuna matta stretta al membro che gli ne levai anco un pezzo di carne, con tutto ciò lui non stimò niente e continuò a fare il fatto suo che mi stette un pezzo adosso tendendomi il membro dentro alla natura e doppo ch'ebbe fatto il fatto suo mi si levò da dosso et io vedendomi libera andai alla volta del tiratoio della tavola e presi un cortello et andai verso Agostino dicendo: 'Ti voglio || (f. 19) ammazzare con questo cortello che tu m'hai vittuperata.' Et esso aprendosi il gippone disse: 'Eccomi qua', et io li tirai con il cortello che lui si reparò altrimenti gli havrei fatto male e facilmente ammazzatolo; con tutto ciò le ferii un poco nel petto e gli uscì del sangue che era poco perché a fatiga l'havevo arrivato con la punta del cortello. All'hora poi detto Agostino si allacciò il gippone e io stavo piangendo e dolendomi del torto che m'haveva fatto et esso per aqquietarmi mi disse: 'Datemi la mano che vi prometto di sposarvi come sono uscito dal laberinto che sono' et anco mi disse: 'Avvertite che pigliandovi non voglio vanità' et io gli risposi: 'Io credo che vediate se ci sono vanità.' E con questa buona promessa mi racquetai e con questa promessa mi ha indotto a consentir doppo amorevolmente più volte alle sue voglie che questa promessa anco me l'ha più volte riconfermata. [. . .]

(f. 21) [. . .] *Signor no ch'io non ho havuto mai che trattare carnalmente* || *(f. 22)*
con alcuna persona altro che con detto Agostino. È ben vero che Cosmo ha fatto tutte
le sue forze per havermi innanzi e doppo che Agostino mi havesse, ma mai io ho voluto
consentire, et una volta in particolare venne a casa mia doppo che havevo havuto che fare
con Agostino e fece tutte le sue forze per volermi sforzare ma non gli riuscì et perch'io
non volsi consentirci lui disse ch'inogni modo se ne voleva vantare e lo voleva dire con
tutti, sì come ha fatto con infinite persone e particolarmente con il suo fratello chiamato
Giovan Battista e con la sua cognata et anco con Agostino che per questo sdegno si è
retirato di volermi pigliare. [. . .]

Part II: Judith

15 The Curia and the State against Agostino Tassi on Charges of Rape and Procurement, Tor di Nona Prison, Monday, 14 May 1612

The whole of this part of the trial, together with the part I use in chapter 18
(they took place on the same day), was published by Eva Menzio (*op. cit.*).
I have made a point of letting the magistrates, the witnesses and the
defendants speak exactly as they did nearly four hundred years ago. I have
merely clarified the circumstances as necessary, and put them into their
historical and legal context. This first part of the cross-examination can be
found on f. 120 and the top of f. 121 in ASR, TCG, *Processi, sec.* XVII,
vol. 104.

16 & 17 The First Five Months after the Rape, May to November 1611 & The Stiattesi Affair, November 1611–May 1612

I had the proceedings of Tassi's 1612 trial on charges of rape and procurement
running through my head day and night. Although substantial extracts have
been published by Eva Menzio in her outstanding edition, I felt it was
important to go back to the original, and to transcribe and retranslate the
whole document.

It very soon became clear to me that the magistrates conducting the trial had
proceeded with such rigour that there was no possibility of Tassi's having been
released before a verdict was reached.

Oddly enough, I discovered the verdict (see below, chapter 20) thanks to a
pair of previously unpublished statements made by two minor characters in

the story, Olimpia Bagellis, who gave her evidence on 17 September 1612, and Valerio Ursino (on 5 October).

I should like now to detail the key trial documents that enabled me to reconstruct the facts. I have given the references for each scene separately.

Where a document I've drawn from has been published, I recommend consulting Eva Menzio's edition, since she made very faithful transcriptions. I have therefore indicated only who made the statement, and the date.

Where the account I've used is not in Eva Menzio's edition, or if I felt it was very important to reproduce that piece of evidence to back up my theories, I have given my own transcription, together with the folio number (in the new pagination system) referring to the original documents in ASR.

Here is the extract from Orazio's petition that I used in the text (in ASR, TCG, *Processi, sec. XVII*, vol. 104, f. 4):

Beatissimo Padre Horatio Gentileschi Pittore, humilissimo servo della Santità Vostra, con ogni reverentia Le narra come per mezzo et a persuasione di Donna Tutia sua pigionante; una figliola del'oratore è stata forzatamente sverginata et carnalmente conosciuta più volte da Agostino Tassi pittore et intrinseco amico et compagno del'oratore, essendosi anche intromesso in questo negotio osceno Cosimo Quorli suo furiere; Intendendo oltre allo sverginamento, che il medesimo Cosimo furiere con sua chimera habbia cavato dalle mane della medesima zittella alcuni quadri di pittura di suo padre et inspecie una Iuditta di capace grandezza; Et perché, Beatissimo Padre, questo è un fatto così brutto et commesso in così grave et enorme lesione e danno del povero oratore et massime sotto fede di amicitia che del tutto si rende assassinamento. [. . .]

Giovan Battista Stiattesi (frequently referred to as Giovanni Battista or Giovanbattista) gave me a lot of trouble. He pops up throughout the trial, though he never seems to have played anything other than a minor part in it – a sidekick, an insignificant character made himself a confidant or intercessor on someone's behalf. But having studied the case so closely, I now think that, despite every indication to the contrary, he was the one who was pulling the strings. The whole business started with him, and he was instrumental in getting it resolved. It seems as though the trial for rape and procurement was nothing more than a settling of accounts, not between Orazio and Tassi, but between Cosimo Quorli and Stiattesi.

The first clue that alerted me to this was the way that, when he was in prison, Tassi cursed Stiattesi, reviling him and accusing him of having written the letter signed by Orazio and the petition to the Pope that set the trial in

motion. The second clue lay in the threatening letters Stiattesi wrote to Quorli. He was apparently scrupulously careful about keeping copies of them, since he himself handed them over to the magistrate to add to the prosecution's file. The third clue was that several of the witnesses for the prosecution said they had been contacted by Orazio, but also by a tall man dressed in black, possibly Orazio's lawyer, in any case his inseparable partner in the hunt for evidence against Quorli and Tassi. Some of the witnesses gave a name to this black-clad figure: Giovan Battista Stiattesi. He bore the same surname as the man who was so unexpectedly to become Artemisia's husband, Pierantonio Stiattesi. By a stroke of luck I was able to discover the link between – they were brothers.

In consulting the Archivio del Capitolo di San Lorenzo in Florence, I tracked down the Stiattesi family in the *Stati delle Anime* for 1575–92, no. 3933, f. 131. They came from a long line of tailors. The father was called Vincenzo del Valore Stiattesi, and the mother's name was Maddalena. They had a large number of other children as well as Giovan Battista and his younger brother Pierantonio. On 7 September 1594, Giovan Battista started up a practice as a notary public in the parish of San Lorenzo, in the Via Campaccio – the street where the Stiattesis lived (ASF, *Notarile Moderne*, vol. 8732, 1594–1607). He was to keep up the practice, on and off, for the rest of his life. In 1607 he seems to have had serious money problems. The statements he made during the trial and his letters to Quorli suggest that Quorli was responsible for his being ruined financially. They had known each other since they were children in Florence. Indeed they were first cousins.

Giovan Battista met Tassi in Livorno, where he practised as a notary from 1607 to 1609. In 1609 he moved to Rome and set up a practice at the Porta Angelica (*Artemisia Gentileschi/Agostino Tassi, op. cit.*, Tassi's second cross-examination, on 28 March 1612). Between April and December 1611 he was a frequent visitor to Quorli's house, and got to know Tassi much better. He gave evidence for Tassi against Valerio Ursino when they were fighting it out in court (ASR, TNC, *Ufficio 19*, *Testamenti*, vol. 5 [1611], no page number).

He was introduced to Orazio by Tassi and Quorli, and it was they who, in December 1611, got him into the Gentileschi household to act as a paid spy on their behalf. 'I live in Santo Spirito [. . .] in the same house as Orazio Gentileschi [. . .] It was you who put me there . . .' (*Artemisia Gentileschi/Agostino Tassi, op. cit.*, confrontation between Tassi and Stiattesi, 15 May 1612). On 7 March 1612 Stiattesi sent his first insulting letter to Quorli.

He accused him of having given him bad advice, of having ruined his reputation and of having brought about his financial ruin. And he threatened to take his revenge (see the original document in ASR, TCG, *Processi, sec.* XVII, vol.104, ff. 64–9, which I have transcribed below). In fact it was he who, the following week, composed Orazio's petition, writing it out in his elegant notary's hand. And it was he too who took charge of the case for the prosecution, acting officially in his professional capacity as *procuratore* (see the second time the barber Bernardino de Franceschis gave evidence: statement dated 27 September 1612 in ASR, TCG, *ibid.*).

I also found in ASR two notarial deeds executed in Rome by the Stiattesi brothers. In the first one, dated 10 December 1612, Pierantonio – who was by then married to Artemisia – gave power of attorney over his affairs in Rome to Giovan Battista, appointing him as his *procuratore*. Giovan Battista officially stood guarantor for the debts Pierantonio had contracted with Orazio Gentileschi (ASR, TNC, *Ufficio 36*, vol. 24 [1612], ff. 646r, 646v). In the second deed, dated 10 October 1614, it was Giovan Battista's turn to appoint a *procuratore* resident in Florence to look after his affairs in Tuscany. This deed clearly states that Giovan Battista is a '*cittadino e notaio pubblico fiorentino . . .*' ('Florentine citizen and notary public') (ASR, TCG, *Ufficio 36*, vol. 26 [1614], ff. 683–8).

I think it likely that it was Giovan Battista Stiattesi who told Orazio that his daughter was having an affair with Tassi. But this is only a theory; I cannot be certain that he did so. In my text I have used a substantial number of extracts from the threatening letter that Stiattesi sent Quorli on the first day of Lent, i.e. around 7 March 1612. Here is what he wrote (the original is in ASR, TCG, *Processi, sec.* XVII, vol. 104, ff. 64–9). As far as I am aware, this letter has never been transcribed or published in its entirety.

(f. 64) Al magnifico Messere Cosimo Quorli furiere di nostro Signore. In casa.

 Magnifico et Honorando, non so a che mi devo attribuire questa vostra ultima sollevatione che havete fatto con me, non potendo inmaginarmi la causa et il perché habbiate di nuovo revoluto il vostro cervello et non solo vi siate accordato con il Sig. Agostino, ma anco mettete su la vostra moglie che faccia quello che non farebbe il Diavolo.

 Resto molto confuso ne sò che resolutione mi debba fare per farvi credere che io non desidero la vostra amicitia anzi l'abborrisco come il Diavolo la Croce perché un temp fà io ho conosciuto che non solo l'amicitia vostra mi hava giovato, ma dannificato in

digresso; se mi havete pasciuto di speranze per consumarmi la vita e le scarpe Iddio ve ne renda quel giusto merito che vi si aspetta. Credevo che dovessi esser fornito il Carnovale, et le commedie, et che come cristiano anco voi dovesse mostrar segno a Dio di ricordavi di lui che vi ha fatto tanti benefitij, ma conosco che non sono solo a esser gabbato da voi poichè alla scoperta gabbate chi vi ha creato e messo al mondo et continuamente la offendete con altro che con parole vane et otiose. Ricordatevi che alli vostri giorni mi havete fatto infinitissimi dispiaceri et siate || (f. 65) sempre ingrassato con il travagliarmi et ve ne siete gloriato in detti et in fatti, et io ho sempre havuto patienza come Jobbe sperando sempre che Iddio fusse per ravedervi, et toccarvi il core conoscendo la vostra iniquità et malo modo di trattare con chiunque si impaccia con voi, ma mi giova di credere che sarà vero quello che piu volte hò pensato tenendo per certo che Iddio non possa mancare a suo luogo e tempo di gastigarvi secondo li demeriti vostri poichè sempre havete usato di maltrattare li poverelli e tutti quelli che sudano per voi et vi danno le loro fatiche et le loro mercantie e quel che è peggio non havete mai stimato, né parenti né fratelli, né nipoti, né cugini, né tampoco il padre ne la madre, che sapete quanti strapazzamenti havete fatto a tutti, et se bene havete fatto havere un benefitiato al Nepote non per questo glielo havete dato, ò donato ma l'havete succhiato le vene sino al core, sapete bene quanta centinara di scudi è costato à suo padre. Ricordatevi dell'ira di Dio, che è grande e non paga il Sabato et fate capitale di questa mia lettera che vela mando a posta accio la consideriate bena, et la mostriate a tutto il mondo perché da poi che havete più caro di havermi per inimico che per amico e senza occasione alcuna mi fate || (f. 66) questi torti al meno serva per sgravio della coscienza mia che come cugine sono stato e sono obligato a dirvi quanto ne intendo per servitio dell'anima vostra, ricordandovi che nel'ultima malattia voi non volesti che io vi leggessi alcune cose spirituale dicendomi che vi davo troppo travaglio a leggervi quelli casi di coscientia et che indugiassi quando fussi guarito. Voi siate guarito et ritornato a far peggio che mai et vi sete scordato de Dio in tutto et per tutto, et vi domina il Diavolo con chimere strane, mettendovi in gelosia et martello di chi voi sapete, perché vi davi ad intendere che io fusse per essere mezzano allo vostra disonesta voglia, ma perché doppo molto cimenti e tentationi che mi havete dato mi havete trovato duro et homo da bene vi siate indettato con la vostra moglie, et con il signor Agostino et con un malissimo termine havete preso occasione di slontanarmi dalla mia pratica. Ma ancora non è venuto il tempo che il signor Agostino vi habbia conosciuto bene che quando sarà l'ora ancora egli si risolverà da galantomo a fare quello che hanno fatto tutti li altri con chi havete praticato perché in capo al'anno siate || (f. 67) caro per le spese et voi lo sapete, et in quel ultimo lui conoscerà me et voi, se bene adesso la passione l'accieca et si mostra ritroso verso di me, ma il tutto fa a vostra persuasione et per darvi gusto. Godetevi

allegramente senza invidia alcuna; ma ricordatevi che hormai doveresti contentarvi di tanti stratij fattimi, et pensare che sono homo carico di molti figlioli povero et rovinato per amor vostro, et per li vostri mali consigli et bastivi quello che mi havete fatto sin qui di bene et di male; et non passate più oltre con questo procedere vostro, lassatemi vivere et non mi travagliate più ingiustamente perché mi darete occasione di vedere il fine di tanti stratij che mi havete fato voi et vostra moglie, et ricordatevi che a Roma ci è buona giustitia, et ci sarà anco chi mi ascolterà; et anco sarei stato inteso sino ad ora se mi fusse resoluto velarmi la faccia, ma fui sempre homo honorato et voglio essere sino al fine con l'aiuto de Dio.

Alla vostra moglie non è bastato quello che ha detto in voce alla signoria Artimitia più et più volte che anco oggi stimolata dal Diavolo non bastandoli scrivere una lettera ce ne ha scritte tre del tenore et forma || (f. 68) che vedrete dalle medesime lettere delle quali ve ne mando dua perché l'altra si serba per la più infame et per servirmene a suo luogo et tempo.

Io non ho mai detto contro questa casa, et massime contro questa povera fanciulla cosa che le habbia tolto l'honore come havete fatto voi, et se nessuno l'ha vituperata di fatti et di parole voi siate quello; la vostra moglie ha poco cervello habbiatene voi per lei et rimediate alli inconvenienti perché mi darete causa di qualche diabolica bestialità et se non mi volete far bene, ò utile, non mi fate male et danno, che se sto qui senza pigione et con altre amorevolezze non ne dovereste havere asio; anzi doveresti per questo et per l'amicitia che è tra voi et il signor Horatio remunerarlo con altri regali che di questi obbrobrij. Et anco doveresti vergognarvi di pigliare da questa fanciulla un quadro di quella sorte come proprio ella sia anco obbligata pagarvi per havervi dato copia del suo naturale et pure non veggo che la coscienza ve ne rimorda. Pensata al fine fate ad altri quello che vorreste per voi et niente manco et credete che Dio vede e sente ogni nostra minima atione, non ve || (f. 69) mettete in canzona, et non dite che io scriva per rabbia, perché vi ingannate, preparatevi alla confessione, et alla restitutione di tutto quello che havete supra coscienza, oggi siamo vivi et domani potremo essere sotto terra. Vi dico il tutto dal meglio senno che hò et in visceribus Christi. Se fussimo in luogo di verità ne sentiresti qualche migliaro delle belle più di queste perché hò lo stomaco tanto corrotto dale vostre chimere che non posso più sofrire.

Per ultimo ricordo vi dico che vi riguardiate alli piedi et pensiate a tanti vostri amici et patroni che erono in florido et sono caduti da pollaio; l'opere vostre vi giudicheranno in vita et in morte, et de male acquisitis non gaudebit tertius heres, la robba la mena il fiume, vale più un oncia di honore che centomila scudi, statevi con le vostre fabbriche fatte di sangue di poveri et di robba venuta da graffignaro che io mi starò con li mia figlioli et mi netterò il culo con li mia stracci; et Iddio sarà sempre per me adesso et nel punto

di morte; et a voi lasso il pensare a questa lettera scritta di core et d'anima per vostro
amaestramento et per svegliarvi dal sonno.

 Giovanbattista Stiattesi vostro cugino carnale.

For Stiattesi's allegations concerning Tassi's passion for Artemisia and his
urge to possess her, see the statement he made on 24 March 1612 (in *Artemisia*
Gentileschi/Agostino Tassi, op. cit.). Here is my transcription of the original
Italian of the passage I have quoted in my text (Stiattesi's account is in ASR,
TCG, *Processi, sec.* XVII, vol. 104, ff. 42–3):

(f. 42) [. . .] *ultimamente dormendo io con lui in casa sua alla salita di Santo Honofrio*
la notte, doppo un lungo discorso, havendolo io strettamente forzato a dirmi il perché,
detto Agostino si risolvette dicendo: 'Stiattese io vi sono talmente obligato che non posso
mancare di dirvi tutto il seguitomi, ma datemi parola da huomo da bene di non parlare
con il Signor Cosmo.' E così presici per la mano li promisi di non ne parlare con Cosmo
altrimente e così promessoli, detto Agostino cominciò a parlare dicendo: 'Sappiate
Stiattese ch'il Signor Cosmo è stato lui origine et inventore di farmi conoscere
Artimitia, e per mezzo suo son entrato in questo gran labirinto, e talmente son intricato
che proprio bisogna che mi risolva andarmene in Toscana perché conosco che tra il
Signor Cosmo e me ci nascerebbe qualche disgusto notabile; ma perché li sono tanto
obligato || (f. 43) *come sapete li voglio levare l'occasione, perché sapendo lui quanto io*
ami Artimitia e quello ch'è seguito tra me e lei e la promessa ch'io ho fatto a Dio et a
detta Artimitia, lui non doveria ardire di volersi cimentare con Artimitia per volerla
conoscere carnalmente come ha fatto. Ch'oltre all'haverla forzata doi volte, una nella
strada della Croce, l'altra nella casa in strada di San Spirito, gli ha anco detto di me
quello che gli è piaciuto; e non bastandoli questo cerca di andare in quella casa per
mettermi in disgrazia et ha messo tra di noi mille ciarle e poi, doppo ch'io più e più volte
mi son ristretto con il Signor Cosmo per pigliare appuntamento di questo negotio e per
proprio risolvermi a sposarla, conforme all'obligo mio, il Signor Cosmo m'ha detto in
sul saldo ch'io non me ne devo impicciare perch'è donna di gran girandole e da darmi da
travagliare mentre io viva; et in somma per l'obligo ch'io ho al Signor Cosmo, havendo
io la vita per lui come sapete, non ne posso fare niente senza suo bene placito. [. . .]

We can only speculate about which painting of Artemisia's Quorli took
without her knowledge during the 1612 carnival. Stephen Pepper has
suggested that this 'large-scale *Judith*' could be the picture sold by Christie's in
London in December 1995 as 'the Colnaghi *Judith*'. He bases his theory on
the inscription on the back of the canvas: 'A° 1612 Pizz', saying that it could

be the reference of the notary on whose premises the painting was sequestrated during the trial. I think this is highly likely, since I discovered that Tassi, Orazio and, later, Artemisia all used the same notary's practice: the one run by Tranquillo Pizzuti – Ufficio 19, in the Via Frattina. I went right through the documents of this practice for the period 1610–13, but I could not find any reference to the painting. However, Pizzuti's name is frequently abbreviated in the documents to 'Pizz°'.

I have used Artemisia's own words, from her first statement (ASR, TCG, *Processi, sec.* XVII, vol. 104, f. 13), which has been published by Eva Menzio.

The accounts given by Stiattesi and his wife in their statements on 15 and 16 May 1612 (see *Artemisia Gentileschi/Agostino Tassi, op. cit.*) provided the inspiration for my scene in which Artemisia visits Corte Savella Prison. Artemisia referred to the visit herself when she was cross-examined on 14 May 1612 (see chapter 18 above). We also have an eyewitness account from someone who was not involved in the Artemisia drama. Pietro Giordano, one of the prison inmates, made the following previously unpublished statement on 29 June 1612 (the original is in ASR, TCG, *Processi, sec.* XVII, vol. 104, ff. 208–12):

(f. 208) [. . .] *Essendo io questa Settimana Santa andato carcerato in Corte Savella ci trovai il signor Giovan Battista Stiattese il quale mi diede commodità di dormire vicino al suo letto, e raggionandomi della causa per la quale era carcerato mi disse, che era stato un suo cugino chiamato Cosmo a requisitione di Agostino Tasso, il quale havendo sverginato una zitella e lui cercando di farla prendere per moglie per dispetto l'havevano fatto porre preggione, e narrandomi dal principio come l'haveva stuprata, e che dopoi essendo loro cioè detto Stiattese et Agostino cari amici per poter haver maggiore || (f. 209) commodità detto Agostino le fece andare ad habitare nella propria casa di quella zitella, e che non volendo esso Stiattese tener mano à simil errore, nè fare tradimento al padre di detta giovane si corrocciorno e per questo l'havevano fatto meter preggione, e cosi all'uscire che feci di carcere detto Stiattese mi pregò, che uscendo Agostino Tasso alla larga che io li dovese parlar e dire tutto quello che esso m'haveva conferito e che quanto haveva fatto e cercava di fare, l'haveva fatto per bene e per salute dell'anima sua, e così uscendo detto Agostino Tasso alla larga io lo chiamai e li riferii quanto il Stiattesi m'haveva conferito e detto Agostino mi confessò che veramente detto Giovan Battista Stiattese era huomo honorato e che li voleva hora più bene che mai, e che quello che haveva fatto l'haveva fatto per bene e per utile suo, e raggionando alla stretta delle cose particolori mi disse, che veramente lui era obligato di prenderla per*

moglie detta fanciulla e ce l'haveva promesso e che lui non poteva far di manco di pigliarla e bisognava che fosse sua perche l'haveva havuta vergine, ma che li restava solo un sospetto nella mente e così mi pregò che io havessi scritta una lettera a detto Stiatesse || (f. 210) che fosse venuto à Corte Savella per conferirli il dubio e che voleva fare quanto voleva lui, havendolo conosciuto per huomo honorato, et havendoli io scritto à detto Stiattese subito all'entrare s'abbracciorno alla presenza mia e dissero che si volevano bene l'uno e l'altro et Agostiño particolarmente li disse che l'haveva conosciuto per huomo honorato e da bene e passeggiando tutti tre insieme di nuovo detto Agostino confessò esser vero quanto il Stiattese m'haveva conferito in sua assenza, e in particolare come lui doveva prenderla per moglie e che saria stata sua senza altro già l'haveva havuta zitella, ma che un sol dubio li remaneva che era questo, che lui sospettava che la moglie fusse viva se bene gl'era stato scritto che era morta e che si ritrovasse rimedio a questo che lui era per fare quanto voleva, e far scrittura et instrumento al padre di detta giovane e dopoi ho visto più volte star insieme, mangiar e bevere detto Stiattese et Agostino dentro le carceri e negotiorno insieme come carci amici che si dimostrorno per trovar modo di sapere se la moglie di detto Agostino fosse morta || (f. 211) e con questa occasione io ho conosciuto Agostino Tasso.

[. . .] Questa giovane che detto Agostino m'ha detto havere sverginata si chiama come m'ha detto Agostino Artimitia figliola di Horatio Gentileschi pittore.

Subdens ex se: Et una sera viddi doi donne à Corte Savella con il Stiatesse e li figli e dopoi haver parlato in Cancelleria un buon pezzo con detto Agostino et il Stiattese viddi che una di quelle donne all'uscire di Cancelleria sin'al cancello || (f. 212) andava appoggiata al braccio di detto Agostino et al separarsi fecero gran sego di amore et affettione insieme, e dimandando io la matina à detto Agostino chi era quella donna che andava appoggiata al suo braccio come di supra lui mi disse che era la sua cara Artimitia, e moglie, e così li dimandai a che havevano raggionato, lui mi disse che havevano concluso il parentato et che lui gl'haveva dato la fede e giuratole di sposarla e mi disse che restava in obligo infinito al Stiattese che gl'haveva fatto uno delli più gran servitij che si potessero fare al mondo e che era il più huomo da bene che havesse ancor conosciuto e che quell'altra donna era la moglie del detto Stiattese. [. . .]

When I was trying to understand the workings of papal justice, the legal status of women and what was at stake for Artemisia, I consulted a large number of books and articles. They are all listed in the bibliography, but three of them proved particularly helpful: *Words and Deeds in Renaissance Rome: Trials Before the Papal Magistrates* by Thomas V. Cohen and Elizabeth S. Cohen; Gaetano Cozzi (ed.), *Stato società e giustizia nella Repubblica Veneta (sec.*

XV–XVIII); and the proceedings of a symposium called *La Famiglia e la vita quotidiana in Europa dal '400 al '600*. I also drew on four articles dealing with rape cases in the sixteenth and seventeenth centuries: Elizabeth S. Cohen's 'No Longer Virgins: Self-Presentation by Young Women in Late Renaissance Rome' (which was particularly useful); *'Differenza sociale e differenza sessuale nelle questioni d'onore, Bologna sec. XVII'* and *'Pro mercede carnali . . .'*, both by Lucia Ferrante; and Giorgia Alessi's *'Il gioco degli scambi: seduzione e risarcimento nella casistica cattolica degli XVI° e XVII° secoli'*.

18 The Continuation of Agostino Tassi's Seventh Interrogation, Tor di Nona Prison, Monday, 14 May 1612

This chapter covers the second part of the cross-examination that started in chapter 15. I was keen to let Tassi and Artemisia confront one another, so have merely added a few explanatory passages. Here is the text in full, so that readers can judge for themselves how strong and dignified Artemisia was, and see what a marvellous sense of humour she had (document in ASR, TCG, *Processi, sec.* XVII, vol. 104, ff. 121–30):

(f. 121) [. . .] *Interrogatus: Quid dicet ipse constitutus si dicta Artemitia adducta in faciem ipsius [ill.] praedicta omnia comprobabit ipsumque de mendacio convincet.*

Respondit: Dirò tutta volta che Artemitia mi verrà in faccia a dirmi che habbi havuto che fare con lei et che l'habbi sverginata che lei non dice il vero.

Tunc dominus ad convincendum ipsum constitutum de mendacio super premissis ipsumque magis ad veritatem disponendum ac ad omnem alium bonum finem et effectum mandat ad ipsius constituti faciem adduci praedictam Dominam Artemitiam Horatii Gentileschi.

Qua adducta delatoque ambobus iuramento veritatis dicendae prout tactis etc. factaque prius mufua personarum et nominum recognitione, fuit eadem adducta per Dominum. Interrogata an ea quae diebus elapsis ipsa adducta deposuit circa personam presentis constituti fuerint et vera sint et ab ipsa pro veritate deposita eaque modo ad faciem presentis constituti ratificare et comprobare intendat.

Respondit: Signor sì che quel tanto che alli giorni passati || (f. 122) dissi nel mio essamine fatto davanti a Vostra Signoria circa la persona di Agostino Tasso qui presente è la verità et per la verità sono pronta a ratificarlo et confermarlo qui in faccia sua.

Interrogata: Ut modo substantialiter factum praedictum recenseat.

Respondit: Io altre volte ho detto a Vostra Signoria che dello anno passato pratticando in casa di mio Padre Agostino qui presente del mese di maggio, quale faceva l'amico di mio Padre e è della medesima professione et veniva in casa come amico che mio Padre et io ci fidavamo de fatti suoi, et un giorno capitò fra gli altri in casa sotto certi suoi pretesti ch'altre volte ho raccontato nelli miei essamini, ch'io come ho detto mi fidavo di lui, et non haveria mai creduto havesse ardito d'usarmi violenza et far torto et a me et alla amicitia che ha con detto mio Padre, et non mi accorsi se non quando mi pigliò per mezzo, mi buttò sur letto, chiuse la porta della camera et mi si mise attorno per violentarmi et tormi la mia verginità et sebene io commattei un pezzo che venne in casa dopo magnare, durò il commattimento, || (f. 123) sino alle 23 hore et come ho detto nell'altro mio essamine al quale io mi riferisco, et la colonna del letto fu quella che mi reparò sino a quell'hora col tenermi attaccata et voltarmi ad essa.

Et dum haec scriberentur praefatus constitutus ex se dixit: Scrivete giù stampato tutto quello che dice lei et notate che asserisce che il commattimento durò sino alle 23 hore.

Tunc Dominus mandavit per me Notarum ad amborum intelligentiam sibi legi examen alias factum praedictae adductae de quo supra in processu sub die 28 Martii, quo lecto et per ambos bene audito, ut asserunt, fuit per dominum eaden adducta.

Interrogata: An ea quae modo sibi legi audivit sint illamet quae ipsa alias deposuit in suo examine et an illa omnia pro veritate deposuerit et modo velit illa approbare et ratificare in faciem ipsius constituti.

Respondit: Io ho inteso l'essamine che mi avete fatto leggere qui dal vostro notaio et riconosco che l'essamine ch'io ho fatto altre volte et tutto quello che si contiene in esso l'ho deposto per la verità et per la verità hora lo confermo qui || (f. 124) alla presentia di Agostino.

Interrogante dicto constituto et dicente: Io dico così che tutto quello che ha detto la Signora Artemitia et messo in carta è busia et non è punto di verità et che io l'habbia sverginata non è vero né meno ho avuto che trattare seco, perché in casa sua c'è stato uno scarpellino chiamato Francesco al quale non gli si potrebbe fidare manco una gatta et è stato con lei a solo a solo di giorno et di notte. Paquino da Fiorenza il quale si vantava pubblicamente di havere havuto qui la Signora Artemitia. Et io in casa sua ci sono bazzicato con quell'honore et rispetto che si deve bazzicare in casa di un amico né ho defraudato l'amico né lei et sempre ho sfuggito l'andarci perché mi mettevano in continue risse; et in somma tutto quello che lei dice non è la verità.

Replicante ipsa adducta et dicente: Io dico così che tutto quello che ho detto è la verità et se non fosse la verità non l'haverei detta.

Interrogata dicta adducta an sit parata etiam in tormentis ratificare dictum suum

examen et depositionem et omnia in ea contenta. ||

(f. 125) *Respondit: Signor sì che son pronta anco a confirmare nelli tormenti il mio essamine et dove bisognarà; anzi che vi dico di più che quando io andai a San Giovanni costui mi dette una torchina che io non la volevo.*

Tunc Dominus, ad tollendam omnem maculam infamiae omnenque dubietatem quae oriri posset contra personam dictae adductae sive illius dicta, ex eo quia socia criminis videatur, et ad magis conroborandum et fortificandum eius dictum et ad omnem alium bonum finem et effectum tantoque magis afficiendum personam dictae adductae, decrevit et mandavit in caput et faciem ipsius constituti dictam adductam supponi tormento sibilorum attento quod sit mulier et annorum, ut aspectu dici posset, decem et septem; et vocato custode carcerum ad effectum inferrendi dicti tormenti antequam per eumdem sibila accomodarentur fuit eadem adducta.

Interrogata et monita ut caveat ne inculpet de stupro dictim Augustinum iniuste et quatenus verum non reponatur factum per ipsam narratum quod si etiam veritas se se habet modo quo ipsa adducta deposuit in eius examine non dubitet omnia || (f. 126) *confirmari etiam in dicto tormento sibillorum.*

Respondit: Io la verità l'ho detta e sempre lo dirò perché è vero e son qui per confermarlo dove bisogna.

Tunc Dominus mandavit per custodem carcerum accomodari sibila et iunctis manibus ante pectus et inter singulos digitos sibilis accomodatis de more et secondum usum ... per eundem custodem carcerum, in caput et faciem ipsius constituti ... eodem custode carcerum funiculo currente dicta sibila comprimente, coepit dicta adducta dicere:

È vero è vero è vero, pluries atque pluries praedicta verba replicando et postea dixit: Questo è l'annello che tu mi di et queste sono le promesse.

Interrogata an ea quae in eius examine deposuit et modo confirmavit ad faciem ipsius fuerint et sint vera et in dicto tormento velit approbare et ratificare.

Respondit: È vero è vero è vero tutto quello che ho detto.

Interrogante dicto adducto et dicente: Non è vero, tu ne mente per la gola.

Replicante dicta adducta: È vero è vero è vero. ||

(f. 127) *Dominus ambobus in eorum dicta permanentibus mandavit disligari sibila et amoveri e manibus. Cum stetisset accomodata per spatium unius miserere et deinde licentiavit dictam adductam.*

Et inter licentiandum ipsam idem constitutus dicit: Non la lassiate andare che gli voglio fare certe interogatorii.

Et Domino dicente ut dicat quidquid dicere intendat.

Respondit: L'interrogatorii che io voglio fare son questi. Exhibens quandam

paginam in qua erant descripta quaedam interrogatoria super quibus fuit dicta adducta per Dominum.

Interrogata et super primo respondit: È stata la verità che mi ha indotta ad essaminarmi contro di voi et nessuno altro.

Super secundo respondit: Io ho detto tanto questa sera che mi pare che basti intorno a questo et del luogo et del tempo che fu.

Super tertio respondit: Come lui pratticassi in casa mia io l'ho detto et in casa di mio padre ci pratticano di molte genti di Gentilhuomini et Signori ma per causa mia non ci pratticava nessuno.

Super quarto respondit: Predetto Artigenio è un procuratore del Cardinale Tonti il quale era comparo di Tutia et pratticava in casa sua e non pratticava altrimente in casa mia. ||

(f. 128) Et dum haec scriberentur dictus constitutus dixit: Interrogatela se mai ha fatto ritratto nessuno al detto Artigenio.

Et dicta adducta respondit: Signor sì che fui ricercata a fare un ritratto per una donna che diceva essere sua innamorata et lo feci et che volete voi dire per questo et fu Tutia che mi ricercò a fare questo ritratto.

Super quinto dixit ut supra.

Super sesto respondit: Quando Artigenio bazzicava in casa di Tutia mio padre l'ha visto nel passare e nello scendere, mio padre stava dipingendo et Tutia disse: 'Venita un poco a vedere Signor Artigenio', et lui andò a vedere in detta sala che lui passava le petture, et raggionò con lui et quanto ad Agostino qui lui veneva in casa alle volte, ma quando veniva per me lui non lo vedeva.

Super settimo respondit: Signor sì che mio padre mi dava quello che mi bisognava.

Super ottavo dixit: Mio padre non mi ha mai lassata sola con huomo alcuno.

Super nono dixit: Io non sono mai restata sola con Francesto Scarpellino che ci restavano anco li miei fratelli che ce n'era uno che haveva 16 anni. ||

(f. 129) Super decem dixit ut supra.

Super undecim dixit: Questo Pasquino quando stavo in casa mia io non havevo più che sette anni et io non ho mai detto che lui mi habbi sverginato.

Super 12 dixit ut ad proximum.

Super 13 dixit: Io non so scrivere et poco leggere.

Super 14 dixit: L'essamine l'hoi fatto con speranza che voi fuste castigato dell'errore commesso.

Super 15, fuit omissum tamque impertinens.

Super 16 dixit prout in eius examine: Perché lui mi atturava la bocca e non potevo gridare.

Super 17 dixit: Io ho detto nel mio essamine che quando lui mi violò la prima volta io havevo li miei tempi et veddi che il mestruo era più rosso dell'altra volta.

Super 18 dixit prout in eius examine.

Super 19 dixit: Io l'ho detto al Schiattese et alla moglie che voi mi havete sverginata et voi ancora l'havete detto con lo Schiattese.

Super 20 dixit: Io dissi con il Schiattese che voi mi havete sverginata quando venne ad habitare in casa nostra che fu di decembre et voi gli l'havevate detto inanzi et però gli lo dissi ancio io et non || (f. 130) se n'è data querela prima perché s'era ordinato di fare qualche altra cosa acciò non si divolgasse questo vittuperio.

Super 21 dixit: L'havete scoperto voi che io son stata sverginata con lo Schiattese.

Super 22 dixit: Io speravo di havervi per marito ma adesso non lo spero perchè so che havete moglie che son due o tre giorni che l'ho saputo che havete moglie.

Super 23 dixit: Nessuno mi ha detto questa cosa ma l'ho detta per la verità.

Et speditis dictis interrogatoriis Dominus licentiavit dictam adductam et prefatum constitutum ad locum suum reponi mandavit animo etc.

19 The Santo Spirito in Sassia District, the Gentileschi Household, 1 June 1612

For the 'society gossip' on the visit Pope Paul V made to his nephew Scipione Borghese's gardens, I drew on the *Avvisi di Roma* for 1612, in BAV, *Urbinati latini*, 1080. The visit took place on 6 June, but the Pope seems only to have admired the fountains and the 'water theatres'. For all the other occasions when the papal court paid a visit to the various building projects in Rome, particularly to the basilica of Santa Maria Maggiore, see Orbaan, *Documenti sul Barocco in Roma, op. cit.*

20 The Casino of the Muses, Garden of Cardinal Scipione Borghese, 1 July 1612

The fees paid by Scipione Borghese to the artists who worked on his Monte Cavallo gardens are listed in the Archivio Segreto Vaticano, *Archivio Borghese*, vol. 23, ff. 110v, 112v, 114r, 115v, 116, 121v, 127v, 143v. Art historians have always maintained that the commission had gone to Tassi. But in many cases his name has been misspelt in the list of payments, or in some cases left out, then put in later. Most of the list has been published by Federico Zeri, in *La Galleria Pallavicini in Roma*.

For information about Tassi's career, see Giovan Battista Passeri, *op. cit.*,

Teresa Pugliatti, *op. cit.*, and Patrizia Cavazzini, *op. cit.*, and also the titles on Tassi listed in the bibliography. I should say here that one of Tassi's pupils was the French painter Claude Gellée, also known as Claude Lorrain.

Howard Hibbard's article 'Scipione Borghese's Garden Palace' was an invaluable source of details about the three hanging gardens, the last of which is no longer there. See also Hibbard's monograph on the architect Carlo Maderno, published in London in 1971.

For information on the choice of flowers for early seventeenth-century gardens and the way flower beds were laid out, see David R. Coffin, *Gardens and Gardening in Papal Rome, op. cit.* See Patricia Waddy's *Seventeenth-Century Roman Palaces. Use and the Art of Plan* for details of the building of the Palazzo Borghese and the layout of the rooms.

To find out what Cardinal Scipione Borghese was like, see Cesare D'Onofrio, *Roma vista da Roma*. See also L. von Pastor, *Storia dei papi, op. cit.*; Torgil Magnuson, *Rome in the Age of Bernini*, vol I, *op. cit.*; and Francis Haskell, *Patrons and Painters, op. cit.* For more on the cardinal's entourage, see Giacinto Gigli's *Diario romano, 1608–1670, op. cit.*

For an account of what Lelio Guidiccione – or Guidiccioni – was like and his career in the Church, as well as his relationship with Cardinal Scipione Borghese and Cardinal Francesco Barberini, see L. Spezzaferro's excellent contribution to *Poussin et Rome*; and Moroni's *Dizionario di Erudizione, op. cit.*, vol. 12, p. 265, vol. 49, p. 51, vol. 79, p. 157 and vol. 86, p. 45. See also Vincenzo Forcella's *Iscrizioni delle chiese ed altri edifici di Roma, op. cit.*, vol. XI, pp. 126 and 131. Guidicciono was buried in San Gregorio al Monte Celio in 1643. He had chosen as his executors three leading figures in Rome, including the two Cardinal Barberinis.

On the relationship between painters and those who gave them commissions, see Francis Haskell, *Patrons and Painters, op. cit.* And on the relationship between the State and patrons of art, see Peter Burke, 'Investment and Culture in Three XVIIth Century Cities: Rome, Amsterdam, Paris'. See also *L'Âge d'or du mécénat*, the proceedings of an international symposium held at the Centre national de la recherche scientifique in Paris in 1983.

For biographical material on Ludovico Cigoli and the work he did on the Psyche Casino in Scipione Borghese's gardens, see A. Matteoli, *Ludovico Cardi Cigoli, pittore e architetto*.

I invented the scene where Artemisia visits the Casino of the Muses and is introduced to Scipione Borghese. But Orazio's words when he addresses the

cardinal, speaking in favour of his daughter and against Tassi, are virtually identical to those he used when writing to the Grand Duchess of Tuscany, Christine of Lorraine, on that same day, 3 July 1612. The letter is in ASF, *Mediceo del Principato*, bundle 6003, for the year 1612, and has been published by Leopoldo Tanfani-Centofanti in *Notizie di artisti, op. cit.*, pp. 221–4. It demonstrates how Orazio used Artemisia's gifts, which he boasts about here for the first time, to make Tassi's crime seem worse.

Here is the original letter:

Serenissima Madama,

La vassallanza ricercava che molto prima dovessi farmi conoscere a Vostra Altezza Serenissima, ma perché speravo farmeli conoscere di presenza, ho usato negligenza, ma poiché per causa urgentissima son forzato farmili conoscere per lettere, La supplico restar servita di sentir volontieri quel ch'appresso con ogni riverenza gli espongo.

Sappia Vostra Altezza Serenissima che da 36 anni in qua habito in questa Città sendomi tutto questo tempo impiegato nelle virtù, et in specie nella professione della pittura, nella quale ho avuto per scopo principale di arrivar al segno degli altri huomini celebri, professando puoi in tutte le mie attioni di far cose honoratissime et da huomini da bene.

Mi ritrovo una figliuola femina con tre altri maschi, e questa femina, come è piaciuto a Dio, havendola drizzata nella professione della pittura, in tre anni si è talmente appraticata, che posso ardir de dire che hoggi non ci sia pare a lei, havendo per sin adesso fatte opere, che forse principali Mastri di questa professione non arrivano al suo sapere, come a suo luogo e tempo farò vedere a Vostra Altezza Serenissima. E perché doi anni sono capito in questa Città un certo Agostino Tasso Pittore già della felice memoria del Gran Duca Serenissimo Ferdinando suo consorto, io, per mezzi d'altri amici, m'intrinsicai in amicitia con lui, il quale dandomi ad intendere di volermi introdurre con il mezzo del Signor Lorenzo Usimbardi nella servitù dell'Altezze Loro Serenissime in breve tempo mi si dimostro amico svisceratissimo et io con reciproco benevolenza non solo l'amavo, ma anche mentre fu priggione per commerzio carnale havuto con una sua cognata, con mezzi potentissimi lo liberai della forca. Laonde mostrandomi detto Agostino obligatissimo fui necessitato aiutarlo nel depingere la Sala Regia fatta da Nostro Signore nel Palazzo di Monte Cavallo, dalla qual pittura, come notissimo è la tutto il mondo, Agostino ne restò assai essaltato.

Per ricompensarmi di quanto avevo fatto per lui, egli come publico scelerato suggerito da un potentissimo mio nemico cerco per strade indirette e mezzi diabolici di cognoscere

per vista questa mia figliola, et finalmente havendola veduta trovò il modo, e la strada d'introdursi in casa mia, e havendo trovato la porta aperta, presuntuosamente entrò in casa et arrivato in sala, dove detta mia figliola stava depingendo, cominciò con sue chimere et lusinghe a persuaderla ad amarlo, significandoli esser confidente servitore et amatissimo dell'Altezze Loro Serenissime, e finalmente ripiena di vane offerte ritornò un altra volta in casa, et forzatamente, e con minaccie ardi di conoscere carnalmente questa mia figliola, et havendola per forza serrata in camera e statoli attorno con gran violenza per spatio disei, o sette hore, la svergino promettendoli di sposarla, e cosi assuefatto nel venire in casa mia più e più volte andava di continuo mantenendo in speranza questa mia gigliola di volerla sposare et volerla menare costà a Firenze, et farla conoscere all'Altezze Loro Serenissime, et mill'altre menzogne solite promettersi da un par suo. Quando poi piacque a Dio torno a gli orecchi di questa mia figliuola, ch'egli haveva moglie, e che s'era fuggita, et in somma fu certificata che questo scelerato l'haveva assassinata solto false promesse.

Hoggi il traditore si ritrova priggione per questo svergimento, et da tre mesi e mezzo in qua nella causa di continuo si fabrica il processo. Et perche ho presentito che da cotesta Corte vengano qua lettere molto favorabili in aiuto di questo scelerato, et havendo presentito da altra banda che dal signor Lorenzo Usimbardi dependano tutti li suoi favori, et aiuti, confidato nella bontà, et clemenza di Vostra Altezza Serenissima mi son resoluto farl'intendere quest'assassinamento, acciò volendo conforme al genio suo che la giustitia non sia defraudata e soffogata, l'Altezza Vostra Serenissima non solo ordini al signor Lorenzo che desista dal favorire questo tristo, se pero sia vero che lo favorisca, ma anco favorisca me con sue lettere appresso l'Illustrissimo signor Cardinal Borghese, con pregarlo à commandare, che in questa causa si faccia la giustitia rettamente, et si gastighi chi ha errato, che cosi facendo, io L'assicuro, che fara opera meritoria appresso Dio benedetto, perche quando vederà l'opere, e la virtù di questa mia povera figlia unica in questa professione, mi rendo sicuro, che haverà cordoglio d'un assassinamento cosi grande fattomi sotto protesto d'amicizia dal piu infame huomo, che sia al mondo, poiché ha tre sorelle meretrici publiche qui in Roma, la moglie meretrice, la sua cognata il simile, et egli se la gode, un fratello stato appiccato, et un altro fratello hoggi bandito per ruffiano di sodomiti, et egli processato in Genova, in Pisa, in Livorno, in Napoli, et in Lucca, et qua in Roma per incesti, e per latrocinij, et altre cose oscene, come dalli processi di Livorno potra vedere, et è stato frustrato qui in Roma per ladro, come tutto si potra far vedere a Vostra Altezza Serenissima, alla quale per fine gli si manda un summario di due processi, et io quanto prima gli mandarò saggio dell'opere di questa mia figlia, dalle quali vedra in parte la virtù sua, et quanto si deve stimare questo assassinamento. Con che facendoli humilmente reverenza, li prego da Nostro Signore

ogni colmo di felicità con longhezza di vita.

 Di Roma a 3 di luglio 1612.

 Di Vostra Altezza Serenissima

 Humilissimo Servitore e Vassallo

 Horatio Gentileschi Pittore

 (a tergo) Alla serenissima madama Christina gran duchessa di Toscana, unica mia
signora.

 In propria mano

 Alla corte dove sia.

In composing the cardinal's reply, I used an account of how Pope Paul V reacted when the young Gian Lorenzo Bernini was presented to him by his father. I also referred to what Louis XIV said when he received Bernini in Paris. Both these episodes are reported in Paul Fréart de Chantelou's *Journal du voyage en France du Cavalier Bernin.*

21 *The Gentileschi Household and the Corte Savella Prison, August to November 1612*

The exchange of letters between the court in Florence and Tassi in his prison cell in Rome really did take place. The documents can be found in various different files in ASF. Tassi's first letter, dated 25 August 1615, is in *Mediceo del Principato*, bundle 3506. It describes the Adam Elsheimer paintings on copper that he had admired in the home of their Spanish owner, Juan Perez. On the same piece of paper, the Grand Duke of Tuscany scribbled a note to his secretary on 8 September 1612, telling him to write to the Florentine ambassador in Rome saying that he (the Grand Duke) would like the ambassador to contact the painter Ludovico Cigoli and go with him to the Spaniard's home.

That same day, 8 September, another secretary, Lorenzo Usimbardi, of whom Orazio feared the worst (see his letter to the Grand Duchess in chapter 18 above), wrote to Tassi asking him to contact the Florentine ambassador from his prison cell. This led to the lengthy correspondence I refer to (see ASF, *Mediceo del Principato*, bundles 3327, 3334 and 3514). The episode ended exactly as it does in my text: the Grand Duke eventually bought Elsheimer's paintings in December 1619. They later went to the English collector Lord Arundel and are now in Frankfurt. The last predella came to

light very recently, in 1981. For full details of this sequence of paintings depicting St Helena's quest for the True Cross, nowadays known as the 'Frankfurt Polyptych', see Keith Andrews, *Adam Elsheimer*.

The two statements that led to Tassi's being convicted are in ASR, TCG, *Processi, sec.* XVII, vol. 104, and, as far as I am aware, have never been published. I transcribed both of them, but they are hard to read, and it proved impossible to produce a completely faithful version. The first statement was made by Olimpia Bagellis and is dated 17 September 1612. It appears on ff. 295–301 and I have given a free translation of extracts from it. The second was made by Valerio Ursino on 5 October 1612 (ff. 331–6). This was the last but one interrogation in the trial. However, Valerio Ursino did not disappear from Tassi's life. I came across a whole series of deeds from April 1613 in which the two of them crossed swords. They can be consulted in ASR, TCG, *Registrazioni d'Atti*, vol. 167, ff. 165v, 183r, 192r, 222v).

This second clash between two men who had once been friends led to Tassi's being convicted all over again. This time he was not just banished from Rome, but from all the Papal States (see *ibid.*, 8 April 1613). However, this sentence was replaced the day after it had been pronounced by a general pardon (*ibid.*, f. 222v). The document, dated 9 April 1613, even revokes the verdict against Tassi of November 1612, at the end of the rape trial. Patrizia Cavazzini published this document in her article 'Agostino Tassi and the Organisation of his Workshop. Filippo Franchini, Claude Lorrain and the Others'. In it, she wondered why the document referred to revoking 'exile from the Papal States' when Tassi's sentence had been only exile from Rome. It was by comparing our notes that we realised that another conviction came between the two: the one obtained by Valerio Ursino. I should add here that this was only the first skirmish in the battle between Ursino and Tassi, which continued right through July 1613. But it died out when Tassi accepted a commission to work on a large-scale project away from Rome, the Villa Lante at Bagnaia, which belonged to Cardinal Montalto. He may have been advised to do so by his powerful protectors. At any rate, it kept him in provincial exile for nearly three years.

When he got back he launched into more wrangling. I came across another conviction, the outcome of a case involving a dispute with one of the courtesans he was friendly with (ASR, TCG, *Registrazioni d'Atti* , vol. 195, ff. 1r, 1v). This conviction is dated 29 June 1622 and sentences him to remain at his home in the Marchese Patrizi's residence – he was painting the

Marquis's palace at the time – unless he be given permission to leave it by the cardinal-nephew of the day, Cardinal Ludovisi. If he was spotted in the streets of Rome he would be sentenced to five years' on the galleys (see above, chapter 1).

22 The sentencing of Agostino Tassi at the Corte Savella Prison, Tuesday, 27 November 1612

I found the document setting out the sentence that brought the rape trial to an end in a file that is not part of the trial proceedings. It is in ASR, TCG, *Registrazioni d'Atti* , vol. 166, f. 101r and is set out again on f. 103r. I should add that this file also contains the final trial documents, particularly the complaint that Orazio lodged against Niccolò Bedino, accusing him of committing perjury (*ibid.*, ff. 9v, 26v, 57r).

The curse Tassi utters towards the end of this chapter is a free translation of a sentence in one of the letters he wrote to Giovan Battista Stiattesi. It is dated 22 April 1612 (see Menzio, *op.cit.*) and here is the original wording: '*Ma farà che vole il Gentileschi che verrà tempo averà carestia di vederla e anco che lei lo guardi con ochio di pietà questo lo permettera idio per le continove impietà che continovo lui li fa.*'

23 Church of Santo Spirito in Sassia, Thursday 29 November 1612

Although I spent a long time in Rome hunting through the Archivio di Stato, the Archivio de Vicariato and especially the Archivi Capitolini, I could not find any sign of the marriage contract that Orazio must have entered into with Pierantonio Stiattesi around October or November 1612.

Artemisia's and Pierantonio's marriage certificate has been published by R. Ward Bissell (*op. cit.*) and Mary Garrard (*op. cit.*). It is in ASVR, Santo Spirito in Sassia, XVII, Libro de' Matrimoni II (1607–30), f. 17. One of the witnesses to their wedding was Lelio Guidicciono, who later became a canon at Santa Maria Maggiore and at San Giovanni in Laterano.

On 10 December 1612, Pierantonio was still in Rome, but probably about to leave for Florence, since he gave his brother Giovan Battista power of attorney for all his affairs in Rome. This meant particularly his lawsuits and the debts he had contracted with none other than Orazio Gentileschi. This very helpful document is in ASR, TNC, *Ufficio 36*, vol. 24 (1612), f. 646 (cf. chapter 16 above).

BOOK TWO: EXCESS WAS THEIR MEASURE

Before embarking on this journey round seventeenth-century Europe, I should point out that the calendar was not necessarily the same from one country or one town to another. In particular, in Florence the year did not start on 25 December as it did in Rome, but on 25 March, i.e. three months later. England also worked to a different calendar. This often leads to confusion over dates (see below, chapter 28). In order to respect the chronology of events, I have converted the Florence and London dates in my text to the Roman calendar.

The same applies to the currency, which differed from one town to another. To keep things straightforward, I decided to keep the scudo as the currency where possible, so that readers could compare the prices Artemisia charged for her work as her career progressed.

And lastly I have converted the measurements of the paintings into centimetres, so that it is easier to visualise how big they were. But I will just mention that in Florence, 1 *braccio* equalled 3 *palmi* (i.e. approximately 58 centimetres).

In these notes, the dates, currency and measurements are given as they appear in the original documents.

Part III: Holofernes

24 *The Pitti Palace, 17 February 1615*

A great deal of research has been done into feasts and festivities in early seventeenth-century Florence, with its grand spectacles, its ballets, concerts and plays. The bibliography lists the books and articles I consulted, but I should still like to refer to seven titles that were particularly helpful when I was writing this ball scene. The first is A. M. Nagler's *Theatre Festivals of the Medicis*, which lists year by year the subject matter of the spectacles that were put on, their scenery and where they took place. As the organisation of these various festivities was extremely complicated, when I was describing the tableaux vivants in my account I selected two episodes that I felt were representative. These are two interludes taken from two different plays, one performed at the Pitti Palace in 1613, the other in the Uffizi in 1616. I also used the exhibition catalogue *Feste e Apparati Medicei da Cosimo I a Cosimo II*, compiled by Giovanna Gaeta Bertelà and Annamaria Petrioli Tofani. See

also Sarah Mamone, *Il Teatro nella Firenze medicea*. For the music used, see Claude F. Palisca, *The Florentine Camerata*. See also the first volume of *Musica in scena, Il Teatro musicale dalle origini al primo Settecento*. Then there is Warren Kirkendale's *The Court Musicians in Florence*, which is a mine of information about the whole Caccini family. Lastly, in A. Solerti's key title, first published in 1905, *Musica, Ballo e Drammatica alla Corte Medicea dal 1600 al 1637*, one Signora Artimisia (*sic*) is listed as a dancer and singer in an interlude composed by the famous Francesca Caccini. Could this be Artemisia Gentileschi? Her first name was very unusual in Florence in those days, and at that period 'our' Artemisia was close to Buonarroti the Younger and his circle, and Buonarroti was in turn a close friend of Francesca Caccini. But I have not been able to find anything specific as to the true identity of the Signora Artimisia who performed before the Grand Duke in the *Ballo delle Zingare* on 24 February 1614 (February 1615).

For information about the musician Giulio Caccini and his career, and about his two daughters Francesca and Settimia, see the entries by L. Pannella and C. Casellato in the *Dizionario biografico degli Italiani*. See also Kirkendale, *op. cit.* The Caccini sisters' relationship with their father seems to have been just as complex as Artemisia's with Orazio. My evidence for this is a letter that Francesca sent to Michelangelo Buonarroti the Younger, asking him to write a preface for an edition of her monodies. Here is my translation of part of it:

> *I should like you [in introducing my work] to refer specifically to my father, speaking of him as my teacher. I would not want him to think that I was too proud to say that I was dependent on him. Rather the reverse, I want to acknowledge how much I owe him. But I do not want to let people think that he has touched up my work. I'm told it is not the done thing, or a sensible policy, for an artist's daughter to sing her father's praises. But I would very much like to be able to give him some more causes for satisfaction.*

The original text of this letter has been published by Kirkendale, *op. cit.* Giulio Caccini's correspondence is in ASF, *Mediceo del Principato*, bundle 6068, f. 270r, 378r, 386, 387r, 388v, 389r, 469r. The correspondence between Francesca Caccini and Michelangelo Buonarroti the Younger is in the Buonarroti Archives in Florence (*Inventario*, Ms nos 41–57).

My sources for the multi-faceted character of Buonarroti were M. G. Masera's book *Michelangelo Buonarroti il Giovane* and Adrian W. Vliegenthart's *La Galleria Buonarroti e Michelangelo il Giovane*. See also Ugo Procacci, *La Casa Buonarroti a Firenze*, Charles de Tolnay, *Casa Buonarroti*,

and the following articles: Massimiliano Rossi, 'Capricci, frottole e tarsie di Michelangelo Buonarroti il Giovane'; Umberto Limentani, 'Il Capitoli di Michelangelo Buonarroti del Giovane a Niccolò Arrighetti'; and Bianca Maria Fratellini, 'Appunti per un'analisi della commedia *La Fiera* di M. Buonarroti il Giovane in rapporto alla cultura di G. L. Bernini', in *Barocco romano e barocco italiano*. Lastly, it is important to read Buonarroti's plays, which give a clear idea of what he was trying to do, particularly *La Tancia* and *La Feria*.

The relevant accounts ledgers, order forms and letters from Buonarroti about setting up his gallery are all in the *Archivio Buonarroti* in Florence, in no. 101 in the *Inventario* of the Buonarroti papers, especially in three notebooks marked A (nos 101–4), 1612–18; B (nos 101–5), 1619–36; and C (nos 101–6), July 1636.

Artemisia's letter to her 'godfather', with a postscript from Pierantonio asking Buonarroti for five ducats instead of twenty-one lire (i.e. two ducats more than Artemisia was asking for), is in the *Archivio Buonarroti* Ms 103, ff. 67, 68v. The original was included in Ugo Procacci's book on the Casa Buonarroti (*op. cit.*). Here is the extract I've quoted from:

> *Magnifico Signor Compare, desidero una grazia da lei che mi favorissi d'accomodarmi de lire ventiuna che io glene restituiro quanto prima. Di V. S. affezionatissima come figliola. Artemisia Lomi.*

The note is addressed '*Al molto magnifico Signore Compare il Signore Michelagnolo Buonaroti, in casa*'.

And Pierantonio adds:

> *Molto illustre Signor Compare, pigliandomi ardire delle offerte che mi à fatto. V. S. vengo con questa mia a pregarla mi favorisca di mandarmi quattro ovvero cinque ducati, che sa S.V. quanti disastri il ho passato; e con tal fine me le offro e raccomando e mi perdoni della brigga. Di casa il dì 7 di settembre 1615. Di V. S. molto illustre affezionatissimo per servirla Pierantonio Stiatessi.*

So both Artemisia and Pierantonio call Buonarroti the Younger '*compare*' – godfather. I have not been able to find out why. Buonarroti did not act as godfather at either of their christenings, or at Artemisia's confirmation, and he was not a witness at their wedding. Maybe they were using the term out of affection and gratitude, to indicate familiarity. Since the end of the sixteenth century, the word *compare* has also been used to mean someone you share secrets

with. See in this connection Christiane Klapisch-Zuber's *La Maison et le Nom, Stratégies et rituels dans l'Italie de la Renaissance,* especially chapters V and VI on godparents and *compare* relationships. The catalogue of the *Artemisia* exhibition, edited by Roberto Contini and Gianni Papi (*op. cit.*), also offers an excellent picture of the relationship between the young woman and her patron.

Four centuries after their deaths, the Casa Buonarroti is still standing in Florence, with its wealth of paintings that have miraculously survived. Just one detail has changed: immediately after Buonarroti the Younger's death, his prudish heir had drapery added to one of the figures on the coffered ceiling, to cover up her nudity, which he considered too suggestive. And who was this naked lady? It was Artemisia Gentileschi.

For information on Buonarroti's friend, the painter Cristofano Allori, see Claudio Pizzorusso, *Ricerche su Cristofano Allori.* See also *Disegni e bozzetti di Cristofano Allori*, an exhibition catalogue compiled by Giuseppe Cantelli and Giulietta Ghelazzi; and *Cristofano Allori*, an exhibition catalogue compiled by Miles L. Chappell. See also the articles by C. del Bravo ('Su Cristofano Allori') and John Shearman ('Cristofano Allori's *Judith*'), as well as 'A Note on Cristofano Allori' by Miles L. Chappell, and the entry by M. L. Becherucci in *Dizionario biografico degli Italiani* (*op. cit.*).

On the overall history of painting in seventeenth-century Florence, I recommend consulting the three-volume catalogue of the exhibition held in the Strozzi Palace from 21 December 1986 to 4 May 1987: *Il Seicento fiorentino, Arte a Firenze da Ferdinando I a Cosimo III.* See also another exhibition catalogue, *Caravaggio e Caraveggeschi nelle gallerie di Firenze,* compiled by Evelina Borea.

For information on Buonarroti the Younger's circle, particularly on the playwright Jacopo Cicognini and the poet Jacopo Soldani, see the bibliography. I should just like to refer to Anna Maria Crinò's article, 'Documenti inediti sulla vita e l'opera di Jacopo e Giacinto Andrea Cicognini'. In 1605 Jacopo Cicognini married Isabella Berti, who was later to be godmother to one of Artemisia's daughters. As well as being the author of plays that won him great fame, Jacopo Cicognini was a notary; his archives, which I was able to consult in ASF, are crammed with very useful information about the transactions entered into by the group of Florentine intellectuals who were in Galileo's circle (ASF, *Notarile moderno,* 1606–33, prot. 11093–7, bundles 5498 and 5499).

See the bibliography for the large number of books and articles on Galileo. But I should like to highlight the two books that proved particularly helpful for an understanding of the type of man he was, his links with painting and painters and his aesthetic tastes. The first is Erwin Panofsky's *Galilée critique d'art*, which I relied on when I was writing the whole of chapter 25 (see below). The second is Pietro Redondi's *Galilée hérétique*, which paints an overall picture of the scientific world of the day. On the literary front, Galileo was a great admirer of Ariosto's *Orlando Furioso*, but a fierce critic of Torquato Tasso's *La Gerusalemme liberata*. All of the seventeenth-century painters constantly reproduced a whole range of scenes from these two masterpieces. I should perhaps just say here that discovering Ariosto made a greater impact on me than almost anything I have read in recent years.

For my description of the court, and for the characters of Grand Duke Cosimo II and his wife Marie-Madeleine of Habsburg, I relied on Estella Galasso Calderara's *La Granduchessa Maria Maddalena d'Austria*, which gives a very detailed – and often humorous – picture of the daily life of the Medicis in the early seventeenth century. See also Eric Cochran, *Florence in the Forgotten Centuries*. Lastly, see the journal of Cesare Tinghi, a courtier, published in Solerti, *op. cit.* For the physical appearance of the main figures at court, and what they wore, see Clarissa Morandi, *Ritratti Medici del Seicento,* and the catalogue of an exhibition called *Visiti reali a palazzo Pitti,* compiled by Marco Chiarini with Maddalena De Luca Savelli. The inspiration behind my descriptions of Artemisia's outfits was her self-portraits. In the seventeenth century, the way people dressed varied from one town to another and I have drawn on Rosita Levi Pisetsky's book *Storia del costume in Italia* for other descriptions of clothing.

For the atmosphere in Florence in the first couple of decades of the seventeenth century, see the bibliography. However, I should like to single out Gaetano Imbert's *La Vita fiorentina secondo memorie sincrone (1644–77)*. I also used what we might call 'guidebooks for tourists' written by Artemisia's contemporaries, especially *Le Bellezze della città di Firenze* (1677) by F. Bocchi and G. Cinelli.

There is a good deal of material on the years Artemisia spent in Florence. A detailed chronology appears in the catalogue of the *Artemisia* exhibition (*op. cit.*). Most of the source material had already been published by Mary Garrard in her monograph *Artemisia Gentileschi* (*op. cit.*) and by R. Ward Bissell in his *Orazio Gentileschi* (*op. cit.*). So readers should consult the bibliography. But I

must mention in particular the key articles that I relied on when I was working out the sequence of events in my own text: first and foremost R. Ward Bissell's 'Artemisia Gentileschi, a new documented chronology'; then Elizabeth Cropper's extremely useful article setting out what she had found out about the birth of Artemisia's four children, 'New Documents for Artemisia Gentileschi's Life in Florence'; and Anna Maria Crinò's 'More Letters from Orazio and Artemisia Gentileschi'. The last two articles include all the letters I have quoted from (see also chapters 25 and 27 below).

I was fortunate enough to come across various pieces of information that throw light on the character of Artemisia's husband, Pierantonio Stiattesi. It is fairly obvious why he was prepared to marry a girl who had been dishonoured (see chapter 23 above, ASR, TNC, *Ufficio 36*, for the year 1612, vol. 24, ff. 646r and 646v, the document stating that he was in debt to Orazio Gentileschi), but until now we have only been able to speculate on his earlier life and his occupation. I think that I can now safely say that he was indeed a painter – or at any rate that he claimed to be one. My evidence for this is the action that was brought against him in Rome in June 1622 (ASR, TCG, *Processi, sec.* XVII, vol. 181, ff. 52–5). This document provided very useful information about Pierantonio. Firstly, it shows that he was living in the Via del Corso in Rome with Artemisia until at least 1622 (this is confirmed by the *Stati delle Anime* for 1621; see ASVR, Santa Maria del Popolo, *Stati delle Anime*, for 1621, f. 9r, and for 1622, f. 20r). So the Stiattesis didn't separate in Florence, as had been thought. Secondly, the action brought against Pierantonio shows that he was touchy about his wife's virtue, since he would tackle anyone parading up and down below Artemisia's windows with a guitar (for the details of this incident, see the notes for chapter 29). And lastly, at the end of his statement, the plaintiff refers to Stiattesi as 'the *painter* Pierantonio, Artemisia's husband'. The label 'Pierantonio *pittore*' appears in the statements given by all the witnesses.

We know how old he was because I found his baptism certificate in Florence, in the *Archivio dell'Opera del Duomo, Battesimi maschi*, 1577–88, f. 123v. He was born at 6.30 p.m. on 16 January 1583 (according to the Florentine calendar), which means 16 January 1584 in the Roman calendar. So he was nine years older than Artemisia. His godfather was one of the Medicis: Leone, the son of Niccolò. His father, Vincenzo, the son of Valore Stiattesi, was a tailor in the Via Campaccio. I tracked down his mother and father in the Biblioteca Medicea Laurentiana in Florence, in the *Stati delle*

Anime for 1575 to 1592, in the Archivio del Capitolo di San Lorenzo Collection, no. 3933, f. 13r. This document is dated 20 March 1582, before Pierantonio was born, but his brother Giovan Battista may well feature under no. 91. At any rate, when Giovan Battista opened his practice as a notary public in 1594, it was at that same address in the Via Campaccio. I found his notary's archives in ASF, *Notarile Moderno,* nos 8732–6. Under Medici legislation, twenty-four was the earliest age at which a notary could open a practice. So Giovan Battista was born in or before 1570. That means he was at least fourteen years older than his brother Pierantonio. Simona Feci very kindly helped me to track them down in 1612 and 1614 in Rome, when they swore allegiance to the '*Consisto della Nazione fiorentina*'. This document is in the Biblioteca Apostolica Vaticana in Rome (Chig. G.V. 139–46), in Cavaliere Cesare Magalotti's *Notizie di varie famiglie italiane et ultramontane,* vol. III, f. 671. It is puzzling that Pierantonio took the oath in Rome in 1614, when he was living in Florence.

As for his brother the notary, Giovan Battista was back in Florence between 1616 and 1619 (see his archives in ASF). He must have been in contact with his sister-in-law Artemisia during those three years, but I could not find any reference to her among his papers. He does not seem to have had a heavy workload, as his files are rather thin compared to those for other practices. He moved to Pisa in 1619 and stayed there until 1631. Then between 1632 and 1638 he was in Livorno, where he had previously practised as a notary, since we know he was handling Agostino Tassi's affairs in 1602. He probably died around 1638, as there are no references to him after that.

The Stiattesi clan was not limited to the household of Vincenzo Stiattesi, Pierantonio's father, and that of his uncle, both of whom resided in the Via del Campaccio in 1582. As Elizabeth Cropper (*op. cit.*) rightly remarks, the Stiattesis seem to have been a large family that was scattered all over Florence. I found them very much in evidence in three districts: San Lorenzo (see above); Santa Croce (ASF, *Cittadinario Santa Croce,* bundle 4, f. 122r, and Inventario 90, *Indice dei cittadini fiorentini*); and lastly Santa Maria Novella (ASF, *Cittadinario Santa Maria Novella,* bundles 3 and 4). Artemisia's children's baptism certificates, which Elizabeth Cropper found, suggest that Pierantonio and his wife were constantly on the move during their seven years in Florence. Moving home within the same district was common practice for all seventeenth-century families. But Pierantonio and Artemisia also moved from one district to another. In September 1613, their eldest son Giovan

Battista was christened in the church of Santa Maria Novella. In November 1615, their second son Cristofano was christened in Sant'Ambrogio. In August 1617, Prudenzia's turn came, in San Salvatore al Monte, and then Lisabella's, in October 1618, in Santa Lucia sul Prato. So the children were baptised in different parishes. And their funerals were held in different parishes too. In ASF I found the date of Lisabella's death – she was buried in San Pier Maggiore on 9 June 1619 (ASF, *Grascia,* 194, f. 265r) – and also the date when Pierantonio's sister Lisabetta died, as she was buried in Santa Lucia sul Prato on 8 September 1620 (ASF, *Grascia,* 194, f. 316r). A lengthy search failed to turn up the death certificates for Artemisia's two sons.

I started off trying to keep up with my various characters as they moved house. But my story was getting very muddled, and I could not discover any reason for these endless moves, so eventually I settled arbitrarily on one parish, Santa Maria Maggiore, since that was the one that cropped up most frequently in the various documents, and stuck to a single address.

25 The Studio of Pierantonio and Artemisia in the District of San Pier Maggiore, 15 March 1615

I have invented Grand Duke Cosimo II de Medici's visit to Artemisia's studio. However, he really did buy a copy of *Judith Slaying Holofernes.* The first version of this famous painting is now in the Capodimonte Museum in Naples. Both Mary Garrard, in her monograph on Artemisia (*op. cit.*), and R. Ward Bissell in his book on Orazio (*op. cit.*), say that it was painted in Rome in about 1612, before Artemisia went to Florence. The second version, now in the Vasari Corridor in the Uffizi in Florence, is thought to date from the end of her period in Florence, 1619–20 or thereabouts. She had the greatest difficulty getting paid for it after the Grand Duke's death. She referred to this painting in the letter she wrote to Galileo in 1635, part of which I have quoted in my text. Mary Garrard (*op. cit.*) has published the original, which is in the Biblioteca Nazionale in Florence, among Galileo's papers (*MSS. Gal.* P.I.T., XIII, ff. 269–70). The painting proved so distasteful to successive grand duchesses that it was banished to the darkest corner of the Pitti Palace. See also Frima Fox Hofrichter's article 'Artemisia Gentileschi's Uffizi *Judith* and a lost Rubens'. For what happened to the other paintings by Artemisia in the Medici collections, see Garrard, *op. cit.*, and the *Artemisia* exhibition catalogue (*op. cit.*). I learned some helpful details about which paintings of Artemisia's were in

Florentine collections from Elena Fumagalli, who very kindly filled me in on her research into *post mortem* inventories, particularly in relation to an *Amazon Dressed for Battle*, which has not yet been traced.

For more about the people in the Grand Duke's entourage who visited the studio with him, see chapter 24 above. I found some very helpful information about the Secretary of State Andrea Cioli in the entry by P. Malanima in vol. 25 of the *Dizionario biografico degli Italiani* (*op. cit.*). His letter to Piero Guicciardini, the Tuscan ambassador in Rome, asking for information about Orazio Gentileschi's worth as a painter, was discovered by Anna Maria Crinò and published in her article 'More Letters from Orazio and Artemisia Gentileschi' (*op. cit.*). The ambassador's reply was published by Anna Maria Crinò and Benedict Nicolson in their article 'Further Documents relating to Orazio Gentileschi' (*op. cit.*). Guicciardini's archives, which I consulted in ASF, turned out to be a fascinating source of information about Cosimo II's tastes as a collector. They are in the Mediceo Principato Collection, particularly nos 3327, 3334, 3506 and 3514. See also Gino Corti's article about the account books covering all Piero Guicciardini's expenditure on *objets d'art*: 'Il "Registro dei mandati" dell'ambasciatore granducale Piero Guicciardini e la commitenza artistica fiorentina a Roma nel secondo decennio del Seicento.'

The retrospective exhibition of Artemisia's work that Pierantonio organised could indeed have been viewed as sacrilegious. Art exhibitions open to the public were rare in Rome, and they were usually held to mark a religious feast day. The most common date was 19 March, the Feast of St Joseph, when artists were allowed to display their work at the Pantheon, beneath the portico. But the paintings on show had to be selected by the 'Virtuosi' brotherhood – the painters' brotherhood – who chose them not only on aesthetic, but also religious grounds. Painting exhibitions were never designed to foster a painter's career, but to promote religion; to exalt faith, not artistic talent.

Bissell (*op. cit.*) and Garrard (*op. cit.*) have published the date when Artemisia was admitted to the Accademia del Disegno, as well as the text of the original document. In his article 'Artemisia Gentileschi – a New Documented Chronology' (*op. cit.*), Professor Bissell discusses the meaning of the phrase '*riconobbe per il padre*', 'ratified by the father', which seems to have been added to the original registration document by someone else. I have compared the wording of the entry for Artemisia with the entries for another

fifty-odd artists in the academy's records. Far from being standard usage, the phrase 'ratified by the father' appears only a few times and seems to apply only to young artists. Does this perhaps mean that before minors could be admitted, their fathers had to give their agreement? Or is the phrase simply a reminder that the father – or uncle, in some cases – was already a member of the academy himself? That is what Claudio Pizzorusso says in his article 'Rivedendo il Gentileschi nelle Marche'. He thinks that Orazio Gentileschi had been a member of the academy since December 1596, but had been entered under the name of his brother Aurelio Lomi as a result of a mix-up – this brother had already paid his registration fee in 1579.

I was greatly helped by the information given by Olivier and Geneviève Michel about the admittance procedures to the Accademia di San Luca in Rome, and by their suggestions as to the meaning of this phrase in the entry for Artemisia's registration. Also very helpful was Zygmunt Wazbinski's two-volume *L'Accademia Medicea del Disegno a Firenze*, which gives an account of the background to the setting up of the Accademia del Disegno, the spirit underlying it and how it developed over the years. See also Nikolaus Pevsner, *Academies of Art, Past and Present*. For the history of the large number of academies in Florence, see the bibliography. In researching how they operated, I found one title particularly useful: *Storia della Società Italiana, la Controriforma e il Seicento,* especially Luigi Besana's contribution, 'Le Accademie e l'organizzazione del sapere'.

For information about Artemisia's legal status, and about her rights and duties in seventeenth-century Italian society, I relied on Christiane Klapish-Zuber's *La Famiglia e le donne nel Rinascimento a Firenze, Marriage Alliance in Late Medieval Florence* by Anthony Molho and *Law, Family and Women, Toward Legal Anthropology of Renaissance Italy* by Thomas Kuehn.

For insights into the way the artist's place in Italian society changed, particularly in relation to Florence and Rome, see the first part of *Storia dell'arte italiana*, edited by Giovanni Previtali: *Materiali e problemi*, 3 vols, with special reference to vol. 2, *L'Artista e il pubblico*.

For information about the painters who were working in Florence at the same time as Artemisia, about how they influenced one another and how their work progressed, see the exhibition catalogue *Il Seicento a Firenze* (*op. cit.*), and also Mina Gregori's contribution to *Studi di Storia dell'Arte*: 'Nuovi accertamenti in Toscana sulla pittura "caricata" e giocosa', and the exhibition catalogue *Artisti alla corte granducale*.

Monographs on the Tuscan painters who were Artemisia's contemporaries are listed in the bibliography. I should like to draw attention particularly to the exhibition catalogue on Jacques Callot. See also the proceedings of a symposium on Callot, edited by Daniel Ternois. I found both these volumes extremely helpful, since Callot was in Florence for the same period of time as Artemisia, and they were the same age.

Despite lengthy research I could not find any further evidence of Orazio's having been in Tuscany in 1615–6 or thereabouts. For stylistic reasons – since his work was influenced by Tuscan Renaissance painters after then – I elected to follow the chronology set out by R. Ward Bissell, who believes that Orazio went to Florence when his daughter was admitted to the Accademia del Disegno, which means around 19 July 1616. Mary Garrard feels that Artemisia influenced his work from then on, and sees Orazio's *Judith*, now in Oslo, as a variant of one of Artemisia's Florence canvases.

26 *Artemisia's bedroom, 13 November 1615*

I relied on Marina d'Amelia's 'La presenza delle madri nell'Italia medievale e moderna', in *Storia della maternità*, for Artemisia's relationship with her in-laws and her children immediately after she gave birth.

Artemisia did receive Buonarroti the Younger's servant in her bedroom on 13 November 1615, when he came to hand over three florins on his master's behalf. Buonarotti entered this item of expenditure in his accounts book, adding a note that Artemisia had just given birth. This ties in with Cristofano's birth on 8 November (see above, chapter 24).

27 *Travelling between Rome and Florence, July 1616 to February 1620*

In describing Orazio's journey from Rome to Florence, and all the other journeys from one Italian town to another, I relied on six books, all of which I found extremely helpful: *Voyage en Italie, 1606*, edited by Michel Bideau; *À la rencontre de Galilée, deux voyages en Italie*, edited by F. Moureau; *Travels through France and Italy*, edited by Luigi Monga; and Jean-Jacques Bouchard's two-volume *Journal*, which describes the mishaps and delights experienced by French travellers. Bouchard's book has an unforgettable description of carnival time in Rome in 1632 (see above, chapter 6). For travelling seen through the eyes of English tourists, see Edward Chaney's outstanding *The*

Grand Tour and the Great Rebellion. See also *The Paradise of Travellers*, by A. Lytton-Sells.

I consulted files 16, 64 and 65 in the Accademia del Disegno archives (in ASF). The complaints lodged against Artemisia by her creditors in the Accademia del Disegno's registers had already been listed and published by Mary Garrard (*op. cit.*), by R. Ward Bissell in his article 'Artemisia – A New Documented Chronology' (*op. cit.*) and by Roberto Contini and Gianni Papi in their catalogue to the *Artemisia* exhibition. Artemisia's letters to the Grand Duke of Tuscany have also been listed and published in these same three titles, as well as in Crinò's articles, 'Due lettere autografe inedite di Orazio e di Artemisia Gentileschi' and 'More Documents . . .' (*op. cit.*), and in C. del Bravo, *op. cit.* and Cropper, *op. cit.* In copying out the lists of Artemisia's debts I soon became aware that she had a marked fondness for *objets d'art* and costly fabrics.

The Francesco Lomi who managed to win a case for debt against Artemisia – which she contested in a document dated 26 June 1619 (ASF, Accademia del Disegno, *Atti e Sentenze*, vol. 64, ff. 701r and 701v) – was not her brother, as had been thought, but the son of Matteo Lomi, a jeweller, originally from Pistoia, who lived in Santa Trinità parish. This other Francesco Lomi, who lodged his complaint with the Consiglio dell'Arte degli Speziali in 1618, was indeed dependent on this guild, which he had belonged to since 4 November 1611 (ASF, *Arte dei Medici e Speziali*, bundle 14, rolls 1592–1614, f. 7). Francesco Maringhi, who – on 15 February 1619 (= 15 February 1620) – stood guarantor for the personal effects that Artemisia left as security for her debts when she left Florence for Rome (ASF, *Guardaroba Mediceo*, bundle 390, *inserto* 5, f. 455), was a senior official at the Pitti Palace. He countersigned most of the *Guardaroba Mediceo* documents. He stayed in touch with Artemisia and always knew where to find her, since fifteen years later Galileo was to hand him his reply to a letter from Artemisia.

The last but one petition Artemisia delivered to the Grand Duke, on 5 June 1619, is in ASF, among the Accademia del Disegno registers, vol. 64, f. 724. Some extracts from it have been published. Here is the full text as I copied it down – it seems to me particularly interesting in that it enables us to form an opinion about Artemisia's state of mind concerning her husband when they left Florence:

Ser. mo Granduca.

Artemisia donna al presente di Pierantonio Stiatesi humilissima devota di V.A.S.
ad reverenzia gli narra come detto suo marito a fatto debito ad un certo Michele bottegaio
et volendo detto essere pagato ha ottenuto sentenzia da l'Accademia del Disegno contro
alla detta Artemisia senza saputa sua di cosa alcuna perché le citazioni andavano in
mano di detto suo marito et essendo gravata istanza di detto [creditore?] havendo il
pieno della sua dota. Ricore genuflessa a benigni piedi di V.A.S. suplicandola a fargli
grazia che detta sentenzia si rivegha perché come donna non puo fare debito mentre che
il marito stava con detta donna, sospendendo il gravamento che di tal grazia sempre
pregera N.S. Iddio ogni sua maggiore felicita et grandezza.

Il luog. te e consoli dell'Accademia del Disegno informino nonostante citata la parte.
Curlio Pichina 5 giugno 1619.

In this document Artemisia implies that Pierantonio has frittered away the
whole of her dowry, whereas legally speaking he could only touch the interest,
the usufruct – never the capital. She also reminds the Grand Duke that if her
husband is living in the marital home, a married woman is not entitled to
undertake any personal expenditure without her husband's authorization. As
she will always be a minor in the eyes of the law, she cannot be held responsible
for her 'guardian's' malpractices. This is a clever defence.

In my account I quote an extract from Artemisia's letter, dated 10 February
1619 (= February 1620), in which she asks Cosimo II for permission to leave
Florence so that she can spend some time in Rome. Here is the original text of
the passage I have used: '. . . *molti mie indispositioni passate alle quali si sono giunti*
anche non pochi travagli della mia casa e famiglia.' The original letter is in ASF,
Mediceo del Principato, vol. 998, f. 204. Mary Garrard (*op. cit.*) has published it
in an English translation.

Part IV: The Allegory of Painting

28 London, Six years later, December 1626

First of all, I must point out that, in the seventeenth century, the dates on the
calendar used in England were different from both the Roman and the
Florentine calendars. London was ten days behind Rome throughout the year,
and a year less ten days ahead of Florence from January to March. For instance,
a date of 28 January 1626 on a despatch written from London would
correspond to 7 February 1626 in Rome and 7 February 1625 in Florence. To
avoid confusion in the sequence of the despatches sent by diplomats from

England to elsewhere in Europe, I have unified the various systems by converting the dates in my account to follow the Roman calendar. In the notes, the dates appear as they did on the original documents.

The despatch at the beginning of this chapter, sent by the Grand Duke of Tuscany's agent and describing the part played by Orazio Gentileschi in English politics, was published in 1967 by Anna Maria Crinò, in her article 'The Date of Orazio Gentileschi's Arrival in London'. Here is the original wording (ASF, *Mediceo del Principato*, 4196, unpaginated):

> *Sono da due mesi incirca che venne qui di Francia il Signor Orazio Gentileschi pittore, il quale oltre all'impiegarsi nella sua arte, mi pare di sentire che tratti qualcosa altro di molta qualità, essendo spesse volte col signor Duca di Buchingam, et anco col Re, et dal molto scrivere ch'egli fa, come ancora da alcune spedizioni segrete fatte a Bruselles, mi do a credere che possa questo huomo essere impiegato per far apertura a qualche modo da potere attaccare il filo ad un accomodamento con quella Serenissima Arciduchessa e per mezzo suo con Spagna ancora, et tanto più me ne assiguro quanto che veggo il signor Duca adherirvi et ancora esso impiegare un suo gentil'huomo di là dal mare molto spesso, però è negozio di tanta delicatezza che malamente si potrà perfezionare senza l'autorità di Gran Principe neutro e disinteressato.*

We can deduce from this letter that Orazio arrived in Paris and then settled in England right at the beginning of October 1626, which was precisely the time when Marshal Bassompierre came to London on a special mission. Despite lengthy research in the Public Record Office (PRO) in London, I could not find Orazio's name among the lists of the ambassador's servants. It is true that these lists are of people deemed to be undesirables in England. I also consulted the passport registers, and the Queen's household lists (SP 78/79, SP 78/80, SP 78/81, SP 78/82). But I found nothing. So the link between Orazio's arrival and Bassompierre's is speculation on my part. Nevertheless the account given by Bassompierre himself confirms that the two men were closely linked, since when he describes in his *Mémoires* his last dinner in London, on Sunday 21 November 1626, he says that he dined with the Duke of Buckingham and Orazio Gentileschi. Anna Maria Crinò (*op. cit.*) published an extract from this account.

The bibliography gives details of material on the part played by painters in Europe's international politics in the seventeenth century. I should just like to point readers in the direction of the three sources of information that I found particularly helpful: *The Letters of Peter Paul Rubens*, translated and edited by

Ruth Saunders Magurn, Jonathan Brown's *Velázquez, Painter and Courtier*; and lastly the large number of articles on the role played, in both Paris and Brussels, by the painter and architect Balthazar Gerbier, who was keeper of the Duke of Buckingham's pictures. To find out more about this somewhat shady character, I suggest consulting Hugh Ross Williamson's *Four Stuart Portraits*. I am also very grateful to Anne Brookes, who very kindly let me read her 1992 Oxford University thesis 'Sir Balthazar Gerbier 1591–1663, A 17th Century Type?'

Sorting out the fluctuating course of the Thirty Years' War was a real challenge. Nevertheless several titles helped me to unravel the main lines of force underlying the war, especially *La Guerre de Trente Ans* by Georges Pagès and François Lebrun's *Le XVIIe Siècle*.

When I was describing the comings and goings of English agents in continental Europe and trying to understand what the middlemen, buyers and collectors of Italian art in seventeenth-century England were like, I relied on six books and four articles, which provided the back-up for all my research. The first two books were the exhaustive studies by Edward Chaney, *The Grand Tour and the Great Rebellion* and *The Evolution of the Grand Tour*. Then there were Jonathan Brown's *Kings and Connoisseurs*; David Howarth, *Lord Arundel and his Circle*; and Sir Oliver Millar, *The Queen's Pictures* and *Van Dyck in England*. The articles were: Philip Mcevansoneya, 'Some Documents Concerning the Patronage and Collections of the Duke of Buckingham'; Paul Shakeshaft, '"To Much Bewiched with those Intysing Things": the Letters of James, Third Marquis of Hamilton and Basil, Viscount Fielding, Concerning Collecting in Venice 1635–1639'; E. K. Waterhouse, 'Paintings from Venice for Seventeenth-Century England'; and I. G. Philip, 'Balthazar Gerbier and the Duke of Buckingham's Pictures'.

For the career of the musician Nicholas Lanier, see the bibliography. But I must add that there is a wonderful performance of Lanier's music by the soprano Julianne Baird and the lutenist Ronn McFarlane on two CDs in the *English Lute Song* collection (Dorian Recordings, 1988 and 1989). Gordon James Callon's doctoral thesis, *Nicholas Lanier, His Life and Music* (Washington University, 1983), sets his virtuoso talent and his orginality as a composer in the context of music at the English court.

For information about the years when Orazio Gentileschi was constantly on the move before he settled in England, see the bibliography and the large number of articles about that period in his career as a painter. My main sources were R. Ward Bissell's *Orazio Gentileschi (op. cit.)*; Claudio Strinati's article

'Un quadro di Orazio Gentileschi a Genova'; Elisabetta Giffi Ponzi, 'Gentileschi a Genova: un nuovo dipinto e alcune considerazioni sulla cronologia delle opere'; and Charles Sterling's articles 'Gentileschi in France' and 'Une nouvelle oeuvre de Gentileschi peinte en France'. I also frequently used the catalogue to the *Van Dyck a Genova* exhibition.

For information on Orazio's accounts, the cost of his journey to England and of his London house, the salary paid to him by the Duke of Buckingham or the King, and the price his paintings fetched, see the accusations made by Balthazar Gerbier on 12 September 1629 and the accounts that Orazio presented to the Secretary of State Lord Dorchester between 13 and 30 April 1629. This document is in London PRO, and is also published in *Calendar of State Papers Domestic, Charles I* (1629). Orazio's letter was translated into English by Noël Sainsbury, and he also published Balthazar's report accusing Orazio in *Original Unpublished Papers*. I should just point out here that Gerbier's allegations concerning what Orazio cost England make no sense. If you were to add up the prices stated by Gerbier, the sums reimbursed to Orazio in London plus the prices paid for his paintings would come to half what was paid for the Mantua sale. See appendix II in R. Ward Bissell's book (*op. cit.*). At any rate, the exaggeration of his enemy Balthazar Gerbier show how successful Orazio was in both France and England.

Mary Garrard's monograph (*op. cit.*) is a good source of information about the great success Artemisia enjoyed in Rome in the period 1620 to 1626, about her standing in the artistic community and about her relationship with French painters such as Vouet. The inscription on Jérôme David's portrait engraving of her in the British Museum in London refers to her as a member of the Accademia dei Desiosi. This is most surprising – and a great compliment! See, on this topic, Ricardo Merolla's 'L'Accademia dei Desiosi', in *Roma moderna e contemporanea* (III, 1, 1995). See also M. Maylender's book, (*op. cit.*). Lastly, see *Le Libertinage érudit dans la première moitié du XVIIe siècle* by R. Pintard. The members of this academy, which was founded in 1625–6, were Rome's leading intellectuals in Cardinal Maurizio di Savoia's circle. They were all admirers of Galileo. Perhaps it was the support of Artemisia's old friend Galileo that effected her introduction into this intellectual milieu. It seems unlikely that she actually had a seat in the academy – she could only have been an honorary member. But the fact that she was accepted into such an inner circle is a clear indication of the esteem in which both she and her painting were held in learned circles.

The large number of letters that she went on sending from Naples to the Cavaliere dal Pozzo, her patron in Rome, over a period of eight years (1630–8) shows what an important part he played in her career (see Giovanni Bottari's anthology, *Raccolta di lettere sulla Pittura*). Anyone interested in finding out more about the Cavaliere Cassiano dal Pozzo, who was a patron and friend of Poussin and of all the great painters in Rome in the first half of the seventeenth century, should consult the many books and articles about him listed in the bibliography.

We can only speculate as to why Artemisia left Rome when she was at the height of her fame. I do not believe now that she went to Genoa between 1621 and 1622 – although I had assumed she did when I first started researching this book – or that she worked there with her father. I have every reason to think that it was not until much later that she saw Orazio's paintings in the Doria Palace and the church of San Siro in Genoa – as art historians are sure she did, in view of the *Annunciation* she was to paint in Naples in 1630.

29 Travelling between Rome, Genoa and Venice, Winter 1626

Artemisia did not leave her husband behind in Florence when she left Tuscany in 1620, as had previously been thought (see above, chapter 24). Pierantonio followed her to Rome, and they moved together into the Via del Corso. My evidence for this is the 1621 and 1622 *Stati delle Anime* for the parish of Santa Maria del Popolo (see above, *ibid.*). But in 1623 Pierantonio is no longer to be found in the marital home. He did not die – not then, anyway – since fourteen years later Artemisia asked her patron the Cavaliere dal Pozzo about him, writing from Naples on 24 October 1637: '*Sia servita darmi nuova della vita o morte di mio marito.*' ('I should be very grateful if you would send me news of whether my husband is dead or alive.') The original text was published by Bottari (*op. cit.*).

So what happened to Pierantonio? Why and how would the Cavaliere have information about the movements of someone so insignificant? It's true that Dal Pozzo's position in the Pope's entourage enabled him to get hold of all sorts of information. But did he play some part in getting rid of his protégée's troublesome husband? In another letter, dated 24 August 1630 (in Bottari, *op. cit.*), Artemisia was quite happy to ask the Cavaliere to send her urgently six pairs of gloves for a number of ladies she wanted to please. Later she asked him for slippers, permission to bear arms and a whole host of

favours, big and small. She could just as easily have asked him to get rid of her husband. It was common practice in those days to find a woman a husband just for show and then relieve her of him later – a prerogative of the powerful. But if so, how did she set about it? Pierantonio had nothing whatsoever to gain by disappearing from her life.

I was fortunate enough to find (in ASR) the complaint that was lodged against him in June 1622 (see above, chapter 24). A Spanish national who had been wounded in the face in a brawl told how he had been sitting minding his own business on the doorstep of a house in the Corso, when for some unknown reason a man who claimed to be the *padrone di casa* hurled insults at him, then assaulted and wounded him with a knife. The eyewitness accounts suggest that the assailant was out of his mind. But one little detail sets us thinking: the Spaniard knew exactly who he was dealing with, because his assailant was known to him – it was Pierantonio Stiattesi. He and his friends were not sitting on any old doorstep they happened to have come across, as they claimed. They were 'at the woman painter's'. They also said they were carrying a guitar. Could they have been serenading Artemisia Gentileschi?

Artemisia's reputation for amorous intrigue persisted till her dying day. A handful of lines written by way of an epitaph, and published in 1653 by two of her Venice friends, Gian Francesco Loredano, a man of letters, and the collector Pietro Michiele, ensured that she enjoyed posthumous fame as a great seductress and a lewd woman. These two quatrains appear on page 60 of the second edition of *Il Cimiterio, Epitafi Giocosi*. Here is the first one:

Co'l dipinger la faccia a questo, e a quello
Nel mundo m'acquistai merito infinito
Nell intagliar le corna al mio marito
Lascai penello e presi lo scalpello.

(In painting the face of first one, then the other,
I acquired in the wide world merit for ever;
In carving out horns for that husband of mine
I swapped my brush for a chisel so fine.)

I must add here that although these lines are scarcely flattering, burlesque epigraphs come under a literary genre that flourished in Italy in the Baroque period, and that Artemisia was not the only victim of Gian Francesco Loredano's ribald humour. All the other poems in the collection are written

in the same vein. They are usually addressed to a generic type: 'To a miser', 'To a parasite', 'To a liar', 'To a whore' and so on. A mere handful of historical figures get their own personal dedication – Alexander the Great, the major poet Politian and . . . Artemisia Gentileschi. Being included in this company was no insult, but raised her to the heights of universal glory!

Nevertheless, many letters written to Artemisia, and the verses, inscriptions and poetry written in her memory, are as enthusiastic in celebrating her beauty as in praising the magnificence of her paintings. Does this mean we should conclude that she had as many lovers as she had admirers?

One little detail makes me think that she might well have looked elsewhere than to her husband when they were in Rome. Monsignore Sandro Corradini very kindly told me about three notarial deeds in ASR, and this enabled me to study the leases she signed during the period 1621–5. One of them, dated 9 December 1625, applies to the house in the Via del Corso where she'd been living for the last five years. It is in fact an inventory of fixtures and statement of repair, plus an agreement with the owner concerning some work that was to be carried out there (ASR, TNC, *Ufficio 19*, vol. 136, f. 523). This is an extremely useful document, as it enables us to find out what Artemisia's lifestyle was and how her home was decorated. But the other two documents raise a number of questions. As well as renting the flat she lived in and her studio in the Via del Corso, she was at the same time sub-leasing two rooms for her own personal use. On the first occasion, on 17 November 1621 she sub-leased a small flat in the Via della Croce – the street where she had been raped all those years ago (ASR, TNC, *Ufficio 19*, vol. 121, ff. 385r, 385v and 396r). On the second occasion, on 20 June 1625, the flat was in Via Rasella, 'known as Via dei Serpenti', a rather seedy street in a part of Rome that was quite a long way from the artists' district. We can only speculate about what she was going to do there (ASR, TNC, *Ufficio 19*, vol. 136, f. 735).

Although it is almost certain that Nicholas Lanier was Artemisia's lover in Rome in 1625 and 1626 (see below, chapter 30), I have found virtually nothing to show how well versed in literature he was. As with most artistic people of the day, it is highly likely that he was familiar with some passages from Ovid's *Ars Amatoria*. It was not just the ordinary citizens of Rome who had a taste for salacious poetry and dirty jokes – scholarly philanderers and free thinkers enjoyed obscene verse. The Baroque Age was the era *par excellence* when licentious volumes circulated clandestinely.

But it is only a conjecture on my part that the Duke of Alcalá was

Artemisia's lover. I have used him as a focus for the rumours alleging that she slept with some of her most powerful patrons. The duke had the reputation of being a ladies' man and of having fathered a string of illegitimate children. He assumed power in Naples at exactly the same time as she arrived there. And the highly prestigious Neapolitan marriage she negotiated for one of her daughters, with a knight of the order of San Giacomo (see below, chapters 34, 36 and 37), made me think that the girl's father must have been of high rank. I do not know any more than that.

At any rate, along with Prudenzia, who was Pierantonio's daughter – on the censuses she is sometimes called Palmira rather than Prudenzia – and two servants, Artemisia lived in the Via del Corso, opposite the gardens of the San Giacomo degli Incurabili hospital, until 1626 (ASVR, Santa Maria del Popolo, *Stati delle Anime* for the year 1621, f. 9r; for 1622, f. 20r; for 1623, f. 11r; for 1624, f. 11v; for 1625, f. 27v; for 1626, f. 6r).

On 15 September 1625, Artemisia was sued by one of her servants, a woman called Dianora Turca, who claimed that she was owed thirty scudi for work she had done. Simona Feci very kindly put me on to this, by passing on the relevant document (in ASR, TCG, *Sentenze*, bundle 309, 1621–32). Artemisia was ordered to pay the servant twenty scudi. But on 18 October the woman appealed against this ruling, claiming the outstanding ten scudi. The court upheld the earlier verdict, saying that she had already received that sum in various forms of payment.

By 1627, Artemisia had left the Via del Corso. It had previously been thought that the 'Signora Artemisia' who still appears on the censuses referred to her. But this namesake of hers, who said she was a widow, was already living in the Corso when Artemisia herself was there (ASVR, Santa Maria del Popolo, *Stati delle Anime* for 1626, f. 6v). So in 1625 and 1626 there were two *padrone di casa* on the Via del Corso called Artemisia – quite a coincidence, since it was not a common first name. But was 'our' Artemisia still in Rome? I could not find her in the ASVR under any of the streets belonging to the parishes of Santa Maria del Popolo, San Lorenzo in Lucina, Santo Spirito in Sassia, Santa Maria dei Monti or Santa Maria della Scala.

A number of people left Rome between spring 1626 and spring 1627, including four people connected in some way with Artemisia – the Spanish ambassador the Duke of Alcalá; the English agent Nicholas Lanier; the French painter Simon Vouet; and the Venetian ambassador Pietro

Contarini. This made me think that she might well have followed them – to Venice.

30, 31, 32 & 33 Venice, Murano & Mantua, 1627–8

My theory that Artemisia might have travelled to Venice as early as the winter of 1626 was confirmed by my discovery of a volume of letters published in 1627 by someone called Antonio Colluraffi (*Lettere di Antonio Colluraffi*). He was tutor to the children of Venice's aristocratic families, including Gian Francesco Loredano, who was one day to write Artemisia's epitaph. On page 4 of part 2 of his volume of letters is a missive he wrote to one of his disciples, Alvise da Mosto, in which he spoke highly of both the character and the talent of a painter living in Venice – Artemisia Gentileschi. The next three pages are devoted to two inscriptions in Latin and a couple of madrigals glorifying Artemisia. Then on page 137 he writes directly to her, asking her to do a drawing of 'a female bear licking her newborn cub'. Michel Hochmann very kindly agreed to copy out this letter for me in Venice, to explain the circumstances and share his theories. This enabled me to understand the meaning behind Colluraffi's commission. My research subsequently led to my finding out that, in early 1627, Colluraffi founded a new academy in Venice, the Accademia degli Informi, whose motto was the Latin phrase '*Dum Mobilis Aetas*', while its emblem was '*l'orsa che lambisce il proprio parto*' ('a female bear licking her newborn cub'). Now all I needed was to find Artemisia's engraving. It might be the frontispiece to the inaugural speech for the academy, made on 6 January 1627 (see *L'Accademia. Orazione dell'illustre Signor Alvise da Mosto, recitata nell'aprirsi dell'Accademia degl'Informi in casa propria, fondatore e rettore Antonino Colluraffi*). No doubt this piece of work, which has not been published to date, will never go down in the annals of emblem making, but the very fact that the Accademia degli Informi commissioned an emblem from Artemisia shows how popular she was in intellectual circles in Venice.

Other evidence suggests that she lived in Venice from 1627 to 1629. In particular, there is some anonymous verse in praise of her in the Biblioteca Apostolica Vaticana (*Ottoboniano Latino* 1100, ff. 100–1). The poems refer to her as a Roman painter living in Venice: '*Pittrice Romana in Venetia*'. They were discovered by Ilaria Toesca and published in her article 'Versi in lode di Artemisia Gentileschi' in the journal *Paragone*, no. 251. It is interesting, too, to note that the leading figures in Venice who bought Artemisia's paintings

all belonged to the same group as Antonio Colluraffi and Gian Francesco Loredano. Apart from his burlesque epitaphs, Loredano also published several letters he sent to Artemisia, addressed to the parish of San Fantino in Venice and to Padua. Nicola Ivanoff published two of these letters in his article 'Gian Francesco Loredan e l'ambiente artistico a Venezia nel Seicento', in which he discusses when they were written. He believes they date from after Artemisia's journey to England. It is highly likely that she stopped off in Venice in 1638, on her way to join her father in London, or when she was travelling back down to Naples in 1641. At any rate, the links she had forged with Venice's intellectuals lasted a long time, since they included their correspondence with her in collections published as late as 1659. And shortly before her death, Artemisia herself reminded a client who was showing reluctance in paying for a commission that in all the places she had worked in – Rome, Florence *and Venice* – the greatest princes had been happy with her work (see Vincenzo Ruffo's *La Galleria Ruffo nel secolo XVII° in Messina*).

For my description of the atmosphere in Venice and in the world of art collectors, I consulted Michel Hochmann, *Peintres et Commanditaires à Venise*; Simona Savini Branca, *Il Collezionismo veneziano nel '600*; and *La Civiltà veneziana nell'età barocca*. For more on the relationship between Venice and the English ambassadors, see *The Life and Letters of Sir Henry Wotton*, by Pearsall Smith Logan. For Venice's reaction to England's policy, see the despatches sent by Venetian ambassadors posted to London, in *Calendar of State Papers Venetian* for 1623–5, 1626, 1627 and 1628 (in Archivio di Stato di Venezia (ASV). Lastly, for information on feminism in Venice, see *La Semplicità Ingannata o Tirannia paterna*, written by a nun called Arcangela Tarabotti. I should also mention that Arcangela Tarabotti was close to Gian Francesco Loredano and dedicated some of her books to him; and that her sister was married to Giacomo Pighetti, who owned some paintings by Artemisia (see the anonymous verse in BAV, *Ottoboniano Latino* 1100, ff. 100–1).

For the vicissitudes of the sale of the Mantua collection to Charles I of England, see Alessandro Luzio's exhaustive *La Galleria dei Gonzaga venduta all'Inghilterra nel 1627–1628*. And for the part played in the sale by Nicholas Lanier, see the biography of him by F. Graham Lanier, *The Earlier Life and Work of Nicholas Lanier*, and Michael Wilson's book, *Nicholas Lanier*.

To find out more about Lanier, see what another English traveller visiting Italy, Richard Symonds, said about him in his journal, which is in the British Library in London (Harl MS 991, f. 34). He described him as a man who

was '*inamorato di Artemisia Gentileschi che pingeva bene*' ('in love with Artemisia Gentileschi, who was a good painter'). Was Nicholas Lanier the great love of Artemisia's life? Another scholar, Charles I's physicist Théodore Turquet de Mayerne, alluded to a link between them. In his *Pittura, scultura e delle arti minori 1620–1646*, the manuscript of which is in the British Museum in London (MS Sloane 2052), he embarks on an extensive scientific investigation into the techniques used by painters. He discusses the way they used their tools, what they painted on, their use of canvases, glues, pigments and varnishes. He talked to all the artists living in London, had a discussion with Rubens when he was staying in England, and also with Van Dyck, Orazio Gentileschi and Nicholas Lanier. Lanier told him about the little trick with amber varnish and the technique known as 'wet on wet'. Nicholas Lanier had been let into these secrets – Orazio Gentileschi's secrets – by none other than Artemisia. When did they meet? Perhaps in Rome in 1625, during Lanier's first visit to Italy. Or perhaps in Venice in 1627. At any rate, Lanier and Orazio Gentileschi both belonged to London's art world, so they moved in the same circles and frequented the same society drawing-rooms. Artemisia's brothers Francesco and Giulio travelled to Venice to join Lanier on three occasions, in September 1627, November 1627 and April 1628. For information about the Gentileschi brothers' movements in Italy, concerning what they had been sent to do there, and about their relationship with Lanier, see the letter Orazio sent to Lord Dorchester, the Secretary of State, previously Dudley Carlton and a leading collector who had been the English ambassador in Venice. This letter, written in London in March 1629, appears in *Calendar of State Papers, Domestic (op. cit.)* and was published in W. Noël Sainsbury's article 'Artists' Quarrels in Charles I's Reign', pp. 121–2. In it, Orazio offers a detailed justification for his sons' conduct and their comings and goings between Genoa and Venice. He gives a list of their expenditure, and insists that Lanier had authorised them to draw on the sum that the King had earmarked for buying the Genoa collection. The least we can say is that Orazio seems to be rather uncomfortable about his explanation. I used this document as the basis for my scene where Lanier confronts Giulio Gentileschi at the English embassy.

However, I invented the quarrel between Lanier and Artemisia over the drawings that he had sold. In constructing the dialogues, I used the body of letters that Artemisia wrote from Naples to her patron Antonio Ruffo (*Galleria Ruffo, op. cit.*) in 1649. Her reactions to what Lanier has done, and

all her rejoinders, come from the letter dated 13 November 1649, where she is up in arms over a similar contretemps. Here is an extract from the original letter, where Artemisia sets out her aesthetic creed, and in particular her conviction that invention matters much more than execution, and says that if she'd been a man, no one would have dared to help themselves to her drawings: '*Che fusse homo i non so come se passerebbe perché quando è fatta l'inventione, et stabilito con li suoi chiari e uscuri, e fundati sul'loro piani tutto il reso ei baia . . .*' (The sentence 'You will find that I have the soul of Caesar in a woman's heart', was written on the same date, 13 November 1649, in another letter to Ruffo (see *Galleria Ruffo, op. cit.*). Here is the original wording: '. . . *Ritroverà un animo di Cesare nell'anima d'una donna*'.)

For information about Artemisia's move to Naples and her relationship with the new Spanish viceroy, see Jonathan Brown and Richard L. Kagan's article, 'The Duke of Alcalá: His Collection and Its Evolution'.

34, 36 & 37 Naples, 1629–38

To find out about this period in Artemisia's life, see Bernardo De' Dominici, *Vite de' Pittori, Scultori ed Architetti Napoletani* (1742). For material on her relationship with the leading Naples painter Massimo Stanzione, see the monograph by Sebastian Schütze and Thomas C. Willette, *Massimo Stanzione, L'Opera completa*; see also Filippo Baldinucci, *Notizie de' professori del disegno da Cimabue in qua* (1681–1728), vols III, IV, V and VI. For information on her relationship with other artists in this capital of the Kingdom of the Two Sicilies, I recommend consulting the excellent catalogue to an exhibition called *Painting in Naples from Caravaggio to Giordano* (1982), and also titles by Gérard Delille, especially *Famille et Propriété dans le Royaume de Naples, XV–XIXe siècles*. For comments made by French visitors to Naples, see Anthony Blunt's article 'Naples as seen by French Travellers (1630–1780)', in *The Artist and the Writer in France*. See also the description of Naples given by Jean-Jacques Bouchard (*op. cit.*).

Artemisia's pictures crop up again and again in the inventories drawn up after the deaths of members of most of the leading families in Naples. On this topic see the three outstanding books written by Gérard Labrot: *Baroni in città. Residenze e comportamenti dell'aristocrazia napoletana, 1530–1734; Collection of Painting in Naples, 1600–1780*; and *Etudes napolitaines. Villages, palais, collections, XVII–XVIIIe siècles*. Gérard Labrot generously shared with me the results of

his most recent research – as yet unpublished – and this enabled me to draft a list of the canvases painted by Artemisia in Naples whose whereabouts are unknown. In fact, a substantial proportion of her huge output seems to have disappeared for good. Part of the reason for this could be that art historians are reluctant to attribute to her anything that does not depict half-naked women, biblical heroines, or violent subject matter of some sort, since we are used to her painting such things. Yet, as I drew up this list of paintings that the clerks of the court had attributed (rightly or wrongly) to *la mano d'Artemisia* when they were compiling their inventories, I noticed that she was not only inspired by the 'strong-minded women' in the Old and New Testaments. Or at any rate, in her Naples paintings she did not produce any more of these 'heroines' than her contemporaries. She painted *The Seven Angels of the Passion*, several *St Joseph*s, *Souls in Purgatory*, an *Ecce Homo*, a *Head of Christ*, a *Hercules* and so on. So it would be a pity to reduce her talent to nothing but images of Mary Magdalene, Judith, Susanna and Bathsheba. I should add here that in the second half of the seventeenth century, historians praised her for the beauty of her still-life paintings and for her portraits. But we have no knowledge of her work in these two genres, apart from her magnificent *Portrait of a Gonfalonier*, painted in Rome and dated 1622, which is now in Bologna.

Artemisia's pictures cannot all have disappeared from Naples, but it is difficult to know how to track them down. I tried going through the notaries' deeds in the Archivio di Stato di Napoli. Deeds of this type had brought me luck in Rome, enabling me to track down information about her financial affairs, to find the leases she signed for her various lodgings and the inventories that were drawn up for them. But after three weeks in Naples, I was still going through archives for notaries' practices starting with the letter A – and over a period of three hundred years.

Professor Nappi very kindly consulted the indexes of payments made through Naples banks in 1630–9 and 1641–53. But this merely told me that there is only one reference to Artemisia in the ledgers (which are in the Archivio del Banco di Napoli). Professor Nappi published this document on page 74 of his book *Ricerche nel Seicento Napoletano*, which unfortunately offers no information about Artemisia's address.

However, one clue enabled me to assume that she lived not far from the Via Toledo. This was an account by an English traveller called Bullen Reymes, who, like Artemisia's brother Marco, was a member of the Duke of

Buckingham's household. He was the bearer of letters of recommendation signed by Orazio Gentileschi and intended for various influential Frenchmen and Italians (see Helen Andrews Kaufman's biography of him, *Conscientious Cavalier*). And on two occasions, on Wednesday 15 March and Saturday 18 March 1634, he noted down in his journal that, when he left the brothels in the *passaggia* (i.e. Via Toledo), he went to visit Signora Gentileschi and her daughter, who also painted, and who played the spinet well. Professor Edward Chaney very kindly gave me this extremely useful piece of information. He quotes from the source document in his recent book, *The Evolution of the Grand Tour* (*op. cit.*), of which he sent me the proofs. Bullen Reymes went straight from Artemisia's home to the Concezione Church, where he listened to the nuns' singing. If we assume that he did not travel right across Naples, Artemisia must have been living in the small area between the *passaggia* and the Via della Concezione.

I failed to find any references to her daughters' weddings, which she alludes to in her letters to Andrea Cioli on 1 April 1636, to Cassiano dal Pozzo on 24 October and 24 November 1637 (Bottari, *op. cit.*) and to Antonio Ruffo on 13 March 1649 (*Galleria Ruffo, op. cit.*). In the letter to Ruffo, she gives the exact date of a wedding, since it took place that very day – 13 March 1649 – and says that the bridegroom was a knight of the order of San Giacomo. Unfortunately, although the city's marriage registers are in the Archivio Diocesano di Napoli (ADN), they are not classified by first name, as they are in Rome, but by the husband's surname. And the husband's surname was precisely what I was looking for. Also, while the diocesan archives include the marriage contracts entered into before the wedding, they are not classified in alphabetical order, or even by parish. Out of desperation I consulted the confirmation registers for girls (ADN, *Donne Cresime*, section 58, 1632–9) in the hope of coming across the name Prudenzia/Palmira. But in 1632 she would have been fifteen, which would have made it a very late confirmation. The registers for the preceding period are missing. I also tried to find some mention of Artemisia's younger daughter, but we do not even know what her first name was. In her monograph *Artemisia Gentileschi* (*op. cit.*), Mary Garrard puts forward the theory that Artemisia had another daughter, and when I reread Artemisia's letters in Italian, I found evidence that confirms that this younger daughter did indeed exist. Artemisia bemoans the fact that she has had to take responsibility twice over for getting a daughter settled, once in 1637, and again in 1649. If Prudenzia had been widowed and

had remarried in 1649, her mother would not have been responsible for paying for her dowry. Artemisia writes that the wedding in 1649 has ruined her. So I agree with Mary Garrard in thinking that it cannot be the same daughter.

And lastly, although I have not been able to find the name of either of the husbands, the fact that the second belonged to the order of San Giacomo suggests that the younger girl was the daughter of someone highly aristocratic. The knights of the order of San Giacomo could only marry into families claiming four quarters of nobility. So a lot of quarters would have been needed to outweigh the Gentileschis' obscure background, or that of the Stiattesis. But I cannot be certain of this. Naples did not yield up any of her secrets. I invariably came back empty-handed. To make up for this substantial gap, I tried to conjure up the life Artemisia led there by drawing on descriptions of the circles she moved in.

It is a conjecture on my part that Artemisia took the *Self-portrait* that is now in London with her in 1638. I agree with R. Ward Bissell and Mary Garrard in thinking that this painting dates from the very early 1630s. Could it be the picture that she promised to Cassiano dal Pozzo at that point? If so, how did it get to England? It is not listed in the inventories for the royal collections before she arrived in England, but does appear after she had been there. It is definitely true that she frequently depicted herself; that the Duke of Alcalá took several of her self-portraits with him to Spain; and that the duke's collections were eventually put up for sale in Genoa from 9 May to 12 June 1637. See, on this topic, the brilliant article by Jonathan Brown and Richard L. Kagan, 'The Duke of Alcalá: His Collection and Its Evolution'. The inventory for the Alcalá sale only occasionally specifies the painters' names and there is no mention of Artemisia. But her brother Francesco was definitely in Genoa at the end of the winter of 1636–7 and in spring 1637 (see Bissell, *op. cit.*). As I knew about his having acted as an agent on the Genoa art market, I assumed that he could have bought, on behalf of Charles I, pictures that had belonged to his sister's patron, the Duke of Alcalá. At any rate, when this Genoa visit was over, Francesco left for Naples. He had already invited Artemisia to London on two occasions, on behalf of Charles I: see the letters (published in Bottari, *op. cit.*) that Artemisia sent from Naples in 1635 – one dated 25 January to Duke Francesco d'Este in Modena, the other to the Grand Duke of Tuscany on 20 July.

35 London, 1629–30

See above, chapter 28.

Part V: The Triumph of Peace and the Arts

38 London, November 1638

When I was describing the relationship between Charles I of England and the papacy, I relied on the huge number of despatches sent by Pope Urban VIII's three London agents to the cardinal-nephew between 2 May 1635 and 25 December 1642. The agents were called Gregorio Panzani, George Conn and Carlo Rossetti and their despatches are in BAV (*Barb. Lat.* 8634–6, 8641–3, 8646–52). The accounts given by these agents, their comments on the English Catholics' past and their speculation about what the future might hold for them, read like the most thrilling of novels. They are a mine of useful information. I also used the London *Avvisi*, a chronicle that gives a weekly summary of all the gossip and rumours circulating at court and in town (BAV, *Barb. Lat.* 8671).

The account given by Father Cyprien de Gamaches in *Mémoires de la mission des capucins de la province de Paris en Angleterre* conveys a very clear idea of the extraordinary ceremonies held in the Queen's Chapel at Somerset House. They were clearly on a par with the most sumptuously staged ceremonials in Rome. See also the letter written by Father de Trélon to the *Ufficio della Propaganda* Fide in Rome on 17 September 1636 (PRO, *Roman Transcripts* 9/19, 'Propaganda Fide', vol. CCCXLVII, p. 571). For a description of the chapel at Somerset House, see Elizabeth and Wayland Young, *Old London Churches*.

To get an idea of the atmosphere at the English court just before the Civil War, see the master of ceremonies' journal published by Father Loomie, *Ceremonies of Charles I*. For information on Charles I's collections, see *The Late King's Goods* (*op. cit*), Oliver Millar's *The Queen's Pictures* (*op. cit.*) and his article 'Some Painters and Charles I', and 'Notes on the Royal Collection' (*op. cit.*) by J. Bruyn and Oliver Millar.

For information on the King, see Pauline Gregg's biography, *Charles I*; and for material on Queen Henrietta Maria, see Erica Veevers, *Images of Love and Religion*. To understand England's domestic policy, I recommend Kevin Sharpe's *The Personal Rule of Charles I*, and C. V. Wedgwood's *The Great Rebellion*, vols I and II.

39 The Queen's House at Greenwich, November 1638

In writing this scene I relied partly on George H. Chettle's book, *The Queen's House, Greenwich*, but most of all on my own notes, the photos I took and all the impressions I took away from an extended visit.

40 The Studio of Orazio and Artemisia at Greenwich, January 1639

The painter Andrea Fortina very kindly allowed me to watch an amazing demonstration of seventeenth-century painting techniques. I saw him grinding his colours in his studio, boiling up his oils and sizing his canvases. I made use of all these impressions. And as I write, this sheet of paper is still impregnated with the smell of turpentine, as Artemisia's dress would have been.

41 The Queen's Chapel at Somerset House, 7 February 1639

It is not in the least surprising that Orazio Gentileschi was buried beneath the Queen's altar. All the Catholics in Henrietta Maria's service were entitled to be buried in the crypt of her chapel. As for the allegations made by Orazio's old enemy, the painter Giovanni Baglione, in his book on painters' lives (*op. cit.*), in which he claims that Orazio died alone, without being fortified by the rites of the Church, on heretical soil, they are nothing but malicious gossip. The crypt in the Queen's Chapel was consecrated ground and the Capuchin friars would have administered the last rites.

WHAT BECAME OF THEM

The Late King's Goods (*op. cit.*) describes how the royal collections were dispersed by the Commonwealth. Although the sales were open to the public, they were not auctions. The prices had been decided in advance and those who bought them paid the valuation figure. For a list of the purchases made by the Spanish ambassador, see Father Loomie's 'Alonso Cardenas and the Long Parliament', in his book *Spain and the Early Stuarts*.

Oddly enough, I came across some later correspondence between the Venetian merchant, Daniel Nys, who had negotiated the Mantua sale, and

Orazio's old enemy Balthazar Gerbier. These letters were written in 1638 and 1639 (PRO, SP 77/28, III, f. 592 and 610). From September to December 1638, Nys was in The Hague, and it was from there that, in October, Marie de Médicis – and probably Artemisia Gentileschi too – set out for England. It is possible that Artemisia and Nys met again at that point. At any rate, Gerbier later described Nys as 'an honnest plane creature', which seems somewhat excessive (PRO, SP 77/29, I, f. 81).

Francesco Gentileschi had a spell in Rome in February 1640, a year after his father's death. I found a reference to him among the letters that the cardinal-nephew Francesco Barberini wrote to his London agent, Count Rossetti (BAV, *Barb. Lat.* 8646, f. 434). The cardinal remarks that, in spite of the fact that Francesco Gentileschi was not bearing a single letter from Queen Henrietta Maria, he claimed that she had sent him to Italy to buy some fabrics. The cardinal was presented by Francesco with the gift of a painting, and offered to facilitate his affairs in Rome, or rather those of Henrietta Maria, since Francesco claimed to be in her service. A few days later, on 25 February 1640, it was the turn of Hamilton, the Queen's representative at the papal court, to write to Count Rossetti to recommend Francesco to him, as he was returning to London. He asked Hamilton to help Francesco to settle his father's estate. The crown had allegedly still not paid for some paintings that Orazio had delivered long before. Francesco is one of only two people named as Orazio's heirs, the other being his brother – probably Giulio (BAV, *Barb. Lat.* 8646, ff. 472, 473).

It was Gabriele Finaldi, Curator of Later Italian and Spanish Painting at the National Gallery in London, who very kindly informed me that Orazio Gentileschi's will had recently been discovered (PRO, Prob 11/180, f. 473r). Of his family, only Francesco and Giulio inherit. The exclusion of Marco seems to suggest that he had a bad relationship with his father. The will makes no reference to Artemisia, perhaps because she had already received her inheritance with her dowry.

Despite lengthy research, I failed to find Artemisia's grave in Naples. Some of the graves from the crypt of the church of San Giovanni dei Fiorentini, where she is said to have been buried, were transferred to Santa Anna dei Lombardi when the floor was restored in the eighteenth century. On 21 February 1953, when the church was demolished, twenty-four tombstones were taken to the crypt of Santi Apostoli. Another ten urns containing remains went to Santa Anna dei Lombardi. In March 1953, the town council

in Florence asked the Naples council for information about the whereabouts of the remains of the Tuscan families who had been buried in San Giovanni dei Fiorentini. The official in charge of historic buildings confirmed that the small number of tombs that had just been opened had turned out to be empty, and that the remains from the others had been buried in Santa Anna dei Lombardi. But after searching through the inscriptions that had been deemed worth keeping in the Santa Anna archives, I did not notice anything that might lead me to Artemisia Gentileschi.

Acknowledgements

If I can't, to my great regret, thank here all those who have helped me in this undertaking, I would like each one of them to know that I owe to their kindness, generosity and patience, not only the writing of this book, but also the most extraordinary adventure of my life. This long quest was only made possible by the confidence of others: that of my family, my friends, my editors, and the confidence of the innumerable people I met in the course of my work. Over the five years I spent researching this book, doors opened to me wherever I knocked. In Italy, England, France, Spain and America, I was welcomed – often several times – by art historians, collectors and artists with a warmth and enthusiasm which I am extraordinarily grateful for.

First, I would like to thank Simona Feci who, for many months, interrupted her own work to guide me through the Italian archives. Without her erudition and generosity, I would not have been able either to copy or to interpret the documents.

I am grateful to Danielle Guigonis, who was unfailingly loyal and generous with her expertise; to Marie-Françoise Brouillet, whose kindness and knowledge were a wonderful support during the writing of the book; and to Antoine Caro, Marcelle Hartmann, Mathieu and Véronique Meyer, who spent many hours correcting the manuscript.

How can I express my gratitude to my first readers – Sophie Bajard, Catherine Bernard, Odile Bréaud, Sylvie Guigan, Carole Hardoüin, Frédérique Hochmann, Aliette Lapierre and Dominique and Dominique Lapierre – who were prepared tirelessly to read and reread the different stages of my work?

The warmest thanks go to Olivier Bonfait, currently *chargé de mission* for history of art at the Académie de France in Rome, and to Michel Hochmann, professor of art history at Grenoble University, both of whom were a constant help. Their suggestions, advice and encouragement at moments of uncertainty were precious to me. Without them, this book would not exist.

I must also express my immense gratitude to those who were the directors of studies at the École française in Rome at the time of my research – Catherine Brice, Jacques Dalarun and Catherine Virlouvet – who were always kind and a constant support.

I would like to thank Jean-Pierre Angremy, Jean-Louis Lucet, Jean-Bernard Mérimée, Claude Nicolet, Bruno Racine and André Vauchez for the warmth and hospitality with which they received me in the places of memory and magic that they knew so well: the Villa Medici, the Palazzo Farnese and the Villa Bonaparte.

I would never have been able to write this book without the help and friendship of all those who welcomed me to Italy and guided me through the labyrinths of the past and the network of streets at the heart of Rome and all the towns that they love so much. I thank Rina and Takis Anoussis, Marco Fabio Apolloni, Frank Auboyneau, Christiane Baryla, Noëlle de La Blanchardière, Ondine de Buoï, Thérèse Boespflug, Francesca Cappelletti, Andrea and Mara Carandini, Maria Teresa De Bellis, Patrizia Cavazzini, Monsignor Sandro Corradini, Catherine Dalarun, Leonardo and Allegra Donati, Vicky and Isabella Ducrot, Jean-Michel and Chantal Dumond, Judy Flowers, Gérard Fontaine, Andrea Fortina, Elena Fumagalli, Alessandra Ginobbi, Alain and Clémentine Gomez, Laure de Gramont, Jane Green, Tony Guigonis, André Haize, Christian and Éliane Huber, Vincent Jolivet, Dieter Kopp, Gérard Labrot, Fabrizio and Fiammetta Lemme, Annick Lemoine, Judith Mann, Stephen Margoli, Maurizio and Alessandra Marini, Olivier and Geneviève Michel, Joanne and Tom McGrevey, Andrès Neuman, Xavier and Lucile North, Jacopo and Florence Patrizi, Stephen and Geraldine Pepper, Laurent Peyrefitte, Giorgio Piccinato, Ludovico and Delphine Pratesi, Pauline Prévost-Marcilhacy, Dominique Reviller, Anna Rossi, Beppe and Daria Scaraffia, Serge Sobczynski, Pierre and Martine Spitz, Rose-Marie Tasca.

Heartfelt thanks go to Sir Denis Mahon, Sir Oliver Millar and Professor Jacques Thuillier who did not hesitate to take time away from their own work to answer my questions. I also thank all my correspondents across the

channel – Anne Brooks, Edward Chaney, Joe Cowell, Rupert Featherstone, Gabriele Finaldi, Christopher Lloyd, Gregory Martin, Elizabeth McGrath and Jeremy Wood – for all their help and hospitality in England.

I would like my daughter Garance, who accompanied me with such patience and good humour to the hundreds of churches we visited, to know how much I appreciated her drawings, poems and suggestions when I felt doubtful. I must also thank Emilia Rosa who agreed to join us on this adventure and who surrounded us with her affection during that time.

Finally, I want to thank my translator, Liz Heron, for her passion and care in conjuring up the spirit of Artemisia's world; the section of notes was translated separately and I am grateful to those who worked on it. I would also like to thank my agent Gloria Loomis, Susanna Lea in Paris, and my editors, Rebecca Carter in Great Britain and Joan Bingham in the United States, who sustained this project with tireless faith and enthusiasm.

Bibliography

Manuscript Sources

FABRIANO
Archivio capitolare di San Venanzio.
Istromenti, II.
Decretorum capitularium ab anon 1615 bis 1633.
Archivio comunale.
MS 209, Costanzo Gilii, Silvestro Guerrieri, *Memorie storiche di Fabriano.*

FLORENCE
Archivio Buonarroti, 41–57; 101; A, 101–4, 1612–1618; B, 101–5, 1619–
1636; C, 101–6, luglio 1636; 103, 67 and 68v.
Archivio dell'Opera del Duomo.
Battesimi Maschi, anni 1561–1571, f. 7v.
Battesimi Maschi, 1577–1588, f. 123v.
(ASF) Archivio di Stato di Firenze.
Accademia del Disegno, Atti e Sentenze, bb, 16; 64; 65.
Accademia del Disegno, Debitori e creditori delle matricole, 57.
Arte dei Medici e Speziali, filza 14, matricole 1592–1614, f.7.
Carteggio Mediceo, 4199.
Cittadinario Santa Croce, filza 4, c.107r, 122r.
Cittadinario Santa Maria Novella, filza 3 and 4.
Grascia, 194 ff. 265r and 316r.
Guardaroba Mediceo, filza 390, inserto 5, f.455.

Mediceo del Principato, 998, 3327, 3334, 3506, 3508, 3514, 4196, 4199, 4232, 5143, 6003, 6028, 6068, ff, 270r, 378r, 386, 387r, 388v, 389r, 469r,

Notarile Moderno, 1606–1633, prot. 11093–11097, filze 5498 and 5499; nos. 8732–8736.

Biblioteca Medicea Laurentiana.

Archivio del Capitolo di San Lorenzo, *Stati delle Anime* (1575–1592), n. 3933, f. 13r.

Biblioteca Nazionale di Firenze.

MSS Gal. P.I.T., XIII, ff. 269–270.

LIVORNO

Archivio di Stato di Livorno.

Tribunale del Governatore e Auditore, filze 52 (1609), cc. 71–72.

LONDON

British Library, Harley, MS 991; MS 4898, *The Inventory of the Effects of Charles I, 1649–1652.*

(PRO) Public Record Office, SP 16/79/78; 77/19; 77/20; 77/21; 77/28; 77/29; 78/72; 78/79; 78/80; 78/81; 78/82; 78/90/97; 78/90/216; 78/90/386; 78/95/105; 78/99/226; 78/104/90; 78/105/293; 78/105/367; 78/105/466; 78/106/196; 78/106/198; 78/106/270; 78/106/274; 78/107/47; 78/107/112; 78/108/45; 79/1; 84; 93; 99; 99/26/153; 99/28/29.

Somerset House, Witt Library, Photographic Library, Dutch C 159/3; Folders Artemisia Gentileschi, Orazio Gentileschi, Francesco Gentileschi.

LUCCA

Biblioteca Governativa, MS 1547, *Lucca pittrice in cui si vedono i quadri delle chiese di Lucca e i loro autori* (1778).

PISA

Archivio della Primiziale.

Libro dei Battezzati, 1561–1564, f. 91.

Archivio di Stato di Pisa.

Sagrestia debitori e creditori, anni 1576–1598, 17 aprile 1589.

ROME

Archivio dell'Accademia di San Luca.

Entrate e uscite del Camerlengo, 1593–1625, 42.

Archivio Segreto Vaticano.

Archivio Borghese, 23 (1607–1613), n. 12; 6083 *Registro dei mundati dell'E.mo Card. le Borghese* (1612–1623).

Miscellanea Armadi I-XV, arm. IV, t. 6, pp. 300–301.

Biblioteca Apostolica Vaticana.

Barberiniani Latini 8634–8636; 8641–8643; 8646–8652; 8671.

Ottoboniani Latini 1100.

Urbinati Latini 1067, 1078, 1079, 1080.

Vaticani Latini 9727.

(ASR) Archivio di Stato di Roma.

Camerale I, *Giustificazioni di tesoreria,* b. 39.

Camerale I, *Maggiordomo del Pontefice,* bb. 1368; 1605.

Camerale I, *Mandati,* bb. 949–950.

Camerale I, *Mandati delle Fabbriche,* b. (1611–1612).

Camerale I, *Ufficiali camerali,* b. 1725.

(TNC) 30 Notai capitolini, *Ufficio 19, Testamenti,* b. 5 (1611).

(TNC) 30 Notai capitolini, *Ufficio 19,* 1611, I; 1621; 1625, I and III.

(TNC) 30 Notai capitolini, *Ufficio 22,* b. 42 (1610), ff. 332–334 and 344r.

(TNC) 30 Notai capitolini, *Ufficio 34,* anno 1612, p. I, cc. 337r–v; 338r–v and 354–355r–v; 364r–v; 381r–v; 446–456v.

(TNC) 30 Notai capitolini, *Ufficio 36,* b. 24 (1612), f. 646r–v; b. 26 (1614), ff. 683–688.

(TCG) Tribunale Criminale del Governatore, *Fideiussioni,* b. 58, ff. 15v–17r.

(TCG) Tribunale Criminale del Governatore, *Registrazioni di Atti,* bb. 166, 167, 195, ff. 1r–v.

(TCG) Tribunale Criminale del Governatore, *Processi, sec.* XVII, b. 28bis, ff. 377r; 383r–v; 387r–v; 391r; b. 62 (1611), ff. 109–142 and 550–597; b. 104 (1612), ff. 270–447 old pagination; ff. 1–340, new; b. 181, ff. 52–55, 407–413.

(TCG) Tribunale Criminale del Governatore, *Relazioni dei Birri,* b. 100, reg. 5, ff. 1r, 21r, 51r–v.

Tribunale Civile del Governatore, *Sentenze,* b. 309.

(ASVR) Archivio Storico del Vicariato di Roma.

San Giovanni in Laterano, *Cresime,* 1601–1608, vol. 3, 12 June 1605.

San Lorenzo in Lucina, *Liber baptizorum,* 1590–1603, f. 78r.

Santa Maria del Popolo, *Liber IV baptizatorum,* 1595–1619, c. 52v; *Morti IV,*

1595–1620, c. 140; *Stati delle Anime,* 1601; 1621, f. 9r; 1622, f. 20r; 1623; 1624; 1625; 1626.

San Pietro, *Morti,* bobina 38, c. 203.

Santo Spirito in Sassia, *Libro de' Matrimoni* II (1607–1630); *Stati delle Anime* (1641).

Printed Sources

Abromson, Morton C., *Painting in Rome during the Papacy of Clement VIII (1592–1605). A Documented Study.* (New York–London: Garland, 1981)

Accademia Nazionale di San Luca (L') ed. C. Pietrangeli, P. Marconi, L. Salerno *et al.* (Rome: De Luca, 1974)

Accademia Nazionale di San Luca, *I disegni di figura nell'Archivio storico dell'Accademia di san Luca,* ed. A. Cipriani and E. Valeriani, with an essay by Oliver Michael, 2 vols (Rome: Quasar, 1988–1989, 2 vols)

Ackerman, G., 'Gian Battista Marino's contribution to Seicento Art Theory', *Art Bulletin* XLIII (1961), 326–336.

Actes d'un procès pour viol en 1612 (Les) (Paris: Éditions des Femmes, 1982)

Acton, Harold, *Gli ultimi Medici* (Turin: Einaudi, 1966)

Acts of the Privy Council of England, 1628 July–1629 April; 1629 May–1630 May (London: 1930–1960)

Âge d'or du Mécénat (1598–1661) (L'), Actes du Colloque international CNRS (March 1983), ed. R. Mousnier and J. Mesnard (Paris: Éditions du CNRS, 1985)

Age of Caravaggio (The), exhibition cat. (Milan: Electa, 1985).

Agnelli, Jacopo, *Galleria di pitture del card. Tommaso Ruffo vescovo di Ferrara,* (Ferrara: per B. Pomatelli, 1734)

Ago, Renata, *Carriere e clientelé nella Roma barocca* (Rome–Bari: Laterza, 1990)

Alabiso, Annachiara, 'Aniello Falcone's frescoes in the villa of Gaspar Roomer at Barra', *Burlington Magazine* CXXXI (1989), 31–36

Albion, Gordon H. J., *Charles I and the Court of Rome. A Study in Seventeenth-Century Diplomacy* (Louvain: Bibliothèque de l'université, 1935)

Alessi, Giorgia, 'Il gioco degli scambi seduzione e risarcimento nella casistica cattolica del XVIᵉ e XVIIᵉ secolo', *Quaderni storici* XXV (1990), 805–831

Alisio, Giancarlo, *Napoli nel Seicento. Le vedute di Francesco Cassiano de Silva* (Naples: Electa, 1984)

Alizeri, Federigo, *Guida artistica per la città di Genova* (Bologna: Forni, 1969)

Alizeri, Federigo, *Guida illustrativa del cittadino e del forestiero per la città di Genova e sue adiacenze* (Bologna: Forni, 1972)

Alizeri, Federigo, *Notizie dei professori del disegno in Liguria dalla fondazione dell'Accademia al secolo XVI* (Genova: L. Sambolini, 1864–1866)

Amayden, Teodoro, *Storia delle Famiglie Romane* (Rome: collezione Araldica, n.d.)

Anderson, Jaynie, 'The Giorgionesque Portrait from Likeness to Allegory', in *Giorgione. Atti del Convegno internazionale per il V Centenario della nascita, 29–31 May 1978* (Comune di Castelfranco Veneto, 1979), 153–158

Andrews, Keith, 'Judith and Holophernes by Adam Elsheimer', *Apollo* XCVIII (1973) 206–209

Andrews, Keith, *Adam Elsheimer* (Munich: Schirmel Mosel, 1985)

Andrieux, Maurice, *La Vie quotidienne dans la Rome pontificale du XVIIIe siècle* (Paris: Hachette, 1962)

Antonetti, Pierre, *Histoire de Florence* (Paris: Presses universitaires de France, 1989)

Argan, Giulo Carlo, *Borromini* (Milan: Mondadori, 1952)

Arioste, Ludovico, *Roland furieux*, ed. Italo Calvino, (Paris: Garnier–Flammarion, 1982)

Armanni, Vincenzo, *Della nobile et antica famiglia de Capizucchi* (Rome: per N. A. Tinassi, 1684)

Armellini, Mariano, *Le chiese di Roma dal sec. IV al XIX* (Rome: Ed. R.O.R.E., 1942)

Around 1610: the Onset of the Baroque, exhibition cat. (London: Matthiesen Fine Art Ltd, 1985)

Art and Patronage in the Caroline Courts, Essays in honour of Sir Oliver Millar, ed. D. Howarth (Cambridge: Cambridge University Press, 1993)

Art in Italy: 1600–1700, cat. entries by Alfred Moir *et al.* (Detroit: Detroit Institute of Arts, 1965)

Arte per i papi e per i principi nella campagna romana: grande pittura del '600 e del '700 (L'), exhibition cat., 2 vols, (Rome: Quasar, 1990)

Artemisia, essays by R. Barthes, Eva Menzio, Lea Lublin (Paris: Yvon Lambert, 1979)

Artemisia, exhibition cat., ed. R. Contini and G. Papi, with an essay by L.

Berti (Rome: Leonardo–De Luca, 1991)

Artist and Writer in France (The). Essays in honour of Jean Seznec (Oxford, Clarendon Press, 1974)

Artisti alla Corte granducale, exhibition cat., ed. Marco Chiarini (Florence: Centro Di, 1969)

Ashley, Maurice, *England in the Seventeenth Century* (Harmondsworth: Penguin Books, 1961)

Askew, Pamela, 'Ferdinando Gonzaga's Patronage of the Pictorial Arts: the Villa Favorita', *Art Bulletin* LX (1978) 274–296

Astell, Mary, *A Serious Proposal to the Ladies for the Advancement of Their True and Greatest Interest by a Lover of their Sex* (London: printed for R. Wilkin at the Kingshead in the St. Paul's Churchyard, 1694)

Astell, Mary, *Some Reflexions upon Marriage, occasioned by the Duke & Duchess of Mazarine's Case; which is also considered* (London: J. Nutt, 1700)

Baccheschi, Edi, *L'Opera completa di Guido Reni* (Milan: Rizzoli, 1971).

Baglione, Giovanni, *Le Nove Chiese di Roma* (Rome: Archivio Guido Izzi, 1990)

Baglione, Giovanni, *Le Vite de'pittori, scultori et architetti dal pontificato di Gregorio XIII del 1572 in fino a'tempi di papa Urbano Ottavo nel 1642*, 2 vols. (Bologna: A. Fornia, 1996)

Bajard, Sophie and Bencini, Raffaello, *Villas et jardins de Toscane* (Paris: Terrail, 1992)

Baldinucci, Filippo, *Notizie de'professori del disegno da Cimabue in qua, secolo v dal 1610 al 1670* (Florence, Franchi, 1728)

Baldinucci, Filippo, *Vita di Gian Lorenzo Bernini . . . studio e note di Sergio Samek Ludovici* (Milan: Edizioni del Milione, 1948)

Bamboccianti pittori della vita popolare nel Seicento, (I), exhibition cat., ed. Giuliano Briganti (Rome: Organizzazione Mostre d'Arte 'Antiquaria', 1950)

Banti, Anna, *Artemisia* (Paris: P.O.L., 1985)

Baretti, G., *An Account of the Manners and Customs of Italy* (London: T. Davies, 1768)

Barocco al femminile, ed. G. Calvi (Rome–Bari: Laterza, 1992)

Barocco romano e Barocco italiano. Il teatro, l'effimero, l'allegoria, ed. Marcello Fagiolo and Maria Luisa Madonna (Rome: Gangemi editore, 1985)

Bassani, Riccardo and Bellini, Fiora, *Caravaggio assassino*, (Rome: Donzelli ed., 1994)

Basso, Jeannine, *Le Genra épistolaire en langue italienne (1538–1662)*. *Répertoire chronologique et analytique,* 2 vols (Nancy: Presses universitaires de Nancy, Bulzoni, Rome, 1990)

Bassompierre, François de, *Mémoires du Maréchal de Bassompierre,* 2 vols (Paris: chez Pierre de Martineau, 1692)

Batorska, Danuta, 'Grimaldi as collaborator of Agostino Tassi', *Paragone* XLII (499, 1991), 67–69

Battistello Caracciolo e il primo naturalismo a Napoli, exhibition cat., ed., F. Bologna (Naples: Electa, 1991)

Battisti, Eugenio, 'La data di morte di Artemisia Gentileschi', *Mitteilungen des Kunsthintorisches Institutes in Florenz* X (1963) 297

Baudson, E., 'Apollon et les neuf Muses du Palais du Luxembourg', *Bulletin de la Société de l'histoires de l'art français* (1941–1944) 28–33

Beal, Mary, *A Study of Richard Symonds* (New York: Garland Pub., 1984)

Bell, Susan Groag, 'Christine de Pizan (1364–1430): Humanism and Problems of a Studious Woman', *Feminist Studies* III (1976) 173–184

Bellori, Giovan Pietro, *Le Vite de'pittori, scultori et architetti moderni* (Bologna: A. Forni, 1997)

Belloni, Venanzio, *Pittura genovese del Seicento. Dal manierismo al barocco* (Genoa: Emmebi, 1969)

Benichou, Paul, *Morales du Grand Siècle,* (Paris: Gallimard, 1976)

Bentivoglio, Enzo and Valtieri, Simonetta, *Santa Maria del Popolo a Roma* (Rome: Bardi ed., 1976)

Bergeon, Ségolène and Martin, Élisabeth, 'La Technique de la peinture française des XVIIᵉ et XVIIIᵉ siècles', *Techné* 1 (1994) 65–78

Bernardo Cavallino of Naples, 1616–1656, exhibition cat., eds Ann T. Lurie and Ann Percy (Cleveland, Ohio and Fort Worth, Texas: The Cleveland Museum of Art and The Kimbell Art Museum, 1984)

Bernini, Domenico, *Vita del cavaliere Gio. Lorenzo Bernini* (Rome: for Rocco Bernabò, 1713)

Bertolotti, Antonino, 'Agostino Tassi: suoi scolari e compagni pittori in Roma', *Giornale di erudizione artistica* V (1876), 183–204

Bertolotti, Antonino, *Artisti lombardi a Roma nei secoli XV, XVI e XVII. Studi e ricerche negli archivi romani* (Milan: Hoepli, 1881)

Bertolotti, Antonino, *Giornalisti, astrologi e negromanti in Roma nel secolo XVII* (Florence: Tip. della Gazzetta d'Italia, 1878).

Bertolotti, Antonino, *Artisti veneti in roma nei secoli, XV, XVI e XVII. Studi e*

ricerche negli archivi romani (Venezia: R. Deputazione veneta sopra gli studi di storia patria, 1884)

Bertolotti, Antonino, *Artisti francesi in Roma nei secoli XV, XVI e XVII. Studi e ricerche negli archiv romani* (Mantua: G. Mondovi, 1886).

Bertolotti, Antonino, *Le prigioni di Roma nei secoli XVI–XVIII* (Rome: Mantellate, 1890)

Bertolotti, Antonino, *Artisti bolognesi, ferraresi ed alcuni altri del già stato pontificio in Roma nei secoli XV, XVI, XVII. Studi e ricerche tratte dagli archivi romani* (Rome: Aldo Forni, 1962)

Besana, Luigi, 'Le Accademie e l'organizzazione del sapere', in *Storia della Società Italiana, La Controriforma e il Seicento* (Milan: Teti editore, 1989) 455–462

Betcherman, Lita Rose, 'Balthazar Gerbier in Seventeenth Century Italy', *History Today* XI (1961), 325–331

Betcherman, Lita Rose, 'Letter on Gentileschi in France', *Burlington Magazine* C (1958), 252

Betcherman, Lita Rose, 'The York House Collection and Its Keeper', *Apollo*, XCII (1970), 250–269

Biet, Christian, 'De la veuve joyeuse à l'individu autonome'. *Revue du XVIIᵉ siécle* XLVII (1995), 307–330

Bissell, R. Ward, 'Dipini giovanili di Orazio Gentileschi a Farfa (1597–1598)', *Palatino* VIII (1964) 197–201

Bissell, R. Ward, *The Baroque Painter Orazio Gentileschi, His Career in Italy* (Ph.D. Dissertation, The University of Michigan, 1966)

Bissell, R. Ward, 'Orazio Gentilschi's *Young Woman with a Violin'*, *Bulletin of the Detroit Institute of Arts*, XLVI (4) (1967), 71–77

Bissell, R. Ward, 'Artemisia Gentileschi. A new documented Chronology', *Art Bulletin* L (1968), 153–168

Bissell, R. Ward, Orazio Gentileschi and the Theme of *Lot and His Daughters',* *Bulletin of the National Gallery of Canada* XVI (1969), 16–33

Bissell, R. Ward, 'Orazio Gentileschi: Baroque with Rhetoric', *The Art Quarterly* XXXIV (3) (1971), 275–300

Bissell, R. Ward, 'Review of Anna Ottani Cavina, *Carlo Saraceni*, Milano, 1968', *Art Bulletin* LIII (2) (1971), 248–250

Bissell, R. Ward, 'Concerning the Date of Caravaggio's *Amore Vincitore*, in *Hortus Imaginum: Essays in Western Art*, ed. R. Enggass and M. Stokstad, (Kansas: Lawrence, 1974), 113–123

Bissell, R. Ward, *Orazio Gentileschi and the Poetic Tradition in Caravaggesque Painting* (University Park and London: Pennsylvania State University Press, 1981)

Bissell, R. Ward and Darr, Alan P., 'A rare Painting by Ottavio Leoni', *Detroit Institute Bulletin* LVIII, (1) (1980), 46–53

Blancher-Le Bouris, Magdaleine, 'Les peintures de Jean Monier au Luxembourg', *Bulletin de la Société de l'histoire de l'art français*, for 1939 (1940), 204–215

Blunt, Anthony, 'Poussin's "Et in Arcadia ego"', *Art Bulletin* XX (1938), 96–100

Blunt, Anthony, *The French Drawings in the Collection of His Majesty the King at Windsor Castle* (Oxford–London: Phaidon, 1945)

Blunt, Anthony, *Art and Architecture in France, 1500–1700* (London, Melbourne, Baltimore: Penguin Books, 1953)

Blunt, Anthony, *The Drawings of G. B. Castiglione and Stefano della Bella in the Collection of Her Majesty the Queen at Windsor Castle* (London: Phaidon, 1954)

Blunt, Anthony, 'The Palazzo Barberini: the contributions of Maderno, Bernini and Pietro da Corton', *Journal of the Warburg and Courtauld Institutes* XXI (1958), 256–287

Blunt, Anthony, *Artistic Theory in Italy, 1450–1600* (Oxford: Oxford University Press, 1962)

Blunt, Anthony, *The Paintings of Nicolas Poussin. A critical catalogue* (London: Phaidon, 1966)

Blunt, Anthony, 'A Series of Paintings Illustrating the History of the Medici Family Executed for Marie de Medicis', *Burlington Magazine* CIX (1967), 492–498 and 562–568

Blunt, Anthony, *Supplements to the catalogues of Italian and French Drawings of the Royal Collection of Drawings,* with Edmund Schilling, *The German Drawings in the · Collection of Her Majesty the Queen at Windsor Castle* (London and New York: Phaidon, 1971)

Blunt, Anthony, 'Gianlorenzo Bernini: Illusionism and Mysticism', *Art History*, I (1978), 67–89

Blunt, Anthony, *Borromini* (London: Allen Lane, 1979)

Blunt, Anthony, *Guide de la Rome baroque* (Paris: Hazan, 1992)

Blunt, Anthony and Cooke, Hereward Lester, *The Roman Drawings of the XVII and XVIII centuries in the collection of Her Majesty the Queen at Windsor Castle* (London: Phaidon, 1960)

Blunt, Anthony and Croft–Murray, Edward, *Venetian Drawings of the XVII and XVIII centuries in the collection of Her Majesty the Queen at Windsor Castle* (London: Phaidon, 1957)

Bocchi, F., Cinelli, G., *Le Bellezze della città di Firenze* (Gugliantini: Florence, 1677)

Bonfait, Olivier, 'Le public du Guerchin: recherches sur le marché de l'art à Bologne au XVII^e siècle', *Revue d'histoire moderne et contemporaine* XXXVIII (1991), 401–427

Bonnefoy, Yves, *Rome 1630*, (Paris: Flammarion, 1994)

Bonsanti, Giorgio, *Caravaggio* (Florence: Scala, 1990)

Boone, Danièle, *L'Âge d'or espagnol* (Neuchâtel: Ides et Calendes, 1993)

Borea, Evelina, *Annibale Carracci* (Milan: Fratelli Fabbri, 1964)

Borea, Evelina, *La Quadreria di don Lorenzo de' Medici,* exhibition cat. (Florence: Centro Di, 1977)

Borea, Evelina, *Domenichino* (Florence: G. Barbèra, 1965)

Borea, Evelina, 'Caravaggio e la Spagna: osservazioni su una mostra a Siviglia', *Bollettino d'arte* LIX (1974), 43–52

Borromeo, Agostino, 'Clemente VIII', in *Dizionario Biografico degli Italiani,* vol. 26 (Rome: Istituto dell'Enciclopedia Italian, 1982), 259–282

Borzelli, Angelo, *Il Cavaliere Marino con gli artisti e la 'galeria',* (Naples: Filinto Cosmi, 1891)

Bossuet, Jacques, *Traité de la concupiscence*, in *Œuvres choisies* IV (Paris: Hachette, 1871)

Bottari, Giovanni G., *Raccolta di lettere sulla Pittura, Scultura ed Architettura scritte da'più celebri personaggi dei secoli XV, XVI e XVII pubblicata da M. Gio. Bottari e continuata fino ai nostri giorni da Stefano Ticozzi,* 8 vols. (Milan: G. Silvestri, 1822–1825)

Bottineau, Yves, *L'Art Baroque* (Paris: Hachette, 1986)

Bouchard, Jean–Jacques, *Journal* (Turin: Giappicchelli editore, 1976)

Bousquet, Jacques, 'Documents sur le séjour de Simon Vouet à Rome', *Mélanges d'archéologie et d'histoire* LXIV (1952), 287–300

Bousquet, Jacques, *Recherches sur le séjour des peintres français à Rome au XVII^e siècle* (Monpellier: A.L.P.H.A., 1980)

Briganti, Giuliano, *I Bamboccianti pittori della vita popolare nel Seicento* (Rome: Stab. Staderini, 1950)

Briganti, Giuliano, 'P. Van Laer e M. Cerquozzi', *Proporzioni* III (1950), 185–198

Briganti, Giuliano, 'Cerquozzi pittore di nature morte', *Paragone* V (53) (1954), 47–52

Briganti, Giuliano, *Il Palazzo del Quirinale* (Rome: Istituto Poligrafico dello Stato, 1962)

Briganti, Giuliano, *et al, La villa Lante di Bagnaia* (Milan: Electa, 1961)

Briganti, Giuliano, *Pietro da Cortona o della pittura barocca* (Florence: Sansoni, 1982)

Briganti, Giuliano, Tressani, Ludovica and Laureati, Laura, *I Bamboccianti pittori della vita quotidiana a Roma nel Seicento* (Rome: U. Bozzi, 1983)

Brookes, Anne, *Sir Balthazar Gerbir 1591–1663, A 17th Century Type?* (M.A. Dissertation in English Studies, Historical Studies and Art Historical Studies, Oxford, 1992)

Brosses, Président de, *Lettres d'Italie* (Paris: Mercure de France, 1990)

Brown, Christopher, *Van Dyke* (Ithaca, N.Y.: Cornell University Press, 1982)

Brown, Emerson Jr., 'Biblical Women in the Merchant's Tale: Feminism, Anti-feminism and Beyond', *Viator* V (1974), 387–412

Brown, Jonathan, *Image and Ideas in Seventeenth-Century Spanish Painting* (Princeton: Princeton University Press, 1978)

Brown, Jonathan, *Velázquez, Painter and Courtier* (New Haven: Yale University Press, 1986)

Brown, Jonathan, *The Golden Age of Painting in Spain* (New Haven: Yale University Press, London: 1991)

Brown, Jonathan, *Kings and Connoisseurs. Collecting Art in Seventeenth-Century Europe* (New Haven and London: Yale University Press, London: 1991)

Brown, Jonathan, Elliott, J. H., *A Palace for a King: the Buen Retiro and the Court of Philip IV* (New Haven and London: Yale University Press, 1980)

Brown, Jonathan, Kagan, Richard L., 'The Duke of Alcalá: His Collection and its Evolution', *Art Bulletin* LXIX (1987), 231–255

Brownmiller, Susan, *Against Our Will: Men, Women and the Rape* (New York: Simon and Schuster, 1975)

Bruyn, J., Millar, Oliver, 'Notes on the Royal Collection – III. The "Dutch Gift" to Charles I', *Burlington Magazine* CIV (1962), 291–294

Bufalini, Giovanna, *Il Casino dell'Aurora Pallavicini* (Rome: Eliograf, 1985)

Bulgarelli, Sandro et Tullio, *Il giornalismo a Roma nel Seicento* (Rome: Bulzoni, 1988)

Buonarroti, Michelangiolo, il Giovane, *La Tancia* (Florence: Edizione del

Comitata, 1930)

Buonarroti, Michelangiolo, il Giovane, *La Fiera* (Florence: Le Monnier, 1860)

Burke, Marius B., *Private Collections of Italian Art in 17th Century Spain* (New York: New York University Press, 1984)

Burke, Peter, *Venice and Amsterdam: A Study of XVIIIth Century Elites* (London: Temple-Smith, 1974)

Burke, Peter, *The Historical Anthropology of Early Modern Italy: Essay on Perception and Communication* (Cambridge: Cambridge University Press, 1987).

Burke, Peter, 'Investment and Culture in three XVIIth Century Cities: Rome, Amsterdam, Paris', *Journal of European Economic History* VII, (1978), 311–336

Burke, Peter, *The Fabrication of Louis XIV* (New Haven: Yale University Press, 1992)

Burney, Charles, *The Present State of Music in France and Italy, or the Journal of a Tour through Those Countries* (London: printed for T. Becket, 1771)

Calendar of State Papers, Domestic Series, Reign of Charles I, 1628–1629 (London: 1859); *1629–1631* (London, 1860); *1631–1633* (London: 1862)

Calendar of State Papers and Manuscripts Relating to English Affairs, Existing in the Archives and Collections of Venice and in Other Libraries of Northern Italy, vols. XV, XVIII, XX, XXI, XXIII (Hereford, London: 1909–1921)

Callari, Luigi, *I Palazzi di Roma e le case d'importanza storica ed artistica* (Rome: Bardi, 1970)

Callon, Gordon J., *Nicholas Lanier, His Life and Music* (Ph.D. Dissertation, University of Washington, 1983)

Callman, Ellen, 'The Growing Threat to Marital Bliss as Sin in Fifteenth-century Florentine Paintings', *Studies in Iconography* 5 (1979), 73–92

Calvesi, Maurizio, *Caravaggio*, (Florence: Giunti, 1986)

Campbell, Malcolm, 'Medici Patronage and the Baroque: a Reappraisal', *Art Bulletin* XLVIII (1996), 133–141

Campbell, Malcolm, *Pietro da Cortona and the Pitti Palace* (Princeton: Princeton University Press, 1977)

Campolieti, Giuseppe, *Masaniello* (Novara: De Agostini, 1989)

Canones et decreta sacrosanti œcumenici et generalis Concilii tridentini (Romae, apud Paulum Manutium, in aedibus Populi Romani, 1564)

Cantaro, Maria Teresa, *Lavinia Fontana bolognese* (Milan: Jandi Sapi ed., 1989)

Capecelatro, Francesco, *Degli annali della città di Napoli* (Naples: Tip. Reale, 1849)

Capozzi, Frank, *The Evolution and Transformation of the Judith and Holophernes Themes in Italian Drama and Art before 1627* (Ph.D. dissertation, The University of Wisconsin-Madison, 1975)

Cappelli, A., *Cronologia, cronografia e calendario perpetuo* (Milan: Hoepli, 1988)

Carandini, Silvia, 'Roma "Gran teatro del mondo". Festa e società nel XVII secolo', *Ricerche di storia dell'arte* (1976)(1–2), 71–80

Caravage et la peinture italienne du XVII^e siècle (Le), exhibition cat. (Paris: ministère d'État, Affaires culturelles, 1965) .

Caravaggeschi francesi, exhibition cat. (Rome: De Luca, 1973)

Caravaggio e caravaggeschi nelle Gallerie di Firenze, exhibition cat., ed. E. Borea, (Florence: Sansoni editore, 1970)

Caravaggio e il suo tempo, exhibition cat. (Milan: Electa, 1985)

Carducho (Carducci), Vincenzo, *Diàlogos de la pintura* (Madrid: Franco Martinez, 1633)

Carità, R., 'La data di nascita di Orazio Gentileschi', *Le arti figurative* II (1946) (1–2), 81–82

Carmona, Michel, *Marie de Médicis* (Paris: Fayard, 1988)

Carmona, Michel, *Richelieu* (Paris: Fayard, 1990)

Carpenter, W. H., *Memoires et Documents inédits sur Antoine Van Dyck, P.P. Rubens at autres aristes contemporains* (Anvers: Buschmann, 1845)

Carrache et les décors profanes (Les) (Rome: École française de Rome, 1988)

Carriera, Rosalba, *Le Journal de Rosalba Carriera pendant son séjour à Paris traduit, annoté et augmenté … par A. Sensier* (Paris: J. Techner, 1865)

Carteggio di Cassiano dal Pozzo (Il), ed. Anna Nicolo (Florence: Olschki, 1991)

Carusi, Enrico, 'Lettere di Galeazzo Arconato e Cassiano dal Pozzo per lavori sui manoscritti di Leonardo da Vinci', *Accademie e Biblioteche d'Italia* III (1929–1930), 504–518

Carutti, Domenico, *Breve storia dell'Accademia dei Lincei* (Rome: Salviucci, 1883)

Casa Buonarroti: Arte e storia in biblioteca (Milan: Charta, 1995)

Casa Buonarroti: Il Museo (Milan, Florence: Charta, 1993)

Casale, Gerardo, *Giovanna Garzoni* (Milan: Jandi Sapi ed. 1991)

Casey, Paul F., *The Susanna Theme in German Literature. Variations of the Biblical Drama* (Bonn: Bouvier, 1976)

Cassiano dal Pozzo, Atti del seminario internazionale di studi, ed. F. Solinas, (Rome: De Luca, 1989)

Castiglione, Baldassarre, *Il cortegiano,* ed. B. Maier (Turin: UTET, 1955)

Castronovo, Valerio, 'Borghese Caffarelli, Scipione', *Dizionario Biografico degli Italiani,* vol. 2 (Rome: Istituto dell'Enciclopedia Italiana, 1970), 620–624.

Causa, Raffaello, 'La pittura del Seicento a Napoli dal naturalismo al Barocco', in *Storia di Napoli,* vol V (Naples: Società editrice Storia di Napoli, 1972), 915–994

Cavaliere d'Arpino (Il), exhibition cat. (Rome: H. Roettgen, 1973)

Cavazzini, Patrizia, 'New documents for Cardinale Alessandro Peretti Montalto's Frescoes at Bagnaia', *Burlington Magazine* CXXXV (1993), 316–327

Cavazzini, Patrizia, 'La sala dei palafrenieri in Palazzo Lancellotti a Roma', *Paragone* XLVI (1995) (543–545), 16–40

Cavazzini, Patrizia, *Palazzo Lancellotti ai Coronari and Its Fresco Decoration* (Ph.D. dissertation, Columbia University, New York, 1996)

Cavazzini, Patrizia, 'Agostini Tassi and the Organization of His Workshop: Filippo Franchini, Claude Lorrain and the Others', *Storia dell'Arte* XCL (1997)

Cecchi, Alessandro, 'Borghini, Vasari, Naldini e la "Giuditta" del 1564', *Paragone* XXVIII (1977) (323), 100–107

Ceci, Giuseppe, 'Un mercante mecenate del secolo XVII: Gaspare Roomer', *Napoli nobilissima,* n.s. I, (1920), 160–164

Celio, Gaspare, *Memoria delli nomi dell'artefici delle pitture che sono in alcune chiese, facciate e palazzi di Roma* (Naples: S. Bonino, 1638)

Cellini, Benvenuto, *Mèmoires de ma vie* (Paris: Scala, 1992)

Ceremonies of Charles I, The Note Books of John Finet, 1628–1641, ed. A. J. Loomie, (New York: Fordham University Press, 1987)

Chadwick, Whitney, *Women, Art and Society* (New York: Thames and Hudson, 1990)

Chaney, Edward, *The Grand Tour and the Great Rebellion* (Geneva: Slatkine, 1985)

Chaney, Edward, *The Evolution of the Grand Tour* (London: Frank Cass, 1998)

Chantelou, Paul Fréart de, *Journal du chevalier Bernin en France,* with notes by J.-P. Guibbert (Aix-en-Provence: Pandora éditions, 1981)

Chappell, Miles L., 'Cigoli, Galileo and *Invidia*', *Art Bulletin* LVII (1975), 91–98

Chappell, Miles L., *Cardi, Ludovico, detto il Cigoli*, in *Dizionario Biografico degli Italiani*, vol. 19 (Rome: Istituto dell'Enciclopedia Italiana, 1976), 771–776

Chappell, Miles L., 'A Note on Cristofano Allori', *Southeastern College Art Conference Review* IX (1977) (2), 62–68

Charlton, John, *The Queen's House, Greenwich,* (London: H.M. Stationery Office, 1976)

Chastel, André, *L'Art italien* (Paris: Flammarion, 1982)

Cheetham, F.H., 'Hampstead Marshall and Sir Balthazar Gerbier', *Notes and Queries*, VII (1913), 406–408

Chettle, George H., *The Queen's House, Greenwich* (Greenwich: Trustees of the National Maritime Museum, [1937])

Chiarini, Marco, 'Documenti sui pittori Tassi, Saraceni, Lanfranco e Antonio Carracci', *Bollettino d'arte* XLV (1960), 367–368

Chiarini, Marco, 'Gli inizi del Gentileschi', *Arte figurativa* X (1962), 26–28

Chiarini, Marco, 'I quadri della collezione del principe Ferdinando di Toscana', *Paragone* XXVI (1975) (301), 57–98; (303), 75–108; (305) 55–88

Chiarini, Marco, 'Agostino Tassi: Some New Attributions', *Burlington Magazine*, CXXI (1979), 613–629

Christiansen, Keith, *Le Caravage et 'L'esempio davanti del naturale',* (Paris: Gérard Montfort, 1995)

Chubb, Thomas C., *The Letters of Pietro Aretino* (Hamden, Conn.: Archon Books, 1967)

Ciardi, R. P., 'Le regole del disegno di Alessandro Allori e la nascita del dilettantismo pittorico', *Storia dell'Arte* (1971)(12), 267–283

Ciardi, R. P., Galassi, Maria Clelia, Carofano, Pierluigi, *Aurelio Lomi, Maniera e innovazione* (Pisa: Pacini, 1989)

Cicogna, E., *Delle iscrizioni veneziane*, 6 vols, (Venice: G. Orlandelli, 1824–1853)

Cinotti, Mia, *Caravage*, (Paris: Adam Biro, 1991)

Cinotti, Mia, Dell'Acqua, Gian Alberto, *Il Caravaggio e le sue grandi opere da San Luigi dei Francesi* (Milan: Rizzoli, 1971)

Cinotti, Mia *et al.*, *Immagine del Caravaggio. Mostra didattica itinerante* (Milan: Pizzi, 1973)

Civiltà del Seicento a Napoli, exhibition cat., ed. Nicola Spinosa *et al.,* (Naples: Electa, 1984)

Civiltà veneziana nell'età barocca (La), (Florence: Sansoni, 1959)

Claude Lorrain e i pittori lorenesi in Italia nel XVII secolo, exhibition cat., ed. J. Thuillier, (Rome: De Luca, 1982)

Clementi, F., *Il carnevale di Roma,* 2 vols, (Città di Castello: Unione Arti Grafiche, n.d.)

Clifton, James, '"Ad vivum mire depinxit". Toward Reconstruction of Ribera's Art Theory', *Storia dell'Arte* (1995) (83), 111–133

Cloulas, Annie, *Greco* (Paris: Fayard, 1993)

Cochran, Eric W., *Florence in the Forgotten Centuries, 1527–1800. A History of Florence and the Florentines in the Age of the Grandukes* (Chicago and London: University of Chicago Press, 1973)

Coffin, David, R., *Gardens and Gardening in Papal Rome* (Princeton: Princeton University Press, 1991)

Cohen, Elizabeth S., 'No Longer Virgins: Self–Presentation by Young Women in Late Renaissance Rome', in *Refiguring Woman: Perspectives on Gender and the Italian Renaissance,* ed. M. Migiel and J. Schiesari, (Ithaca: Cornell University Press, 1991), 169–191

Cohen, Elizabeth, Cohen, Thomas V., *Words and Deeds in Renaissance Rome; Trials before the Papal Magistrates* (Toronto: University of Toronto Press, 1992)

Colapietra, Raffaele, *Vita pubblica e classi politiche del viceregno napoletano (1634–1734)* (Rome: Ed. di Storia e Letteratura, 1961)

Collins Baker, C. H., *Catalogue of the Pictures at Hampton Court* (Glasgow: Glasgow University Press, 1929)

Colluraffi, Antonio, *Lettere . . .* (Venice: appresso Giacomo Sarzina, 1628)

Colluraffi, Antonio, *Le tumultuazioni della plebe di Palermo* (Palermo, 1651)

Colombier, Pierre du, 'Un texte négligé sur les *Sacrements* de Cassiano dal Pozzo', *Gazette des beaux-arts* CVI (1964)(63), 89–90

Colvin, Howard, *The Canterbury Quadrangle* (Oxford: Oxford University Press, 1988)

Comte, Philippe, 'Judith et Holopherne, ou la naissance d'une tragédie', *Revue du Louvre* XXVII (1977)(3), 137–139

Connors, Joseph, *Borromini and the Roman Oratory: Style and Society* (Cambridge, Mass., New York: MIT Press, 1980)

Contini, Roberto, *Il Cigoli* (n.p.: edizioni dei Soncino, 1991)

Corneille, Pierre, *Œuvres complètes,* ed. G. Couton, 3 vols (Paris: Gallimard, 1985)

Corradini, Sandro, *Caravaggio: materiali per un processo* (Rome: Alma Roma, 1993)

Corti, Gino, 'Il "Registro de'mandati" dell'ambasciatore granducale Piero Guicciardini et la commitenza artistica fiorentina a Roma nel secondo decennio del Seicento', *Paragone* XL (1989)(473), 109–146

Costello, Jane 'The Twelve Pictures "Ordered by Velázquez" and the Trial of Valguarnera', *Journal of Warburg and Courtauld Institutes* XIII (1950), 237–284

Crelly, William R., *The Painting of Simon Vouet* (New Haven and London: Yale University Press, 1962)

Crinò, Anna Maria, 'Due lettere autografe inedite di Orazio e di Artemisia Gentileschi De Lomi,' *Rivista d'Arte* XXIX (1954), 203–206

Crinò, Anna Maria, 'More Letters from Orazio and Artemisi Gentileschi', *Burlington Magazine* CII (1960), 264–265

Crinò, Anna Maria, 'Rintracciata la data di morte di Orazio Gentileschi', *Mitteilungen des kunsthistorischen Institutes in Florenz* IX (1960), 258

Crinò, Anna Maria, 'Documenti inediti sulla vita e l'opera di Jacopo e Giacinto Andrea Cicognini', *Studi seicenteschi* II (1960–1961), 255–286

Crinò, Anna Maria, 'The Date of Orazio Gentileschi's Arrival in London', *Burlington Magazine* CIII (1961), 533

Crinò, Anna Maria, Nicolson, Benedict, 'Further Documents Relating to Orazio Gentileschi', *Burlington Magazine* CIII (1961), 144–145

Cristofano Allori, 1577–1621, exhibition cat., ed. Miles L. Chappell (Florence: Centro Di, 1984)

Croft-Murray, E., *Decorative Painting in England, 1537–1837,* vol. I: *Early Tudor to Sir James Thornhill* (London: Country Life, 1962)

Cropper, Elizabeth, 'Bound Theory and Blind Practice: Pietro Testa's Notes on Painting and the Liceo della Pittura', *Journal of the Warburg and Courtauld Institutes* XXXIV, (1971) 262–296

Cropper, Elizabeth, 'Naples at the Royal Academy', *Burlington Magazine* CXXIII (1983), 104–106

Cropper, Elizabeth, 'New Documents for Artemisia Gentileschi's Life in Florence', *Burlington Magazine* CXXXIII (1993), 760–761

Cuomo, Franco, *Beatrice Cenci* (Rome: Rendina ed., 1994)

Cust, L., 'Notes on Pictures in the Royal Collections', *Burlington Magazine*

XXIII (1913), 150–162, 267–275

D'Amelia, Marina, 'La presenza delle madri nell'Italia medievale e moderna', in *Storia della maternitá,* (Rome: Laterza, 1997)

Da Mosto, Alvise, *L'Accademia. Orazione nell'aprirsi . . . degl'Informi* (Venice: appresso Giacomo Sarzini, 1627)

Dargent, Georgette, Thullier, Jacques, 'Simon Vouet en Italie', in *Saggi e Memorie di Storia dell'Arte,* (Venice: Neri Pozza, 1965), 27–63

Dati, Carlo, *Delle lodi del commendatore Cassiano dal Pozzo* (Firenze: all'insegna della stella, 1664)

Davies, Randall, 'An Inventory of the Duke of Buckingham's Pictures, etc., at York House in 1635', *Burlington Magazine* X (1906–1907), 376, 379–382

Davis, James C., *The Decline of the Venetian Nobility as a Ruling Class* (Baltimore: John Hopkins Press, 1962)

Decorazione pittorica della Palazzina Montalto (La), ed. G. Briganti.

De'Dominici, Bernardo, *Vite dei pittori, scultori ed architetti napoletani,* 3 vols, Naples: tipografia Trani, 1844)

Defoe, Daniel, 'An Academy for Women', in *An Essay upon Projects* (London: Facsimile reprint, Menston Scholar P., 1969 (1697)

De Grazia, Diane, Schleir, Erich, 'St. Cecilia and an Angel: the heads by Gentileschi, the rest by Lanfranco', *Burlington Magazine* CXXXVI, (1994) 73–78

Del Bravo, C., 'Su Cristofano Allori', *Paragone* (1967) (205), 68–83

Delcorno, Carlo, 'Un avversario del Marino: Ferrante Carli', *Studi secenteschi,* XVI (1975), 69–150

Delille, Gérard, *Famille et Propriété dans le Royaume de Naples, XV–XIXᵉ siecles,* (Paris: Ed. de l'Ecole des hautes études en sciences sociales, 1985)

Delumeau, Jean, *Vie économique et sociale de Rome dans la seconde moitié du XVIᵉ siècle* (Paris: Ed. E. Boccard, 1957–59)

Delumeau, Jean, *Rome au XVIᵉ siècle* (Paris: Hachette, 1975)

De Rinaldis, Aldo, 'D'Arpino e Caravaggio', *Bollettino d'Arte* XXIX (1936), 577–580

De Rinaldis, Aldo, 'Le opere d'arte sequestrate al Cavaliere d'Arpino', *Archivi* III (1936), 110–118

De Rinaldis, Aldo, 'Documenti inediti per la storia della R. Galleria Borghese in Roma, II; una inedita nota settecentesca delle opere pittoriche nel palazzo Borghese in Campo Marzio' *Archivi* III (1936), 194–206

De Rinaldis, Aldo, *Neapolitan Painting of the Seicento* (New York: Hacker Art Books, 1976 (1929)

Descartes, René, *Œuvres et lettres* (Paris: ed. A. Bridoux, 1970)

Descriptions des beautés de Gênes et de ses environs (Gênes, Y. Gravier, 1788)

De Seta, Cesare, *Architettura, ambiente e società a Napoli nel'700,* (Turin: Einaudi, 1981)

De Seta, Cesare, *Napoli* (Rome-Bari: Laterza, 1981)

De Seta, Cesare, *Luoghi e architetture perdute* (Rome-Bari: Laterza, 1986)

De Seta, Cesare, *Napoli fra Rinascimento e Illuminismo* (Naples: Electa, 1991)

Desiato, Luca, *Bocca di Leone: avventure di una cortigiana* (Milan: Rizzoli, 1989)

Desiato, Luca, *La Notte dell'angelo: Vita scellerata di Caravaggio* (Milan: Mondadori, 1994)

Dessin à Gênes du XVI^e au XVIII^e siècle (Le) (Paris: Réunion des musées nationaux, 1985)

Dessin à Rome au XVII^e siècle (Le) (Paris: Réunion des musées nationaux, 1988)

Didi-Huberman, Georges, *Devant l'image* (Paris: Éditions de Minuit, 1990)

Di Giacomo, S., *La Prositutzione in Napoli nei secoli XV, XVI, XVII°* (Naples: Ed. Gazzetta di Napoli, 1994)

Dictionnaire de la peinture italienne (Paris: Larousse, 1989)

Dipinti fiamminghi e olandesi della Galleria Doria Pamphilj (Genoa: Tormena editore, 1996)

Dirani, Maria Teresa, 'Mecenati, pittori e mercato dell'arte nel Seicento: il "Ratto di Elena" di Guido Reni e la "Morte di Didone" del Guercino nella corrispondenza del cardinale Bernadino Spada', *Ricerche di storia dell'arte* (1982) (16), 83–94

Disegni e bozzetti di Cristofano Allori, exhibition cat., ed. Giuseppe Cantelli and Giulietta Ghelazzi (Florence: Unione Fiorentina, 1974)

Domenichi, Lodovico M., *La nobiltà delle donne* (Vinegia: appresso G. Giolito de Ferrarii e fratelli, 1551)

Donahue, Kenneth, 'The Ingenious Bellori, a biographical study', *Marsyas* III (1943, 1945), 107–138

Donaldson, Ian *The Rapes of Lucretia. A Myth and Its Transformations,* (Oxford: Clarendon Press, 1982)

D'Onofrio, Cesare, *Roma vista da Roma.* (Rome: Edizioni Liber, 1967)

Donzelli, Carlo, Pilo, Giuseppe Maria, *I pittori del Seicento veneto* (Florence: Ed. Remo Sandron, 1967)

Doria, Gino, *Viaggiatori stranieri a Napoli* (Naples: Guida editore, 1984)

Drake, Stillman, *Galileo at Work: His Scientific Biography* (Chicago and London: University of Chicago Press, 1978)

Dubois, Claude-Gilbert, *Le Baroque*, (Paris: Larousse, 1973)

Duchêne, Jacqueline, *Henriette d'Angleterre* (Paris: Fayard, 1995)

Duchêne, Roger, *Madame de Sévigné ou la chance d'être femme* (Paris: Fayard, 1982)

Duchêne, Roger, 'La Veuve au XVIIᵉ siècle', in *Onze études sur l'image de la femme dans la littérature française du XVIIᵉ siècle*, ed. Wolfgang Leiner (Tübingen and Paris: Narr et Place, 1984)

Duchêne, Roger, *Ninon de Lenclos, la courtisane du Grand Siècle* (Paris: Fayard, 1988)

Dulong, Claude, *Anne d'Autriche* (Paris: Hachette, 1980)

Dulong, Claude, *L'Amour au XVIIᵉ siècle* (Paris: Hachette, 1980)

Dulong, Claude, *La Vie quotidienne des femmes au Grand Siècle* (Paris: Hachette, 1984)

Dulong, Claude, *Marie Mancini* (Paris: Perrin, 1993)

Dumesnil, J., *Histoire des plus célèbres amateurs italiens* (Paris: G. Dentu, 1856)

Dunn, M., 'Piety and Patronage in Seicento Rome: Two Noblewomen and Their Covenants', *The Art Bulletin* LXXVI, (1994(644–663

Dupuy, Micheline, *Henriette de France* (Paris: Perrin 1994)

Elliott, John H., *Olivares*, (Paris: Robert Laffont, 1992)

Emiliani, Andrea, 'Orazio Gentileschi: nuove proposte per il viaggio marchiagiano', *Paragone* IX (1958) (103), 38–57

Enggass, Robert, Brown, Jonathan, *Italy and Spain, 1600–1750, Sources and Documents in the History of Art Series,* ed. H.W. Janson, (Englewood Cliffs, N.J.: Prentice Hall, 1970)

Enggass, Robert, Brown, Jonathan, *Italian Spanish Art, 1600–1750* (Evanston: Northwestern University Press, 1992)

Europa della pittura nel XVII secolo. Ottanta capolavori dai musei ungheresi (L') (Milan: Leonardo Arte, 1993)

Evelyn, John, *John Evelyn's Diary*, ed. E. S. De Beer, 6 vols (Oxford: Clarendon Press, 1955)

Fagiolo Dell'Arco, Maurizio, 'Quarant'hore, fochi d'alegrezza, catafalchi, mascherate e cose simili. Dall'effimero alla struttura stabile in Roma barocca', *Ricerche di storia dell'arte* (1976) (1–2), 45–69

Fagiolo Dell'Arco, Maurizio, *Bibliographia della Festa barocca a Roma* (Rome: A. Pettini, 1994)

Fagiolo Dell'Arco, Maurizio, Carandini, Silvia, *L'Effimero Barocco. Strutture della festa nella Roma del Seicento*, 2 vols (Rome: Bulzoni, 1977–1978)

Fairfax, Brian, *A Catalogue of the Curious Collection of Pictures of George Viliers, Duke of Buckingham,* ed. W. Bathoe (London: 1758)

Famiglia e la vita quotidiana in Europa dal '400 al '600. Fonti e problemi (La), (Rome: Istituto Poligrafico e Zecca dello Stato, 1986)

Favaro, A., *Amici e corrispondenti di Galileo* (Florence: Salimbeni, n.d.)

Febvre, Lucien, *Armour sacré, amour profane* (Paris: Gallimard, 1944)

Feci, Simona, *La formalizzazione dei contratti delle donne a Roma in età moderna* (Doctoral thesis, Istituto Universitario Orientale, Naples, 1997)

Felibien, André, *Entretiens sur les vies et les ouvrages des plus excellents peintres anciens et modernes*, 2 vols, ed. René Demoris (Paris: Les Belles Lettres, 1987)

Felici, Giuseppe, *Villa Ludovisi in Roma* (Rome: no publisher, 1952)

Feminism and Art History: Questioning the Litany, ed. Norma Broude and Mary D. Garrard (New York: Harper and Row, 1982)

Fernandez, Dominique, *Le Promeneur amoureux* (Paris: Plon, 1980)

Fernandez, Dominique, *Le Banquet des anges* (Paris: Plon, 1984)

Fernandez, Dominique, *La Perle et le Croissant* (Paris: Plon, 1995)

Ferrante, Lucia, 'Differenza sociale e differenza sessuale nelle questioni d'onore, Bologna sec. XVII', in *Onore e storia nelle società mediterranee,* ed. G. Pomata (Palermo: La luna, 1989), 105–127

Ferrante, Lucia, 'Pro mercede carnali. Il giusto prezzo rivendicato in tribunale', *Memoria,* 1986) (17), 42–58

Ferrero, Giuseppe G., *Marino e i Marinisti* (Milano-Naples: R. Ricciardi, 1954)

Festa a Roma dal Rinascimento al 1870 (La), exhibition cat., ed. M. Fagiolo and M. Fagiolo dell'Arco (Turin: Allemandi, 1997)

Feste e Apparati Medicei da Cosimo I a Cosimo II, ed. Giovanna Gaeta Bertelà and Annamaria Petrioli Tofani (Florence: Leo S. Olschki Editore, 1969)

Fetis, F. J., *Biographie universelle des musiciens* (Paris: Didot, 1863) vol 5, 194–195

Filipczak, Zaremba Z., *Picturing Art in Antwerp, 1500–1700* (Princeton: Princeton University Press, 1987)

Fine, Elsa Honig, *Women and Art. A History of Women Painters and Sculptors from the Renaissance to the Twentieth Century* (Montclair, N.J., London:

Allenheld and Schram/Prior, 1978)

Flandrin, Jean-Louis, *Familles* (Paris: Le Seuil, 1955)

Fochessati, G., *I Gonzaga di Mantova e l'ultimo duca* (Milan: Ceschina, 1930)

Foisil, Madeleine, *La Vie quotidienne au temps de Louis XIII* (Paris: Hachette, 1992)

Fontana, G. J., *Cento palazzi di Venezia, prima ristampa dall'originale* (Venice: G. Scarabellis, 1934)

Forcella, Vincenzo, *Iscrizioni delle chiese e d'altri edificii di Roma dal sec. XI fino ai giorno nostri,* 14 vols (Rome: Tip. delle scienze matematiche e fisiche, 1869–1884)

Fornilli, Carlo Cirillo, *Delinquenti e carcerati a Roma alla metà del Seicento* (Rome: Pontificia Università Gregoriana Editrice, 1991)

Freedberg, David, 'Fame, Convention and Insight: on the Relevance of Forenbergh and Gerbier', *The Ringling Museum of Art Journal* I (1983), 236–257

Freedberg, Sydney J., 'Gentileschi's "Madonna with the Sleeping Christ Child"', *Burlington Magazine* CXVI (1974), 730, 732–735

Freedberg, Sydney J., *Autour de 1600* (Paris: Gallimard, 1993)

Freedberg, Sydney J., *Painting in Italy, 1500–1600* (New Haven: Yale University Press, 1993)

Friedländer, Walter, *Caravaggio Studies* (Princeton: Princeton University Press, 1955)

Friedländer, Walter, *Mannerisim and Anti-Mannerism in Italian Painting* (New York: Columbia University Press, 1957)

Frohlich-Bume, L., 'A Rediscovered Picture by Artemisia Gentileschi', *Burlington Magazine* LXXVII (1940), 169

Frommel, Christoph Luitpold, 'Caravaggio's Frühwerk und der Kardinal Francesco Maria Del Monte', *Storia dell'Arte* (1971)(9–10), 5–52

Fumagalli, Elena, 'Guido Reni e il cardinale Carlo de'Medici', *Paragone,* XLV (1994) (529–533), 241–246

Fumagalli, Elena, 'Battistello Caracciolo, 1612', *Paragone,* XIV (1993) (519), 89–93

Fumaroli, Marc, *'L'Inspiration du poète' de Poussin. Essai sur l'allégorie du Parnasse* (Paris: Réunion des musées nationaux, 1989)

Fumaroli, Marc, *L'École du silence, le sentiment des images au XVII^e siècle* (Paris: Flammarion 1994)

Gabrieli, Giuseppe, *Il carteggio Linceo della Vecchia Accademia di Federico Cesi*

(1603–1630), 4 vols. (Rome: G. Bardi, tip. dell'Accademia Nazionale dei Lincei, 1939–1942)

Galassi, M. C., 'L'attività genovese di Aurelio Lomi', *Studi di storia dell'Arte* IV (1981–1982), 95–139

Galasso, Giuseppe, *Napoli spagnola dopo Masaniello,* 2 vols (Florence: Sansoni editore, 1982)

Galasso Calderara, Estella, *La Granduchessa Maria Maddalena d'Austria* (Florence: Sagep editrice, 1985)

Galilei, Galileo, *Opere complete. Ristampa dell'edizione nazionale,* 20 vols (Florence: Barbera ed., 1929–1939)

Galluzzi, Jacopo, R., *Istoria del Granducato di Toscana sotto il governo della Casa Medici* (Florence: nella stamperia di R. Del Vivo, 1781)

Gamaches, Cyprien de, *Mémoires de la mission des capucins de la province de Paris en Angleterre* (Paris: 1881)

Gamba, C., 'Orazio Gentileschi', *Dedalo* III (1922–1923), 245–266

Gamba, C., 'Aurelio Lomi', in *Enciclopedia italiana di Scienze, Lettere ed Arti*, XXI (Milan-Rome: Istituto dell'Enciclopedia italiana, 1934), 445.

Garas, Clara 'The Ludovisi Collection of Pictures in 1633', *Burlington Magazine* CIX (1967), 287–289, 330–348

Garms, Jörg, *Vedute di Roma, Dal Medioevo all'Ottocento*, 2 vols (Naples: Electa, 1995)

Garrard, Mary, D., 'Artemisia Gentileschi's *Self-Portrait as the Allegory of Painting',* Art Bulletin LXII (1980) 97–112

Garrard, Mary, D., 'Review of Laura M. Ragg, The Women Artists of Bologna (1907)', *Woman's Art Journal* II, fall/winter (1980–1981), 58–64

Garrard, Mary, D., 'Artemisia Gentileschi: The Artist's Autograph in Letters and Painting', in Donna C. Stanton, guest ed. 'The Female Autograph', *New York Literary Forum* (1984) (12–13), 91–105

Garrard, Mary, D., *Artemisia Gentileschi. The Image of the Female Hero in Italian Baroque Painting* (Princeton: Princeton University Press, 1989)

Garrard, Mary, D., 'Artemisia Gentileschi's "Corisca and the Satyr"', *Burlington Magazine* CXXXV (1993) 34–37

Gash, John, *Caravaggio* (London: Jupiter Books Publishers, 1980)

Gavazza, Ezia, Nepi Scire, Giovanna, Rotondi Terminiello, Giovanna, *Bernardo Strozzi* (Milan: Electa, 1995)

Genova nell'età barocca, ed. E. Gavazza and G. Rotondi Terminiello (Genoa: Nuova Alfa Editoriale, 1992)

Gerard, André-Marie, *Dictionnaire de la Bible* (Paris: Robert Laffont, 1992)

'Gerbier, Sir Balthazar' in *Dictionary of National Biography* 1106–1108

Geymonat, Ludovico, *Galilée* (Paris: Le Seuil, 1992)

Ghelli. M. E., 'Il viceré marchese del Carpio (1683–1687)', *Archivio storico per le province napoletane* n.s. XIX (1933), 280–318, n.s. XX (1934), 257–282

Giffi Ponzi, Elisabetta, 'Gentileschi a Genova: un nuovo dipinto e alcune considerazioni sulla cronologia delle opere', *Bollettino dei Musei civici genovesi* XVI (1994), 51–66

Gigli, Giacinto, *Diario di Roma* (Rome: Colombo editore, 1994)

Ginzburg, Silvia 'The Portrait of Agucchi at York reconsidered', *Burlington Magazine* CXXXVI (1994), 4–14

Giovanni Francesco Barbieri: il Guercino, 1591–1666, ed. Sir Denis Mahon (Bologna: Nuova Alfa ed., 1991)

Giustiniani, Vincenzo, *Galleria Giustiniana del Marchese Vincenzo Giustiniani*, 2 vols (Rome; 1631)

Goldberg, Edward, *After Vasari: History, Art and Patronage in Late Medici Florence* (Princeton: Princeton University Press, 1988)

Gombrich, Ernst, *Histoire de l'art,* (Paris: Flammarion, 1994)

Gonzales Moreno, J., *Don Fernando Enrique di Ribera tercer Duque de Alcalá de los Gazules, 1583–1637* (Seville: 1969)

Gordon, D. J., 'Poet and Architect: The Intellectual Setting of the Quarrell between Ben Jonson and Inigo Jones', *Journal of the Warburg and Courtauld Institutes* XII (1949), 152–178

Gordon, D. J., 'Rubens and the Whitehall Ceiling', in *The Renaissance Imagination: Essays and Lectures,* ed. Stephen Orgel (Berkeley and Los Angeles: University of California Press, 1975), 24–50

Gotch, J. Alfred, *Inigo Jones* (London: Methuen, 1928)

Grabski, Jòzef, 'On Seicento Painting in Naples. Some Observations on Bernardo Cavallini, Artemisia Gentileschi and Others'. *Artibus et historiæ* VI (1985), 23–40

Graham, F. L., *The Earlier Life of and Work of Nicholas Lanier Collector of Painting and Drawings* (Ph.D. Diss., Columbia University, New York, 1955)

Grand Siècle: peintures françaises du XVIIᵉ siècle dans les collections publiques françaises, Paris: Réunion des musées nationaux, 1993)

Grand Tour. Il fascino dell'Italia nel XVIII secolo, ed. Andrew Wilton and Ilaria Bignamini (Milan: Skira editore, 1997)

Graves, Algernon, *Art Sales. From Early in the Eighteenth Century to Early in the Twentieth Century* (New York: Franklin, 1970)

Gregg, Pauline, *Charles 1ᵉʳ* (Paris: Fayard, 1984)

Gregori, Mina, 'Avant-propos sulla pittura fiorentina del Seicento', *Paragone* XIII (1962) (145), 21–40

Gregori, Mina, 'Nuovi accertamenti in Toscana sulla pittura "caricata" e giocosa', *Arte antica e moderna* (1961) (13–16), 400–16

Gregori, Mina, 'Su due quadri caravaggeschi a Burghley House', *Festschrift Ulrich Middeldorf*, ed. Antje Kosegarten and Peter Tigler (Berlin: De Gruyter, 1968), 414–421

Gregori, Mina, 'Note su Orazio Riminaldi e i suoi raporti con l'ambiente romano', *Paragone* XXIII (1972) (269), 35–66

Gregori, Mina, Blasio, Silvia, *Firenze nella pittura e nel disegno dal Trecento al Settecento* (Florence: Silvana Editoriale, 1994)

Griffiths, Anthony, 'The Print Collection of Cassiano dal Pozzo', *Print Quarterly* VI (1989), 3–10

Grimal, Pierre, *Dictionnaire de la mythologie* (Paris: Presses universitaires de France, 1994)

Gronau, Georg, *Documenti aristici urbinati* (Florence: G. C. Sansoni, 1936)

Guercino (Giovanni Francesco Barbieri), 1591–1666 (Il), exhibition cat., ed. D. Mahon, (Bologna: Alfa, 1968)

Guglielmi, Carla, 'Intorno all'opera pittorica di Giovanni Baglione', *Bollettino d'arte* XXXIX (1954), 311–326

Guglielmi, Carla, 'Baglione, Giovanni', in *Dizionario Biografico degli Italiani*, vol.5 (Rome: Istituto dell'Enciclopedia Italiana, 1963), 187–191

Guide Rionali di Roma, Rione IV. Campo Marzio, ed. P. Hoffmann (Rome: Fratelli Palombi editore, 1981)

Guido Reni, 1575–1642, exhibition cat. (Bologna: Nuova Alfa ed., 1988)

Hamilton, Elizabeth, *Henrietta Maria,* (New York: Coward, McCann and Geoghegan, 1976)

Hanotaux, Gabriel, *Recueil des instructions données aux ambassadeurs et ministres de France*, VI, *Rome, 1648–1687* (Paris: F. Alcan, 1888)

Harris, Ann Sutherland, *Andrea Sacchi* (Oxford: Phaidon, 1977)

Harris, Ann Sutherland, Nochlin, Linda (eds.), *Women Artists, 1550–1950* (New York: Los Angeles County Museum of Art, Alfred A. Knopf, 1976).

Harris, Enriqueta, 'El Marqués del Carpio y sus cuadros de Velázques',

Archivo Español de Arte XX (1957) (118), 136–139

Harris, Enriqueta, 'Velázques's portrait of Camillo Massimi', *Burlington Magazine* C (1958), 279–280

Harris, Enriqueta, 'La misión de Velázques in Italia', *Archivo Español de Arte* XXIII (1960) (130–131), 162–166

Harris, Enriqueta, 'A letter from Velázques to Camillo Massimi', *Burlington Magazine* CII (1960), 162–166

Harris, Enriqueta, 'Orazio Gentileschi's "Finding of Moses" in Madrid', *Burlington Magazine* CIX (1967) , 86–89

Harris, Enriqueta, 'Cassiano dal Pozzo on Diego Velázques', *Burlington Magazine* CXII (1970), 364–373

Harris, Enriqueta, Andres, Gregorio de, 'Descripcións del Escorial pro Cassiano dal Pozzo (1626)', *Archivo Español de Arte* (1972)

Harris, John, 'A Prospect of Whitehall by Inigo Jones', *Burlington Magazine* CIX (1967), 89–90

Harris, John, 'The Link between a Roman second-century sculptor, Van Dyck, Inigo Jones and Queen Henrietta Maria', *Burlington Magazine* CXV (1973), 526–530

Harris, John, Bellaigue, Geoffrey de, Millar, Oliver, *Buckingham Palace* (London: Thomas Nelson, 1968)

Harris, John, Orgel, Stephen, Strong, Roy, *The King's Arcadia: Inigo Jones and the Stuart Court*, exhibition cat., (London: Arts Council of Great Britain, 1973)

Haskell, Francis, 'Painting and the Counter Reformation,' *Burlington Magazine* C (1958), 396–399

Haskell, Francis, 'The market for Italian art in the 17th century', *Past and Present* (1959)(15), 48–59

Haskell, Francis, 'Art exhibtions in Seventeenth century Rome'. *Studi secenteschi* I (1960), 107–121

Haskell, Francis, 'A note on artistic contacts between Florence and Venice in the 18th century', *Bollettino dei Musei civici veneziani* V (1960), 32–37

Haskell, Francis, *Mécènes et peintres: L'Art et la société au temps du baroque italien* (Paris: Gallimard, 1991); French edition of *Patrons and Painters* (Yale University Press)

Haskell, Francis, *L'Amateur d'art* (Paris: Librairie générale française, 1997)

Haskell, Francis, Levey, M., 'Art exhibtions in 18th century Venice', *Arte veneta* (1958), 179–185

Haskell, Francis, Rinehart, Sheila, 'The Dal Pozzo Collection: Some New Evidence', *Burlington Magazine* CII (1960), 318–326

Haskell, Francis, Penny, Nicholas, *Taste and the Antique. The Lure of Classical Sculpture, 1500–1900,* (London and New Haven: Yale University Press, 1981)

Hazard, Paul, *La Crise de la conscience européenne (1680–1715),* (Paris: Ancienne Librairie Furne Boivin et Cie, 1935)

Held, Julius, S., 'Ruben's Sketch of Buckingham Rediscovered', *Burlington Magazine* CXVIII (1976), 547–551

Heller, Nancy G., *Women Artists* (New York, London, Paris: Abbeville Press Publishers, 1977)

Herrmann, Frank, *The English as Collectors* (London: Chatto and Windus, 1971)

Hersant, Yves, *Italies* (Paris: Robert Laffont, 1988)

Hervey, Mary F. S., *The Life, Correspondence and Collections of Thomas Howard, Earl of Arundel* (Cambridge: Cambridge University Press, 1921)

Hess, Jacob, *Agostini Tassi, der Lehrer des Claude Lorrain. Ein Beitrag zur Geschichte der Barockmalerei in Rome* (Munich: im selbstverlag des authors, 1935)

Hess, Jacob, 'Precisazioni su Orazio Gentileschi', *English Miscellany* IV (1953) 247–256

Hess, Jacob, 'Villa Lante di Bagnaia e Giocomo Del Duca', *Palatino* X (1966) 21–32

Hess, Jacob, *Kunstgeschichtliche Studien zu Renaissance und Barock*, 2 vols (Rome: Edizioni di Storia e Letteratura, 1967)

Hibbard, Howard, *Caravaggio* (London: Thames and Hudson, 1988)

Hibbard, Howard, *Le Bernin* (Paris: Macula 1965)

Hibbard, Howard, 'Scipione Borghese's Garden Palace on the Quirinal', *Journal of the Society of Architectural Historians* XXIII (1964), 163–192

Hibbard, Howard, *Carlo Maderno and Roman Architecture, 1580–1630,* (London: 1971)

Hibbard, Howard, 'Recent Books on Earlier Baroque Architecture in Rome', *Art Bulletin* LV (1973) 127–135

Hibbert, Christopher, *Rome, the Biography of a City* (London: Viking Press, 1995)

Hill, C. P., *Who's Who in Stuart Britain* (London: Shepheard-Walwyn, 1988)

History of the King's Work (The), ed. H. M. Colvin (London: Her Majesty's

Stationery Off., 1982)

Hochmann, Michel, 'La collection de Giacomo Gontarini', *Mélanges de l'École française de Rome; Moyen Âge – Temps modernes* XCIX (1971),(1), 447–489

Hochmann, Michel, *Peintres et Commanditaires á Venise (1540–1628)* (École française de Rome, 1992)

Hofrichter, Frima Fox, 'Artemisia Gentileschi's Uffizi *Judith* and a Lost Rubens', *The Rutgers Art Review* I (1980), 9–15

Hofrichter, Frima Fox, 'Judith Leyster's "Self-Portrait": "Ut pictura poesis"', *Essays in Northern European Art Presented to Egbert Haverkamp-Begemann on His Sixtieth Birthday* (The Netherlands: Davaco Doornspijk, 1983), 106–109

Hoogewerff, Gottfried Johannes, *Bescheiden en Italie omtrent Nederlandsche Kunstenaars en Geleerden*, vols. 2–3 (Gravenhage: M. Nijoff, 1913)

Hoogewerff, Gottfried Johannes, 'Il conflitto fra la insigne Accademia di san Luca e la banda dei pittori neerlandesi', *Archivio della società romana di storia patria* LVIII (1935), 189–203

Hoogewerff, Gottfried Johannes, 'Nederlandsche Kunstenaars te Rome, 1600–1725. Uittreksels uit de parochiale Archieven: I, Parochie van Santa Maria del Popolo', *Mededelligen van het Nederlandsch Historische Instituut te Rome* VIII (1938), 49–125

Hoogewerff, Gottfried Johannes, *Die Bentveughels* (Gravenhage: Martinus Nijhoff, 1952)

Hoogewerff, Gottfried Johannes, 'Via Margutta: centro di vita artistica', *Studi romani* I (1953), 135–154; 270–290

Howard, George, *Castle Howard* (London and New York: 1958)

Howarth, David, *Lord Arundel and his Circle* (New Haven: Yale University Press, 1985)

Imbert, Gaetano, *La Vita fiorentina secondo memorie sincrone (1644–1677),* (Florence: R. Bemporad, 1906)

Imparato, Francesco, 'Documenti relativi ad Artemisia Lomi Gentileschi pittrice', *Archivio storico dell'Arte* II (1889), 423–425

Important Italian Baroque Paintings, 1600–1700, exhibition cat. (London: Matthiesen Fine Art Ltd., 1981)

In the Light of Caravaggio, exhibition cat. (London: Trafalgar Galleries, 1976)

Inigo Jones, Complete Architectural Drawings, exhibition cat., ed. J. Harris and G. Higgott (New York: the Drawing Center, 1989)

Italian Art and Britain, exhibition cat., ed. Ch. Wheeler and D. Mahon (London: Royal Academy of Arts, 1960)

Ivanoff, Nicola, *Valentin de Boulogne* (Milan: Fratelli Fabbri Editori, 1966)

Ivanoff, Nicola, 'Gian Francesco Loredan e l'ambiente artistico a Venezia nel Seicento', *Ateneo veneto* CLVI (1965), 186–190

Jacques Callot, 1592–1635, exhibition cat. (Paris: Réunion des musées nationaux, 1992)

Jacques Callot, papers from the conference organised by D. Ternois, Musée du Louvre, Ville de Nancy, Klincksieck, Paris, 1993.

Jaffe, M., 'Peter Paul Rubens and the Oratorian Fathers', *Proporzioni* IV (1963), 209–241

Jamis, Rauda, *Artemisia ou la Renommée* (Paris: Presses de la Renaissance, 1990)

Jonson, Ben, *The Complete Masque*, ed. S. Orgel (New Haven and London: Yale University Press, 1969)

Judson, J. Richard, *Gerrit van Honthorst: A Discussion in Dutch Art*, 2nd edn (The Hague: M. Nijhoff, 1959)

Jusepe de Ribera, ed. Alfonso E. Perez Sanchez and Nicola Spinosa (Naples: Electa, 1992)

Jusepe de Ribera, lo Spagnoletto, 1591–1652, ed. Craig Felton and William B. Jordan (Fort Worth: Kimbell Art Museum, 1982)

Justi, Carl, *Diego Velázquez and His Time* (London: H. Grevel, 1889)

Kahr, Madlyn Millner, 'Velázquez and *Las Meninas*', *Art Bulletin* LVII (1975), 225–246

Kahr, Madlyn Millner, *Velázquez: The Art of Painting* (New York: Harper and Row, 1976)

Kahr, Madlyn Millner, 'Danaë: Virtuous, Voluptuous, Venal Woman', *Art Bulletin*, LX (1978), 43–55

Kaufman, Helen Andrews, *Conscientious Cavalier, Colonel Bullen Reymes, MP, FRS, 1613–1672, The Man and his Time* (London: Jonathan Cape, n.d.)

Kaufmann, Thomas Da Costa, 'Ester before Ahasuerus: A New Painting by Artemisia Gentileschi in the Museum's Collection', *The Metropolitan Museum of Art Bulletin* XXIX (1970), 165–169

Keith, W. Grant, 'The Queen's House, Greenwich,' *Journal of the Royal Institute of British Architects* XLIV (1936–1937), 943–947

Kelly, Joan, 'Early Feminist Theory and the *Querelle des Femmes, 1400–1789*',

Signs VIII (1982), 4–28

King's Pictures (The), exhibition cat. (London: Royal Academy of Arts, n.d.)

Kirkendale, Workin, *The Court Musicians in Florence* (Florence: Leo S. Olschki Editore, 1993)

Klapische-Zuber, Christiane, *La famiglia e le donne nel Rinascimento a Firenze,* (Rome-Bari: Laterza, 1988)

Klapische-Zuber, Christiane, *La Maison et le Nom — Stratégies et rituels dans l'Italie de la Renaissance* (Ehess, 1900)

Koortbojian, Michael, *Autoportraits* (Paris: Réunion des musées nationaux, 1992)

Krautheimer, Richard, *Roma di Alessandro VII, 1655–1667* (Rome: Edizioni dell'Elefante, 1987)

Krautheimer, Richard and Jones, Roger, 'The Diary of Alexander VII: Notes on Art, Artists and Bulding', *Römisches Jahrbuch für Kunstsgeschichte* XV (1975) 199–233

Kuehn, Thomas, *Law, Family and Women, Toward Legal Anthropology of Renaissance Italy* (Chicago: University of Chicago, 1991)

La Blanchardiere, Noëlle de, 'Simon Vouet, prince de l'académie de Saint-Luc', *Bulletin de la Société de l'histoire de l'art français* (1972), 79–93

Labrot, Gérard, *Baroni in città. Residenze e comportamenti dell'aristocrazia napoletana, 1530–1734* (Naples: Società editrice napoletana, 1979)

Labrot, Gérard, *L'Image de Rome* (Seysel: Champ Vallon, 1987)

Labrot, Gérard, *Collection of Paintings in Naples, 1600–1780* (Paris: Saur, 1992)

Labrot, Gérard, *Études napolitaines. Villages, palais, collections, XVII–XVIII^e siecles* (Seysel: Champ Vallon, 1993)

Labrot, Gérard, 'La critique du maniérisme dans les traités du XVI^e siècle', in *Du manierisme au baroque,* papers from the Chambery conference (1997), 41–56.

Lambert, Gilles, *Caravage, la gloire d'un scélérat* (Paris: Mengès, 1988)

Lange, Bente, *I colori di Roma. Spazi urbani e facciate dal Rinascimento ad oggi* (Rome: Edizioni d'Europa, 1993)

Larsen, Erik, 'Van Dyke's English Period and Cavalier Poetry', *Art Journal* XXXI (1972), 252–260

Larsen, Erik, *L'Opera completa di Van Dyck*, 2 vols (Milan: Rizzoli, 1980)

Larsen, Erik, *The Paintings of Anthony Van Dyck* (Freren: Luca Verlag, 1988)

La Serre, J.-P. de, *Histoire de l'entrée de la Reyne Mère du Roy Très-Chrestien dans*

la Grande-Bretagne, par Jean Raworth, pour George Thomason et Octavian Pullen, à Londre, 1639.

Late King's Goods. Collections, Possessions and Patronage of Charles I in the Light of the Commonwealth Sale Inventories (The), ed. Arthur MacGregor (London and Oxford: McAlpine and Oxford University Press, 1989)

Lavin, Marilyn Aronberg, *Seventeenth-Century Barberini Documents and Inventories of Art* (New York: New York University Press, 1975)

Lavinia Fontana, ed. Vera Fortunati (Milan: Electa, 1994)

Law, Ernest, The New Authorised Historical Catalogue of the Pictures and Tapestries in the King's Collection at Hampton Court (London: Hughes Hees, 1911)

Leach, Mark C., 'Rubens' *Susanna and the Elders* in Munich and Some Early Copies', *Print Review* V (1976), 120–127

Lebrun, François, *Le XVII*ᵉ *Siècle* (Paris: A. Colin, 1995)

Lee, Rensselaer, W., *Ut pictura poesis* (Paris: Macula, 1991)

Lees-Milne, James, *The Age of Inigo Jones* (London: Batsford, 1953)

Le Moyne, Pierre, *La Galerie des femmes fortes*, 2 vols (Lyon: Les Librairies de la Compagnie, 1667)

Leone, Nino, *La Vita quotidiana a Napoli ai tempi Masaniello* (Milan: Rizzoli, 1994)

Lescourret, Marie-Anne, *Pierre Paul Rubens,* (Paris: J.-C. Lattès, 1990)

Le Roy Ladurie, Emmanuel, *L'Ancien Régime (1610–1715)* (Paris: Hachette, 1993)

*Le XVII*ᵉ *siècle au Musée des beaux-arts de Nantes* (Nantes: Musée des beaux-arts de Nantes, 1993)

Levey, Michael, *Painting in 18th Century Venice* (London: Phaidon, 1959)

Levey, Michael, 'Notes on the Royal Collection, II: Artemisia Gentileschi's "Self-Portrait" at Hampton Court', *Burlington Magazine* CIV (1962), 79–80

Levey, Michael, 'Charles I and Baglione', *Burlington Magazine* CIV (1962), 334–374

Levey, Michael, *The Later Italian Pictures in the Collection of Her Majesty the Queen* (Greenwich, Conn. and London: New York Graphic Society, 1964)

Levey, Michael, 'Sacred and Profane Significance in Two Paintings by Bronzino', *Studies in Renaissance and Baroque Art Presented to Anthony Blunt* (London and New York: Phaidon, 1967) 30–33

Levi, Cesare A., *Le collezioni veneziane d'arte e d'antichità dal secolo XIV ai nostri*

giorni (Venezia: F. Ongania, 1900)

Levi Pisetsky, Rosita, *Storia del costume in Italia*, vol. 3 (Milan: Istituto Editoriale Italiano, 1966)

Lewis, Lesley, *Connoisseurs and Secret Agents in XVIIIth Century Rome* (London: Chatto and Windus, 1961)

Limentani, U., 'I Capitolo di Buonarroti il Giovane a Niccolo Arrighetti', *Studi secenteschi* XVI (1975) 3–42

Livorno e Pisa: due città e un territorio nella politica dei Medici, exhibition cat. (Pisa: Pacini e Nistri Lischi, 1980)

Logan, Olivier, *Culture and Society in Venice, 1470–1790, The Renaissance and its Heritage* (London: Batsford, 1972)

Loire, Stéphane, Brejon de Lavergnee, Arnaud, *Caravage, La Mort de la Vierge* (Paris: Adam Biro, 1990)

Lombardi, Ferruccio, *Roma, palazzi, palazzetti, case: progetto per un inventario, 1200–1870* (Rome: Edilstampa, 1992)

Longhi, Roberto, 'Gentileschi, padre e figlia', *L'Arte* XIX (1916), 245–314

Longhi, Roberto, 'Ultimi studi su Caravaggio e la sua cerchia', *Proporzioni* I (1943), 5–63

Longhi, Roberto, 'Sui margini caravaggeschi', *Paragone* II (1951) (21), 20–34

Longhi, Roberto, *Sritti giovanili, 1912–1922* 2 vols. (Florence: Sansoni, 1961)

Longhi, Roberto, 'Progetti di lavoro di Roberto Longhi su Genova pittrice (1938–1946)', *Paragone* XIX (1979) (349–351), 4–25

Longhi, Roberto, 'Velázquez 1630: "La rissa all'ambasciata di Spagna"', *Paragone* I (1950)(1), 28–34

Longhi, Roberto, 'Il Goya romano e la "cultura di via Condotti"', *Paragone* V (1954) (53), 28–39

Longhi, Roberto, 'Un collezionista di pittura napoletana nella Firenze del '600', *Paragone* VII (1956) (75), 61–64

Longhi, Roberto, 'Il vero "Maffeo Barberini" del Caravaggio', *Paragone* XIV (1963) (165), 3–11

Longhi, Roberto, *Caravaggio* (Rome: Editori Riuniti, 1982)

Loomie, A. J., *Ceremonies of Charles I* (London: Variorum, 1987)

Loomie, A. J., *Spain and the Early Stuarts, 1585–1655* (London: Variorum, 1996)

Loredano, G., Francesco, *Il Cimiterio, Epitafi giocosi*, (Venice: appresso Domenico Bona, 1680)

Lucie-Smith, Edward, ed., *Art Anecdotes* (London: Faber and Faber, 1992)

Lurie, Ann Tzeutschler, 'Pictorial Ties between Rembrandt's Danaë in the Hermitage and Orazio Gentileschi's Danaë in the Cleveland Museum of Art', *Acta Historiæ Artium* XXI (1975), 75–81

Luzio, Alessandro, *La Galleria dei Gonzaga venduta all'Inghilterra nel 1627–1628* (Milan: Cogliati, 1913)

Magnuson, Torgil, *Rome in the Age of Bernini* (New Jersey, USA: Humanities Press, 1982)

Mahon, Denis, *Studies in Seicento Art and Theory* (London: Warburg Institute, University of London, 1947)

Mahon, Denis, 'Guercino's paintings of Semiramis', *Art Bulletin* XXXI (1949), 217–223

Mahon, Denis, 'Addenda to Caravaggio', *Burlington Magazine* XCIV (1952), 3–23

Mahon, Denis, 'Poussin's early development: an alternative hypothesis', *Burlington Magazine* CII (1960), 288–304

Mahon, Denis, 'Mazarin and Poussin', *Burlington Magazine* CII (1960), 352–354

Mahon, Denis, 'Réflexions sur les paysages de Poussin', *Art de France* (1961)(1), 119–132

Mahon, Denis, 'Poussiniana. Afterthoughts arising from the exhibition', *Gazette des Beaux-Arts* LX (1962), 1–138

Major, Suzan Germond, 'Orazio Gentileschi and S. Giovanni dei Fiorentini', *Burlington Magazine* CXXXV (1993), 754–58

Malamani, V., *Rosalba Carriera* (Bergamo: Istituto italiano d'arti grafiche, 1910)

Malanima, Paolo, 'Cioli, Andrea', in *Dizionario biografico degli Italiani,* vol.25, (Rome: Istituto dell'Enciclopedia Italiana, 1981), 666

Male, E., *L'Art religieux de la fin du XVIᵉ siècle, du XVIIᵉ siècle et du XVIIIᵉ siècle: étude sur l'iconographie après le concile de Trente, Italie, France, Espagne, Flandres* (Paris: A. Colin, 1951)

Malvasia, Carlo Cesare, *Felsina pittrice. Vite de' pittori bolognese,* 2 vols (Bologna: A. Forni, 1967)

Mamone, Sarah, *Il Teatro nella Firenze medicea* (Milan: Mursia, 1981)

Mancini, Giulio, *Consierazioni sulla pittura. Viaggio per Roma,* ed. Adriana Marucchi and Luigi Salerno, 2 vols (Rome: Accademia Nazionale dei

Lincei, 1956–57)

Mann, Judith, W., 'The Gentileschi Danae in the Saint Louis Art Museum, Orazio or Artemisia?', *Apollo* CXII (1996), 39–45

Marcheix, L., *Un Parisien à Rome at à Naples en 1632* (Paris: S. Leronc, n.d.)

Marin, le Cavalier, *Madrigaux* (n.p.: La Différence, 1992)

Marini, Maurizio, *Io Michelangelo da Caravaggio* (Rome: Studio B, Bestetti e Bozzi, 1974)

Marini, Maurizio, *'Michael Angelus Caravaggio Romanus'* (Rome: De Luca, 1978)

Marini, Maurizio, 'Caravaggio e il naturalismo internazionale', in *Storia dell'Arte italiana*, VI, *Dal Cinquecento all'Ottocento*, 1, *Cinquecento e Seicento* (Turin: Einaudi, 1981), 347–445

Marini, Maurizio, *Caravaggio. Michelangelo Merisi da Caravaggio 'pictor prœstantissimus'*, (Rome: Newton Compton, 1989)

Marino, Giovan Battista, *La Galeria* (Venice: Ciotti, 1619)

Martin, Gregory, 'The Banqueting House ceiling. Two newly-discovered projects', *Apollo* CXXXIX (1994), 29–34

Martin, John Rupert, *Baroque* (New York: Harper and Row, 1977)

Martinelli, Valentino, 'L'Amor Divino "tutto ignudo" di Giovanni Baglione e la cronologia dell'intermezzo caravaggesco', *Arte antica e moderna* II (1959), 82–96

Martini, L., *Aurelio Lomi. Nascita di san Giovanni Battista*, in *Galleria Nazionale di Palazzo Spinola. Interventi di restauro,* Quaderno n.6. (Genoa: Sagep, 1983), 35–39

Masera, M. G., *Michelangelo Buonarroti il Giovane* (Turin: Regio Università, 1941)

Massing, Ann, 'Orazio Gentileschi's *Joseph and Potiphar's Wife*: a 17th century use of "vitaminous" paint', *Bulletin of the Hamilton Kerr Institute* (1988), 89–91, 99–104

Matteoli, A., *Ludovico Cardi-Cigoli pittore e architetto* (Pisa: Giardini, 1980)

Matteucci, Anna Maria, *Bernardo Strozzi* (Milan: Fratelli Fabbri Ed., 1966)

Mattia Preti, ed. Erminia Corace (Rome: Fratelli Palombi, 1989)

Maylender, Michele, *Storia delle Academie d'Italia* 5 vols, (Bologna: Cappelli, 1926–1930)

Mazzini, U., 'Due quadri di Aurelio Lomi', *Giornale storico della Lunigiana* IV (1913), 218–221

Mcevansoneya, Philip, 'Some Documents Concerning the Patronage and

Collections of the Duke of Buckingham', *Rutgers Art Review* VIII (1987), 27–38

Medioli, Francesca, *L"Inferno monacale', di Arcangela Tarabotti* (Turin: Rosenberg & Selliers, 1990)

Meloni Trkulja, Silvia, 'Luca Giordano a Firenze', *Paragone* XXIII (1972) (267), 25–74

Mentalità, comportamenti e instituzioni tra Rinascimento e decadenz, 1500–1700, ed. Giuseppe Galasso (Milan: Electa, 1988)

Menzio, Eva *Artimisia Gentileschi/Agostino Tassi. Atti di un processo per stupro* (Milan: Edizioni delle Donne, 1981)

Merola, A., 'Barberini, Antonio', in *Dizionario biografico degli Italiani,* vol.6, (Rome: Istituto dell'Enciclopedia Italiana, 1964), 166–170

Merola, A., 'Barberini, Francesco', in *Dizionario biografico degli Italiani,* vol.6, (Rome: Istituto dell'Enciclopedia Italiana, 1964), 172–176

Merola, A., 'Barberini, Taddeo', in *Dizionario biografico degli Italiani,* vol.6, (Rome: Istituto dell'Enciclopedia Italiana, 1964), 180–182

Merolla, Riccardo, 'L'Accademia dei Desiosi', *Roma moderna e conteporanea* III (1995), 121–155

Mezzetti, Tilde, 'L'attivitá di Orazio Gentileschi nelle Marche', *L'Arte* XXXIII (1930), 541–551

Miani, G., 'Antelminelli, Alessandro' *Dizionario biografico degli Italiani*, vol.3 (Rome: Istituto dell'Enciclopedia Italiana, 1961) 443–445

Michel, Olivier, *Vivre et peindre à Rome au XVIII^e siècle* (École française de Rome, 1996)

Millar, Oliver, 'Charles I, Honthorst, and Van Dyck', *Burlington Magazine* XCVI (1954), 36–42

Millar, Oliver, 'Some Painters and Charles I', *Burlington Magazine* CIV (1962), 325–330

Millar, Oliver, 'The Inventories and Valuations of the King's Goods, 1649–1651', *The Walpole Society* XLIII, Oliver Millar, ed., (1970–1972)

Millar, Oliver, *The Age of Charles I,* (London: The Tate Gallery, 1972)

Millar, Oliver, *The Queen's Pictures* (London: Weidenfeld and Nicolson, 1977)

Millar, Oliver, *Van Dyck in England* (London: National Portrait Gallery, 1982)

Miller, John, *Bourbon and Stuart,* (New York: F. Watts, 1987)

Missirini, Mechior, *Memorie per servire alla storia della Romana Accademia di S.*

Luca fino alla morte di Antonio Canova (Rome: stamperia de Romanis, 1823)

Moir, Alfred, *The Italian Followers of Caravaggio*, 2 vols (Cambridge, Mass.: Harvard University Press, 1967)

Moir, Alfred, *Caravaggio and His Copyists* (New York: New York University Press, 1976)

Moir, Alfred, *Caravaggio* (New York: Harry N. Abrams, 1982)

Molojoli, Bruno, 'A proposito del Gentileschi nelle Marche', *Rassegna marchigiana* IX (1931), 99–106

Molho, Anthony, *Marriage Alliance in Late Medieval Florence* (London: Harvard University Press, 1994)

Monconys, Balthazar de, *Journal des voyages,* 3 vols (Lyon: chez H. Boissat et G. Remeus, 1665–1666)

Montagu, Jennifer, 'The Painted Enigma and French Seventeenth-Cenury Art', *Journal of the Warburg and Courtauld Institutes* XXX (1968), 307–335

Montagu, Jennifer, *An Index of Emblems of the Italian Academies based on Michele Meylander's Storia delle Accademie d'Italia* (London: Warburg Institute, 1988)

Montagu, Jennifer, *Roman Baroque Sculpture* (New Haven: Yale University Press, 1989)

Montagu, Jennifer, 'Antonio Raggi in s. Maria della Pace', *Burlington Magazine* CXXXVI (1994), 836–839

Montaigne, *Essais*, ed. Michel Pierre, 3 vols (Paris: Librairie générale française, 1985)

Montaigne, *Journal de voyage*, ed. Fausta Garavini (Paris: Gallimard, 1983)

Morandi, Clarissa, *Ritratti Medici del Seicento* (Florence: Arnaud, 1995)

Moroni, Gaetano, *Dizionario di erudizione storico-ecclasiastica da san Pietro sino a' nostri giorni*, 109 vols, (Venice: Tipografia Emiliana, 1840–1879)

Moroni, Gaetano, *Histoire des chapelles papales* (Paris: Sagnier et Bray, 1846)

Morrona, Alessandro da, *Pisa illustrata nelle arti del disegno* (Pisa: F. Pieracchini, 1787)

Mostra del Cigoli e del suo ambiente, exhibition cat., ed. L. Berti, M. Bucci, A. Forlani, M. Gregori (San Miniato al Tedesco: Giacomelli ed., 1959)

Musica in scena, il Teatro musicale dalle origini al primo Settecento (Turin: UTET, 1975)

Nagler, A. M., *Theatre Festivals of the Medici, 1539–1637* (New Haven and London: Yale University Press, 1964)

Napoli sacra (Naples: Elio de Rosa ed., 1995)

Nappi, E., *Ricerche sul Seicento napoletano. Saggi e documenti per la storia dell'arte* (1992)

National Portrait Gallery Collection (The) (London: National Portrait Gallery Publications, 1994)

Nicodemy, Giorgio, 'Otto lettere di Ludovico Carracci a don Ferrante Carlo', *Aevum* (1935) (3), 305–313

Nicolas Poussin, exhibition cat., ed. Sir Anthony Blunt (Paris: Les Presses artistiques, 1960)

Nicolson, Benedict, 'Caravaggio and the Caravaggesques: Some Recent Research', *Burlington Magazine* CXVI (1974), 603–616

Nicolson, Benedict, *The International Caravaggesque Movement, Lists of Pictures by Caravaggio and His Followers throughout Europe from 1590 to 1650* (Oxford: Phaidon, 1979)

Nochlin, Linda, 'Why Have There Been No Great Women Artists?', *Art News* LXIX (1971)(9), 22–39, 67–71

Nuttall, W. L. F., 'King Charles I's Pictures and the Commonwealth Sale,' *Apollo* LXXXII (1965), 302–309

Orbaan, J. A. F., 'Virtuosi al Pantheon. Archivalische Beiträge zur römischen Kunstgeschichte', *Repertorium für Kunstwissenschaft* XXXVII (1914–1915), 17–52

Orbaan, J. A. F., *Documenti sul Barocco in Roma* (Rome: Soc. romana di storia patria, 1920)

Orso, S. N. *Philip IV and the Decoration of the Alcazar of Madrid* (Princeton N.J.: Princeton University Press, 1986)

Ottani, Anna, *Carlo Saraceni* (Milan: M. Spagnol, 1968)

Ottani, Anna, 'On the Theme of Landscape, II. Elsheimer and Galileo', *Burlington Magazine* CXVIII, (1976), 139–144

Pacelli, Vincenzo, 'New Documents Concerning Caravaggio in Naples', *Burlington Magazine* CXIX (1977), 819–829

Pacelli, Vincenzo, 'Caracciolo studies', *Burlington Magazine* CXX (1978), 493–497

Pacelli, Vincenzo, *Caravaggio: Le sette opere di misericordia* (Salerno: 10/17 Cooperativa editrice, 1984)

Pacheco, Francisco, *Arte de la pintura*, ed. B. Bassegoda i Hugas (Madrid: Cátedra, 1990)

Pages, Georges, *La Guerra de Trente Ans, 1618–1648* (Paris: Payot, 1991)

Paglia, Vincenzo, *'La Pietà dei Carcerati', Confraternite e società a Roma nei secoli*

XVI–XVIII (Rome: Edizioni di Storia e Letteratura, 1980)

Paliaga, Franco, 'Per la storia della pittura di marine in Toscana nel Seicento: aggiornamenti a Pietro Ciafferi', *Antichità viva* XXXII (1993), 13–23

Palisca, Claude F., *The Florentine Camerata* (New Haven: Yale University Press, 1989)

Pallavicino, Ferrante, *Il corriero svaligiato pubbicato da Ginifaccio Spironcini* (Villafranca: G. Gibaldo, 1644)

Pane, Roberto, *Seicento napoletano* (Milan: Edizioni di Comunità, 1984)

Panofsky, Dora, Panofsky, Erwin, *Pandora's Box. The Changing Aspects of a Mythological Symbol* (New York: Pantheon Books, 1956)

Panofsky, Erwin, *Galilée, critique d'art* (Paris: Les Impressions nouvelles, 1992)

Panofsky, Erwin, *Studies in Iconology: Humanistic Themes in the Art of the Renaissance* (New York and Evanston, Ill: Harper Torchbooks, 1962)

Panofsky, Erwin, *Idea: a Concept in Art Theory,* trans. by Joseph J. S. Peake (Columbia, SC: University of South Carolina Press, 1968)

Papi, Gianni, 'Novità sul soggiorno italiano di Gerrit Honthorst', *Paragone* XLI (1990) (479–481), 46–82

Papi, Gianni, *Cecco del Caravaggio* (Florence: Opus Libri, 1992)

Papi, Gianni, *Orazio Borgianni* (Soncino: Edizioni di Soncino, I Cardini, 1993)

Papi, Gianni, 'Artemisia, senza dimora conosciuta', *Paragone* XLVII (1996), 197–202

Parry, Graham, *The Golden Age Restored: Culture of the Stuart Court, 1603–1642* (New York: St. Martin's Press, 1981)

Pascal, Blaise, *Œuvres complètes,* ed. J. Chevalier (Paris: Gallimard, 1969)

Passeri, Giovan Battista, *Vite de' pittori, scultori, ed architetti che ànno lavorato in Roma, morti dal 1641 fino al 1673* (Rome: N. Barbiellini, 1772)

Pastor, L. von, *Storià dei Papi dalla fine del Medioevo* (Rome: Desclée, 1943)

Il Patrimonio artistico del Quirinale, 2 vols (Milan: Electa, 1993)

Peinture à Naples au XVII^e siècle (La), exhibition cat. (Strasbourg: éd. des Musées de la Ville de Strasbourg, 1994)

Peintures françaises du XVII^e siècle, exhibition cat. (Paris: Réunion des musées nationaux, 1982)

Peinture française du XVII^e siècle dans les collections américaines (La), (Paris: Réunion des musées nationaux, 1982)

Peinture italienne: Seicentro, le siècle de Caravage (La), Connaisssance des Arts, (special edition, 1988)

Peiresc, Nicolas Claude Fabri de, *Lettres [...] aux frères Dupuy, publiées par P. Tamizey de Larroque,* 7 vols (Paris: Imprimerie nationale, 1888–1889)

Peiresc, Nicolas Claude Fabri de, *Lettres a Cassiano dal Pozzo (1626–1637),* ed. J.-F. Lhote and D. Joyal (Clermont-Ferrand: Adosa, 1989)

Pepper, D. Stephen, 'Caravaggio and Guido Reni: Contrasts in Attitudes', *Art Quarterly* XXXIV (1971), 325–344

Pepper, D. Stephen, 'Caravaggio riveduto e corretto: la mostra di Cleveland', *Arte illustrata* V (1972), 170–178

Pepper, D. Stephen, 'Orazio Gentileschi and the Poetic Tradition in Caraggesque Painting by R. Ward Bissell – Book Review', *Burlington Magazine* CXXV (1983), 594–596

Pepper, D. Stephen, 'Baroque Painting at Colnaghi's, *Burlington Magazine* CXXVI (1984), 315–316

Pepper, D. Stephen, *Guido Reni, A Complete Catalogue of His Works, an Introductory Text,* (New York: New York University Press, 1984)

Perez Sanchez, Alfonso E., *Borgianni, Cavorozzi y Nardi en España* (Madrid: Instituto Diego Velázquez del Consejo Superior de Investigaciones científicas, 1964)

Perez Sanchez, Alfonso E., *Pintura italiana del siglo XVII en España* (Madrid: Universidad de Madrid, Fundación Valdecilla, 1965)

Perlingieri Ilya, Sandra, *Sofonisba Anguissola, femme peintre de la Renaissance* (Paris: Liana Levi, 1992)

Peters, Edward, *Torture* (Oxford: Basil Blackwell, 1985)

Petrocchi, Massimo, *Roma nel Seicento* (Bologna: Cappelli, 1970)

Pevsner, Nikolaus, *Academies of Art, Past and Present* (Cambridge: Cambridge University Press, 1940)

'Pictures at Hampton Court (The),' Editorial, *Burlington Magazine* LXXXI (1942), 185-186

Philip, I. G. 'Balthazar Gerbier and the Duke of Buckingham's Pictures', *Burlington Magazine* XCIX (1975), 155–156

Piles, Roger de, *Cours de peinture par principes* (Paris: Gallimard, 1989)

Pillorget, René and Suzanne, *France baroque, France classique,* 2 vols (Paris: Robert Laffont, 1995)

Pinelli, Antonio, 'La "philosophie des images". Emblemi e imprese fra manierismo e barocco', *Ricerche di storia dell'arte* (1976), 3–28

Pinetti, A., 'La decorazione pittorica seicentesca di s. Maria Maggiore', *Bollettino della Civica Biblioteca di Bergamo* X (1916), 113–142

Pintard, R., *Le Libertinage érudit dans la première moitié du XVII^e siècle*, 2 vols (Paris: Boisin, 1943)

Pintura italiana del siglo XVII, exhibition cat., ed. Alfonso E. Pérez Sánchez (Madrid: Graficas Reunidas, 1970)

Pittura a Napoli da Caravaggio a Luca Giordano (La) exhibition cat. (Milan: Electa, 1983)

Pittura in Italia. Il Seicenta (La), ed. Mina Gregori, Erich Schleier, 2 vols (Milan: Electa: 1989)

Pittura napoletana del 600 (La), ed. N. Spinosa, (Milan: Longanesi, 1984)

Pizzorusso, Claudio, *Ricerche su Cristoforo Allori* (Florence: Leo S. Olschki editore, 1981)

Pizzorusso, Claudio, 'Rivendendo il Gentileschi nelle Marche', *Notizie del Palazzo Albani* I (1987), 72

Pomian, Krystov, 'Antiquari e collezionisti', in *Storia della cultura veneta,* vol. IV, *Il Seicenta* (Venice: Neri Pozza, 1983), 493–547

Pope-Hennessy, J., 'Some bronze statues by Francesco Fanelli', *Burlington Magazine* XCV (1953), 157–162

Portoghesi, Paolo, 'I monumenti borrominiani della Basilica Lateranense', *Quaderni dell'Istituto di storia dell'architettura* (1955)(11), 1–20

Portoghesi, Paolo, *Roma barocca* (Rome-Bari: Laterza, 1992)

Portoghesi, Paolo, Quattrocchi, Luca, Quilici, Folco, *Baroque et Art nouveau, le miroir de la métamorphose* (Paris: Seghers, 1986)

Posner, Donald, 'Caravaggio's homo-herotic early works', *Art Quarterly* XXXIII (1971), 301–324.

Posner, Donald, *'Annibale Carracci: A Study in the Reform of Italian Painting around 1590,* 2 vols (London: Phaidon, 1971)

Poussin et Rome, paper from a conference at the Académie de France, Rome, 16–18 Nov. 1994 (Paris: Réunion des musées nationaux, 1996)

Poussin, Nicolas, *Lettres . . .,* with an introduction by P. Du Colombier, 2 vols (Paris: La Cité des livres, 1929)

Poussin, Nicolas, *Lettres et propos sur l'art* (Paris: Hermann, 1989)

Pouasin, Sacraments and Bacchanals. Paintings and Drawings on sacred and profane themes by N. Poussin, 1594–1655, exhibition cat. (Edinburgh: National Gallery of Scotland, 1981)

Power, M. J., 'Sir Balthazar Gerbier's Academy at Bethnal Green', *East London Papers* X (1967), 19–33

Pratesi, Ludovico, *Il Rione Ponte* (Rome: Newton Compton, 1994)

Previtali, Giovanni, 'Gentileschi's "The Samaritan Woman at the Well"', *Burlington Magazine* CXV (1973), 358–361

Prinzivalli, Virginio, *Gli Anni Santi (1300–1925)* (Terni: G. Garzoni Provenzani, 1924)

Procacci, Ugo, *La Casa Buonarroti a Firenze* (Milan: Electa, 1968)

Prunières, H., *L'Opéra italien en France avant Lulli* (Paris: E. Champion, 1913)

Pugliatti, Teresa, *Agostini Tassi tra conformismo e libertà* (Rome: De Luca editore, 1978)

Pugliatti, Teresa, 'Chiarimenti e nuove attribuzioni ad Agostino Tassi', *Quaderni dell'Istituto di Storia dell'Arte medievale e moderna. Facoltà di Lettere e Filosofia. Università di Messina* I (1991) (1988), 33–43

Racine, Jean, *Œuvres complètes,* ed. R. Picard (Paris: Gallimard, 1990)

Ragionieri, Pina, *Michel-Ange, invitation à la Casa Buonarroti* (Florence: Artificio, 1995)

Ranke, L., *Histoire de la papauté pendant les XVIe et XVIIe siecles* (Paris: Robert Laffont, 1986)

Redig De Campos, Deoclecio, 'Una "Giuditta" opera sconosciuta des Gentileschi nella Pinacoteca Vaticana'. *Rivista d'arte* XXL (1939), 311–323

Redig De Campos, Deoclecio, *I Palazzi vaticani* (Bologna: Cappelli, 1967)

Redondi, Pietro, *Galilée hérétique* (Paris: Gallimard, 1985)

Reinbold, Anne, *Georges de La Tour,* (Paris: Fayard, 1991)

Relazioni degli ambasciatori veneti al Senato, raccolte, annotate ed edite da E. Alberi, 15 vols (Soc. editrice fiorentina, 1839–1863)

Répertoire des peintures italiennes du XVIIe siècle (Paris: Réunion des musées nationaux, 1988)

Ricci, Corrado, *Beatrice Cenci* (Milan: Fratelli Treves, 1923)

Richardson, A. E., 'Seventeenth-Century Buildings in Search of an Architect', *Journal for the Royal Institute of British Archives,* XL (1993), 624–634

Rinehart, Sheila, 'Cassiano dal Pozzo (1588–1657): Some Unknown Letters', *Italian studies* XVI (1961), 35–59

Ripa, Cesare, *Iconologia, overo Descrittione d'imagini dell'virtù vitij, affeti, passioni humane, corpi celesti, mondo e sue parti* (Padua: P. P. Tozzi, 1611)

Rodis-Lewis, Geneviève, *Descartes* (Paris: Calmann-Lévy), 1995)

Roma sancta. La città delle basiliche, ed. Marcello Fagiolo and Maria Luisa Madonna, (Rome: Gangemi editore, 1985)

Roma dei Longhi. Papi e architetti tra manierismo e barocco (La), exhibition cat., ed. M. Fagiolo (Rome: De Luca, 1982)

Roma 1630. Il trionfo del pennello, exhibition cat., ed. O. Bonfait (Milan: Electa, 1994)

Rosa, Salvator, *Poesie e lettere edite e inedite* ... 2 vols (Naples: Tip. della Regia Universitá, 1892).

Rosci, Marco, *Orazio Gentileschi* (Milan: Fratelli Fabbri, 1965)

Rosenberg, Pierre, "'La main d'Artémise', *Paragone* XXII (1971) (261), 69–70

Rosenberg, Pierre, Prat, Louis-Antoine, *Nicolas Poussin* (Paris: Réunion des musées nationaux, 1994)

Rossi, Massimiliano, 'Capricci, frottole e tarsie di Michelangelo Buonarroto il Giovane', *Studi seicenteschi* XXXVI (1995), 151–180

Rubens, Peter Paul, *The Letters*, ed. Ruth Saunders Magurn (Evanston: Northwestern University Press, 1991)

Ruffo, Vincenzo, 'La galleria Ruffo nel secolo XVII in Messina', *Bollettino d'Arte* X (1916), 21–64, 95–128, 165–192, 237–256, 284–320, 369–388

Ruggiero, Guido, *The Boundaries of Eros: Sex, Crime and Sexuality in Renaissance Venice* (New York and Oxford: Oxford University Press, 1985)

Ruotolo, Renato, 'Collezioni e mecenati napolitani del XVII secolo', *Napoli nobilissima* XII (1973), 118–119, 145–153

Ruotolo, Renato, 'Aspetti del collezionismo napoletana: il cardinale Filomarino', *Antologia delle Belle Arti* I (1977), 71–82

Ruotolo, Renato, *Mercanti-collezionisti fiamminghi a Napoli. Gaspare Roomer e i Vandeneyden* (Naples: 1982)

Russell, Conrad, *The Origins of the English Civil War* (London: Macmillan, 1973)

Russell, H. Diane, *Jacques Callot, Prints and Related Drawings* (Washington D.C.: National Gallery of Art, 1975)

Russell, H. Diane, *Claude Lorrain, 1600–1692,* (Washington D.C.: National Gallery of Art, 1982)

Sainsbury, William N., *Original Unpublished Papers Illustrative of the Life of Sir Peter Paul Rubens as an Artist and Diplomatist* (London: Bradbury and Evans, 1859)

Sainsbury, William N., 'Artists' Quarrels in Charles I's Reign', *Notes and Queries* VIII (1859), 121–122

Sainte Bible (La) (Paris: Éditions du Cerf, 1991)

Salerno, Luigi, 'Cavaliere d'Arpino, Tassi, Gentileschi and Their Assistants. A Study of Some Frescoes in the Villa Lante, Bagnaia', *Connoisseur* CVLVI (1960), 157–162

Salerno, Luigi, 'The Picture Gallery of Vincenzo Giustiniani', *Burlington Magazine* CII (1960), 21–27, 93–104, 135–150

Salerno, Luigi (ed.), *Palazzo Rondanini* (Rome: De Luca, 1965)

Salerno, Luigi, 'Poesia e simboli nel Caravaggio: i dipinti emblematici', *Palatino* X (1966), 106–112

Salerno, Luigi, *L'Opera completa di Salvator Rosa* (Milan: Rizzoli, 1975)

Salerno, Luigi, 'Il dissenso nella pittura. Intorno a Filippo Napoletano, Caroselli, Salvator Rosa e altri', *Storia dell'Arte* (1970) (5), 35–65

Salerno, Luigi, 'Il vero Tassi e il vero Filippo Napoletano', *Storia dell'Arte* (1970) (6), 139–150

Salerno, Luigi, *I dipinti del Guercino* (Rome: Ugo Bozzi, 1988)

Salerno, Luigi, *Pittori di paesaggio del 600 a Roma*, 3 vols (Rome: U. Bozzi, 1977–1978)

Salmonson, Jessica Amanda, *The Encyclopedia of Amazons* (New York: Doubleday, 1991)

Salvagnini, Gigi, *Il 'teatro adattabile' dei granduchi medicei* (Florence: G. Capponi, 1983)

Samek Ludovici, Sergio, *Vita del Caravaggio dalle testimonianze del suo tempo* (Milan: Ed. Del Milione, 1956)

Sandrart, Joachim von, *Academie Bau-, Bild- und Mahlerey-Künste*, Commentary by A. R. Peltza (Farnborough, Hants: Gregg, 1971)

Sarrazin, Béatrice, *Catalogue raisonné des peinteures italiennes du Musée des beaux-arts de Nantes,* (Paris: Réunion des musées nationaux, 1994)

Saward, Susan, *The Golden Age of Maria de'Medici* (Ann Arbor: UMI Research Press, 1982)

Savini Branca, Simona, *Il collezionismo veneziano nel 600* (Florence: Leo S. Olschki, 1964)

Scavizzi, G., 'Cerquozzi, Michelangelo, in *Dizionario Biografico degli Italiani*, vol. 23 (Rome: Istituto dell'Enciclopedia Italiani, 1979), 801–805

Scavizzi, G., 'Codazzi, Viviano' in *Dizionario Biografico degli Italiani*, vol.26 (Rome: Istituto dell'Enciclopedia Italiana, 1982), 578–580

Schiffano, Jean-Noel, *Naples* (Paris: Gallimard, 1981)

Schiffano, Jean-Noel, *Chroniques napolitaines* (Paris: Gallimard, 1984)

Schleier, Erich, 'An Unknown Altar-Piece by Orazio Gentileschi',

Burlington Magazine CIV (1962), 433–436

Schleier, Erich, 'Panico, Gentileschi and Lanfranco at San Salvatore in Farnese', *Art Bulletin* LII (1970), 172–182

Schleier, Erich, 'Les projets de Lanfranc pour le décor de la Sala Regia au Quirinal et pour la loge des Bénédictions à Saint-Pierre', *Revue de l'art* (1970)(7), 40–67

Schleier, Erich, 'Pintura italiana del siglo XVII', *Kunstchronik* XXIII (1970), 341–349

Schleier, Erich, 'Caravaggio e Caravaggeschi nelle Gallerie di Firenze: Sur Ausstellung im Palazzo Pitti, Sommer, 1970', *Kunstchronik* XXIV (1971) (4), 85–112

Schnapper, Antoine, *Curieux du Grand Siècle: collections et collectionneurs dans la France du XVIIᵉ siècle,* (Paris: Flammarion, 1994)

Schreiber, Roy E., *The First Carlisle. Sir James Hay, First Earl of Carlisle as Courtier, Diplomat and Entrepreneur, 1580–1636* (Philadelphia: The American Philosophy Society, 1984)

Schutze, Sebastian, Willette, Thomas C., *Massimo Stanzione: l'opera completa* (Naples: Electa, 1992)

Scott, John Beldon, *Images of Nepotism. The Painted Ceilings of Palazzo Barberini* (Princeton, Princeton University Press, 1991)

Scott, John Beldon, 'The Art of the Painter's Scaffold, Pietro da Cortona in the Barberini Salone,', *Burlington Magazine* CXXXV (1993), 327–337

Scott, Jonathan, *Salvator Rosa,* (New Haven & London: Yale University Press, 1995)

Seicento: le siècle de Caravage dans les collections françaises, exhibition cat. (Paris: Réunion des musées nationaux, 1988)

Seicento europeo: Realismo, Classicismo e Barocco (Il), (Rome: De Luca, 1967, 2nd edn)

Seicento fiorentino: arte a Firenze de Ferdinando I a Cosimo III (Il), exhibition cat. (Florence: Cantini, 1986)

Seicento (Rencontres de l'École du Louvre, Documentation française, 1990

Sells, Arthur Lytton, *The Paradise of Travellers. The Italian Influence on Englishmen in the Seventeenth century*, (London: Allen and Unwin, 1964)

Settanta pitture sculture del 600 e 700 fiorentino, exhibition cat., ed. M. Gregori. (Florence: Officine tipografiche Vallecchi, 1965)

Shakeshaft, Paul, 'Documents for the History of Collecting: I "To much bewiched with those intysing things": the Letters of James, third Marquis

of Hamilton and Basil, Viscount Feilding concerning collecting in Venice 1635–1639', *Burlington Magazine* CXXVIII (1986), 114–132

Sharpe, Kevin, 'The Earl of Arundel, his Circle and the Opposition to the Duke of Buckingham', in *Faction and Parliament* (Oxford: Oxford University Press, 1978)

Sharpe, Kevin, *The Personal Rule of Charles I* (New Haven: Yale University Press, 1992)

Shearman, John, 'Cristofano Allori's *Judith*', Burlington Magazine CXXI (1979), 3–10

Simon Vouet, papers from the conference at the Grand Palais, Paris, 5–7 Feb. 1991, publiés sour la direction de S. Loire (Paris: La Documentation française, 1992)

Smith, Logan P., *The Life and Letters of Sir Henry Wotton*, 2 vols (Oxford: 1907)

Solerti, Angelo, *Musica, ballo e drammatica alla Corte Medicea dal 1600 al 1637* (Bologna: Forni ed., 1969)

Solinas, Franceso, 'Cassiano dal Pozzo (1588–1657): il ritratto di Jan Van den Hoecke e l'*Orazione* di Carlo Dati', *Bollettino d'Arte* LXXX (1995), 141–164

Soprani, Raffaello, *Le vite de'pittori, scoltori, et architetti genovesi . . .* (Genoa: G. Bottaro G. B. Tiboldi, 1674)

Sparti, Donatella L., *Le Collezioni dal Pozzo. Storia di una famiglia e del suo museo nella Roma seicentesca*, (Modena: F. C. Panini, 1992)

Spear, Richard E., *Caravaggio and His Followers*, exhibition cat. (Cleveland, Ohio: The Cleveland Museum of Art, 1971)

Spear, Richard E., 'The Pseudo-Caravaggisti', *Art News* 70 (1971), 38–41, 93–96

Spear, Richard E., 'Unknown Pictures by the Caravaggisti (with Notes on "Caravaggio and His Followers"), *Storia dell'Arte* (1972) (14), 149–161

Spear, Richard E., 'Studies in Conservation and Connoisseurship: Problematic Paintings by Manfredi, Saraceni, and Guercino', *Dayton Art Institute Bulletin* 34 (1975), 5–19

Spear, Richard E., *Domenichino*, 2 vols (New Haven and London: Yale University Press, 1982)

Spear, Richard E., 'Domenichino addenda', *Burlington Magazine* CXXXI (1989), 5–16

Spear, Richard E., 'Guercino's "prix fixe": observations on studio practices

and art marketing in Emilia', *Burlington Magazine* CXXXI (1994), 590–602

Specchio di Roma Barocca. Una guida inedita del XVII secolo, J. Connors and L. Rice (Rome: ed. dell'Elefante, 1990)

Spezzaferro, Luigi, 'La cultura del cardinal Del Monte e il primo tempo del Caravaggio', *Storia dell'Arte* (1971) (9–10), 57–92

Spezzaferro, Luigi, 'Un imprenditore del primo Seicento: Giovan Battista Crescenzi', *Ricerche di storia dell'arte* (1985)(26), 50–73

Spezzaferro, Luigi, 'Il recupero del Rinascimento', in *Storia dell'Arte italiana* p.2, vol.II, 1, *Cinquecento e Seicento* (Turin: Einaudi, 1981), 185–279

Spike, John T., *Italian Baroque Paintings from New York Private Collections*, (Princeton, N.J.: Art Museum, Princeton University Press, 1980)

Spike, John T., *Italian Still-Life Paintings from Three Centuries* (Florence: National Academy of Design and Old Masters Exhibition Society of New York, Centro Di, 1983)

Spike, John T., 'Orazio Gentileschi and the Poetic Tradition in Caravaggesque Painting – Book Review', *The Art Bulletin* LXVI (1984), 696–698

Spike, John T., 'Florence, Casa Buonarroti, Artemisia Gentileschi', *Burlington Magazine* CXXXIII (1991), 732–734

Spink, Ian, 'Nicholas Lanier in Italy', *Music and Letters* XL (1959), 242–252

Spink, Ian, 'Nicholas Lanier', in *The New Grove Dictionary of Music and Musicians*, ed. Stanley Sadie, vol.3 (London: Macmillan, 1980), 454–455

Spink, Ian, *English Song: Dowland to Purcell* (London: Batsford, 1974)

Splendours of the Gonzaga, exhibition cat., ed. D. Chambers and J. Martineau (London: Victoria and Albert Museum, 1981)

Springhall, Francis C., *Connoisseur and Diplomat* (London: Maggs Bros., 1963)

Stanze del Cardinale Monti, 1635–1650 (Le), (Milan: Leonardo Arte, 1944)

Starkey, David, *The English Court from the Wars of the Roses to the Civil War* (London: Longman, 1993)

Starobinski, Jean, *L'Œil vivant* (Paris: Gallimard, 1975)

Stato società e giustizia nella Repubblica Veneta (sec. XV–XVIII), ed. Gaeteno Cozzi (Rome: Jouvance, 1980)

Stendhal, *Chroniques italiennes*, (Paris: Garnier-Flammarion, 1977)

Stendhal, *Nouvelles romaines* (Paris: Le Seuil, 1994)

Stendhal, *Promenades dans Rome*, ed. V. Del Litto, (Grenoble: J. Millon, 1993)

Sterling, Charles, 'Gentileschi in France', *Burlington Magazine* C (1958), 110, 112–121

Sterling, Charles, 'Une nouvelle œuvre de Gentileschi peinte en France', *La Revue du Louvre et des Musées de France* XIV (1964), 217–220

Stolzenwald, Susanna, *Artemisia Gentileschi. Bindung und Befreiung in Leben und Werk einer Malerin* (Stuttgart, Zurich: Belser Verlag, 1991)

Storia dell'arte italiana, p. I. *Materiali e problemi,* 2 vols, *L'artista e il pubblico* (Turin: Giulio Einaudi editore, 1979)

Strazzullo, F., *La corporazione dei pittori napoletani* (Naples: D'Agostino, 1962)

Strazzullo, F., 'Le collezione artistiche del duca di Sant'Elia (1716), *Napoli nobilissima* XXIX, (1990), 28–35

Strinati, Claudio, 'Un quadro di Orazio Gentileschi a Genova', *Ricerche di storia dell'arte* (1976)(1–2), 189–196

Summerson, John, *Inigo Jones* (Harmondsworth: Penguin Books, 1966)

Tableaux français et italiens du XVII^e siècle, exhibition cat. (Paris: Réunion des musées nationaux, 1982)

Talley, M. K., *Portrait Painting in England. Studies in Technical Literature before 1700* (n.p.: 1981)

Tanfani Centofanti, Leopoldo, *Notizie di artisti tratte dai documenti pisani* (Pisa: E. Spoerri, 1987)

Tappi-Cesarini, Anselmo, 'Il pittore Orazio Lomi Gentileschi a Farfa (1597)', *Benedictina* VI (1952), 329–333

Tarabotti, Arcangela [pseud. Galerana Baratotti], *La semplicità ingannata, o Tirannia paterna* (Leiden: G. Sambix, 1654)

Tarde, Jean, *À la rencontre de Galilée, Deux voyages en Italie,* ed. F. Moureau (Geneva: Slatkine, 1984)

Tasso, Torquato, *La Jérusalem délivrée,* ed. Jean-Michel Gardair (Paris: Livre de poche, 1997)

Thuillier, Jacques, 'Un peintre passionné', *L'Œil,* n° 47 (Nov. 1958), 26–33

Thuillier, Jacques, *Rubens' Life of Marie de'Medici,* with a catalogue and a documentary history by Jacques Foucart (New York: H. N. Abrams, 1967)

Thuillier, Jacques, *Nicolas Poussin* (Paris: Fayard, 1988)

Thuillier, Jacques, *Propos sur Latour, Le Nain, Poussin, Le Brun* (Paris: Réunion des musées nationaux, 1991)

Thuillier, Jacques, '"La Galerie de Médicis" de Rubens et sa genèse: un document inédit', *Revue de l'Art* (1969)(4), 52–62

Tiberia, Vitaliano, 'Una notizia sul Gentileschi e sugli altri pittori alla Madonna dei Monti', *Storia dell'Arte* (1973) (18), 181–184

Toesca, Ilaria, 'Un documento del 1595 sul Gentileschi', *Paragone* IX (1960)(123), 59–60

Toesca, Ilaria, 'Versi in lode di Artemisia Gentileschi', *Paragone* XXII (1971)(251), 89–92

Tolnay, Charles de, *Casa Buonarroti* (Florence: Ed. Arnaud, 1970)

Trapier, Elizabeth du Gué, *Ribera* (New York: Hispanic Society of America, 1952)

Trapier, Elizabeth du Gué, 'Sir Arthur Hopton and the Interchange of Paintings between Spain and England in the Seventeenth Century, part 1', *Connoisseur* CLXIV (1967), 239–243

Travels through France and Italy, ed. Luigi Monga (Geneva: Slatkine, 1987)

Trevor-Roper, Hugh R., *The Plunder of the Arts in the Seventeenth Century* (London: Thames and Hudson, 1970)

Tufts, Eleanor, *Our Hidden Heritage: Five Centuries of Women Artists* (New York, London and Toronto: Paddington Press, 1974)

Turcic, Lawrence, Newcome, Mary, 'Drawings by Aurelio Lomi', *Paragone* XLII (1991)(499), 33–46

Turner, Nicholas, 'A Newly Discovered Painting by the Cavaliere d'Arpino', *Burlington Magazine* CXIX (1977), 710–713

Turquet de Mayerne, Theodor, *Pittura, scultura e delle Arti minori, 1620–1646,* ed. S. Rinaldi (Anzio: De Rubeis, 1995)

Tutto Caravaggio, ed. F. Cappelletti (Rome: Rotundo, 1988)

Ultimo Caravaggio e la cultura artistica a Napoli in Sicilia e a Malta (L'), ed. Maurizio Calvesi (Syracuse: Editprint, 1987)

Valentin et le Caravagesque français, exhibition cat., ed. Arnaud Brejon de Lavergnée (Paris: Réunion des musées nationaux, 1974)

Van der Doort, Abraham, 'Catalogue of the Collections of Charles I', ed. Oliver Millar, *Walpole Society* XXXVII (1960), XI–XXIV, 1–235

Van Dyck a Genova. Grande pittura e collezionismo, exhibition cat., ed. S. J. Barnes, P. Boccardo, C. Di Fabio, L. Tagliaferro (Milan: Electa, 1997)

Varagine, Jacques de, *La Légende dorée* (Paris: Garnier-Flammarion, 1993)

Vasari, Giorgio, *Le vite de' più eccellenti pittori, scultori e architetti scritte di nuovo ampliate da Giorgio Vasari pittore et architetto aretino* (Florence: I. Giunti, 1568)

Veevers, Erica, *Images of Love and Religion. Queen Henrietta Maria and Court Entertainments* (Cambridge: Cambridge University Press, 1989)

Vertue, George, 'The Note Books of George Vertue relating Artists and Collections in England', *Walpole Society* XXIV (1935–1936)

Vigarello, Georges, *Histoire du viol* (Paris: Le Seuil, 1998)

Villari, Rosario, ed., *L'Uomo barocco* (Rome: Laterza, 1991)

Visite reali a Palazzo Pitti: Ritratti dal XVI al XVII secolo, exhibition cat., ed. Marco Chiarini and Maddalena De Luca Savelli (Florence: Centro Di, 1995)

Vitzthum, Walter, 'Lanfranco at the Quirinal: two new documents', *Burlington Magazine* CVII (1965), 468–471

Vliegenthart, Adrian W., *La Galleria Buonarroti e Michelangelo il Giovane* (Florence: Istituto Universitario Olandese di Storia d'Arte, 1976)

Voss, Hermann, 'Artemisia Gentileschi', in *Allgemeines Lexikon der bildenden Künstler von der Antike bis zur Gegenwart; unter Mitwirkung von 300 Fachgelehrten des In- und Auslandes,* Ulrich Thieme and Felix Becker, eds, (Leipzig: Seeman, 1920) vol. 13, 408–409

Voss, Hermann, 'Letter of expertise for Orazio Gentileschi's *Judith and Her Maidservant* at Hartford, Conn.' 11 January, 1949.

Voss, Hermann, 'Orazio Gentileschi: Four Versions of His "Rest on the Flight into Egypt"', *Connoisseur* CXLVI (1959), 163–164

Voss, Hermann, '*Venere e Amore* di Artemisia Gentileschi', *Acropoli* I (1960–1961), 79–82

Voss, Hermann, 'La cappella del Crocifisso di Orazio Gentileschi', *Acropoli* I (1960–1961), 99–107

Vouet, ed. J. Thuillier, B. Brejon de Lavergnée and D. Lavalle (Paris: Réunion des musées nationaux, 1990)

Voyage d'Italie, 1606, ed. Michel Bideau (Geneva: Slatkine, 1981)

Waddingham, Malcolm, '"Artisti alla corte Granducale" at Palazzo Pitti', *Burlington Magazine* CXI (1969), 639–641

Waddy, Patricia, *Seventeenth Century Roman Palaces. Use and the Art of Plan* (New York: The Architectural History Foundation, 1990)

Walpole, Horace, *Anecdotes of Painting in England,* 4 vols (London: Printed for J. Dodsley, 1782) (3rd edn)

Van Dyck 350 (Washington: Trustees of the National Gallery of Art, 1994)

Ward, M. A. J., 'The Accademia del Disegno in Sixteenth-Century Florence: A Study of an Artists' Institution', (Ph.D. dissertation, University of Chicago, 1972)

Wark, R. R., 'Notes on Van Dyke's *Self-Portrait with a Sunflower*', *Burlington*

Magazine XCVIII (1956), 53–54

Waterhouse, Ellis, *Baroque Painting in Rome. The Seventeenth Century* (London: Macmillan & Co., 1937)

Waterhouse, Ellis, 'Paintings from Venice for XVIIth Century England', *Italian Studies* VII (1952), 1–23

Waterhouse, Ellis, 'Some Old Masters other than Spanish at the Bowes Museum', *Burlington Magazine* XCV (1953), 120–123

Waterhouse, Ellis, *Italian Baroque Painting* (London: Phaidon, 1962)

Waterhouse, Ellis, *Paintings in Britain, 1530–1790* (New Haven: Yale University Press, 1994)

Watson, D. R., *The Life and Times of Charles I* (London: Weidenfeld and Nicolson, 1972)

Wazbinski, Zygmunt, *Il Cardinale Francesco Maria del Monte, 1549–1626*, 2 vols (Florence: Leo S. Olschki, 1994)

Wazbinski, Zygmunt, *L'Accademia Medicea del Disegno a Firenze*, (Florence: Leo S. Olschki, 1997)

Weaver, E. B., 'Le muse in convento. La scrittura profana delle monache italiane (1450–1650)', in *Donne e fede. Santità e vita religiosa in Italia*, ed. L. Scaraffia and G. Zarri (Rome-Bari: Laterza, 1994), 253–276

Wedgwood, Cicely V., *The Great Rebellion,* I. *The King's Peace, 1637–1641,* II. *The King's War, 1641–1647* (London: Collins, 1955–1958)

Wedgwood, Cicely V., *Poetry and Politics under the Stuarts* (Ann Arbor, Mich.: The University of Michigan Press, 1964)

Wethey, Harold E., 'Borgianni, Orazio', in *Dizionario Biografico degli Italiani,* vol.12 (Rome: Istituto dell'Enciclopedia Italiana, 1970), 744–747

Wethey, Harold E., 'Orazio Borgianni in Italy and Spain', *Burlington Magazine* CVI (1964), 147–159

Whinney, Margaret, Millar, Oliver, *English Art, 1625–1714* in *Oxford History of English Art*, vol.VIII (Oxford: Clarendon Press, 1957)

Williamson, Hugh Ross, *Four Stuart Portraits* (London: Evans Brothers, 1949)

Wilson, Michael I., *Nicholas Lanier, Master of the King's Music* (Aldershot: Scolar Press, 1994)

Wittkower, Rudolf, *Arte et architecture en Italie, 1600–1750* (Paris: Hazan, 1991)

Wittkower, Rudolf, Wittkower, Margot, *Les Enfants des Saturne* (Paris: Macula, 1991)

Woodhouse, J. R., *Baldescar Castiglione: A Reassessment of 'The Courtier',* (Edinburgh: Edinburgh University Press, 1978)

Young, Elizabeth and Wayland, *Old London Churches* (London: Faber and Faber, 1956)

Zanette, Emilio, *Suor Arcangela monaca del XVII veneziano* (Rome–Venice: Istituto per la collaborazione culturale, 1960)

Zanetti, Girolamo, F., *Elogio di Rosalba Carriera letto in une privata sessione dell'Accademia di Belle Lettere ed Arti in Padova il di 6 dicembre 1781* (Venice: Ed. tip. Alvisopoli, 1818)

Zapperi, Roberto, *Annibale Carracci* (Aix–en–Provence: Alinéa, 1990)

Zeri, Federico, *La Galleria Spada in Roma. Catalogo dei dipinti* (Florence: Sansoni, 1954)

Zeri, Federico, The Pallavicini Palace and Gallery in Rome, I. The Palace', *Connoisseur* CXL (1955), 184–190

Zeri, Federico, *La Galleria Pallavicini in Roma. Catalogo dei dipinti* (Florence: Sansoni, 1959)

Zeri, Federico, *Pittura e controriforma. L'arte tra 'senza tempo' di Scipione da Gaeta,* 1957 (Turin: Einaudi, 1970)

Zeri, Federico, *Italian Paintings. Florentine School. A catalogue of the Collection of the Metropolitan Museum of Art* (New York: New York Graphic Society, 1971)

Zeri, Federico, *Italian Paintings in the Walters Gallery*, 2 vols (Baltimore: The Trustees, 1976)

Zorzi, Alvise, *La Vita quotidiana a Venezia nel secolo di Tiziano* (Milan: Rizzoli, 1990)

Zuccari, Federico, *L'Idea de'pittori, scultori ed architetti* (Turin: Agostino Disserolo, 1607)

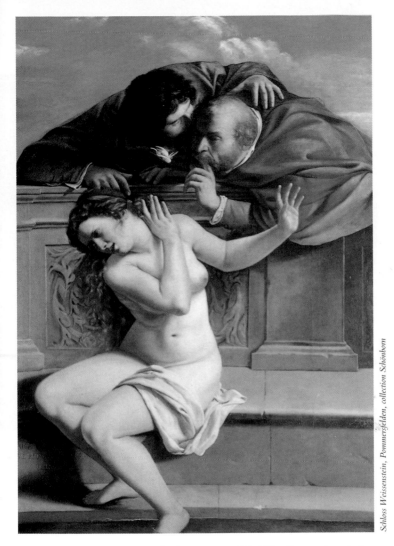

1. Artemisia and Orazio Gentileschi, *Susanna and the Elders* (Rome, *circa* 1610)

The inscription at the bottom left of this painting – *'Artemisia Gentileschi F. 1610'* – raises a number of questions. In 1610, Artemisia was just seventeen. Can one reasonably attribute a work of this quality to someone so young? Some art historians believe the date to be wrong. Others question the signature and suggest that Artemisia was helped by her father Orazio. '1610': this is still the period of innocence in her life, before the rape. Could the Gentileschis have deliberately given this masterpiece an earlier date and signed it with the name of a child prodigy – Artemisia – in order to show the world how talent had been profaned, and to obtain justice in the 1612 trial? There is an interesting detail: in contrast to the bible story, here the men who seek to possess Susanna are not two old men. One of them has beautiful brown curls – as did Agostino Tassi, Artemisia's rapist.

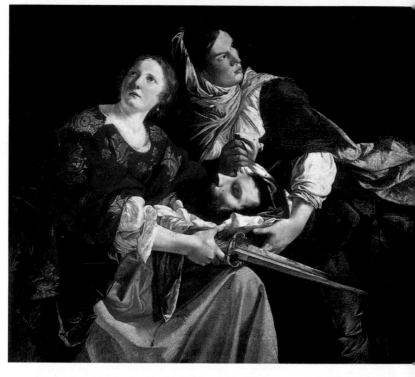

2. Artemisia or Orazio Gentileschi, *Judith and Her Maidservant with the Head of Holofernes* (Rome, *circa* 1612)

There are several versions of this composition, notably another very beautiful *Judith* attributed to Orazio. This particular painting, which seems the most juvenile and clumsy, could be the one that was cunningly taken from Artemisia by Tassi and Quorli – the stolen *Judith* that was among the causes of the 1612 rape trial.

3. Artemisia Gentileschi, *Judith Slaying Holofernes* (Rome, *circa* 1612)

This painting, executed in Rome at the time of the rape trial and the torture of Artemisia, is probably her most famous work. She uses a composition that is familiar from Caravaggio's painting on the same subject, but the violence and realism of Artemisia's interpretation, the depiction of the servant who leans on the stomach of the victim, and that of Judith who calmly slits the tyrant's throat, suggest that the painter is settling personal scores. Some admirers of this painting have thought they have seen in the decapitated head of Holofernes a resemblance to Artemisia's false lover, Agostino Tassi.

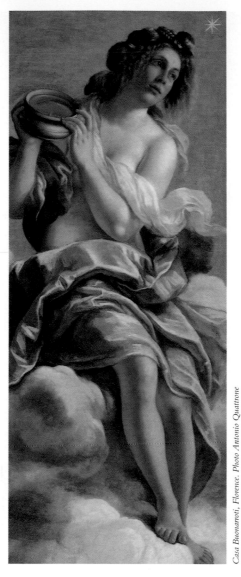

Casa Buonarroti, Florence. Photo Antonio Quattrone

4. Artemisia Gentileschi, *Allegory of Inclination* (Florence, *circa* 1615)

Commissioned by the great-nephew of Michelangelo, this painting formed part of a series of works representing the artistic virtues. These were to decorate a ceiling glorifying the memory of Buonarroti the Younger's illustrious ancestor. In the painting, Artemisia audaciously depicted herself completely naked. An object of desire for men and the subject of her own paintings, she alluded to the beauty of her body and her genius as a painter. Some years later, however, the more modest inheritor of the painting had drapery painted over the body of this far too tempting seductress.

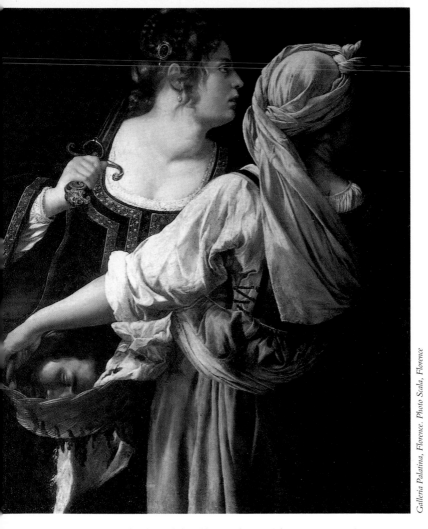

5. Artemisia Gentileschi, *Judith and her Maidservant* (Florence, *circa* 1615)

Acquired by the Grand Duke Cosimo II de' Medici, this painting still has pride of place on the walls of the Palazzo Pitti in Florence. It is possible that Artemisia copied the profile of Michelangelo's famous *David*. However she varied the theme of the justice-giver by replacing David's sling with Judith's sword. The jewels in the heroine's hair very probably belonged to Artemisia since they appear in several of her paintings.

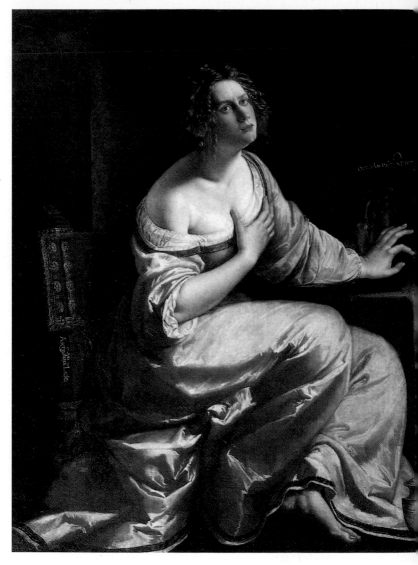

6. Artemisia Gentileschi, *The Penitent Magdalen* (Florence, *circa* 1615)

The richness of the colours in this painting, the sumptuousness of the dress and the low décolleté suggest an invitation to pleasure and sin, rather than a rejection of vanity. The saint renounces the world, but Artemisia's heroine turns towards the viewer. The signature on the back of the chair, Artemisia Lomi' – no longer Gentileschi – is typical of the Florentine period when Artemisia was trying to distinguish herself from her father. The Latin inscription on the mirror, 'Optimam partem elegit', seems to prove that Artemisia now knew how to read and write.

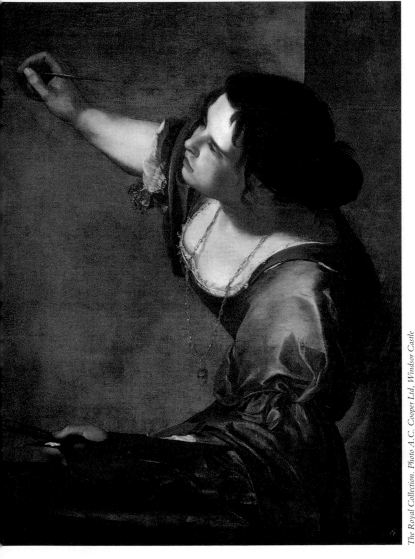

7. Artemisia Gentileschi, *Self Portrait as the Allegory of Painting* (Naples, *circa* 1630)

In order to paint herself almost in profile, in this acrobatic position, Artemisia used a clever arrangement of mirrors. The fact that the artist depicts herself, not sitting in front of her canvas in her best clothes, calmly looking out at the viewer, but in overalls, her sleeves pushed up to the elbows and her hair undressed, is highly original in the history of the self-portrait. She gives herself over entirely to the struggle in hand. However, the most surprising thing is not the treatment of the self-portrait but the fact that it is an allegory. The gold chain, the mask, the shimmering dress are all attributes recommended by the treatises on iconography for the representation of 'Painting'.

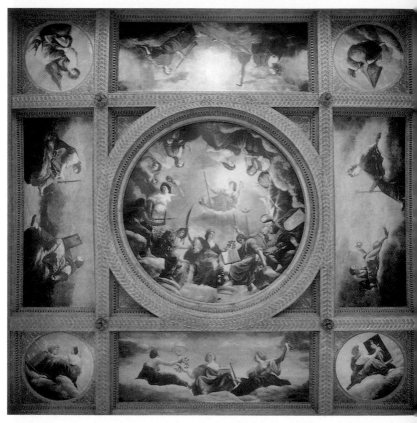

8. Artemisia and Orazio Gentileschi, *Allegory of Peace and the Arts under the English Crown* (London, *circa* 1639)

In this series of nine canvases commissioned for the ceiling of the central hall at the Queen's House, Greenwich, it is difficult to separate the hand of the father from that of the daughter. Both knew perfectly how to adapt their art to the tastes of their patrons. The English Court, to which the dying Orazio summoned Artemisia, was steeped in an atmosphere of artifice and pleasure as it teetered on the brink of the abyss. The Puritans' first great gesture was to destroy the paintings of the Catholic idolators. Many were thrown into the Thames. This last great work of the Gentileschis, however, escaped destruction. Today it decorates the ceiling of the entrance hall at Marlborough House.

9. Van Dyck, *Orazio Gentileschi* (drawing)

Gentileschi and Van Dyck met in Genoa fifteen years before the execution of this portrait. They later re-encountered each other in London. Here, Van Dyck immortallses his old rival in all his splendour as court painter to Charles I.

10. Pierre Dumonstier le Neveu, Drawing of Artemisia's hand

In 1625, Artemisia's reputation was so great that foreign painters considered it an honour to meet her in Rome. A French artist commemorated the emotion of his visit by drawing her hand holding a paintbrush.

11. Artemisia's signatures

Artemisia signed herself '*Artemisia Gentileschi*' until 1612 and the scandalous rape trial. When she married she moved to Florence, where she lived from 1613 to 1620 and built a career without her father. There she signed herself '*Artemisia Lomi*'. Lomi is not, however, her husband's name, but that of her paternal grandfather. After her separation from her husband in 1622, she reverted to '*Gentileschi*'. By that stage she felt strong enough to enjoy the honour of the name that had previously been tainted with shame.

12. Anonymous, Medal of
Artemisia Gentileschi

13. Jérôme David,
Engraved portrait of Artemisia Gentileschi

This engraving, a copy of a self-portrait
by Artemisia, must have been made in
Rome around 1625. The inscription
under the signature of the artist
pronounces that it is easier to envy
Artemisia, a miracle in painting, than to
imitate her. The border describing her as
a member of the Accademia del Desiosi
is even more flattering, since this
academy welcomed only great
scholars and learned men.

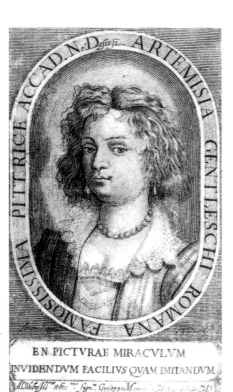

14. Van Dyck, *Nicholas Lanier*

Musician at the court of Charles I,
Lanier negotiated in Venice what his
contemporaries called the 'sale of the
century'. He was very in love with
Artemisia Gentileschi.

15. Agostino Tassi, *Seascape*

For thirty years, Artemisia's
first lover painted frescoes on
the walls of Rome's most
beautiful palaces. Agostino
Tassi employed a huge
workforce and specialised in
painting 'seascapes' in all
sizes. Paintings like this one
of boats in harbour or run
aground on the shore gave
rise to a fashion for painting
landscapes with complex
perspectives. Agostino Tassi
was one of the first artists to
paint nature in the open air.
He influenced Claude
Gellée, *dit* Claude Lorrain.

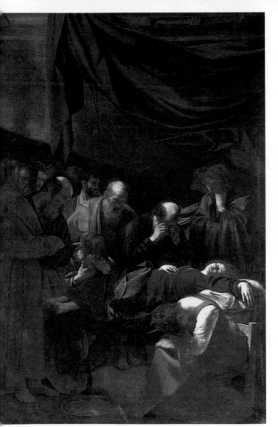

16. Caravaggio,
Death of the Virgin

Bought secretly in Venice by
Nicholas Lanier for Charles
I, this canvas was sold after
Charles I's execution. It is
now in the Louvre.

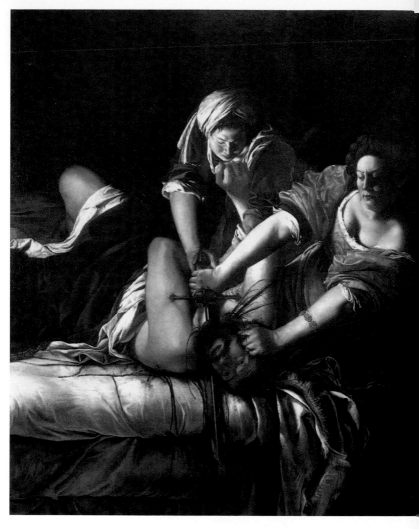

17. Artemisia Gentileschi, *Judith Slaying Holofernes* (second version)

This *Judith* is a more flamboyant, sumptuous version of the painting that made Artemisia's name. Commissioned by the Grand Duke of Tuscany, it echoes in its colours the work of another great painter of the period, Artemisia's friend Cristofano Allori, who has been thought by some to have been her lover.

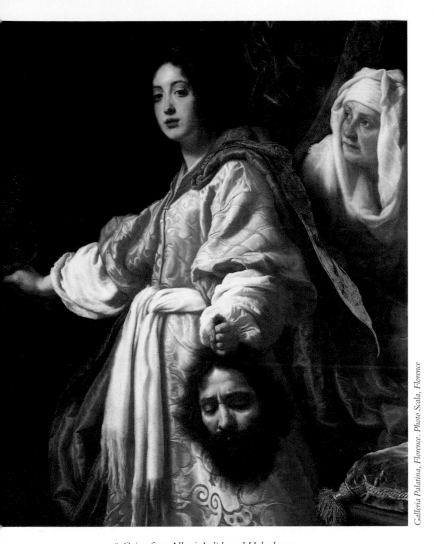

18. Cristofano Allori, *Judith and Holophernes*

Like Artemisia, Cristofano Allori used the theme of Judith to tell his own story. The splendid female figure with the hard look and cruel mouth represented a woman he loved and who tortured him. He painted himself as the victim: Holofernes. Artemisia also painted herself into her own paintings. But triumphant – as Judith. Were Cristofano and Artemisia seeking to revenge themselves for their unhappy love affairs?

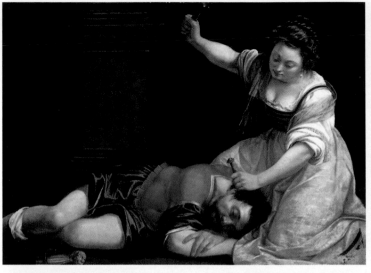

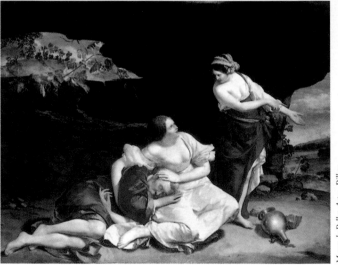

19. Artemisia Gentileschi, *Jael and Sisera*
20. Orazio Gentileschi, *Lot and his Daughters*

The position of Artemisia's Sisera, lying between Jael's knees, strangely echoes that of Orazio's Lot asleep in his daughter's arms. In Artemisia's painting, however, the woman hammers a nail into the temple of the sleeper, while in Orazio's painting she gently caresses her father's head. In their paintings, Orazio and Artemisia often reinterpreted themes that were dear to the other. In *Lot and his Daughters,* the story of two young women who lust after an old man reverses the subject that Artemisia was so fond of. *Susanna* – the story of two old men who lust after a young woman.

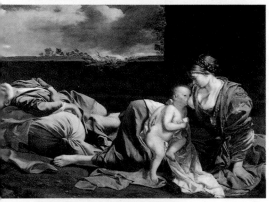

21. Orazio Gentileschi,
Saint Cecilia and the Angel

22. Orazio Gentileschi,
The Rest on the Flight into Egypt

23. Orazio Gentileschi, *The Lute Player*

These paintings give off a moving sense of harmony, tenderness and poetry which is in direct contrast to the dramatic canvases of Artemisia.

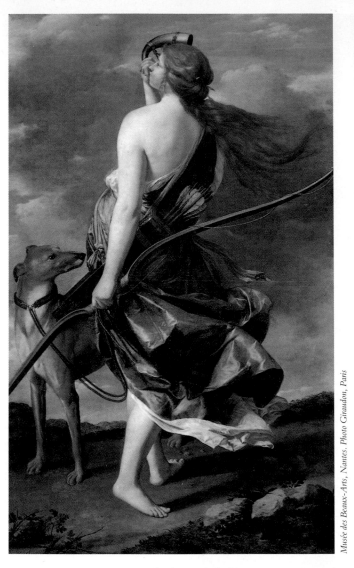

24. Orazio Gentileschi, *Diana the Huntress*

Acquired in 1630 by the Duc de La Roche-Guyon, this painting is one of the few remaining
from Orazio's time in France. It is a wonderful example of his genius: the refinement of his
colours, the subtle rendering of the flesh which absorbs the light, the balance of the
composition, the virtuosity of its execution. As for the woman who sounds her horn in the
sunset, with her bronze hair blowing in the wind and the folds of her shimmering green tunic
clinging to her body, she recalls a familiar figure. For Diana is another name for Artemis.
Artemisia – the virgin goddess, eternally youthful, who fights fiercely against
monsters and triumphs over giants.